© 2000 Benedikt Taschen Verlag GmbH Hohenzollernring 53, D–50672 Köln www.taschen.com

© 2000 for the works by Charles & Ray Eames:
Eames Office, Venice, CA, www.eamesoffice.com
© 2000 for the works by Le Corbusier:
FLC/VG-Bild-Kunst, Bonn
© 2000 for the works by Mogens Andersen, Ingrid Atterberg, Bele Bachem, Barbara Brown, Paul Brown, Zephir Busine, Gunnar Cyrén, Eva Englund, Erik S. Höglund, Alf Jarnestad, René Lalique, Lisa Larson, Arne Lindaas, Stig Lindberg, Marino Marini, Roberto-Sebastian Matta Echaurren, Rolf Middelboe, Ludwig Mies van der Rohe, Tom Möller, Benny Motzfeldt, Ake Nilsson, Bengt Orup, Sigurd Persson, Erik Ploen, Axel Salto, Kurt Spurey, Göran Wärff: VG-Bild-Kunst, Bonn

Design: UNA (London) designers
Production: Marina Ciborowius, Cologne
Editorial coordination: Susanne Husemann, Cologne
© for the introduction: Charlotte and Peter Fiell, London
German translation by Uta Hoffmann, Cologne
French translation by Philippe Safavi, Paris

Printed in Italy ISBN 3-8228-6405-6

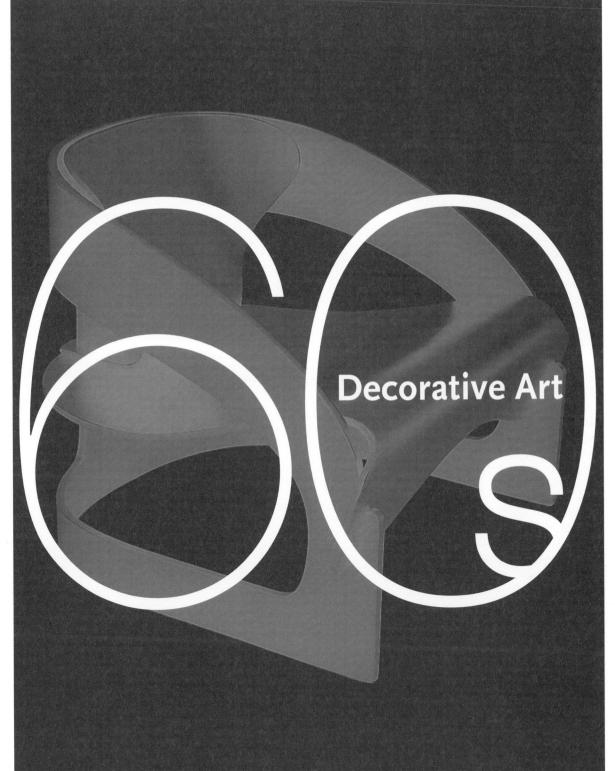

A source book edited by Charlotte & Peter Fiell

TASCHEN

KÖLN LONDON MADRID NEW YORK PARIS TOKYO

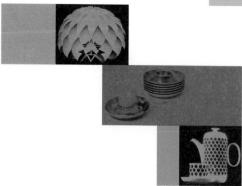

CONTENTS INHALT SOMMAIRE

preface Vorwort Préface	9
introduction Einleitung Introduction	13
houses and apartments Häuser und Apartments Maisons et appartements	26
interiors and furniture Interieurs und Möbel Intérieurs et mobilier	174
textiles and wallpapers Stoffe und Tapeten Textiles et papiers peints	298
glass Glas Verrerie	348
lighting Lampen Luminaires	416
silver and tableware Silber und Geschirr Argenterie et arts de la table	480
ceramics Keramik Céramiques	552
index Index	570

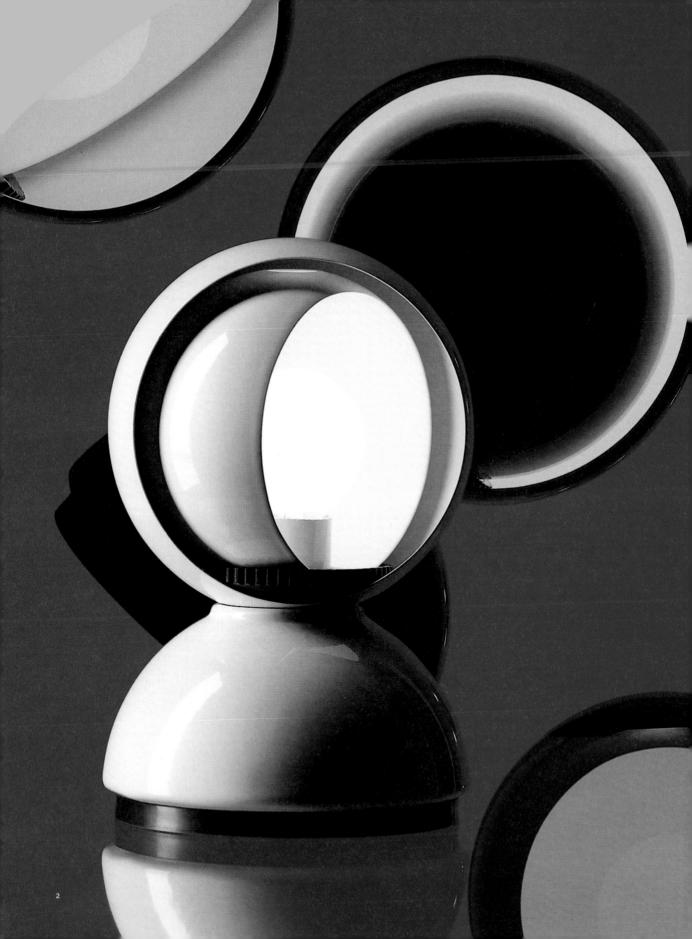

- 1. Wendell Castle, Molar sofa for Beylerian, 1969
- 2. Vico Magistretti, Eclisse lamp for Artemide, 1965
- 3. Enzo Mari, Selection of vases for Danese, 1968–1969

The "Decorative Art" Yearbooks

The Studio Magazine was founded in Britain in 1893 and featured both the fine and the decorative arts. It initially promoted the work of progressive designers such as Charles Rennie Mackintosh and Charles Voysey to a wide audience both at home and abroad, and was especially influential in Continental Europe. Later, in 1906, The Studio began publishing the Decorative Art yearbook to "meet the needs of that ever-increasing section of the public who take interest in the application of art to the decoration and general equipment of their homes". This annual survey, which became increasingly international in its outlook, was dedicated to the latest currents in architecture, interiors, furniture, lighting, glassware, textiles, metalware and ceramics. From its outset, Decorative Art advanced the "New Art" that had been pioneered by William Morris and his followers, and attempted to exclude designs which showed any "excess in ornamentation and extreme eccentricities of form".

In the 1920s, *Decorative Art* began promoting Modernism and was in later years a prominent champion of "Good Design". Published from the 1950s onwards by Studio Vista, the yearbooks continued to provide a remarkable overview of each decade, featuring avant-garde and often experimental designs alongside more mainstream pro-

ducts. Increasing prominence was also lent to architecture and interior design, and in the mid-1960s the title of the series was changed to *Decorative Art in Modern Interiors* to reflect this shift in emphasis. Eventually, in 1980, Studio Vista ceased publication of these unique annuals, and over the succeeding years volumes from the series became highly prized by collectors and dealers as excellent period reference sources.

The fascinating history of design traced by *Decorative Art* can now be accessed once again in this new series reprinted, in somewhat revised form, from the original yearbooks. In line with the layout of *Decorative Art*, the various disciplines are grouped separately, whereby great care has been taken in selecting the best and most interesting pages while ensuring that the corresponding dates have been given due prominence for ease of reference. It is hoped that these volumes of highlights from *Decorative Art* will at long last bring the yearbooks to a wider audience, who will find in them well-known favourites as well as fascinating and previously unknown designs.

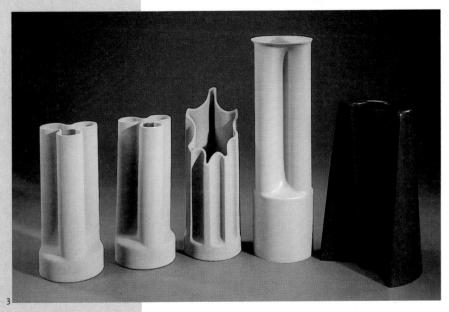

1960s · preface · 9

Die »Decorative Art« Jahrbücher

Die Zeitschrift The Studio Magazine wurde 1893 in England gegründet und war sowohl der Kunst als auch dem Kunsthandwerk gewidmet. In den Anfängen stellte sie einer breiten Öffentlichkeit in England und in Übersee die Arbeiten progressiver Designer wie Charles Rennie Mackintosh und Charles Voysey vor. Ihr Einfluss war groß und nahm auch auf dem europäischen Festland zu. 1906 begann The Studio zusätzlich mit der Herausgabe des Decorative Art Yearbook, um »den Bedürfnissen einer ständig wachsenden Öffentlichkeit gerecht zu werden, die sich zunehmend dafür interessierte, Kunst in die Dekoration und Ausstattung ihrer Wohnungen einzubeziehen.« Diese jährlichen Überblicke unterrichteten über die neuesten internationalen Tendenzen in der Architektur und Innenraumgestaltung, bei Möbeln, Lampen, Glas und Keramik, Metall und Textilien. Von Anfang an förderte Decorative Art die von William Morris und seinen Anhängern entwickelte »Neue Kunst« und versuchte, Entwürfe auszuschließen, die »in Mustern und Formen zu überladen und exzentrisch waren.«

In den zwanziger Jahren hatte sich *Decorative Art* für modernistische Strömungen eingesetzt und wurde in der Folgezeit zu einer prominenten Befürworterin des »guten Designs«. Die seit 1950 von englischen Verlag Studio Vista veröffentlichten Jahrbücher stellten für jedes Jahrzehnt ausgezeichnete Überblicke der vorherrschenden

avangardistischen und experimentellen Trends im Design einerseits und des bereits in der breiteren Öffentlichkeit etablierten Alltagsdesigns andererseits zusammen. Als Architektur und Interior Design Mitte der sechziger Jahre ständig an Bedeutung gewannen, wurde die Serie in *Decorative Art in Modern Interiors* umbenannt, um diesem Bedeutungswandel gerecht zu werden. Im Jahre 1981 stellte Studio Vista die Veröffentlichung dieser einzigartigen Jahrbücher ein. Sie wurden in den folgenden Jahren als wertvolle Sammelobjekte und hervorragende Nachschlagewerke hochgeschätzt.

Die faszinierende Geschichte des Designs, die *Decorative Art* dokumentierte, erscheint jetzt als leicht veränderter Nachdruck der originalen Jahrbücher. Dem ursprünglichen Layout von *Decorative Art* folgend, werden die einzelnen Disziplinen getrennt vorgestellt. Mit großer Sorgfalt wurden die besten und interessantesten Seiten ausgewählt. Die entsprechenden Jahreszahlen sind jeweils angegeben, um die zeitliche Einordung zu ermöglichen. Mit diesen Bänden soll einer breiten Leserschaft der Zugang zu den *Decorative Art* Jahrbüchern und seinen international berühmt gewordenen, aber auch den weniger bekannten und dennoch faszinierenden Entwürfen ermöglicht werden.

PRÉFACE

Les annuaires « Decorative Art »

Fondé en 1893 en Grande-Bretagne, The Studio Magazine traitait à la fois des beaux-arts et des arts décoratifs. Sa vocation première était de promouvoir le travail de créateurs qui innovaient, tels que Charles Rennie Mackintosh ou Charles Voysey, auprès d'un vaste public d'amateurs tant en Grande-Bretagne qu'à l'étranger, notamment en Europe où son influence était particulièrement forte. En 1906, The Studio lança The Decorative Art Yearbook, un annuaire destiné à répondre à «la demande de cette part toujours croissante du public qui s'intéresse à l'application de l'art à la décoration et à l'aménagement général de la maison». Ce rapport annuel, qui prit une ampleur de plus en plus internationale, était consacré aux dernières tendances en matière d'architecture, de décoration d'intérieur, de mobilier, de luminaires, de verrerie, de textiles, d'orfèvrerie et de céramique. D'emblée, Decorative Art mit en avant «l'Art nouveau» dont William Morris et ses disciples avaient posé les ialons, et tenta d'exclure tout style marqué par «une ornementation surchargée et des formes d'une excentricité excessive».

Dès les années 20, Decorative Art commença à promouvoir le modernisme, avant de se faire le chantre du «bon design». Publiés à partir des années 50 par Studio Vista, les annuaires continuèrent à présenter un remarquable panorama de chaque décennie, faisant se côtoyer les créations avant-gardistes et souvent expérimentales et les produits plus «grand public». Ses pages accordèrent également une part de plus en plus grande à l'architecture et à la décoration d'intérieur. Ce changement de politique éditoriale se refléta dans le nouveau titre adopté vers le milieu des années 60: Decorative Art in Modern Interiors. En 1980, Studio Vista arrêta la parution de ces volumes uniques en leur genre qui, au fil des années qui suivirent, devinrent très recherchés par les collectionneurs et les marchands car ils constituaient d'excellents ouvrages de référence pour les objets d'époque.

Grâce à cette réédition sous une forme légèrement modifiée, la fascinante histoire du design retracée par *Decorative Art* est de nouveau disponible. Conformément à la maquette originale des annuaires, les différentes disciplines sont présentées séparément, classées par date afin de faciliter les recherches. Les pages les plus belles et les plus intéressantes ont été sélectionnées avec un soin méticuleux et on ne peut qu'espérer que ces volumes feront con-

naître *Decorative Art* à un plus vaste public, qui y retrouvera des pièces de design devenues célèbres et en découvrira d'autres inconnues auparavant et tout aussi fascinantes.

Les années 60 · Préface · 11

INTRODUCTION THE 1960s

Youth Culture and Lifestyle Fashion

The 1960s were a decade of unprecedented social change. Characterised by emancipation and permissiveness, they saw the suburban dream of the 1950s renounced in favour of a utopian vision of alternative lifestyles. Cognisant of the failings of the previous generation, young people in particular agitated for a better world in the face of the rapid urbanisation of the West. Their collective social conscience and pursuit of sex, drugs and rock'n'roll were key uniting features that led the youth movement to become a powerful force in sixties' society. Cities such as London, Paris and New York became cultural epicentres of this phenomenon, while advances in mass communications made possible the true globalisation of youth culture. The decorative arts acted as a social barometer of these changes and reflected the hopes and aspirations of this new generation.

In the early 1960s, as in previous decades, the decorative arts were divided into two distinct categories - the crafted object and the industrially manufactured product. During this period, the notion of "Good Design" remained influential and Finnish products in particular were widely celebrated for their high quality and design integrity. In Italy, the Neo-Liberty style continued to flourish, while German design was characterised by the logical planning and geometric purity that was largely responsible for bringing about its "economic miracle". Japanese design continued to exert a strong influence upon Western artists, who drew potent inspiration from its traditional aesthetic, as well as from its mass-produced industrial products. America, which had the most competitive market-place, on the one hand promoted design excellence through, for example, the furniture and exhibition designs of Charles and Ray Eames, while on the other produced some of the worst quality and badly designed products of any industrialised

Design was promoted not only by the plethora of lifestyle journals that emerged during the decade, but also by the establishment of institutions such as the Design Centre in London, which acted as a showcase for high-quality progressive products. What the principles of "Good Design" actually were, however, was a question which much of the public would have been hard pressed to answer. The glossy magazines and colour supplements which packed their pages with the latest trends in interiors and furnishings were ultimately spotlighting changes in taste rather than fundamental innovations in design. Similarly, cautious retailers preferred to stick with tried-and-tested products, or "knock-offs" of previously successful designs, rather than risk the introduction of more progressive manufactured goods.

Even though design was now a truly international phenomenon, consumers were thus largely fashion conscious rather than design conscious. Manufacturers felt compelled to bring out new cars, furniture, glassware, metalware etc. annually to sate this seemingly never-ending appetite for the grooviest, coolest and hippest products. This search for the "new" also brought the increasing introduction of ethnic objects into interior design. As air travel became more accessible, so did trinkets from the Far East, India and Mexico. Such objects were regarded as offering an outlet for personal expression within interior design, as too did experimental Pop designs. Although the Design Council and publications such as Decorative Art advocated well-designed and good-value products that were impervious to the evanescence of fashion, the youth generation required short-lived, fun and gimmicky solutions that were cheap and expendable.

Visions of the Future

In the 1960s the idea of "living units" rather than homes reflected the influence of Modernist architects such as Le Corbusier and Ludwig Mies van der Rohe as well as the changing demographics of Western populations - the new generation did not aspire to its parents' ideal of suburban security. Instead, youth culture fought for liberation from traditional domestic bonds and expectations - the wide availability of the contraceptive pill and the ensuing culture of sexual liberation meant that "settling down" was no longer necessarily desirable nor a requirement. The 1960s also saw the proliferation of concrete modular tower blocks on city skylines, although these sad homages to Le Corbusier's utopian dreams were often shoddy and over-hasty in their construction. Futuristic visions were also reflected in Moshe Safdie's Habitat project for Expo '67, which was made up of cell-like units that were adaptable to differing sizes of family.

The Space Age also did much to fuel the imaginations of designers and consumers and led to futuristic and

modular design becoming increasingly popular. The earth tones of the 1950s gave way to bold black and white patterns inspired by Op Art, while textiles and wallpapers took on dynamic designs and vibrant, "synthetic" colours. As class structures became less fixed, the prejudices that had in the past favoured antiques over modern furnishings slowly ebbed. Reissued tubular metal furniture by Le Corbusier, Marcel Breuer and Ludwig Mies van der Rohe in particular was increasingly used in domestic interiors, as well as in prestigious contract environments. Classic designs such as these rapidly assumed a social cachet and accelerated the acceptance of more progressive design in general. During this period, too, great emphasis was placed on the importance of light in interiors, which in turn led to more windows, brighter lighting, white walls and even white floors. There was also a sudden realisation of the benefits of "knock-down" furniture, which could be collapsed and easily transported by an increasingly nomadic populace.

Expression and Experimentation

As the decade progressed, design became ever more stylistically diverse, allowing greater personal choice and greater freedom of expression. Bold new concepts were explored within the sphere of interior design - from the sunken seating pit to the self-contained living unit that comprised everything needed for daily life: kitchen, bathroom, bedroom and so on. Furniture design also became an arena for experimentation, leading to inflatable PVC seating and the ubiquitous beanbag. These new designs and the fashion for cheap yet comfortable, brightly-coloured floor cushions reflected the more casual lifestyle of the 1960s. This new informality was also reflected in the preference for heavy rustic glassware over cut crystal or delicate glassware. By the mid to late 1960s, youth culture was irreverently challenging the status of the Modern designer by advancing the notion of democratic design through the do-it-yourself, anything-goes school of practice.

During this time, too, the divisions between art and design became increasingly blurred, with established artists such as Victor Pasmore and Eduardo Paolozzi dabbling in design, and designers such as Ettore Sottsass executing symbolic "art-like" furniture. Performance art also influ-

enced design – De Pas, D'Urbino and Lomazzi's *Blow* chair and Gaetano Pesce's *Up* Series produced the same spontaneous quality as an art "happening". Interiors by designers such as Verner Panton became spatial experiences, while futuristic habitations, mega-structures and self-regulating environments were projected by radical design groups such as Superstudio and Archizoom.

The 1960s were essentially a kaleidoscope-like decade in which colour and form changed rapidly and interacted unexpectedly to produce sensory stimulation. The utopian dreams of the Bauhaus were somehow strangely reflected and at the same time subverted in the Pop designs of the 1960s. The invisible chair famously predicted by Marcel Breuer was realized by Quasar Khanh and De Pas, D'Urbino and Lomazzi with their inflatables, while Josef Albers' paper and cardboard experiments were the antecedents of Peter Murdoch's expendable throwaway fibreboard furniture. Socialism had been replaced by capitalism, community by individualism, collective responsibility by personal freedoms. For better or for worse, momentous and irreversible cultural change had taken place.

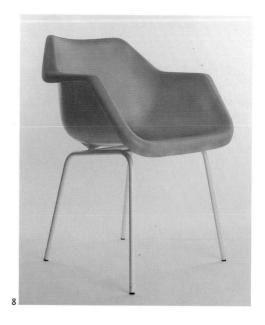

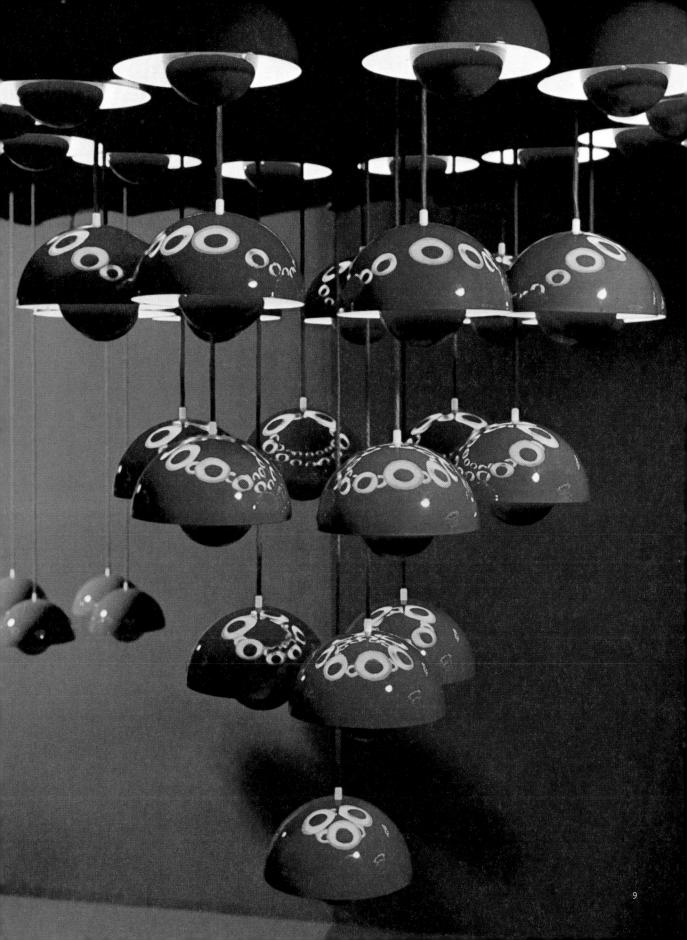

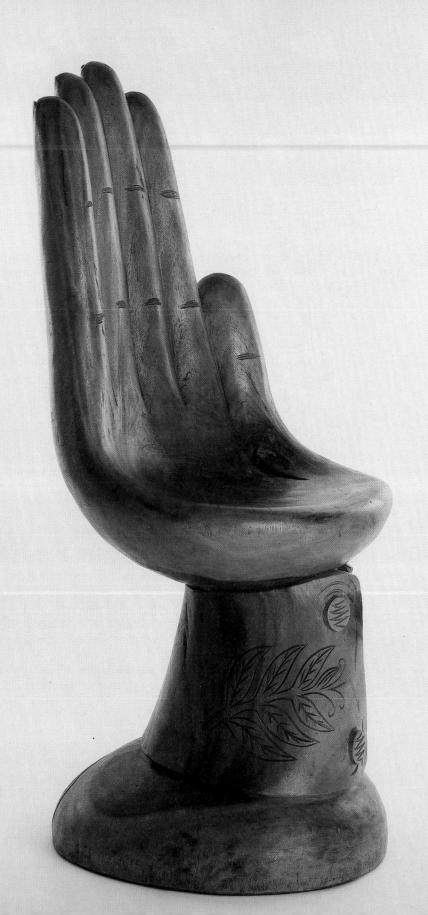

Jugendkultur und Lifestyle Mode

Die sechziger Jahre waren ein Jahrzehnt der sozialen Veränderungen. Emanzipation und Freizügigkeit waren die erklärten großen Ziele, und die utopische Vision alternativer Lebensstile löste den Traum der fünfziger Jahre – ein Leben im eigenen Haus in den sicheren Vororten der Städte - ab. In den westlichen Ländern schritt die Urbanisierung rapide voran Im Bewusstsein des Scheiterns der Generation ihrer Eltern agitierte die Jugend für den Aufbau einer besseren Welt. Ein kollektives soziales Bewusstsein und das Ausleben von Sex, Drogen und Rock'n'Roll waren Ideale, welche die Jugend vereinten und zu einer maßgebenden Kraft in der Gesellschaft der sechziger Jahre werden ließ. London, Paris und New York waren die kulturellen Epizentren dieses Phänomens, und die ungeheuren Fortschritte in der Entwicklung der Massenmedien bahnten den Weg zu einer umfassenden Globalisierung der Jugendkultur. Die angewandte Kunst reagierte als soziales Barometer auf diese Veränderungen und reflektierte die Hoffnungen und Wunschvorstellungen dieser neuen Generation.

In der angewandten Kunst wurden in den frühen sechziger Jahren wie in vorangegangenen Jahrzehnten noch immer zwei verschiedene Kategorien unterschieden – kunsthandwerkliche Objekte und seriengefertigte Industriegüter. In den siebziger Jahren bestimmten die Maßstäbe des »guten Designs« die Richtung. Finnische Produkte wurden zum Inbegriff harmonischen zeitgenössischen

Formempfindens und hoher Qualität. In Italien hielt sich der Neo-Liberty Stil. In Deutschland war Formgebung durch logische Planung und geometrische Klarheit charakterisiert und hat wesentlich zum »Wirtschaftswunder« beigetragen. Japanisches Design übte einen unverändert starken Einfluss auf die westlichen Künstler aus, die sich von der Ästhetik traditionellen japanischen Handwerks einerseits und industriell gefertigten Massenprodukten andererseits inspirieren ließen. Die USA, das Land mit den schärfsten Wettbewerbsbedingungen der westlichen Welt, förderten hochmodernes Design wie die Möbel- und Ausstellungsentwürfe von Charles and Ray Eames, produzierten aber gleichzeitig Industriegüter mit der schlechtesten Formgebung und minderwertigsten Qualität aller Industrienationen.

Design gewann immer mehr an Bedeutung, was durch das wachsende Angebot von Lifestyle Journalen und die Einrichtung von Institutionen wie das Design Centre in London, das als Schaufenster für zukunftsorientierte Formgebung auftrat, zum Ausdruck kam. Was nun eigentlich unter »gutem Design« verstanden wurde, konnten die meisten Verbraucher nicht konkret nennen. Illustrierte Zeitschriften und Farbbeilagen, deren Seiten mit den neuesten Trends für Interieurs und Möbel gefüllt waren, forcierten letztendlich nur Veränderungen des Geschmacks, nicht aber richtungsweisende Innovationen in der Formgebung. Auch vorsichtige Möbelhäuser orientierten sich vorzugsweise an gängigen Produkten oder Kopien erfolgreicher Entwürfe, statt formschöne zeitgenössische Industriemöbel anzubieten.

Obwohl Design sich inzwischen zu einem wahrhaft internationalen Phänomen entwickelt hatte, war das Gros der Verbraucher eher mode- als designbewusst. Die Industrie stand unter dem Druck, jährlich neue Prototypen von Autos, Möbeln, Glas- und Metallwaren zu entwerfen, um den scheinbar unersättlichen Hunger nach den verrücktesten, coolsten und modischsten Novitäten zu stillen. Auf der Suche nach diesem »Neuen« wurden nun auch ethnische Objekte in die Innendekoration einbezogen. Die Ausweitung des internationalen Flugverkehrs erleichterte den Import von Dekorationsobjekten aus dem Fernen Osten, Indien und Mexiko, die ebenso wie experimentelles Pop-Design geeignet waren, einen persönlichen Stil bei der Gestaltung von Interieurs zu verwirklichen. Obwohl sich das Design

Council und Publikationen wie *Decorative Art* für ausgewogenes und preiswertes Gebrauchsdesign jenseits der modischen Trends engagierten, bevorzugte die Jugend modische und witzige Designlösungen, die Spaß machten, preiswert und leicht austauschbar waren.

Zukunftsvisionen

Das die sechziger Jahre bestimmende Konzept – »Wohneinheiten« statt Häuser – reflektierte einerseits den Einfluss der Architekten der Moderne wie Le Corbusier und Ludwig Mies van der Rohe und andererseits die demographischen Veränderungen in den Ländern der westlichen Welt. Die junge Generation lehnte das Ideal eines Lebens in sicheren Vorstädten, von dem ihre Eltern geträumt hatten, ab und kämpfte für die Befreiung ihres Lebens von traditionellen häuslichen Bindungen und Erwartungen. Im Zuge des erleichterten Zugangs zu Verhütungsmitteln und der damit einhergehenden sexuellen Freizügigkeit wurde ein »sesshaftes Leben« nicht mehr als wünschenswert oder notwendig erachtet. In diesen Jahren begannen sich modulare Wohntürme aus Zement in den Silhouetten der Großstädte durchzusetzen, obwohl diese traurigen Huldigungen an Le

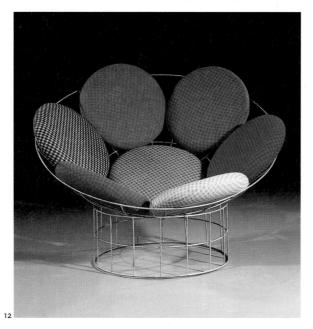

Corbusiers utopische Träume oft schäbig und allzu hastig gebaut wurden. Futuristische Visionen spiegelten sich auch in Moshe Safdies Habitat Projekt für die Expo '67 wider: zellenähnliche Einheiten, die sich unterschiedlichen Familiengrößen anpassen ließen.

Das Weltraumzeitalter hatte dazu beigetragen, die Imagination von Designern und Konsumenten zu beflügeln und zukunftsweisenden modularen Entwürfen zu größerer Popularität zu verhelfen. Die Erdtöne der fünfziger Jahre wurden durch kräftige, von der Op-Art inspirierte Schwarzweißmuster abgelöst. Textilien und Tapeten wurden in dynamischen Mustern und leuchtenden »synthetischen« Farben hergestellt. Als Folge der durchlässiger werdenden Klassenstruktur der Gesellschaft nivellierten sich auch Wertvorstellungen, die antike Stilmöbeln höher bewerteten als modernes Möbeldesign. Kopien moderner Stahlrohrmöbel von Le Corbusier, Marcel Breuer und Ludwig Mies van der Rohe wurden nicht nur in der Gestaltung repräsentativer Räume, sondern zunehmend auch in der Einrichtung privater Wohnungen verwendet. Solche klassischen Möbelentwürfe förderten das Sozialprestige und beschleunigten auch dadurch die Akzeptanz eines fortschrittlichen Stilempfindens in der Öffentlichkeit. In dieser Zeit wurde auch auf die Beleuchtung von Innenräumen mehr Wert gelegt und begünstigte Entwürfe mit mehr Fenstern, hellerer Beleuchtung, weißen Wänden und Böden. Man erkannte den Vorteil von Klappmöbeln, die zusammengefaltet und von einer ständig mobiler werdenden Bevölkerung leicht transportiert werden konnten.

Ausdruck und Experiment

Im Verlauf dieses Jahrzehnts wurde das Stilempfinden vielfältiger und bot dem Einzelnen eine größere persönliche Auswahl und Freiheit des Ausdrucks. Auf dem Gebiet des Interior Design wurden gewagte neue Konzepte ausgelotet – die von versenkbaren Sitzen bis zu isolierten Wohnmodulen reichten, die alles Lebensnotwendige enthielten: Küche, Bad, Schlafzimmer und so weiter. Möbeldesign wurde zu einem Feld des Experimentierens, dessen Ergebnis aufblasbare PVC-Sitzmöbel und der allgegenwärtige »Sitzsack« waren. Derartige Entwürfe, gepaart mit einem Faible für preiswerte, aber bequeme leuchtend bunte Bodenkissen, waren Ausdruck des zwangloseren Lebenstils der sechziger

Jahre. Diese neue Informalität drückte sich auch in einer Vorliebe für schwere rustikale Gläser aus, die geschliffene Kristall- oder zarte Gläser verdrängten. Mitte bis gegen Ende der sechziger Jahre stellte die Jugendkultur den Status des modernen Designers schamlos infrage und setzte ihm das Konzept des demokratischen Design mit Do-It-Yourself- und Alles-ist-erlaubt-Praktiken entgegen.

In diesen Jahren verwischten sich auch die Grenzen zwischen Kunst und Design zunehmend. Etablierte Künstler wie Victor Pasmore und Eduardo Paolozzi begannen, auch als Designer kreativ zu werden, und Designer wie Ettore Sottsass entwarfen Möbelstücke, die zeitgenössischen Skulpturen nicht unähnlich waren. Auch Performance-Kunst beeinflusste das Design – De Pas, D'Urbino und Lomazzis »Blow Chair« und Gaetano Pesces »Up-Serie« hatten die gleiche Spontanität wie die Happening Kunst. Wohnlandschaften von Designern wie Verner Panton wurden zu einem wahren Raumerlebnis, während futuristische Bauentwürfe, Megastrukturen und autoregulatorische Environments von radikalen Designteams wie Superstudio und Archizoom projektiert wurden.

Die sechziger Jahre glichen im Grunde einem Kaleidoskop, in dem Farbe und Form sich laufend verändern und

Utopische Ideen des Bauhauses wurden wieder aufgegriffen, aber gleichzeitig vom Pop-Design der sechziger Jahre unterwandert. Der unsichtbare Stuhl, den bereits Marcel Breuer schon vorausgesagt hatte, wurde von Quasar Khanh und De Pas, D'Urbino und Lomazzi in den Aufblasmöbeln realisiert. Josef Albers Papier- und Pappexperimente wurden zu Vorläufern von Peter Murdochs Wegwerfmöbeln aus Fiberkarton. Der Sozialismus wurde durch den Kapitalismus abgelöst, an die Stelle von Solidarität trat der Individualismus, und kollektive Verantwortung wurde durch persönliche Freiheit ersetzt. Veränderungen von großer Tragweite hatten stattgefunden und waren nicht mehr rückgängig zu machen.

durch unerwartete Interaktionen die Sinne stimulieren.

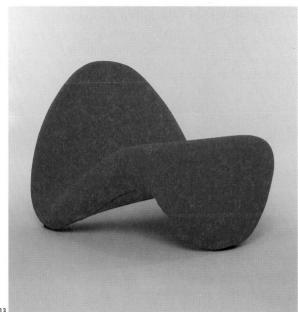

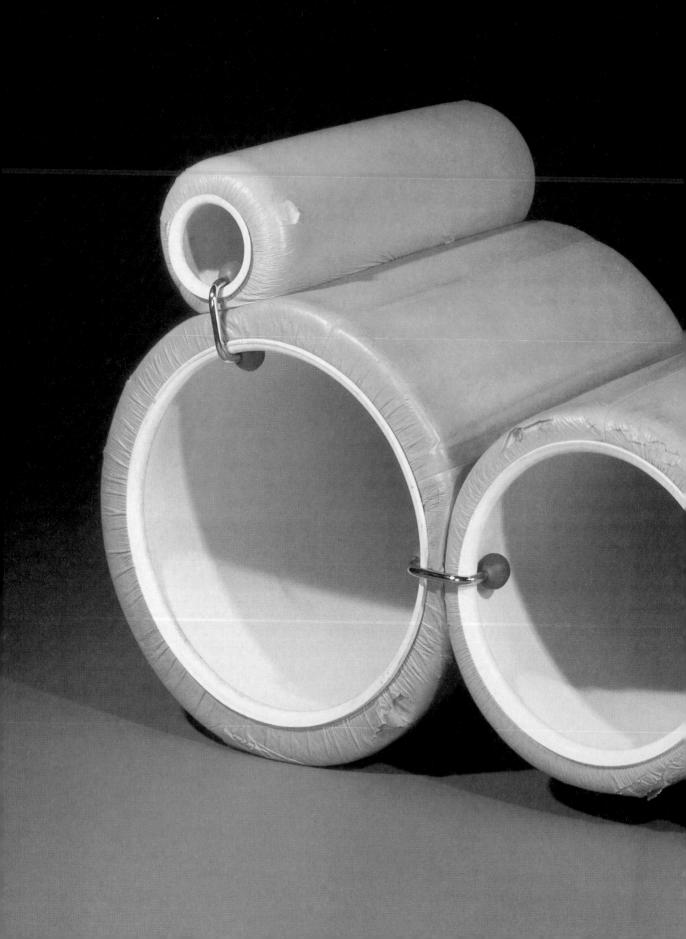

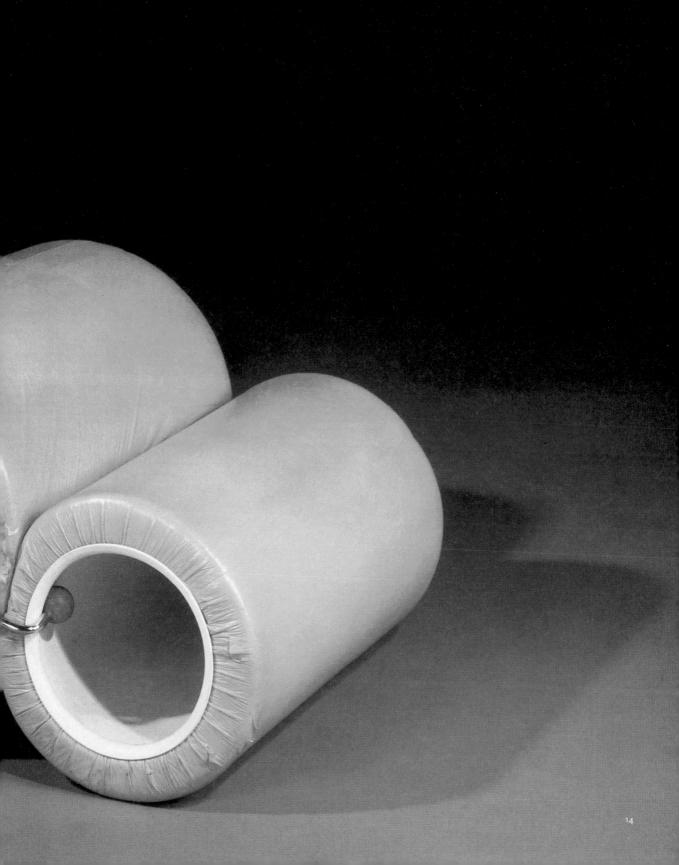

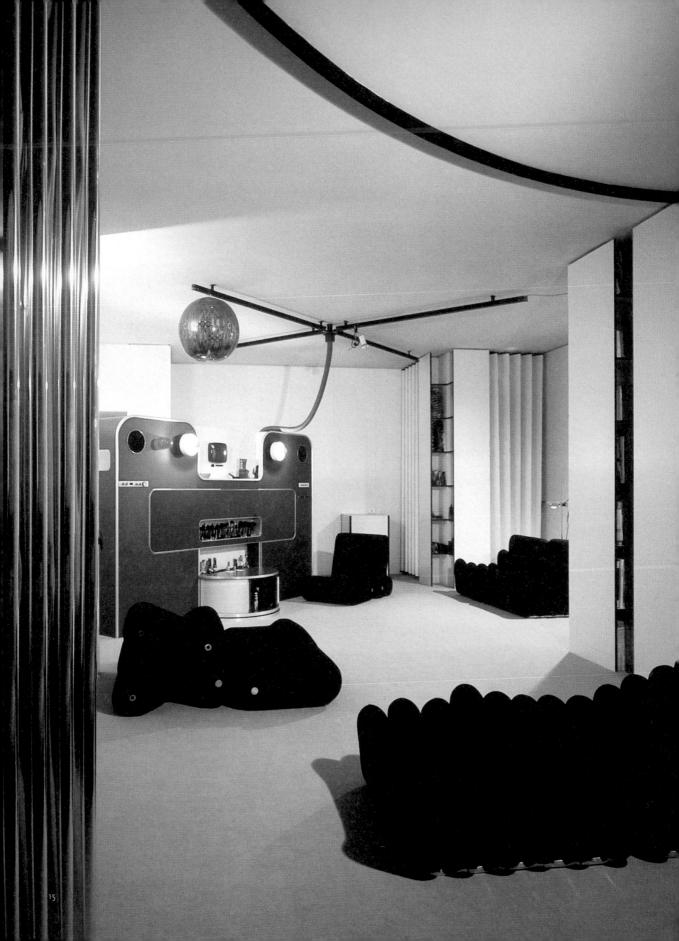

INTRODUCTION LES ANNÉES 60

15. & 16. Joe Colombo, Views of an interior with a Roto-Living Unit, 1969; Cabriolet bed, 1969; Additional Living System 1967–1968 and Multi chairs, 1970 17. Joe Colombo, Combi-Centre storage unit for Bernini, 1963-1964

La culture de la jeunesse et la mode du style de vie

Les années 60 furent une décennie de bouleversements sociaux sans précédent. Caractérisées par l'émancipation et la permissivité, elles marquèrent le renoncement au rêve urbain des années 50 en faveur de l'adhésion à une vision utopique de styles de vie alternatifs. Conscients des échecs de la génération antérieure, les jeunes, notamment, manifestèrent leur volonté de vivre dans un monde meilleur et leur rejet de l'urbanisation rapide de l'Occident. Leur conscience sociale collective et la quête du «sex, drugs and rock'n'roll » furent des facteurs unificateurs qui firent de la jeunesse une force puissante de la société des années 60. Des villes comme Londres, Paris et New York devinrent les épicentres culturels de ce phénomène, tandis que les progrès dans le domaine de la communication de masse rendirent possible une vraie globalisation de la culture de la jeunesse. Les arts décoratifs jouèrent un rôle de baromètre social de ces bouleversements en reflétant les espoirs et les aspirations de cette nouvelle génération.

Au début des années 60, comme au cours des décennies précédentes, les arts décoratifs étaient divisés en deux catégories distinctes: les objets fabriqués à la main et ceux

produits industriellement. Au cours de cette période, la notion du «bon design» continua à jouer un rôle important. Les produits finlandais, notamment, étaient très appréciés et reconnus pour leur grande qualité et l'intégrité de leur design. En Italie, le style « neo-liberty » continuait à fleurir. Le design allemand, lui, se caractérisait par une conception logique et une pureté géométrique qui étaient en grande partie à l'origine de son « miracle économique ». Le design japonais exerçait toujours une forte influence sur les artistes occidentaux, qui s'inspiraient de son esthétique traditionnelle ainsi que de ses produits de consommation de masse fabriqués industriellement. L' Amérique, qui possédait le marché intérieur le plus compétitif, offrait à la fois un design d'une excellente qualité au travers, par exemple, des meubles et des expositions de design de Charles et Ray Eames, et certains des produits les plus mal fabriqués qui soient et d'une qualité pire que dans toute autre nation industrialisée.

Le design était promu non seulement par la pléthore de magazines sur le style de vie qui fleurirent tout au long de la décennie mais également par des institutions nouvelle-

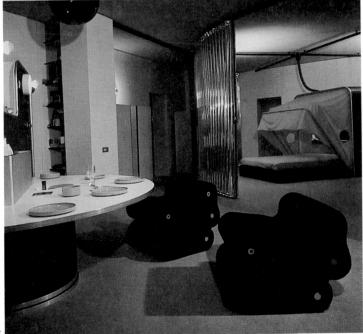

ment créées telles que le Design Center de Londres, qui servait de vitrine aux produits de qualité les plus innovants. Cependant, le public aurait été bien en peine de définir ce qu'étaient au juste les principes du « bon design ». Les revues sur papier glacé et leurs suppléments en couleurs qui présentaient les dernières tendances en matière de décoration d'intérieur et d'ameublement promouvaient plutôt des changements de mode que des innovations fondamentales en matière de design. De même, les détaillants prudents préféraient s'en tenir aux objets et meubles ayant déjà fait leur preuve ou aux ersatz d'anciens articles s'étant bien vendus plutôt que de se risquer à présenter des produits manufacturés plus progressistes.

Même si le design était devenu un phénomène véritablement international, les consommateurs s'attachaient plus à la mode qu'au design des objets. Chaque année, les fabricants se sentaient obligés de sortir de nouveaux modèles de voitures, de meubles, d'objets en verre et en métal pour satisfaire cet appétit apparemment insatiable pour les produits les plus dans le vent. Cette quête du «nouveau» se traduisit également par l'apparition de plus en plus marquée d'objets ethniques dans la décoration d'intérieur. Les voyages en avion devenant plus accessibles, on vit fleurir les babioles d'Extrême-Orient, d'Inde ou du Mexique. Ces dernières permettaient d'apporter une touche personnelle dans la décoration d'intérieur, tout comme les designs pop expérimentaux. Le Design Council et des publications comme Decorative Art défendaient des produits intelligemment conçus et d'un bon rapport qualité-prix qui étaient à

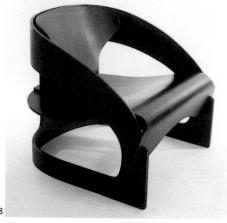

l'abri de l'évanescence de la mode, mais la jeune génération voulait des solutions éphémères et amusantes qui étaient aussi bon marché.

Visions du futur

Dans les années 60, on se mit à penser davantage en termes « d'espaces de vie » plutôt que de maisons, reflétant l'influence d'architectes modernistes tels que Le Corbusier et Ludwig Mies van der Rohe, ainsi que les changements démographiques des populations occidentales. Contrairement à leurs parents, les jeunes n'aspiraient pas à l'idéal de sécurité de la banlieue résidentielle. Au contraire, la nouvelle génération luttait pour se libérer des aspirations et des liens domestiques traditionnels. L'avènement de la pilule contraceptive et la libération sexuelle qui s'ensuivit signifiaient que «s'établir» n'était ni nécessairement souhaitable ni requis. Les années 60 virent également la prolifération des tours d'habitation en béton dans les villes, bien que ces tristes hommages aux rêves utopiques de Le Corbusier aient été souvent de mauvaise qualité et construits à la hâte. Le projet Habitat de Moshe Safdie, réalisé pour l'Expo 67, reflétait également des visions futuristes, avec des unités cellulaires s'adaptant à la taille de la famille qui les habitait.

L'ère spatiale nourrit également beaucoup l'imagination des designers et des consommateurs et entraîna la grande popularité du design futuriste et modulaire. Les tons terreux des années 50 cédèrent la place aux motifs contrastés noirs et blancs inspirés de l'op art, tandis que les textiles et les papiers peints se paraient de motifs dynamiques et de vibrantes couleurs « synthétiques ». Les structures de classes devenant moins figées, les préjugés qui, par le passé, avaient fait la part belle aux meubles anciens par rapport aux modernes, s'estompèrent peu à peu. Les rééditions de meubles tubulaires en métal de Le Corbusier, Marcel Breuer et Ludwig Mies van der Rohe, notamment, étaient de plus en plus utilisées dans les intérieurs privés comme dans les lieux officiels prestigieux. Ces classiques furent rapidement investis d'un cachet social et accélérèrent l'acceptation par le plus grand nombre d'un design plus progressiste. Au cours de cette période, on mit également l'accent sur l'importance de la lumière dans les intérieurs, ce qui se traduisit par davantage de fenêtres, des éclairages plus lumineux, des murs et même parfois des

sols blancs. On prit aussi conscience soudain de l'intérêt des meubles « démontables », qui pouvaient se plier et être facilement transportés par une population de plus en plus nomade.

Expression et expérimentation

Au cours de la décennie, le design se diversifia de plus en plus, permettant un plus grand choix personnel et une plus grande liberté d'expression. Dans le domaine de la décoration d'intérieur, on explorait sans cesse de nouveaux concepts audacieux, comme les banquettes installées dans des fosses au milieu du salon ou les «espaces de vie autosuffisants » qui comportaient tout ce dont on avait besoin pour la vie quotidienne: cuisine, chambre à coucher, salle de bains, etc. La conception des meubles devint également un domaine d'expérimentation, aboutissant au siège gonflable en PVC ou à l'incontournable fauteuil poire. Ce nouveau design, associé à la mode des poufs colorés bon marché mais néanmoins confortables, reflétait le style de vie plus nonchalant des années 60. Cette même décontraction se retrouvait dans la prédominance du verre épais et rustique par rapport au cristal ciselé et au verre délicat. Entre le milieu et la fin des années 60, la culture de la jeunesse défiait même le statut du créateur moderne en promouvant la notion du design démocratique à travers le «do-it-yourself » et l'école du bric-à-brac.

Durant cette même époque, les divisions entre l'art et le design devinrent de plus en plus floues. Des artistes établis

tels que Victor Pasmore et Eduardo Paolozzi s'essayaient au design tandis que des designers comme Ettore Sottsass réalisaient des meubles symboliques «artistiques». L'art de la performance influença également le design: le fauteuil gonflable de De Pas, D'Urbino et Lomazzi et la série de sièges de Gaetano Pesce offraient la même spontanéité qu'un «happening» artistique. Les intérieurs réalisés par des décorateurs tels que Verner Panton devinrent des expériences spatiales, tandis que des groupes de designers radicaux tels que Superstudio et Archizoom concevaient des habitations futuristes, des méga-structures ou des environnements autorégulateurs.

Les années 60 furent essentiellement une décennie kaléidoscopique où couleurs et formes évoluèrent rapidement et s'influencèrent mutuellement de manière inattendue pour produire des stimulations sensorielles. Le design pop fit réapparaître les rêves utopiques du Bauhaus de manière étrangement pervertie. La chaise invisible prédite par Marcel Breuer trouva sa réalisation dans les meubles gonflables de Quasar Khanh, De Pas, D'Urbino et Lomazzi. Les expériences en papier et en carton de Josef Albers préfiguraient les meubles en fibre de bois jetables de Peter Murdoch. Le socialisme avait été remplacé par le capitalisme, la communauté par l'individualisme, la responsabilité collective par les libertés individuelles. Pour le meilleur et pour le pire, des bouleversements culturels immenses et irréversibles avaient eu lieu.

houses and apartments | Häuser und Apartments | Maisons et appartements

IN 1906, HOUSES were rich, dark and exceedingly comfortable. Today's houses are products of functionalism and 'fitness for purpose'. They are neither rich nor dark, a shade inhuman and often lacking the visual and physical comfort for which no amount of light and colour will compensate. Design is all-important and here to stay. Comfort goes by the board and may return tomorrow. The bleak difference between Edwardian and modern furniture is the richness of decoration of the former and the preoccupation with undecorated expanses of the latter. A splendid example of Ernest Gimson's work was shown at the 1952 exhibition of Victorian and Edwardian Decorative Arts at the Victoria and Albert Museum: a cabinet of 1910 in brown ebony inlaid with mother-of-pearl and gleaming with bright iron handles. What would be its modern equivalent? One refuses to believe that the days of welldecorated furniture have gone forever. And, if there is no demand for decorated furniture, why should top designers of exhibition rooms persuade manufacturers to let them doll up their dull chests-of-drawers - or resort to using antique pieces to enliven their schemes?

But the late 'fifties have certainly shown signs of greater subtlety and delight in form. Some of the moulded fibre glass chairs express the real elegance of a proper and original use of a new material. Even more to the point is the fact that many manufacturers of mass-produced furniture have realised that the present generation is no longer interested in travesties of former styles. They want the best they can afford from the designers of their age.

MAISONS APPARTEMENTS MOBILIER

En 1906 la plupart des maisons étaient somptueuses, sombres et confortables à l'excès. Aujourd'hui, les maisons sont créées en fonction du rôle utile à remplir. Elles ne sont plus somptueuses ou sombres, mais un soupçon inhumaine, manquant souvent de confort visuel et physique que ni la lumière ou la couleur, aussi abondantes soient-elles, ne compenseront. Ce qui compte c'est la forme qui dure. Le confort est sacrifié, mais peut revenir demain.

La triste différence entre les meubles du début du 20e siècle et les meubles modernes, c'est la richesse de l'ornementation chez les premiers et l'importance donnée aux grandes surfaces nues chez les seconds. On se refuse à croire que l'époque du mobilier très orné est à jamais révolue. Et si la demande en ce qui concerne le meuble orné est inexistante, pourquoi les décorateurs les plus fameux des Salles d'Exposition ne persuaderaient pas les fabricants de leur permettre de recourir à des objets antiques pour donner plus d'animation à l'ensemble de leurs projets?

Mais la fin des années cinquante a certainement permis de constater une plus grande subtilité et joie dans le modèle créé. Certaines des chaises en fibre de verre moulée expriment une réelle élégance qui vient de l'emploi judicieux et original de la matière nouvelle. Ce qui ressort encore davantage, c'est le fait que de nombreux fabricants de meubles en série ont constaté que les travestis d'anciens styles n'intéressent plus la génération actuelle. Des dessinateurs de son époque, ce qu'elle désire obtenir ce sont les styles les plus intéressants que lui permettent ses moyens.

CASAS APARTAMENTOS MOBILIARIO

En 1906, la mayoría de las casas eran lujosas, oscuras y sumamente cómodas. Hoy día, las casas son producto de un diseño práctico, 'apropiado para su cometido'. No son ni lujosas ni oscuras, un tanto inhumanas y a menudo carentes de la comodidad visual y física que ni la luz ni el color pueden compensar. El diseño es lo más importante y se ha inculcado firmemente en la costumbre. Se ha sacrificado la comodidad, que tal vez vuelva en el futuro.

La principal diferencia entre el mobiliario de la época eduardina y el moderno radica en la lujosidad decorativa del primero y lo preocupación de dar un aspecto de vastedad desierta al segundo.

Mas durante los últimos años se han observado indicios de mayor belleza de forma. Algunas de las sillas de fibra de vidrio moldeada expresan la verdadera elegancia que corresponde al uso debido y original de un nuevo material. Todavía más importante es el hecho de que muchos fabricantes de muebles producidos en serie se han percatado de que la presente generación ha dejado de interesarse en las parodias de los antiguos estilos. Busca lo mejor, que sus medios les permite, de los diseñadores de su propia edad.

HÄUSER WOHNUNGEN MÖBEL

Im Jahre 1906 waren die meisten Häuser prunkvoll, dunkel und gemütlich. Unsere modernen Häuser sind das Endergebnis von Funktionalismus und 'Zweckentsprechung'. Sie sind nicht mehr prunkvoll und dunkel, aber dafür ein klein wenig unmenschlich, und es fehlt ihnen oft an jenem visuellen und physischen Wohlbehagen, für das kein noch so grosser Aufwand an Licht und Farbe jemals eine Entschädigung bietet. Künstlerische Formgebung ist von grösster Wichtigkeit und aus unserem Leben nicht mehr wegzudenken. Die Bequemlichkeit ist nicht mehr da, aber sie wird morgen vielleicht wieder da sein.

Die Möbel aus der Zeit Eduards VII. unterscheiden sich von unseren heutigen Möbeln in einem Hauptpunkt: Sie waren prunkvoll verziert, während grosse schmucklose Flächen unsere Möbel charakterisieren.

Zu Ende der Fünfziger Jahre waren sicher Zeichen dafür vorhanden, dass sich der Geschmack änderte und die Freude an schönen Formen wieder auftauchte. In einigen der gegossenen Fiberglas-Stühle zeigt sich die Eleganz, mit der ein neues Material richtig und seiner Eigenart entsprechend behandelt wird. Weiterhin haben eine Anzahl von Fabrikanten, die Möbel serienmässig herstellen, endlich eingesehen, dass die gegenwärtige Generation nicht mehr an Travestien vergangener Möbelstile interessiert ist und dass sie das Beste im Rahmen der zur Verfügung stehenden Mitteln haben will, das Formgeber ihrer eigenen Zeit entworfen haben.

Town house with Library in New York City

designed by Felix Augenfeld, AIA: associate architect Jan Hird Pokorny

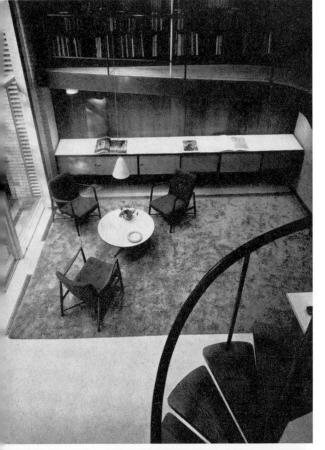

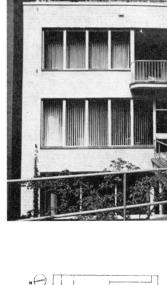

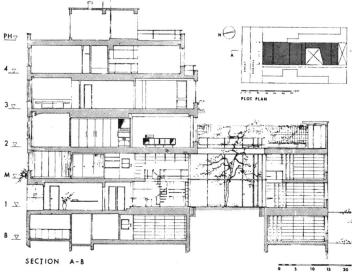

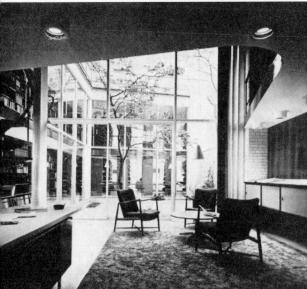

A LIBRARY of some 50,000 volumes, chiefly on political history and social science, is the nucleus around which this four-storey steel frame house is planned. The owner, an author and book collector, wished to arrange it in such a way that it would also be accessible to fellow scholars and students. At the same time, he wished to use the building as a private residence for himself and his wife, and to have a separate apartment for a caretaker-librarian. To avoid unnecessary interference the different functions of the building were to be kept independent from one another, but all had to be contained within a narrow site 25 feet 4 inches × 100 feet in a built-up residential area. The sectional drawing shows the solution, with the library arranged on three levels, wrapped around a glass-walled central garden patio.

 \blacktriangleleft Views from mezzanine balcony down to first-floor library and from first-floor library into patio-garden

photos: Alexandre Georges

Town house with library in New York City

Library detail ▶

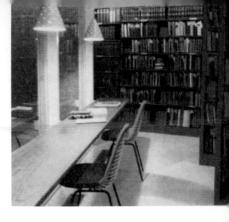

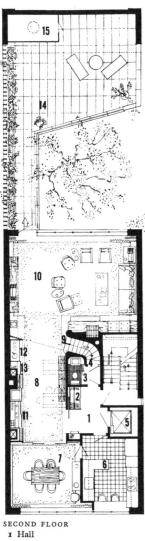

- 2 Coats
- 3 Powder Room
- 4 Closet
- 5 Elevator
- 6 Kitchen
- 7 Dining Room
- 8 Passage
- 9 Stair to bedrooms
- 10 Living Room
- 11 Bar
- 12 Hi-Fi
- 13 Record Storage 14 Roof Garden
- 15 Storage

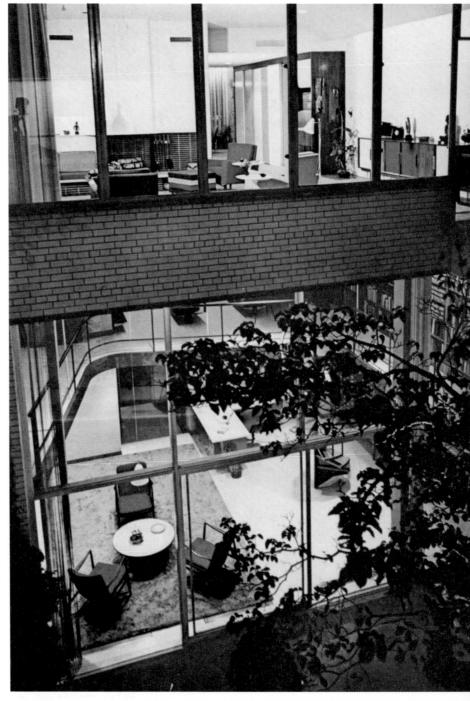

Good daylight for the core of the building and almost complete transparency of the space is achieved. On the first floor a feeling of height is created by the introduction of an intermediate mezzanine level cut out in the shape of a balcony. The owner's study is also on this level, affording him easy access to the whole library. On the second and third floors, connected by a private staircase, is his four-bedroom maisonette flat.

The librarian's flat, which has two bedrooms, is on the fourth floor. Illustrated below is the owner's living-room—colourful and spacious—with an interesting bench seat built into the fireplace wall. It opens onto a roof-garden at the rear, and a short passage connects it with the dining-room at the front of the building.

The street front is faced in travertine and Venetian glass mosaic, other exteriors in glazed brick. Interiors designed by the architect.

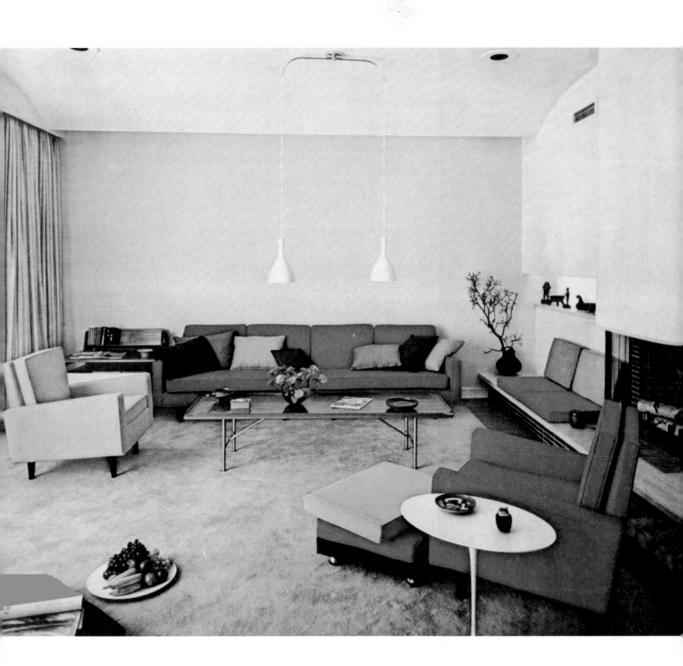

'iew into first, mezzanine and second floors

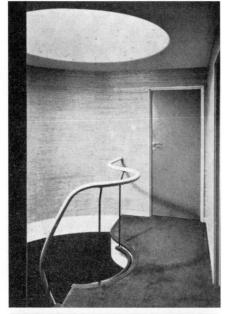

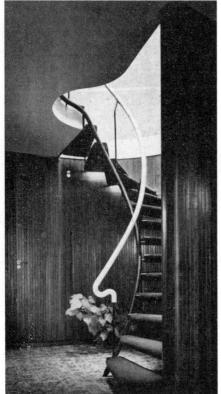

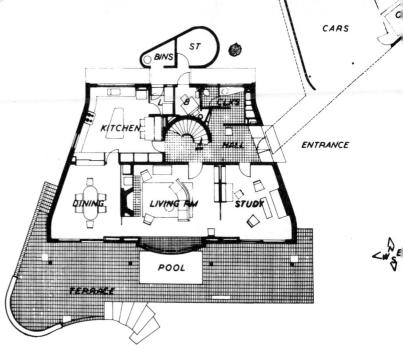

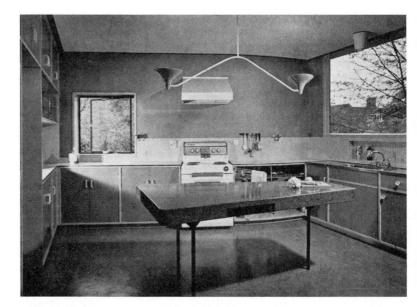

The architect was asked to plan this house with the living-room and main bedrooms all facing south, which meant a layout wider at the front than at the back. This posed some problems, successfully overcome in a design with splayed and curving-in side walls which, blinker-like, direct the outlook towards the main garden and provide privacy from the road.

With the exception of the window-pierced south wall faced in grey-black Mineralite, the exterior is in grey facing bricks with a white mosaic tiled fascia. Slender black concrete columns carrying the roof overhang are an important factor in the proportion of the design.

The hall is panelled in afrormosia with grey-green Japanese grass cloth above, and the open stairway treads and upper landing are carpeted in dark green, the wall lit at each step level.

An open-plan living/dining room and study open off the hall, separated, if desired, by concealed sliding doors. Against a quiet background of pale grey walls and polished Missander wood-block flooring, interest is focused on the fireplace wall in Napoleon marble with an inset illuminated display slot; just below this and to the right of the fireplace, is a hidden panel which opens to reveal a television set. A built-in radiator system runs beneath the wide black-tiled window-sill.

In the kitchen the fittings include a fixed terrazzo-top 'island table', the drawers fitted with chopping and pastry boards, rolling pin, etc. The colour scheme is in two shades of grey.

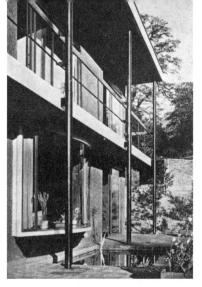

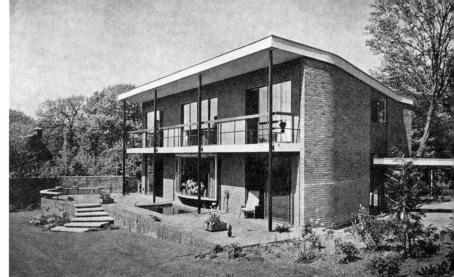

House at Hampstead, London designed by Patrick Gwynne, LRIBA

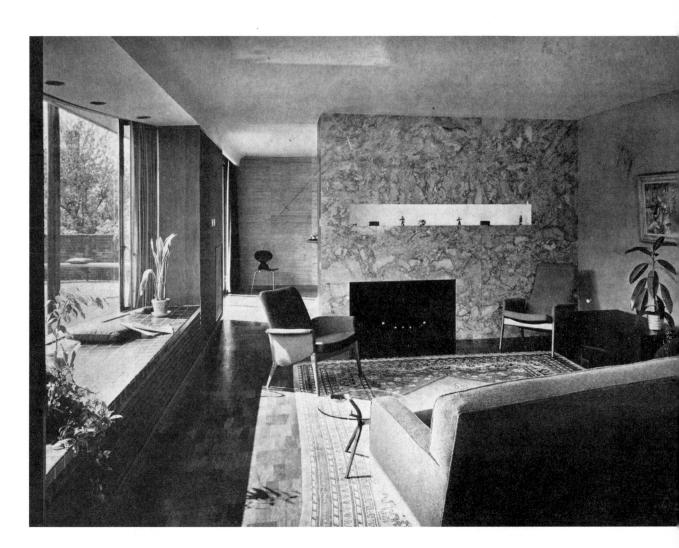

1960–61 \cdot houses and apartments \cdot 33

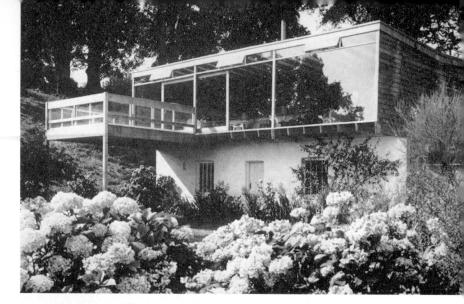

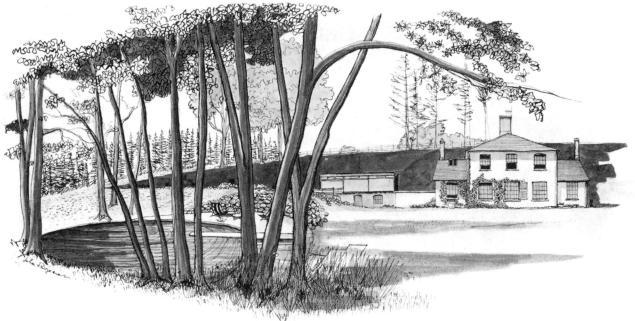

Flat near Maidstone, England

Architects: Spencer and Gore

Designed as an annexe to an existing Regency house sited within a fold of the Kentish hills, this two-bedroom cedar-board flat built over the garage commands an extensive view through a glazed wall of 12-foot bays extending the whole length of the south side. One of the bays is a sliding door giving access to a sun deck projecting from the living-room and increasing the living space. The interior is lined in Pacific coast hemlock and the ceiling in Stramit boarding is painted white on the underside.

Interior fittings include a built-in oven and a double-sided display and storage unit between the living-room and kitchen where the stainless steel sink unit and electric rings are set into asbestos work tops.

Photos by Mann Bros., courtesy 'Architectural Design'

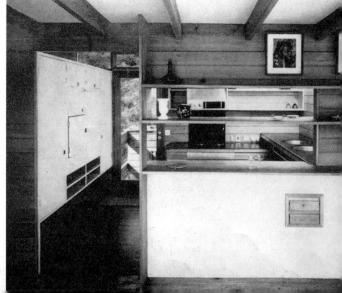

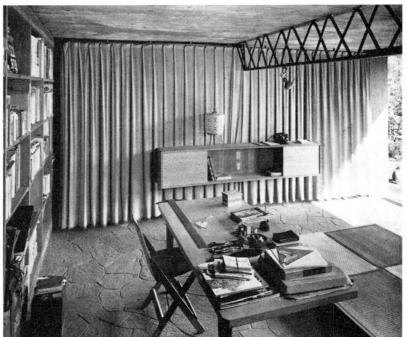

House in Ohtaku-Tokio, Japan

Architect: Kiyosi Seike

Constructed on the open-plan system, this is a small reinforced concrete house built by the architect for his own use. The interior shown is a combined study and living-room with a 'window wall' on the south side, part of which can be slid downwards into the basement thus opening up the interior to the garden.

The ceiling in rough concrete is supported on a welded steel bar painted red. Built-in bookshelves and a suspended wall cabinet keep the floor space clear. The heating system is inlaid under the floor. This is paved in green flagstones, with the paving continuing out into the garden and establishing a harmonious relationship between exterior and interior. The wood framed platform of traditional tatami rush mats mounted on casters is also designed to be used indoors or out with equal felicity.

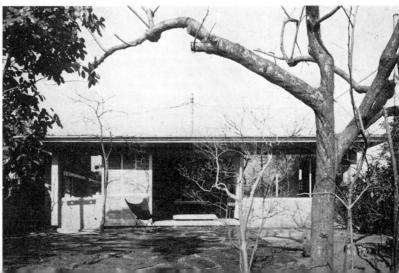

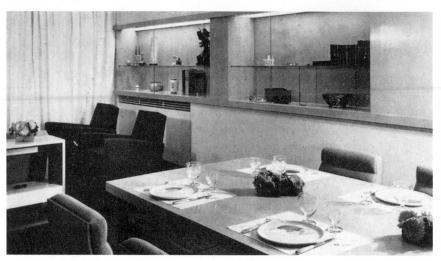

Apartment in Paris designed by Jacques Dumond

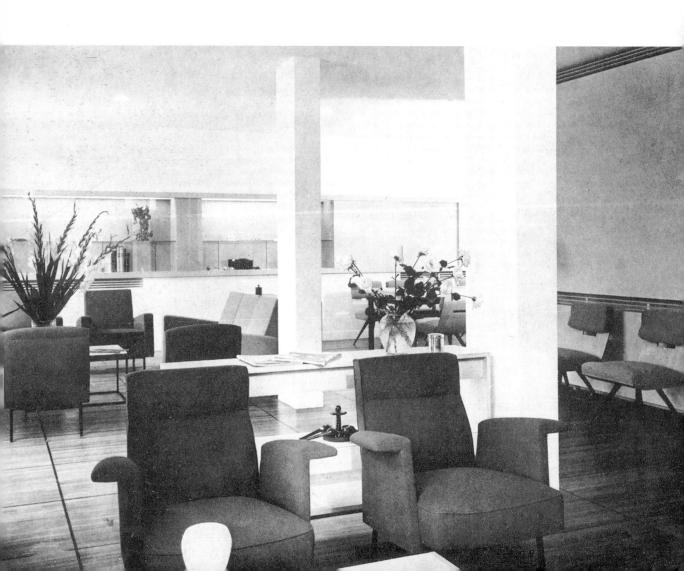

Situated on the seventh and eighth floors of a new building, this apartment was designed for a family of five with young grown-up daughters and a son. To enable the young people to entertain their friends independently the lower floor is designed as a separate unit with a private staircase to the upper floor containing the main living/dining room, kitchen, laundry, and parents' bedroom and dressing room.

1-3 The air-conditioned living-room with white walls, windows curtained in white silk and a walnut parquet floor; the furniture is in polished ash and black lacquer with upholstery in grey, blue and ochre. At one end is a full-length display cabinet and opposite, beneath the bookshelves, is a hung bar-cabinet (4-5) with slideout glassware shelves. A built-in radiator central heating system lines the walls.

6 The son's study/bedroom with adjustable wall shelves faced in black and white Formica, metal frame chair and desk with grey Formica top, surround lacquered blue. 7 The bathroom with black tile floor, green fittings, bath niche in faience tiles decorated with motifs in grey and pale green. The shaving table and small shelves are in acajou with bright green Formica tops. 8 Girl's bedroom with pale grey walls, dark grey carpeting, and window curtains in a black print on white. The chair and table are in white-lacquered metal with light grey Formica top and dark grey surround. The bedcover is a vivid blue and the armchair is upholstered in tobacco brown.

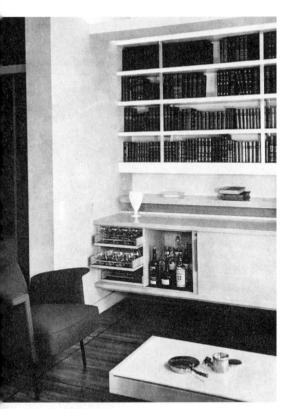

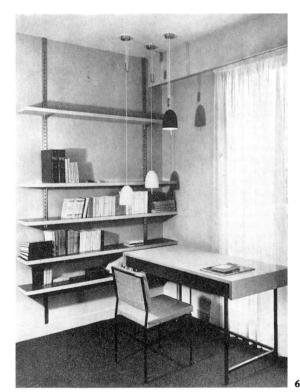

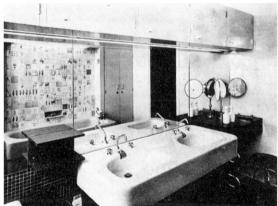

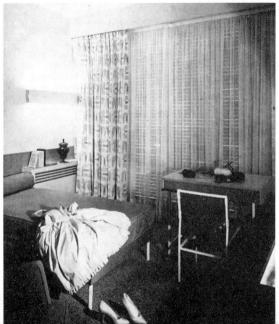

,

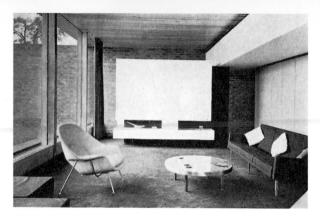

House at Hampstead, London

Architects: Higgins & Ney & Partners AARIBA

Built on a quite small steeply sloping site overlooking north-west London, this house has succeeded in being completely integrated—in its site, in its function and architecturally. The levels allowed a well-defined separation of main entrance, and service entrance, the latter to a first-floor kitchen and dining room with, on the same floor, the living room and master bedroom suite. Children's rooms are situated on the ground floor, visible in 4; this achieves an effective separation of child and adult activities and permits their easy use as bed-sitting rooms in later teenage years.

Also, by raising the main rooms, it has been possible to achieve a larger, more spacious living area than the site suggests and to exploit fully the magnificent view to the south. At the rear, 5, on the same level, the dining room in summer opens right into the shaded copse. Waxed, grooved Canadian pine supplies surfaces of ceilings, and all doors are in mahogany panels. Interior brickwork is left unsurfaced where it forms the logical continuation of an exterior wall, for example, on the first floor landing, seen in detail 9. The only remaining large interior wall surface, in the living room, right, is panelled in soft harmonising tan coach-hide-finish Arlinghide. In this room against the natural finish colours and against the charcoal carpet and black settee, colour accents are introduced mainly in the chairs. The writing desk is teak on a cast iron base with built-in lighting and its own separate filing unit. At the other end of the room, 2, the part-wall forms a screen to the stairway and, in the room, a surface on which home film shows can be conveniently projected

view through children's corridor on ground floor
 Rocking chair in steel rod with foam padded pancake cushions

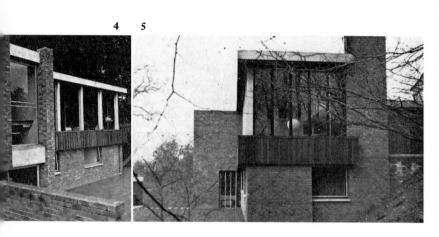

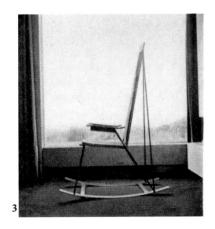

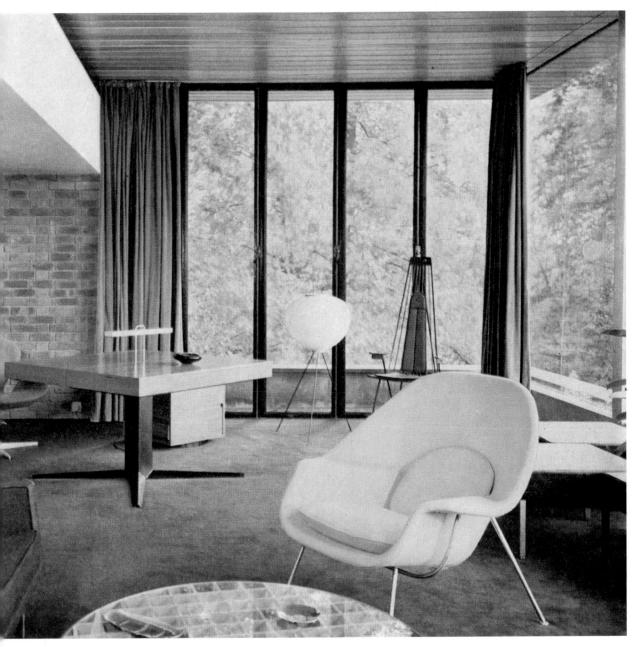

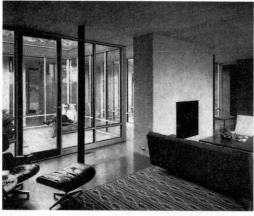

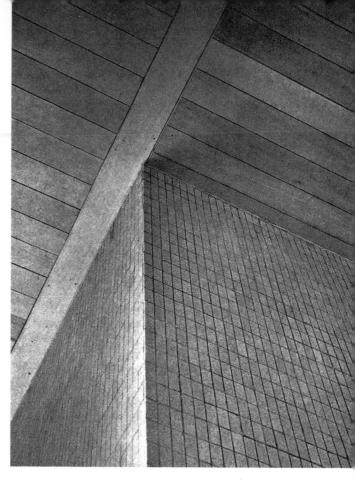

House at Belleville, Ontario

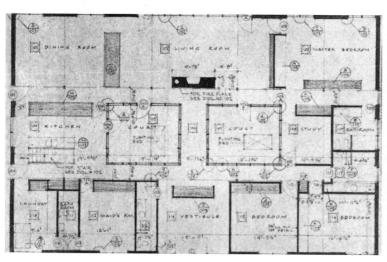

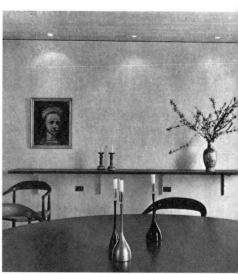

 $\textbf{40} \cdot \text{houses}$ and apartments $\cdot~1961\text{--}62$

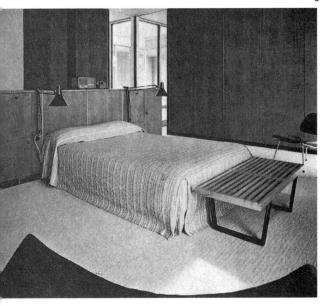

Architects: Grierson & Walker, MMRAIC, ARIBA

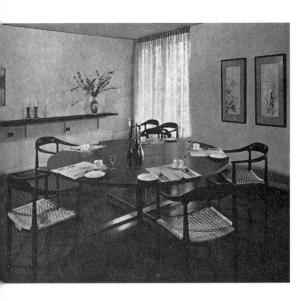

Located on a plateau at the north end of a 200-acre open site adjacent to the Moira River, which forms the western boundary, this house is a simple rectangle sitting on a podium, consisting of three structural bays in width and five in length.

Planned on a steel grid 18½ feet square, the rooms are grouped around two open courtyards, the walls of which are completely glazed and views into these courts are obtained from all parts of the house. Spaces flow freely into each other. This feeling of continuity is heightened by the boarded (basswood) ceiling used throughout the interior and extended over the external colonnade, and the uniform grey-green slate and concrete floor.

Against a neutral background of off-white plaster walls and curtains in open-weave yellow linen sheer, colour is introduced in upholstery, throw cushions and carpets. Interior illumination is by flush mounted ceiling pot lights, recessed incandescent strip lights and free standing floor lamps. Flood lighting mounted in adjacent trees creates pools of light filtering through trees and branches to the interior courts.

1, 2 Detail of living room: free-standing fireplace faced with small white speckled mosaic tile, matching the exterior walls. 3, 4 The master bedroom and kitchen, with large areas of simply arranged built-in fittings in white oak stained to a fumed oak finish.

5, 6 Dining room with 7-foot mahogany table, rush-seated chairs, and neat display shelf.

Interior designers: Kenneth G. Warren Associates

A four-bedroom apartment designed by the architect for his own family, and devised as a continuous system of interconnecting rooms divided by three successive sliding Modernfold partitions. This plan gives a feeling of unity and greater space than the area would seem to offer, emphasised by the continuous diagonal-stripe pattern of floor tiles and ceiling and a colour scheme common to the whole area: white with yellow in tones shading from light to mustard to burnt sienna. Continuity is also expressed in the arrangement of shelves and fittings along the full length of the window facade.

BELOW: through views from end to end

RIGHT: entrance and dining end of the living area illustrated on the facing page. The settee and armchair are upholstered in white and yellow with reddish brown/white/black cowskin rug and tabourets.

All furniture and fittings are custom-made to the designs of the architect.

Architect: Gio Ponti

courtesy Domus

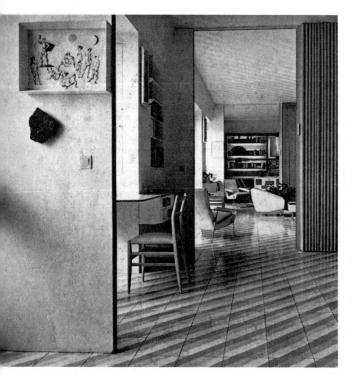

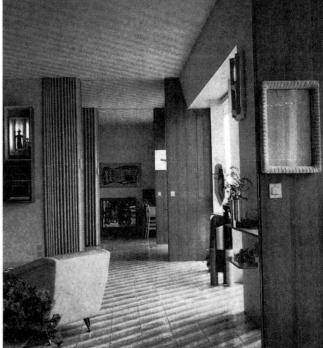

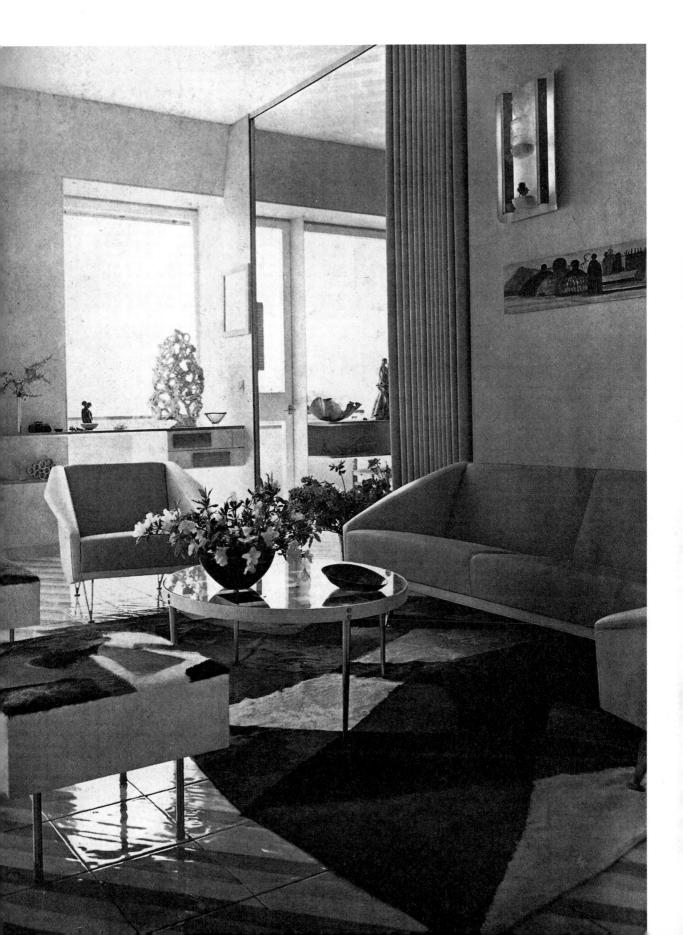

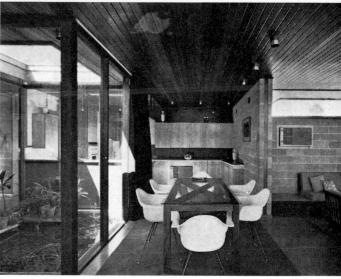

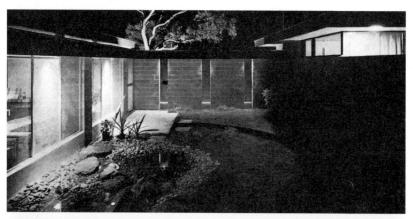

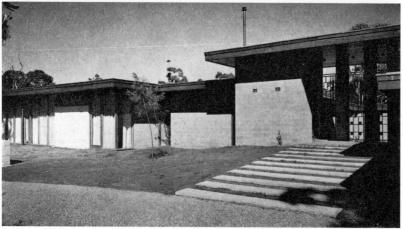

House at St. Ive

Architect: Ross Thorne

The architect, in sharing this home with his parents, wanted separate studio facilities for his work. The plan therefore has a central garden court with living rooms on one side and the studio, connected by a covered way, on the other. This in-turned arrangement is suited to the site-two-and-ahalf acres of flat, stunted native bush bordering on a main road, with virtually no view. The house, built of grey concrete blocks, has a long ground-hugging appearance, with a variation of three roof levels, the highest being at the porch to the main court entered through high wrought iron gates. The whole of the living space, comprising verandah, living/dining area and fitted kitchen, is planned as a single unit

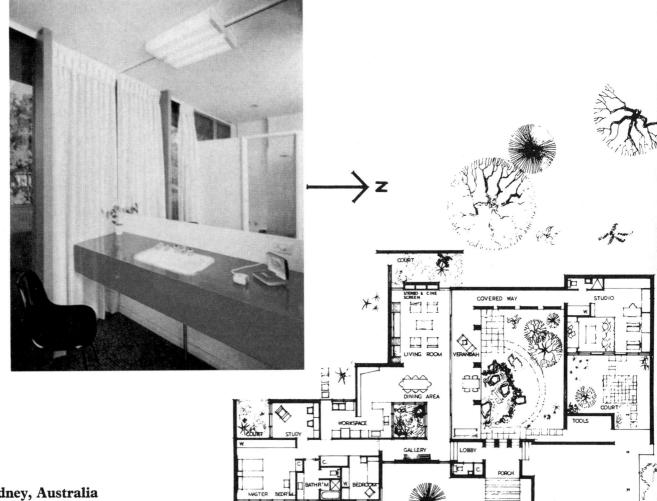

Sydney, Australia

with only slight visual barriers, the main one being a glass-surrounded pool at the dining end dividing the way to the two principal wings. Frameless glass sliding panels open the whole living space to the verandah and central court.

The illustrations on this page show the vivid colourings of interior furnishings against a neutral background. The living room ceiling is in varnished boards, the floor terrazzo, using multi-colour river pebbles. On the right is a ciné screen of white finely perforated plastic with loudspeakers behind.

In the kitchen, the built-in fittings are in Queensland maple with stainless steel and white plastic bench tops.

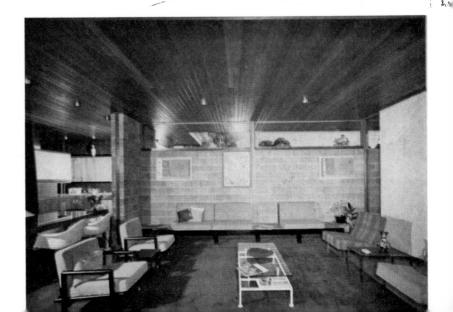

CAR PORT

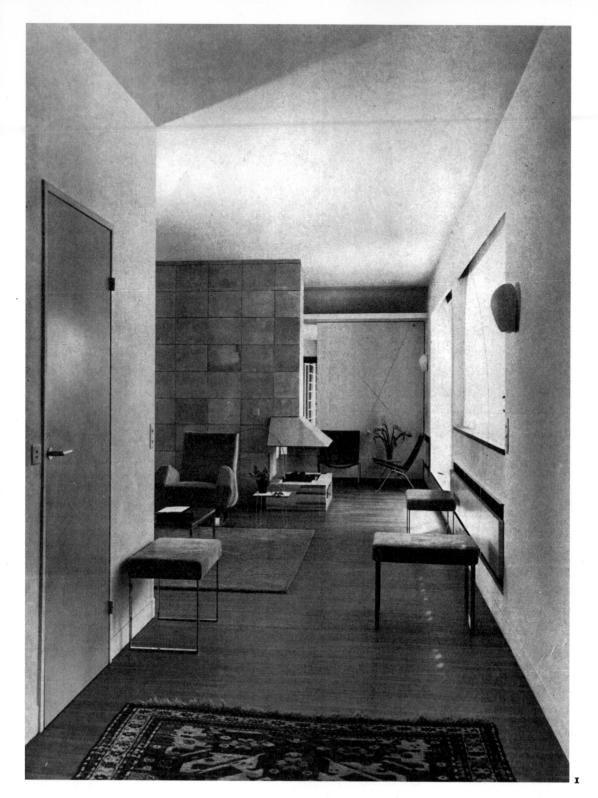

I, 2 Living room: An interesting feature is the central chimney piece of pink refractory tiles with aluminium-hooded open hearth at one end opposite the window wall. Aluminium is also used for the built-in storage fitment with doors faced in Formica in white and three greys, and for the framework of the fabric-panelled sliding screen to the right of it. Flooring is parquet with a deep pile ochre rug defining the sitting area and contrasting with the light grey 'surnyl' upholstery of the stainless steel armchairs and small stools.

Interior designed and executed by Jacques Dumond FRANCE

3, 4 In this interior a dramatic effect is created by the white dining group which, together with sheer white wool window draperies and linen-panelled white end wall, highlight a monochromatic colour scheme in citrus tones. The dining table seats six; the 78-inch long oval top is available in white plastic laminate, walnut veneer or marble finishes, the aluminium base in white, charcoal or grey finishes. Together with the fibreglass-reinforced-polyester moulded chairs, it forms part of the single pedestal collection designed by Eero Saarinen for Knoll Associates, Inc. Interior by the Knoll Planning Unit under the direction of Florence Knoll USA

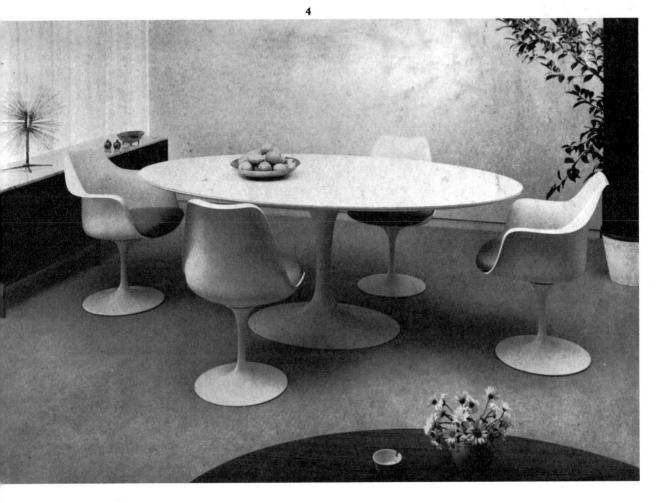

1961-62 · houses and apartments · 47

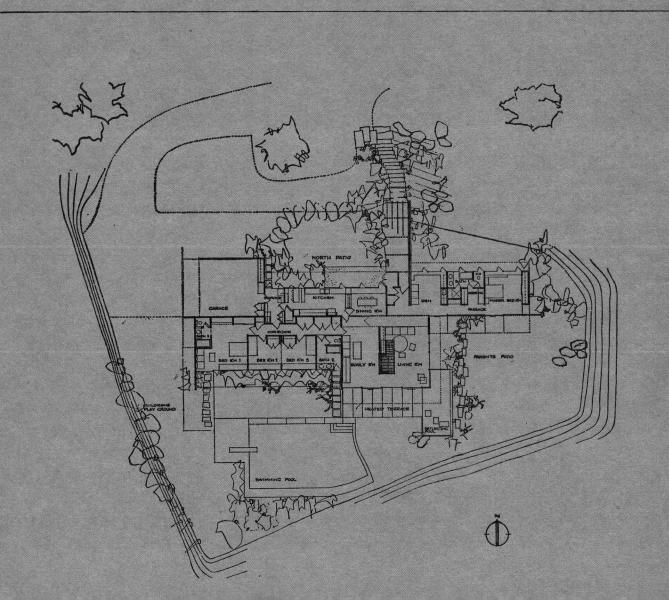

House at Beverly Hills, California

for Dr and Mrs Henry E. Singleton: Architect Richard J. Neutra, FAIA

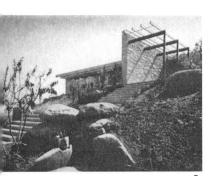

'Where exactly does a tree stop to be beautiful and begin to be utilitarian?' So has Richard Neutra defined the difficulty of separating the utilitarian from the aesthetic. He does not question the possibility of the architect achieving harmony between the two.

On a particular area on the top of a mountain a form will grow which will be found to be a family home, ideal for all its requirements. The form retains the space, without disturbing the contour of the land by being large and low-roofed. To bring into the living area the commanding views towards the Pacific and over the plains, the San Fernando Valley and a mountain lake, visual barriers are reduced to a minimum: steel cased frames support the overhanging roof; the glass walls slide back to extend the area on to a radiant-heated terrace with reflection pool. In the family room 2 floor-level seating permits relaxation 'close to the mountain' (the chair in the right foreground with an elastic metal backrest was

The house is reached from the north by an ascending drive terminating at a parking area, from where an interesting stairway, x, leads up to the entrance

pergola and the north patio (again in 3 through the kitchen). The driveway also continues westward to the garage.

Photos: Julius Shulman

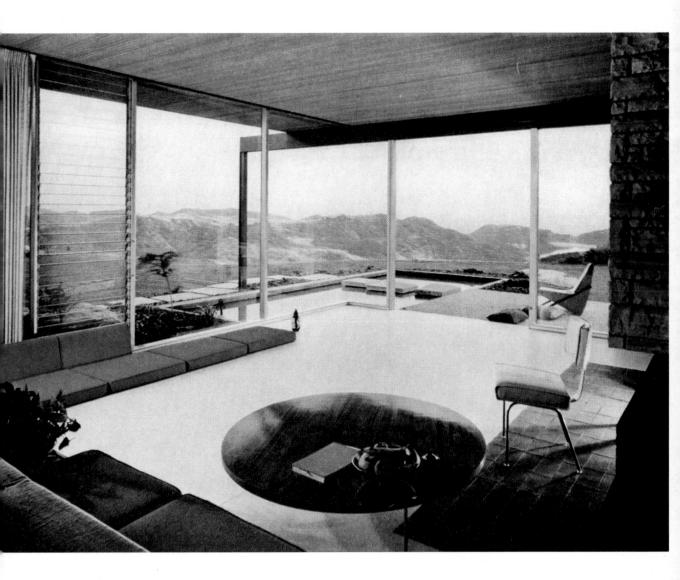

1961-62 · houses and apartments · 49

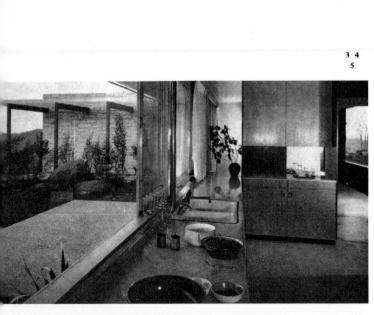

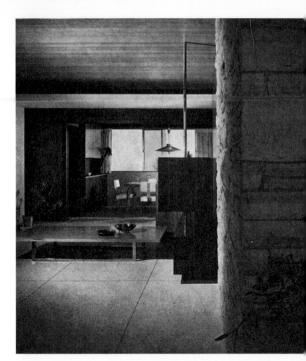

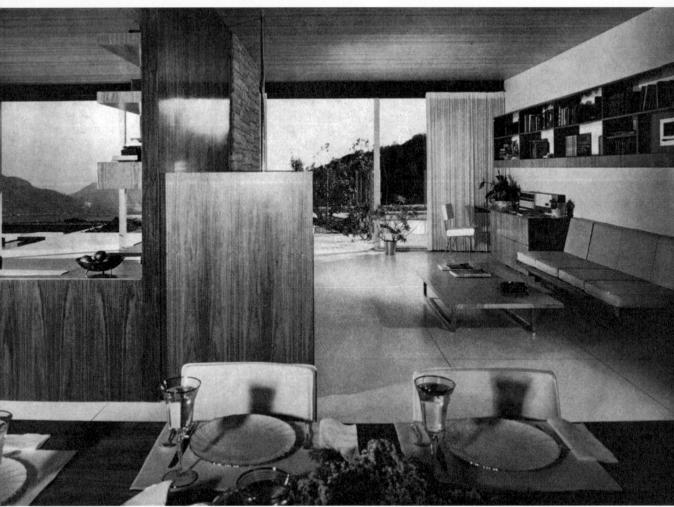

House at Beverly Hills, California

Architect, Richard J. Neutra, FAIA

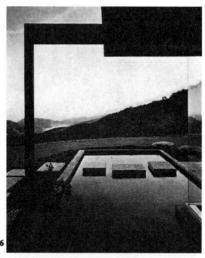

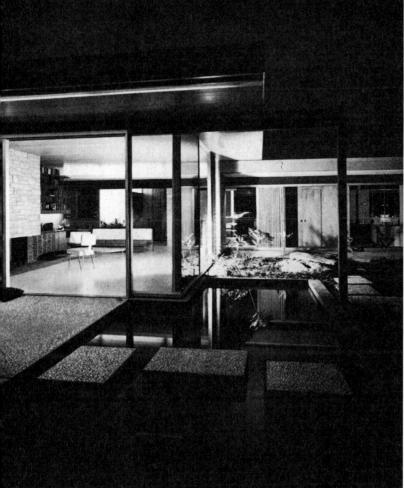

designed by Richard Neutra for dining or desk work). At the right, too, is the natural stone fireplace which divides this room from the living room. These areas connect directly, without break in floor or ceiling levels, with the dining room seen, from the family room, in 4, and in the foreground 5.

This latter illustration looks back into the family room at right and living room at left. From the kitchen 3 sliding doors open onto the shady north patio where the family often dines informally. A hatch leads through into the dining room.

On this page, 6, outward again over the reflecting pool to the southeast, which seems to continue and bring the distant lake close to the house: and, 7, back from the pool into the living room with the parents' wing to the right.

The children's wing lies to the west with convenient access to the swimming pool area.

Like the form, colours are the result of thinking of the house, its material, its needs, as a whole.

Associate designers: Benno Fischer Serge Koschin John Blanton Thaddeus Longstreth Photos: Julius Shulman

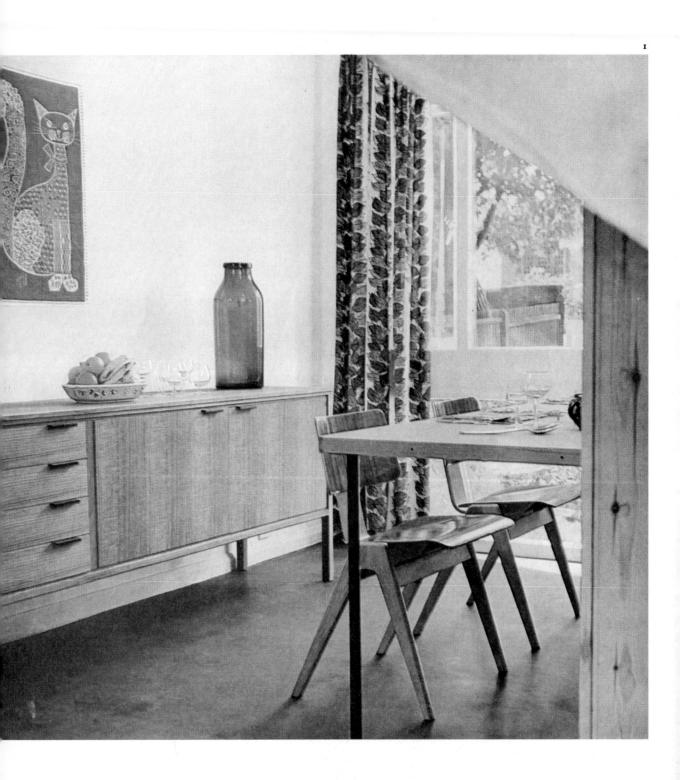

'Menelaus' a house at Wimbledon, near London Architect, Norman Plastow, ARIBA, LSIA

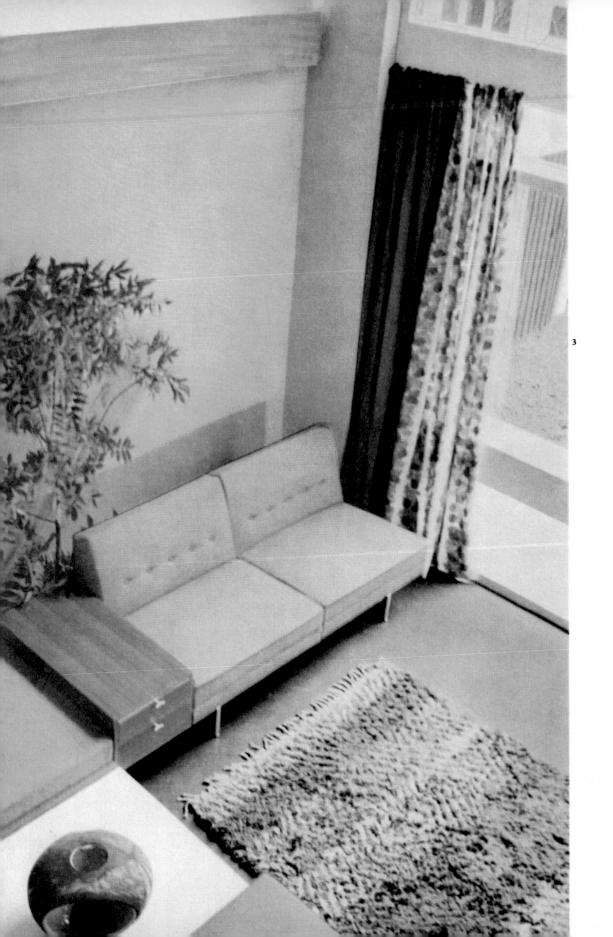

'Menelaus' a house at Wimbledon The architect built this open-plan house on a small

Architect, Norman Plastow, ARIBA, LSIA

The architect built this open-plan house on a small site in the midst of an older developed area. Partly screened from the roadway by its garage and by a tree growing fortuitously on the site, maximum seclusion has been achieved, yet a spacious living area provides for varied arrangements. The main floor area totals but 637 square feet and the space is broken into only by the working kitchen, the hallway and the open stairway flanked by the loadbearing central pillar seen 2 on page 21.

Spaciousness is increased by the double height of part of the living-area achieved by reducing the bedroom sizes to desirable minimums. The lighting of the high main wall is seen opposite. The facing high wall provides display for a large mural. The lower-ceilinged, more intimate end of the living room 4, with interchangeable teak-veneered wall fitments Danish 'Royal', designed by Poul Cadovius, from Streatvales (Sales) Ltd; white Indian-type rug Tangier made by Rivington Carpets, and a hand-woven rug by Peter Collingwood. The occasional chair in the background is

designed by the architect; the unit furniture is from the 30-inch Modular Seating range designed by Herman Miller and made by S. Hille & Co. Ltd. The stoneware pot is by Ruth Duckworth at the Crafts Centre of Great Britain. The whole area is warmed by under-floor, thermostatically controlled heating.

In 1, the dining space is seen from the open staircase looking towards the front of the house. On the 7-foot afrormosia sideboard *Pendennis* by Archie Shine Ltd, is a large Finnish jar in green glass from Danasco. The tea-towel-cum-wall hanging *Pussi* is made by Almedahls of Sweden. The curtains—*Skogsryd* designed by Gisela Hertz for Borås Wäfveri—in one colourway are repeated in a second colourway of brown, olive and yellow on the main windows at the rear (again page 22), there linked with Danasco Plain in olive-green.

Apart from the Atlas display fitting seen in 4 the light fittings are designed and made by Plus Lighting Ltd.

Photos: Carl Sutton

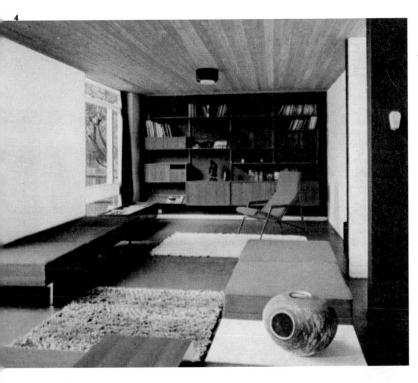

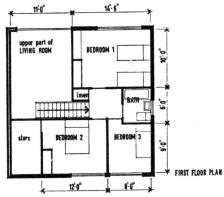

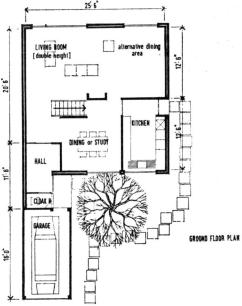

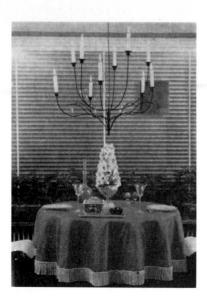

Apartment in Stockholm

Designer, Astrid Sampe

Winter in Northern Europe means long hours of cold and darkness. Set in this darkness, sheltered from it, in the centre of Stockholm, is the flat of Astrid Sampe, glowing with colourful, beautiful objects, warmed by the traditional porcelain stove, and proof that colour plus cosiness can equal good design. Many of the furnishings are of Mrs Sampe's own inspiration. As head of the textile workshop of AB Nordiska Kampaniet (NK), she is among Sweden's (and the world's) leading designers. She is an adviser on schemes as diverse as prison interiors and ambassadorial suites.

In her living room is one of the famous Marieberg stoves of eighteenth century design, with brass doors and tiles decorated with sepia brown flowers. It is the focal point of the room, exuding friendliness and warmth, with cushions piled along a low fireside seat. In front of it is a deep textured handwoven rug by Viola Gråsten, a glass-topped coffee table by Florence Knoll and a Charles Eames moulded plastic chair; in the background, a *Triva* display shelf. The settee is upholstered in a linen hand-print by Sven Markelius.

A light pinoleum blind separates the living from the dining end where, against a geranium-filled window, a table can be set up. It is laid with Orrefors crystal and plates in light blue on a deep crimson Thai silk fringed tablecloth.

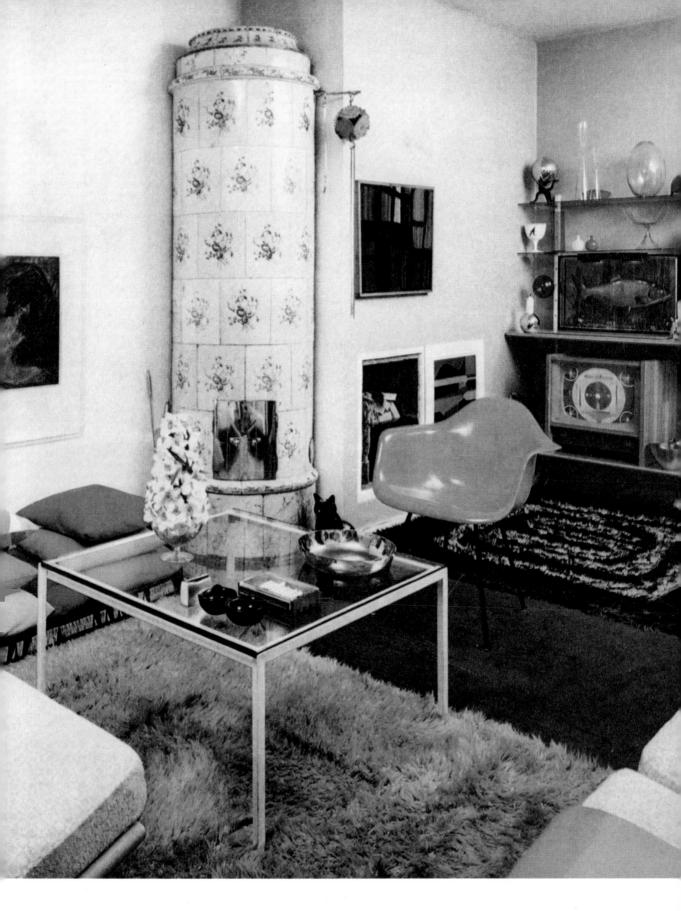

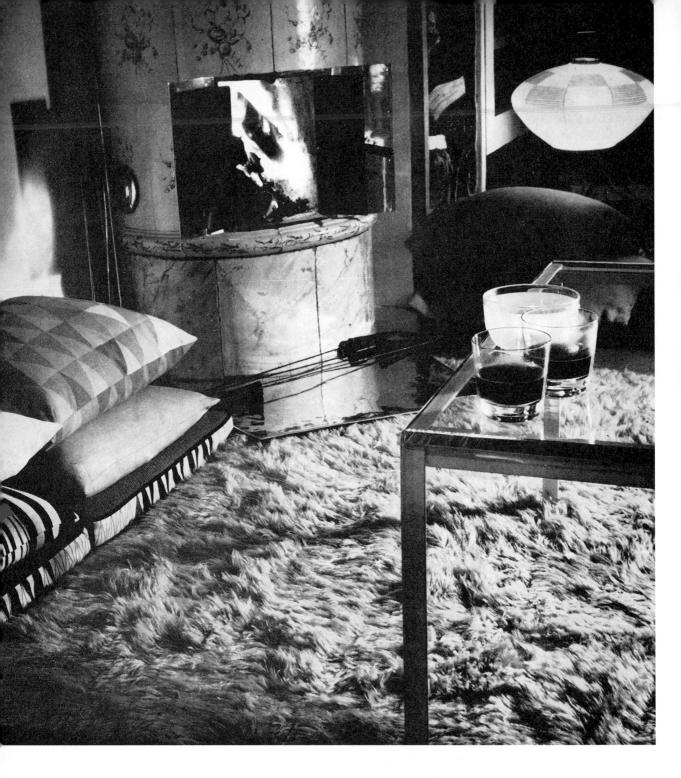

Apartment in Stockholm Designer, Astrid Sampe

The special atmosphere of the fireside can perhaps be better appreciated in close-up.

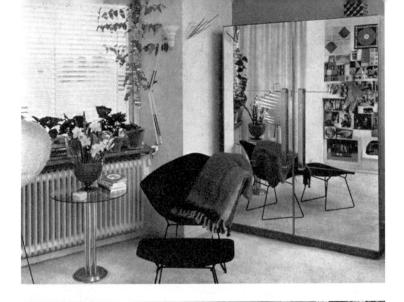

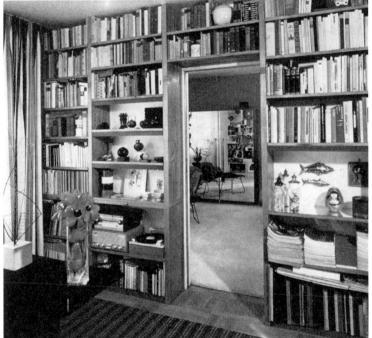

TOP: A corner of Mrs Sampe's bedroom. Reflected in the mirrored doors is the Actwe wall on which are pinned personal photographs of family and friends along with current posters, invitations or even menus from favourite restaurants. In the foreground a Harry Bertoia chair and stool upholstered in purplish-black with a handloomed rug by Viola Gråsten in pinky-orange colourings.

CENTRE: Library wall in Mrs Sampe's study, with doorway leading to the bedroom. On the display shelves folk art is side by side with modern ceramics and glass from many countries.

BOTTOM: Drawing table in teak with black glass top. This was specially designed for Mrs Sampe by Hans Harald Mølander. The spacial sculpture is by Carl Fredrik Lunding, crystal bowl by Tapio Wirkkala. On the wood block floor are handwoven cow-hair runners from the NK Textile Workshop.

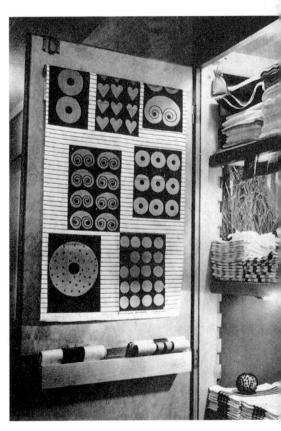

The linen cupboard where, ranged on well lit shelves are many of the household linens designed by Mrs Sampe for Almedahl and Dalsjöfors.

Photos: Studio Conard

House at Dragon Rock, New York State Architect, Russel Wright

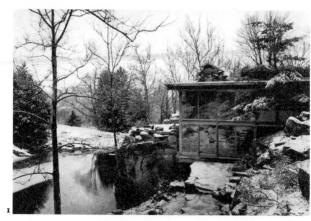

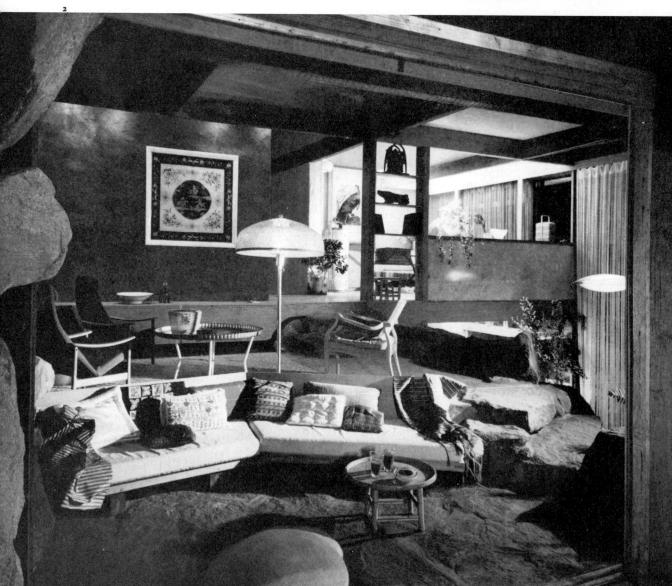

Russel Wright, architect and owner, built this house on Dragon Rock in two distinct parts, designing it to fit both the site by the waterfall and rock-pool and also the habits of the occupants. Built of local materials, it is almost chameleon-like, so well does it blend with its surroundings. In fact to blend with nature and to contrast with nature are basic to its conception: man-made and organic materials coexist: lighting, as on the stage, is used to create a fluid pattern of solid and translucent, advancing and receding surfaces, changing hourly and with the seasons

A terrace, running along the edge of the pool, and a half-covered patio up the slope link the main house with the studio-living wing I. Inside the main block there are several levels. Stairs lead down from the

entrance to the den (illuminated from above through vinyl ceiling) which is built above the kitchen 9 and has a high balcony onto the dining area below

The main feature of the two-level living room 2, 3 is the great stone fireplace (rising above the roof line) and the angled sofa (winter cover, tan wool; summer white vinyl), built against the upper floor level, which faces both fire and windows onto the terrace over the pool, with distant views of the gorge of the Hudson River. Steps cut out of the rock lead down to the dining area, 10 feet below The wall holding a Chinese embroidery panel is of heavily textured dark green plaster embedded with hemlock needles. In winter, the flagstones of the living room floor are covered by a Caucasian

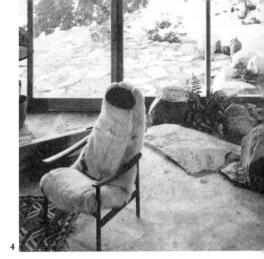

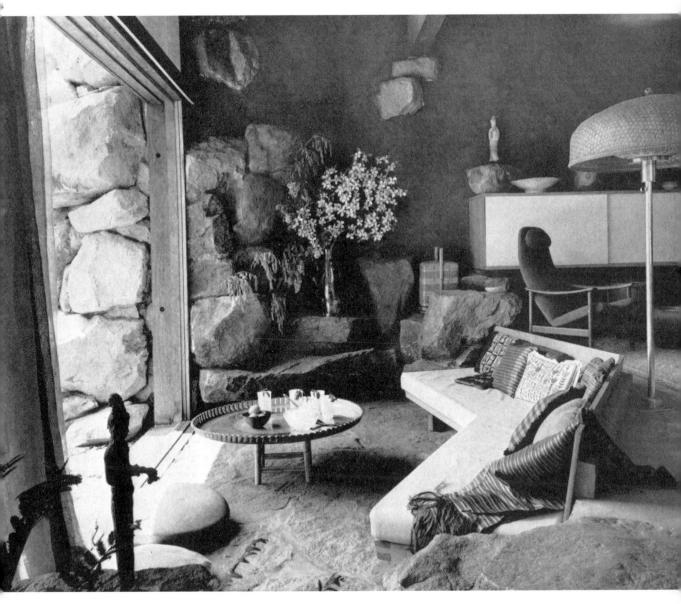

House at Dragon Rock

Architect, Russel Wright

Khilim rug: in summer, a tatami mat. The Danish teak chair 4 also changes from Italian sheepskin cover to blue fabric. The lamp shade is a far eastern basket, the trays are Indian brass

His daughter's bedroom 5 leads out to a terrace 22 feet above the pool. The walls and ceiling are covered in pink metallic foil paper and the window curtains are of pink ninon net over white Swiss eyelet linen. On the one-inch-square mosaic oak floor laid by Miller Brothers is a Hummel Maid multicolour braided rug. The Victorian armchair is upholstered in olive green velour, the rocker in pale blue. Stratopanel drawers and cupboards in white Formica are built-in here, as throughout the house

This room, together with the housekeeper's room adjoining, constitute the 'harem wing' with private bathroom 6. This has a sunken tub into which water flows from the rocks like a waterfall (temperature controls by the Swiss Simix Company). The floor, in Murano glass tile in five shades of blue set in vivid blue mortar, is floodlit through a Filon luminous ceiling. Exotic butterflies mounted between plastic decorate the sliding door

The studio 7, 8 also has alternating winter and summer furnishings. In winter white screens carry formalised patterns of local flora; the natural-coloured Japanese sofa fabric becomes bronze-coloured and light cushion covers become earth-coloured; the Harry Gitlin counter-balanced light loses its white linen accordion cover; an Icelandic sheep rug replaces the Siamese willow matting on the pegged oak plank floor. The desk is faced in white Formica with Stratopanel drawers. The chrome-based round rotating table was designed by Russel Wright, using laminated plastic

The kitchen 9, blasted out of solid rock, is in a neutral scheme of natural white oak, white enamel appliances, white Formica, and Armstrong bleached cork floor, with a luminous ceiling lit through panels of Dow's Styrofoam. Beyond the sink is a fine view of the waterfall. The built-in gate-leg table is designed by Russel Wright; to the left a pass-through to the dining room over a 14-foot counterbalanced cabinet which can be pushed up to a pocket in the ceiling

Photos Louis Reens (2, 7, 8, 9) & Alexander Georges

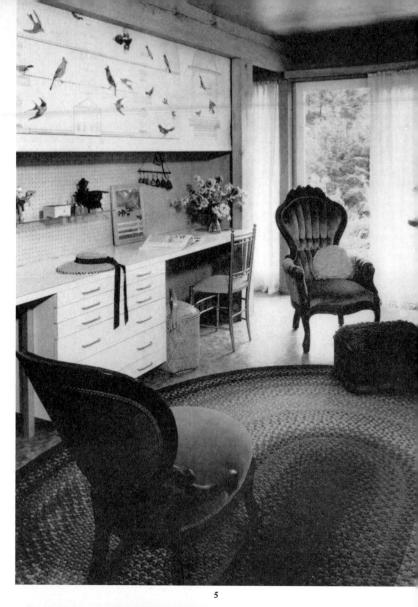

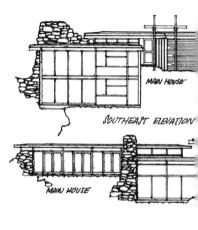

'Harem' wing

Living-dining

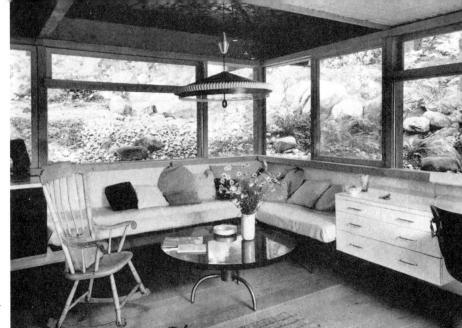

8 >

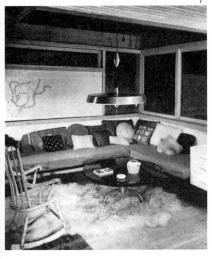

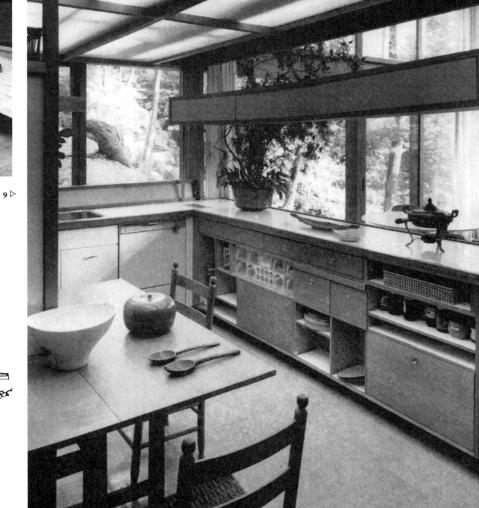

WEST ELEVATION

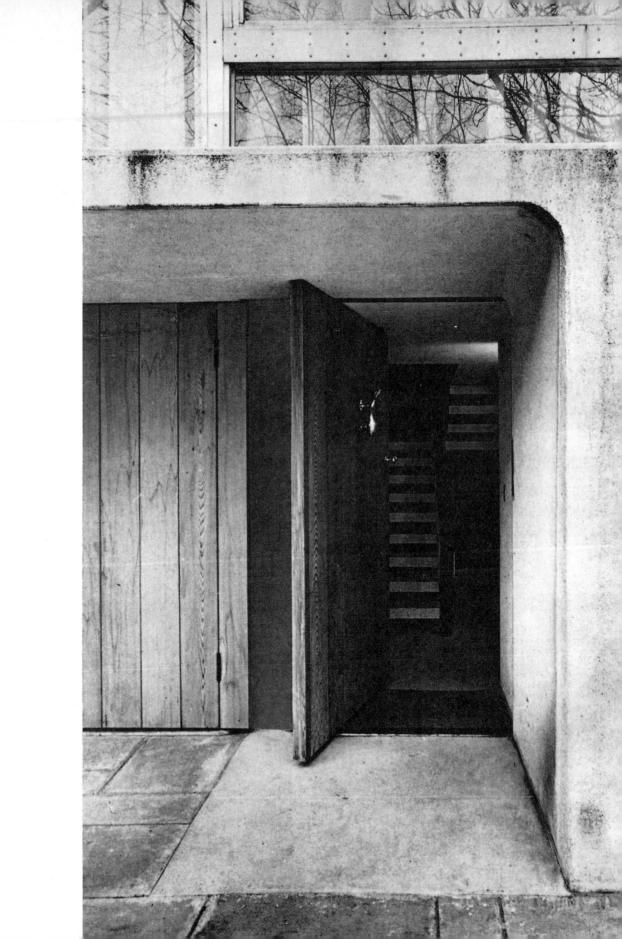

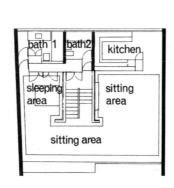

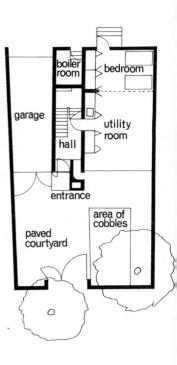

ouse in Kensington, London for Mr and Mrs de Trafford

rchitect Timothy Rendle ARIBA age I in association with Sir Hugh Casson, eville Conder and Partners

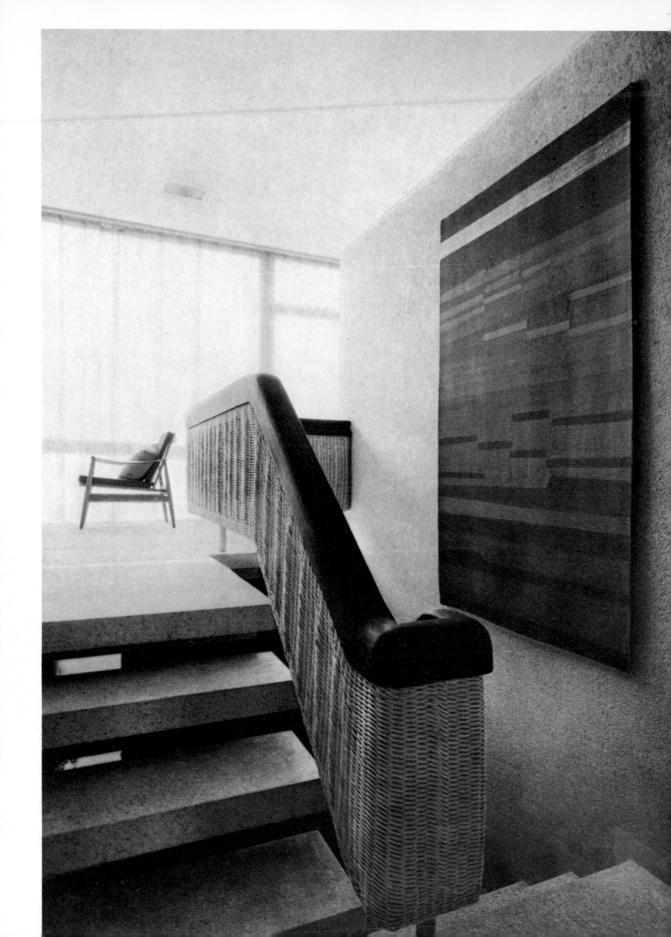

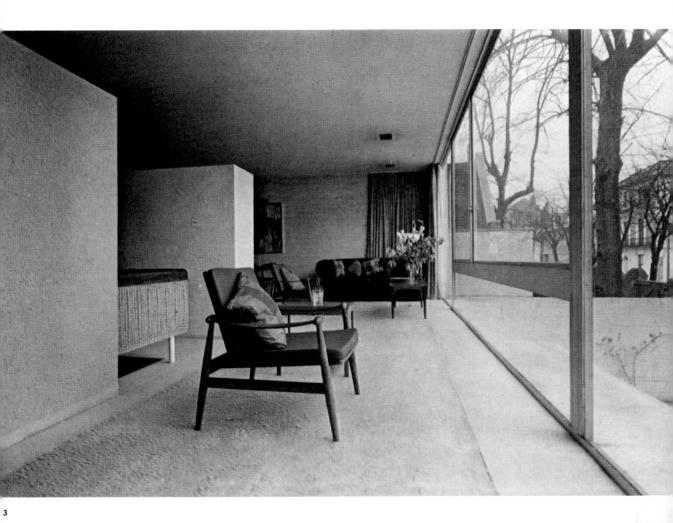

House in Kensington, London for Mr and Mrs de Trafford

Architect Timothy Rendle ARIBA

The front door swings inward, pivoting at a point some three-quarters across its extreme width. Closed, it fits back against the concrete face and into the frame formed by the structure to present, with the doors of the garage, a continuous solid panelling of 6.5 cm natural cedar.

It gives the key to this large pied-àterre built in a quiet residential street of the city to serve the needs of a family often living in the country, but entertaining a good deal in Town.

The architect was given a free hand to design a house combining elements of luxury, with ease of maintenance. With this freedom he has used two materials, wood and concrete, which dominate both the structure and the

internal surfaces and shapes. On the exterior the surface of the concrete is soon weathered: in the interior the walls reappear with white hammered rendering. End walls of the main living area are plaster-finished, with grass paper keeping the general tone. Floors are of white terrazzo with natural long-haired carpeting set into a shallow well through the living areas. Stair treads are of precast terrazzo. Precast terrazzo, too, forms the bathroom

The house is maintained without resident help: often it is unoccupied, but tradesmen's deliveries can be made through the ingenious niche in the hallway.

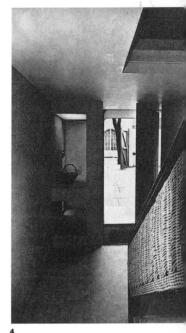

PHOTOS: CRISPIN EURICH

House in Kensington, London

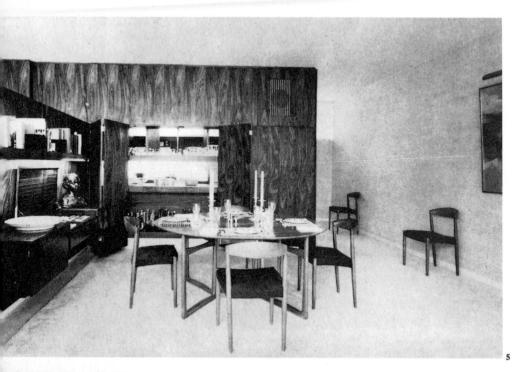

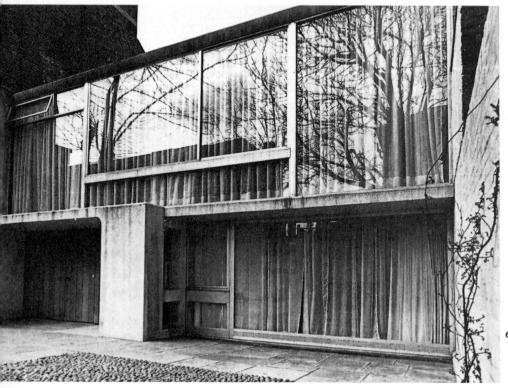

components—the hand basin and the form into which the bath is set, 7.

As can be seen from the plan, the house is more than usually 'open': sitting, dining, bedroom and kitchen areas are divided by timber cupboard units which spread from the central staircase wall. The dark, rich tones of the rosewood impart necessary warmth and intimacy. Curtains are of Indian raw silk. There are well-placed accents of colour and texture; the tapestry on the staircase wall 2 was custom woven by Ruth Harris, the balustrade was created by a cane designer, Kenneth Taylor, ARCA, working on the spot, weaving directly into the metal frame lining the rosewood handrail. The chair in the foreground 3 is from France & Son A/S, as is also the dining table 5; the dining chairs are from Finmar. The bed 8 is orange-covered. A few modern paintings add focal interest.

The kitchen 9 is screened, not shut off, from the dining-end and is doubly accessible through the hatchway in the cupboard fitment.

Some of the seven young children of the family often accompany their parents and are accommodated in the flexible room 10, which covers that part of the ground-level not taken up by garage, entrance hall and utility room. An all-white effect is carried through the vinyl flooring and the Marley room-divider, which enables the space to be broken up into bedrooms, used for extra entertaining or turned into a separate flatlet with its own toilet unit and a 'kitchen' unit, both completely shut into folding doors on each side of the room door. Heating throughout the house is by ducted air from a gas-filled boiler.

PHOTOS: CRISPIN EURICH

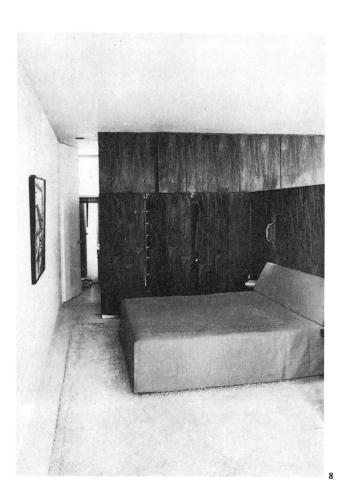

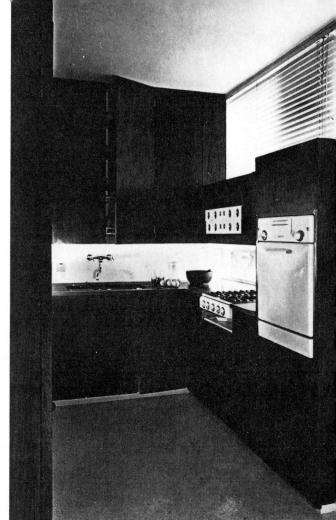

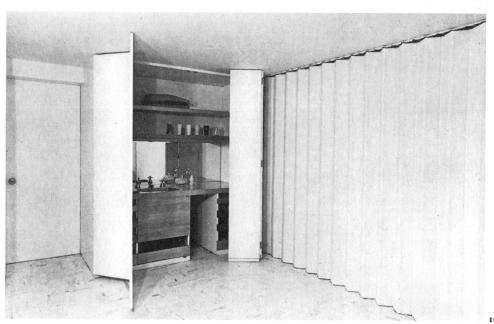

Villa near Tokyo for Mr Matsuura

Designed by Ichigaya Office, Rengo Sekkeisha

Escape from a shell in the city is not retreat to another shell in the Japanese countryside. It means living with Nature with the minimum of 'break' between earth and floor, between air and interior space. So that this house has continuity with the hills in its floor levels, in the lines of its wide sloping roof: the large eaves are stretched lower over the sloping ground, and under them a car can drive in. Where the ground falls away to the south-east on the opposite side of the house the floor is extended to a sundeck above the larch trees growing on the wide hill-side 6.

Space and proportions have been fixed as factors common to a number of

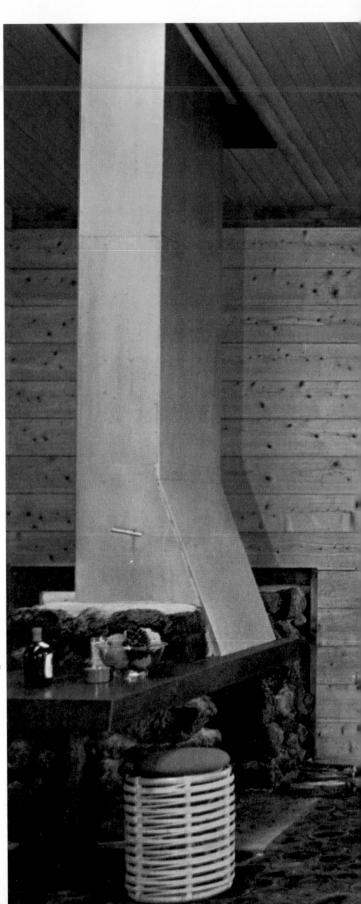

PHOTOS: F. MURASAWA COURTESY Kenchiki Bunka

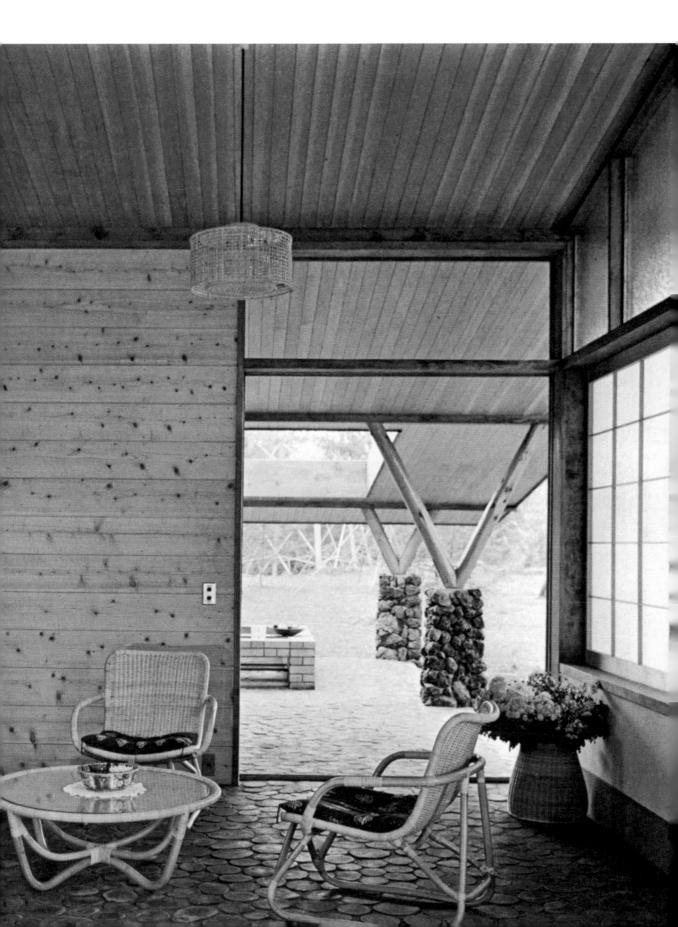

Villa near Tokyo for Mr Matsuura

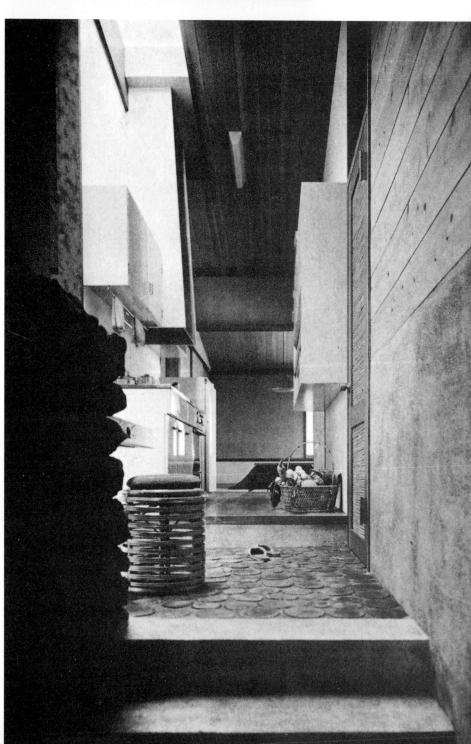

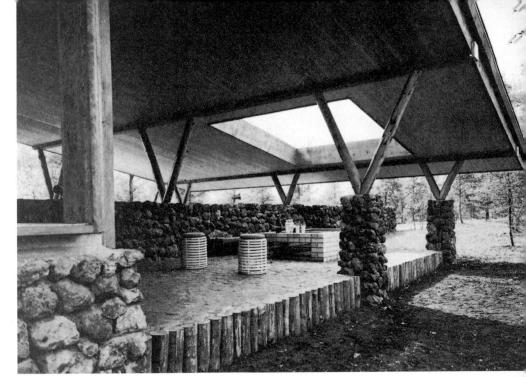

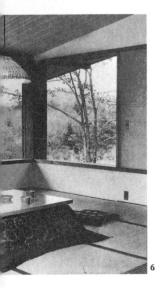

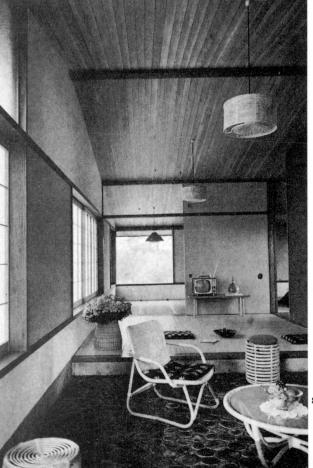

villas built by the Ichigaya Office. But individual arrangement is demanded to achieve advantageous siting and to suit the desires of the owners. In Mr Matsuura's house the wall of Assam hot stones screens the car from the terrace 7, where barbecues can be held on hot evenings. This wall continues into the interior to a stove built of the same stone: the chimney is supported on a lintel which continues to form a dining table.

According to mood and weather the wall at this end can be partially 'removed' and the room and terrace are continuous in the floor of unsquared nutwood blocks. There is then an uninterrupted view from the guest room, a raised sleeping area spread with wisteria-vine tatami, background 8.

The ceilings are lined with Japanese cedar plywood and surfaces of walls and fitments are generally of Lauan flooring with clear lacquer finish. 4 shows a view through that half of the villa behind the line of the wall to other sleeping rooms, food storage and necessary utility space.

PHOTOS: F. MURASAWA COURTESY Kenchiki Bunka

8

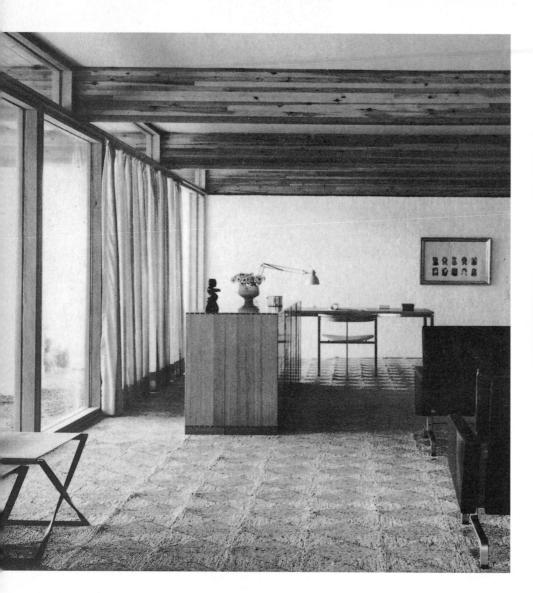

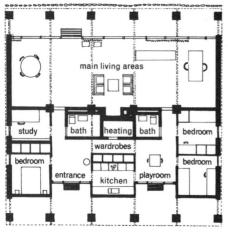

Family house near Copenhagen

Architects Hanna and Poul Kjærholm

On a small site overlooking the Sound north of the city, the architects built this single-storey house for themselves and their two young children.

The structure is a series of white-washed brick pillars which carry six large cross-beams of laminated wood on which rests the flat built-up roof. Extending the length of the house, the large living/dining/work-room faces the Sound: the bedrooms and kitchen are around and behind a central walled unit containing two bathrooms and the furnace room which provides controlled floor heating throughout the house.

Interior walls are either of the same white-washed brick as the pillars or of untreated pinewood which merges with the doors and cupboards of the same wood. From every room there is direct access to the garden through the window-walls. The floor of the main room is completely covered with natural-colour Spanish matting with curtains of natural-colour pure silk. All the furniture has been designed by Mr Kjærholm except for the bookshelves-cupboard unit which was designed by Mogens Koch.

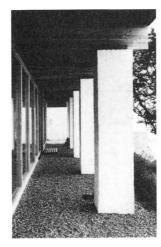

PHOTOS: K. HELMER-PETERSEN

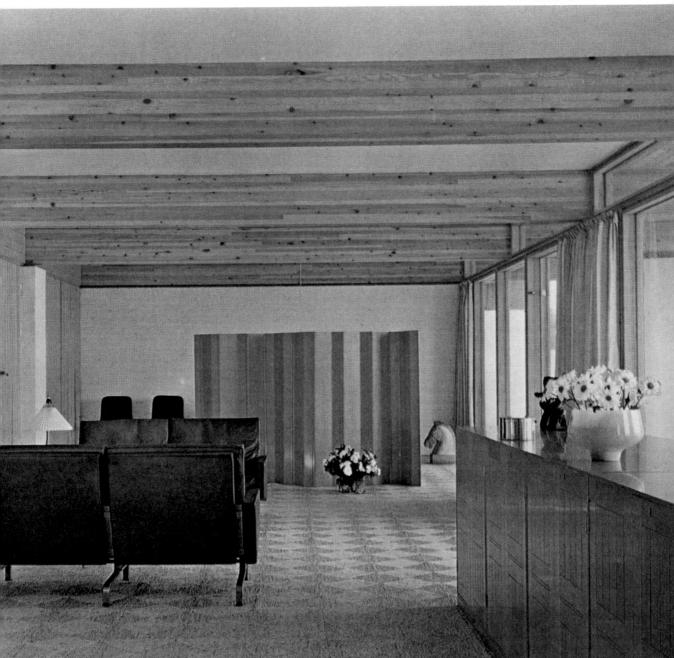

Paris apartments

Designer Jean Royère

Living-room with curved sofa and armchair in pearl-grey velvet on a violet carpet: on the white walls is a tapestry by Picart le Doux—green, mauve and pink on a black ground. Cabinets are of sycamore with panels of yellow fabric: on the white sheepskin rug a black Formica-topped table. 2, 3
Bedroom-in-a-corridor, the bed con cealed by two sliding doors in oak Desk, bookshelves, white-painted cup boards are ranged on the left. Windo curtains and bedcover in a red/blacl on white diabolo print by l'Impression des Dauphins. The pouffe is covere

in white fur velvet.

4 Student's bedroom with built-in bed book-shelves and hanging desk in oak the desk front pulls down and out to form a small table. Dark brown velecovers the bed: the light-blue ceiling creates space, a feeling augmented by the curtains—a bird print on satin, by l'Impression des Dauphins.

5 Fireplace in dark brown brick with marble surround: it incorporates log storage space and cupboards with oal sliding doors.

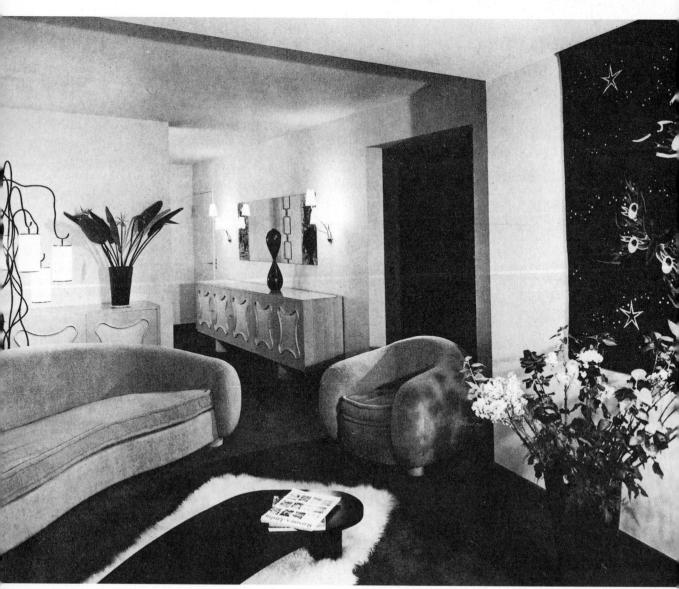

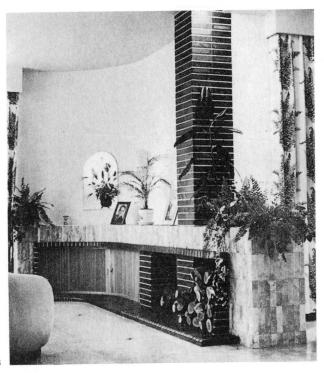

5

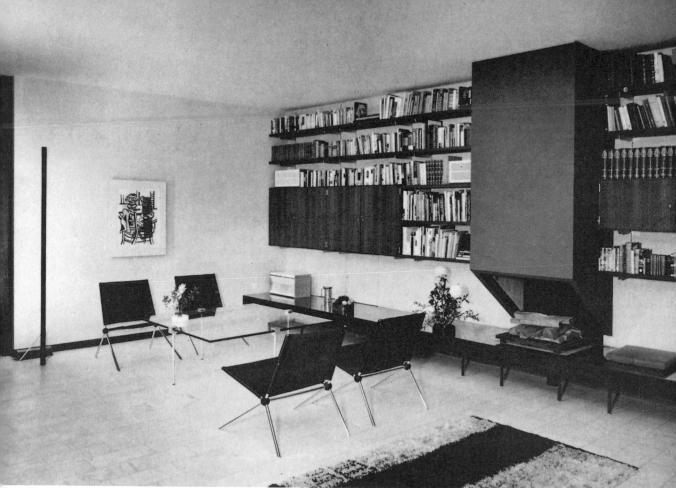

PHOTO: INGE GOERTZ-BAUER

Living-room of a house at Düsseldorf

Designer Professor Paul Schneider-Esleben

The sharp, simple use of black and white is broken only by the teak bookshelving on either side of the chimney, itself formed from black sheet steel lined with firebrick. Interest is added through texture—on the white marble floor is a grey-to-black Rya rug, designed and made by Kirsti Ilvessalo of Finland: on the walls raw white silk meets the white plaster ceiling: on fine chromium-plated steel frames, the chairs have black leather seats and backs. The chairs are made by Hans Kaufeld to the design of Paul Schneider-Esleben, who also designed the glass table.

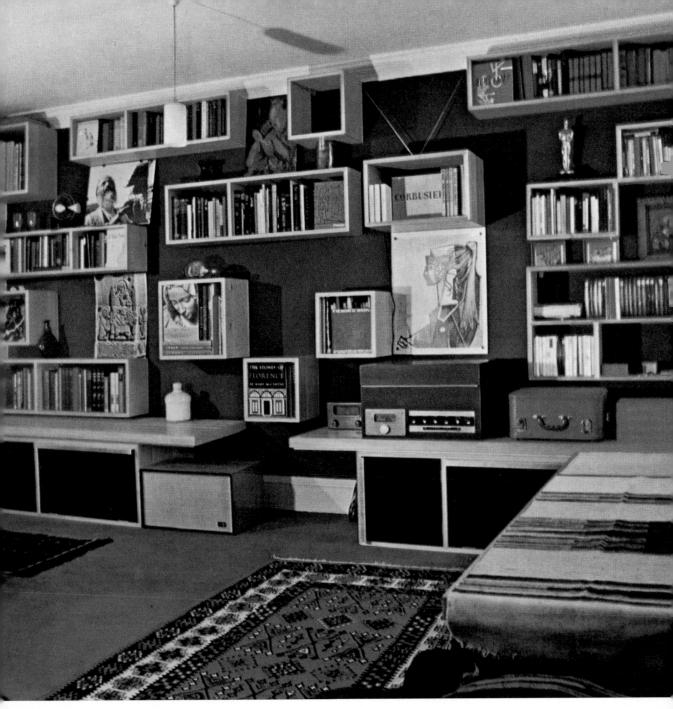

An architectural-photographer with wide interests, John Donat has in consequence a varied collection of books, documents, records and unclassified trivia. To accommodate it, one wall of his apartment has been given an exciting pattern of storage units planned on a module, determined by the overall size of groups of books. Cut from pine, the units are attached directly and simply to the brick walls.

A Turkish Khilim rug echoes the warm colours and textures of covers and woods.

Apartment in Camden Town, London Designer John Donat ARIBA

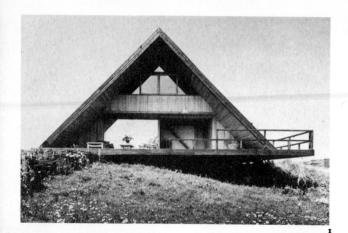

Holiday Home at Hald Beach, Kattegat

Architect Ole Hagen MAA

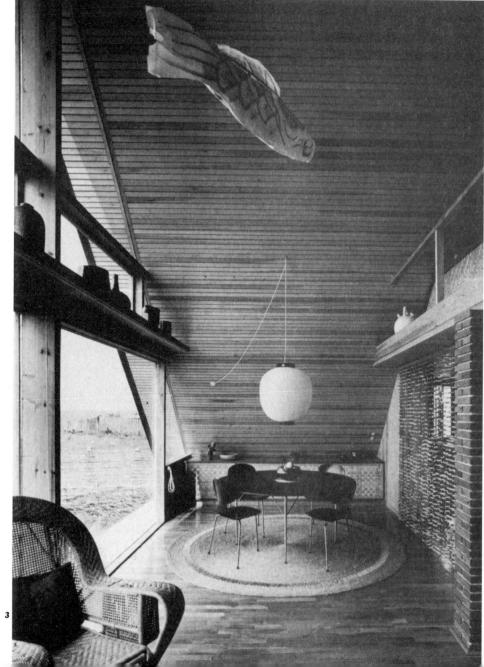

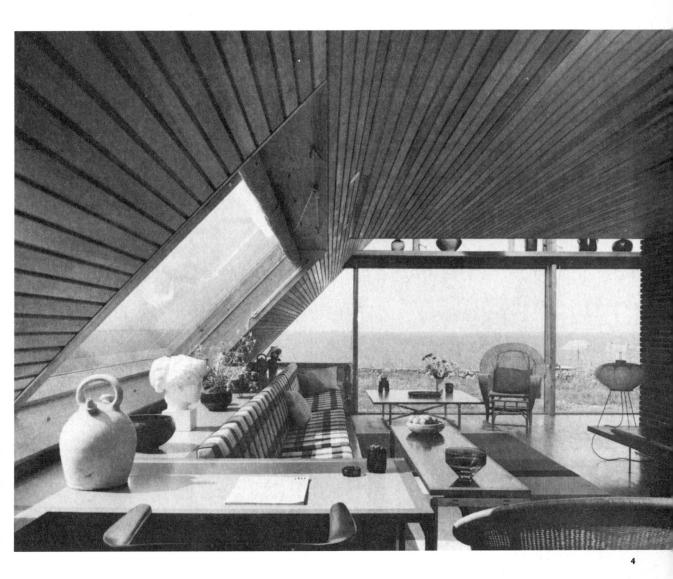

At the top of high cliffs on Zealand's northern coast this tent-like house has been sited so that its 'open ends' face out over the sea at one end and into the countryside at the other.

It is the holiday home of the architect, his wife and their children.

The roof extends to the balcony as walls sheltering a deep, wide terrace on the south, from where large sliding doors lead into the living-room. Dominating this room is the fireplace of dark brick with hearth and extensions to each side formed from a slab of dark soapstone.

The architect himself designed the long, bench-like sofa with its black/white/grey check cushions, the working desk, the sideboard and sofa tables.

At the other, northern, end 3, the room opens up to a double height dining area having a magnificent view over the Kattegat through the glass gable—in fine weather from the open balcony. The kitchen, separated from the dining area by a light bead curtain, has walls ressellated in light blue and cupboard doors finished in similar tones.

Walls and ceilings of the house are finished with pine strip and the parquet floor is of oak, the wood providing a fitting background for fine handwoven Danish rugs, and for the architect's collection of ceramics and chairs by various Danish designers.

All window areas are double glazed and hot-air central heating is controlled from a boiler room in the cellar.

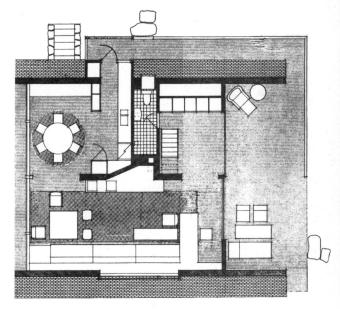

PHOTOS STRUWING

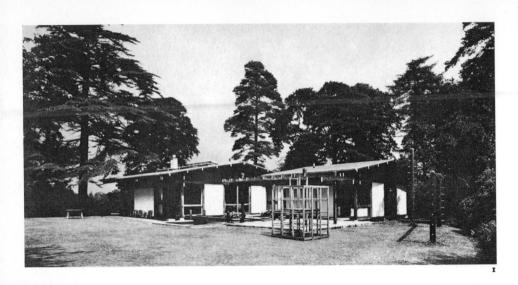

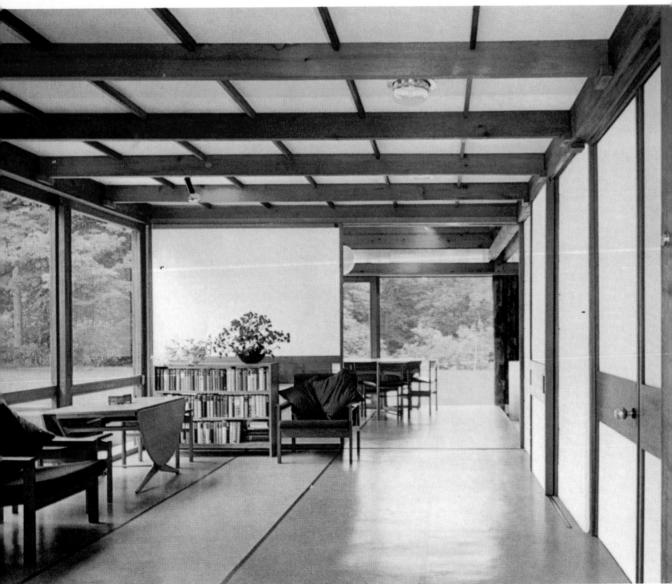

82 · houses and apartments · 1964-65

House in Keston, Kent

Architects Howell, Killick, Partridge & Amis

Together with a site made beautiful by its well-placed cedars and pines the architects were given great freedom to design this family house on the edge of the Kentish Weald. The only requirement was that living, parents' and children's areas should be clearly defined: as the site was not suitable for an atrium construction, the architects created a central living area with the children's wing to the left, and the parents' wing to the right, strung out across its width, 3. Visual interest and practicality are served by raising the parents' wing and its balcony over the car port, right. The house is completely identified with the landscape and with the wild-life which gambols between the edge of the wood and the house.

Construction throughout is of cedar with the structural details providing the main decorative element of the interior. Timber-framed sliding doors, finished with white P.V.C. panels create areas of privacy or a more intimate atmosphere.

The entrance opens into the large hall-lounge area, 2 leading into the dining area beyond, and from the dining area a cosy sitting-room opens to the right. The chairs, dining chairs and tables are from France & Co. Other fittings

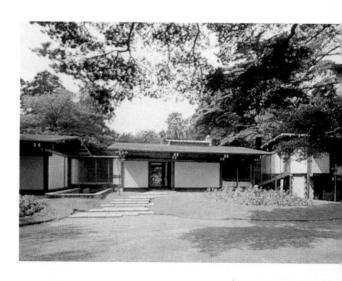

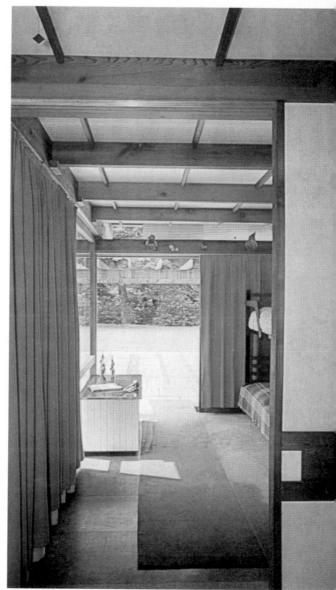

PHOTOS JOHN DONAT

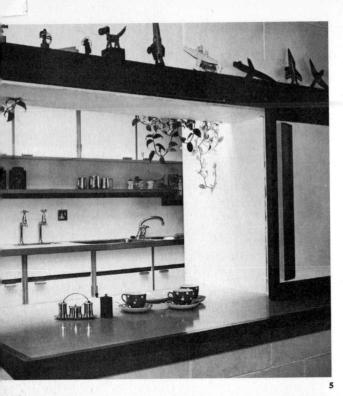

House in Keston, Kent

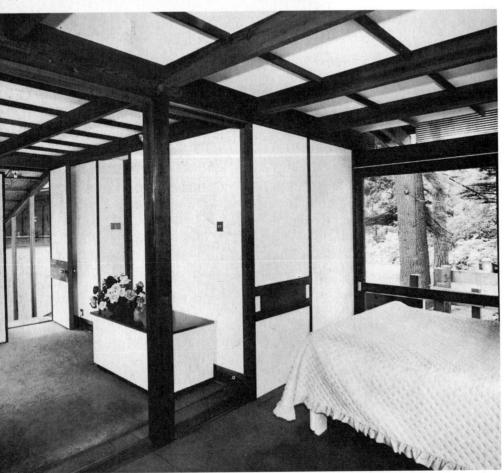

are generally planned for the house by the architects or made by the owner. Kitchen fitments, include the broad through-surface to the playroom, 5 which allows quick meals to be served to the boys, and provides space for more elaborate cooking preparations. 6, parents' room: 8, the north-east corner of the house with the sitting-room: 9, the dining-room from the lawn and woods at rear, 1.

6

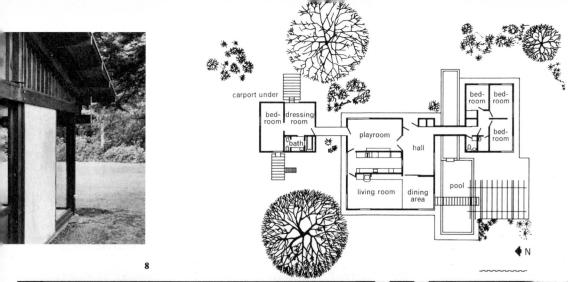

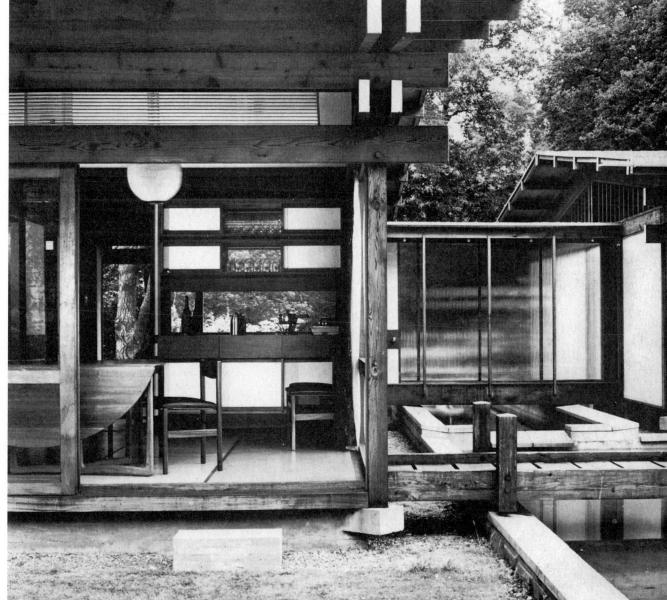

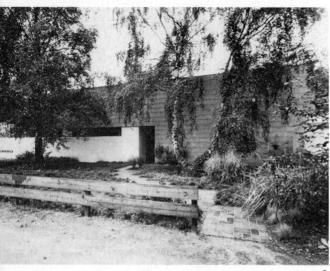

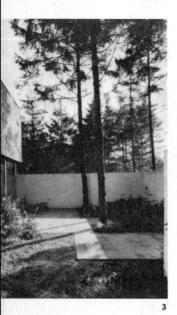

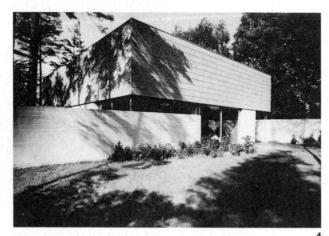

House plus Studio near Hamburg Architect Timm Ohrt

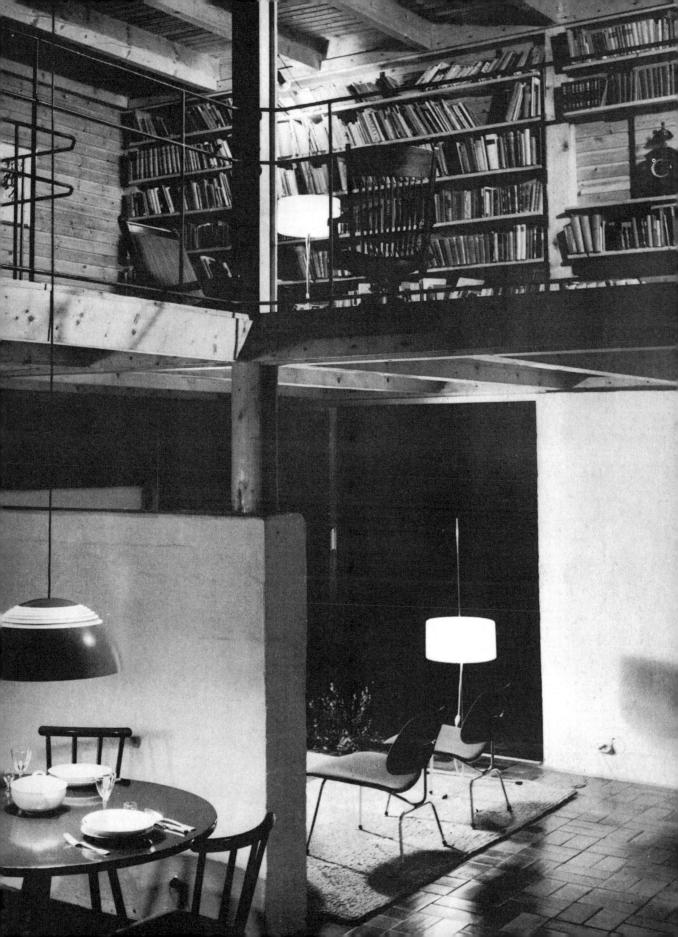

The stony path seems to lead from the road only to a sunny meadow above the Lake of Zürich. The impression is hardly disturbed by the small doorway to the passage between garage and main building. On to this passageway open entrances to the atelier of one of Switzerland's most successful and individual advertising agents and to the private house of Mr and Mrs Halpern and their children.

Most frequented rooms of both atelier and house are situated on the ground floor: 'service' rooms are beneath in the space created by the slope of the hillside, although here too is the main conference room and director's office 5 opening direct to the terrace and pool through the sliding glass wall. The pool and terrace link, visually and physically, the otherwise quite separate parts of the building and

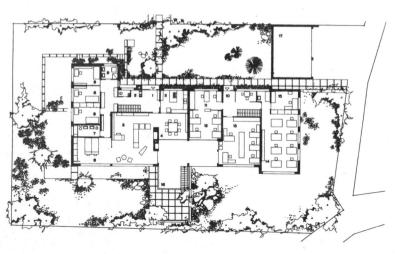

GROUND FLOOR PLAN

- I, entrance private house.
- 2, wardrobe.
- 3, living-room.
- 4, dining-room.
- 5, kitchen.
- 6, bedroom.
- 7, bath.
- 8, children's rooms.
- 9, children's washroom and laundry.
- 10, entrance advertising agency.
- 11, reception.
- 12, office media department.
- 13, account executives.
- 14, atelier.
- 15, treasurer.
- 16, terrace.
- 17, garage.

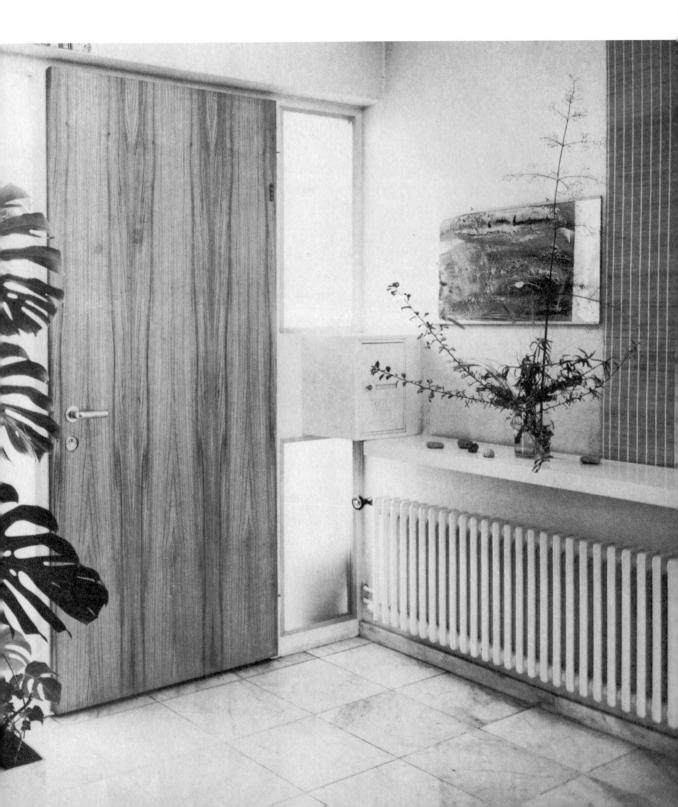

House and atelier near Zürich

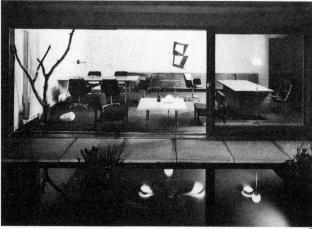

the whole structure of the building is orientated towards this, the southern aspect with views to the lake and city 2, 3.

The exterior walls are of white-painted concrete, the flat roof, also of concrete successfully harmonising the mass of the building in the hillside.

All finishes and fittings were conceived as an integral part of the building—thus room depths and heights were planned to accommodate standard units: wardrobes, kitchen cupboards and living-room fitments are all in the Wohngebau range with matt white finishes. The doors too are painted white. The entrance hall of the house, pages 18/19, has a floor of light grey Swiss marble. A sliding door

between living room and the main bedroom, with some other wood components, are of a pale oiled timber which warms but does not darken the overall light, cool effect of the interior. From the hall open the three children's rooms and the remaining space is divided up, first by a sliding-screen between living area and parents' room 4 then by the fireplace wall between living and dining areas 6, 10 and by the all-embracing wall fitments of the kitchen 7, 8. The result: in the house, the same directness and clarity which mark the campaigns to sell coffee, clothes and cooking-stoves, which are dreamed up in the business end of the building.

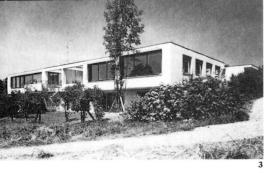

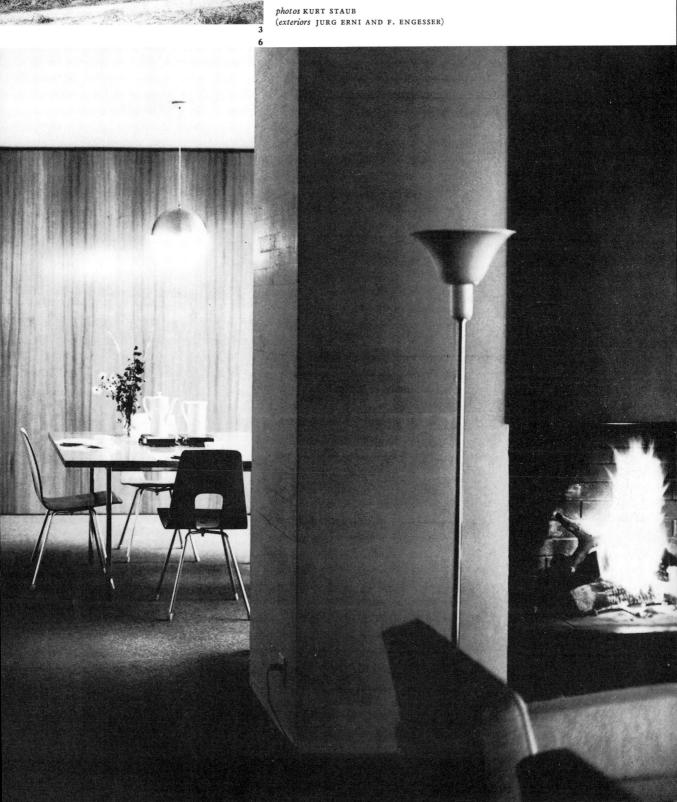

7, the serving hatch to the dining area.

8, the kitchen with Wohngebau fitments and Therma electrical appliances. The Therma cooking table includes hot-plates which swing up when not in use, to reveal stainless steel mixing basins dropped into appropriate cavities. 9, the fireplace wall is faced with black steel: furniture is by Knoll International with the exception of the long chair by le Corbusier, of chrome steel upholstered in cow-skin.

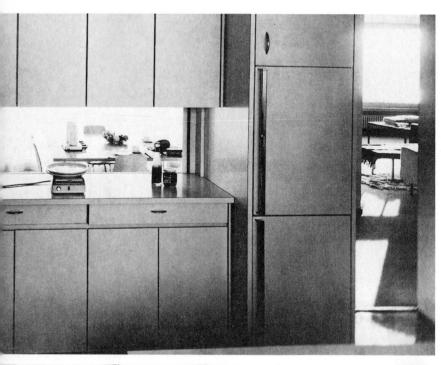

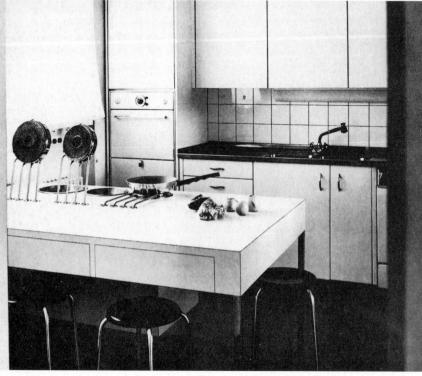

92 · houses and apartments · 1965-66

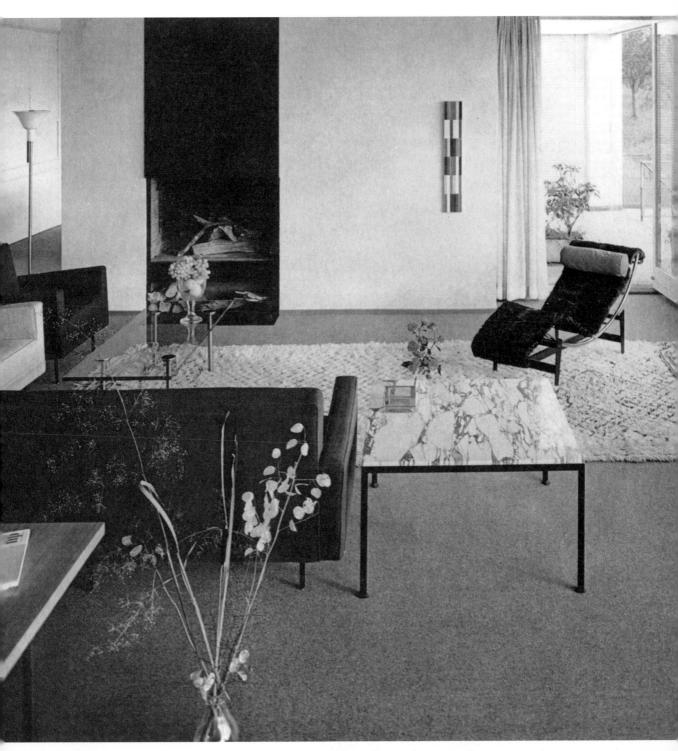

1965–66 · houses and apartments · 93

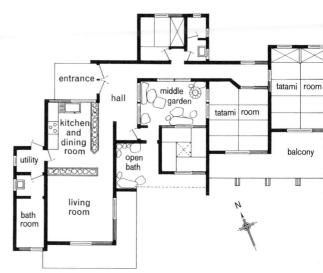

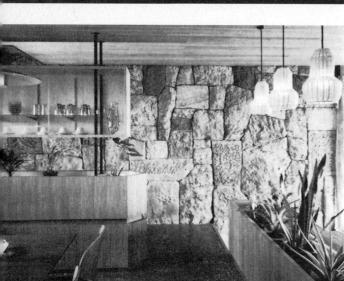

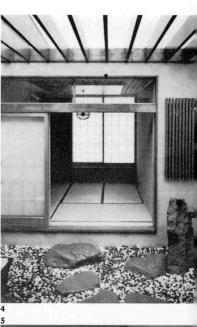

he Ko Residence

chitects GAD and Associates

v stressing its horizontal lines the chitects of this house have emphased the sloping site and the changing or-levels—used partly to accomodate the site, partly to give namism to the structural effect. Instruction is mainly of wood, herever possible using single, largection timbers, where necessary iron mes.

here are two distinct areas of the use, one influenced by Western yles, e.g. in its seating elements, and eretaining traditional characteristics,

2, living-room from the south. kitchen.

inner garden and *tatami* room. entrance hall and inner garden. south aspect from the east. living-room.

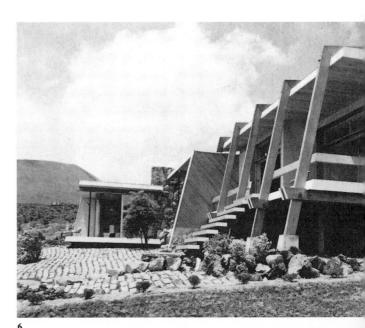

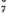

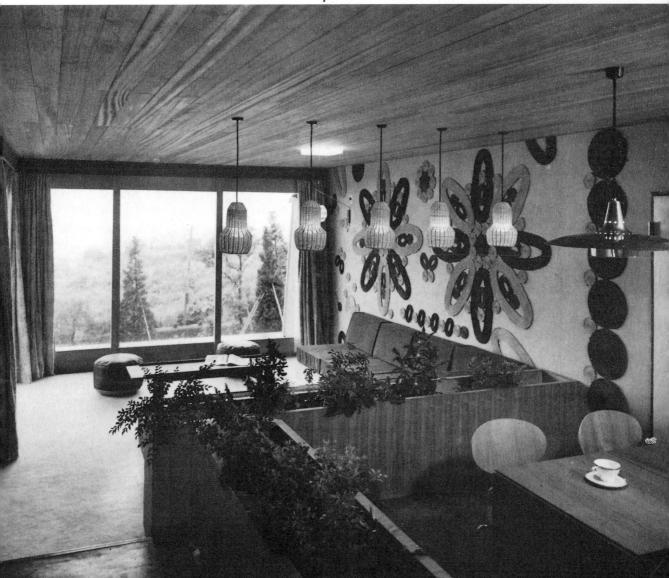

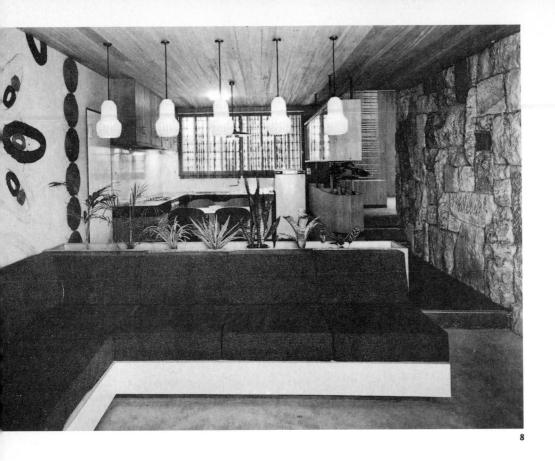

The Ko Residence

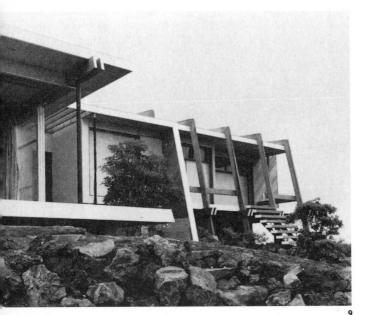

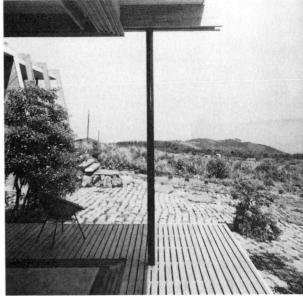

10

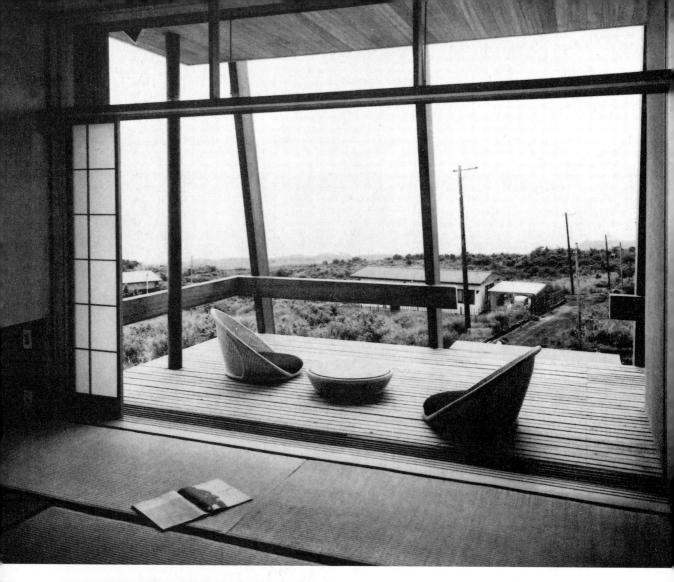

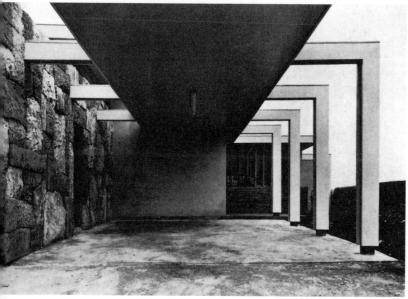

as in the *tatami* rooms 9-11. These areas are unified by the inner garden 4, 5 which also serves as a passageway and gives light to the entrance hall.

While features suited to modern life have been introduced in the main living areas 3, 7, 8 the house suggests continuing use of the materials which have served Japanese building so well for so long. The large-section timbers have become a definite element in the design: igusa, used in the making of tatami mats, is used too for the flower decorations designed by Teruko Yoshida 2, 7: the tatami, all-purpose, rooms are divided from the other areas and from the exterior by light sliding-screens.

- 8, dining-room from living-room.
- 9, tatami rooms, south side.
- 11, balcony of tatami rooms.
- 12, carport.

photos FUMIO MURASAWA courtesy Kenchiku Bunka

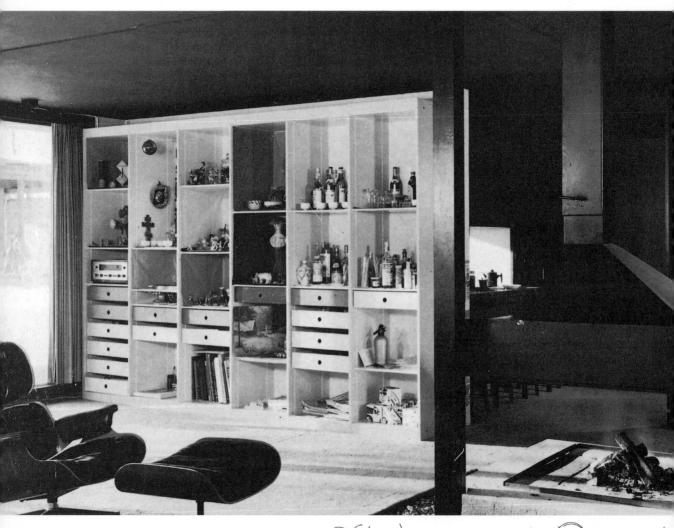

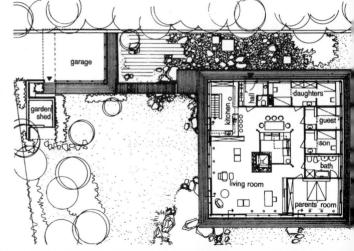

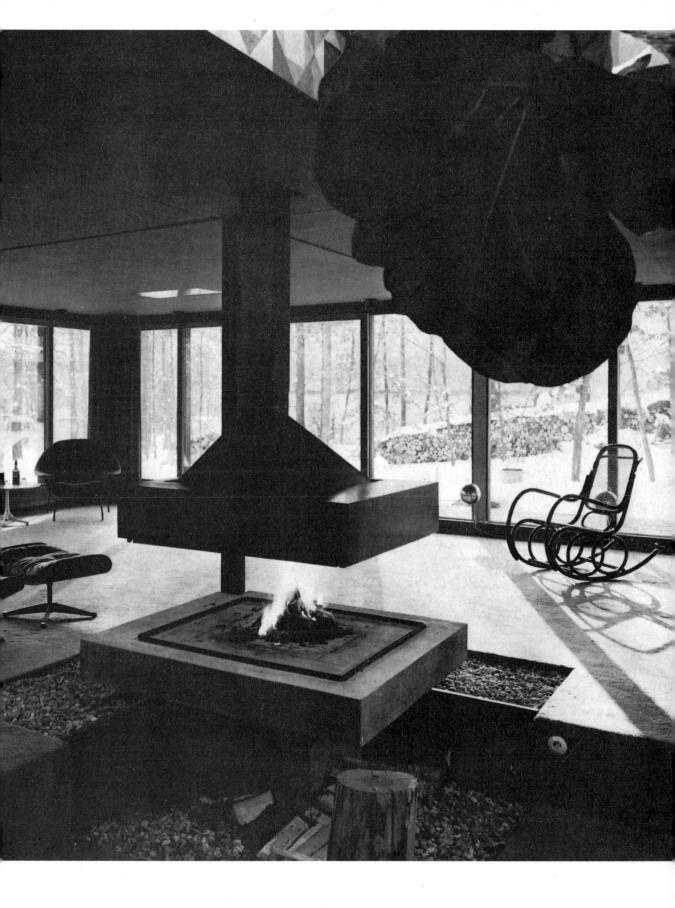

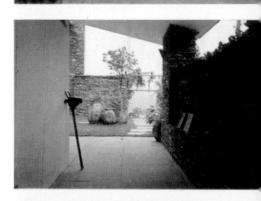

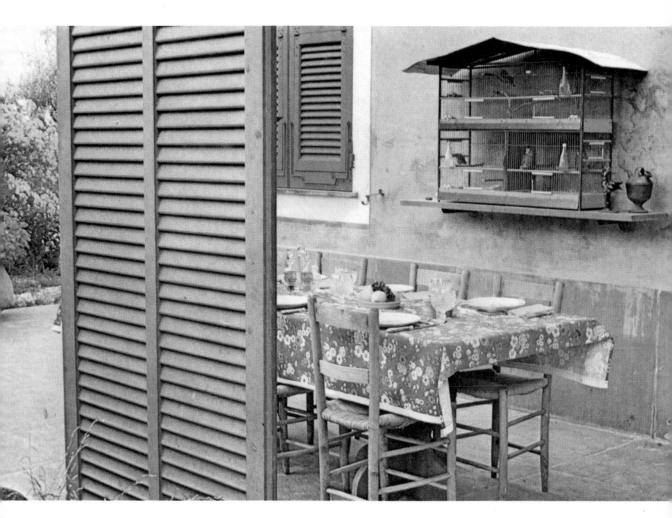

Like other beautiful stretches of coastline the area around the Gulf of Tigullio has lost much of its quiet and magic spell and only in the hinterland can they be recaptured.

Among the olive groves Leo Lionni found a typical Ligurian country house with pink fresco finish, green shutters and slate floors.

American editor, painter and avantgarde designer, Leo Lionni has an apartment in New York but he decided that here, in the midst of this countryside he would make his home and a home for the treasures which he has collected during years of travel. His son, Louis, an architect, collaborated and advised on necessary details of structure and design: the interior has been entirely rethought but local, or at least Italian, materials have been used so that while there is no false rusticity, neither has an alien feeling been created. The result is a setting in which the large collection of pieces are grouped with selective discipline: sometimes an important piece is placed in juxtaposition with a small, simple thing but the whole shows evidence of an informed and affectionate knowledge of the artist and his craft.

Not only inside the house but on paths, patio and garden walls, places have been found for some of the owner's treasures. Above, a spot for eating.

A home among the olive groves of Liguria

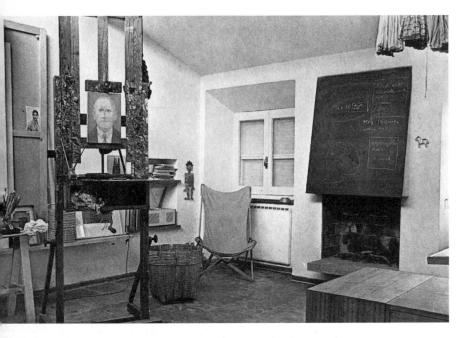

In the studio: the work-table, travel souvenirs, Indian marionettes, Aztec figure, all part of a traveller's collection. There is obvious pleasure from the 'islands' of controlled disorder in the midst of a highly ordered whole. In the living-room: a Calder mobile, a

sculpture by Giacometti, a Bobo mask, Persian carpet, seventeenth-century German cupboard, Eames armchairs, Sarfatti-Arteluce lamps. The table rests on a wood brazier base curiously reminiscent of the base on the Eames chair. Below, the modernised kitchen.

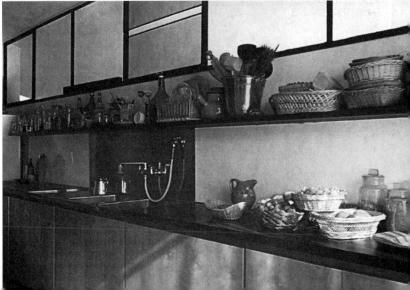

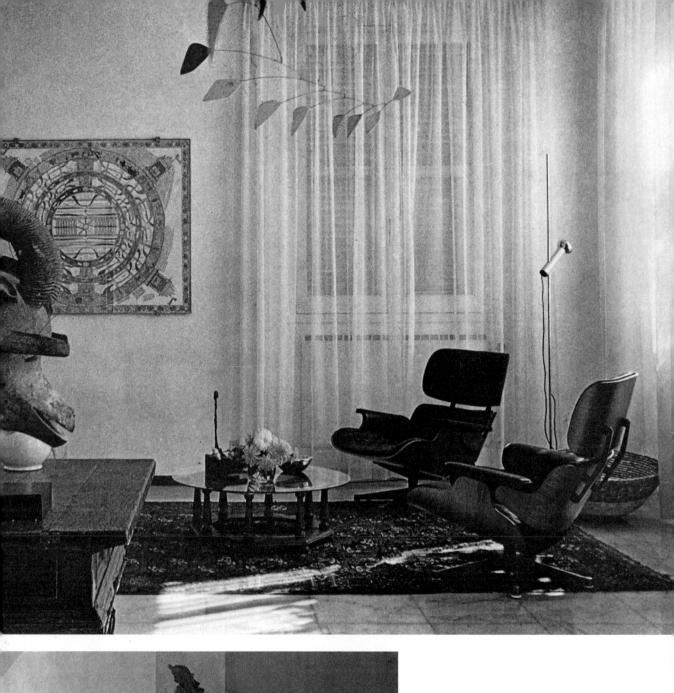

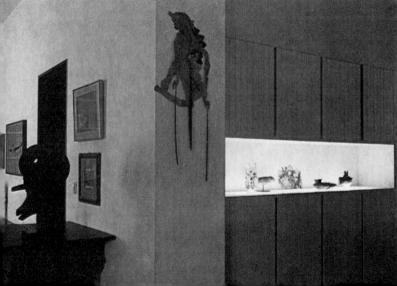

A home among the olive groves of Liguria

Again the living-room: le Corbusier chair, George Nelson sofas by Herman Miller, Mexican figurines on the shelf, in a sudden quickening which vivifies the rigorous rhythm of the decoration. On the walls works by Ben Shahn, Morandi, Klee, Boudin, a Dogon mask, Katchina dolls, a group of Coptic, Indian, Maya and Persian

objects. The Bobo mask, penitentes sculptures from New Mexico. The floor is in white Carrara marble, the shelves in ash, the lamp is from Arteluce.

At right, the door to the studio and a mosaic in the studio: below it, a Calder mobile and two works by the American primitive Werner.

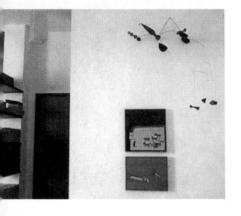

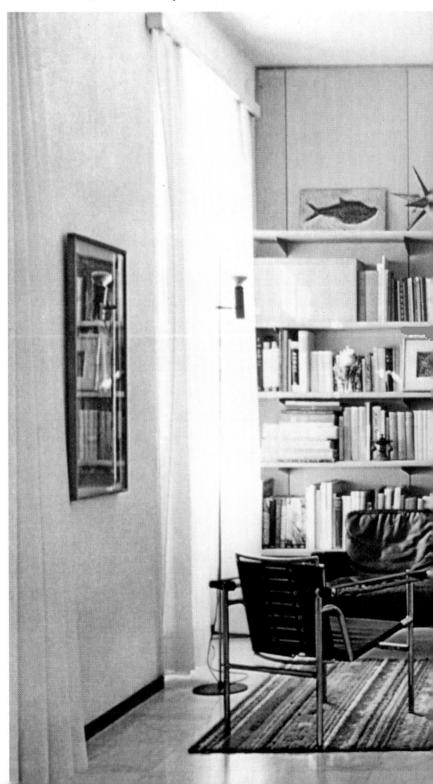

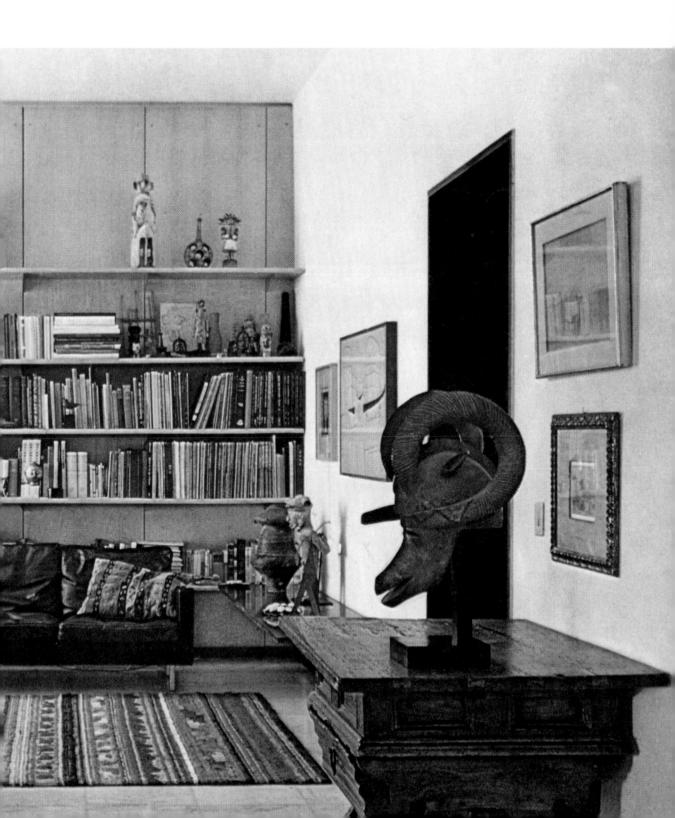

photos JOWA PARASINI

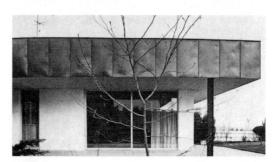

The Architect's Home near Vienn

architect Carl Aubö

This is a large one-storey house on the hills slightly above Vienna and over looking the city.

The wide, overhanging copper roof supported by a steel frame constrution filled by exposed concrete, painte white, or by sliding glass walls.

The interior is arranged for a large family so that sleeping areas as situated in one arm of the L-shape building separate from living areas in the other. They are separated not only the structure but, perhaps ever more strongly, by furnishing.

The whole house has curtains of

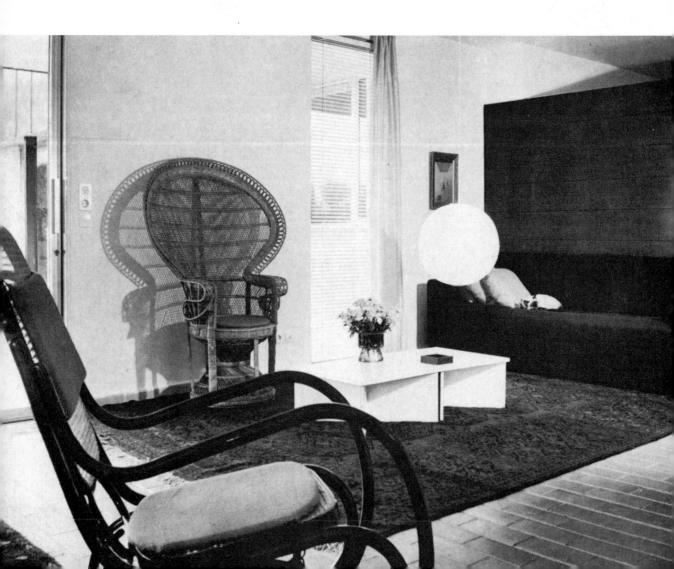

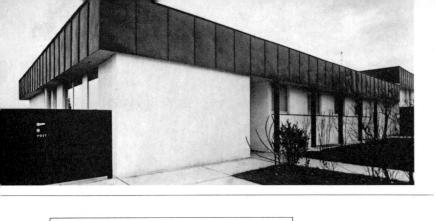

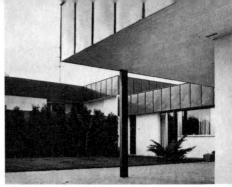

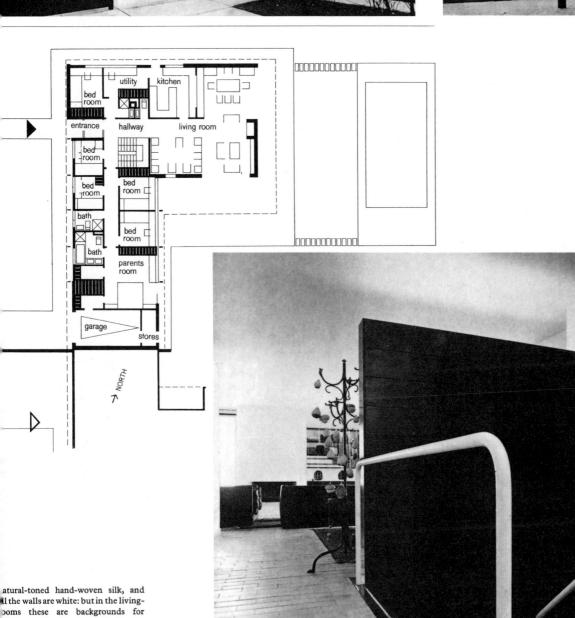

atural-toned hand-woven silk, and II the walls are white: but in the livingooms these are backgrounds for hapes with depth and form urniture upholstered in black leather, tments and doors of Wengé: and the loor is crisp with ceramic tiles.

The sleeping area has floors of cork iles, the wood is bleached ash, and the upholstery is natural-woven wool. The house is glazed with Thermopane broughout and warmed from an oil-purning system.

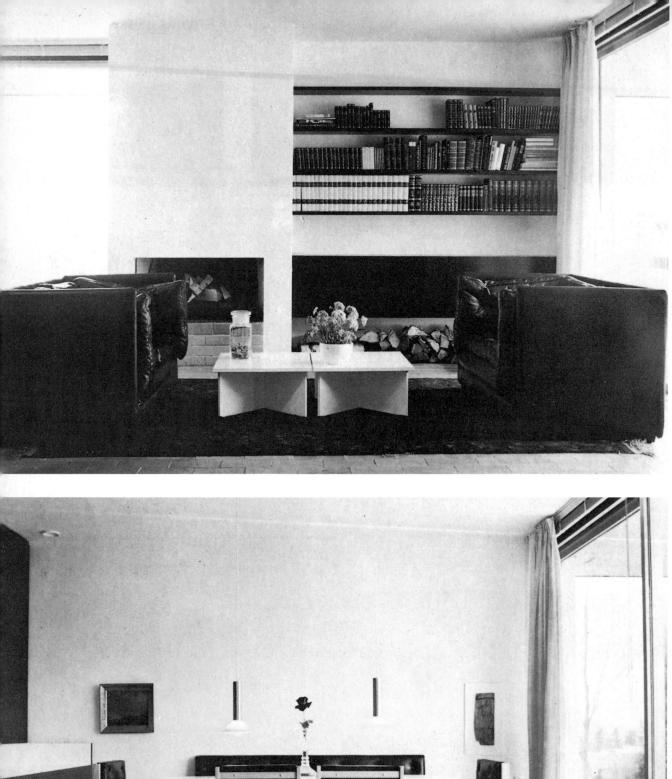

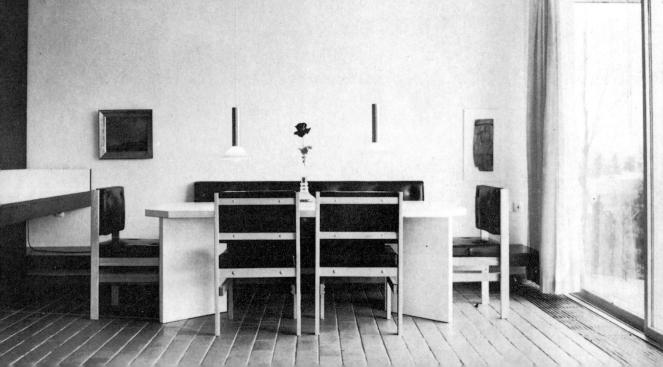

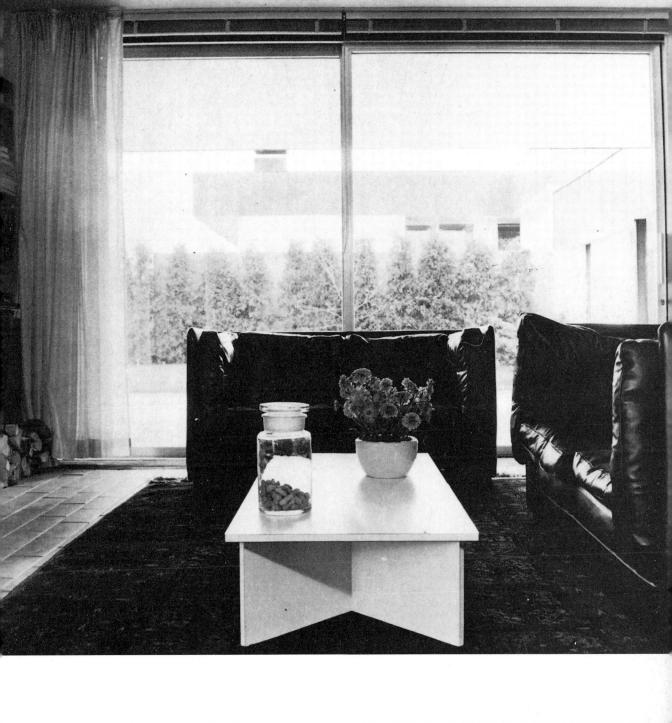

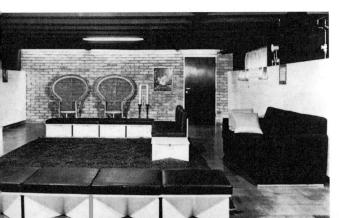

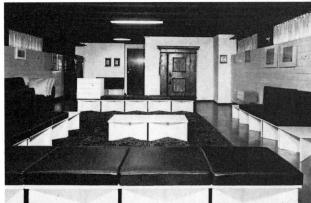

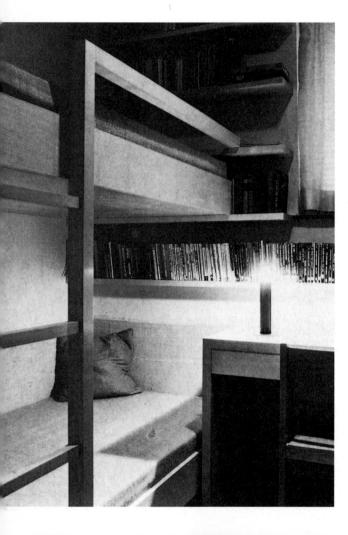

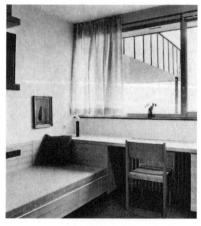

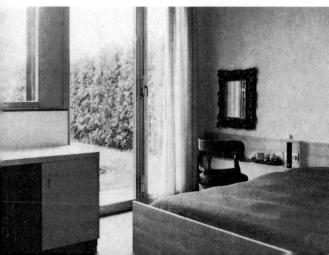

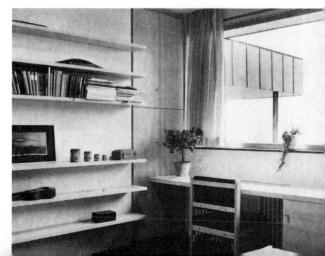

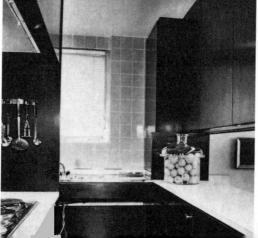

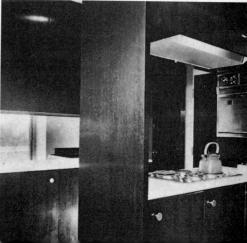

Rosewood combined with stainless steel, and stainless steel with upholstery in Ascot brown, all on a cinnamon-toned rug over a white tile floor
Upholstery is *Chamois*, a Win Anderson Fabric by Jack Lenor Larsen, Inc.
Room designed by Barbara D'Arcy

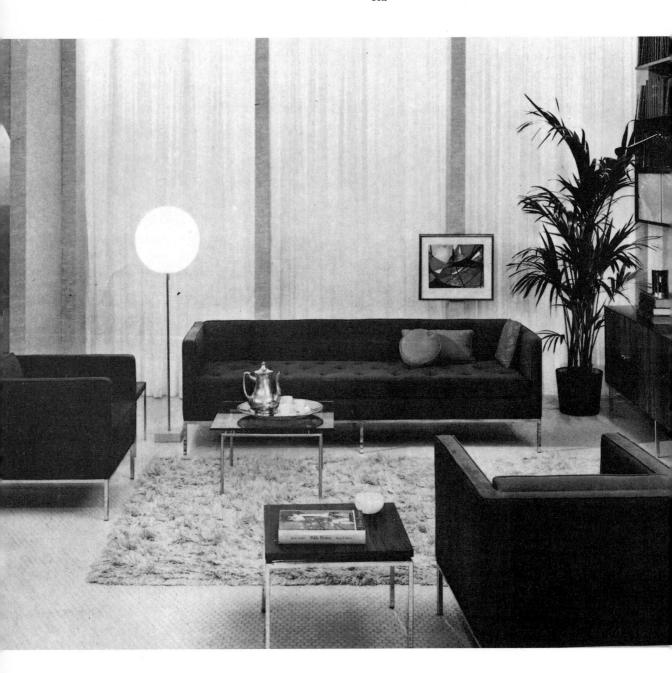

Chimney corner furnished with units from the Modus range (the cushions of black leather, feather filled) designed by Kristian Vedel for Søren Willadsens Møbelfabrik DENMARK Moskus carpet, a broadloom, 200 cm wide, available also in olive green and dark brown Made by L. F. Foght A/S DENMARK

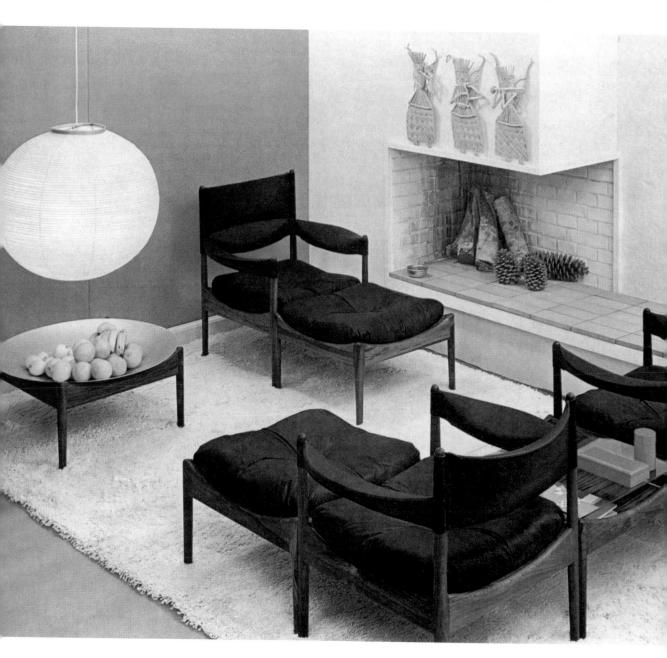

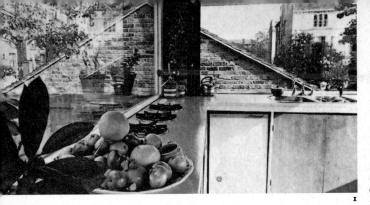

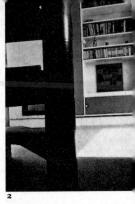

John Winter and his wife found a tiny coachhouse near the Zoo and the Park, which they demolished and rebuilt, necessarily on the former foundation. The work was accomplished by the Winters themselves-with help from piping and wiring specialists and from 'parties' where instead of cocktails, guests were offered beer and concrete-mixing. On the small rectangle (6.5 × 4.6 metres) rose a straight, tower-like little house for themselves and, now, for two small sons as well. The whole floor area is represented by the living-room on the first-floor, broken only by the shaft through which the spiral staircase rises from the entrance hall below to kitchen and roof above 3, 5, 7. Rather like spending all on one glorious meal the Winters decided to have this room full of space and light and warmth. Warmth is from the sun in summer streaming through window-walls, and from Crane skirting heating in winter: space and light are effected by an uncluttered expanse of pale fawn carpet, and by plain white curtains against plain white paintwork. The only pattern is that which comes from books, pictures and other items in the wall fitment, from the chairs-Mies van der Rohe's Barcelonas, two others in moulded plywood by Charles Eames: and from

the black-iron rich pine wall of the stair.

In the space behind the camera is the fireplace and an unobtrusive sleeping area.

Downstairs, 5, are tiny rooms for children, bath and storage.

Life is lived most actively, however, on the roof 1, 4. Here is a working-dining area sandwiched between two useful balconies: a roof-garden where children play in the air, plus a roof-kitchen where the family eats. Double-glazed to be warm in winter, shaded in summer, its splendid tree-top atmosphere is rivalled by few other kitchens in town (or country).

photos CRISPIN EURICH

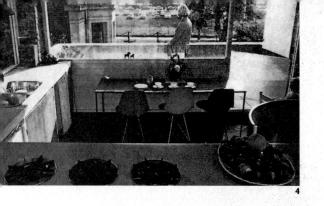

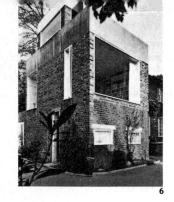

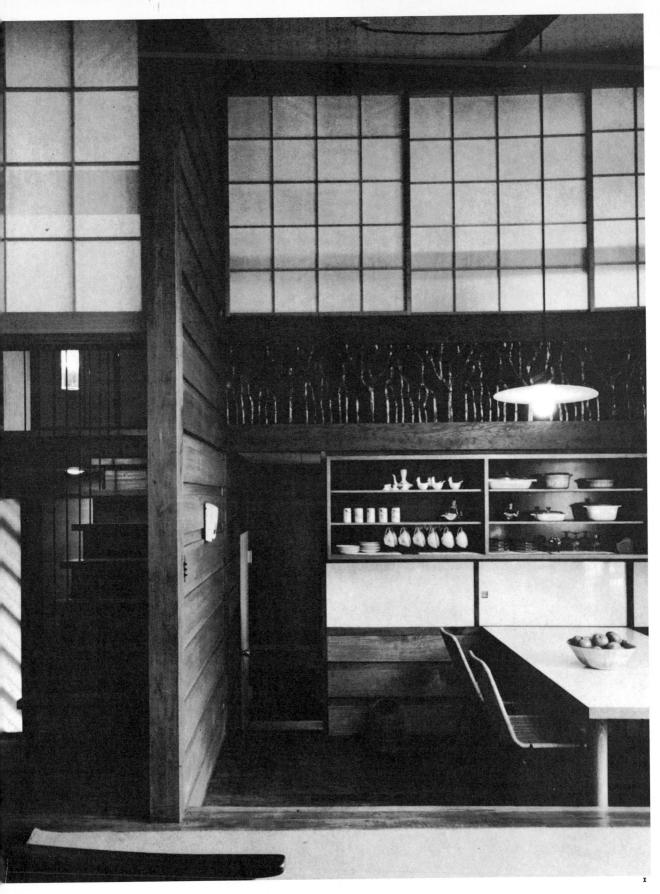

118 · houses and apartments · 1966-67

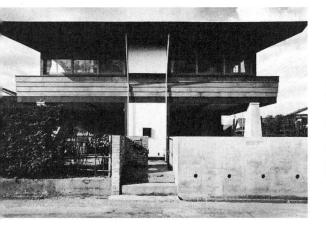

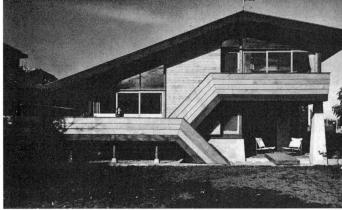

M Residence, Japan
hitects N. Nakajima and Associates

40

- 1 & 2 Tatami Room
- 3 Kitchen Area
- 4 Dining Area
- 5 Living Room

tographs Okamoto, courtesy Kenchiki Bunki

is is a family house in a burban area. To cope with a h humidity rate skipped floors three levels were decided upon. covered terrace, with kitchen, lity and service areas on the ath and the maid's rooms on the orth sides occupy the ground or.

The central living room is on a mezzanine floor with the bedrooms above. This arrangement provides close relationships between several spaces with different functions. Quiet tatami rooms are placed on the north side and more active areas on the south with easy access

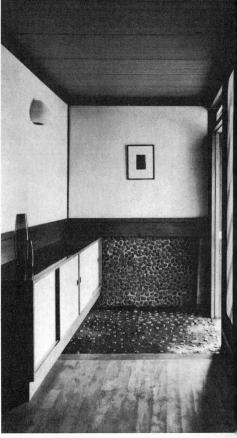

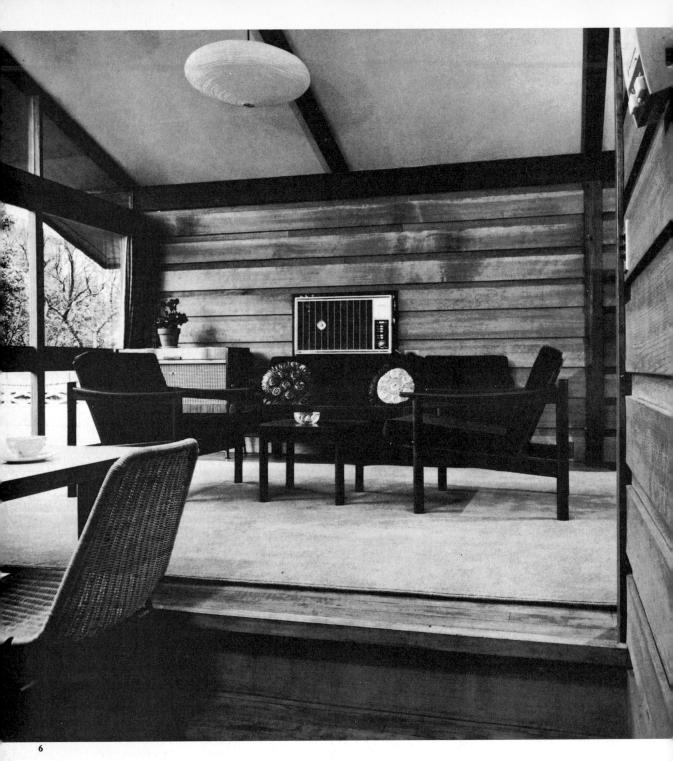

HM Residence, Japan architects N. Nakajima and Associates to the exterior. The dining room is on a lower level of the central 'deck' while the ceiling follows the roof slope and creates a free atmosphere for these spaces. The internal central staircase is supplemented by an exterior stairway.

- 1 dining room from living room 2 east side view
- 3 south side view
- 4 covered service yard

- 4 covered service yard 5 entrance hall 6 living room 7 exterior stairway 8 living room north side 9 bedroom 10 child's room

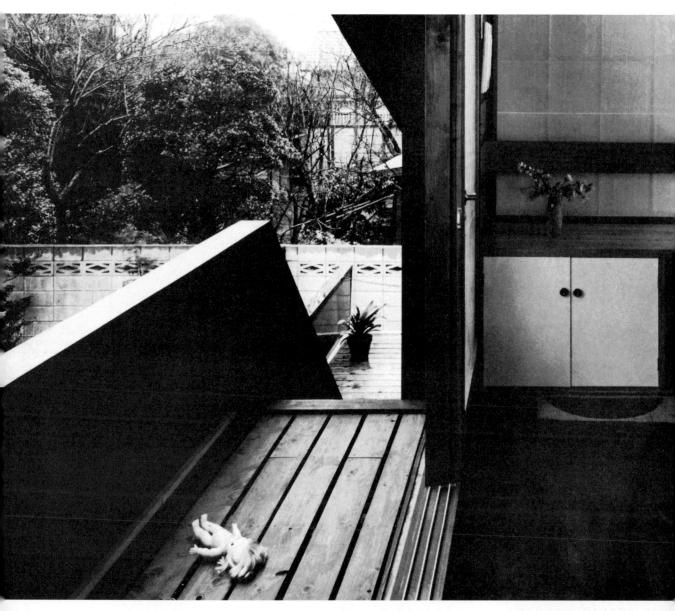

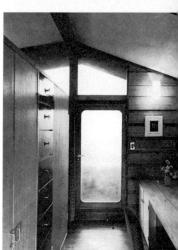

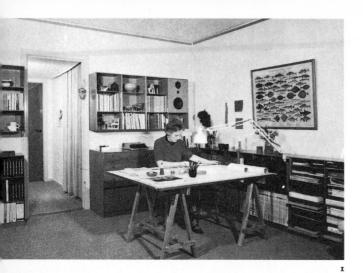

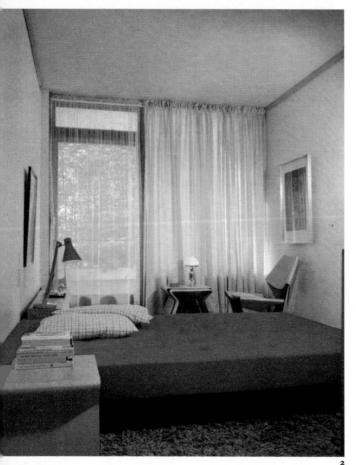

Modern apartment near Copenhagen The home of Grete Jalk

This small apartment could be found almost anywhere in the world: here it is surrounded by pleasant woods and has a view to the coast. It is distinguished too by its warmth—a warmth which has little to do with centigrade. Grete Jalk is one of the most interesting of Denmark's designers today: for P. Jeppesen's Mobelfabrik she has designed many fine pieces of furniture for cabinet-making,

but she is especially interested in machine techniques and (also for Jeppesen's) she has made this exciting 'folded' plywood range. For her own typical, none-too-large, multi-purpose apartment, it seems exactly right: the non-bulk, the sharpish lines, the surprising springy resilience. Real wood complements real wool, sheep-hair rug from Yugoslavia and the glowing cocoa-fibre floor.

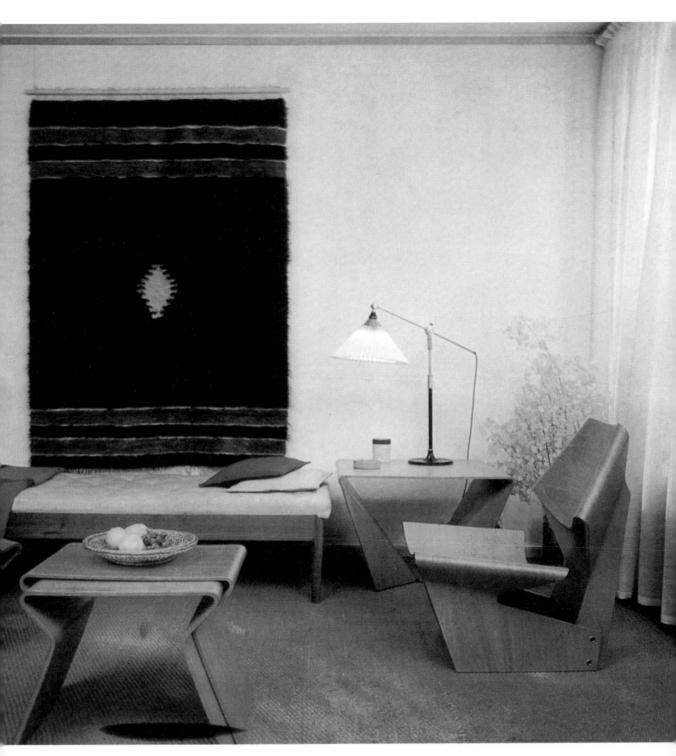

1, The designing-table is of an early, proved and simple type, for quick dismounting! Beyond it, the bedroom 2, bed covered in its daytime dress of cherry wool: for the night this is removed and replaced by the single feather bedding unit which serves the Continent so simply in all seasons.

photographs Helmer-Petersen

House in Canonbury, London interior by Max Clendinning ARIBA

i

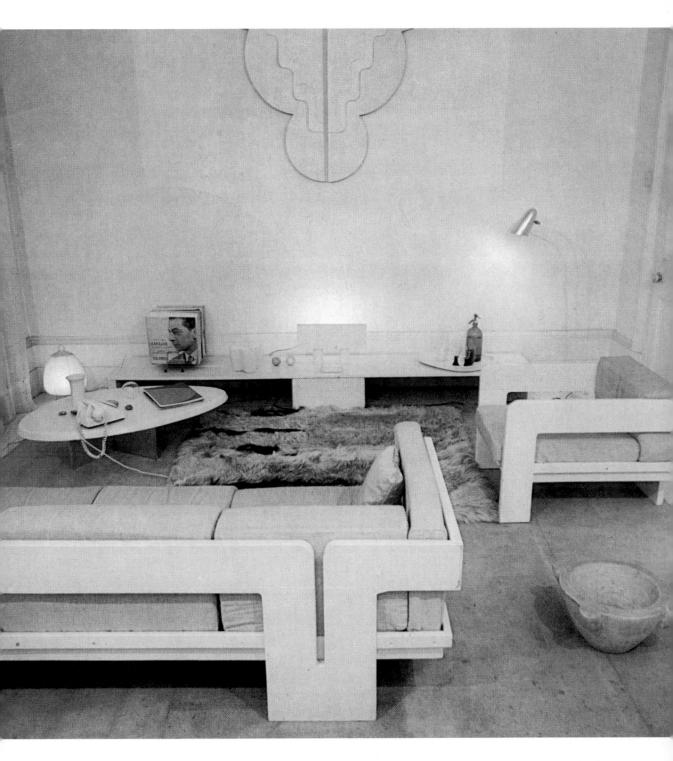

In the true tradition of young architects Max Clendinning has recently turned furniture designer. Without compunction he has also turned his Regency-style house into a setting for his ultra-modern designs.

In fact the clear lines of the furniture are not so incompatible with the character of the house as might seem probable. The structure is left unchanged: white paint picks out original woodwork mouldings: but ceilings are treated without respect—painted in motifs which echo the furniture shapes. The result: cool Pop on a nineteenth-century backcloth. At the door a scarlet grotto greets the visitor: I, looking back to the L-shaped entrance hall, scarlet painted walls meet floor-to-ceiling scarlet curtains and black/white vinyl tiling floor

and relief decoration on the silver wall is made from paint-tin lids—small metal waste is turned into art. A tiny conservatory manages to be green in winter time, 3. The sitting room, 4 is cool with whites and pale mushroom tones. The furniture is a prototype design, white-lacquered with oatmeal linen-covered cushions, curtains are off-white linen sheer by Primavera and the rugs are goatskins.

House in Canonbury, London interior by Max Clendinning ARIBA

The white is sharper in the kitchen/dining room 7, where the only spots of colour are the red lacquered cabinet and a painting by Joe Tilson. The dining table is of plate metal glass on a white-lacquered plywood frame, the chairs completing the suite upholstered in oatmeal Irish tweed.

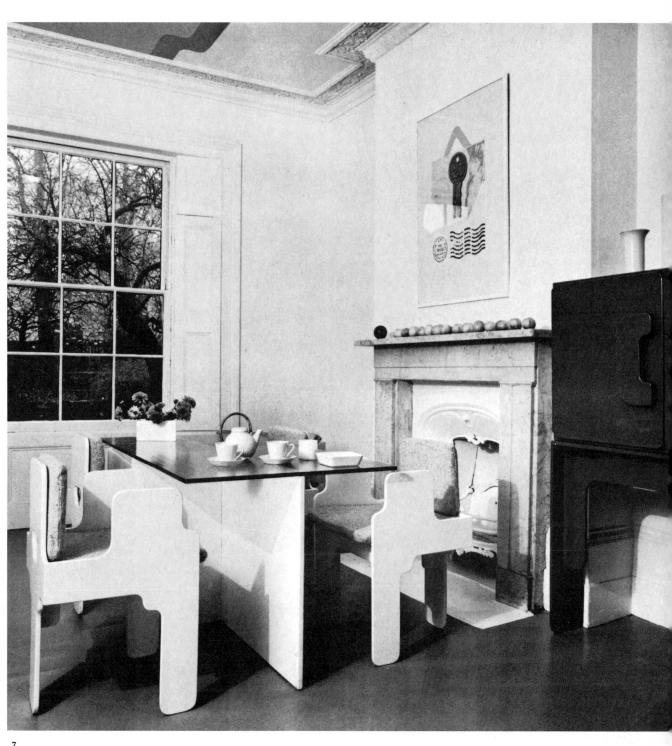

•

On the first floor is complete contrast: Mr Clendinning's den-cum-office is bright rather than light. Walls are a dark muddy ochre, the shelving is heavy timber planking, black-stained, with above them the large painting by Ralph Adron. The mirror in which the whole picture of the room is reflected is heavily gilt and 'silver' paint has been used

liberally to unify the little pieces in the room. The large armchair with the early 30's look is a prototype with Perspex sides: a production model is available with solid plywood sides, lacquered in several colours, as are now some of the paper prototypes. Most of the furniture both upstairs and downstairs represents the development of the *Maxima* and

other ranges now in production either by Race Furniture or by Clendinning Bros of Armagh, all based upon the minimum number of interchangeable components. photographs John Donat

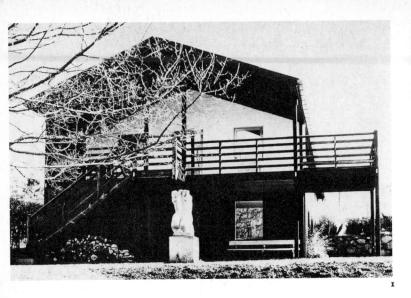

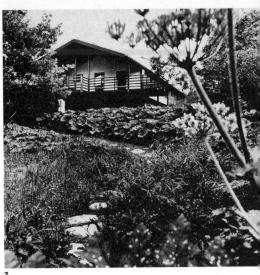

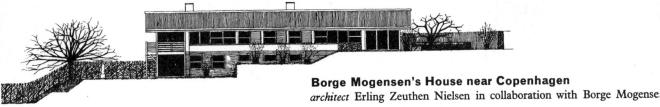

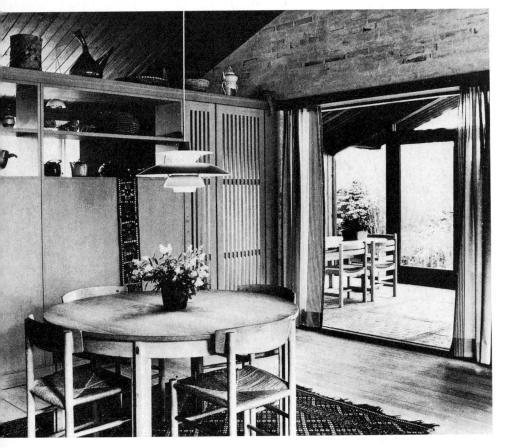

This long, simple building consist basically of two large rooms each at one end of the house with bedrooms and bath between. It stands on a north slope with the sitting room looking over the Ermelunden valley, at the other end the dining room opening to a sun room and in fine weather to as atrium type garden.

The house has grown from a smaller base as its use became more defined and this, its completed form, was achieved with the co-operation of architects Arne Karlsen and Allan Jensen. Interior and furniture designer Borge Mogenson is noted for the strong lines of his furniture. In his own home all the furniture is his own design, the fitted units fol lowing the module of the building Solidity and strength may be said to be the motif of the house: scrubbed deal floors meet scrubbe walls where bricks are visible beneath the thin rendering. The spruce board ceiling follows the roof line and the strong mullions of the window repeat the module of the building, as do cupboards, bookcases and the fitted window tables, seen in 8 at the window of the dining room. Tables and chairs are part of the serial production of Fredericia Stolefabrik.

I The balcony looking over the valley is part of the recent addition to the house: dark stained timber railing against sky and house. The outer walls are painted glossy black below and white above with window frames of bright, varnished deal.

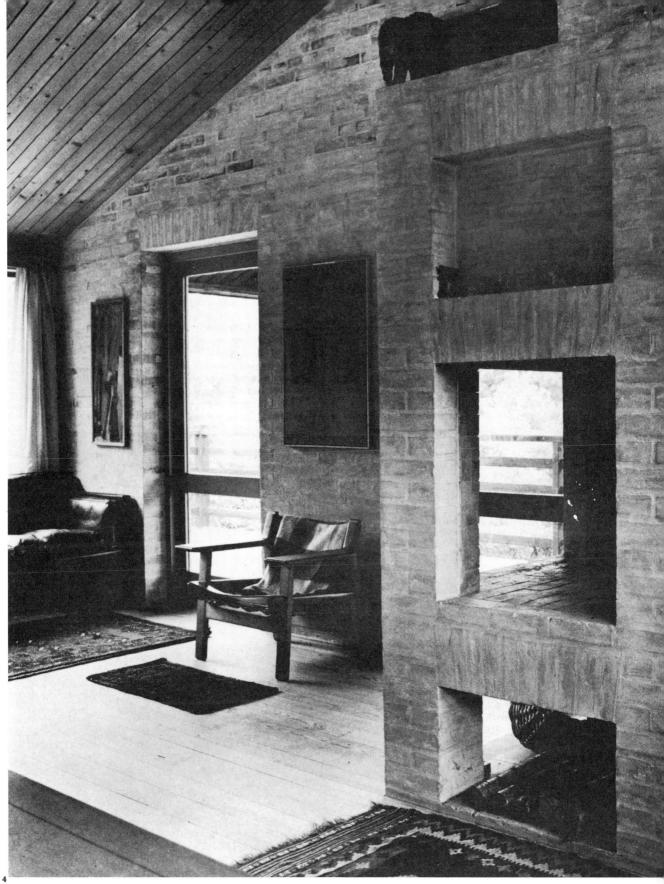

photographs Jesper H∲m

Borge Mogensen's house near Copenhagen

3 The kitchen is separated from the dining room by a cupboard wall: it opens to a garden room for enjoying the sun behind glass walls (the atrium lies beyond). 4, and 8 Sitting room with access to the large balcony in 7.

5 Bedroom walls are panelled, the

ceilings covered with recessed boards.
6, 7 The garden room is a light

timber structure which can be opened on to the atrium-the flooring following a continuous pattern of clinker bricks to the same module as the house itself.

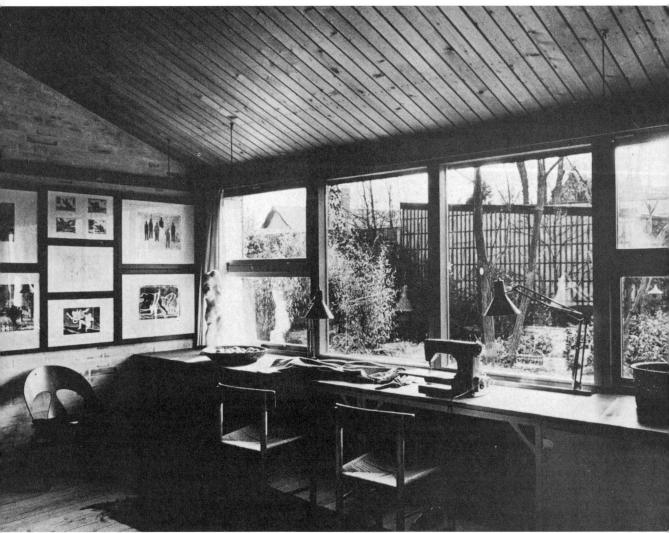

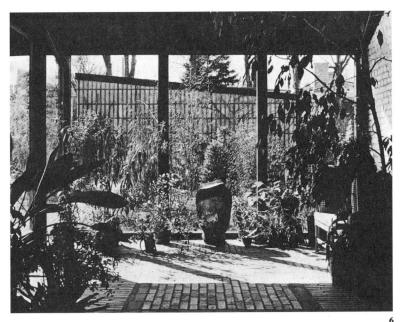

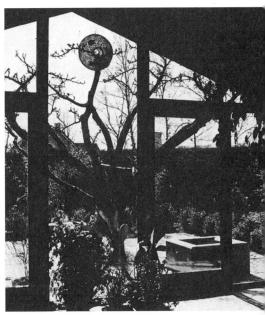

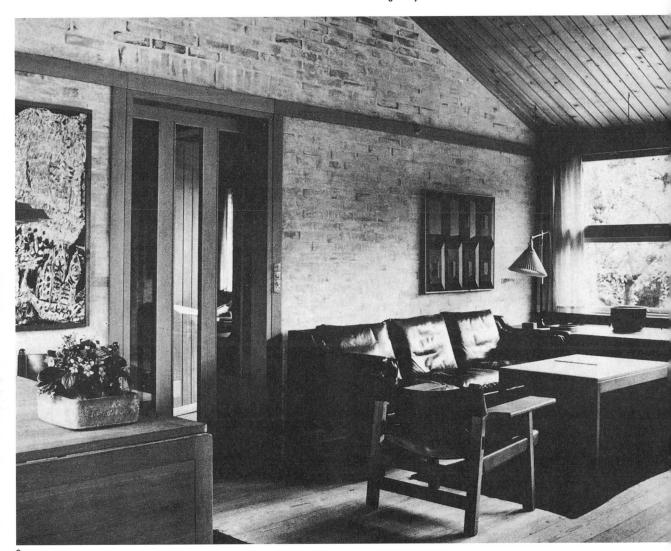

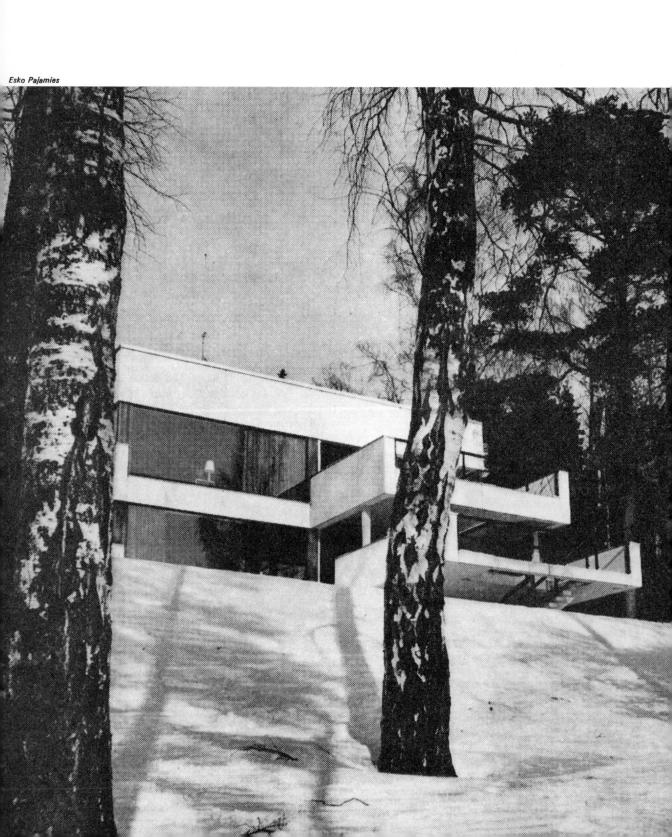

The Villa Aarnio, Kuusisaari near Helsinki architect Toivo Korhonen interior architect Esko Pajamies

1 the façade to the sea

2 traditional sauna pails
3 overleaf: lounge/hall on the ground
floor with concrete screen and mirrorframe: a small bar is tucked behind them

photographs Eero Aarnio

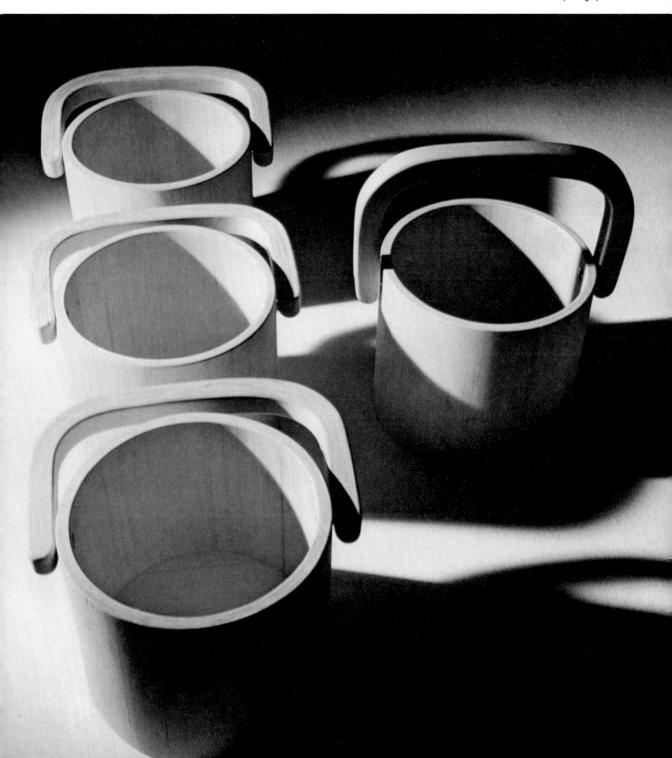

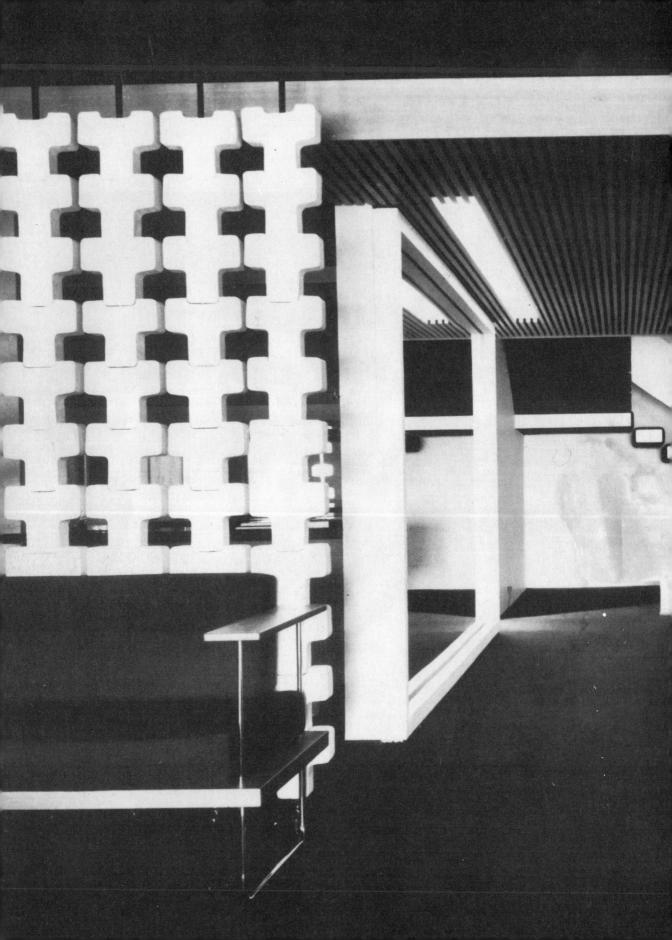

The Villa Aarnio, Kuusisaari near Helsii architect Toivo Korhonen interior architect Esko Pajamies

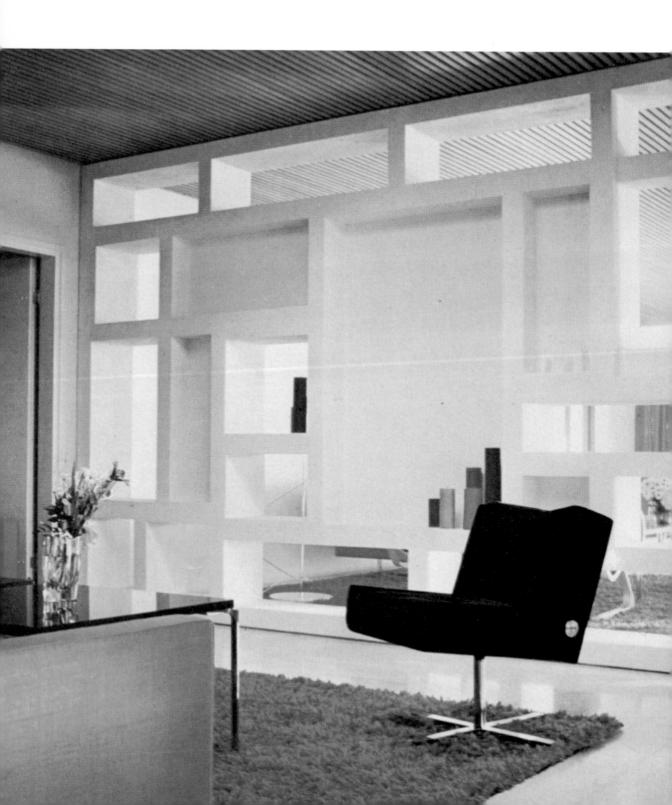

e spirit of this house has been ened to that of a ship in which the erior arrangement is dictated by the erall form. Its form thrusting out as it es towards an inlet from the sea has haps sprung from the site itself. e size and structure of the house also ggest a modern castle fortified not by wbridge and portcullis but by central ating and intercommunications stems, by deep-pile carpets and ntrolled lighting.

e structure inside and out is of

forms balustrade, room partitions, screens and floor-to-ceiling mirror frames - placed to still further enhance the interior spaces: faced with cobaltblue ceramic tiles it is the walls of kitchen, toilet rooms and indoor swimming pool.

Floors are partly covered by Carrera marble, partly by firm woven carpets and deep-pile hand-made carpets fitting planned depressions in the marble. The ground floor consists of the long, central lounge/hall (pages 18-19)

the indoor swimming pool, the sauna and the lower balcony, on the other by several service and storage rooms. 4 the living-room and 5 looking into

the entrance hall.

The main furnishings are architectural details. Movable items have also been specially designed: desk-lamps, floorlamps, sauna pails, chairs and tables. Bangkok teak and Oregon pine make the built-in furniture of kitchen, parents' and children's rooms and the strip ceilings are also of Oregon pine.

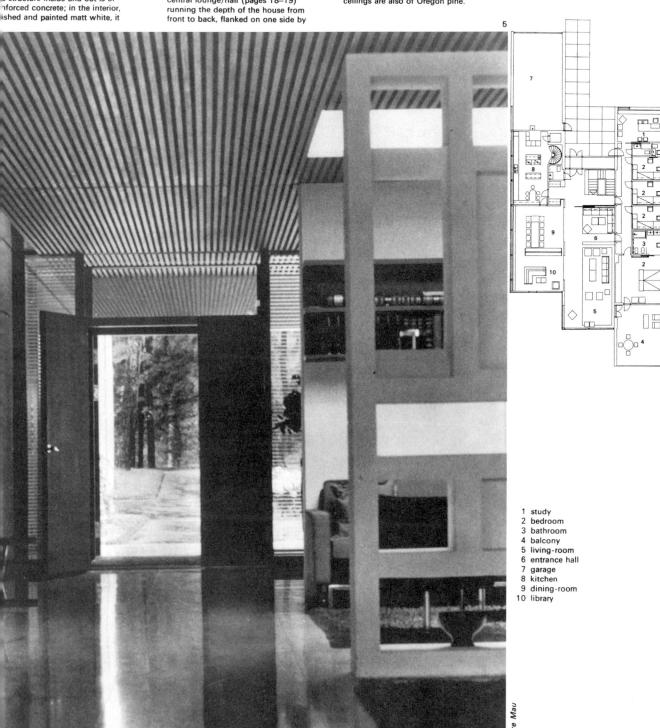

The Villa Aarnio, Kuusisaari near Helsinki architect Toivo Korhonen interior architect Esko Pajamies

photographs Eero Aarnio Esko Pajamies Pietinen Details of the swimming pool 9 the sauna 6, and lamps and chairs designed by Esko Pajamies especially for the house.

The fireplace easy chair of rattan woven on a chrome-plated steel frame with Thai silk-covered cushion.

Table and floor lamps: the bases of cast steel, supports and arms of chrome-plated tube, the floor lamp with a shade of opaque Perspex.

10, Lounge chair, bent laminated bee upholstered with Thai silk over foam rubber. Lower-backed, longer-legged chairs with leather upholstery were migor the dining room, both versions by Boman Oy.

Opposite: Rooms on the first floor whas all the main living areas, including the kitchen, the bedrooms, bathroom and, because of the rising ground bell the house, the garage.

Pajamies

6-8

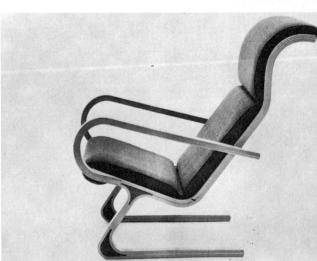

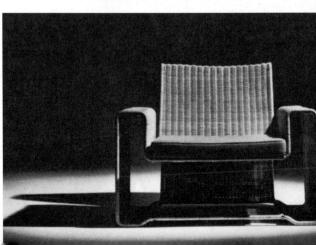

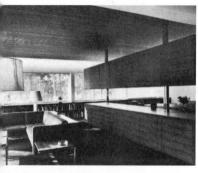

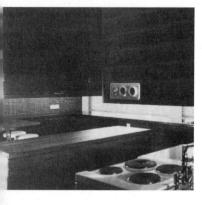

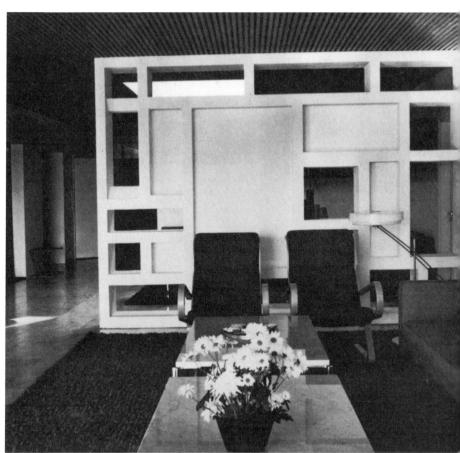

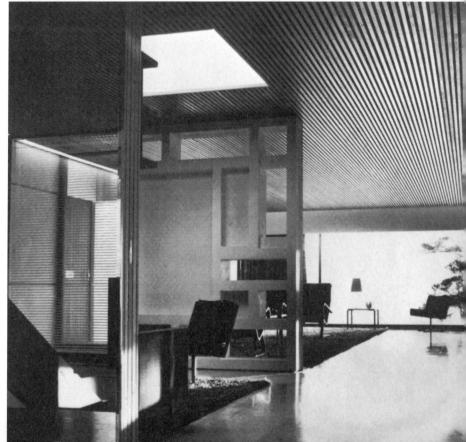

A Summer House at Cadequès, Spain architect Lanfranco Bombelli Tiravanti

1 3

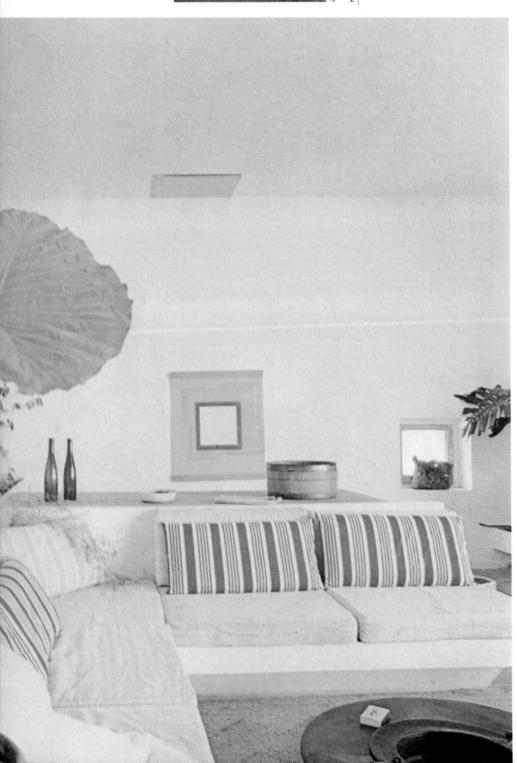

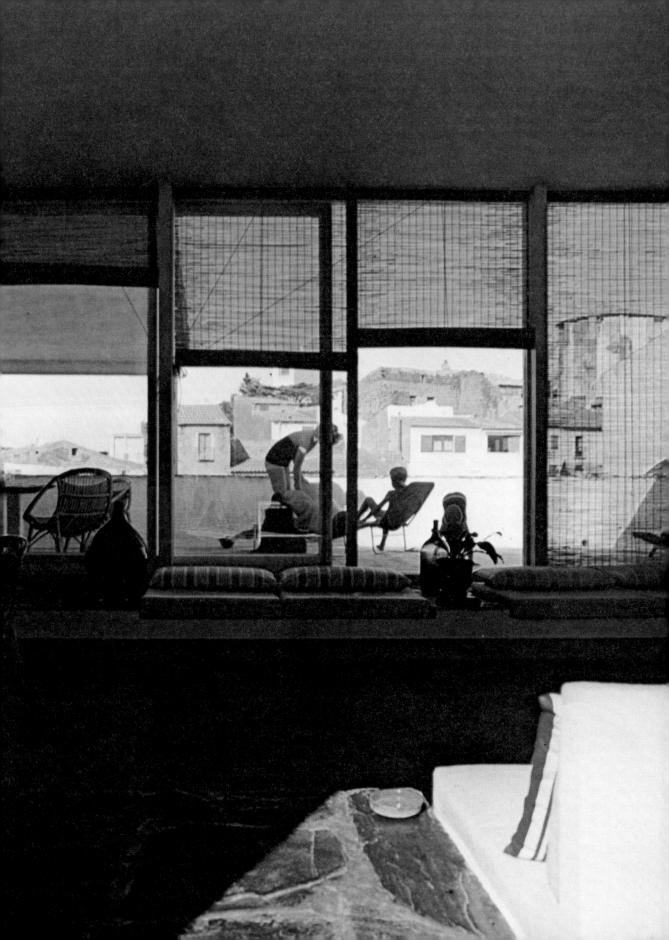

A Summer House at Cadequès, Spain architect Lanfranco Bombelli Tiravanti

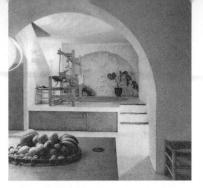

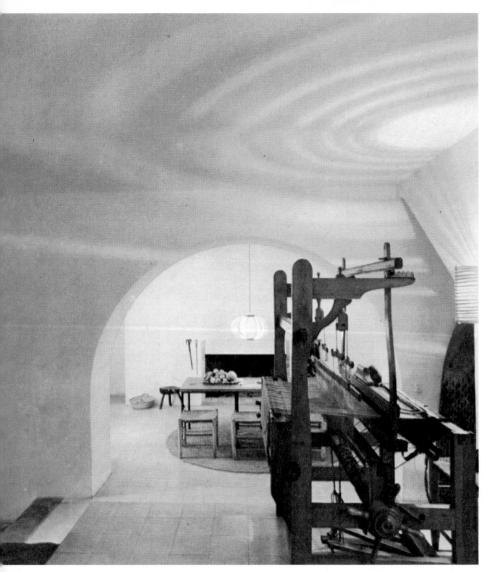

Lanfranco Bombelli Tiravanti is an Italian architect who works in Spain and for himself and his family he reconstructed an old house, abandoned by its peasant inhabitants and falling into dilapidation.

The entrance floor was a stable, the upper part an unpractical two-storey structure 10-50 × 10-50 metres. Walls were repaired and extended, windows re-made, old natural stone walls lime-washed white. Designed primarily for the summer, the house is open to the east and has only essential doors inside, with the sleeping area 'suspended' and isolated in space to increase ventilation, between the ground and top, living, floor.

1 the entrance to the house on street level: the sliding door gives on to the courtyard or patio, covered by the second-floor terrace but lit and aired by the window above. To each side are kitchen, dining room and part of the old building (see 4 and 5)

building (see 4 and 5)
2, 3 in the living-room with the terrace
and the village and sea beyond: walls
and ceilings are white, the long divan
built in in cement with cushions of
beige rustic handweave and striped
sailcloth. The floor is sunk to a depth of
30 cm to accommodate the feet and
covered with Spanish woven straw
matting. A concrete relief by Verena
Lowensberg is on the further wall, 2
4, 5 the dining-room seen 5, from the
entrance with the Swedish loom of the
architect's wife. The arch is part of the

original structure
6, 7, 8 details of the first floor
corridor, parents' room with dressingroom and bath, the children's bunk-bed
built in of cement, covered with
Majorcan handweaves in vivid colours.
10 the living-room chimney and
staircase to the lower floors

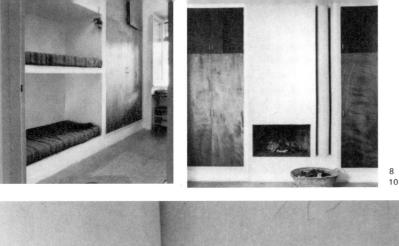

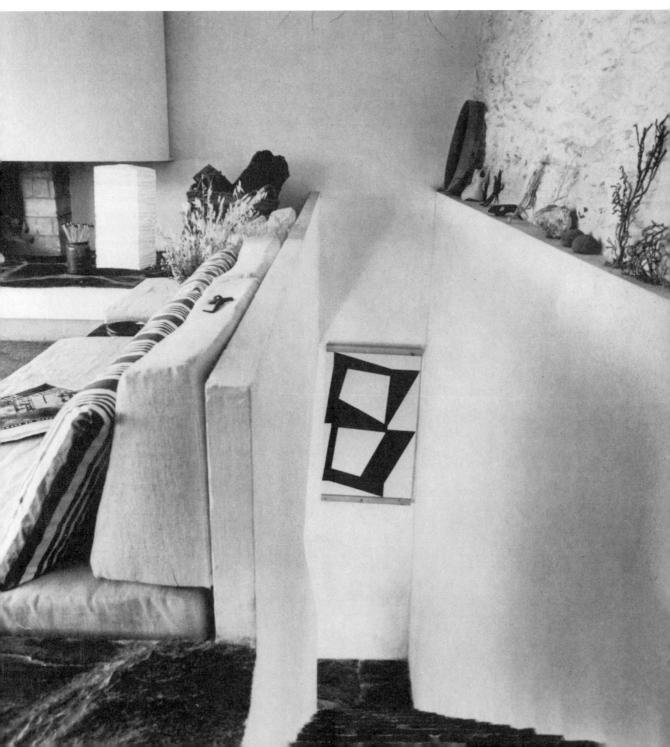

A Summer House at Cadequès, Spain architect Lanfranco Bombelli Tiravanti

11 the living-room seen 12 from the terrace. The table is a local stone slab on a base of lime-washed concrete. The straw blinds are those typical of th

The straw blinds are those typical of the Mediterranean region 13 the living-room chimney with the divans and 'paddling pool' — the sunkel area for the feet. Along the window wall which opens to the terrace are big flagstones of local grey stone. The rattan chairs are Spanish-made

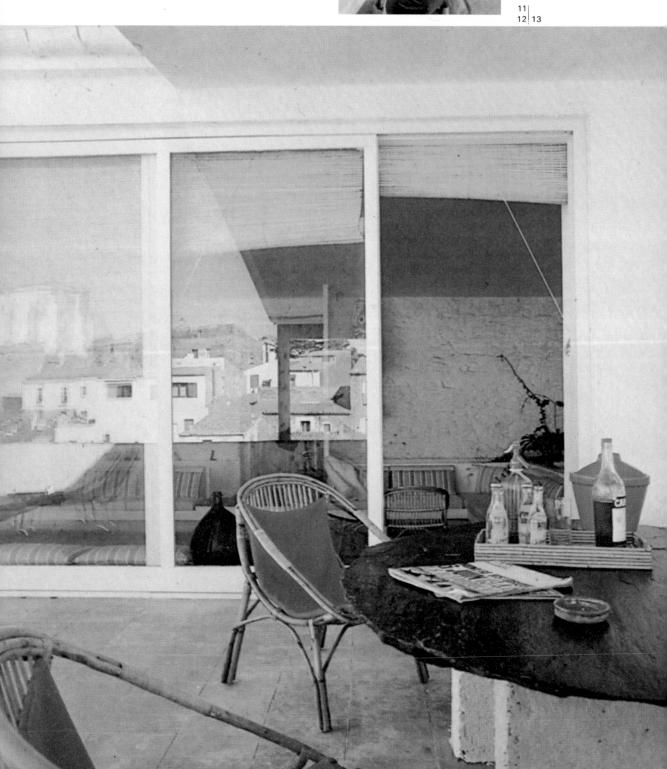

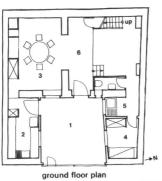

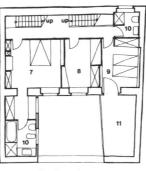

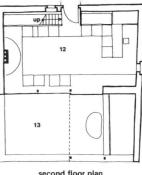

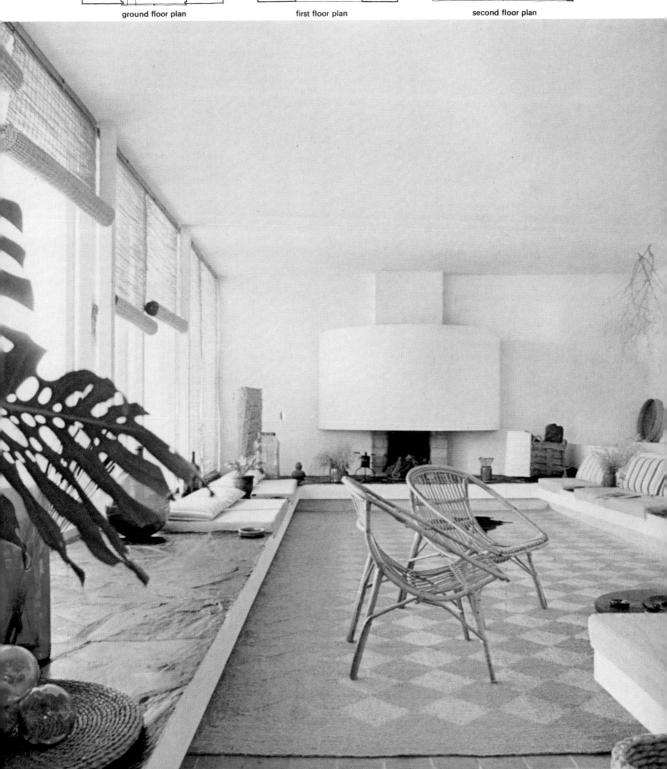

A House in The Terraces, Fredensborg, Denmark architect Jørn Utzon interior design Rolf Middelboe

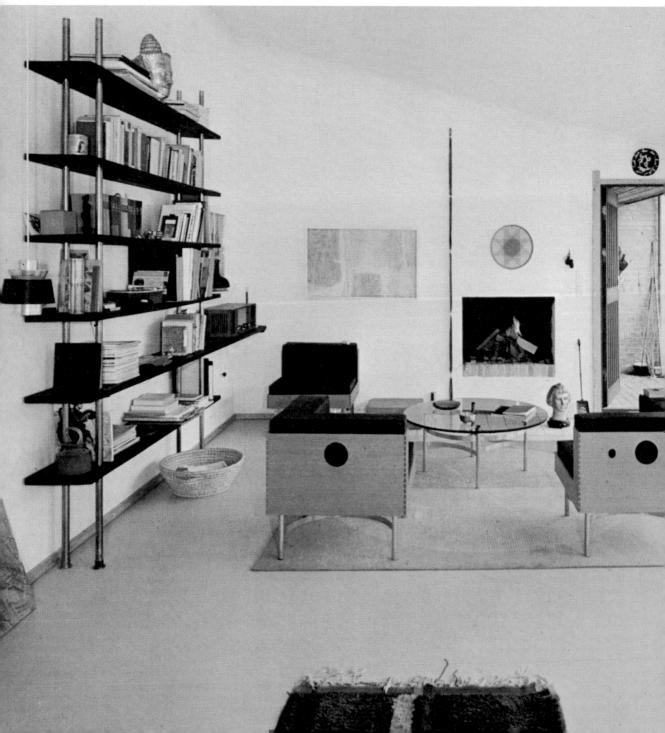

The Terraces is a development set in the North Zeeland landscape: from the surrounding gentle slopes it suggests a small fortified town of yellow brick and red tiles, and was designed to provide some qualities of the medieval city-state, in particular its protection from the outer world.

The single-storied houses attract

The single-storied houses attract tenants of wide-ranging interests: the completely undomesticated can dine in the restaurant and/or hire other facilities provided to give freedom from care. But Rolf Middelboe and his wife with one of the best-situated houses having a view of fields and woods, have created a very personal milieu.

reated a very personal milieu.

The large central living-room has furniture designed by Finn Juhl and Rolf Middelboe himself, against white walls and on white linoleum-covered floors. The low square armchairs are of golden Oregon pine with heavy soft cushions of feather-filled black leather. These, the table in front of the fireplace, the bookcase were all designed by Middelboe as well as the rugs and curtains in festival stripes of red, yellow, gold and orange — colours used again and again, sometimes with a strong clear blue.

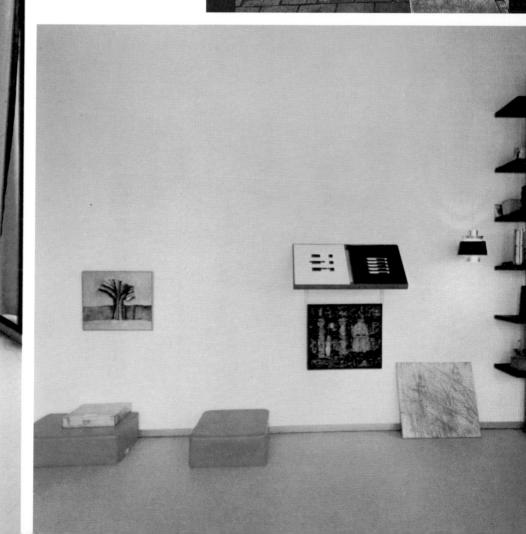

A House in The Terraces, Fredensborg, Denmark architect Jørn Utzon interior design Rolf Middelboe

Husband and wife each have a room furnished according to their respective needs.

Mrs Middelboe's room has a big sleigh bed designed by her husband and a toilet table-cum-writing desk designed by Finn Juhl.

Middelboe's own room is taken up by a large work table and a bed covered like every other available surface with scraps of material, samples, drawings, etc for he works in wool and leather and paper as well as glass and metal and constantly experiments.

The sheltered patio/garden, above, is conveniently easy to reach and perfectly secluded by the walls which give the whole complex its unique effect. Here it can be seen in relation to each end of the living-room — at right, the area generally in use as a dining-room, towards the kitchen. The cupboards can be opened from the kitchen or from the living-room.

living-room.

Above this view, one of the red-lead-painted, roughly finished doors, which help to give The Terraces its character. Rolf Middelboe keeps all the housekeys by the main entrance under the general care of an old family portrait.

photographs Gunvor Betting copyright P.A.F. International Ltd

148 · houses and apartments · 1967-68

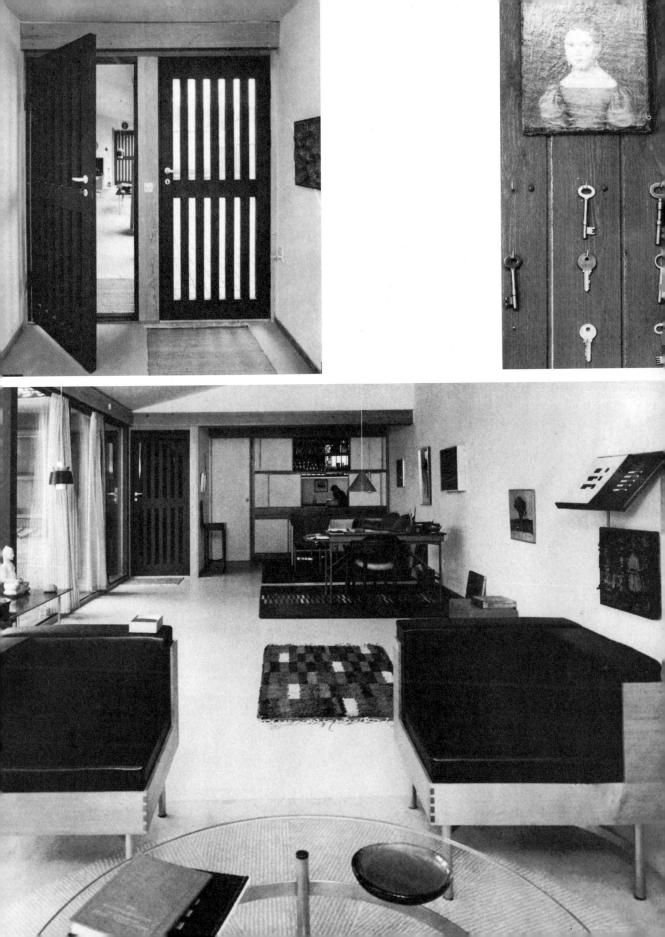

Stratton Park, Hampshire architects Stephen Gardiner & Christopher Knight decoration consultant William McCarty

Stratton Park is the estate of the Baring family and the house has been built on the site of an earlier 'big house' of which only the portico has been retained.

Although one feels an uncompromising modernity of outlook would have eschewed it the great stone portico is visually dramatic to a degree, dominating the view from all the main rooms. Contrary to photographic appearances it belongs to the interior rather than the exterior. It is not usual to approach the house from the south.

The normal approach from the opposite side is no less satisfying as

the new structure comes into view rising behind the old stabling blocks, tied to them by the single storey structure of the entrance, hall and courtyard.

It is when one enters the hall, 5 that the portico makes its first impact, taking the eye back and along the lily pool, into the conservatory, until the whole plan of the house is comprehended.

photograph Henk Snoek

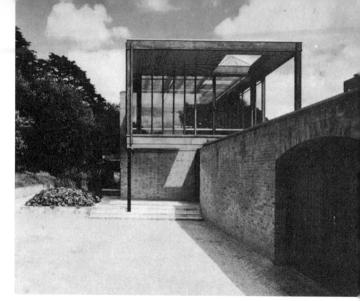

photograph Henk Si

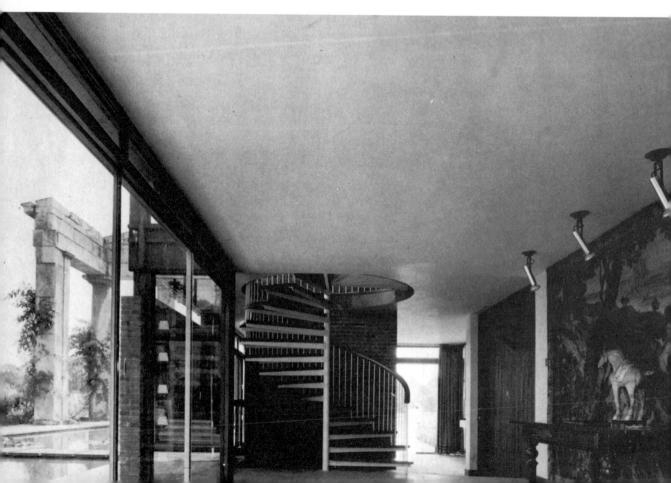

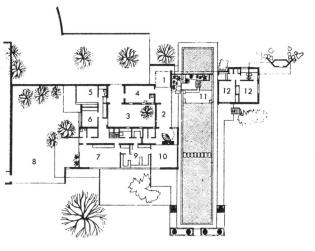

ground floor plan

- 1 entrance 2 hall
- 3 courtyard

- 3 courtyard
 4 gun room
 5 housekeeper's room
 6 bedroom
 7 nursery
 8 children's garden
 9 kitchen
 10 dining room (sitting room over)
 11 conservatory
 2 questrooms (drawing room over)
- 12 guestrooms (drawing room over)

Stratton Park, Hampshire

architects Stephen Gardiner & Christopher Knight decoration consultant William McCarty

photographs Mike Busselle

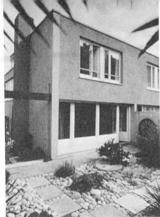

A home near Basle, Switzerland with tapestries by Vera Isler

Suburbia, currently offering the handiest available living space, shelter and comfort may be shunned by the out-and-out individualist. Even the fairly orthodox of the world's cities prefer cleverly converted peasants' huts. Not so, or not so often, in Switzerland. Not so, or not so often, in Switzerland.

There the national temperament tends to improve upon rather than rebel against what is. So have the Islers – journalist and artist – put their stamp of individuality upon this one-of-a-series house in the environs of Basle. The approach for example: together they turned every one of the small patches of garden

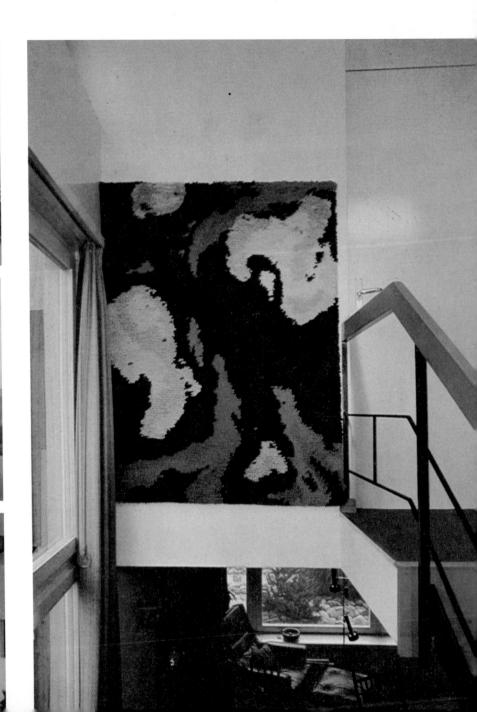

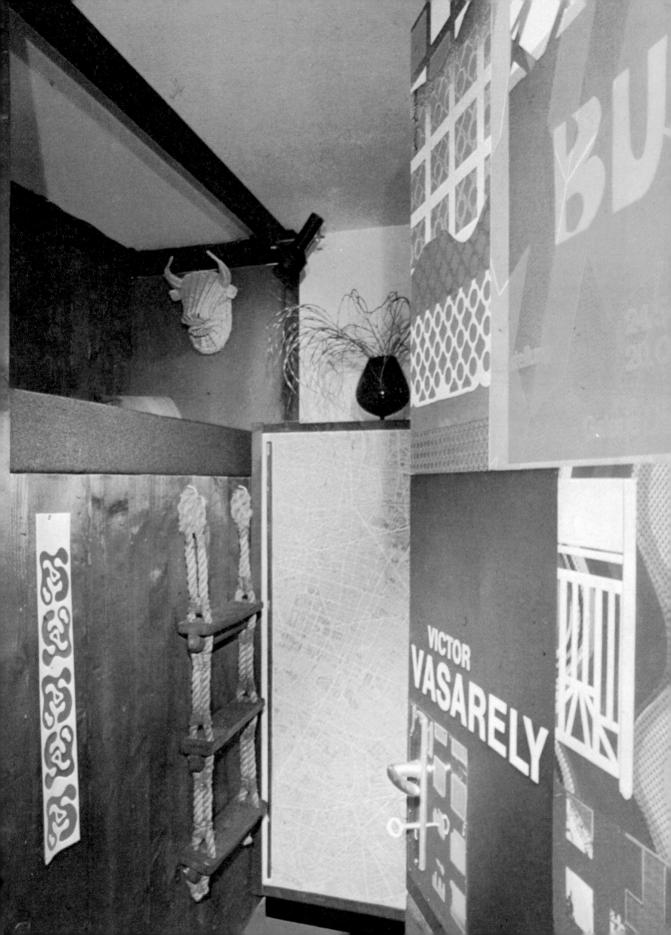

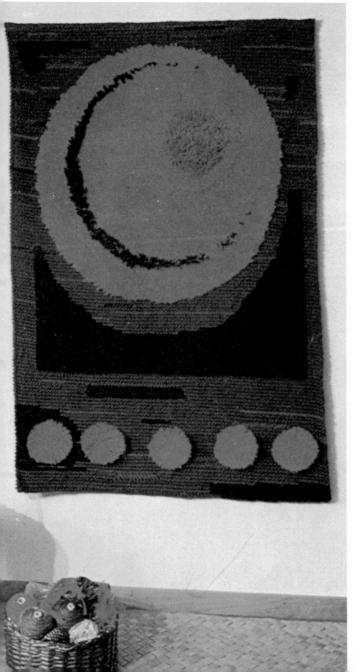

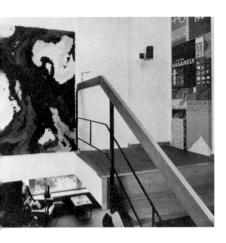

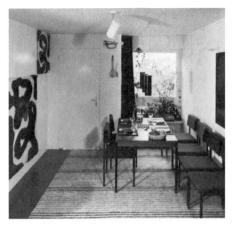

A home near Basle, Switzerland with tapestries by Vera Isler

into a patch of riotous colour, or a focus of interest centred on a shrub set in Rhine flints. The interior, 4, 5 follows the levels of the site. Its arrangement, its plain walls and straightforward timbers proved entirely suitable as home, studio for Frau Isler and background for her three-dimensional tapestries.

From the dining room on the entrance floor to the living room on the next level, 4 the staircase

arrives at the entrance to a guest room: at the top of the stairs *Summer 66* (on the guest-room door a collection of prints and posters).

On the wall of the dining room, 11 are two more tapestries *Happening* and *Imprisoned*. In the atelier itself, 7–9 is the riot of colour from the wool store and projects in hand: on the wall by the cabin bed *Fireball*.

The Islers' collection of old Provencal clocks are grouped on the staircase wall, 13.

7 10 11 12 8 9 13

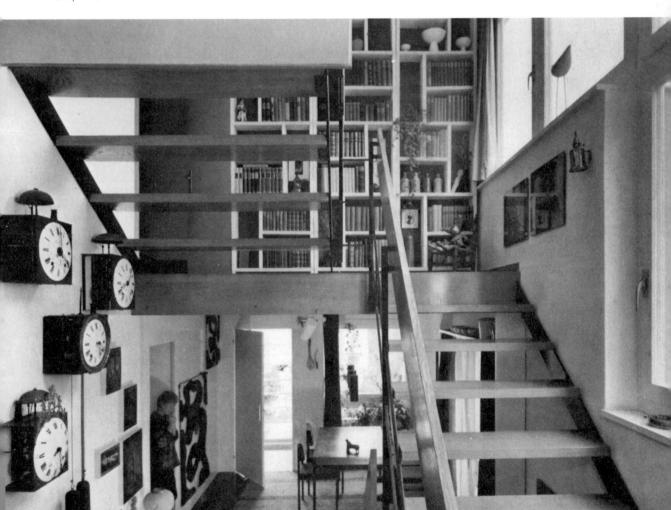

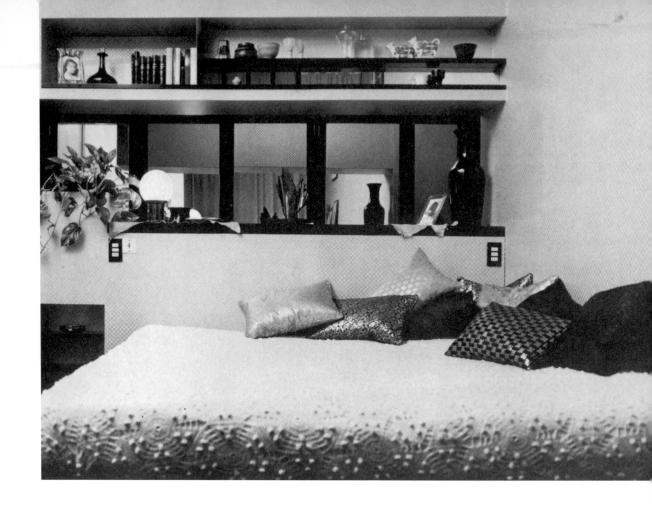

Apartment in Milan designer Sergio Asti

1 4 2 3 5 6

As yet few apartment blocks are planned in such a way as to offer individual tenants the possibility of structural alteration. Italian architect and designer Sergio Asti

accepted the limitations of his new apartment as a challenge.

He wished to give a feeling of continuity to the rooms and to create a spatial arrangement which divided without separating. The first ain he achieved by using the same black carpeting throughout, carrying it up the walls to form a 40 cm deep wainscot, and by finishing all wall and partitions with the same silver and orange design: opposite and on pages 58–9.

Screen 'walls' of varying heights serve to creaseparate areas and are at once functional and decorative. For example the partitions which separate the hall, 3 from the living room, 2, 7 and the living room from the dining area, 4 and deep enough for the installation of plant-hold as well as lighting equipment.

The wall of the living-room is filled by books shelving of a type designed for office files, olive-green-finished and perfect in this particular setting.

Divans are covered in putty-white velvet by Brunelli, and scattered with cushions covered Japanese silks in jewel colours of blue, gold and red. Similar cushions are found on the coverlet of white crocheted cotton in the bedroom, 1. Here the partition becomes a fitment holding books, glasses and other accessories.

With so much general stability it has been possible to integrate successfully Sergio Asti rich collection of modern Italian art (on the walls of the hall) the antique and modern gla silver and ceramics, and the pair of stainless-steel-framed armchairs, like the le Corbusier reclining chair, made in Italy by Cassina.

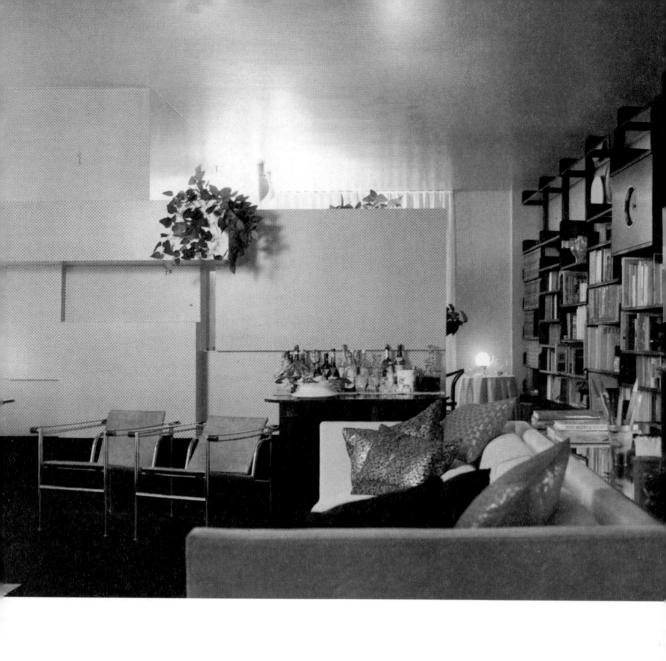

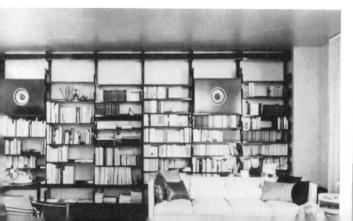

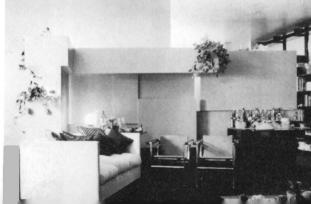

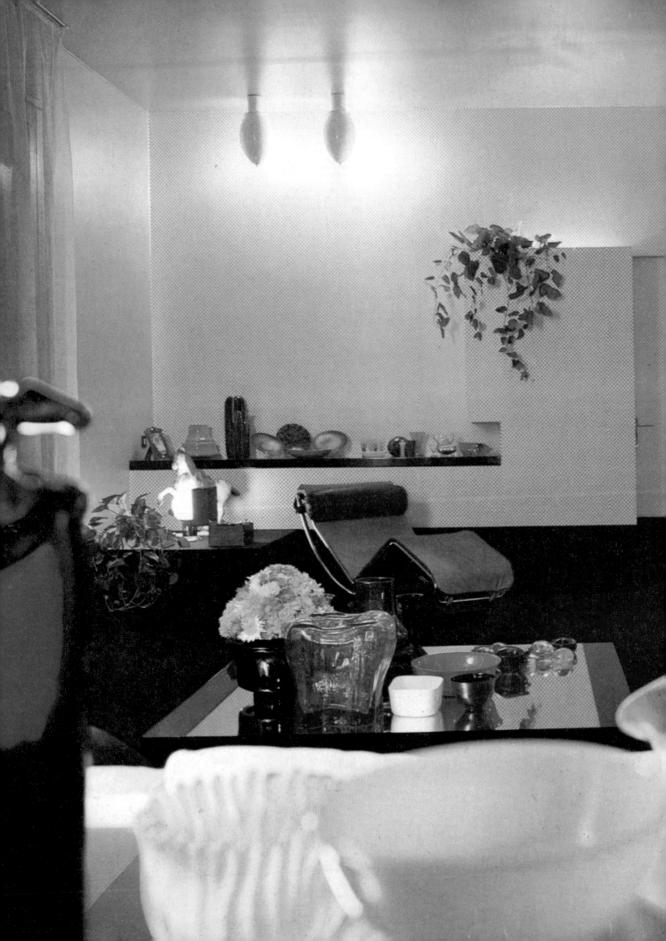

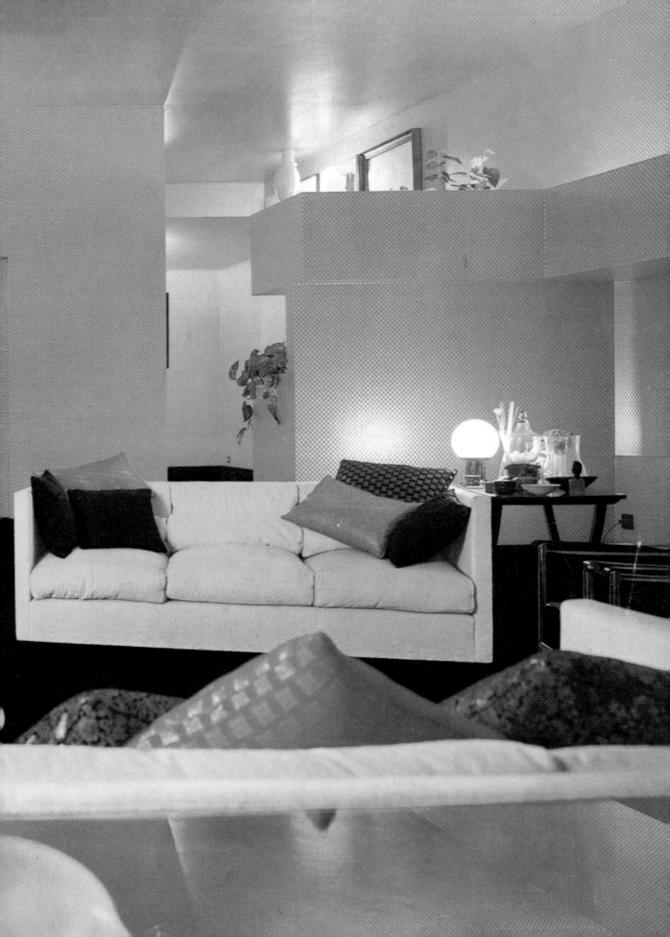

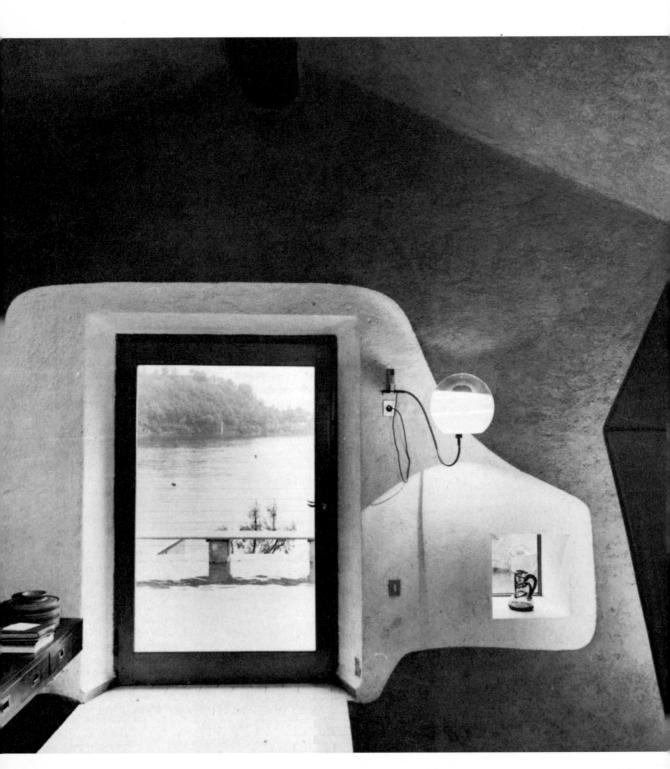

162 · houses and apartments · 1969-70

1969–70 \cdot houses and apartments \cdot 163

Lakeside house at Como designers Ico and Luisa Parisi

A small house in the old village of Spurano on the shore of Lake Como was modernised and internally re-designed to provide this week-end house for two architects, lco and Luisa Parisi Care was taken to integrate the appearance of necessary structural additions—bathroom, hallway, porch, terrace—with the surrounding buildings.

Sharp white ceramic floor tiles and risers with blue treads and roundels are on the stairs which lead from the porch to the floor above. A collection of chopping boards was painted by artist friends of the architects: Fontana, Munari, Baj, Radice, Reggiani, Somaini, Rui, Galli etc.

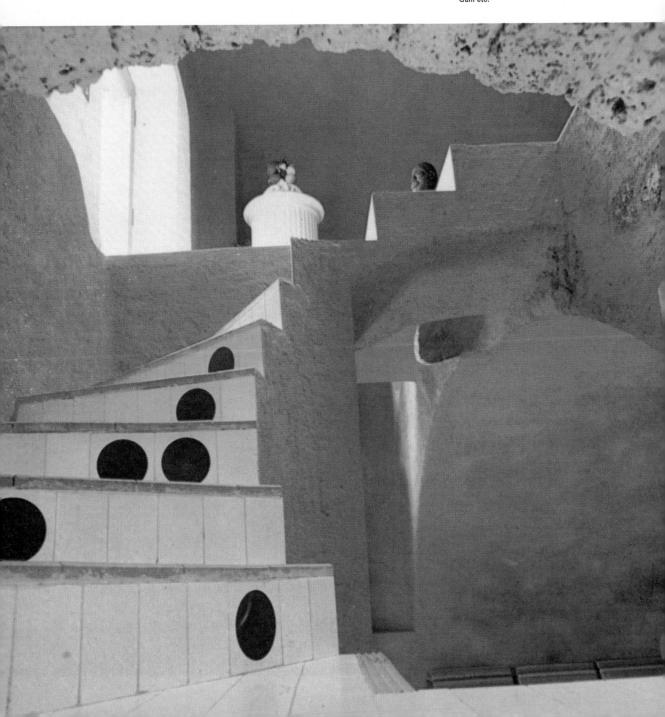

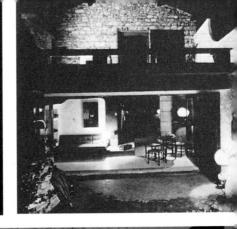

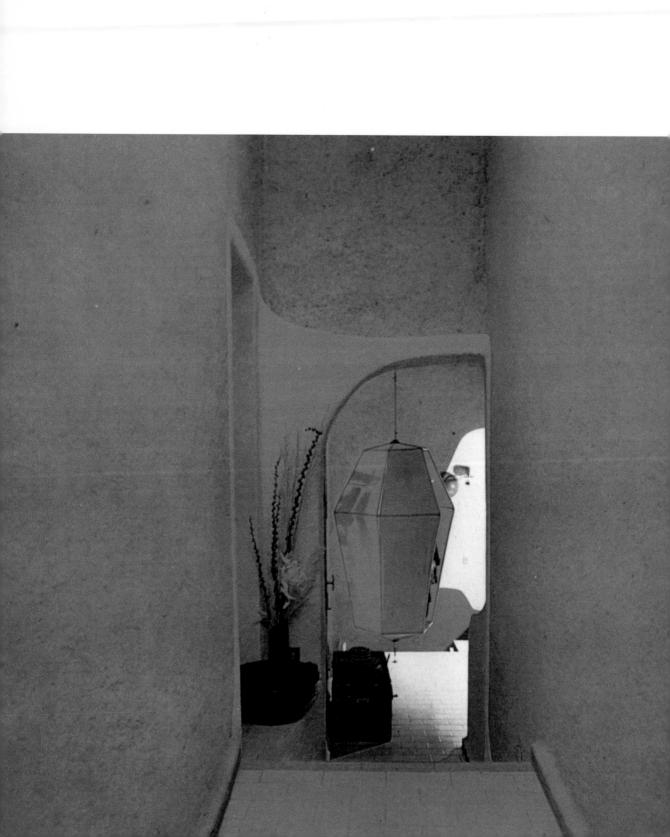

Lakeside house at Como designers Ico and Luisa Parisi

The interior has been opened up to produce a large space in which kitchen, bar and sitting room are separated only by function.

The whole house is heated by the white ceramic stove, especially made by Thun of Bolzano, which reaches from the ground to the floor shove.

Bolzano, which reaches from the ground to the floor above.
Walls and ceilings are painted continuously bright red over rough-cast with window areas broadly patterned in white to emphasize the design of spaces and shapes.

The lantern in which the walls are reflected so strongly was designed by the architects. The other lamps are designed by Ico Parisi for Arteluce.

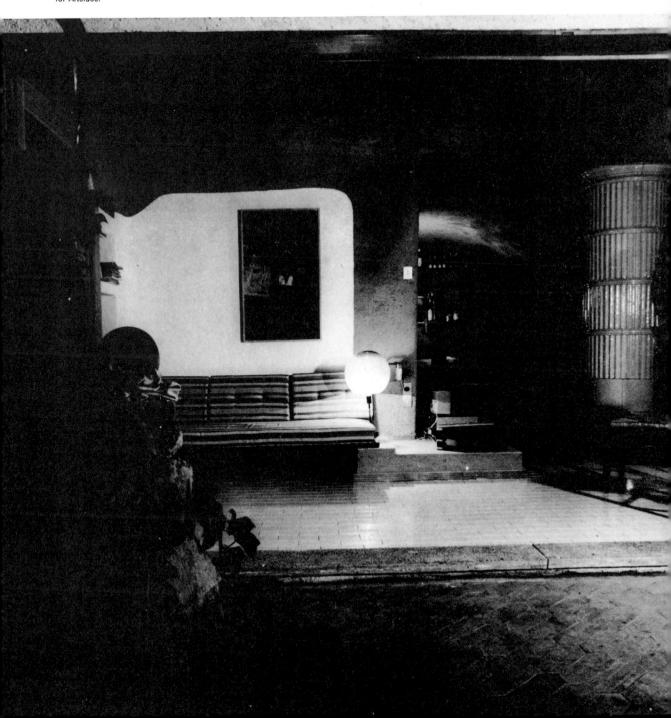

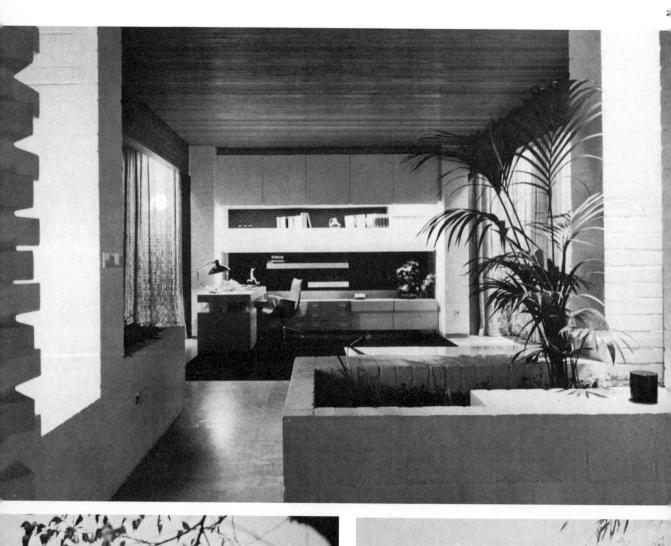

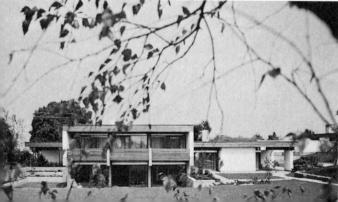

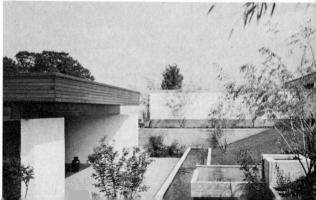

key
palcony
pedroom
guestroom
iving room
snuggery
dining room
sitchen
attrium
wine store
garage
entrance hall
windtrap
bathroom
plantry

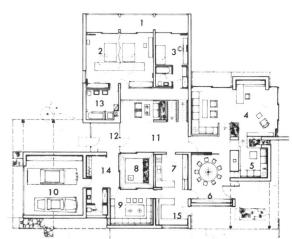

House at Pflaumloch, near the Bavarian border architects Hans Kammerer and Walter Belz in collaboration with Klaus Kucher

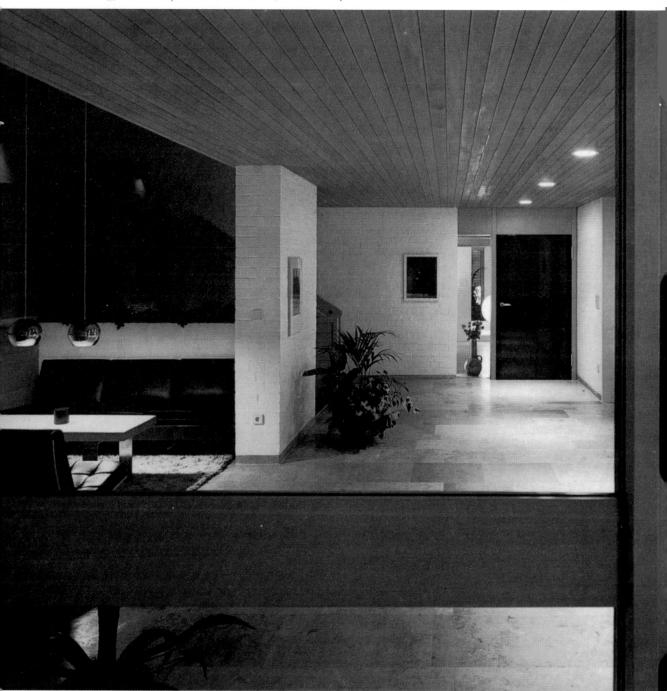

House at Pflaumloch, near the Bavarian border architects Hans Kammerer and Walter Belz in collaboration with Klaus Kucher

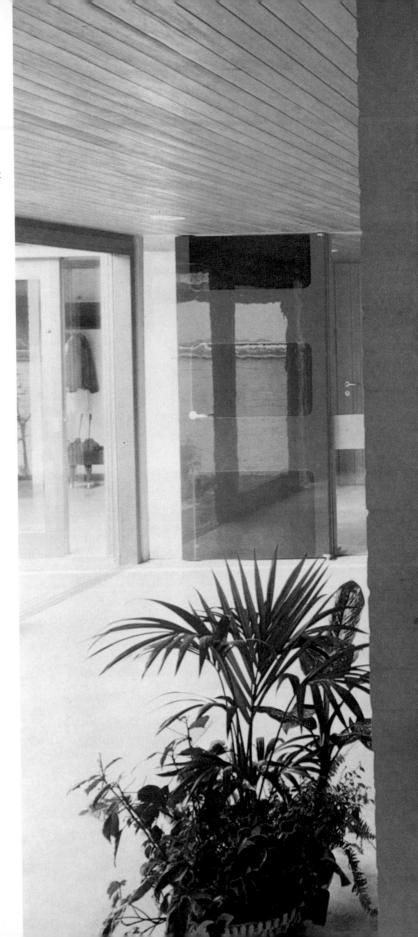

5 6 & 7

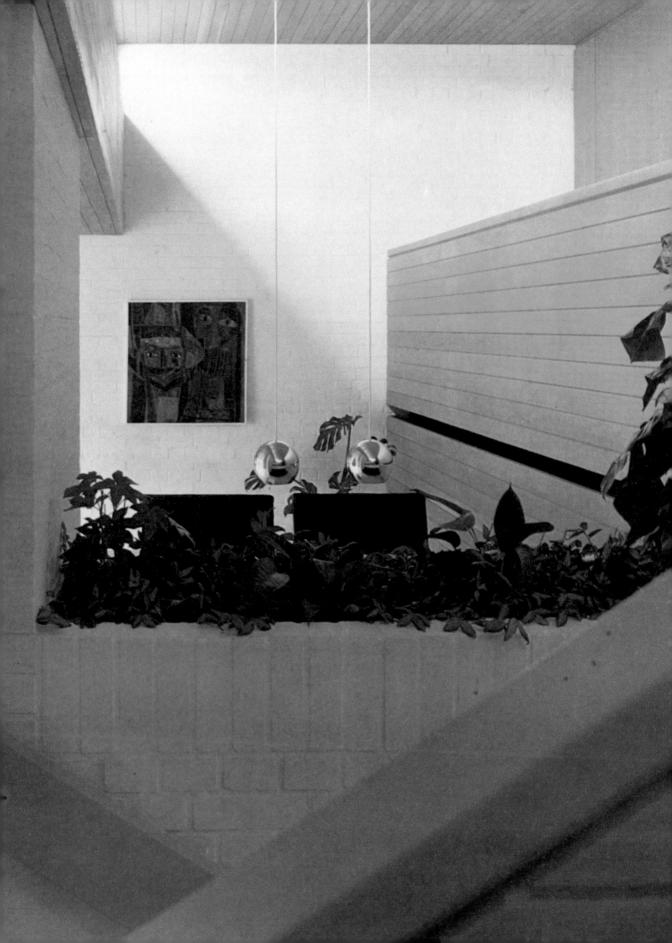

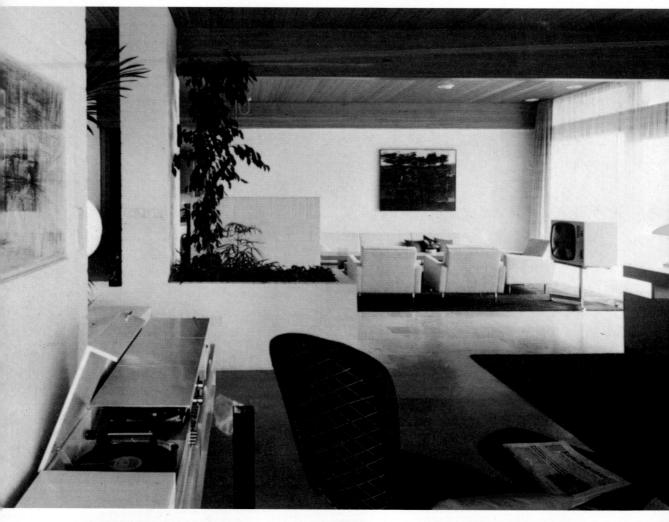

House at Pflaumloch, near the Bavarian border architects Hans Kammerer and Walter Belz in collaboration with Klaus Kucher

On the outskirts of a newly built-up area of smaller houses this site offered little natural interest or variety: it was therefore landscaped to create a fold of land into which the house was integrated.

This handling of the site secured privacy for those areas where it was most desired—a sheltered approach, terrace and entrance hall with access to sauna and swimming pool a half-flight down on the lowered level.

The open plan living area levels are further varied, the main sitting room 3 steps down from the circulation area and a snuggery a further 3 steps down.

Bedrooms are above the sauna and pool areas. White-painted sandstone forms both exterior and interior walls, including certain 'structural furniture', e.g. the planting areas which soften, screen and divide the living space.

Roof, ceiling and window-frames are all of Oregon pine, the roof being insulated by several layers of roofing felt and ballasted with grayel.

Floors are of Jura marble with fitted carpets.

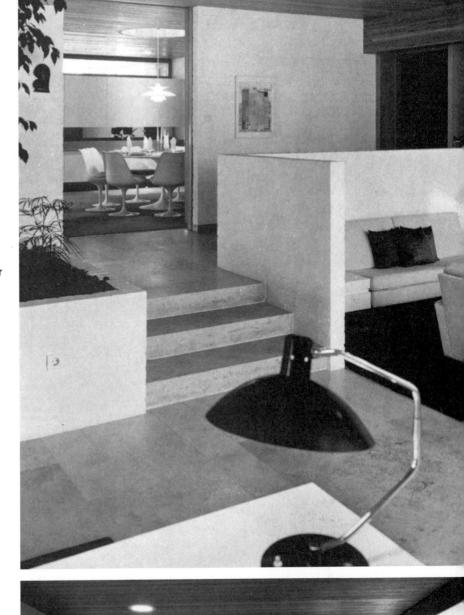

picture

- 1 the study seen from the snuggery well
- 2 south elevation of the house across the garden
- 3 fountain court at the west side
- 4 entrance hall with reception area to the left
- 5 detail of south facade
- 6 umbrella stand
- 7 entrance hall from stairs leading to the bedrooms
- 8 sitting area from the study/hi-fi corner9 detail of swimming pool
- 10 interior fountain courtyard from the entrance hall
- 11 view to the dining room with sitting area on the right
- 12 general view of kitchen

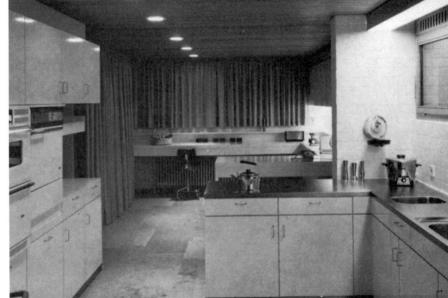

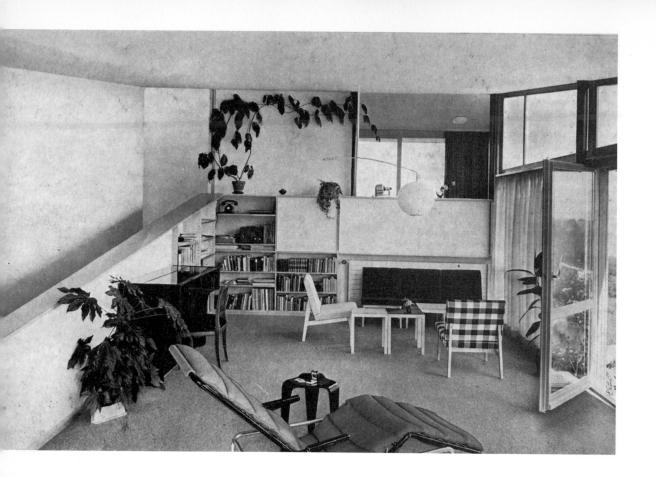

▲ This living room is part of a large studio/living/dining area which can be separated by sliding partitions. A ramp leads up to the studio (background) and bedrooms, its balustrade being integrated with the half-height bookshelf wall. Home of the architect Alfred Altherr, swb Zürich switzerland

▼ Mahogany cabinet with birch top and framing, with one cupboard fitted as a bar. The table on sculptured

legs has a Securit glass top. Interior designed by Max L. van Megen. Executed by NV Asscher HOLLAND

The G-Plan Liang sofabed converts to a full length double bed by lifting the front of the seat which releases a hinge, allowing both back and seat to lie flat. Interior sprung, with storage for bedding under the seat. Made by E. Gomme Ltd UK

▼ Hi-Fi in a setting attuned to its golden tones. The Studio I Combination receiver/record player with separate speaker cabinet, designed by Max Braun GERMANY

▲ Study/reception room furnished for a painter with low-cost mahogany units, Chiavari chairs and small slate-topped olivewood table. The wall fitting is made up of demountable units permitting variable arrangement of shelves and cabinets. ▲ Cherrywood cabinet with black iron legs resting on cherrywood feet—detail from interior

Parigi, executed by F. Sabbadini, Chiavari ITALY

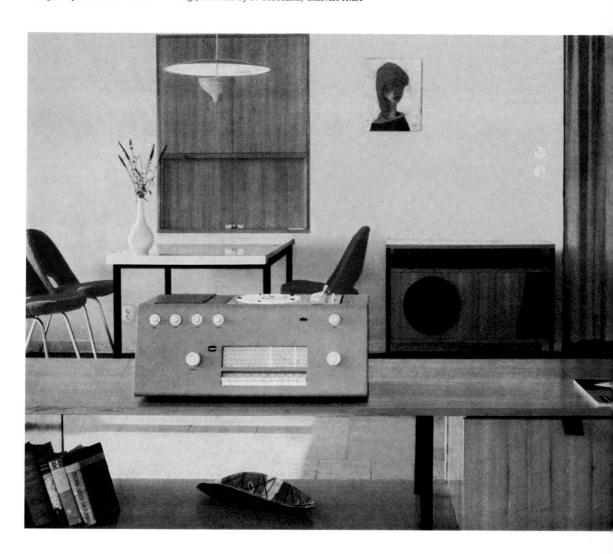

1960-61 · interiors and furniture · 177

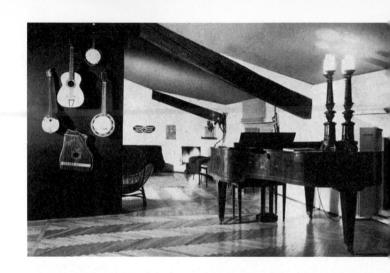

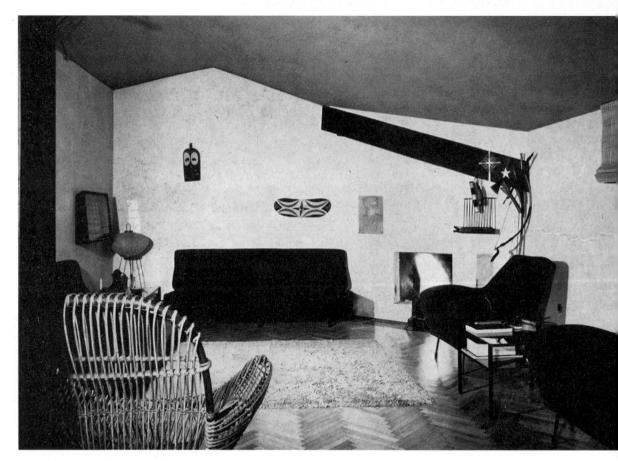

Living-room of an 'attic apartment' of character, created out of the unusual internal spaces unde complicated oak-beamed roof surmounting an old palace. The original structural elements stressed, with low sloping ceilings painted a lead-grey to accentuate their plastic weight; shadow walls painted a dark-brown against which others painted white stand out with sparkling clari windows are at floor level. The chairs, upholstered in vivid colours and in black, are models prototypes of pieces designed by the owner, architect Mario Tedeschi, Milan ITALY

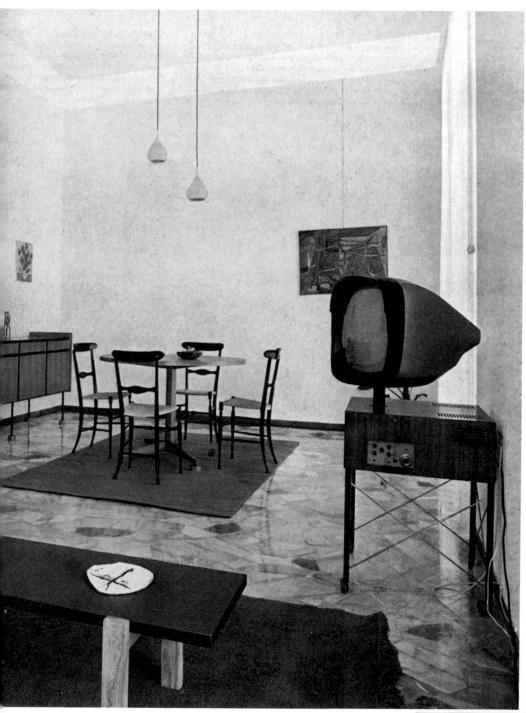

re-designed, this interior has a mosaic floor in Siena marble with washable walls painted white pale-yellow.

The dining table is in cherrywood with rush-seated ised dining chairs of the Chiavari 'campanino' type. The TV set, designed by Danio Montagni, separately mounted tube, which can be tilted and revolved. The living area is simply furnished cane chairs, a slate-topped olive table and an upholstered bench seat with a fall-back which erts it into a bed. Interior designed by Prof. Marcello Parigi, Chiavari ITALY

In the foreground, settee and two *Pernilla* easy chairs in bent-laminated beech with a dull plastic finish. The settee, with sprung seat and back, is upholstered in Eg Ult fabric and felt, the chairs in black leather strapping and a detachable brown sheepskin cover. The centre table is in birch with white Formica top surface, and beside the settee is a drop-leaf table with ash-bordered alder top on nickel-plated steel tube legs. The steel supported bookshelves are in untreated pine with brackets of bent, laminated birch. All are designed by Bruno Mathsson for Karl Mathsson sweden

Terrace of a flat in Buenos Aires forming an open-air extension to the living area. The iron-frame woven wicker chairs and stool, made on a basic oval pattern, are in a natural beige tone; the table top in pinkish-brown and beige wicker. Designed by the architect, Beppi Kraus de Newbery ARGENTINA

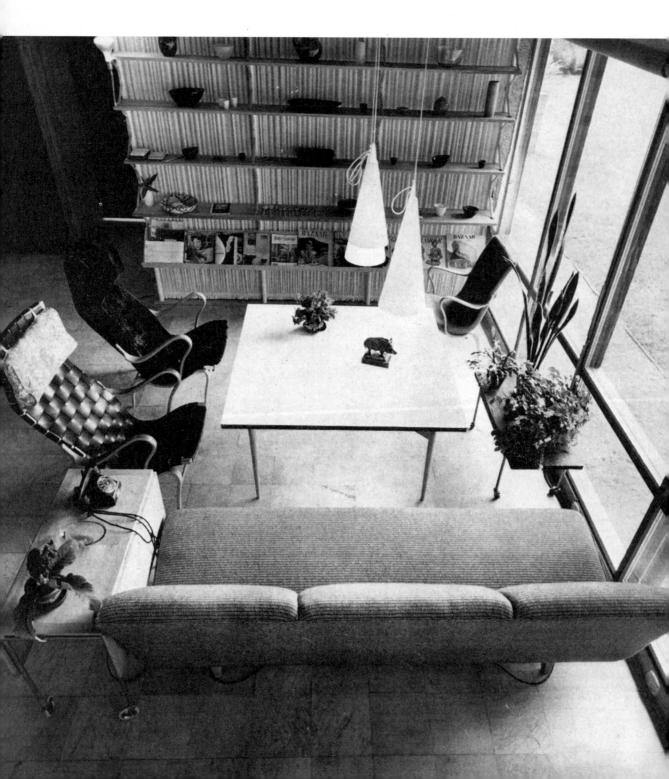

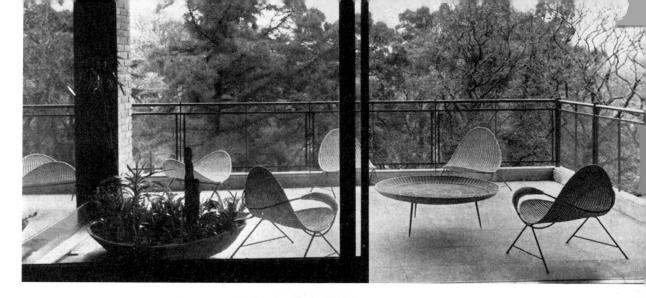

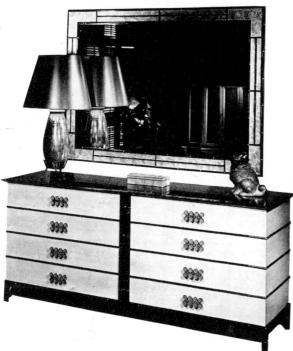

Corner bar in wild cherry with Formica surface to top shelf; the end support and ringed football bar stools are in wrought-iron. Detail from an interior designed by Jean Royère FRANCE

- ▲ Maple dresser, in veneered holly and black lacquer with bamboo and Kappa-shell framed mirror. From the Indonesian collection designed by Renzo R. Rutili for the Johnson Furniture Company USA
- ◀ Corner fireplace in black-lacquered tôle framed in marble, hung on a pale blue wall. The carpet is light green and the chair is upholstered in light tan. Detail from an interior designed by Raphaël SA, FRANCE

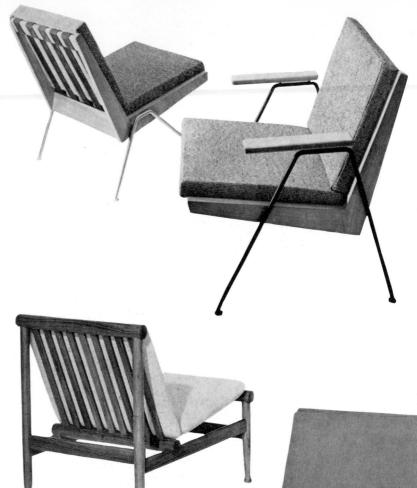

■ Dining chair in afrormosia with woven rush seat, designed by Brian Price;

Laminated elm stacking stools with preformed seats veneered wych-elm; and Latex foam loose cushions. Designed by Roger Fitton. Both at the High Wycombe College of Further Education UK

Sapele dining chair with De Ploeg yellow wool fabric upholstery over foam rubber. Designed by J. H. Tabraham for D. S. Vorster & Co. Pty Ltd SOUTH AFRICA

▲ Knock-down easy chair in teak with reversible foam-padded cushions. Designed by Kai Lyngfeldt Larsen, m.a.a, for Søborg Mobelfabrik A/S, DENMARK

Dining or coffee table on metal base with spring-release top adjustable in height, made in teak, mahogany, walnut, padauk or elm; diameter 41, 43, or 47 inches. Designed I Osvaldo Borsani for Tecno, s.p.a ITALY. ← Chevron mahogany frame chair on plastic-tipped steel legs,
hrome-plated or black finish; Latex foam seat and back cushions.

Designed by Robin Day, RDI, FSIA, for Hille of London UK

Low occasional table on black iron base. The top, measuring 60×40 inches, is in padauk with rhythmic plywood inlays. Designed by Tapio Wirkkala for Askon Tehtaat 0/Y, FINLAND \P

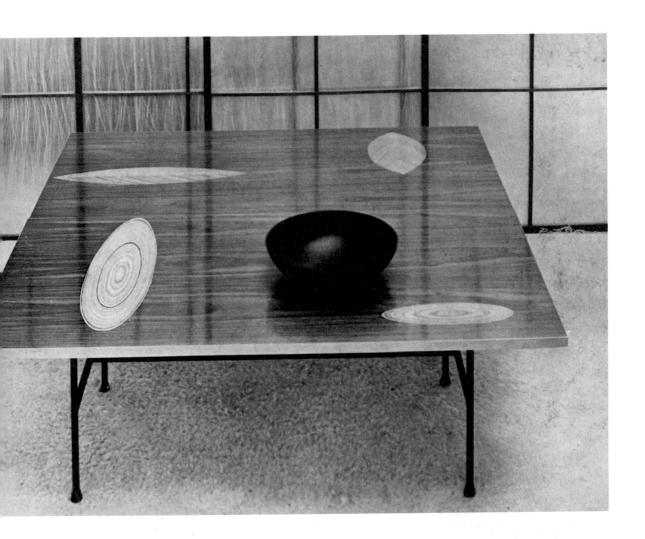

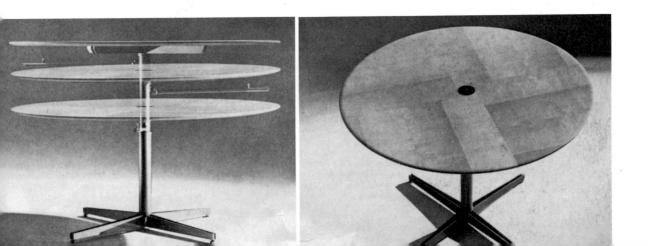

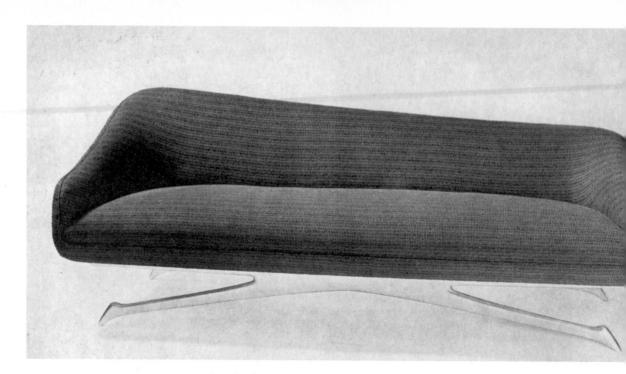

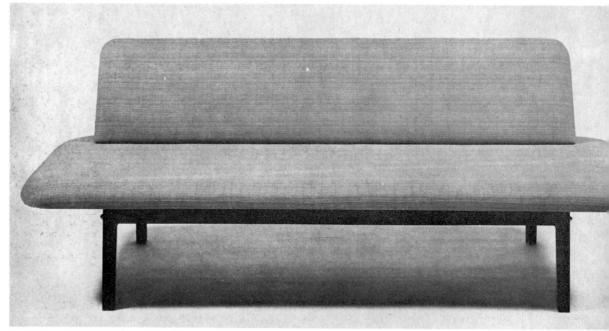

Settee with pre-formed seat 84 inches long on aluminium base, designed by Vladimir Kagan, AID. It is upholstered in fabrics designed by Hugo Dreyfuss and is made by Kagan-Dreyfuss Inc. USA

Day-bed of knock-down construction with detachat back-rest. It is 72 inches long and is made in walr oak, or maple with foam rubber cushioning. Design by John M. Stene for the Brunswick Mfg Co. Ltd CANA

Flamingo easy chair, steel frame with Pirelli webbing on mahogany legs. It is upholstered in Latex foam and plastic foam, and is designed by Ernest Race, RDI, FSIA, for Ernest Race Ltd UK

Orpheus chair and settee with beech frame upholstered rubberised hair; Latex foam cushions. The settee, which is made in two lengths, reflects the comfort of the old-time Chesterfield. Designed by Ronald Long, MSIA, for R. S. Stevens Ltd UK

Easy chair with pre-formed seat on rubber-tipped steel legs, also available with wood underframe. Designed and made by Jens Risom Design, Inc. USA ▼

irage/Omega settee, curved beech frame with moulded atex foam back and reversible cushions, all on tension rings. Also made as a three-seat settee. Designed by B. Keith, MSIA, for H. K. Furniture Ltd UK

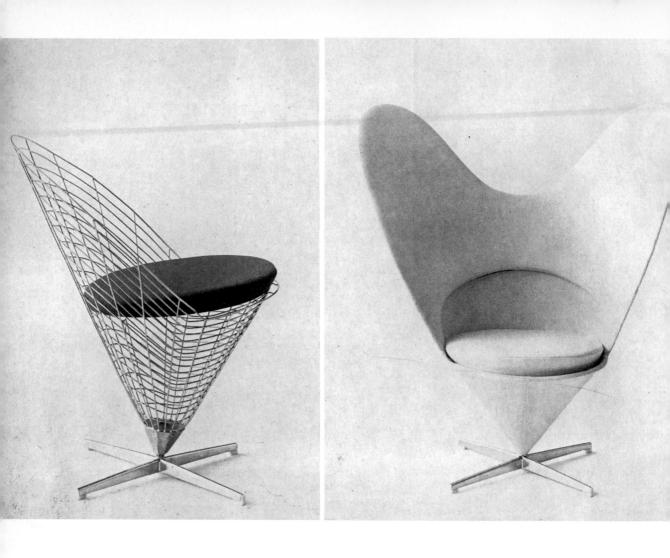

▲ Bar stool and wing chair from a range of chairs, tables and stools in thin plate steel or steel wire on stainless steel profile legs. All stresses are gathered to one point and both models revolve or remain stable at will. Upholstery is in foamrubber with plasticised or wool covering fabrics. Designed by Werner Panton for Unika-Væv A/S, DENMARK

The Tulip high-back armchair, white moulded fibre glass shell on steel base, heigh 51 inches. Designed and made by Laverne Inc. USA

Chromium-plated steel nylon-tipped stacking stools with painted plywood tops an leather-covered cushions. They are just over 12 inches high and 20 inches diameter Designed by Poul Kjærholm for Ejvind Kold Christensen A/S, DENMARK

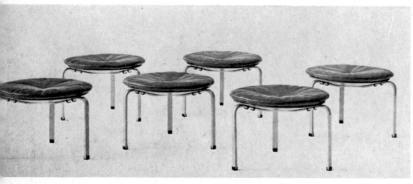

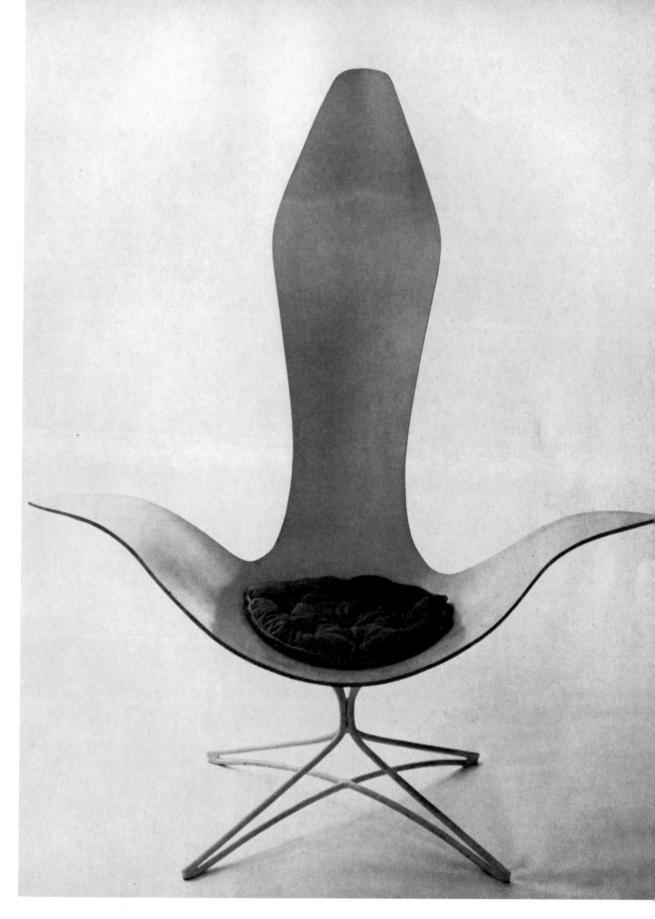

1960-61 · interiors and furniture · 187

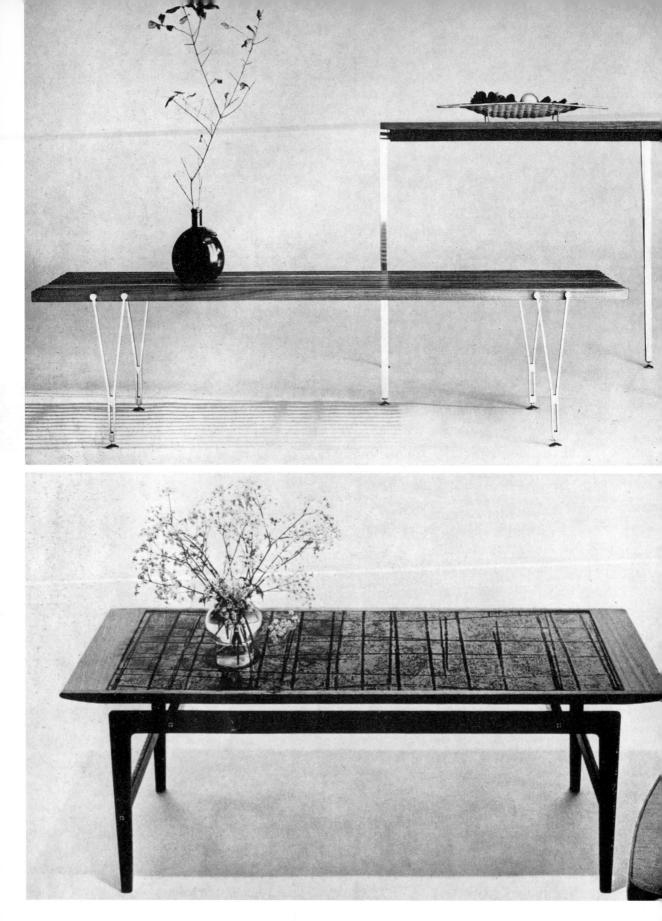

 $\textbf{188} \cdot \text{interiors}$ and furniture \cdot 1960–61

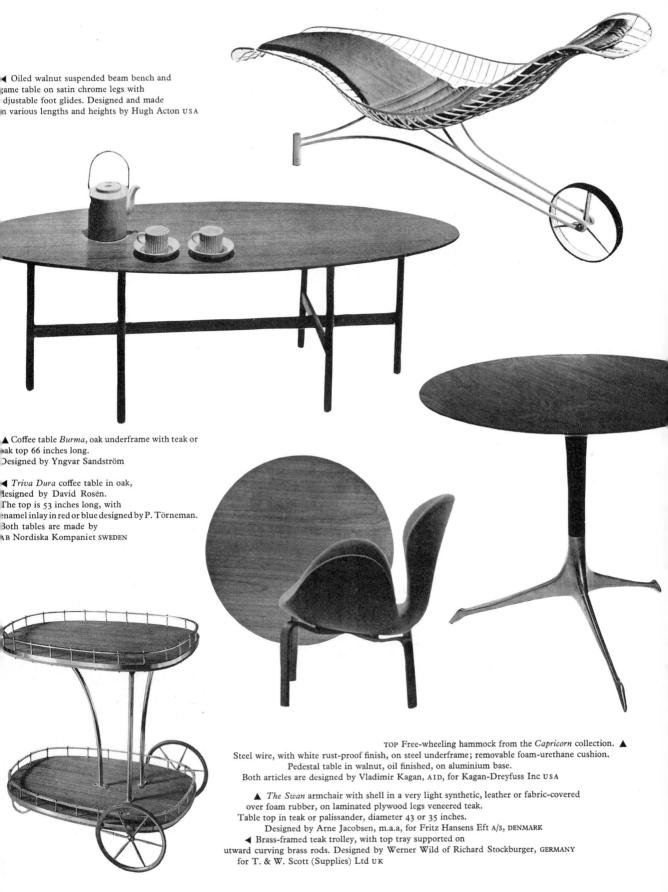

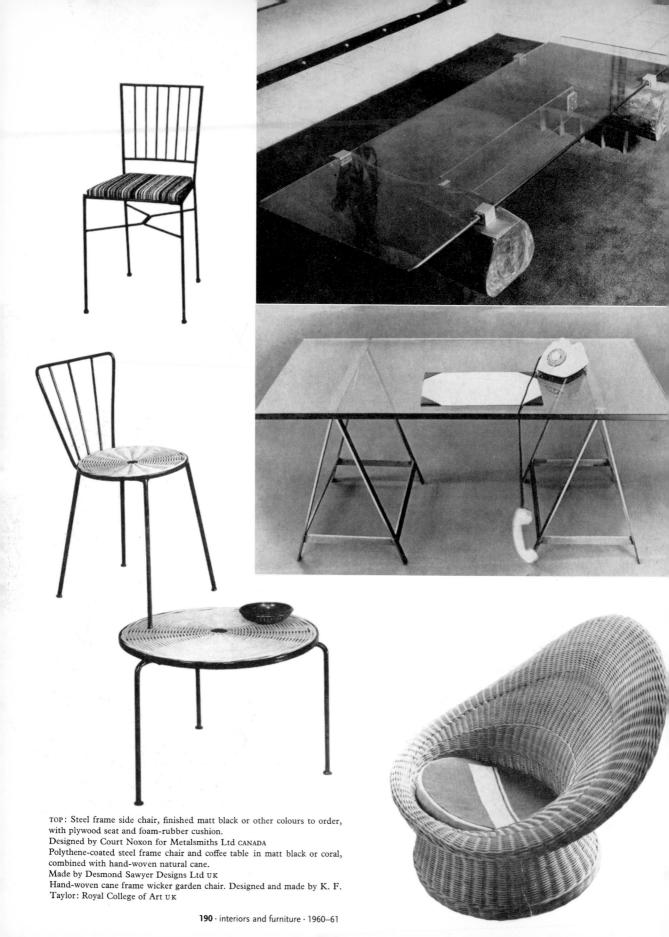

 \blacktriangleleft Low fireside table in Securit glass mounted on ebony logs. By Raphaël France

Polished steel trestle table with one-inch thick plate glass top 60 inches long. Designed by David Hicks for Hicks & Parr Ltd UK Coffee table on black-lacquered metal legs with bevel-edge plate glass top. Designed by Max Ingrand FRANCE for Fontana Arte ITALY ▶

▼ Oiled walnut multiposition armchair with retractible aluminium footrest. Upholstered in Hugo Dreyfuss fabrics, it is designed by Vladimir Kagan, AID, for Kagan-Dreyfuss Inc. USA

Laminated high-frequency pressed shell, upholstered *Structura* weave over Latex foam, on polished metal legs. Designed by Pierre Paulin FRANCE for Wagemans & van Tuinen NY HOLLAND. The brass-ringed dull-lacquered fireirons are designed by Jens H. Quistgaard for Dansk Designs DENMARK

RIGHT, ▼ Circular occasional table in walnut, teak or cherrywood, with smoked-glass top. Made by Wilhelm Renz KG GERMANY Oiled walnut sculptured table with elliptical plate glass top. Designed by Vladimir Kagan, AID, for Kagan-Dreyfuss Inc. USA

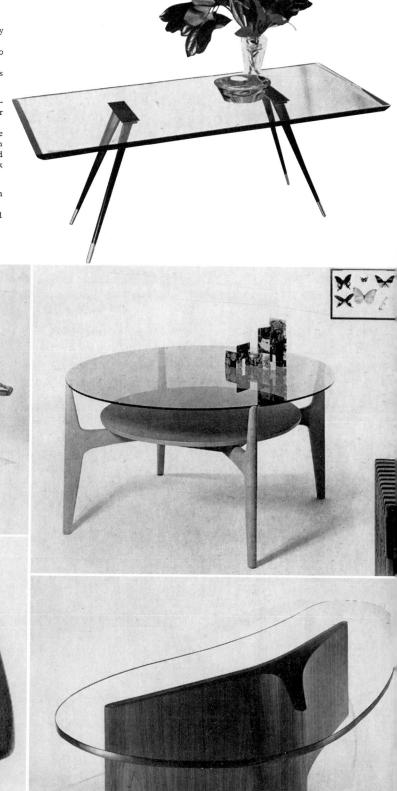

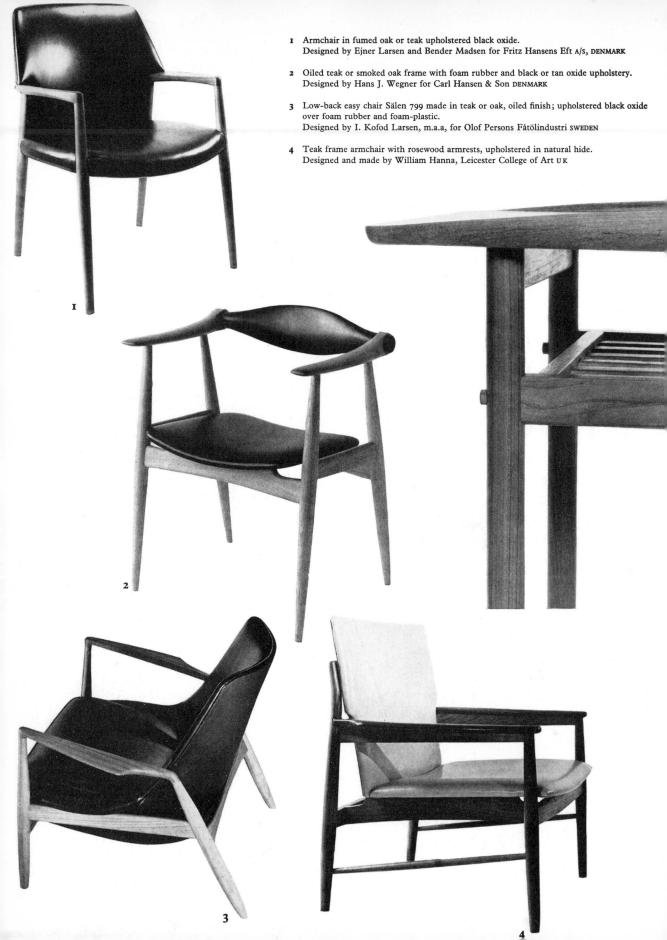

BELOW: Low coffee table in teak, walnut or rosewood with top measuring 65 inches. LEFT: Detail from an end table in the same range. Both designs are of knock-down construction. Designed by Grete Jalk for P. Jeppesen's Møbelfabrik A/S, Denmark. Double-frame armchair in English walnut with leather-covered seatand backrest. Designed by Colin Eggleton, High Wycombe College of Further Education UK

▲ Knock-down easy chair, No. 506, made in solid teak with oxhide seat and back rest; note the flattened curve of the armrests. Designed by Kai Lyngfeldt Larsen, m.a.a, for Søborg Møbelfabrik A/s, DENMARK. BOTTOM: Easy chair on Wengé wood underframe, shell upholstered in natural leather. Designed by E. Veranneman BELGIUM

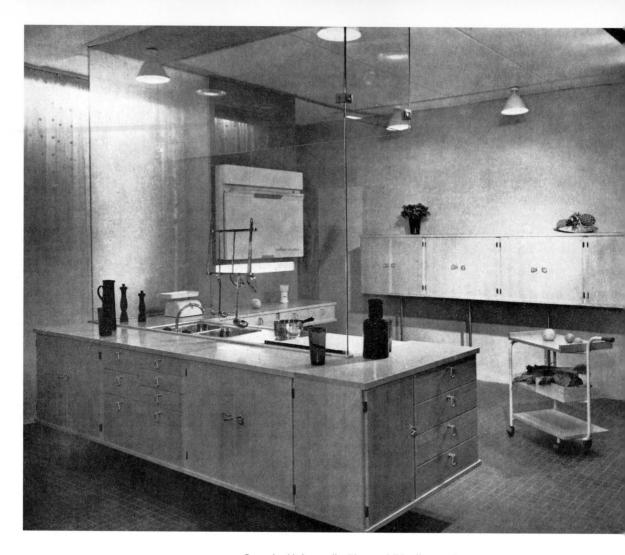

Open-plan kitchen, wall cabinets and 'island' storage/sink unit in polished ash and stainless steel with hooded screen of Securit glass; floor in grey ceramic tiles. Designed by Jacques Hitier FRANCE

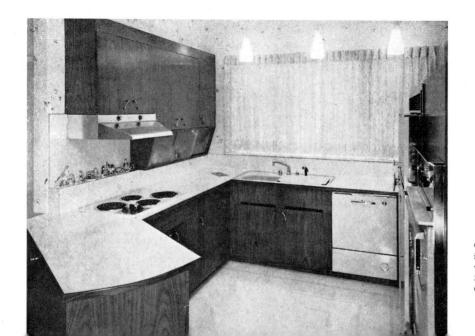

Compact small kitchen with all fittings in; the storage cabinets are in oiled w with counter tops in Formica. Design Sigrun Bulow-Hube for the Aka Fur Co. Ltd CANADA

Julland dining group in hand-rubbed oiled teak. The four-drawer chest and shelf unit (which can be used separately) is designed by Ib Kofod-Larsen, the chairs by Hovmand-Olsen of Denmark for the Selig Manufacturing Co. USA

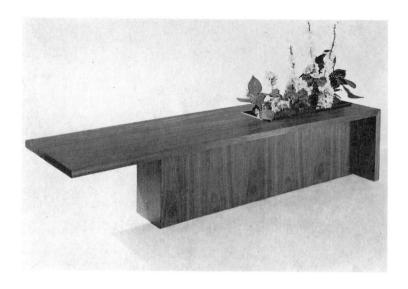

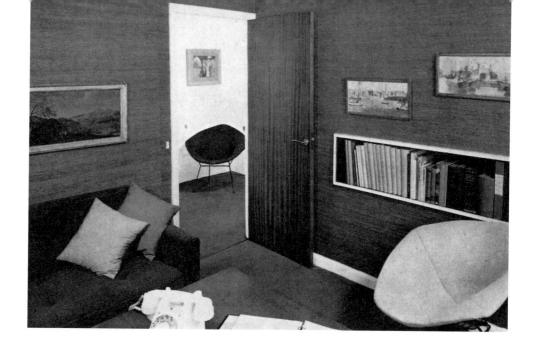

- Wall elements designed for variable arrangement at any height on metal rails. They can be applied directly to the wall or combined as a room divider with or without wood panels. Designed by Osvaldo Borsani for Tecno s.p.a. ITALY
- ◀ BELOW: Coffee table with metal plant container inset in the 66-inch long top. Designed by Vladimir Kagan, AID, for Grosfield House USA
- ▲ Corner of reception room with white-framed bookshelf inset against a background of brownish/black Japanese grasscloth wallpaper. The *Bertoia* chairs are upholstered in off-white and black, the *Vono* sofa in dark olive green with lettuce green cushions. Interior designed by Spencer & Gore UK
- ▼ Fireplace in brick and tile with slate top. Designed by Jean Royère; tapestry by Picart le Doux France

Chimneypiece in two tones of grey brick with white marble mantelshelf. Designed by Emile Veranneman $_{\rm BELGIUM}$

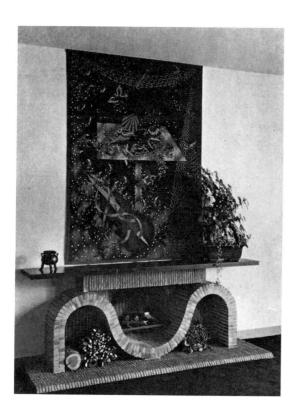

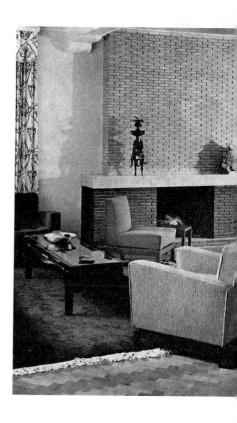

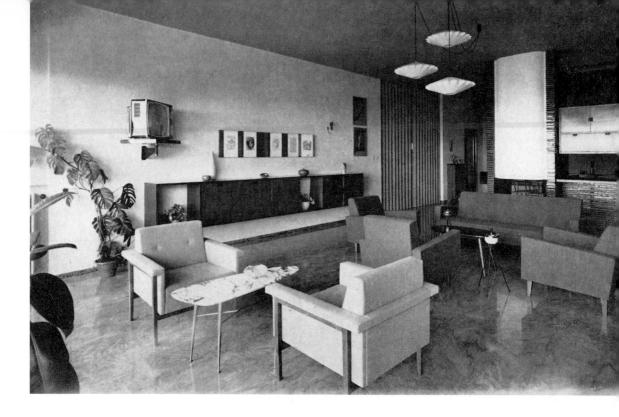

Large living room with glazed brick ceiling-height chimney piece dividing off a small dining area; opposite (not shown) is a window wall opening onto a balcony. Polished marble floor with furniture and wall fittings (which includes a bracket for the television set) in polished walnut. Divans and Pistoai chairs are upholstered in blue and light green wool fabric over foam rubber. Dining room: table, trolley and adjustable wall elements in teak with the doors of the cabinet faced in blue and white Formica; the Chiavari chairs are upholstered in orange.

Both interiors are conversions for large villas designed by Prof. Marcello Parigi, Chiavari ITALY

With the exception of the red-upholstered Knoll chair in the foreground, the main scheme of this living room is kept to white/grey/black with colour brilliance provided by the tropical garden seen through the picture windows. It is furnished with sculptured pieces upholstered in medium and dark grey bouclé fabrics, marble and copper-topped tables and a shelf/cabinet wall fitting on black iron tube supports for bar, radio and record player. Over the corner open hearth a black sheet iron hood. Interior designed by architect Beppi Kraus de Newbery ARGENTINA

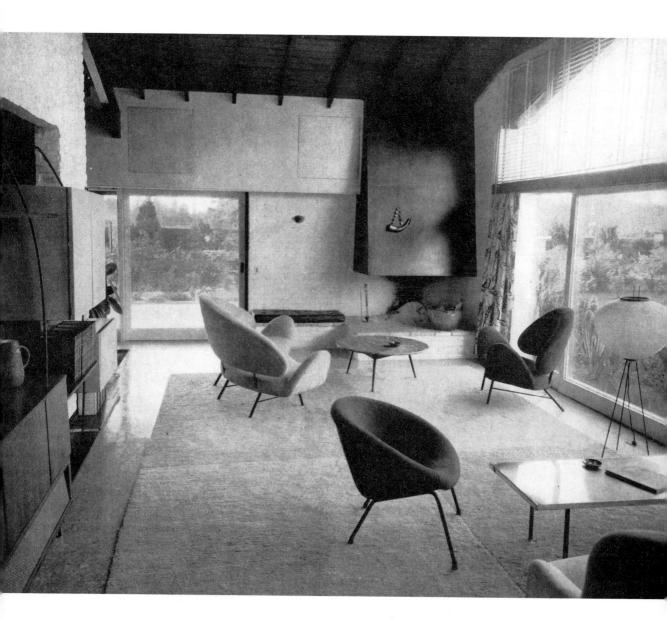

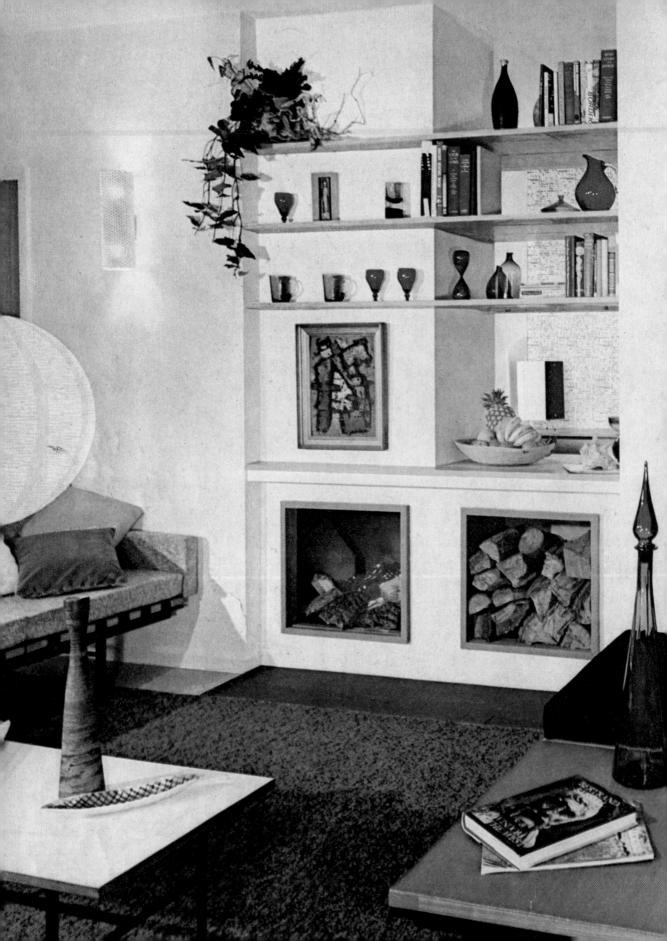

An award-winning interior scheme based on a modified open plan. The chimney piece, fitted with display shelves, forms a dividing link between the two areas. Informality in grouping, continuous curtain treatment, a vibrant colour scheme, furniture of simple lines scaled to the proportions of the room, all contribute to an air of solid comfort. The floor is in 'jointite' cork tiles from Mundet Cork Products with Kosset carpeting;

Tumbeltwist rug from Shelley Textiles at the dining end;

Wallpaper Night Watch by Arthur Sanderson & Sons Ltd.

Curtains Galloway by Edinburgh Weavers;

Modulus seating units by Hille of London Ltd

White plastic top coffee table by Stafford Furniture Ltd; with vase by Briglin Pottery Ltd.

Fluorescent tube standard by Fluorel Ltd and stoneware wine bottle by A. & R. Duckworth Ltd.

At the dining end, a pendant in spun aluminium and opal glass by Merchant Adventurers Ltd hangs above the afrormosia dining group made by D. Meredew Ltd.

House designed by R. J. Nicol and A. M. Edwards, AARIBA; interior furnished by Busbys (Bradford) Ltd to a scheme prepared by Mrs Helen Challen.

Courtesy 'Ideal Home'

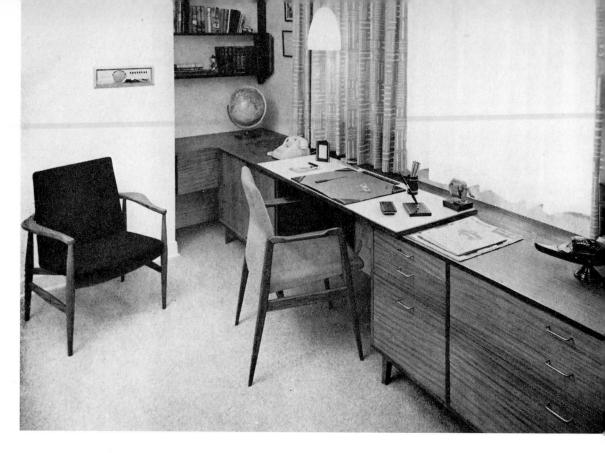

▲ Boy's study with writing shelf bridging a continuous arrangement of storage units in afrormosia. Designed by Sigrun Bulow-Hube for the Aka Furniture Co. Ltd Canada Demountable bedroom units from the AM8 range. In semi-matt cherry or palissander wood with bed frame lacquered black and chromium steel bases to the dressing table and glass-topped bedtable surfaced in white plastic. Designed Willy Guhl, swb/vsi. Made by AG. vorm. Ad. Aeschlimann; steel frame cane chair made by Diettker & Co. SWITZERLAND

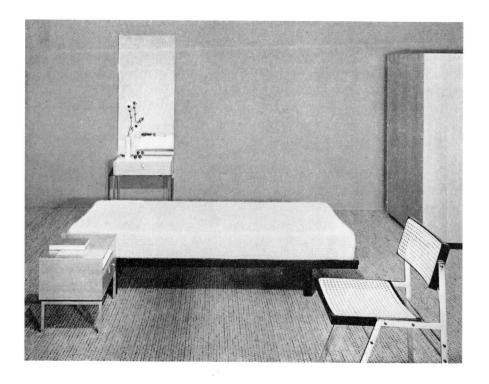

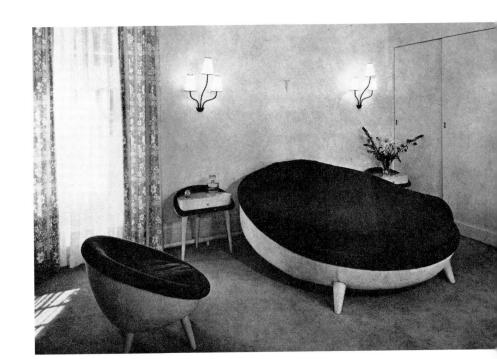

nan's bedroom with bed, armchair and tables upholstered in royal blue and ow fur velvet. Twin-bedded children's n with fitments in natural waxed oak; black metal frame chairs are upholed in 'Havana' plasticised fabric. Both riors are designed by Jean Royère in coloration with Jacques Levy Ravier FRANCE

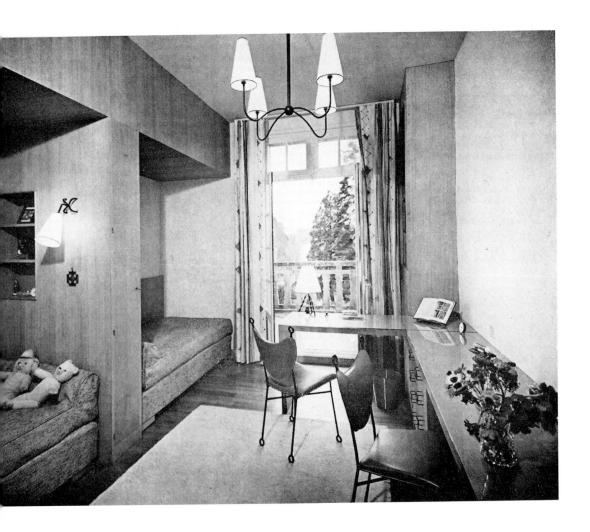

Windsor chair, solid elm with framings in beech; the foam cushion has a detachable cover and straps.

Designed by Lucian R. Ercolani for Ercol Furniture Ltd UK

▼ Stanford panel back dining chairs in natural or oiled walnut or mahogany finishes with upholstered seats.

Designed by Robert Heritage, MSIA, for Archie Shine Ltd UK

▼ Square-section steel frame chair, satin chrome finish, with back and rails in mahogany; laminated upholstered seat.

Designed and made by Harry Sowden, MSIA, UK

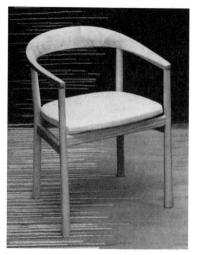

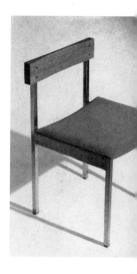

Oak chair with tan leather holstery. Designed by A. nder Madsen and Ejner rsen.

ade by Willy Beck DENMARK ponised beech chair with seat woven cane.

esigned by Gio Ponti ITALY.
om Conran Furniture UK

ning chair in teak, rosewood, Inut or ash with leather or oric covered foam padded seat. ssigned by Renato Venturi for obili MiM s.p.a. ITALY

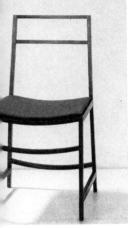

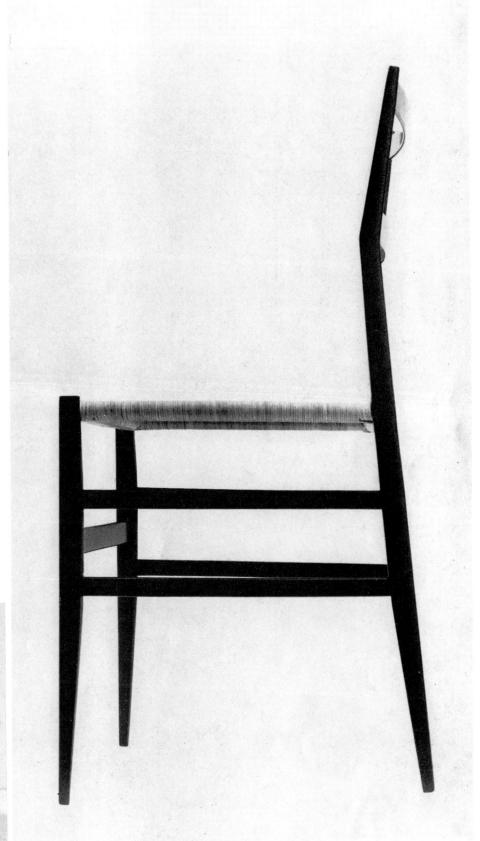

P.32, metal frame with swivel seat and adjustable back-tilt mechanism; removable cover over foam rubber upholstery. Designed by Osvaldo Borsani for Tecno s.p.a. ITALY

Marlowe, beech frame upholstered rubberised hair, with foam cushion on rubber webbings.

Designed by Ronald Long, MSIA, for R. S. Stevens Ltd U

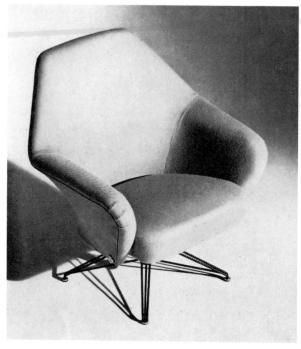

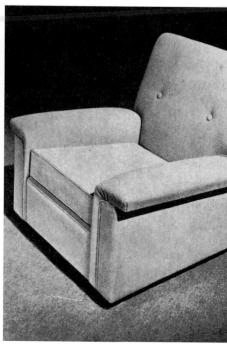

Junior, beech or teak frame with padded seat and backrest.

Designed by I. Relling for West Norway Factories Ltd A/s.

From Westnofa (London) Ltd UK

Aurora glass fibre shell on mahogany legs; removable of plastic foam cushioning.

Designed by W. S. Chenery, Des.RCA, for Lurashell L.

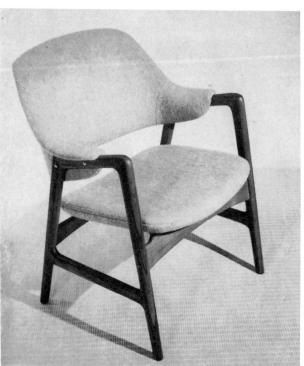

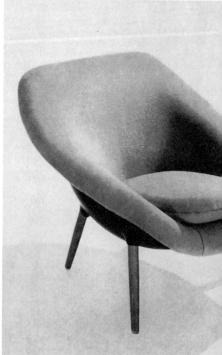

 $206 \cdot \text{interiors}$ and furniture $\cdot 1961-62$

frame wide chair on mahogany legs; upholstered loeg yellow wool fabric over Dunlopillo.

Rned by J. H. Tabraham for R. Schultz SOUTH AFRICA

High back armchair with footrest, made in a variety of woods and a wide range of covering fabrics.

Designed by Sigrun Bulow-Hube for the Aka Furniture Co. Ltd CANADA

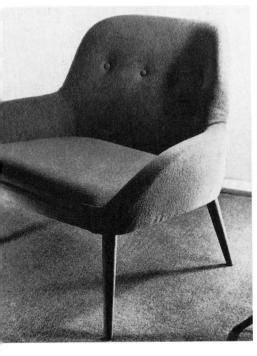

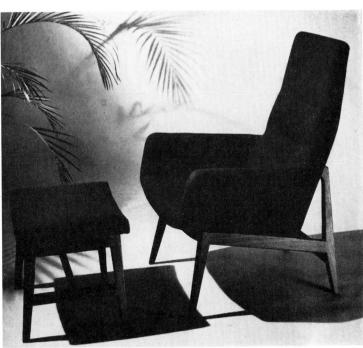

d teak frame armchairs. Spring interior on flat cals with polyurethane and foam rubber upholstery: Model 152 designed by Finn Juhl, m.a.a.

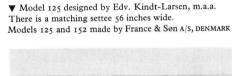

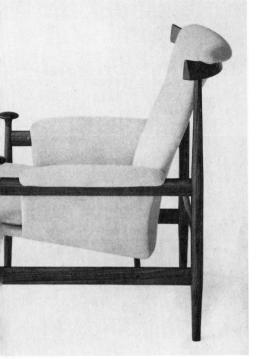

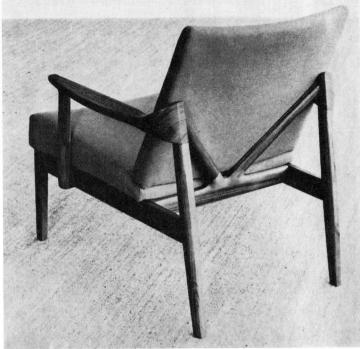

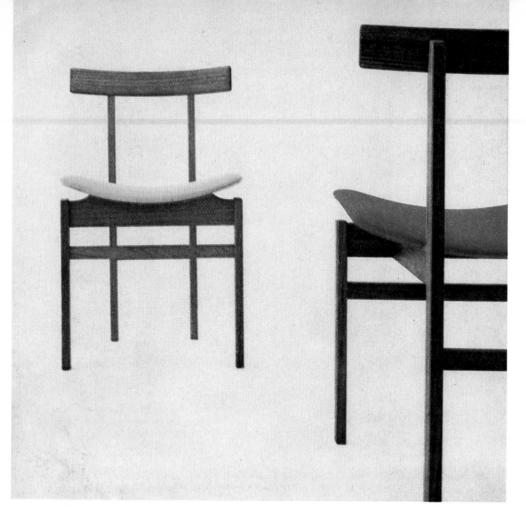

Dining chair, Model 193, solid teak; laminated seat wi upholstery pad of polyurethan Designed by Inger Klingenber Dining chair, Model 205, so teak frame, laminated swivel ba with caned panel, upholsten seat.

Designed by Arne Vodder.
Both made by France & S
A/S, DENMARK

▼ Sideboard Hamilton in ros wood and mahogany, Indilaurel and walnut, or te finishes; length 90 inches. Designed by Robert Heritag MS1A, for Archie Shine Ltd UK

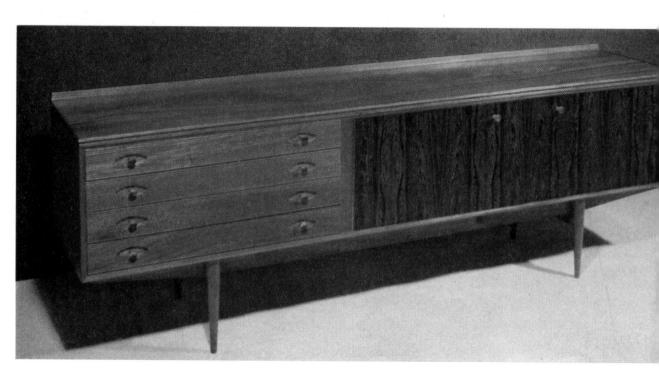

 $\textbf{208} \cdot \text{interiors}$ and furniture $\cdot~1961{-}62$

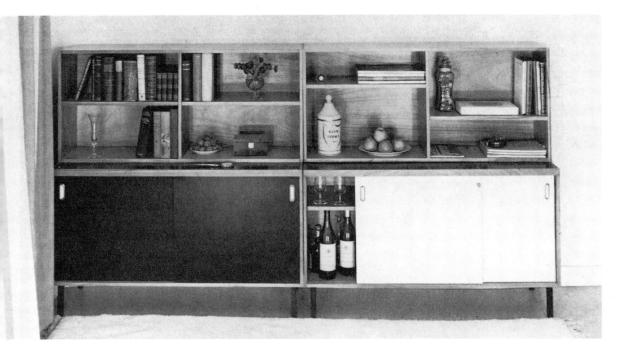

Four storage and display units with adjustable shelves. Made in African walnut on metal base with door fronts faced in Formica. Designed for variable assembly, by Conran Design Group for Conran Furniture UK

Teak tea table with edge lists of Bangkok teak; top 55 inches long with 16-inch pull-out trays in plastic or teak veneers. Designed by Tove and Edv. Kindt-Larsen for AB Seffle Möbelfabrik SWEDEN

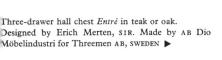

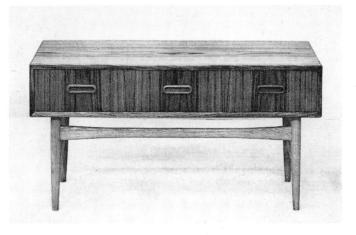

▼ Chaise longue *Eden* from the 'Paradise' suite, with foam-padded moulded light plastic curved frame; the seat, 66½ inches long, has 'No-sag' springs, with mahogany, teak or walnut finishes to the red beech legs. Designed by Kerstin Hörlin-Holmquist for AB Nordiska Kompaniet SWEDEN

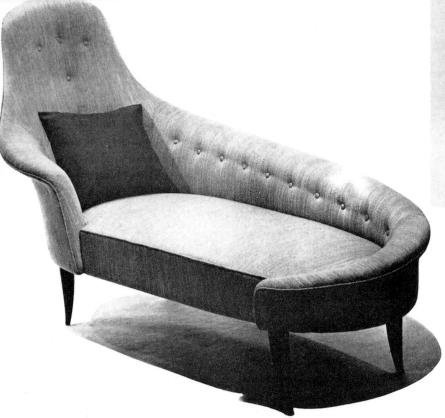

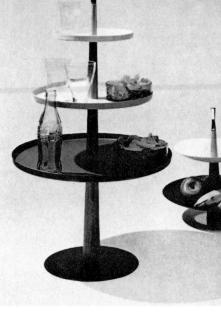

Sofa Duello, with laminated frame and shaped cush upholstered in a wide range of covering fabrics of foam-rubber. Designed by Olof Ottelin for Stockmann-Orno FINLAND

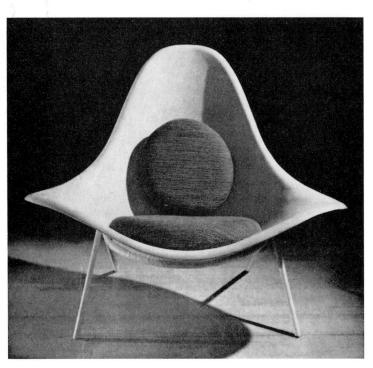

 $\textbf{210} \cdot \text{interiors}$ and furniture $\cdot \, 1961{-}62$

◀ Easy chair of moulded fibreglass on metal le Designed by Sandra Heath, student at the Cen School of Arts & Crafts, for Heal's of London UK

Pedestal group, chrome metal base with revolv foam-padded laminated chair seats, and match footrest; the table tops, 28 and 41 inches diamet are in rosewood or Formica. All designed by Pie Paulin France for the Artifort range made by Wamans & Van Tuinen NV, HOLLAND

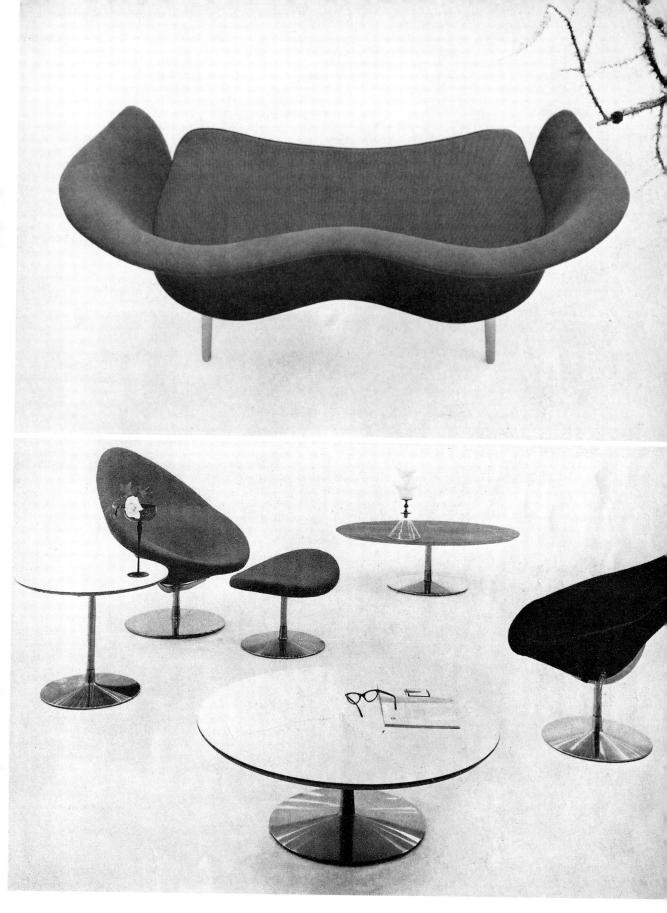

1961-62 · interiors and furniture · 211

Hall chair in moulded plywood with foam rubber padding and leather upholstery; legs in stainless steel. Designed by Stefan Siwinski for Korina Designs CANADA

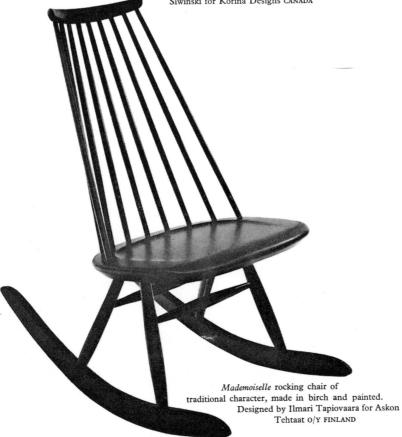

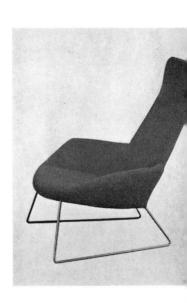

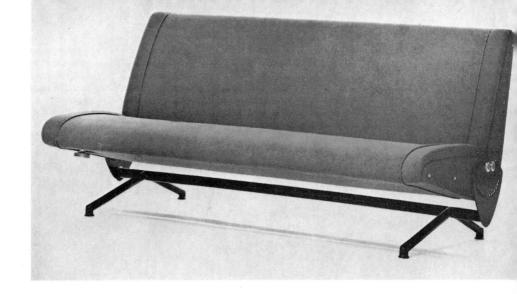

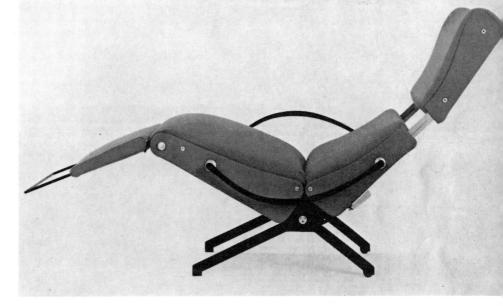

▼ Rocking chair, laminated ash frame with rosewood arms; upholstery rubber webbing and Latex foam under wool tapestry cover. Made by Gordon Gray, High Wycombe College of Further Education UK

■ Rock'n-rest chair in polished mahogany, teak or oak; seat rockable, or fixed in any one of eight positions.

A Norwegian design made by Gimson & Slater Ltd UK

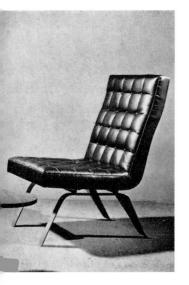

■ Armchair, mild steel rod frame with wool fabric upholstery over foam padding. Designed by Colin Andrews, L.C.C. Technical College for the Furnishing Trades UK ■ Hall chair, flat steel frame with welded steel rod mesh infilling to seat and back; upholstered in quilted black hide over foam rubber. Designed by Alan Hunt for H. Don

Carolis & Sons Ltd CEYLON

Reclining chair P.40 with jointed metal frame adjustable to many positions; upholstery foam rubber with removable covers available in a wide range of colours.

TOP Settee D.70 with back and seat adjustable to any angle, reversible, or extended to make a bed by lever mechanism operated by side knob (see diagram). Underframe in stovenamelled steel tube with brass fittings; upholstery foamrubber with fitted removable cover. Both designed by Osvaldo Borsani for Tecno, s.p.a. ITALY

▼ ► Group and details from the *Form* range of interchangeable Modulus units on metal frames 28 inches wide and 56, 72 or 122 inches long. Table tops are plastic laminated or in makore; seat cushions foam rubber with zip-off covers. Designed by Robin Day, RDI, ARCA, FSIA, for Hille of London UK

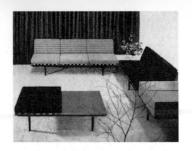

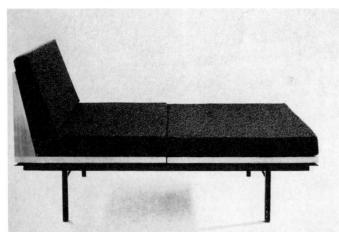

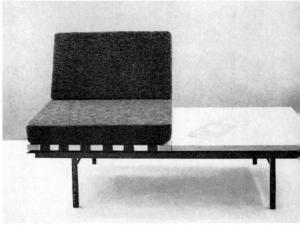

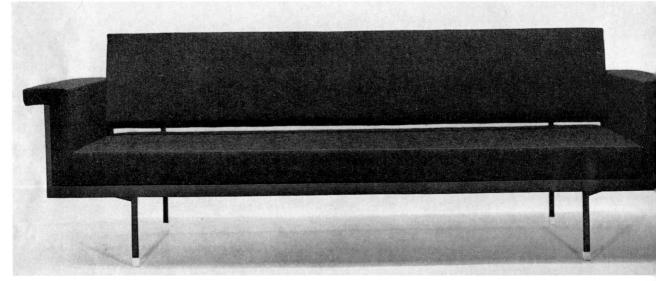

▲ Naeko long low settee, black iron or palissander under-frame, 89 inches long, upholstered latex foam with wool fabric covering.
Designed by Kasuhide Takahama of Japan for Gavina Poltrone ITALY

Tripos easy chair, mahogany or afrormosia seat adjustable to three positions suspended in square-section steel tube frame, fused nylon or satin chrome finish; cushions Latex and plastic foam with detachable covers. Designed and made by Ernest Race Ltd UK

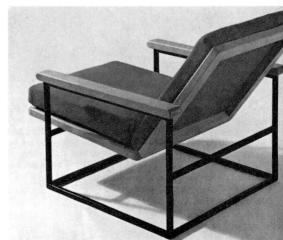

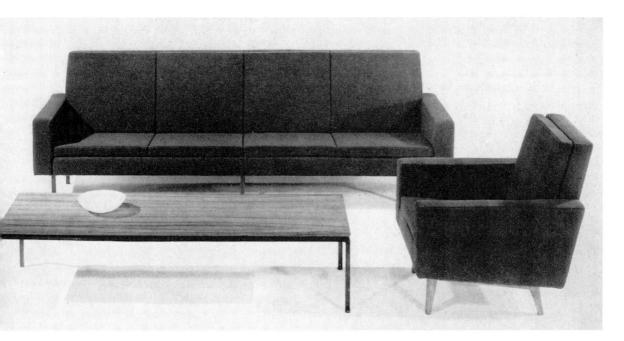

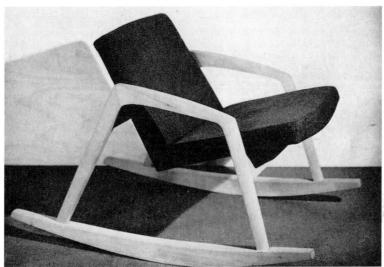

Square built armchair and settee for four h loose foam cushion seats 23 × 22 inches Excelsa teak or metal frame. Florentine nzed frame tea table with Excelsa teak 66 inches long. Designed by Theo mpelman for A. Polak's Meubelindustrie LLAND

cking chair, beech frame, plywood seat holstered foam rubber. Designed and de by Graham Probst, Kingston School Art UK

Aziatica high-backed armchair and stool, lnut frame with slung seat upholstered dish-brown woolfabric over foam rubber. signed by Jos De Mey for Van den rghe-Pauvers BELGIUM

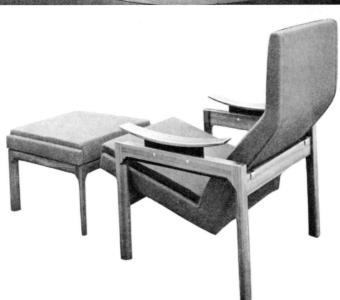

Teak chests of drawers with bevelled finger grips at the sides, recessed in the black spacer between each unit; top surfaces of teak or white plastic veneer. The continuous base is in brushed or polished chrome steel. Designed by Florence Knoll of Knoll Associates, Inc USA

▼ ▷

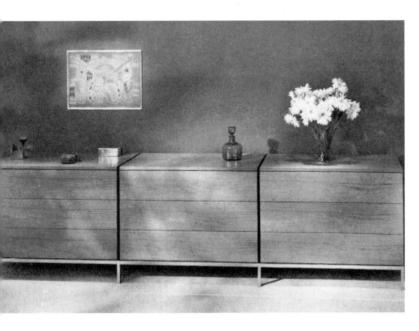

Feak sideboard lined in beech, with veneered door anels and recessed handles; 78 inches long. Deigned by A. Bender Madsen and Ejner Larsen ENMARK. From Georg Jensen Inc USA

Walnut bench with seat cushion covered in a handvoven fabric of calfhide strips and wool. By Hella kowronski USA

I Brilliant panels of colour frame the kitchen equipnent in this New York apartment; spice shelf, hopping boards, moulds, omelet pans, salad basets thus become part of a visual scheme. Undereath, white-lacquered shelves with a wine rack built in provide additional storage space. By Albert Ierbert Design USA

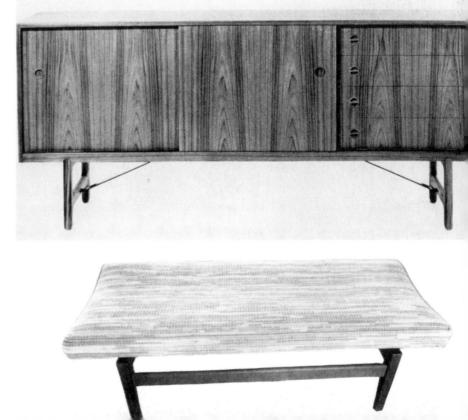

Furniture from SWEDEN

High back easy chair, moulded frame in polystyrene, with base in teak. Designed by Karl Erik Ekselius for AB J. O. Carlsson

Coffee table Carmel designed by Folke Ohlsson. Made in teak and oak or in walnut by AB Svenska Möbelfabrikerna Bodafors

Armchair Generalen made entirely of foam rubber with removable foam seat cushion on rubber bands; the base is in oak. The foam-upholstered hassock Siesta is made in oak or in Bangkok teak. Designed by Ib Kofod-Larsen for Olof Persons Fåtöljindustri.

5 Cabinet and trolley *Signum* in mahogany, signed by Axel Larsson. for AB Svenska Möb fabrikerna

5, 4

POREGROUND Swivel-based Contourett Roto echairs, tubular steel and back frame with zigsprings, foam seat and neck pillow. Designed Alf Svenson. BACKGROUND Derby group (armchedetail 4) on teak legs, upholstery based on zigsprings; foam-padded arms and reversible fo cushions with zipped covers. Designed by Foolhsson. All made by Ljungs Industrier AB/Du

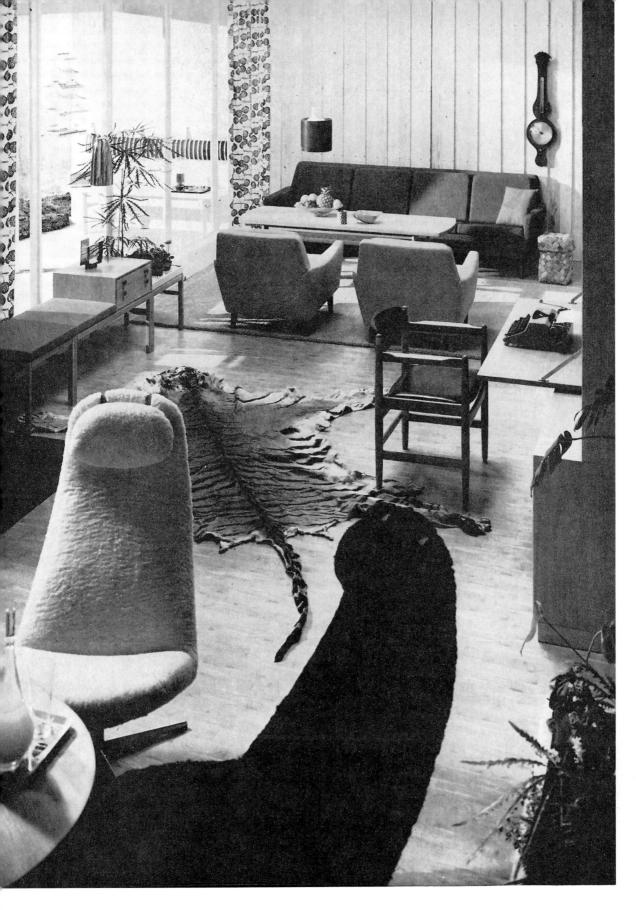

1962–63 \cdot interiors and furniture \cdot 219

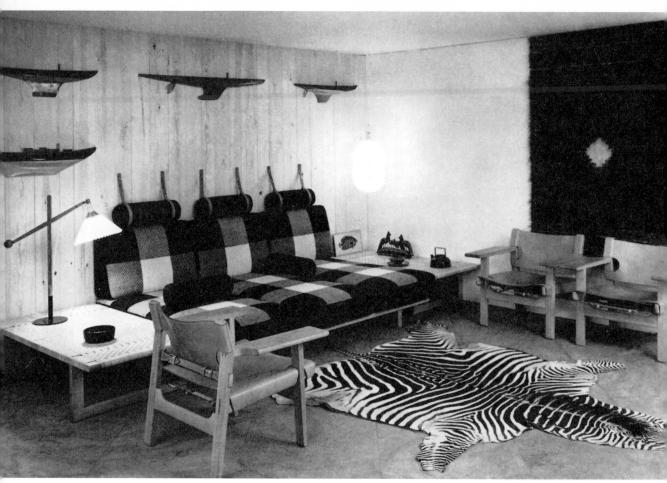

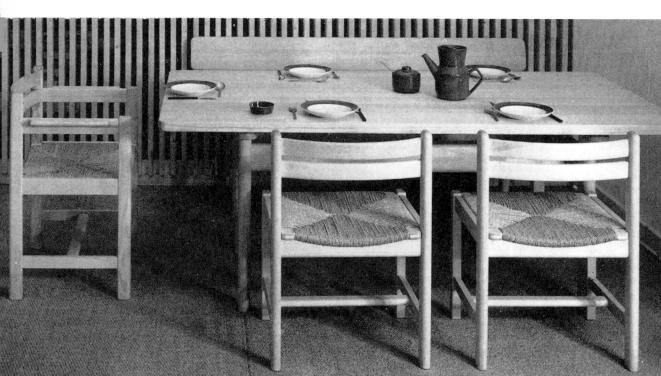

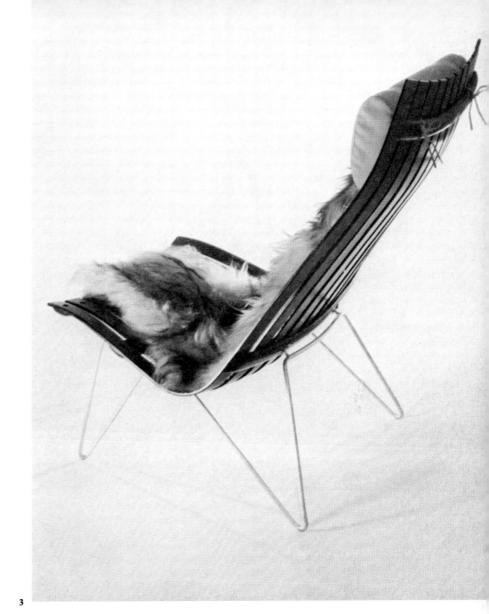

One-, two- or three-seater settee upholstered in brown/white large-check wool designed and woven by Lis Ahlmann has brown cylindrical cushions for the head and for knee support: as 'conveyors' they also facilitate sliding into the very deep seats. The hunting chairs are in light oak with back and seat in natural cow-hide. Made by Fredericia Stolefabrik A/S DENMARK

Dining table in oak or teak/oak, 62 × 32 inches, and chairs in oak and beech. Made by F. D. B. Møbler denmark

Chair and stool in light oak made by Fredericia Stolefabrik A/S DENMARK All designed by Børge Mogensen, m.a.a.

Chair in moulded palissander with dyed sheepskin cover and down-filled head pillow. Designed by Hans Brattrud for Hove Møbler NORWAY

Chair with flag-line threaded seat and back; the steel frame cast in one piece, split, moulded and chrome-plated. Designed by Poul Kjærholm for E. Kold Christensen DENMARK

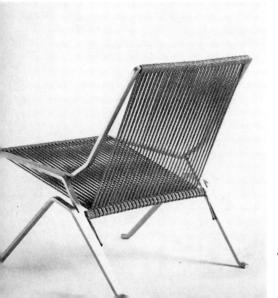

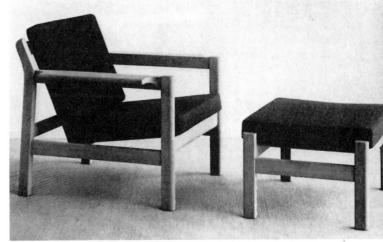

1962-63 · interiors and furniture · 221

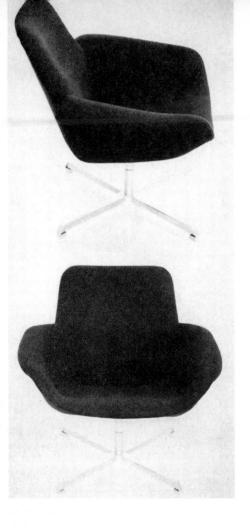

Sculptured chair of ample proportions with laminated shell upholstered in a textured wool fabric over foam padding. It is supported on chrome steel base with mechanism for rotating the seat incorporated in the pedestal.

High-back armchair and stool on chrome steel frame, foam-padded, with wool fabric cover. Both models are designed by Aulis Leinonen. Made by Askon Tehtaat O/Y FINLAND

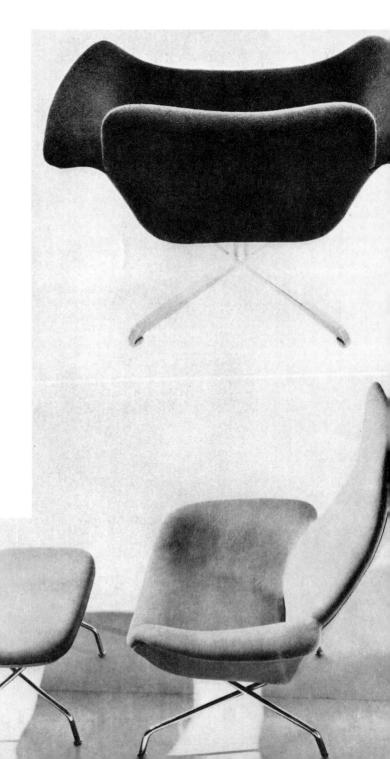

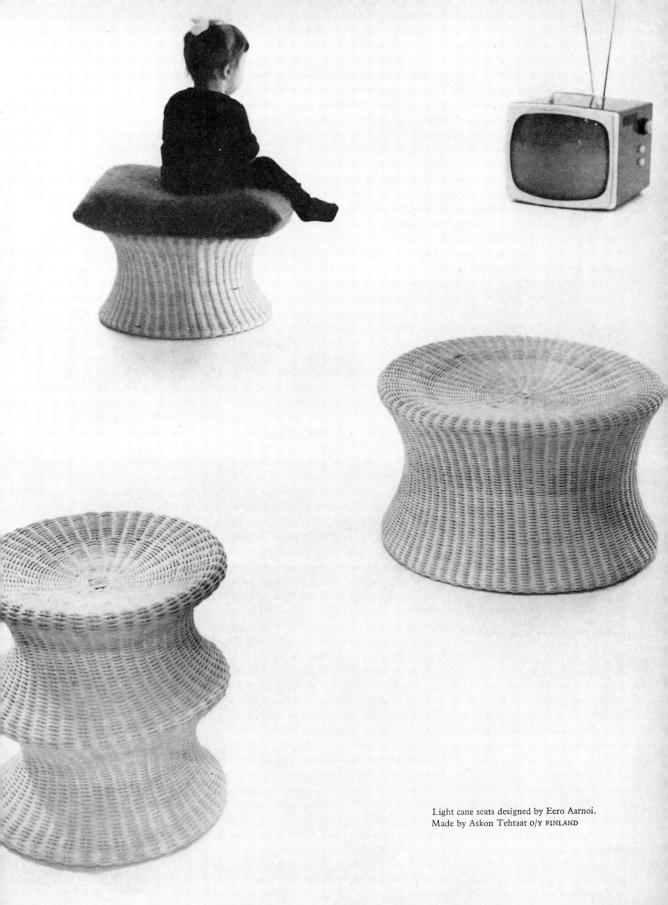

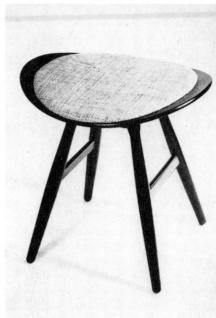

Child's bed in painted wood. With the bunks mounted on a hinged frame, it can be easily taken down and transported.

Elipse tabouret in black-lacquered birch with foam padded seat cushion.

Both are designed by Olof Ottelin for O/Y Stockmann-Orno FINLAND

A simple and easily mounted basic furnishing scheme of two- and three-drawer storage units in natural pine with black lacquered sliding front panels; steel frame moulded chair and stool upholstered in wool fabric over foam padding. Designed by Eero Aarnio for Askon Tehtaat o/y FINLAND

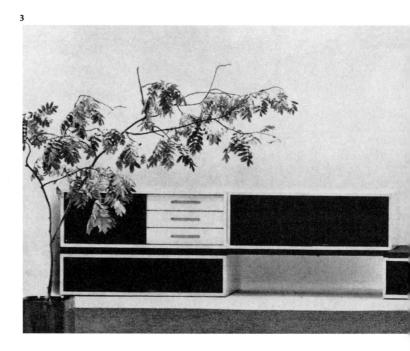

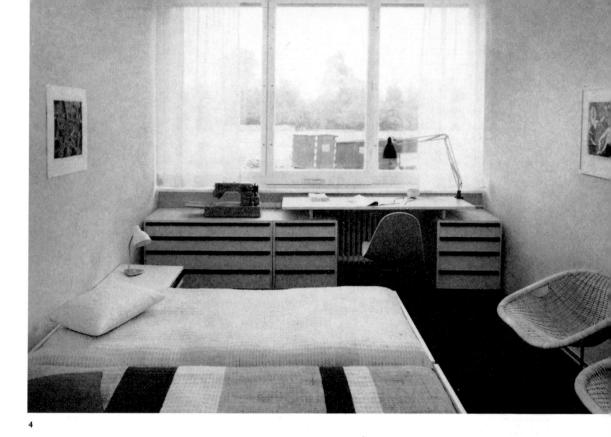

4 Double bedroom fitted with a sewing and work area at the window end. The chest units ranged along the wall are from the Freba range made by K. H. Frei, and a removable shelf placed across them makes a convenient desk. The moulded chair is designed by Hans Bellman for Strässle Söhn & Cie; the cane chairs by Wolfer & Moesch for W. Jenny AG. Interior designed by Alfred Altherr SWB SWITZERLAND

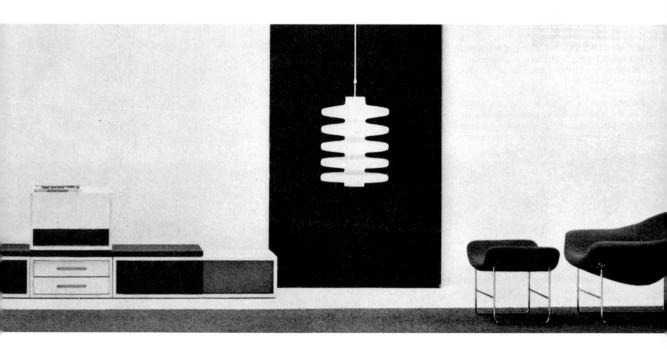

Tubular steel frame chairs with Pirelli webbing and moulded foam rubber padding. The one piece cover is in *Brynje*, a stretchable wool-nylon fabric by Unika Væv.

The chairs are designed by Pierre Paulin france for Wagemans & van Tuinen NV HOLLAND

Small three-drawer desk in imbuya. Designed by Erwin Plaut, MSIA, for Alexander Joles S. AFRICA

Metamorphose upholstered armchair on steel underframe, from a unit range comprising one, two or four seats interchangeable with one another and with table tops in white plastic.

Designed by the Al-Veka team for Kembo Meubelfabrieken NV HOLLAND

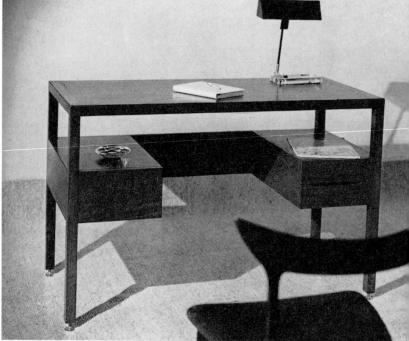

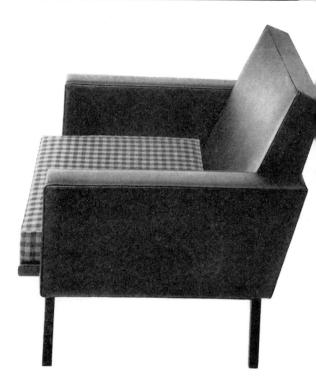

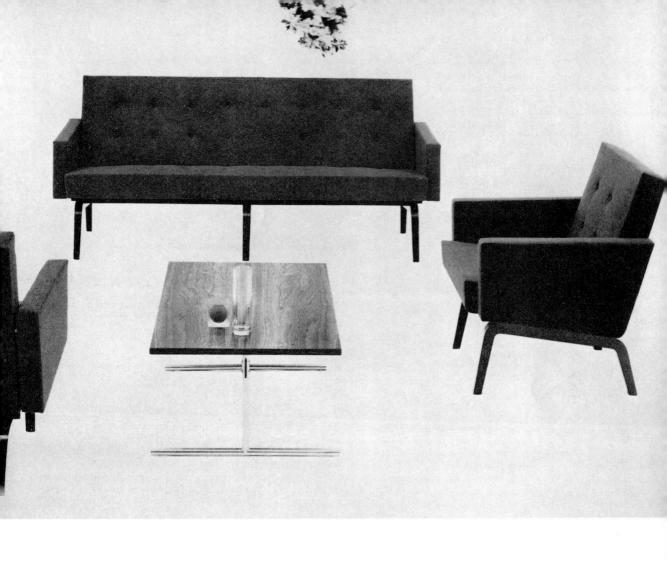

n-padded upholstered sofa and chairs (series on metal or laminated plywood legs. They are able as one-, two-, three- and four-seater units or without arm supports. Table top in jacaa on metal base. Designed by Theo Ruth.

ular steel frame group (set 416) with blacknered side pieces and jacaranda-strip seat and suspension. Foam rubber cushions Vaumollcovered. Designed by Kho Liang Le.

of these groups are made by Wagemans & Van

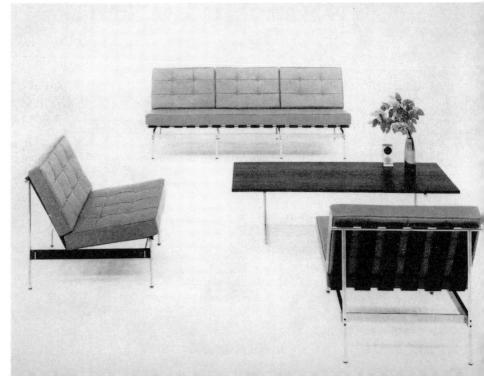

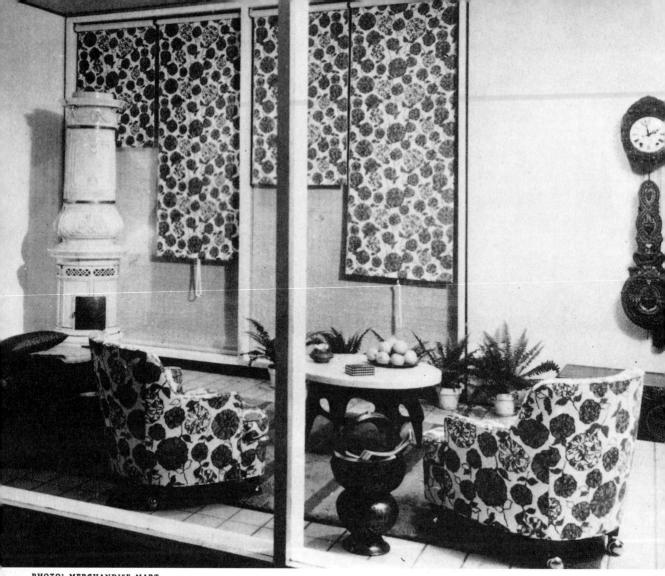

PHOTO: MERCHANDISE MART

On a bright pink rug in an area of li natural wood and within white light-toned wood-panelled walls, armchairs covered in a linen print pinks and reds on a white grou roller shades are of the same mater Armchairs, the large black least pouffe and marble-topped walnut ta all designed by Edward Wormley A setting which uses an old Austr white-enamelled stove, carved w wall clock and other antique pieces Designed by Roy Klipp of John Colby & Sons. Furniture made by Dunbar Furniture Company USA Coffee table model 2143, top of g mirror crystal 149 cm long; m underframe lacquered black. Made Fontana Arte ITALY opposite

Fireplace with chimney breast 'pleated' stainless steel Designed by Gautier-Delaye and m by Usine-Gueunon FRANCE

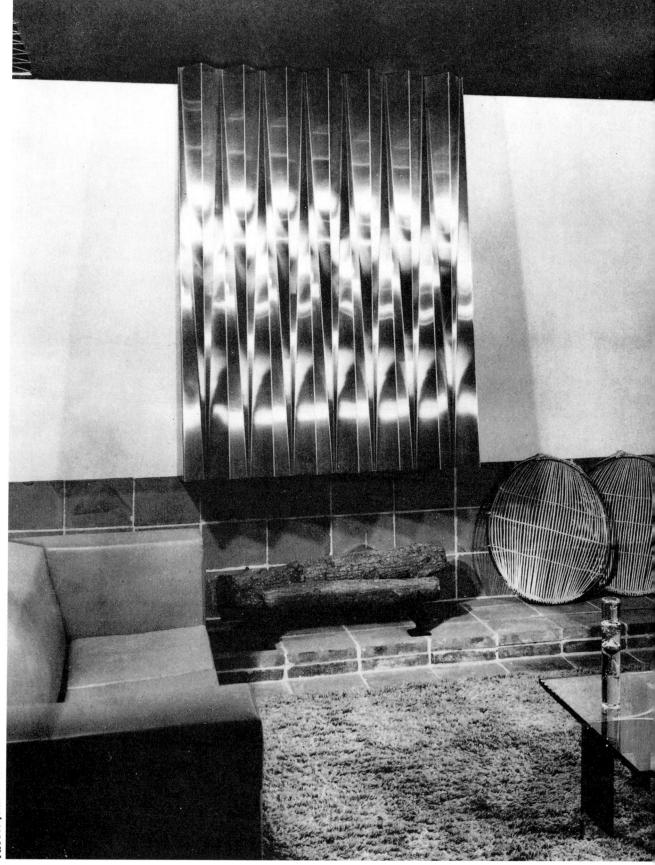

1963–64 \cdot interiors and furniture \cdot 229

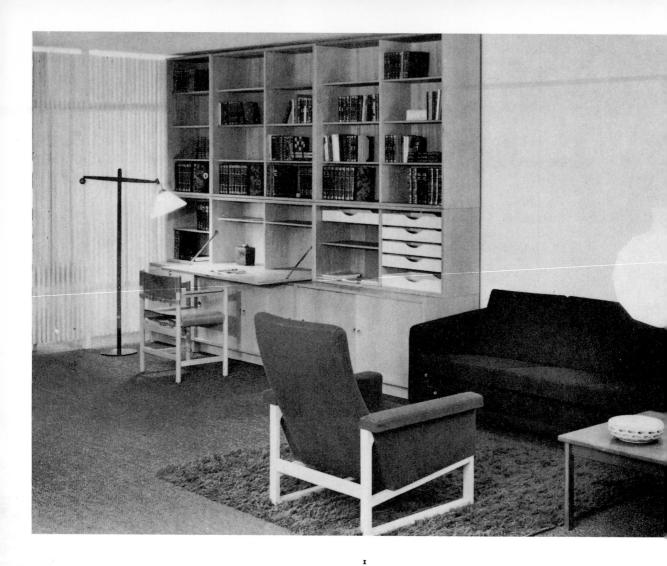

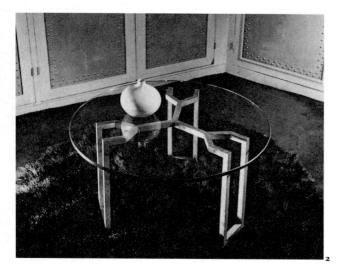

Storage fitting using a combination of units from the Öresund planned system in natural oak or teak, designed by Børge Mogensen and made by Karl Andersson & Söner sweden. The settee and armchair are made by Fredericia Stolefabrik A/S DENMARK

Glass-topped coffee table on gilt iron frame

Designed and made by Jean Royère FRANCE

3, 5 Chrome-steel dining chair with continuous back/arm rest in teak or oak and loose latex foam seat cushion

Lightweight chair with moulded shell seat on a non-swivel aluminium base; overall height 96 cm

Designed by Jan Inge Hovig

Teak table, centre section in black oxhide or black plastic alternative finishes; 79×79 cm×48 cm high Designed by Kristian Vedel 3-6 made by Fritz Hansens Eft. A/S DENMARK

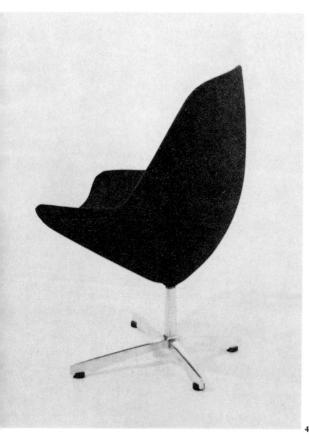

7 Fibreglass armchair on cast aluminium pedestal with moulded interior upholstery in a wide range of colours; exterior finish beige, white and light grey
Designed by Eero Saarinen
Made by Knoll Associates Inc USA

Laminated shell chair on steel tube legs; upholstered in wool fabric in a large range of colours over foam padding; overall height 73 cm

Designed by Pierre Paulin for Wagemans & van Tuinen NV HOLLAND

Circular table in the Silver Line range. Teak or rosewood top 89 cm diameter; underframe of solid teak with aluminium insert

Designed by Hvidt & Mølgaard

3 Coffee table, hand-finished teak with a 33-cm pull-out extension flap in black matt Formica. Made in two sizes, 122 and 152 cm long Designed by Jørgen Hasse

4 Highback rocking chair, oiled teak hand-finished frame with loose seat cushion; wool fabric, p.v.c. or hide upholstery

Designed by Ole Wanscher 2-4 made by C. W. France & Søn A/S DENMARK

5 Sofa SA 30 with buttoned back and seat cushions, and jacaranda coffee table on metal base

Designed by Karl Erik Ekselius Made by J. O. Carlsson SWEDEN

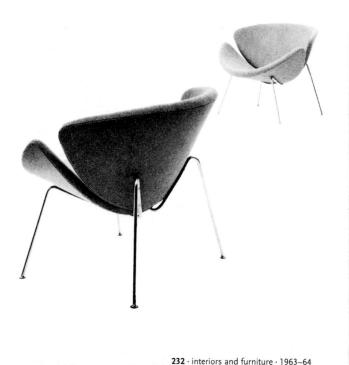

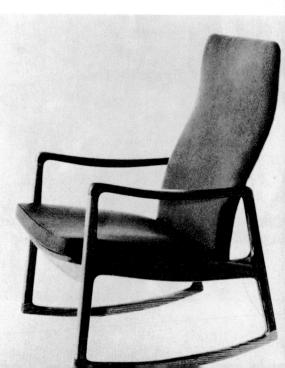

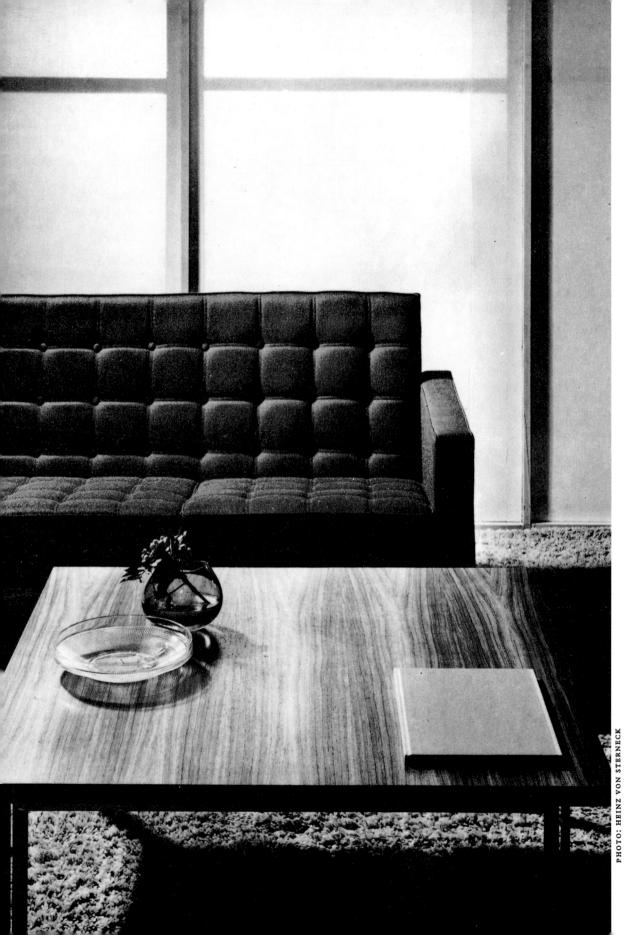

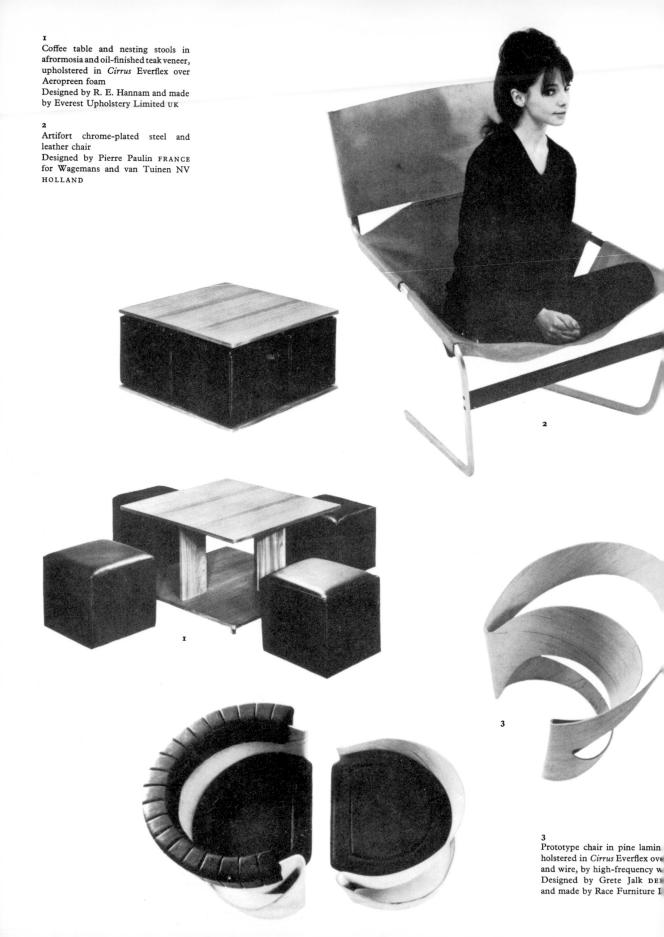

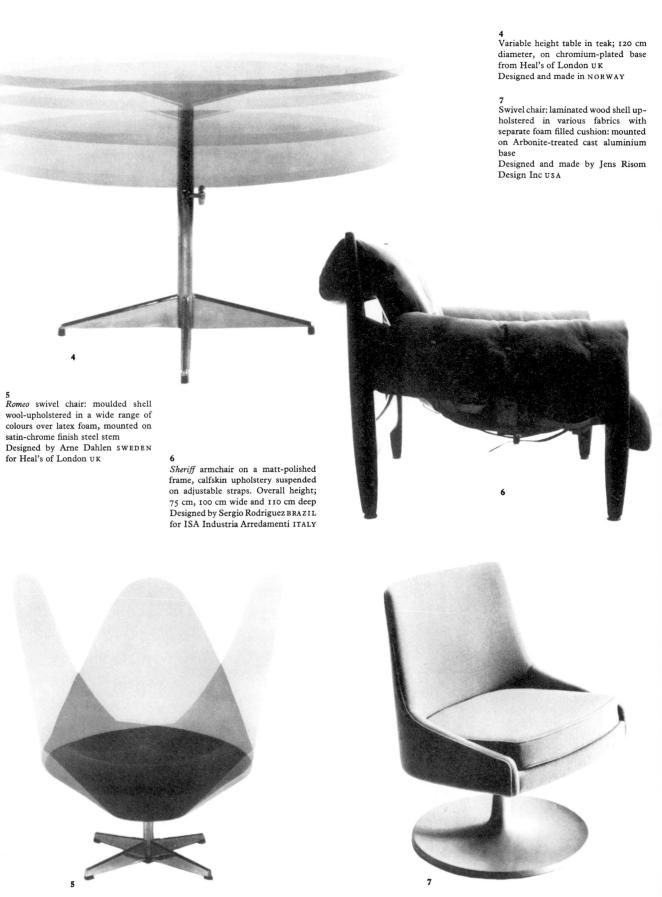

1964-65 · interiors and furniture · 235

All-in-one unit in walnut: alternatively doors can be cloth finished: overall height 190 cm

Designed and made by Mobili MIM s.p.a. ITALY

2

Bunk or single beds in square section steel tube with chromium fittings, beechwood guard rail and imitation leather panels at head and foot; 76×178 or 203 cm and 76 or 90×203 cm Designed by Frank Guille for A.F. Buckingham Ltd uk

3
International range of bedroom units using fine matt-finished cherry wood with Formica laminated plastic top surfaces. Shown here on plain carpeting by J. Crossley & Sons Ltd with a rug from Designs of Scandinavia and curtains made by Edinburgh Weavers. Unit Furniture designed by Gunther Hoffstead for Uniflex UK

PHOTO JEFFRYES

4
Bed in solid wood on steel feet with
Perlon tension support; 100×200 cm
or 90×190 cm
Designed by Ernst Kirchoff for Casa
GmbH w. Germany

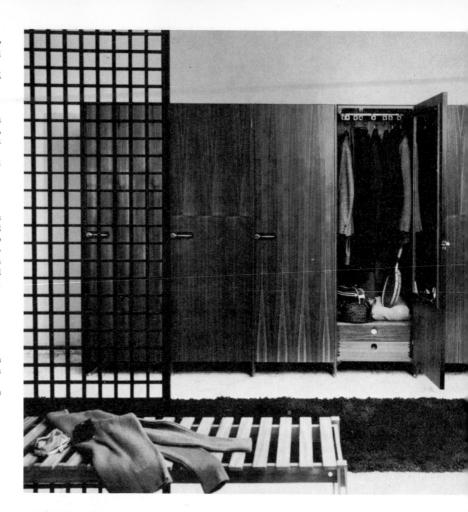

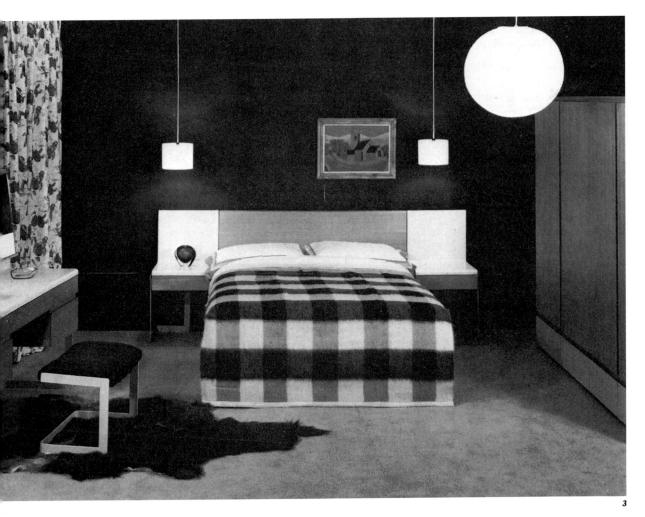

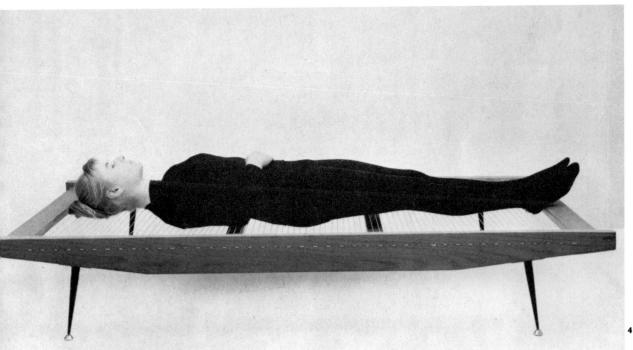

 $1964\text{--}65 \cdot interiors$ and furniture $\cdot\,\textbf{237}$

1, 2

Lower or higher table in solid teak or wenge with natural finish; top surface 154×50 cm

Designed by arch. Harald Roth for Casa GmbH w. GERMANY

3, 4
Zelda tables in walnut and palissander also with red or white lacquer finish; 80×80 cm, 26 or 54 cm high Designed by Sergio Asti and Sergio Favre for Poltronova ITALY

5
'Lady' armchair and dining-chair from the Outline range in 1-inch steel rod finished in resistant black lacquer with corduroy velvet cushions in hot pink, turquoise, curry or fir green

Designed by John Risley and made by Luger Manufacturing Corpn for Raymor USA

Stool of natural or dyed leather woven on walnut frame; 51 cm square Designed and made by Jere Osgood for America House USA

Stool in chromium-plated steel with hide seat; 58 × 42 cm, 45 cm high Designed by Esko Pajamies for J. Merivaara OY FINLAND

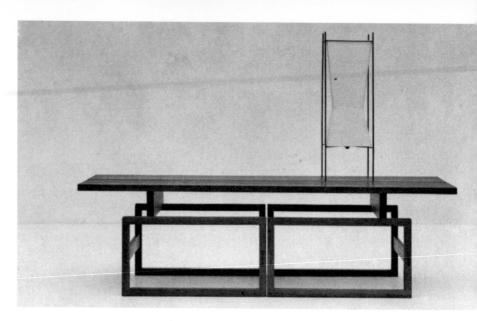

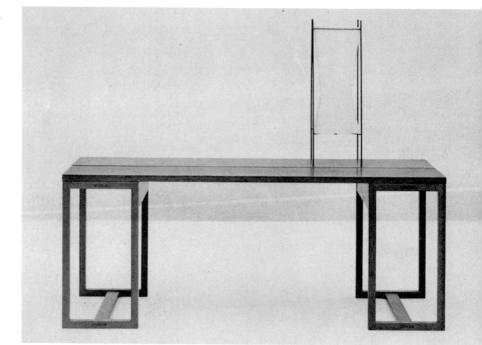

PHOTOS I, 2 WILLI MOEGLE PHOTOS 3, 4 MARI PHOTOS 7, 8 PIETINEN PHOTO 9 STRUWING

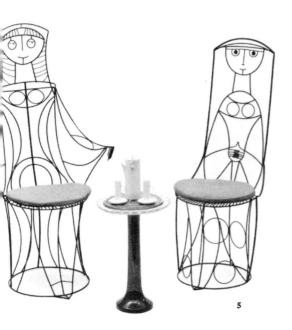

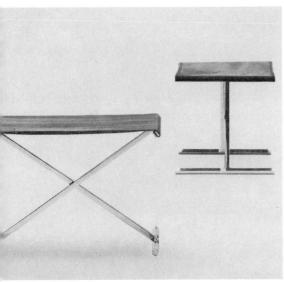

Designed by Toivo Korhonen and Esko Pajamies for J. Merivaara OY FINLAND

Q

Dining-chairs in finest Swedish Kalmar pine with natural finish

Designed by Kai Lyngfeldt Larsen arch.m.a.a. for Søborg Møbelfabrik A/S DENMARK

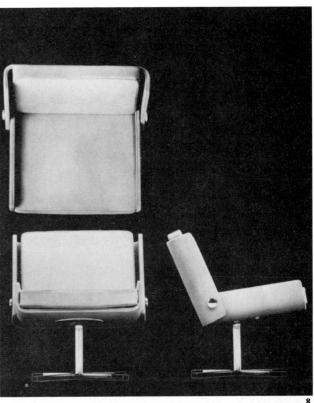

7

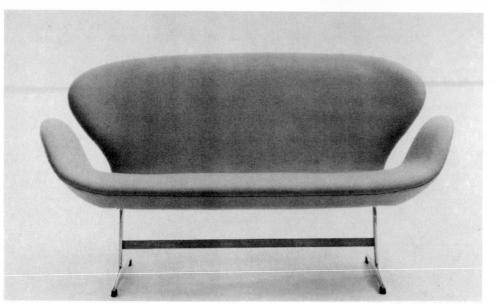

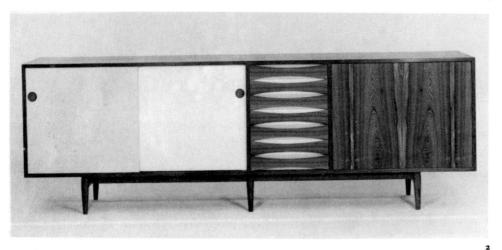

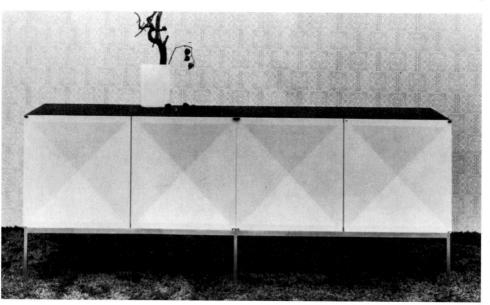

Settee from a lightweight she holstered in fabric or oxhide foam rubber on an aluminium 140×68 cm, 76 cm high Designed by Arne Jacobsen for Hansens Eft. A/S DENMARK

Sideboard in teak or palissander bined with white plastic finished 250 × 47 × 80 cm Designed by Arne Vodder for P. Sibast I/S DENMARK

Sideboard 1307 with white-lacq concave-formed doors (also ava in mahogany): lined with ahorn: feet 340 \times 52 cm, 96 cm high Designed by Antoine Fhill

FRANCE for Behr Möbelfabrik W. GERM! 4, 5

Three-legged chair in natural with seat in woven impregnated cord; 57×57 cm, 72 cm high Designed by Mogens Lassen for Hansens Eft DENMARK

6, 7 Dining-chairs in teak, upholster woollen weave Designed by Grete Jalk for P. pesens Møbelfabrik A/S DENMA

8, 9 Artifort chair No. 042, 'easel' fran

chrome-finish steel Artifort chair No. 040 in chr plated steel with rosewood strips Both chairs upholstered in Sys leather-cloth or Lisboa knitted over pre-formed shells

Designed by Geoffrey Harcoun Wagemans and van Tuinen HOLLAND

Selsdon chair with cantilevered of satin-chrome finished steel anodized aluminium: upholstere Bridge of Weir hide, in va colours

Designed by William Plunket William Plunkett Ltd UK

PHOTOS 1, 4, 5 STRUWING РНОТО 3 BUSCHE PHOTOS 8, 9 GEWEST PHOTO IO BEDFORD LEMERE

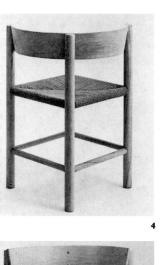

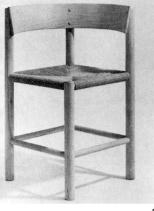

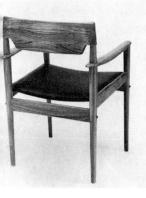

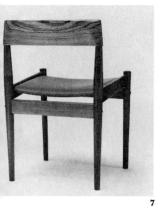

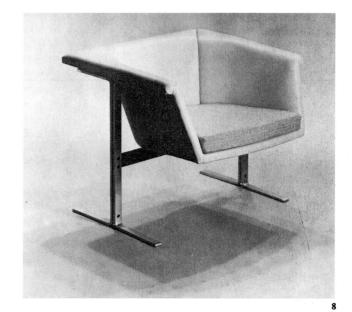

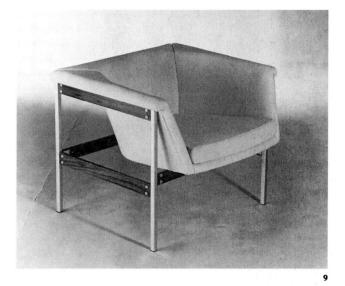

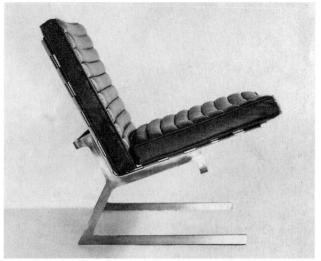

Informal folding tables and chairs, natural beech
Designed by Hans J. Wegner for Johannes Hansen DENMARK

Cot or play-pen in painted birch, white, blue, rose or yellow:

122 × 84 × 56 cm

Designed by Pirkko Stenros and made by Muuramen Huonekalutehdas O/y for Artek O/y AB FINLAND

Hobbies stand in painted ash, diameter 80 cm Designed by J. C. Colombo for G. B. Bernini & Figli ITALY

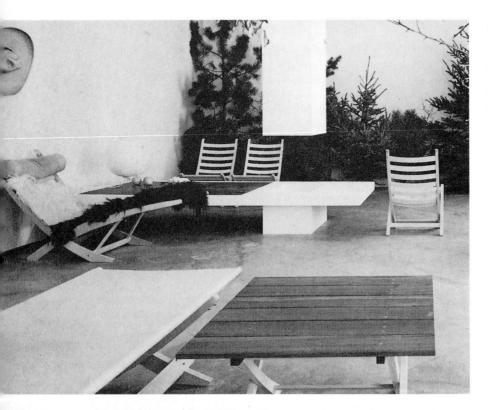

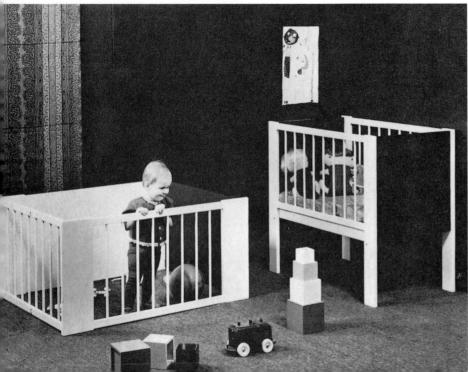

Versatile frame with attachments
Designed by Hans von Klier for
I Sestante ITALY

Shinto-ritual-inspired tea table in laminated oak veneers at bottom of page seat in natural oak worked in a traditional way (with end-section)
Both designed and made by Riki Watanabe, Q Designers Japan

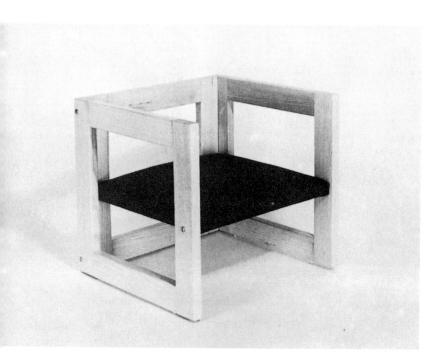

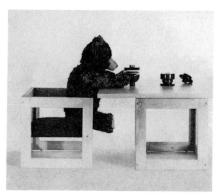

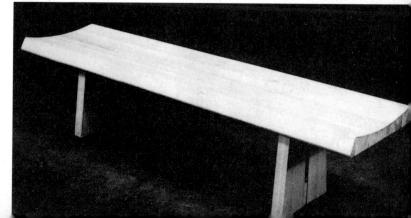

Demountable chair in aluminium and leather Made by Palini s.r.l. ITALY

Convertible settee: chrome rails, black-enamelled support frame upholstered in Den Blaa fabric Made by Design Associates UK

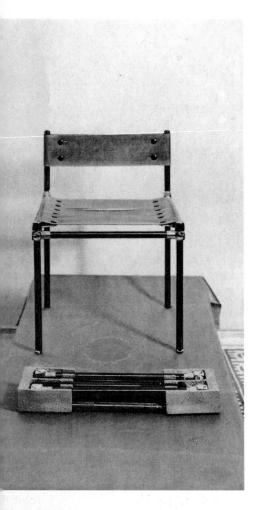

Caori Japanese-inspired low table, incorporating drawers, shelves and central hatch: wood frame lacquered red or charcoal, polished brass top Designed by Vico Magistretti ITALY

Wassily a new version of a famous model in chromium finished steel tube with coach hide in tan, dark brown or black
Designed by Marcel Breuer FRANCE
Both at Aram Designs Limited UK

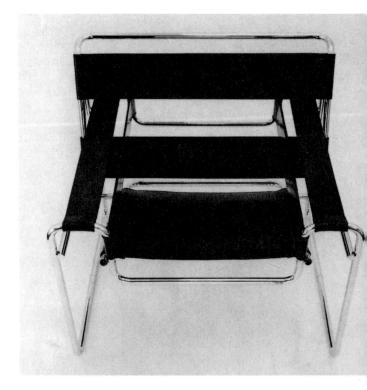

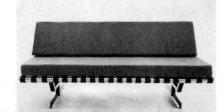

armchair of rectangular sections, ach of steel cords wrapped in foam ubber and upholstered in black Vipla leather cloth Designed by Vico Magistretti for

igli di Amedeo Cassina ITALY
Chair and ottoman, steel with steel

vire mesh
Designed by Darrell Landrum for avard Inc USA

Terry circular table, the top veneered palisander, base of polished spun aluminium or brass 41 cm high, 80 cm diameter Aram Designs Limited UK Chair TU 515 of chrome-finished oval steel tube, woven cane seat Designed by Antti Nurmesniemi for J. Merivaara O/y FINLAND

Table base of black-painted steel for a variety of circular tops, 70 cm high

Designed by Vico Magistretti for Figli di Amedeo Cassina ITALY

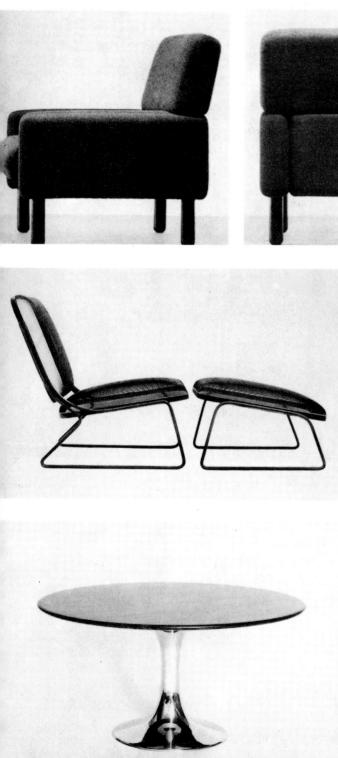

Wall units of macoré, teak, mahogany or walnut, allied to plastic foil in black, white or clear colours: overall 366×223 cm high Made by Erwin Behr Möbelfabrik W. GERMANY

Summa Wall Fix demountable units in oak, overall width of shelf 101×30 cm deep Made by Conran & Co Ltd UK Bentwood chair, cane back and seat Made by Ligna CZECHOSLOVAKIA

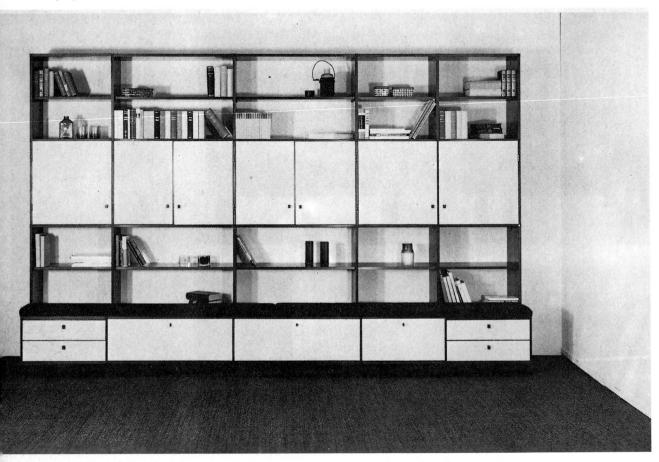

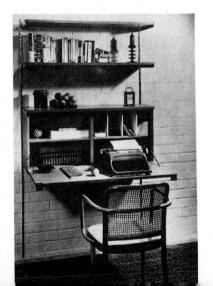

leboard B 45 in rosewood, interior maple, on legs of chrome-finished el, 248 × 55·5 × 80 cm high signed by Dieter Waeckerlin ITZERLAND for Erwin Behr jbelfabrik W. GERMANY arble-topped signed in teak,

arble-topped sideboard in teak, ormosia or rosewood 2×46×74 cm high signed by Robert Heritage for chie Shine Ltd UK

leboard (and detail) in solid hogany 183×43×70 cm high signed by G. E. Schlup for E. Schlup & Co SWITZERLAND

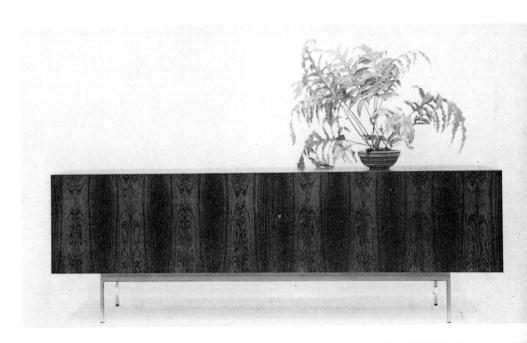

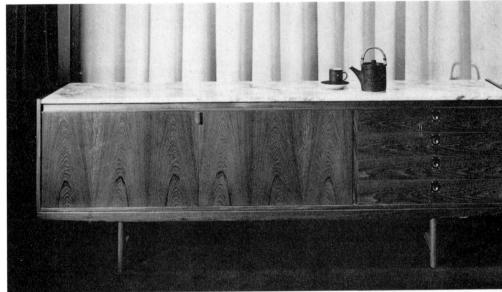

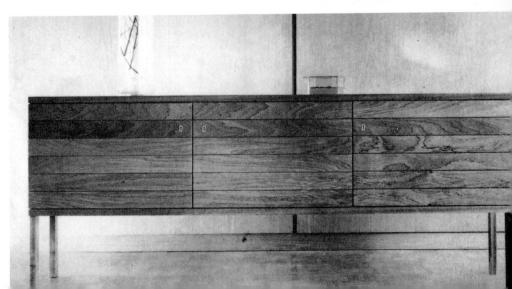

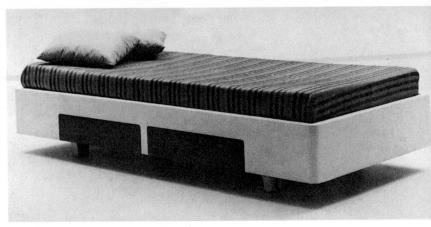

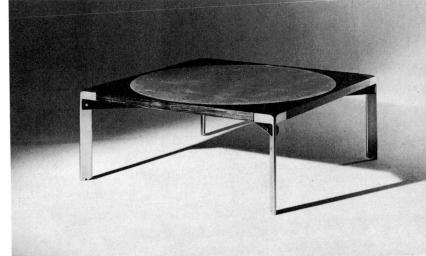

Metal framed, red lacquered cabinet and chest Designed by Carlo de Carli for Sormani 17ALY

Bed lacquered white with draw lacquered in contrast colours Designed by Cesare Casati for Arflex SpA ITALY

Card table, with baize disc, reversing to leather, set in rosewood top: aluminium fram with foldaway legs, leaving sho ones for a table 40 cm high Designed by Eugenio Gerli for Tecno SpA ITALY

photographs Clari

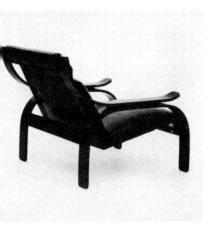

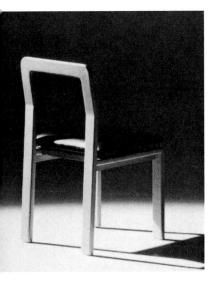

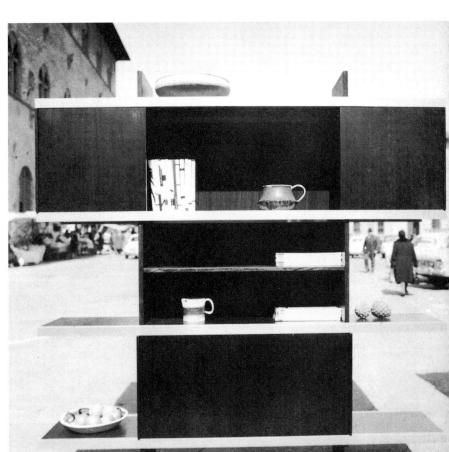

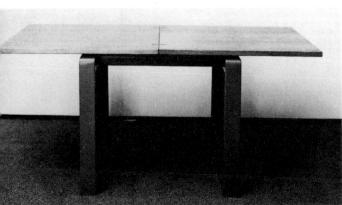

Shelf unit: ash or walnut Designed by Angelo Mangiarotti for Poltronova ITALY

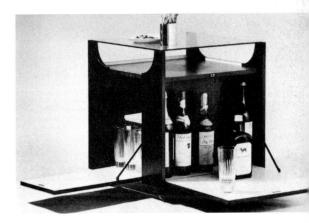

Cocktail bar/table: a cube of rosewood lined with white plastic and glass-topped Designed by Bruno Munari for Stildomus Selezione ITALY

odline chair laminated walnut, e upholstered or lacquered wood a textile igned by Marco Zanuso for ex SpA ITALY

ir and dining-table; table top of nut or palisander natural finish; nes laminated wood with black, age, green or white lacquered h: top 80 cm square, extending 60 cm long igned by Cesare Casati for ex SpA ITALY

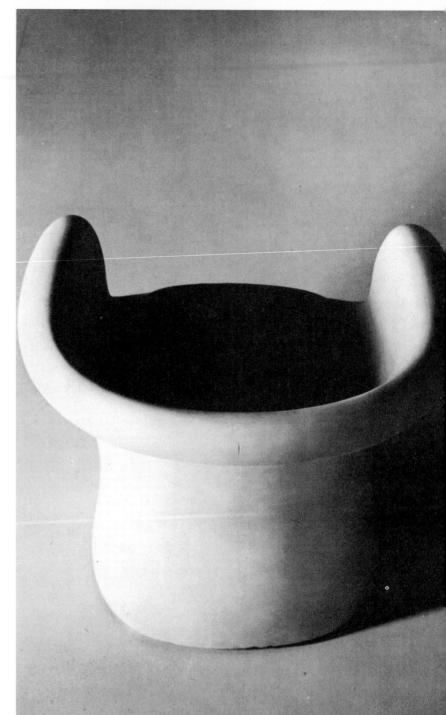

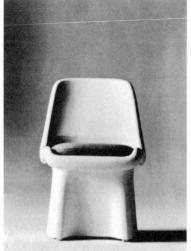

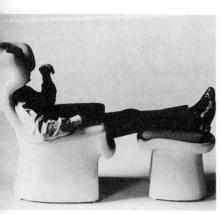

Chairs and foot stool, moulded in expanded polystyrene Unique pieces designed by Angelo Mangiarotti for Figli di Amedeo Cassina ITALY

Sofa with space in its body for bottles, glasses, books etc; foam rubber cushions suspended on rubber webbing, detachable lacquered wood frame on metal structure with integral cigarette lighter: overall length 275 cm Designed by Casati & Hybsch for Arflex SpA ITAL Y

Wall system building up to an combination of music-and-coc unit/writing desk/bookshelves natural finished walnut or palisander: each unit 184 × 80 Designed by Joe Colombo for Arflex SpA ITALY

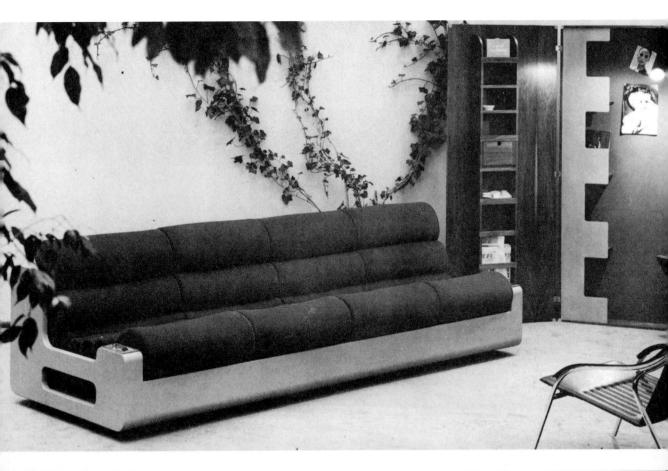

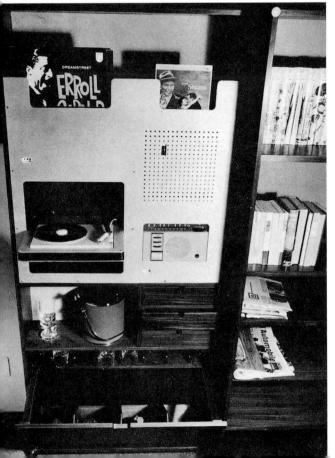

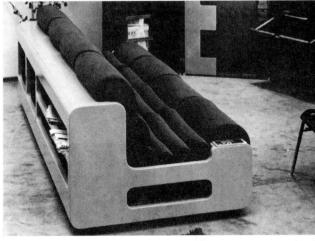

photograph d'Oliveiro

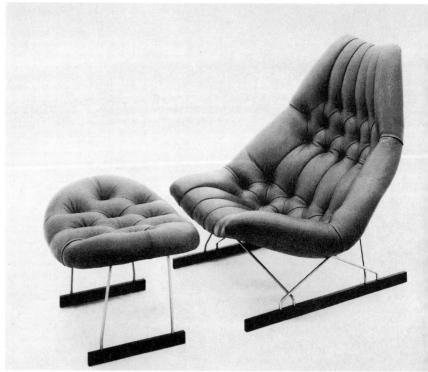

Armchair with stainless steel sleds, upholstered in dark blue wool over foam rubber. Designed and made by Dumond and Leloup FRANCE

Cousso massive chair: palisander frame upholstered in leather over latex foam. Designed by G. Van Rijk for Epeda SA BELGIUM

Folded metal frame chair upholstered in knitted fabric over foam rubber, with rubber straps: overall width 76 cm. Designed by Pierre Paulin for Artifort HOLLAND Spring upholstered settee on wooden frame, covered with black/ white weave: overall width 180 cm Designed by Kho Liang Ie

Chair and foot stool, upholstered in various coloured hide over foam rubber on a moulded shell with metal base. Designed by Geoffrey D. Harcourt Both made by Artifort HOLLAND

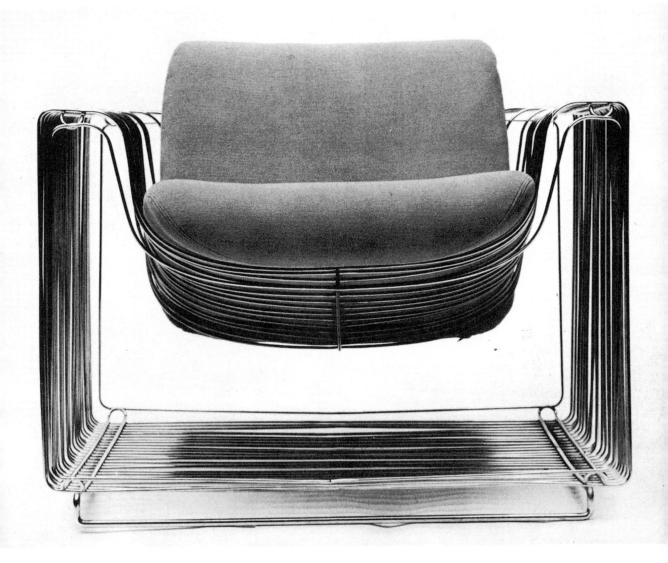

ctrac cage-for-comfort from ome steel wires suspending ex foam interchangeable hions

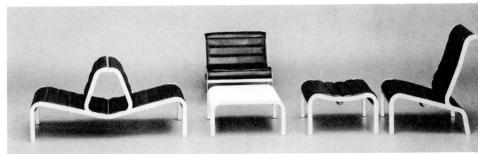

Chairs and ottomans with foamsection upholstery on square section steel frames; the table in pressed wood All designed by Olivier Mourgue for Airborne International FRANCE

photographs Berdoy

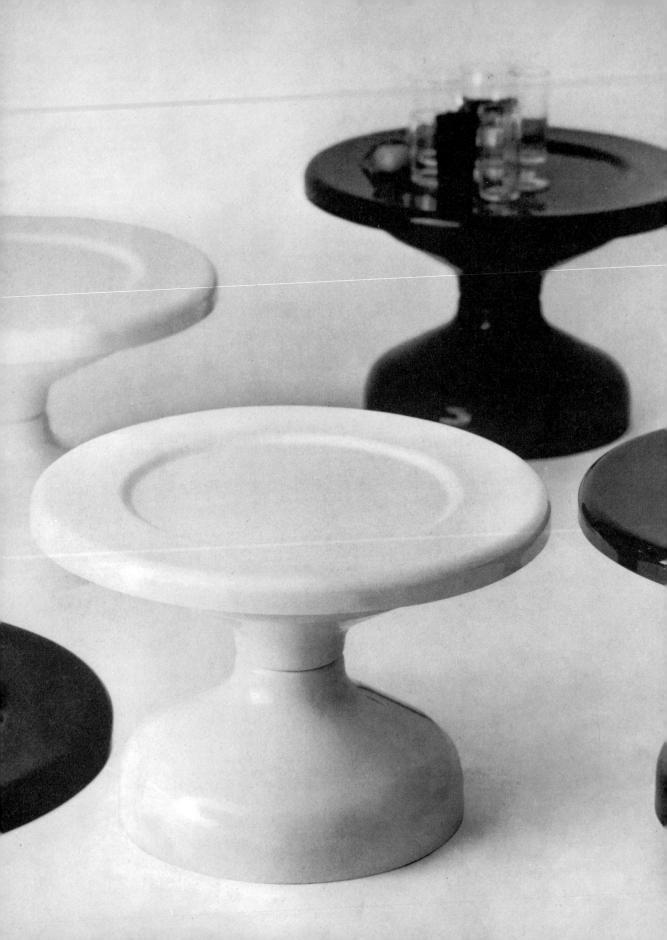

able in polyester resin, white, je, bordeaux or green, 60 cm eter × 38 cm high ned by archs. A. & P. G. Castiglioni artell s.r.l. *Italy*

e chair, swivelling glass fibre shell Istered with polyfoam padded with Dacron ons, red, orange, black or white n diameter ×120 cm overall height ned by Eero Aarnio for Asko Oy nd

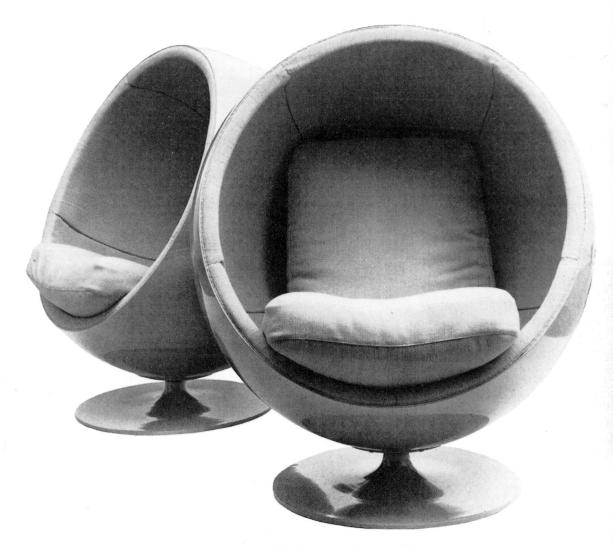

 $1967\text{--}68 \cdot interiors$ and furniture $\cdot\,\textbf{255}$

Springtime demountable chairs, two-seater sofa and square or rectangular table, solid plywood lacquered red, black or white with matching or contrast cushions, based on 65 or 104×75 cm seat unit: right, details Designed by Marco Zanuso for Arflex s.p.a. Italy

Storage-wall: details of television compartment and disc shelving: to the right, the wall closed Designed by Raphaël *France*

centre
922 armchair, wood frame upholstered
in fabric, leather or simulated
leather over foam rubber: series
includes two- or three-seater settee
Designed by Vico Magistretti for
Figli di Amedeo Cassina Italy

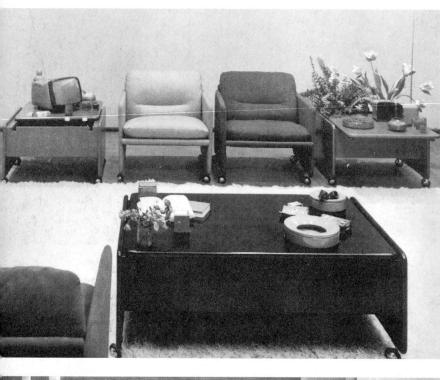

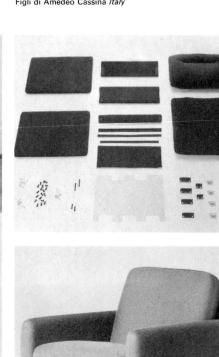

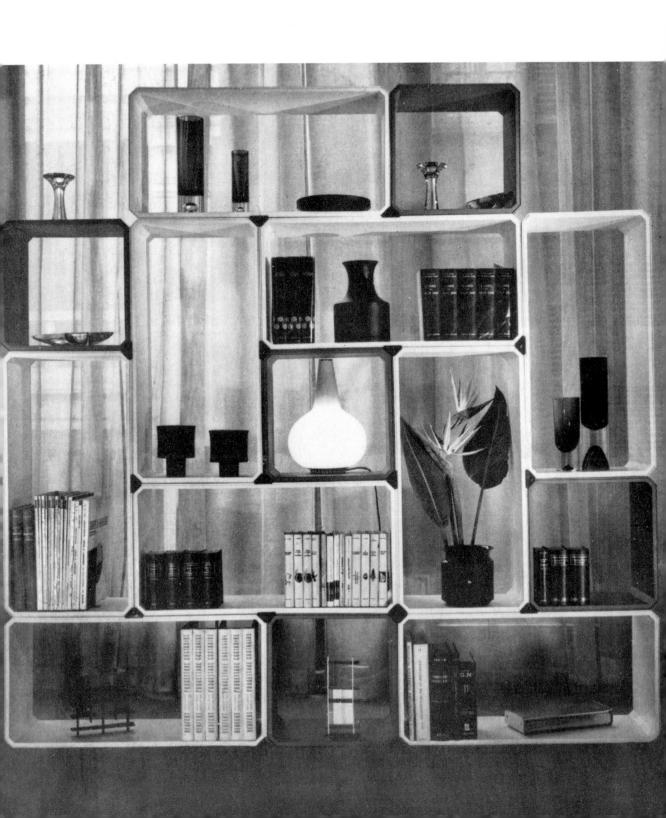

London Combination corner chair 632 which with chairs 630 right and the higher 631 can be utilised in many formal arrangements, moulded-foam on laminated wood and solid timber, suspended on special chromed cast-iron link-frames or as single units Designed by Geoffrey D. Harcourt for Artifort Holland

4700 chair, natural beech with adjustable tilt back: there is a matching side-table and a round occasional table in the series Designed by Arne Jacobsen m.a.a. for Fritz Hansen *Denmark*

centre

Cloisonacc sound-reducing, dividing screen, felt-lined corrugated card in many colours with self or contrasting linings, 165–300 cm high × 30 extending to 150 cm Designed by Pierre Blyweert and made by Usines de Graux/Slosse Belgium

Amersham chair, natural beech with utile seat designed by Børge Mogensen m.a.a. (Denmark) for Finmar Ltd England

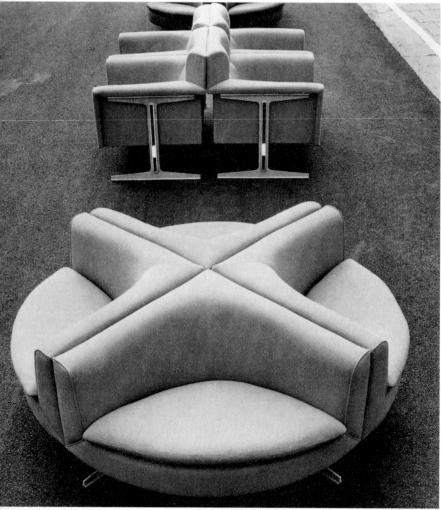

series chairs, stools and stands nated beech, lacquered red, white ue gned by Verner Panton and made sebruder Thonet AG W. Germany

a lounge chair of laminated birch, uspended seat upholstered in er over foam rubber layer, vinyl-red hand-rests, overall height 79 cm gned by Ilmari Lappalainen for Oy Finland

780/784 low and high backed chairs, tubular frame, upholstered in foam rubber and knitted fabric, on iron base

Designed by Pierre Paulin for Artifort Holland

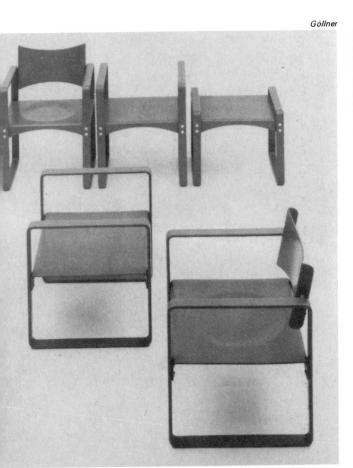

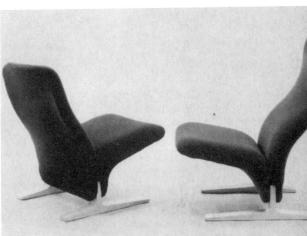

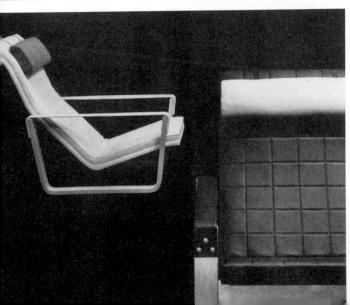

Bent plywood chair with steel spring suspension upholstered in leather over foam rubber Designed by Joe C. Colombo for Comfort di Milano *Italy*

Canada armchair in laminated wood, natural walnut or palisander finish or lacquered white, red or black with hide or plaid woven upholstery Designed by A. O. Borsani for Tecno s.p.a. Italy

Simone three-seater, fibre-glass frame upholstered in black hide, the body accommodating radio, stereophonic controls, cigarette case with lighter and ashtray and a compartment for beer bottles: the whole being mounted on wheels

Designed by Cesare Casati and Enzo Hybsch for Comfort di Milano *Italy*

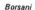

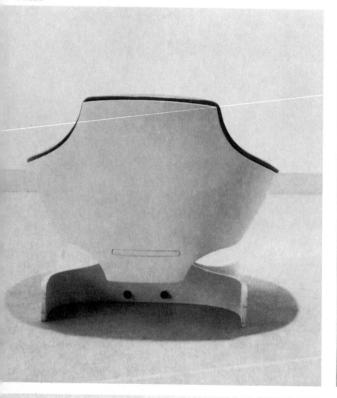

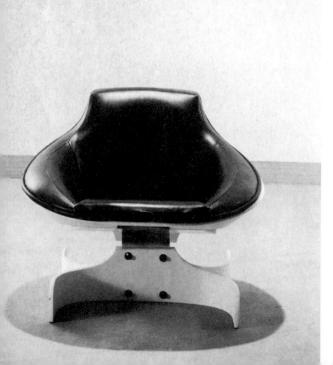

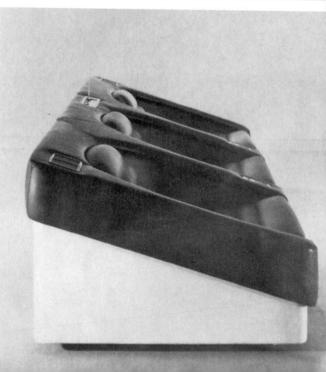

Centro bookcases, subdued palisander 78 cm square × variable height (here 210 and 110 cm) Designed by arch Claudio Salocchi for Sormani s.r.l. Italy

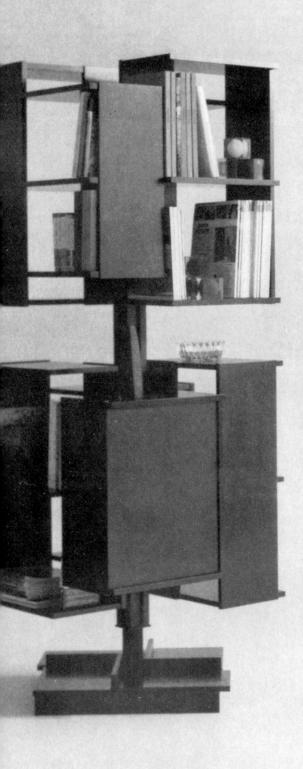

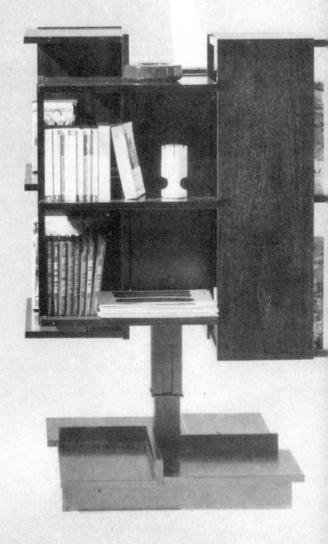

Demetrio 70 tables of reinforced resin surfaced with Riformite in white, red or black, $70 \times 70 \times 30$ cm high: a smaller version $45 \times 45 \times 23$ cm high can be paired as shown Designed by Vico Magistretti for Studio Artemide /taly

Table in polyester resin, white, orange, bordeaux, grey, black, with or without adjustable stainless steel supports, 120 cm diameter

Designed by archs. Anna Castelli and J. Gardella for Kartell s.r.l. *Italy*

Telephone drum-table in red, white or black plastic
Designed by Emma Schweinberger and made by Studio Artemide *Italy*

Magazine, book and record stand, each having three elements of black or red enamelled steel, $30\times30\times30$ cm overall

Designed by Enzo Mari and made by B. Danese Italy

elf unit in polyester resin, ite, red, green, blue or black cm wide × 30 cm deep signed by arch. M. Siard for tell s.r.l. *Italy*

ow and seen on title pages nchairs in laminated wood with cial varnishes white, orange, en or black, overall height cm: available also with PVC-reed back and seat cushions signed by Joe C. Colombo for tell s.r.l. /taly

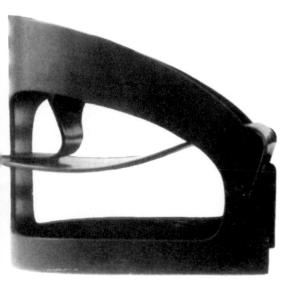

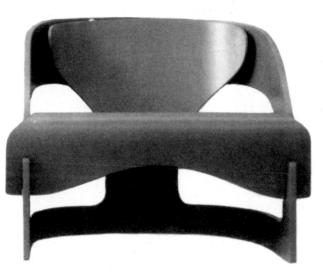

Deep-storage fitment in black-stained beech, $91\times182\times243$ cm high: the twin horizontals accommodate strip lighting Designed and made for Timothy Rendle *England*

 $\begin{tabular}{ll} $Quartetto$ demountable table, besla \\ stone and chrome-steel 1 m square <math>\times$ 40 cm high \\ Designed by Bruno Morassutti and made by Bernini Italy

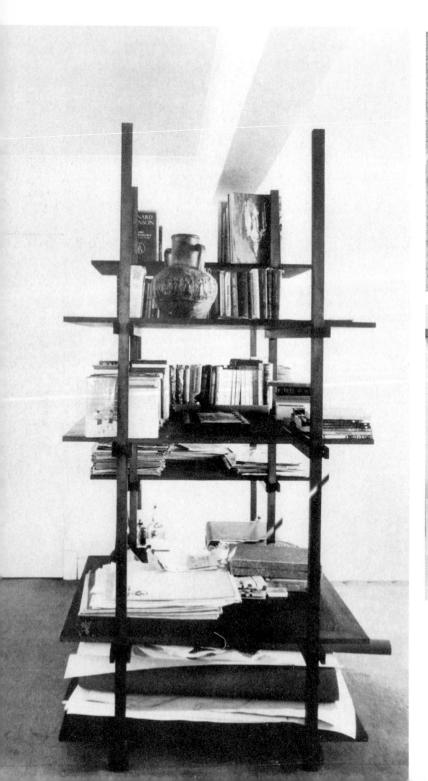

O series: part of a related range in id and bent plywood walnut, lisander or elm, the upholstered items th Arciflex and Dacron-filled shions, covered leather, simulated ther or fabric: tables (basic unit size) -5 × 72 ·5 × 39 cm high signed by Afra and Tobia Scarpa for all id Amedeo Cassina Italy

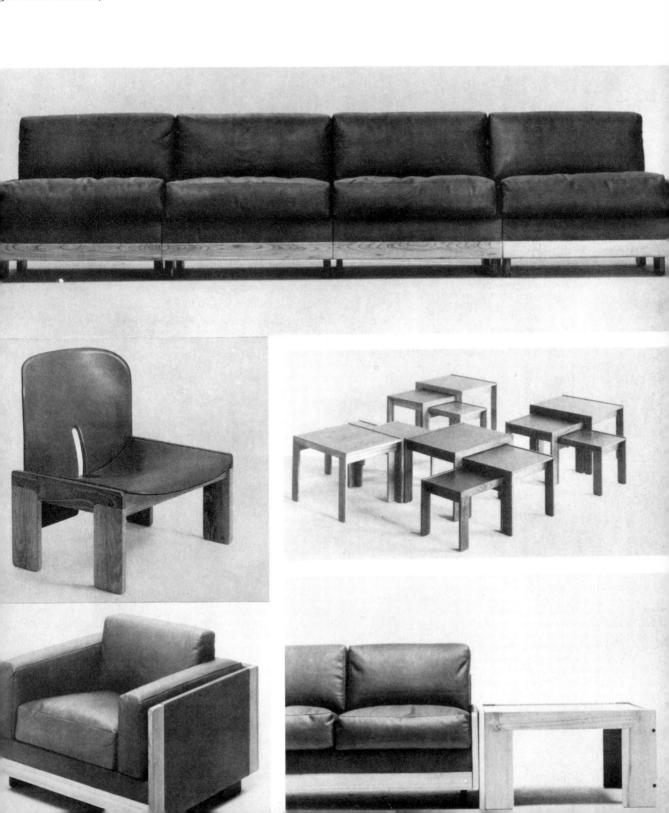

A single block mini-kitchen on wheels: the polished or lacquered wooden cube houses oven, spit and grill, refrigerator, space for 6 place settings of tableware, cutlery and glasses, for cooking equipment and recipe books Designed by Joe C. Colombo for Boffi Italy

Golf Club 1002 sofa, chair, table and stool based on wooden box-shapes with separate wool-filled leather-covered cushions, all pieces moving on wheels Designed by Joe C. Colombo for Comfort Italy

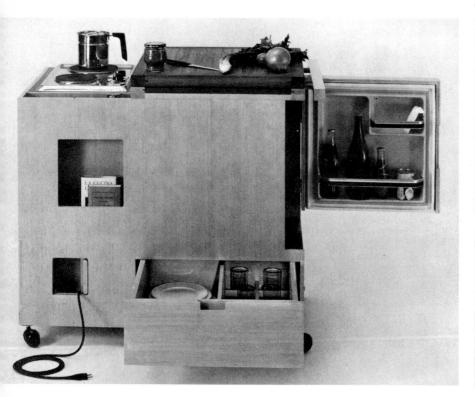

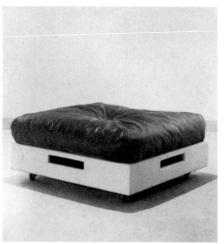

 $\textbf{266} \cdot \text{interiors}$ and furniture $\cdot~1967{-}68$

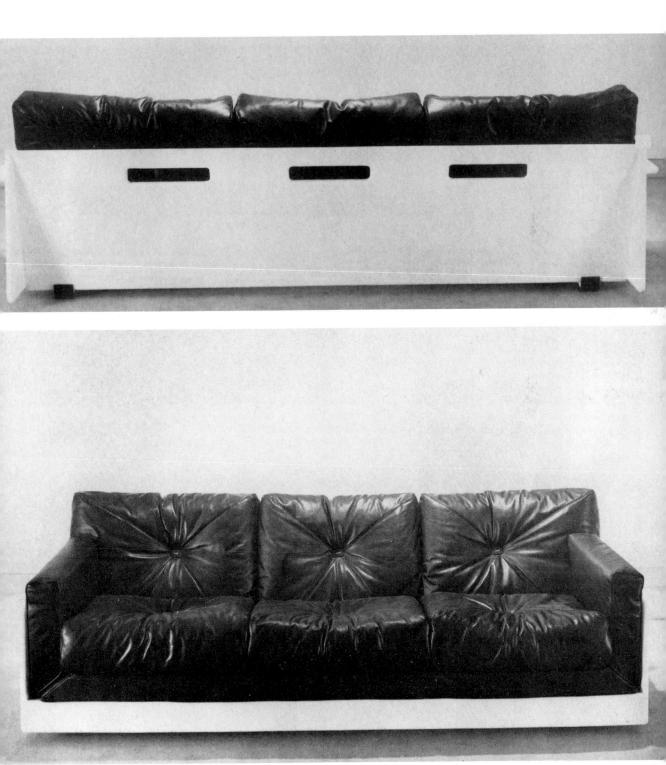

1967–68 \cdot interiors and furniture \cdot 267

989 sofa, foam-rubber-covered frame with down and Diolen fleece-filled seat cushions, loose back and arm cushions natural hide and to order in other colours or materials $257\times77\times94$ cm Designed by Edelhard Harlis for Hans Kaufeld W. Germany

Sofa, beech-framed with ply panels, polyether squabs and Terylene fleece-filled cushions, covered hide or fabric, 190 x 71 x 84 cm
Designed by David Pye for Greaves 8
Thomas England

Schmölz-Hoth

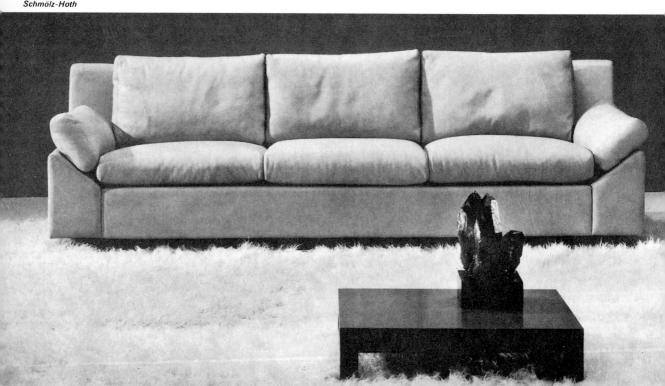

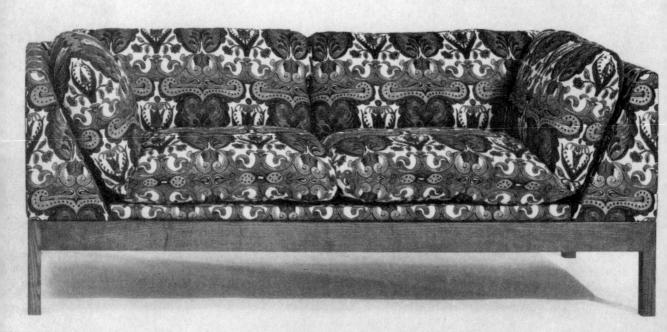

meleontti wood-framed sofa with Nosprings, Dacron-filled cushions vered black/white Mari fabric, natural le or other fabrics 180 × 80 × 65 cm signed by Torsten Laakso and made Oy Skanno AB Finland

ro sofa and chairs upholstered
th polyether and foam rubber over
sag springs, the glass-topped
ble with chrome-plated steel frame
signed by Lindau/Lindekrantz for
glund & Søner Sweden

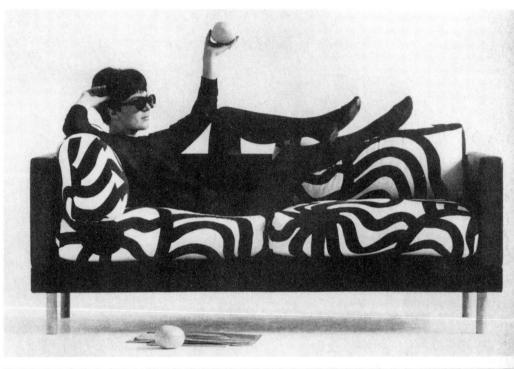

bottom
Tomotom chairs and table, part of a range of dining, playroom and nursery furniture, tough chipboard lacquered vivid red, blue, yellow, green, purple, black or white with matching or contrasting PVC-covered cushions Designed by Bernard Holdaway and made by Hull Traders Ltd *England*

Selsdon table and Coulsdon chair mild steel frames, chromed or dark grey nylon coated, with plate glass: chairs upholstered in polyfoam over rubber webbing Designed and made by William Plunkett Ltd England

Pann seagrass stool for indoor or outdoor use, with a bright felt cushion Designed by Mirja Panula for Velsa Oy Finland

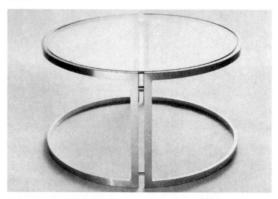

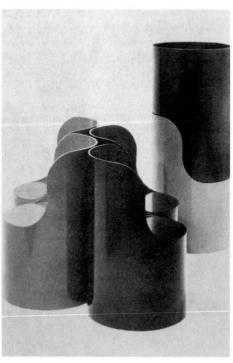

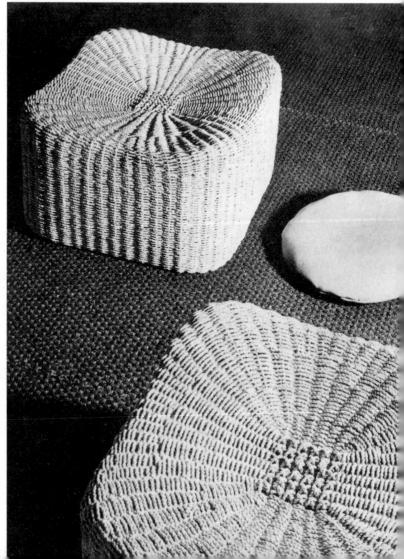

puble rocker in lacquered plywood, holstered wool fabric over lyether chip foam: for outdoor le PVC covered upholstery over a less-fibre frame prototype designed and made by avid Goodship England

sembly of three basic units, sholstered on wooden frame with rings and polyether foam and bric covered Latex foam cushions signed by N. K. Hislop and Gibson for Gimson & Slater Ltd gland

Experimental garden furniture, bright-lacquered iron Designed and made by arch. Otto Rottmayer *Czechoslovakia*

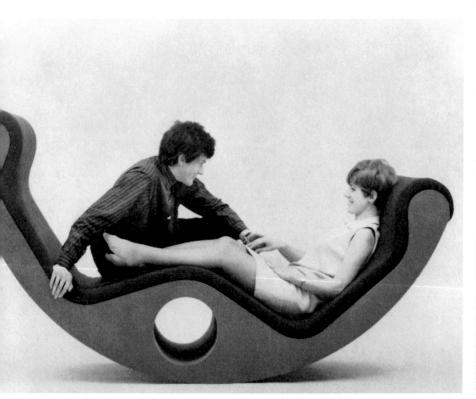

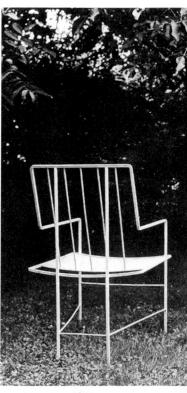

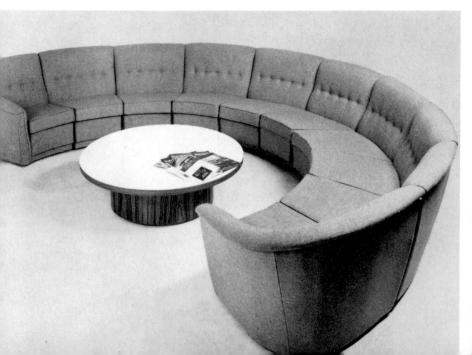

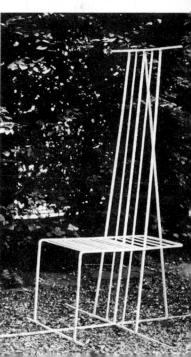

Fluoro Gelogia Psichedelica, wardrobe for an environment from a series of studies in Print laminated plastic Designed by Ettore Sottsass jr for Poltronova Italy

Chest in wengé with white glossy panels $150\times76\times50$ cm deep. Designed and made by Ico and Luisa Parisi Italy

1, 2
Cini Boeri one- or two-seater element from
flexible polyurethane foams, the base protected
by tough resinous net
Designed by Cini Boeri
Gaia armchairs, fibre glass/polyester resin

moulded with constant-thickness walls form agreeable with or without light cushioning: white, red, mustard, dark gi $80 \times 80 \times 70$ cm high Designed by Carlo Bartoli Both for Arflex SpA *Italy*

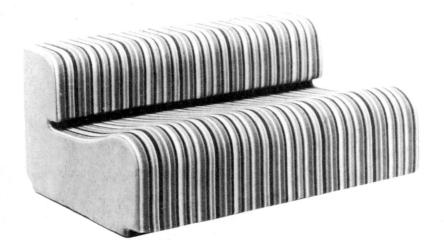

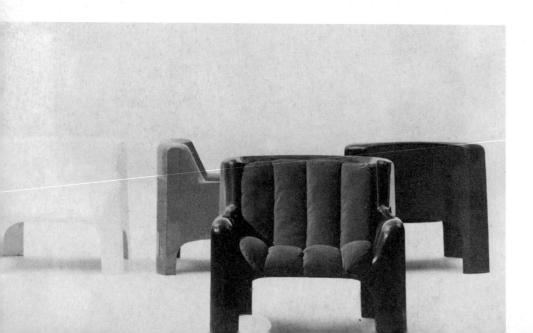

3, 4
Occasional table and bed in polyester resin, the table, black or white, designed by Anna
Castelli: the bed white, orange, bordeaux, green, sky blue. Designed by M. Siard
Both made by Kartell s.r.l. /taly

5 RZ 62 chair, glass fibre/polyester resin shell, grey or matt black with down-filled cushions covered hide or fabric: a settee is built from chair units

Designed by Dieter Rams for Vitsøe & Zapf W. Germany

b

Elisse suspended sideboard, lacquered wood
and plastic laminates with drawer fronts in
anodized aluminium: 75 cm wide overall
Designed by Claudio Salocchi for Sormani SpA
Italy

Chair, stool (also table), anodized solid aluminium frames upholstered over foam rubber with toning fabric, off-white/grey/Lurex, specially woven by Unika Vaev, or custom choice Designed by Grete Jalk for Fritz Hansens Eft

bottom row, left to right Stainless tubular steel upholstered with woollen weave over foam rubber, 70 cm high Designed by H. Verelst for Novalux Belgium

Tubular stainless steel chair with bright sailcloth or natural or black hide seat and back 85 cm high

Designed by Herbert Jutzi for Baumann/Schindler Switzerland

Habitat dining chair, reinforced plastic shell fabric covered on bright-chromed steel tube frame Designed by Dudas Kuypers Rowan Ltd for Interiors International Ltd Canada

Tiered table, 1267 white lacquered be chrome steel swivel base, 50 × 50 cm Designed by arch. Giebisch Cocktail cabinet/table 1236, pre-form plywood lacquered light grey, white c 50 × 50 cm Designed by arch Laprell Both made by W. W. Interart W. Germ

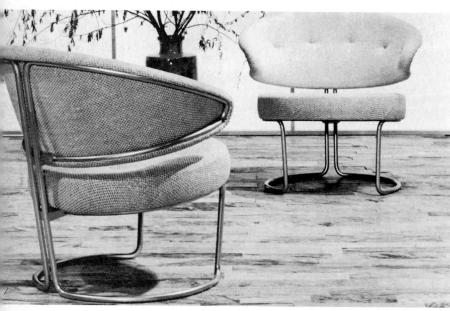

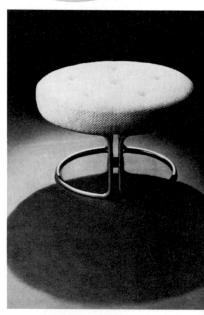

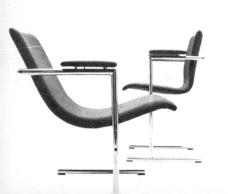

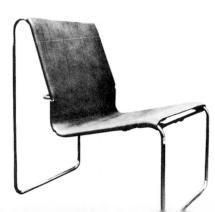

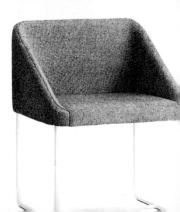

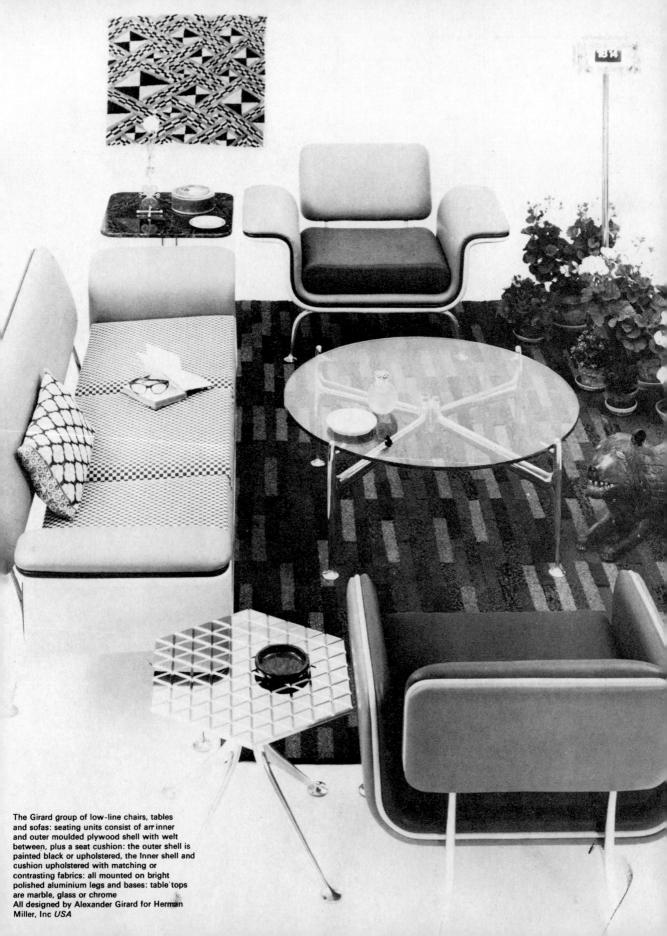

1-3

Stool and chairs: tubular frames upholstered with Unika Vaer *Ellipse* over elasticized webbing and polyether foam, respectively 62, 130, 90 cm deep \times 61 \times 60 cm: the high-backed version (also available with long seat) 91 cm high Designed by Verner Panton for Storz and Palmer *W. Germany*

4

Floor Seat 577, tubular frame and foam rubber upholstered with woollen stretch fabric, $90 \times 85 \times 61$ cm high

Designed by Pierre Paulin for Artifort Holland

5

Chepa steel tube framed chair upholstered with elasticized fabric over foam rubber: 63 cm high \times 80 \times 80 cm

Designed by G. Vanrijk for Beaufort Belgium

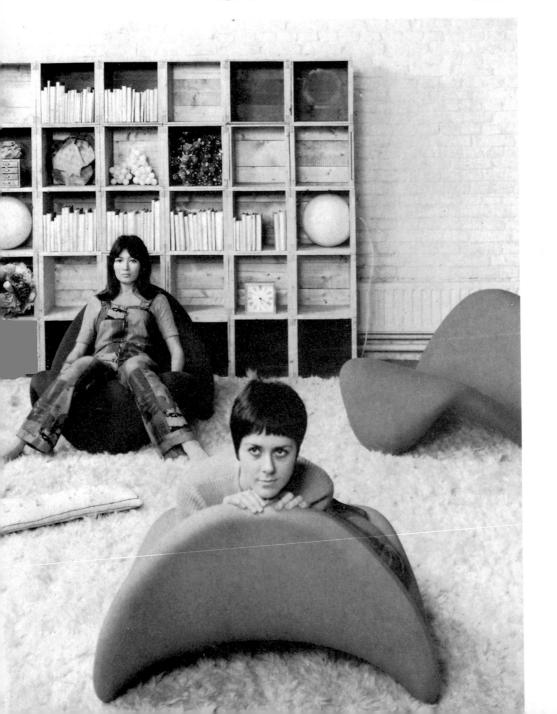

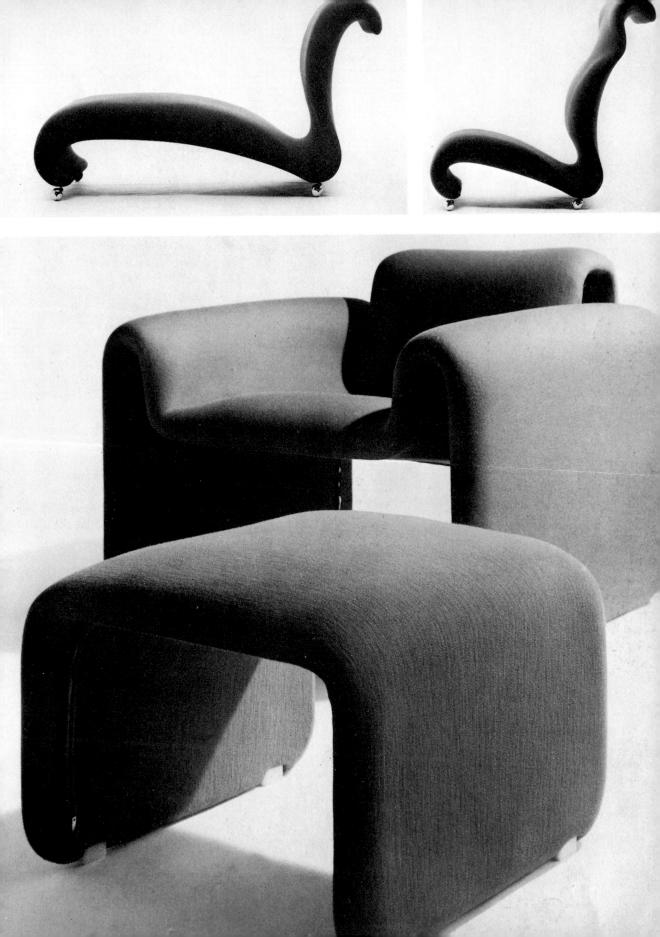

Hammock chair 24, cane-wrapped stainless steel, with adjustable cushion: 155 cm overall length

Designed by Poul Kjaerholm for E. Kold Christensen A/S *Denmark*

RL.1 chair woven hide seat and back on satin anodized aluminium or stainless steel frame Designed by Ross Littell *Denmark* for I C F de Padova *Italy*

1 3 5 6 2 4 7 8 3, 4 Slimline desk, walnut or rosewood 63.5×132 cm high folding to 15.5 cm deep Designed by Vladimir Kagan for Kagan-Dreyfuss, Inc USA

5. 6

Carlotta Young Play KD chair, beech with gloss aniline finish in okapi, colibri, acapulco, safari, bengali or siviglia: polyurethane-filled cushions have specially designed covers: 88 cm wide Designed by Afra and Tobia Scarpa for Figli di Amedeo Cassina Italy

7

Assymetric chair, ash with back rests lacquered 13 shades of blue/green Designed by Peter Karpf, made by Willy Beck Denmark

R

8
Easy chair and stool in the Habitat group
(see also page 76) from rotational cast linear
polyethylene, shell covered with a thin layer
of foam rubber and upholstered: hide, fabric or
synthetic covered cushion
For outdoor use, shells are left uncovered
Designed by Dudas Kuypers Rowan Ltd for
Interiors International Ltd Canada

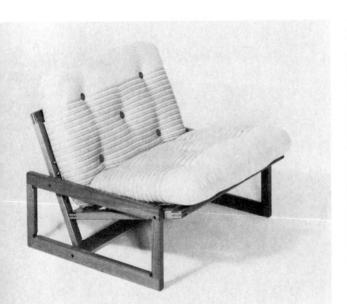

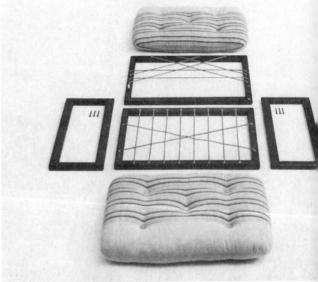

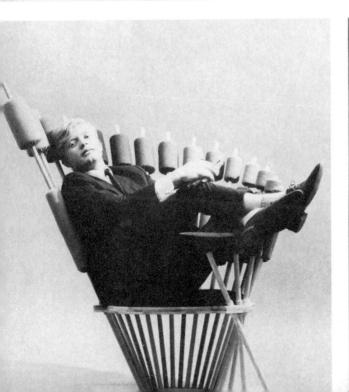

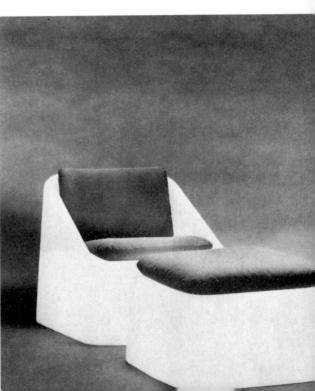

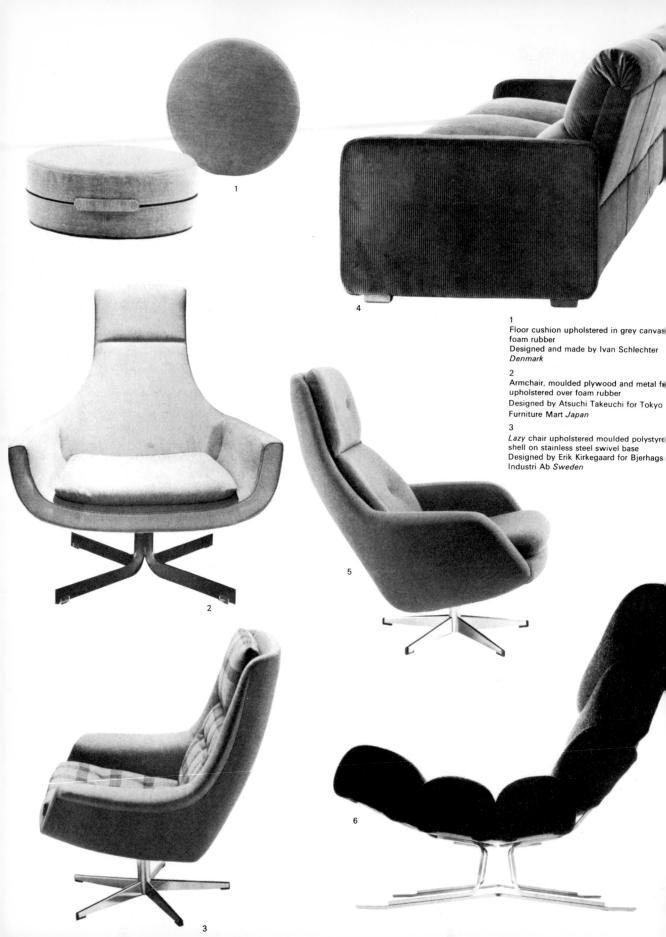

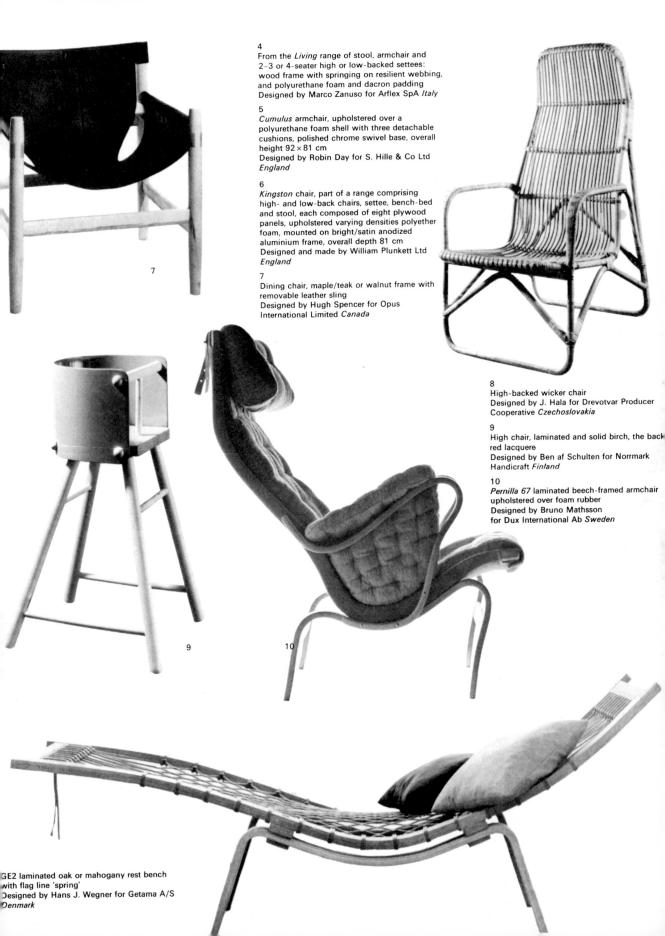

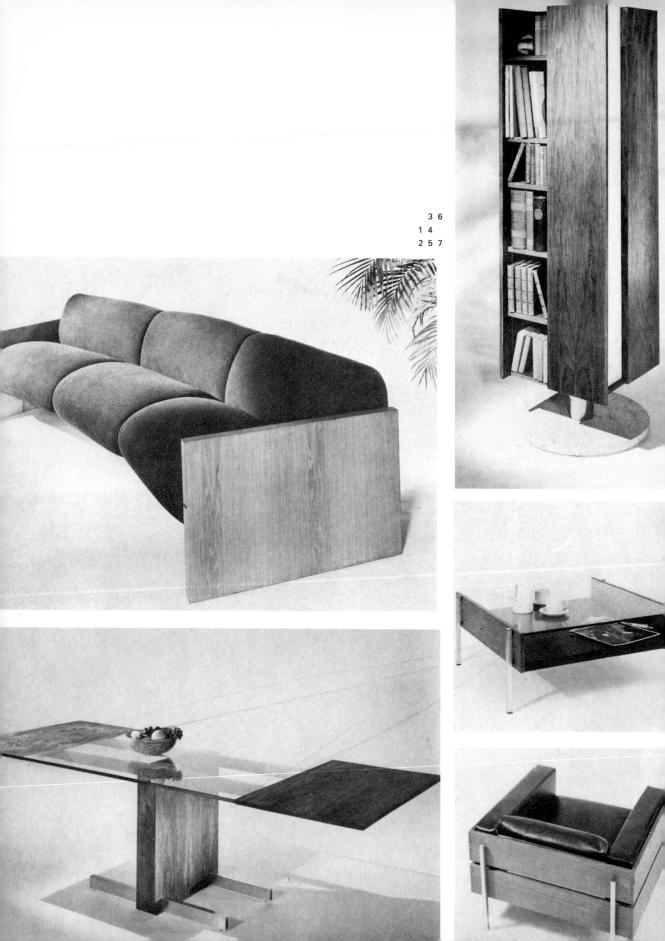

1
Tangent Cubis sofa, plank legs of oak, walnut or rosewood, upholstered leather, vinyl or fabric: overall length 208 cm

Glass-topped dining or conference table, oak, walnut, rosewood or ebony-stained plinth with matching or marble extensions: overall 50-5 × 137 cm and custom sizes: all on satin aluminium stretchers

3
Revolving bookcase pillar and light panel, oak, walnut or rosewood on polished aluminium/ travertine or slate/brass pedestal
All designed by Vladimir Kagan for Kagan-Dreyfuss, Inc USA

4, 5
Forum table and chair, solid rosewood on chrome steel square-section tube: plate glass table top, black pvc-covered shelf 93 × 88 × 38 cm high: chair with polyether, feather and down-filled cushions
A matching settee is available
All designed by Robin Day for S. Hille & Co Ltd England

6
Model 275, three-dimensionally moulded laminated wood, lacquered orange, black or white, approximately 85 cm high overall Designed by Verner Panton for Gebruder Thonet AG W. Germany

7 Working chair in laminated beech and clear acryl Designed by Peter Karpf for Jørgen Christensen Denmark

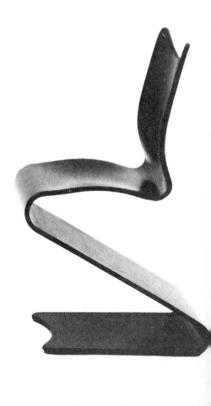

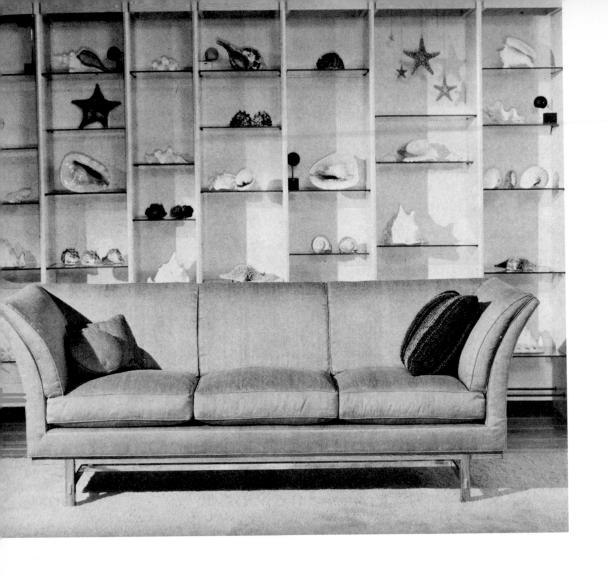

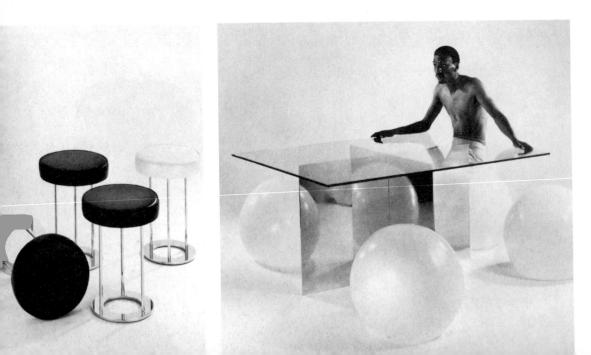

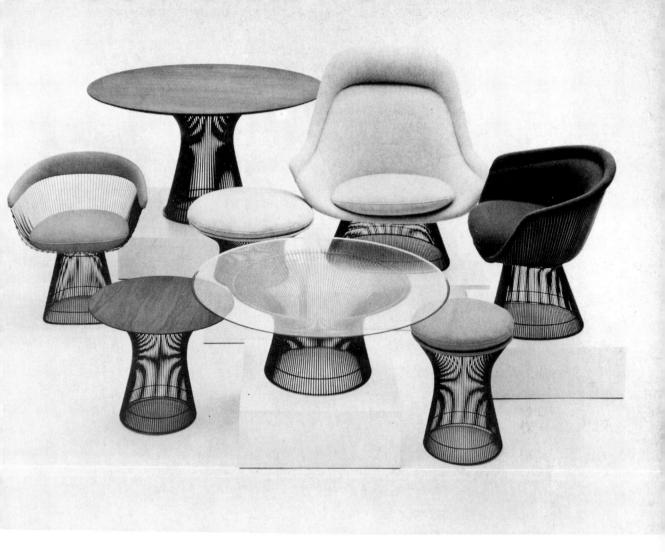

ofa, solid timber frame with exposed ase and brass stretchers, down-filled ishions, rubber-filled back cushions: 9 overall x 84 high ed by Edward J. Wormley for the r Furniture Corporation, USA

ools, polished chrome steel base ems, wood seat upholstered over cm 42 high ed chrome and glass table:

8 × 101 × 76 high lesigned by Paul Mayen for Habitat

r Collection, wire with foam rubber tery in fibreglass shell seats on tension tetal finished dark copper oxide, or (except nair and lounge chair) silvery nickel.
ed by Warren Platner

es long chairs, dining and coffee tables or white, table tops red-orange, yellow,

3 Collection, indoor/outdoor group airs, aluminium frames plastic coated or writte, table tops red-orange, year r brown porcelain enamel, resilient of seats Dacron, all completely erproof led by Richard Schultz de by Knoll Associates, Inc USA

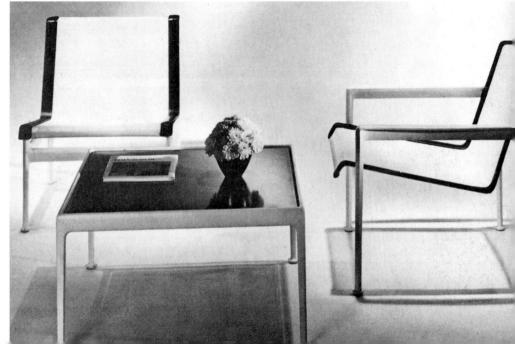

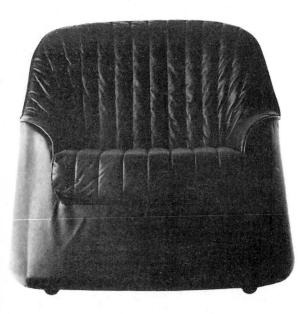

Designed by Eerio Aarnio for Asko Oy, Finland 5

Malitte: five elements form a pattern of floor seating or slot together into a giant puzzle-sculpture: polyurethane foam covered green felt: cm $160 \times 160 \times 63$ Designed by Echaurren Matta for Gavina, Italy

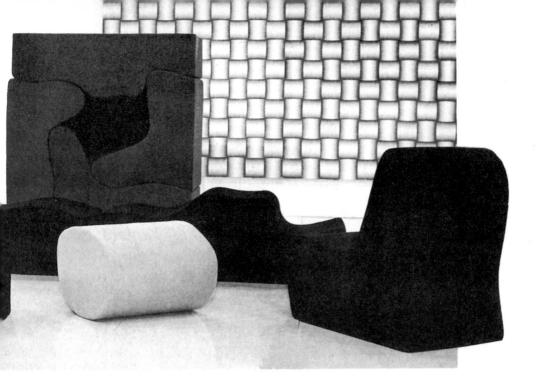

Z, 3, 4

Ciprea armchair and 3 armless chairs formed from injected foam polyurethane; base of expanded polystyrene vacuum moulded; leather, artificial leather or fabric covering Designed by Afra & Tobia Scarpa for Cassina, Italy

Throwaway foam rubber shape covered pink, black, white, red, yellow, lilac, pale blue or orange PVC
Designed by Willie Landels for Zanotta Poltrone, Italy

1, 2

Opus 22 range of bedroom fitments, from particle board, hardwood and hardboard, doors matt white lacquer or American walnut finish, all other surfaces white lacquer: basic module cm $56 \times 225 \times 61$ Designed by Walter Müller, Switzerland for The Stag Cabinet Company Limited, England

Wardrobe units with screen-fold doors, matt light grey laminate surfaces: cm 203 × 296 high × 41 or 63 deep: 62.5 wide, extending by modules of 12.5 cm Designed by H. Gugelot for Wilhelm Bofinger, W Germany

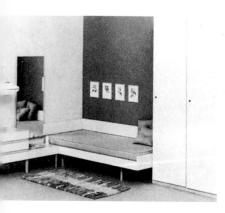

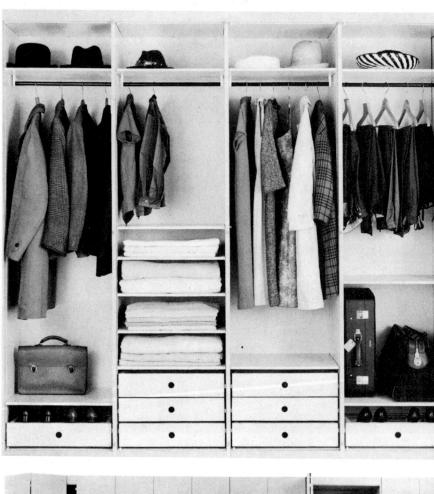

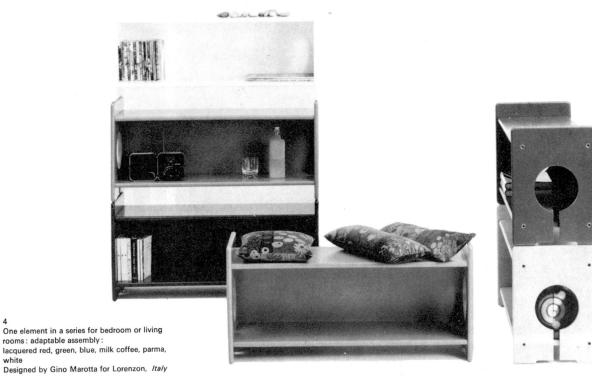

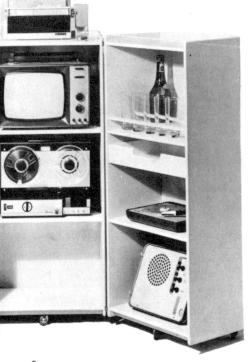

white

Folding storage unit: lacquered white, beige or with wood finishes
Designed by Giovanni Offredi for Alberto Bazzani Italy

Euro 2 stacked vertically: the three elements of the series can also be arranged as horizontal storage, drinks' and music cabinets, as bedside tables and in other combinations: compressed plywood lacquered white, aubergine, red, emerald or shocking pink or natural: basic module cm 57 × 57 × 57

Designed by Carlo Vigano for Cesare Nava, *Italy*

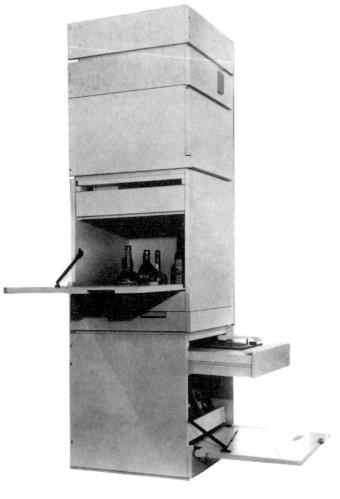

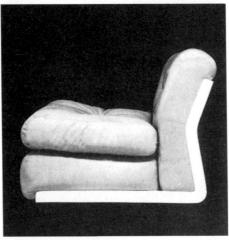

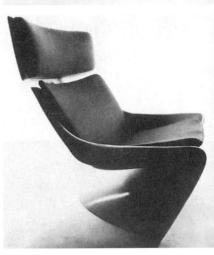

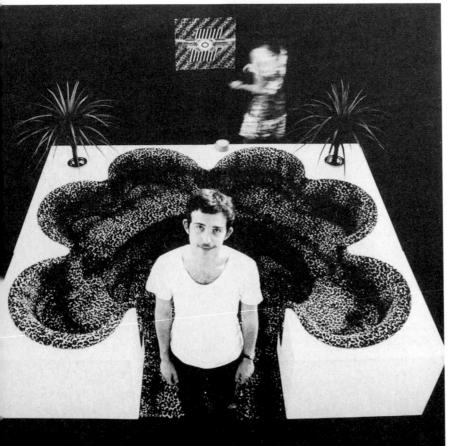

Drinks' cabinet/trolley incorporating ice-box: fibreglass, white, black or orange Designed by Sergio Mazza for Studio Artemie Italy

Amanta chair, white, red, yellow, orange or black Fibrelite shell, with foam rubber and fibrefill cushions covered fabrics or leather Designed by Mario Bellini for C + B Italy

Safari divan group: white PRFV structures w Pirelli foam rubber upholstery, leopard fabric covered: here, two sofas each cm 130 \times 13 two chairs each cm 85 \times 85 and a carpet Designed by Archizoom for Poltronova, s.r.l. Italy

2 Form magazine/end table, shaped from a ribbon of high gloss acrylic red, black or white: cm 46 × 46 × 46 Designed by Andrew Ivar Morrison for Stendig Inc, USA

Easy chair, resilient glass-fibre-reinforced polyester, upholstered solid colour woollen weaves over foam rubber Designed by Steen Østergaard for A/S Franc & Son, Denmark

Marcel armchair/sofa/seat units: dense foam rubber structure with anodised aluminium frames and connecting elements, covered rames and connecting elements, covered heavy wool military cloth: basic seat unit cm $60 \times 80 \times 35$ Designed by Kazuhide Takahama for Gavina,

Italy

Dollaro table, polystyrene stamped low relief white with red, white, black, green, silver or blue top: cm 70 diameter Designed by Franco Angeli for Mana Art

Market, s.r.l. /taly

Bauletti games'-boxes/drinks' trolleys, natural preformed plywood with red and yellow pattern stain resist finished Designed by R. Pamjo, R. Toso, N. Massari for Stilwood, Italy

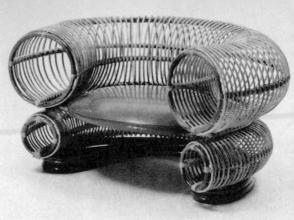

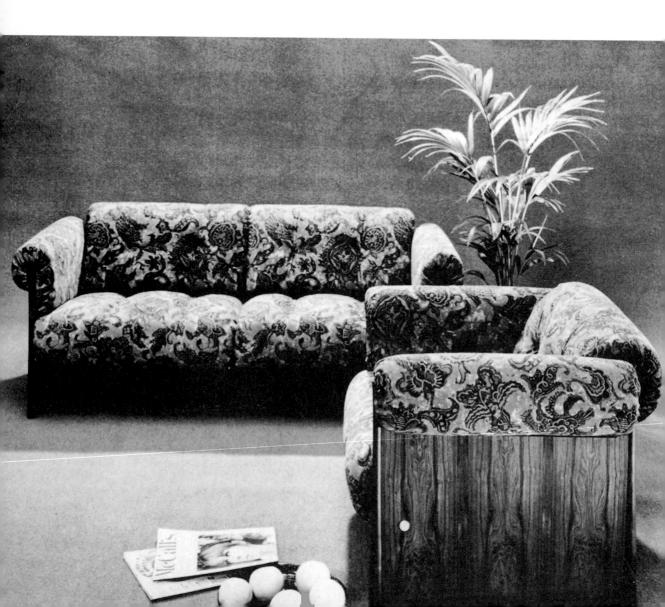

1 Glass-topped table, frame of metal hoops, stove-enamelled colours or polished: cm 108 × 108 × 30.5 high Designed by John Monk for Datum Furniture Limited England

Armchair, giunco with foam rubber cushion
Designed by Giovanni Travasa for Bonacina Italy

Buster two-seater and easy chair, laminated wood with white lacquer or rosewood finish: pre-formed upholstery units are demountable: chair: cm 67 high \times 83 deep \times 93 wide Designed by Ake Nilsson for Dux International Mobel Ab Sweden

Group S420 silver-or matt-finished ball and rod frames allow various arrangements: upholstery specially woven by Unika Vaev, three colourways Designed by Verner Panton for Gebruder Thonet GmbH W. Germany

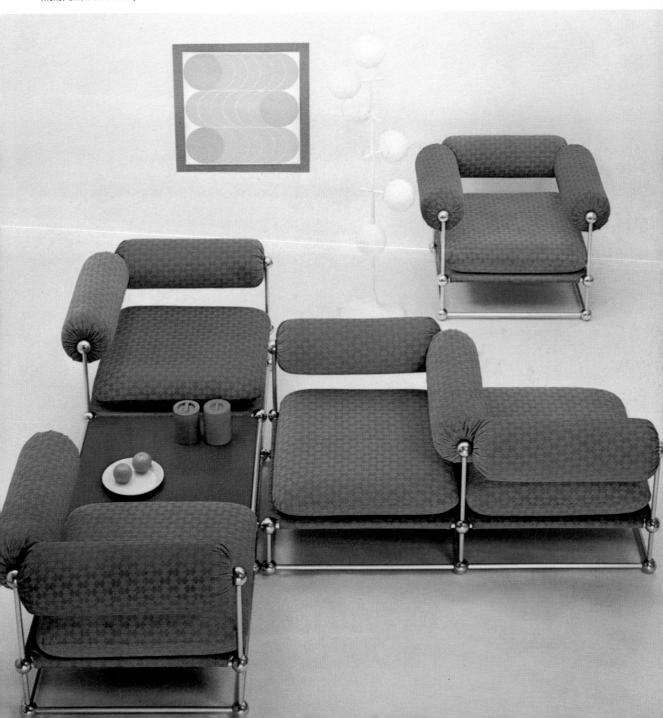

Items in a packaged series: chipboard texture-stained, table tops lacquered: green/lemon/grey or red/black: round tab cm 100 diameter, with overlaid top cm 160 diameter

2, 3 oblong table cm 189 × 39.5 with twe dropped leaves: arm chairs, longer benche with/without arms also available: all piece have visible screws locking into cross nuts Designed by Bard Henriksen, *Denmark* and made by Ums Pastoe, *Holland*, Mobel Fisk *Norway*

Stowaway storage system: five units location pins, mount into any desired combinatiplinth and boxes stained dark brown, back shelves, drawers, doors natural beech: bas unit size cm $50.3 \times 50.3 \times 35.6$ Designed and made by Conran & CompaniLimited England

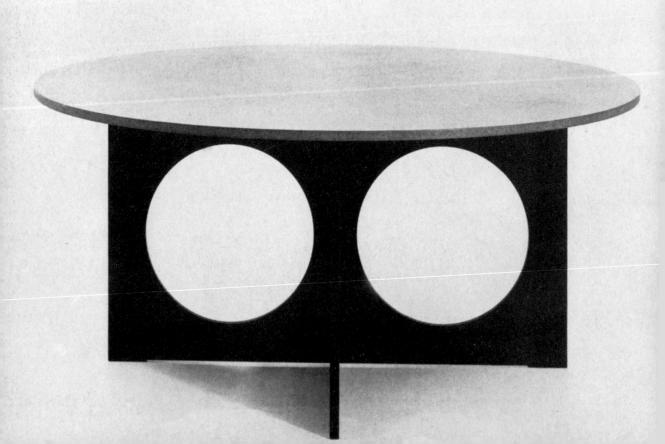

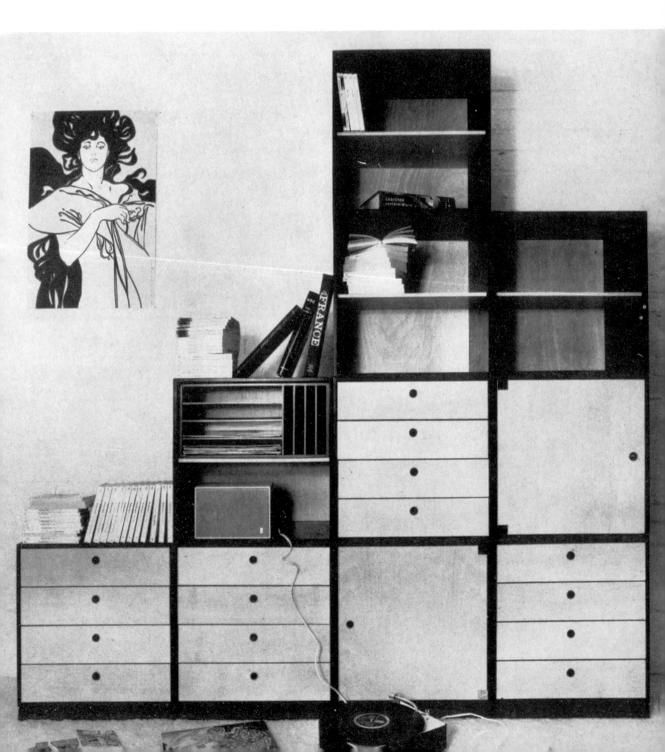

textiles and wallpapers | Stoffe und Tapeten | Textiles et papiers peints

▲ Peru drapery fabric in Belgian linen with sing or double stripe pattern in brown and orange outmeal. The design, inspired by traditional Peruvirugs, is by Suzanne Huguenin SWITZERLAND for t'Knoll International fabric range made by Kne Textiles Inc. USA

A drawn-thread effect transparent white caseme fabric in linen and cotton. Designed by Age Faith-I for AB Claes Håkansson SWEDEN

■ Brown shadow-stripe drapery fabric in an a cotton weave from the Cotil range. Designed by Vibe Klint for A/S C. Olesen DENMARK

TOP: Grotto rayon/cotton texture weave in sever colourways including red/burgundy/black; olive greelemon/white; forest green/blue.

Designed by Tibor Reich, FSIA, for Tibor Ltd UK Open weave transparent casement fabric in limithread.

By Leinenweberei Baumann & Co. SWITZERLAND Media casement fabric, a cotton/rayon/mohair she weave in blue, gold or natural. The rhythmic patte formed by the filling stripes breaks, but does r destroy, the vertical effect created by the fancy wear Designed by Marie Howell for David and Dash US

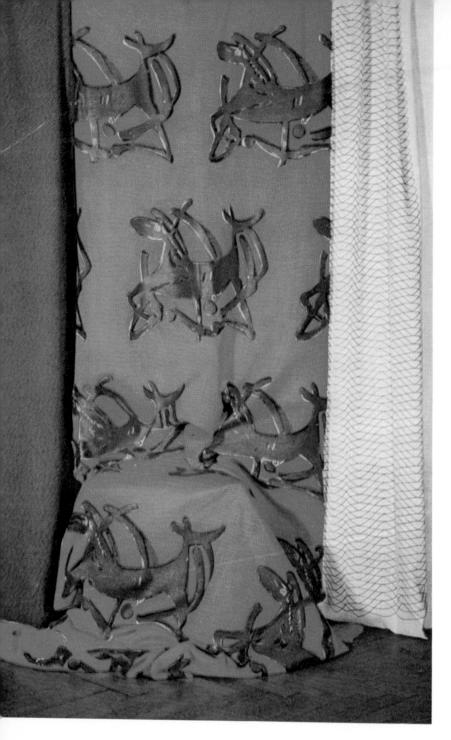

All wool rug (68×32 inches) from a colourful range, each individually designed and hand-knotted by Renata Bonfanti ITALY \blacktriangleright FAR RIGHT: Linen and cotton sheer-weave, 50 inches wide. A Stuttgarter Gardine fabric, also available in yellow or natural. From Danasco Ltd UK

- I Crosh linen weave, 50 inches wide, Sanforized shr finish. Made by The Old Bleach Linen Co. Ltd
- 2-3 Rothes slub weave in cotton, linen, wool/rayon viscose staple; and Broadford wool/rayon texture we Both fabrics are 50 inches wide and are from the Glamis range made by Donald Bros Ltd UK
- 4 A heavy Irish linen weave, 52 inches wide, in st colourways. From Conran Fabrics UK
- 5 Ancona cotton and rayon weave with a knitted effi 50 inches wide. Designed by Tibor Reich, FSIA, m in a wide range of colours by Tibor Ltd UK
- 6 'London shrunk' all cotton spiral repp, 48 inches w Made in a range of 15 colours by W. H. Foxton Ltd
- 7 Le Bosquet by Shirley Craven and Golden Harvess Althea McNish, two large-scale designs from the "T Present' range, hand-screen-printed in glowing cole on 50-inch cotton satin by Hull Traders Ltd UK

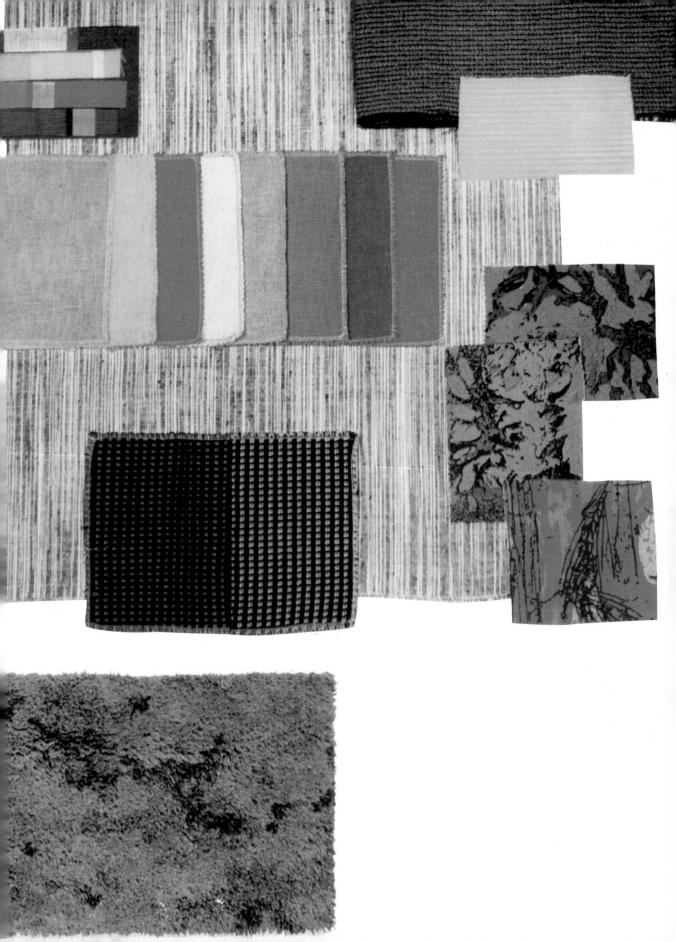

Brandon rayon and Lurex drapery fabric in blue, green, stone, beige, gold; 50 inches wide.

Designed by Frank Davies, MSIA, for Warner & Sons Ltd UK

Anthracite/grey/sand weave, cotton warp, linen weft with pattern in wool; 50 inches wide. Designed by Lennart Svefors for AB Claes Håkansson SWEDEN

Biarritz rayon/nylon multicoloured hexagonal faille available in fourteen colourways; 54 inches wide. By Boris Kroll Fabrics Inc. USA

Linen weave in a wide range of colours; 55 inches wide. By Worb & Scheitlin AG, SWITZERLAND

Anthracite/grey/sand weave, cotton warp, linen weft with pattern in wool; 50 inches wide. Designed by Brita Ahlgren for AB Claes Håkansson SWEDEN

Salix screenprint on cotton, 48 inches wide; green, blue, brown, grey and red are other colourings. Designed by Annika Malström. Radja stripe screenprint on cotton, 48 inches wide, available in nine colourways. Designed by Viola Gråsten.

Both fabrics made by Mölnlycke Väfveri AB, SWEDEN

CP 4051 heavy cotton screenprint, 48 inches wide; also in grey/slate blue, red/pink, violet/turquoise tones.

By David Whitehead Fabrics Ltd UK

Cosmorama hand-screenprinted 'Everglaze' chintz, 50 ii wide; also in pink/green and blue/green on white.

By Arthur Sanderson & Sons Ltd UK

Arden cotton/wool texture weave, 48 inches wide, availal eleven colourways.

Designed by Tibor Reich, FSIA, for Tibor Ltd UK

inge hand-screenprint on cotton tweed, 48 inches wide; green, 1e, and grey are other colours.

esigned by Trevor Bates for Edinburgh Weavers UK

nflower hand-screenprinted 'Everglaze' chintz, 48 inches wide; o in blue/green on white.

Arthur Sanderson & Sons Ltd UK

ntella four-colour leaf print on cotton, 50 inches wide. Designed Ute E. Jansen for Textildruckerei Oberursel GmbH GERMANY

> Akarana cotton-satin hand-print 48 inches wide; also with the poppy motif in purple or lemon. Designed by Althea McNish for Liberty & Co. Ltd UK

Monstera large leaf screenprint on stain and crease resistant glass fabric, 46 inches wide, available in four colourways. Designed by Tootal Studios for Vetrona Fabrics Ltd UK

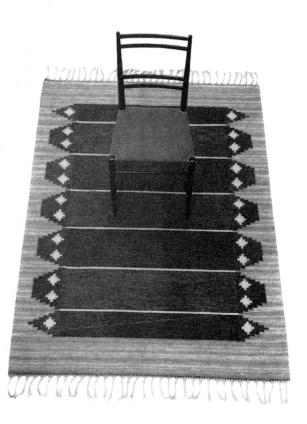

ABOVE Rya rug with cut deep pile. Desigr Mary Beatrice Bloch for Væveboden DENMA Photo Jørn

Handwoven Röllakan rug in wool combine spun rayon, linen and goathair. Made is colour combinations and in sizes 78×45 and 94×67 inches. Designed by Rakel Carl Carlanders Väveri AB, for Eric Ewers AB SV OPPOSITE Duveteen applique wall hanging 41 inches. Conceived as a 'painting in fabric colours are related to the colour scheme particular room. Each is individually design made by Jettie Penraat USA

LEFT Circular wool rug, 72 inches diame Dresden Axminster quality. The design, a ct tic arrangement of colour in a subtle blenc tobacco brown tones, is by Lisa Gronwall so Made by Carpet Trades Ltd UK

1, 2

Pesula 881, Indian cotton 48 inches wide, and Pferd 73 a heavy cotton with 24-inch repeat. Printed by Mech. Weberei Pausa AG for Emtex GmbH GERMANY

3, 4

Naturlarä fine cotton print, 36 inches wide, sanforized finish; available in seven colourways. Designed by Marianne Mandelius;

Duo two-tone medium weight cotton, 50 inches wide, sanforized finish; available in a range of fourteen colourings. Designed by Annika Malmström. Both made by Mölnlycke Väfveri AB SWEDEN 5, 6

Satula and Pyöryläinen cotton prints, 48 inches wide, available in several colourings. Both designed by Maija Isola for Printex O/Y FINLAND

7, 8

Tobago screenprint on crepe cotton, 48 inches wide, available in four colourways. Designed by Althea McNish, Des.RCA, MSIA;

Country Bunch cotton roller-print, 48 inches wide, in five colourways. Designed by Barbara Brown. Both made by Heal Fabrics Ltd UK

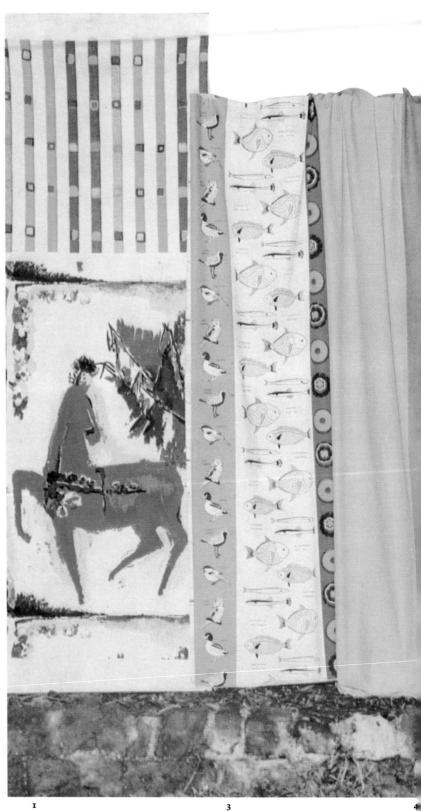

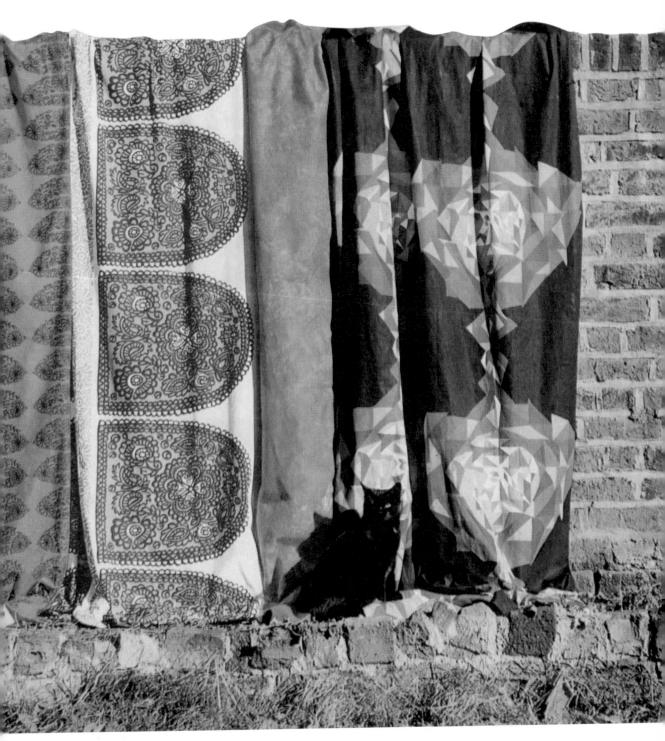

1962–63 \cdot textiles and wallpapers \cdot 311

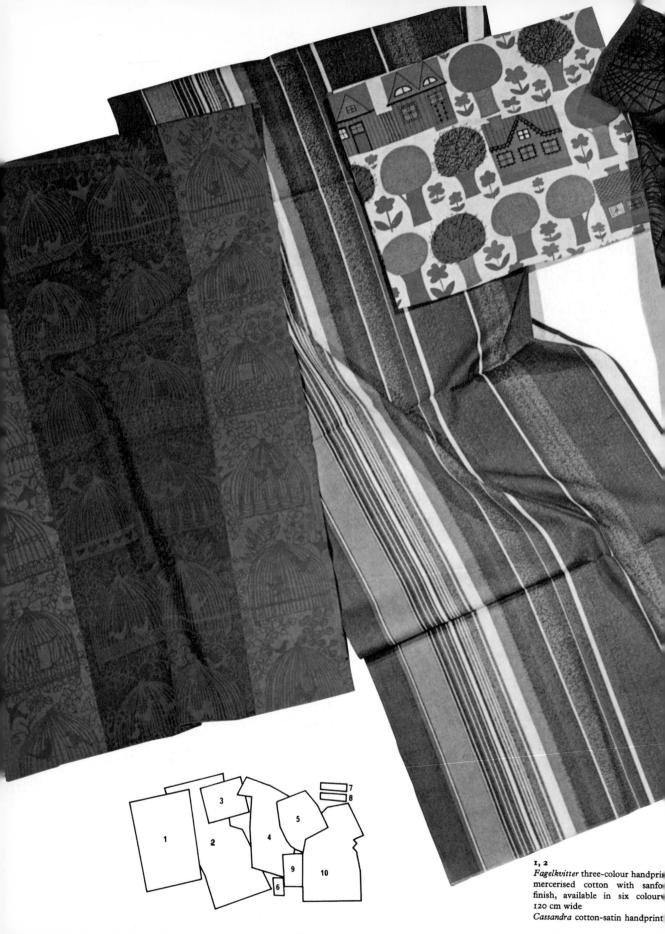

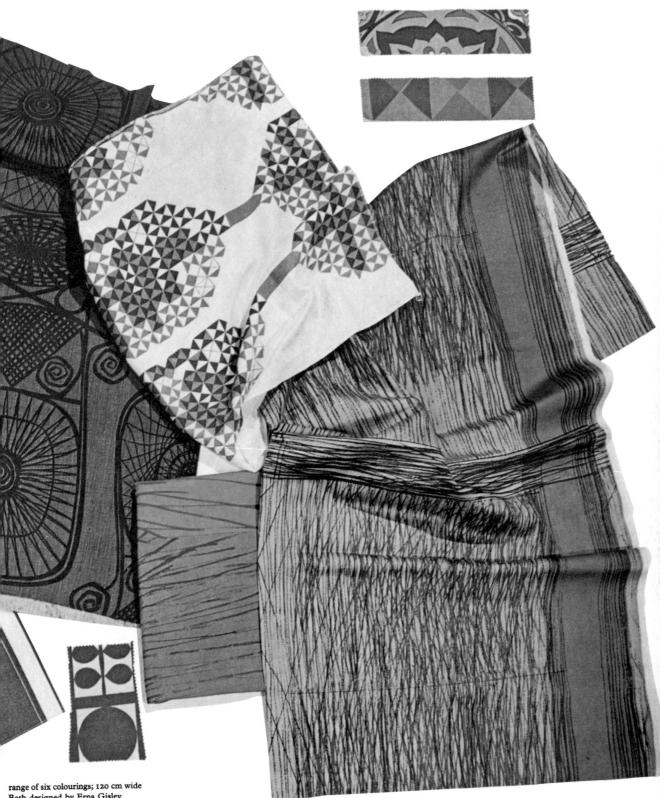

Both designed by Erna Gislev

Småstad a gay nursery handprint on mercerised cotton; 91 cm wide. Four colourways

Designed by Annika Malmström

Korgfläta linen handprint, available in a range of seven different colourways Designed by Viola Grasten. All for Mölnlycke Väfveri AB sweden

Crystal Rosebank roller print on textured cotton; in six colourways; 127 cm wide

Designed by Dorothy Mathew for Turnbull & Stockdale Ltd UK

Grille cotton screenprint; 122 cm wide. Seen in repeat on page 87 From Heal Fabrics Ltd UK

Bianca and Arabella cotton handscreenprints; 122 cm wide. Bianca seen in repeat on page 86 Designed by Shirley Conran for Conran Fabrics Ltd UK

Two from a range of designs screenprinted on heavy cotton-satin; 120 cm wide; ten colourways are available Designed by Leo Wollner for Mech. Weberei Pausa AG GERMANY

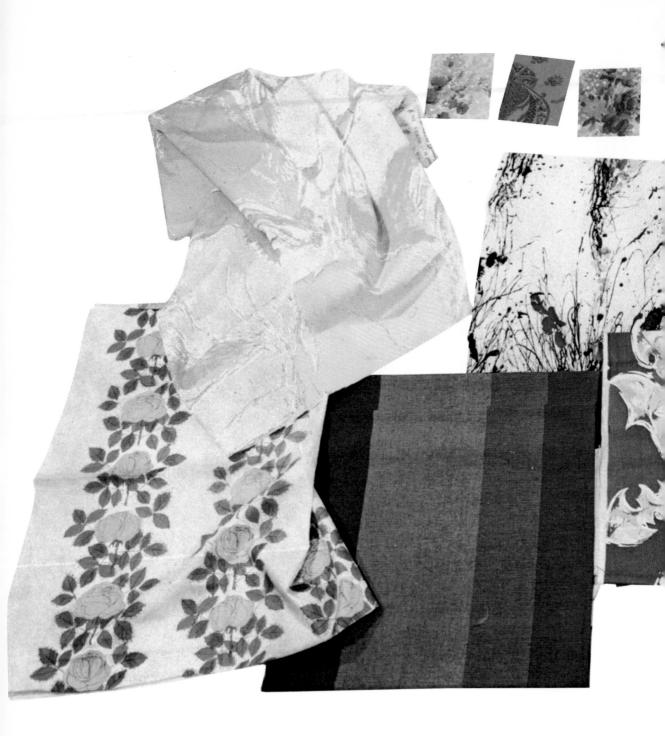

I, 8

Pastoral designed by James Morgan,
Struan designed by Peter McCulloch:
'Time Present' screenprints on heavy
cotton-satin; 122 cm wide; each is
available in three colourways. For
Hull Traders Ltd UK

Rosita screenprint on fine glazed cotton; 91 cm wide; in seven colourways

Designed by Annika Malmström. For Mölnlycke Väfveri AB SWEDEN 3, 5 Two colourways from the Angelique range of screenprints on cotton-satin; 128 cm wide Designed by Pascaline Villon

Chandernagor screenprint on dobby cotton in four colourways
Designed by Laureat Stève
All for Boussac de Paris FRANCE

September Garland screenprint on poplin; 122 cm wide. Available three colourways. From As Sanderson & Sons Ltd UK

7
Baltic Stripe heavy rayon weav
many colourways and several s
of pattern; 122 cm wide. Made
Cavendish Textiles Ltd uk

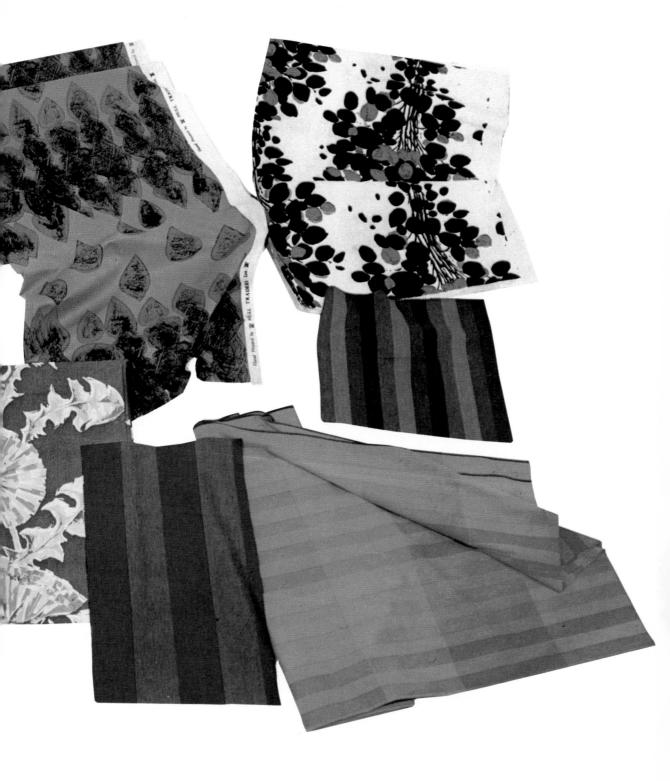

x and Perla two screenprints on wy cotton de by Danasco Fabrics Ltd UK Woven cotton stripe, range 373/45, in four colourways; 152 cm wide 12, 13
Fine cotton weaves, ranges 374/35 and 392/65, each in four colourways; 132 cm wide

All designed by Uhra Simberg for Finlayson-Forssa FINLAND. From Danasco Fabrics Ltd uk

Kakoset wall tapestry in traditio 'täkänä' double hollow-weave: lis yarn in khaki/brown on green/purs 100×180 cm

Designed by Maija Kolsi-Mäkelä Helmi Vuorelma O/Y FINLAND

Fästmansgåva screenprint on fine p lin with sanforised finish: available four colourways

four colourways
Designed by Beret Helena Ruu
Made by Borås Wäfveri A/B for A
Sörensen AB sweden

3
Korppa, another 'täkänä' design, the hollow-weave technique producing counterchange effects on the reverse: linen yarn in light/dark purple with bright red/dark blue; 47 × 140 cm
Designed by Maija-Liisa Forss-Heinonen for Helmi Vuorelma O/Y FINLAND

Fireside Evening machine-made rya rug; 184 × 138 or 276 × 184 cm Designed by Ritva Puotila Made by O/Y Finnrya A/B FINLAND

PHOTOS I, 3 KUVAKIILA PHOTO 4 PIETINEN

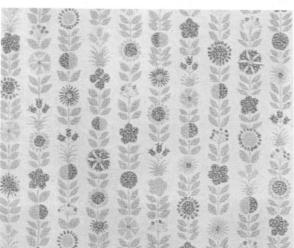

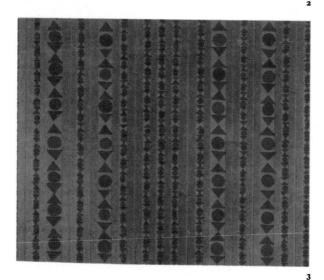

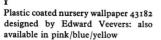

2 Floral stripe 43186 designed by Derek Healey: three colourways are available, one on black ground 3 Geometric stripe 43202 designed by Pamela Kay: in three colourways

4 Mosaic 43196 designed by Edward Veevers: metallic gold on matt brown paper, copper on grey, pale yellow or pale grey on white Vertical stripe 43173, a plastic coated paper available in three colourways Designed by Roger Nicholson

00 00 00 00

6 Discs 43195, plastic coated and available also in blue/grey pastel tones on white. Designed by Paul Hugener All these papers are in the Pa Mondo Collection made by The Paper Manufacturers Ltd UK Matching or co-ordinating fabri available in the Bevis range 1 factured by Simpson & Godlee L

00 00 00 0

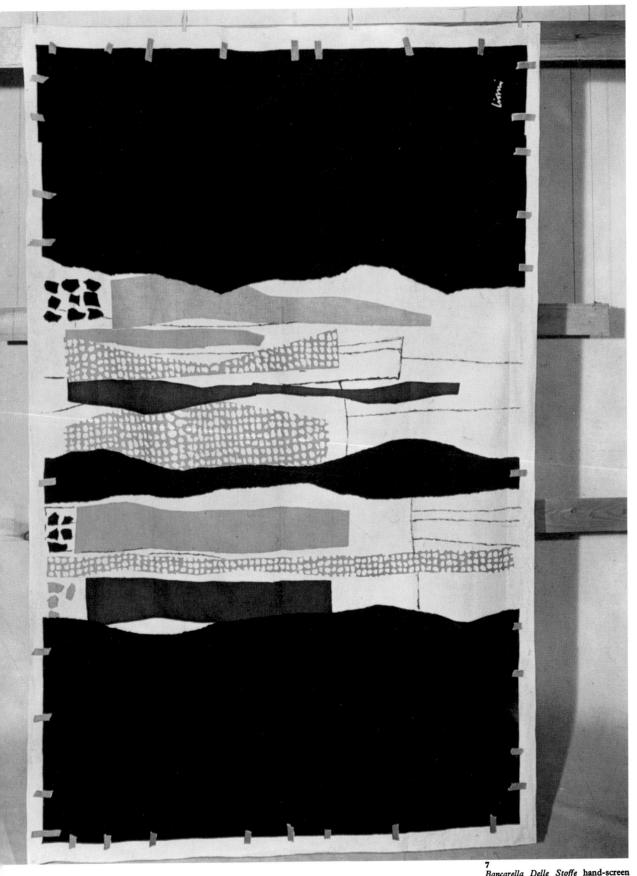

7
Bancarella Delle Stoffe hand-screen
printed panel 228 cm wide, from a
limited series. Designed by Leo Lionni
for M.I.T.A. di M.A. Ponis 1TALY

2 Queen of Spain one-colour screenprint available in three colourways on white cotton and in three colourways on dyed cotton satin—red/orange, blue/green and green/blue Designed by Michael Taylor Both Time Present fabrics made by Hull Traders Ltd UK

3
Oresund three-colour weave in fine cotton, available in eight colourways; 150 cm wide
Designed by Tove Kindt-Larsen for Gabriel DENMARK

4, 6

Love in Idleness and Master Tuggie's: screenprints on heavy cotton; both available in three colourways; 122 cm wide

Both designed by Gillian Farr for Conran Fabrics Ltd UK

5
Loto screenprint on 100% linen or linen/cotton. Available in ten colourways—predominant tone of reds, greens, blues, browns, violet or grey; also yellow/orange, dark brown/greyblue and clear beige; 130 cm wide Made by Falconetto 1TALY

7
Tapestry print on mohair/rayon/cotton
Royale cloth: four colourways; 122
cm wide
Designed by Ballatore & Larsen
Design Corporation for Jack Lenor
Larsen Inc USA

Heavy cotton two-tone repp; 122 cm wide, available in thirty-four colours: Made by Liberty & Co Ltd UK

Bellmansro and Fästmansgåva screenprints on fine sanforised cotton; 90 cm wide: one seen in repeat on page 80 Designed by Beret Helena Ruuth Produced by Boras Wäfveri A/B for A.E. Sörenson AB SWEDEN

Patience screenprint on heavy cotton; 122 cm wide, available in many colours and designs Made by Liberty & Co Ltd UK

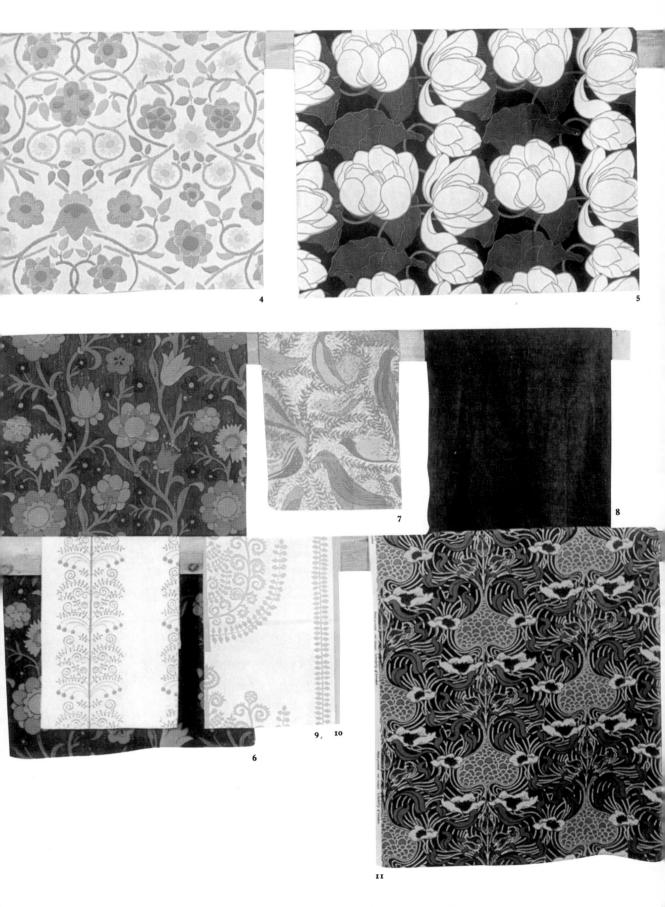

1964–65 \cdot textiles and wallpapers \cdot 321

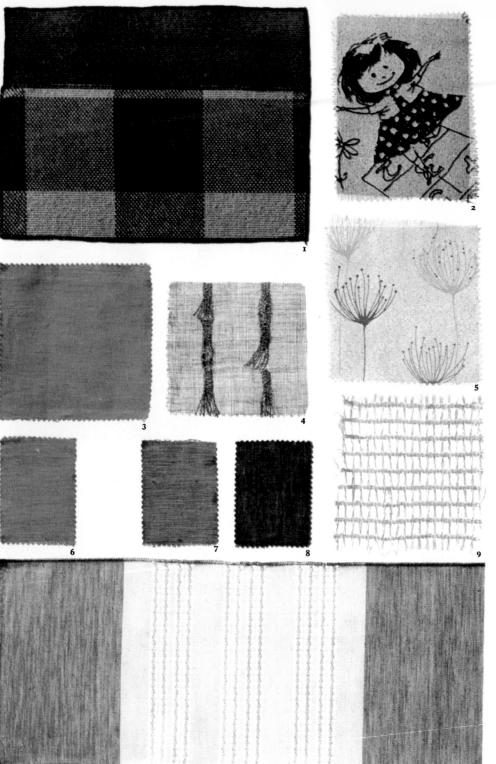

Cotil 742: 100 % wool upholstery in check and matching plain w six colourways; 130 cm wide Designed by Lis Ahlmann and Mogensen for A/S C. Olesen DEN

2,5
Daizy Maizy print on fibbouclé, or on fortisan or cotto cm wide: design available also ordinated wallpaper with wa plastic and other finishes

Summer Silk print on fibreglass t fibreglass Neptune, fortisan or in fifteen colourways; 122 cm also available as co-ordinated covering

Both for Laverne Internationa

3, 6, 7, 8
Heavyweight cotton repp, availated checks and two weaves: thirty-four colours included the colours in the colours included the colours in the colours included the colours included the colours included the colo

4 Crescendo sheer weave, natural cotton/metallic thread; 127 cm Handwoven in Italy for Jack Larsen Inc USA

9 Casablanca mohair/rayon/cotton 127 cm wide for Jack Lenor J Inc USA

Roman 100% cotton weave is white and four colourways; I wide.

Designed by Elsa Lagersson and Nils Gröndahl for A/B Jacquardväveri sweden

11, 12

Sulina designed by Karin Mori Senassi designed by Ulrike Rhon screenprints on indanthren c each available in six colourway cm wide

Both made by Mech. Weberei AG w. GERMANY

13, 15 Glad Påsk 21/414 screenprint o glazed cotton; 91 cm wide: four c ways

Designed by Erna Gislev Allegro 25/848 screenprint on linen/cotton weave; 120 cm wic colourways

Designed by Annika Malmströn Both for Molnlycke Väfveri SWEDEN

Mantilla screenprint on cotton Designed by Maija Isola for D€ Fabrics Ltd UK

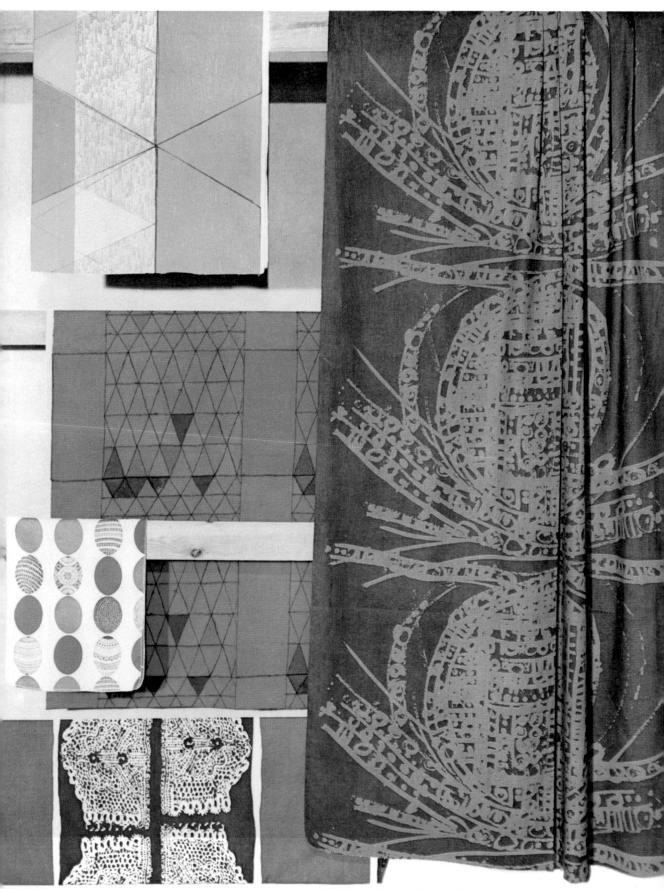

1964–65 \cdot textiles and wallpapers \cdot 323

Ristiretki an all-wool rya rug 110×168 cm Designed by Raija Gripenberg for Helmi Vuorelma O/y FINLAND

1965–66 \cdot textiles and wallpapers \cdot 325

Figment glass-fibre weave in green, orange, black or gold on white 122 cm wide Designed by Estelle and Erwine Laverne for Laverne International Ltd USA

Slingöga 80% linen/20% cotton sheer, 150 cm wide, available in whi and four neutral or light colours Designed by Gerd Stenberg for AB Marks Jacquardvävveri SWEDE

A woven solid/open stripe in Fiberglas Beta yarn, available in white or tan, 122 cm wide Designed by Marie Howell of Howell Design Associates for Qual-Fab, Inc USA

lay a Rovana knit casement onze or white; fireproof, and damp resistant a large-scale design flock ed on organza 122 cm wide and made for Lenor Larsen Inc USA Parcypress room-divider: etch-print on cotton, 127 cm wide, white only Designed by Astrid Sampe for NK Inredning SWEDEN

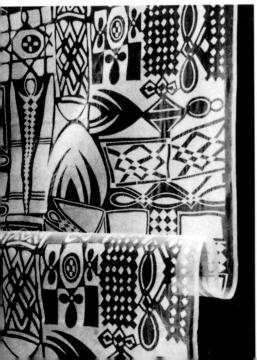

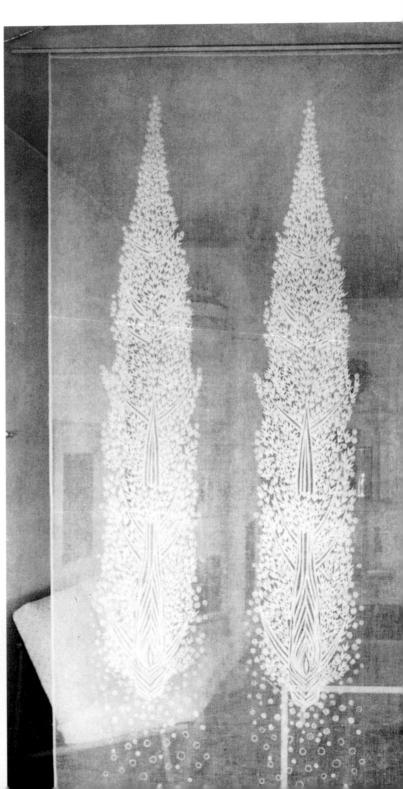

- 1 Prince of Quince screenprint on heavy cotton/linen cloth in three colourways and black/white 122 cm wide
- Designed by Juliet Glynn-Smith for Conran Fabrics Ltd UK
- 2 January print in several colourways on 100% cotton, 122 cm wide
- 3, 4 Tristripe and Diamonds, a 15 cm repeat stripe and a four-colour print, both on Belgian 100% cotton cloth 122 cm wide
- 2, 3, 4 designed by Alexander Girard for Herman Miller Textiles USA
- 5 Morven a 100% linen, 124 cm wide in colours matching Chroma plain Wilton carpet: part of a series of co-ordinating carpets and weaves Designed by Ian Miller for Thomson Shepherd & Co Ltd and Crest Weaving Co Ltd UK
- 6 Jackanapes screenprint on cotton cloth in two colourwa 122 cm wide Designed by Juliet Glynn-S
- for Conran Fabrics Ltd UK

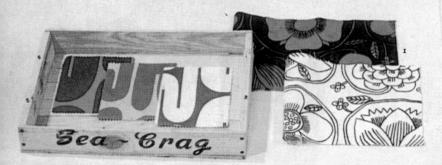

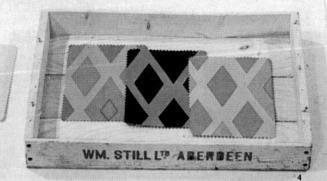

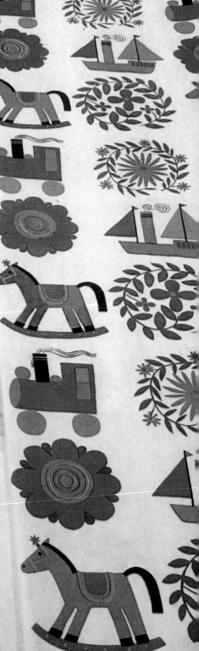

Järter Ess screenprint on fine
-iron cotton, 90 cm wide
colourways
Igned by Erna Gislav for
nlycke Hemtextil AB SWEDEN

8 Fine 100% cotton woven checks in five colourways, 152 cm wide Designed by Uhra Simberg for O/y Finlayson-Forssa AB FINLAND

9 Moidart a 'Time Present' screenprint on heavy cotton-satin, 122 cm wide available in four colourways Designed by Peter McCulloch for Hull Traders Ltd UK

Nomoi screenprint on Dolan: 8 colourways: 120 cm wide Designed by Leo Wollner for Weberei Pausa AG W. GERMANY

Bali printed stripes on sanforized 100% cotton in 5 colourways: 119 cm wide Designed by Erna Gilev for Mölnlycke Hemtextil SWEDEN

Daisy Chain screenprint on cotton poplin in 5 colourways: 122 cm wide Designed by Pat Albeck for Cavendish Textiles Ltd UK

Numea screenprint on Dolan: 8 colourways: 120 cm wide Designed by Leo Wollner for Weberei Paussa AG w. GERMANY

AD Photography

Chanelle screenprint on cotton satin in 4 colourways: 122 cm vide
Designed by Gillian Farr for Bernard Wardle Fabrics UK

seen in repeat on page 97

Törnrosa screenprint on 100% extured weave cotton 8 colourways: 145 cm wide
Designed by Viola Grasten for
Mölnlycke Hemtextil sweden

Florentina screenprint on shrink resistant, cotton crepe in 5 colourways: 122 cm wide. Designed by Jyoti Bhomik Imprint screenprint on shrink resistant cotton crepe in 4 colourways: 122 cm wide Designed by Ian Logan

Both made by Heal Fabrics Ltd UK

Rondo all wool rug also in y or green: 305 cm diameter Designed by Agnethe Gjoed Unika Vaer DENMARK

>

Melting Snow hand-made werug: 150×120 cm
Designed and manufactured
Atelje Airi Snellman-Hännis

Ziggy-Zaggy screen-print on heavy plain cotton 4 colourways 120 cm wide Designed by Shirley Craven and made by Hull Traders Ltd England Chan-Chan 100% cotton, tie-dyed upholstery or curtain weave, flame, flamingo (shown) amberviolet, bluewhite, 137 cm wide Designed and produced in Kenya by Eliza Willcox for Jack Lenor Larsen, Inc USA

Euclide hand screen-print on heavy 100% hemp, 100 cm wide Designed by Alberto Locatelli for Locatex s.r.l. Italy Bellona heavy satin-faced cotton rep pre-shrunk and vat dyed in altogether about 42 colours 127 cm wide Design by Shirley Craven for Hull Traders Ltd England Gran Canyon, Caldonia and Acapu hand screen-prints on cotton/linen cloth All designed by Alberto Locatelli for Locatex s.r.l. Italy

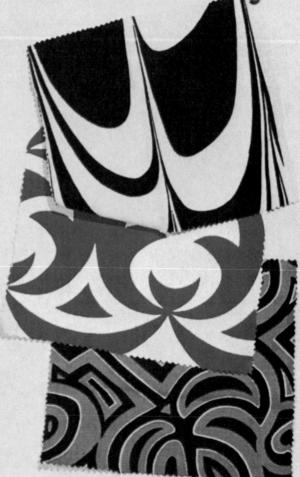

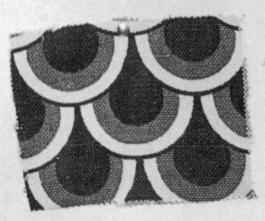

n Kettle and Cabbage two of es of tea towels, 100% Irish printed many bright colours nite 78 × 53 cm ned by Ornella Noorda (Italy) paran Fabrics England

eau Beardsley from a series ated printed trays and mats, black/white only ned and made by Xlon Ltd and

Numeri cotton panels printed in blue and green on turquoise and three reds on white ground Designed by Ornella Noorda Zebra pillow panel in black and white only Designed by Anna Fasolis both produced by Ornella Noorda Italy

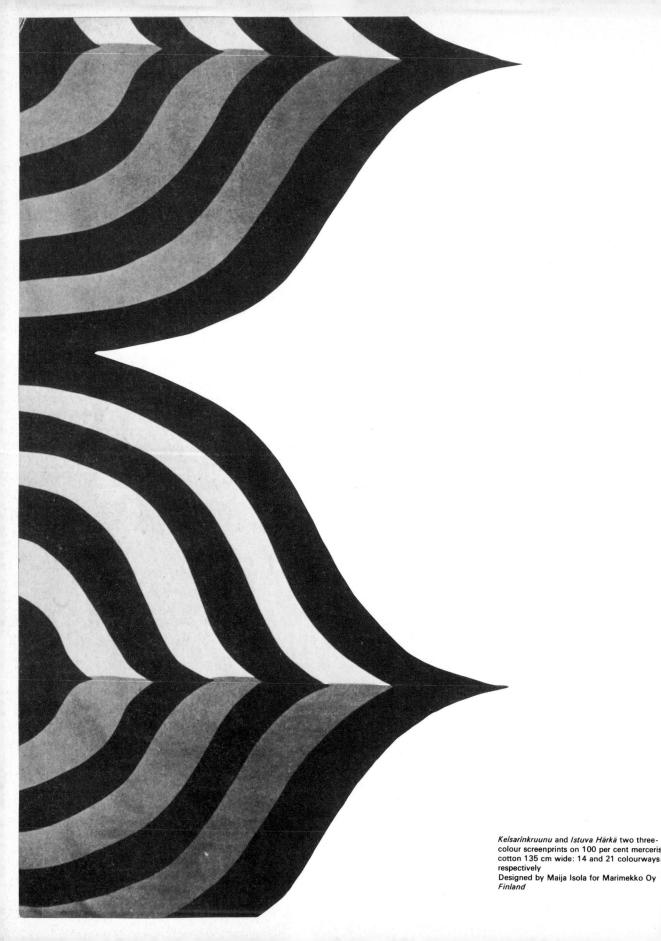

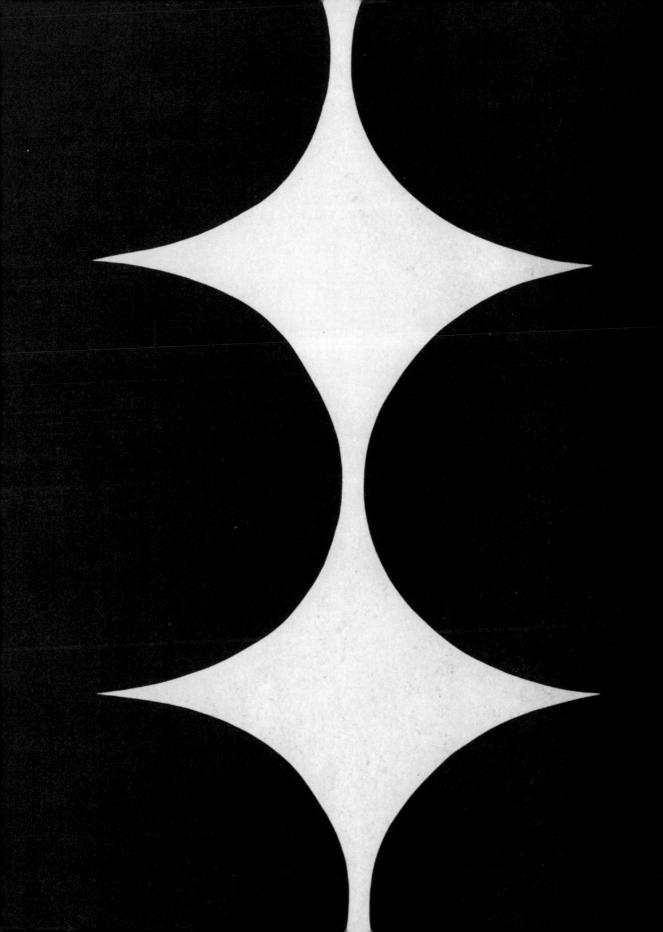

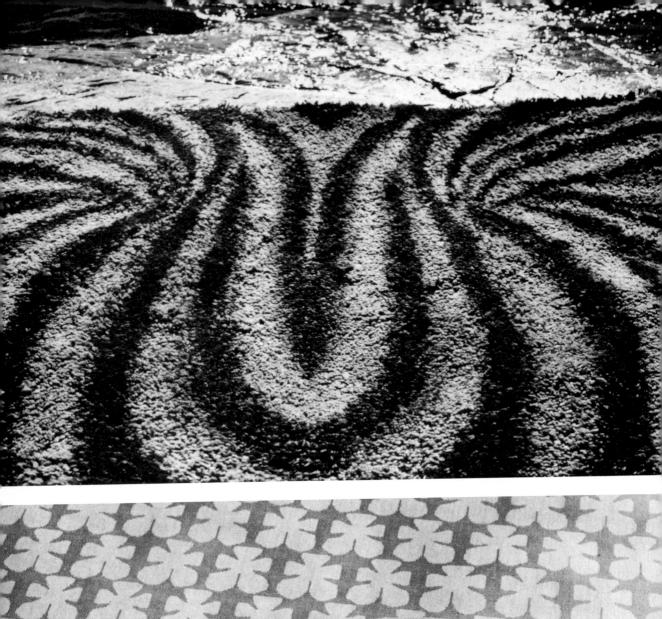

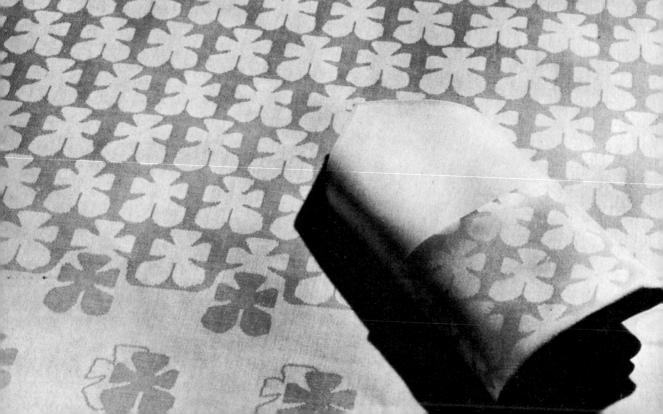

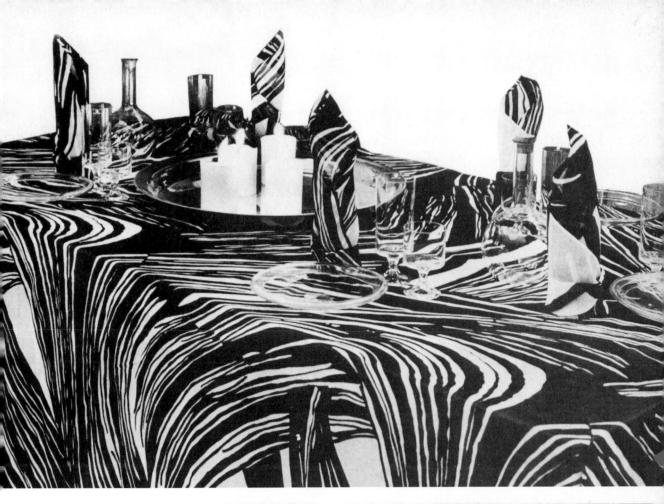

t (waves) all-wool carpet, blue-violet 2.5 m to 10 × 10 m and by Ritva Puotila for Oy Finnrya Ab

kki and Viol damasks, gold, blue, rose, ral or white, the cloth 130 × 130 or 150 0 cm

gned by Dora Jung

a screenprint on cotton 180 cm wide, the ins printed on cotton voile, 10 colours ned by Marjatta Metsovaara for Oy Tampella Ab Finland

inprint on cotton satin, black/white and ther colourways 140 cm wide ned by Raili Konttinen for Porin Puuvilla nland

Fret black, white, red or blue screenpring rret black, white, red or blue screenprin on natural hessian Designed by David Bishop Phulwari and Jaal two of a series of transport Indian designs handblocked colour-fast 100% cotton 91 cm and 122 cm wide All for The David Bishop Company Engli

5, 7 Screenprints on cotton cretonne Screenprints on cotton cretonne
5 designed by Margit Steiner
7 designed by Anne Fehlow
each with 4 colourways, all 120 cm wid
Made by Mech. Weberei Pausa AG W. (

Istuva Härkä three-colour screenprint on mercerized cotton 21 colourways 135 cm

Complex a screen print on cotton satin 122 cm wide 4 colourways

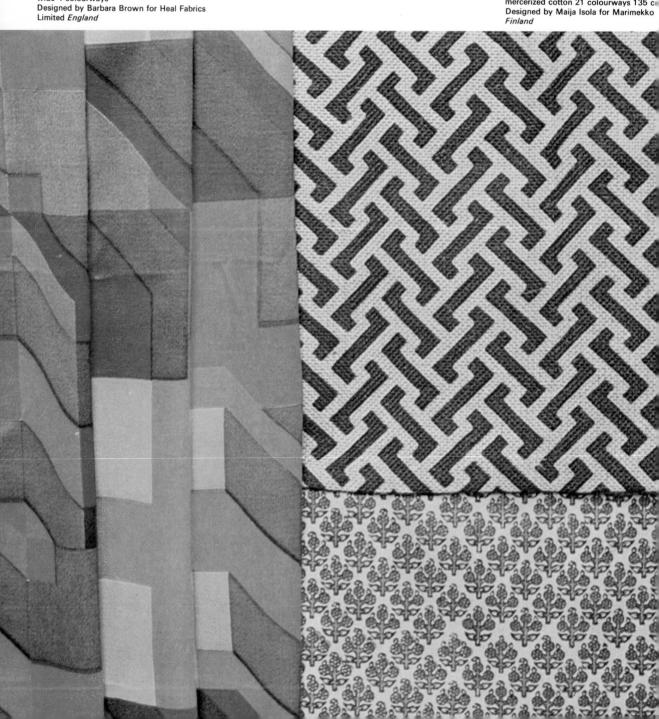

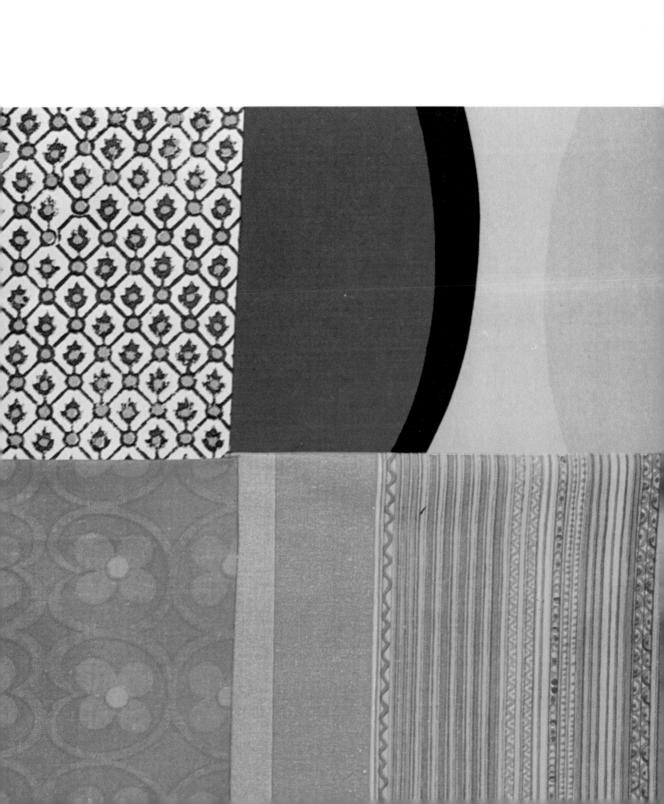

Adriaco all wool rug, cm 137 × 183 Designed by Ritva Puotila, machine-made by Oy Finnrya Ab, *Finland*

Signal screen-printed 100% cotton, four colourways: cm 122 wide
Designed by Peter McCulloch for Heal Fabrics Limited, England

nand-screen printed wallpaper from the dio 8 range: cm 56 wide gned by Judith Cash for The Wall Paper ufacturers Limited, *England*

at Night lithograph cm 51 × 67 Noward Hodgkin, England In a range of prints at the Alecto Gallery, don

1969-70 · textiles and wallpapers · 345

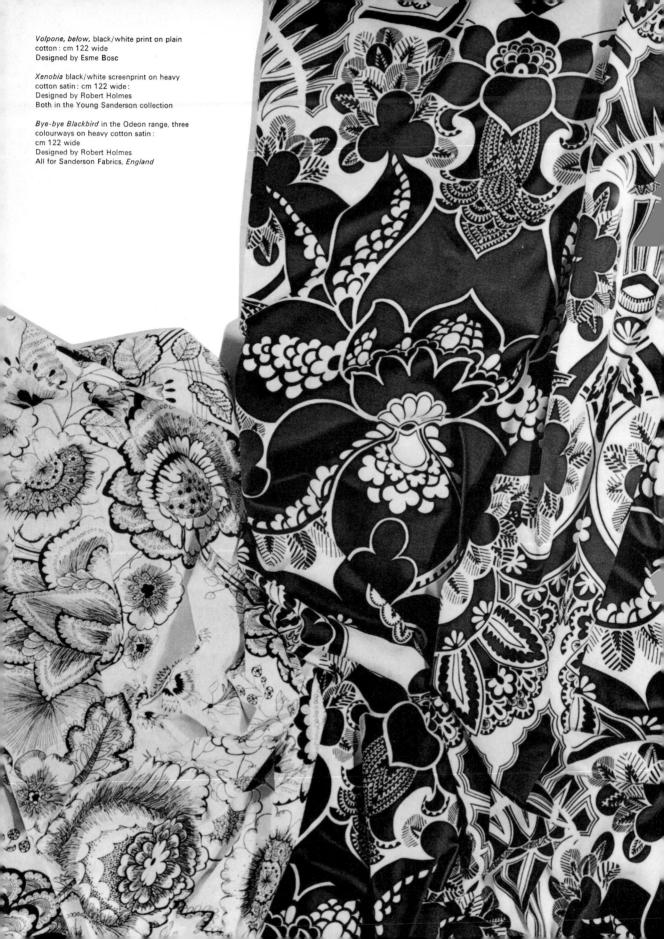

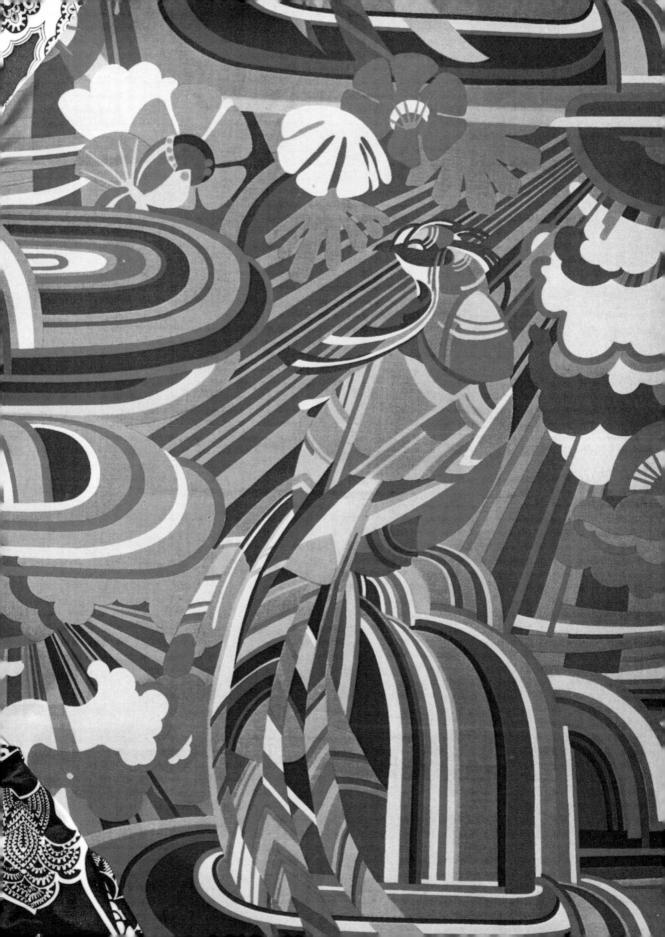

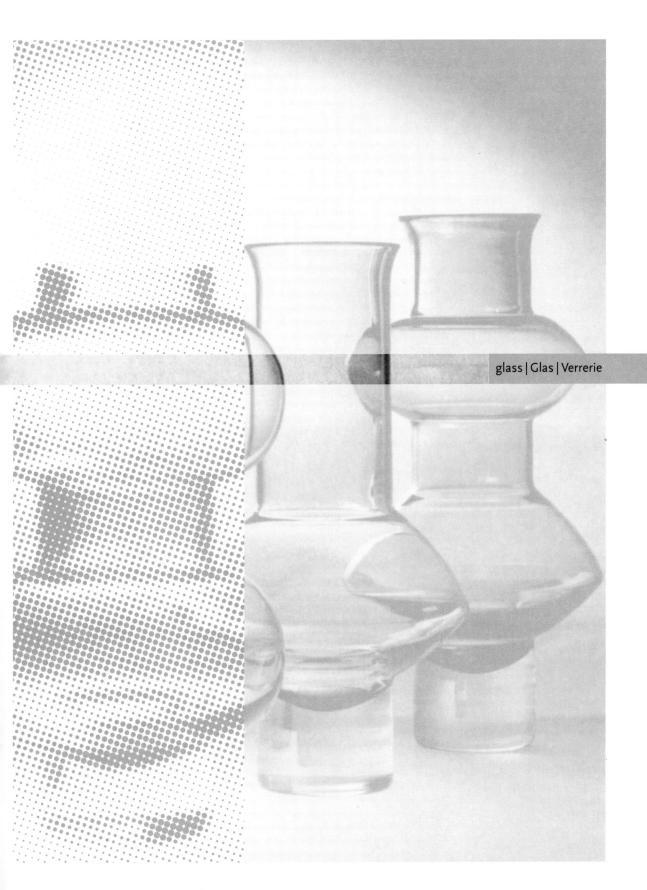

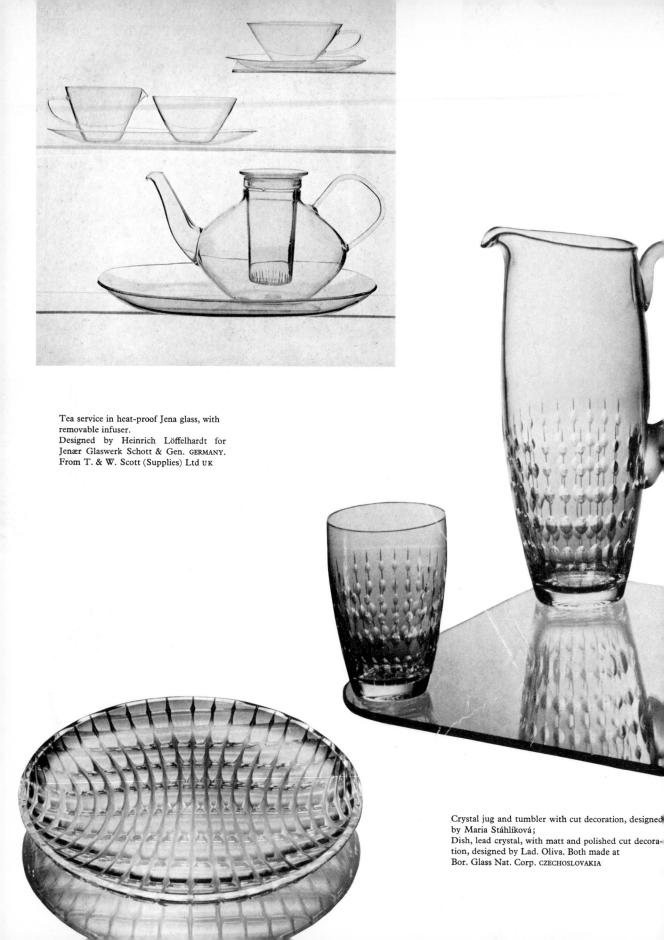

'Giraffe' water jug and tumbler from the <code>Calypto</code> service in bent glass with imprinted milk-white design of eucalyptus leaves and flowers. Designed by W. M. Harris, Royal College of Art, for W. E. Chance & Co. Ltd uk

Thick crystal jugs, clear and coloured; unique pieces designed by Grethe Meyer and Ibi Trier Mørch for A/S Kastrup Glasvaerk DENMARK ▶

Clay-infused crystal tumblers, designed by Masakichi Awashima for the Awashima Glass Company Ltd JAPAN ▼

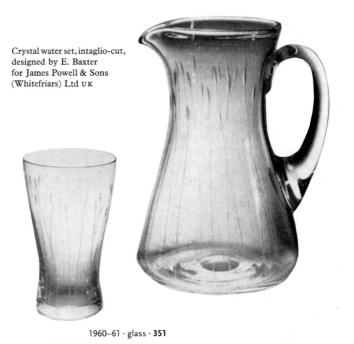

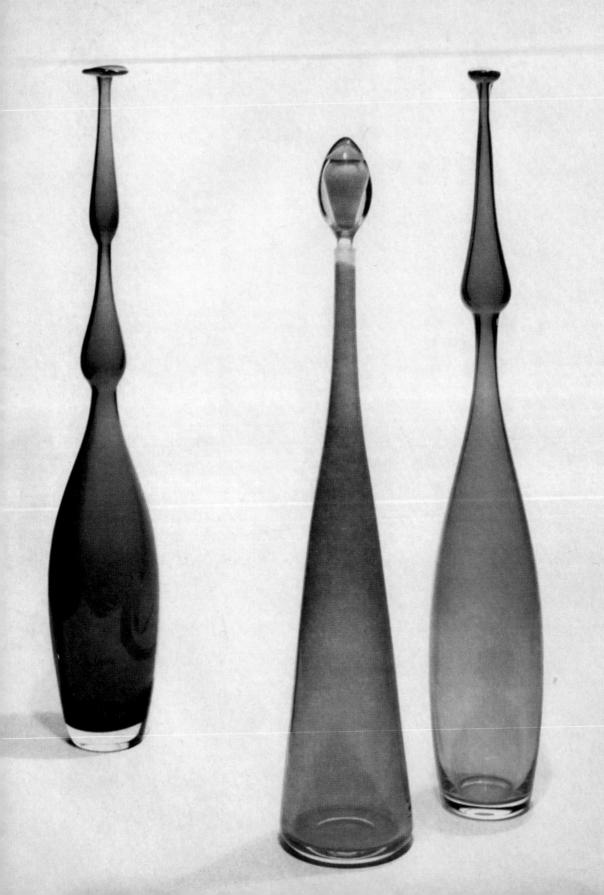

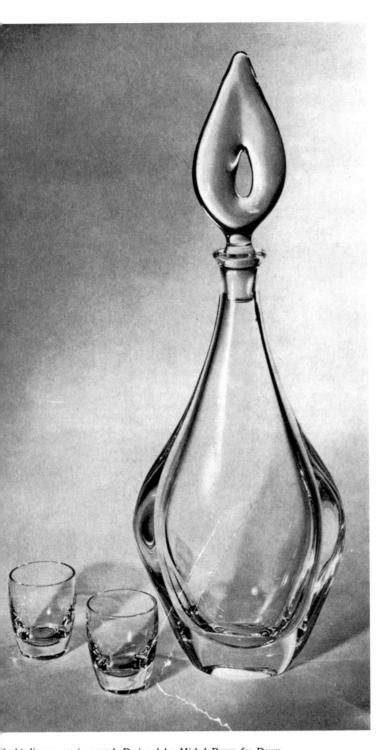

Orphée liqueur set in crystal. Designed by Michel Daum for Daum tallerie de Nancy FRANCE

Coloured crystal bottle vases with clear base. About 29½ inches high, is a unique piece designed by F. Meydam for NV Koninklijke sfabriek Leerdam HOLLAND

▶ Clay infused crystal decanter and beaker designed by Masakichi shima for the Awashima Glass Co. Ltd Japan

il-crystal decanter and glass with cut decoration. Designed by Vicke distrand for AB Kosta Glasbruk SWEDEN

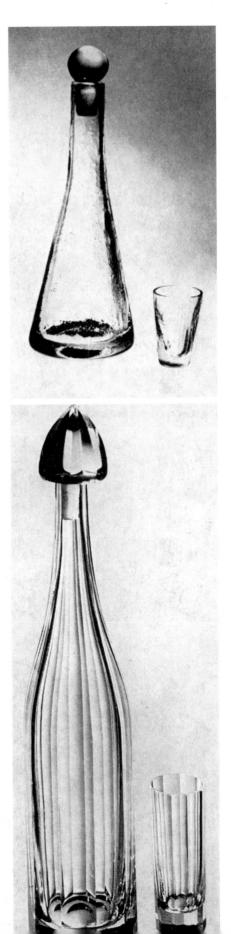

⋅ glass ⋅ 1960–61

OPPOSITE: Vase in thin-walled blown crystal from the *Ypsilon* series with coloured air-filled glass spheres.

Designed by Mona Schildt for

Designed by Mona Schildt for AB Kosta Glasbruk sweden

Shallow fruit bowl in coloured crystal, with curved edge; overall width 13½ inches.
Designed by Max Ingrand FRANCE for Fontana Arte ITALY

Platter of thick rough glass, sand-blasted and polished, diameter 17 inches.
Designed and made by Max Ingrand FRANCE

Thin-walled blown crystal bottle vases, clear or coloured. Designed by Ingeborg Lundin for AB Orrefors Glasbruk SWEDEN

Lead crystal bowl with colour suspended in the body of the glass. Designed by Tapio Wirkkala for Karhula-Iittala Glassworks FINLAND

Two-colour large crystal plates, triangular, oval and square shapes, designed by
Timo Sarpaneva
for Karhula-Iittala Glassworks
FINLAND

Opaline glass bowls with transparent etched bands in acquamarine and blue, or in grey and amber, 14 inches diameter. Designed by Dino Martens for Vetreria Rag. Aureliano Toso ITALY ▼

Free-hand lead crystal bowl, 23 inches diameter. Designed by Vicke Lindstrand for AB Kosta Glasbruk SWEDEN

1960-61 · glass · 357

Antique green vase with rough cut relief decoration. Designed by Victor Berndt for AB Flygsfors Glasbruk SWEDEN

▶ Vases from a series executed in clear colours; about 16 inches high. Designed by F. Meydam for NV Koninklijke Nederlandsche Glasfabriek Leerdam HOLLAND

▼ Bottle vases, 13 inches high, and pedestal bowl in transparent turquoise glass. Designed by Enrico Bettarini for La Fenice ITALY

Horses in clear crystal, smoke, olive green. Designed by Jaakko Niemi for Wärtsiläkoncernen A/B Notsjö Glasbruk FINLAND

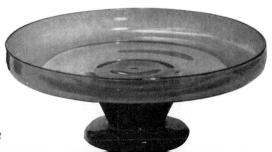

358 · glass · 1961–62

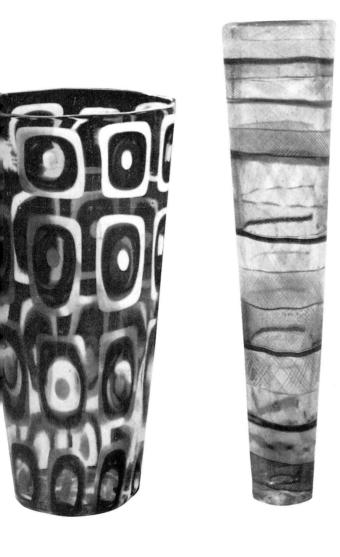

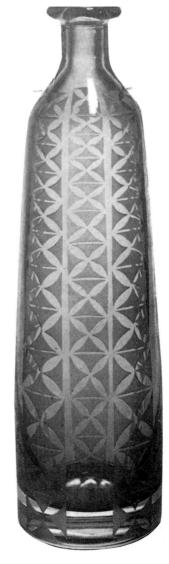

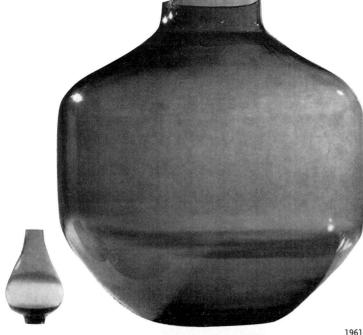

ABOVE, LEFT TO RIGHT

Vase composed of large fused pieces of white and acquamarine transparent glass; 13 inches high.

Designed by Ercole Barovier for Barovier &
Toso ITALY

Floor vase, 21½ inches high, with Zanfirico banded decoration in soft colours.

Unique piece designed by Dino Martens for Vetreria Aureliano Toso ITALY

Lead crystal bottle with amber inside casing and sand-blast decoration; 12 inches high. Designed by George Elliott, Royal College of Art; made by K. Wainwright at Stourbridge School of Art UK

■ Floor vase, about 15½ inches square, and matching specimen vase in green, blue, steel, gold or amethyst transparent glass. Designed by R. Stennett-Willson, MSIA, for Lemington Glassworks UK

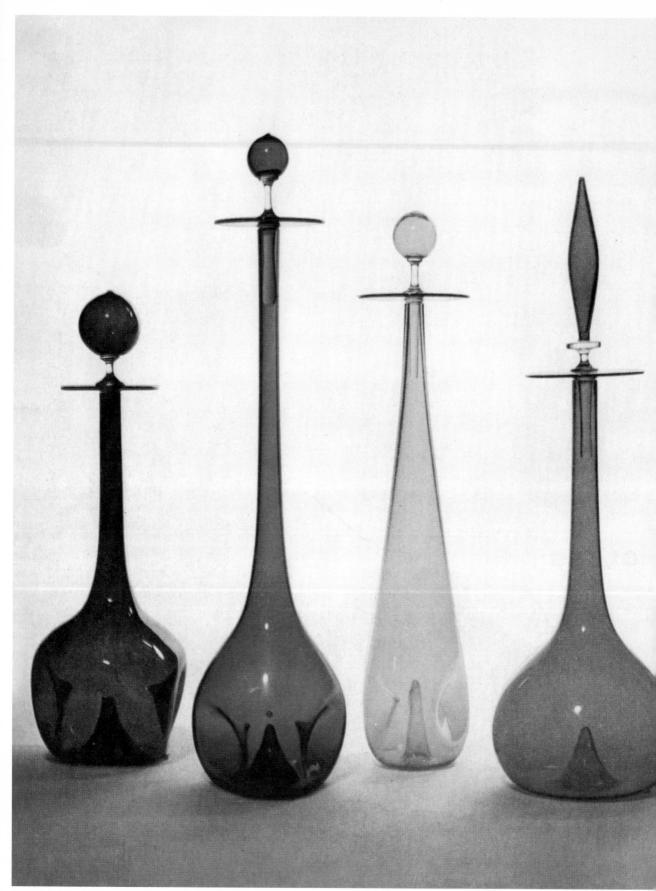

· glass · 1961–62

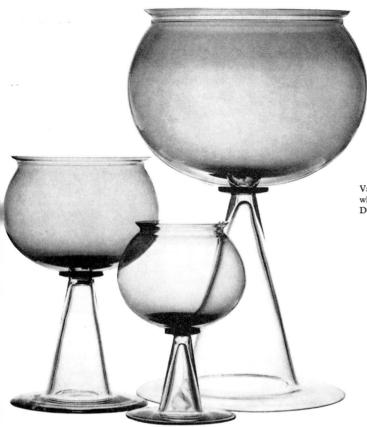

Vases in amethyst or dark indigo soda glass, with blown, clear white stems; 9, 6 and 14½ inches high.

Designed by Kjell Blomberg for Gullaskrufs Glasbruks AB, SWEDEN

Candleholder in heavy crystal with shade in blue, ruby or clear crystal; 11 inches high.

Specimen vases with trapped bubble, made in amber, Arctic blue, ocean green, twilight or clear crystal; 8½ inches high.

Designed by W. J. Wilson, FSIA, for James Powell & Sons

(Whitefriars) Ltd UK

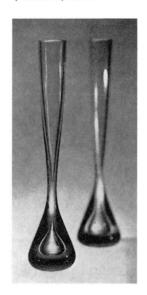

Floor vase in transparent coloured glass, 23½ inches high. Designed by Josef Hospodka for Borské sklo n.p. CZECHOSLOVAKIA

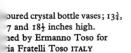

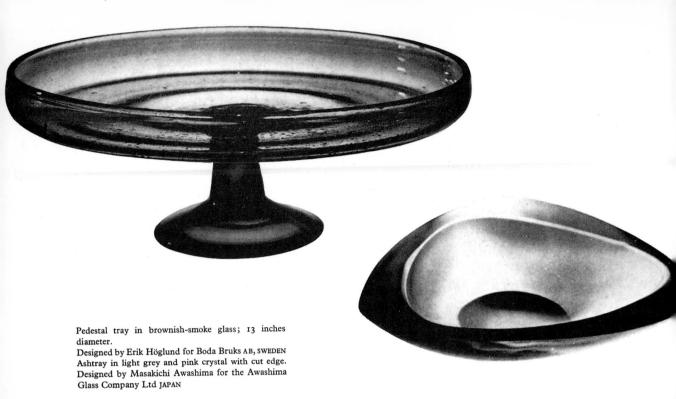

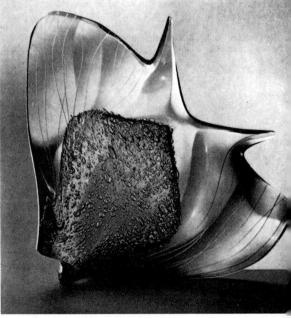

Ashtray Phillippines, engraved crystal; 7 inches diameter.

Designed and made by René Lalique & Cie France Fish in clear crystal with air-filled body and engraved veining; about 10 inches high.

Designed by Stanislav Honzík for Borské sklo n.p. CZECHOSLOVAKIA

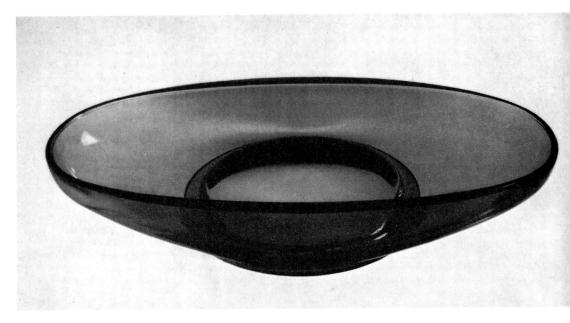

Flint glass dish in coloured glass, as shown, or clear; width overall 12½ inches. Designed by John Cochrane, MSIA, with Milner Gray, RDI, FSIA, of Design Research Unit for Geo. Davidson & Co. Ltd UK Dark topaz cased crystal bowl, 16 inches diameter, and greenish-yellow dark topaz shell.

Designed by Flavio Poli for Seguso Vetri D'Arte ITALY

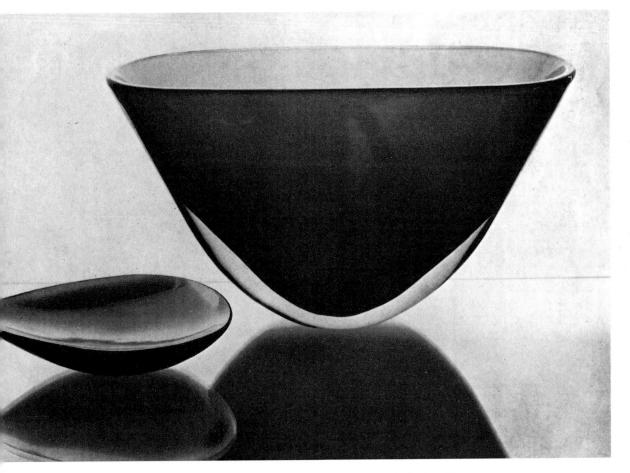

1961–62 · glass · **363**

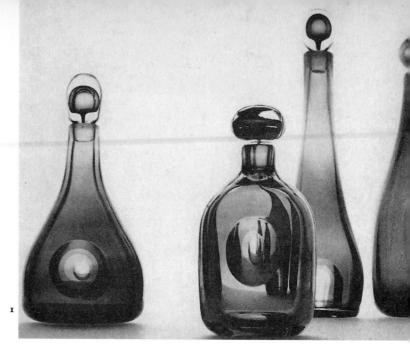

r Crystal decanters with a colour layer suspended in the body of the glass; in individual colourings with contrasting stoppers.

These and the thick crystal vases 3 and 4 OPPOSITE are from the *Ventana* series in which a prism-like effect is obtained by a variation of the 'doubling technique' with coloured layers encased within clear crystal and a 'window' then cut to the coloured core. Each piece is unique, varying in size from 4 to 9 inches high. Designed by Mona Morales-Schildt. Made by AB Kosta Glasbruk SWEDEN

Clear crystal paperweights with colour inlay; the tallest is 7 inches high. Designed by Mona Morales-Schildt. Made in a limited series by AB Kosta Glasbruk sweden

Photos Beata Bergström

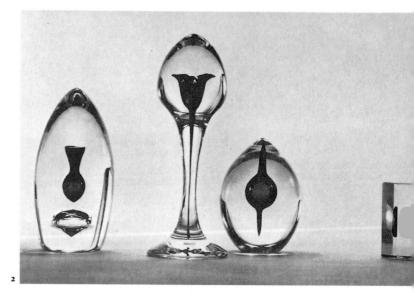

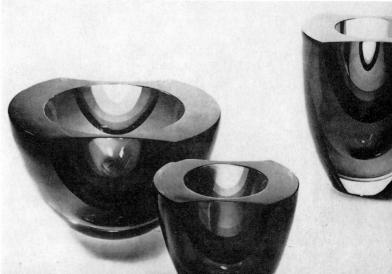

3

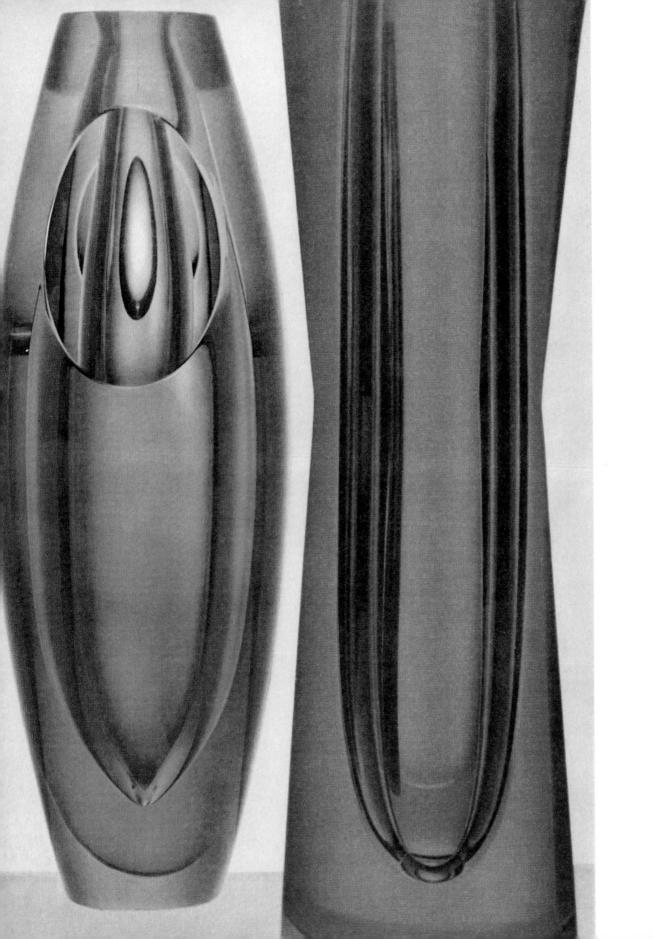

Slender candleholders in crystal, named 'Grete' after the little girl; 5, 9, 12 and 14 inches high. Designed by Per Lütken for Holmegaards Glasværk a/s DENMARK

2 Candlestick, ball and covered jar, transparent and opaline glass in various colours. Designed by Angelo Barovier for Barovier & Toso ITALY

Coloured glass vase and bowl, in blue, green, brown, silver and grey. Designed by Gunnar Ander for AB Lindshammars Glasbruk sweden

4 Crystal vases with fine linear engraved decoration. Designed by Ludvika Smrčková. Made by Borské sklo, n.p. CZECHOSLOVAKIA

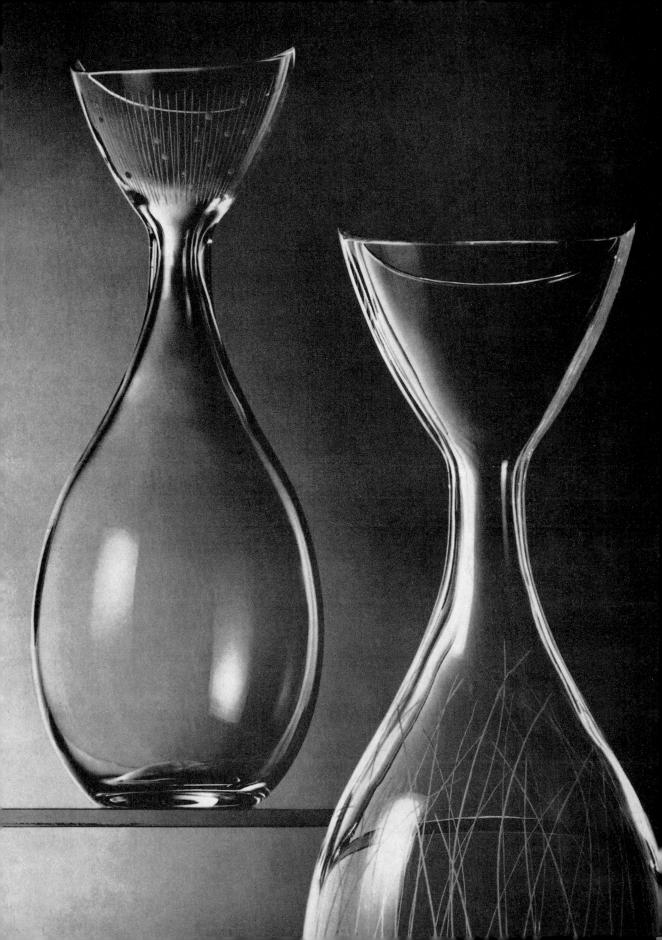

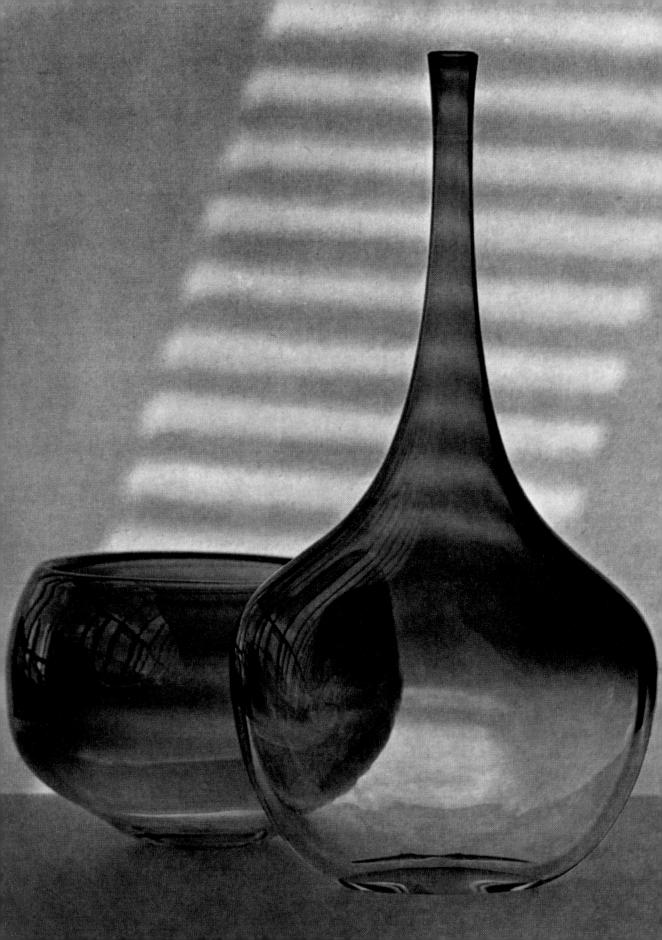

PHOTO: ANN WÄRFF 8

and vase, handblown in light t; vase 45 cm high ned by Bengt Orup for ohansfors Glasbruk SWEDEN

blue glass handblown bowls, with optics; tallest vase 36 cm and by Jacob E. Bang for Kastrup Glasværk DENMARK

ry glass, blown cup in smoke grey, -formed clear crystal base se' savings bank vases, blown e glass with air bubbles trapped e body; 12 cm overall designed by Göran Wärff for bergs Glasbruk sweden

tal ashtrays, pressed glass; diar 12 cm gned by Masakichi Awashima for Coshida Glass Mfg Co Ltd JAPAN

I Leerdamunica deep blue crystal vase; 25 cm high Designed by F. Meydam for NV Koninklijke Nederlandsche Glasfabriek 'Leerdam' HOLLAND

Punch bowl in clear crystal, grey and blue; 20 cm high Designed by Nils Landberg for AB Orrefors Glasbruk SWEDEN 3 Wine and beer glasses in greyish-green glass with trapped air bubbles Designed by Erik Höglund for Boda Bruks AB SWEDEN

4 Hand-ground thick crystal ashtray with colour inlay Designed by Max Ingrand for Fontana Arte ITALY

PHOTOS I, 5: ARCHIEF LEERDAM 3: BEECHES STUDIO, 7: SUNDAHL

lamunica unique clear crystal with colour inlay gned by F. Meydam for Koninklijke Nederlandsche Glasek 'Leerdam' HOLLAND

r crystal vases; 16 and 12 cm high gned by Nils Landberg for AB fors Glasbruk SWEDEN

s in steel grey, copper green or e green crystal; 10, 22 and 11 cm

gned by Tom Möller for Reijmyre bruk SWEDEN

l edge crystal vases with cut ration, clear and smoke grey; 23 15 cm high

15 cm high igned by Ingeborg Lundin for AB fors Glasbruk sweden

8

T Cocktail shaker and glasses in clear crystal. Designed by Nils Landberg
2. 3

2, 3

Ingeborg barware service in clear crystal, blue and grey

Expo clear crystal vase with copper wheel engraved decoration; 23 cm high Designed by Ingeborg Lundin

4 Rocamadour thick-walled clear crystal vase; 50 cm high

Designed by Michel Daum for Daum Cristallerie de Nancy FRANCE

5
Expo high polished clear crystal vases with cut decoration; 20 and 12 cm high Designed by Sven Palmqvist

7
Hock glasses in clear crystal
Designed by Nils Landberg
1-3, 5, 7 all for AB Orrefors Glasbruk
SWEDEN

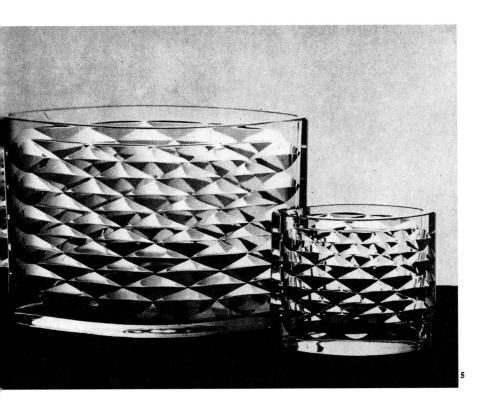

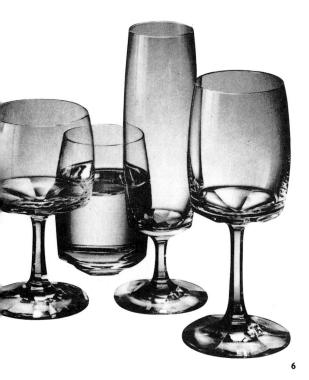

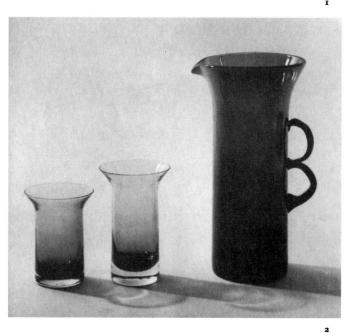

PHOTO I PIETINEN
PHOTO 2 GIORGIO CASALI
PHOTO 3 ERKKI VAALLE
PHOTO 5 ANNELIES SCHOLT;
PHOTO 6 WAHLBERG
PHOTO 7 GEORGES VERCHEVA

anter and glass in blue or lilac tal

igned by Timo Sarpaneva for hula-Iittala Glassworks FINLAND

and glasses, hand-made blown Series 408/9/10 in green or thyst with interior crystal coat, ng a soft effect igned by Sergio Dello Strologo for

estante ITALY

ered jars and bottles, hand-blown arious colours

igned by Nanny Still for Riihimäen O/Y FINLAND

anter and paper weight in fullcrystal

igned by Vicke Lindstrand for Kosta Glasbruk sweden

sky decanter and glass, blown and crystal

igned by A.D. Copier for NV inklijke Nederlandsche Glasfab-'Leerdam' HOLLAND

te carafe and glasses, thin-walled r crystal

igned by Asta Strömberg for A/B imbergshyttan sweden

sky and aperitif tumblers Murcie rystal with solid base igned by Z. Busine for S.A. Manuure de Boussu BELGIUM

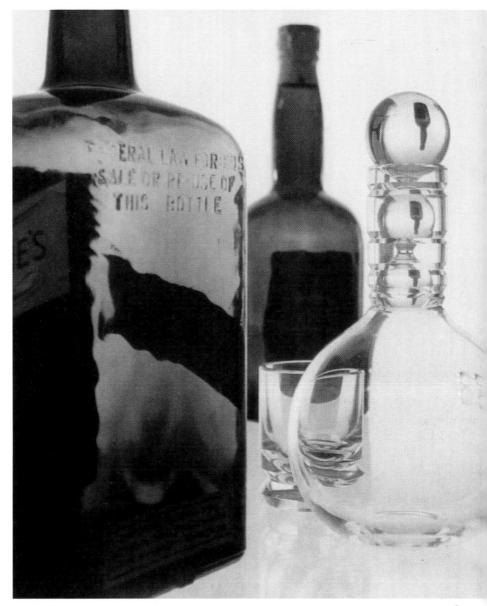

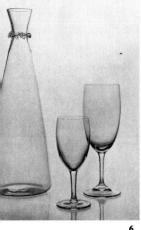

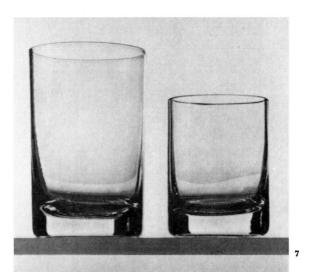

Light blue vase in the Ravenna technique; 24.5 cm high
Designed by Sven Palmqvist for A/B
Orrefors Glasbruk SWEDEN

Plate and bowl in hand-moulglass; 38 cm and 25 cm diameters Designed by Göran Wärff for Pu bergs Glasbruk SWEDEN

2 Pedestal bowls in blown glass; II and 24 cm high Designed by Lojo Linssen for Koninklijke Glasfabriek 'Leerd HOLLAND

3 Decanter 42 cm high, and jars blown glass Designed by Pavel Hlava (UBOK Decanter made at Zeleznobros Sklo, n.p.; jars at Borské Sklo, CSSR

PHOTO I ANN WÄRFF PHOTO 2 ANNELISE SCHOLTZ PHOTO 3 LUMÍR ROTT

Crystal glass vase blown into a burnt mould, 22 cm high, clear or smoke-grey Designed by Timo Sarpaneva for Karhula-Iittala Glassworks FINLAND

Tulip-shaped wine glasses Designed by Claus Josef Riedel for Tiroler Glashütte AUSTRIA Dark brown fruit bowls
Designed by Benny Motzfeldt for
Hadelands Glassverk NORWAY

Olympia vases, lead crystal, surface etched, the base cut and polished tallest 33 cm high Designed by Claus Josef Riedel for Tiroler Glashütte AUSTRIA

photo KJELL

photos JOWA PARISINI

ured vase with metal sheet in the walls of the glass, 35 cm , a unique piece 3ned by Pavel Hlava, UBOK ké sklo, n.p. CZECHOSLOVAKIA

bowl in brown glass edged blue, 15 cm high gned by Göran Wärff for Glasbruk AB SWEDEN Covered jars in smoke-grey glass with lids in cut clear crystal, 16·5 cm, 7·5 cm and 12 cm high Designed by Gunnar Ander for Lindshammars Glasbruk AB SWEDEN Tall thin-waisted vases, 32 cm high Designed by Mona Morales-Schildt for Kosta Glasbruk AB SWEDEN

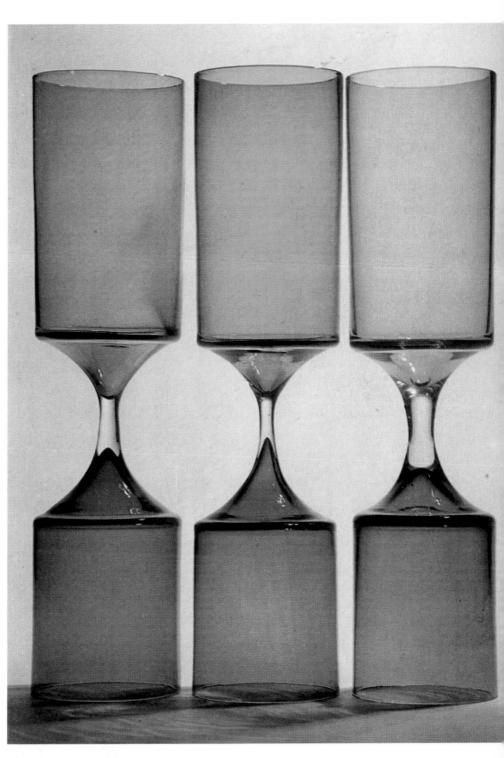

Hock glass in hand-blown crystal 15 cm high Designed by Michel Daum for Daum Cristallerie de Nancy France Viking carafe in blue or green antique glass, largest size 1 litre capacity
Designed by Ole Winther for Holmegaards Glasvaerk A/S
DENMARK
Crystal bottles about 30 cm high
Designed by Masakichi Awashima for Awashima Glass Company Ltd
JAPAN

Classic glass tumblers, clear an midnight-blue, green or smoke 25, 22 and 18 cl capacities Designed by Dumond & Lelou for S.A. Markhbein France Brandy glass and goblet of Shi trickle-glass Designed by Masakichi Awash for Awashima Glass Company Japan

'ypso crystal tumblers and mixer, mixer 55 cl capacity signed by Vicke Lindstrand for sta Glasbruk AB sweden nd-blown crystal glasses, 5 to 35 cl

acities signed by Bengt Orup for llinge Glashytta sweden

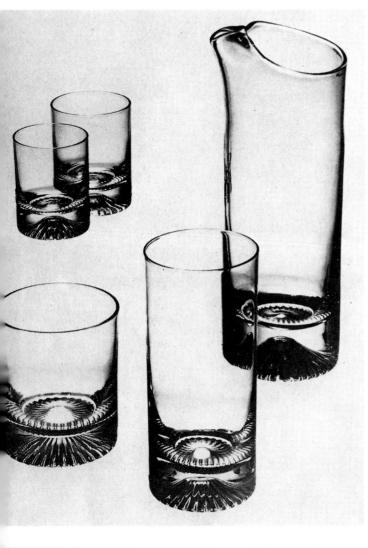

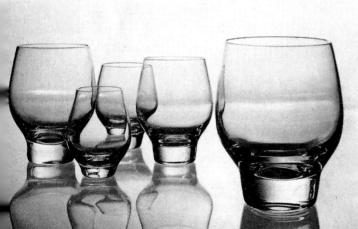

Pitcher and tumbler in smoke-blue glass, the pitcher 800 cc capacity the tumbler 180 cc Designed by the Industrial Arts
Institute for Sasaki Glass Company Ltd JAPAN

Bowls in clear crystal or ruby pressed glass, 11 and 18 cm diameter Designed by Gunnar Ander for Lindshammars Glasbruk AB SWEDEN

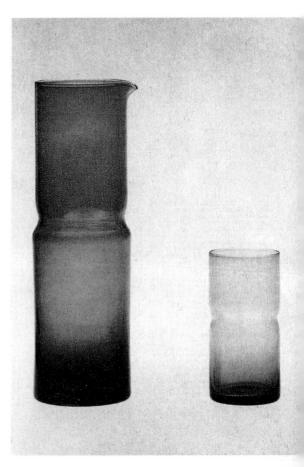

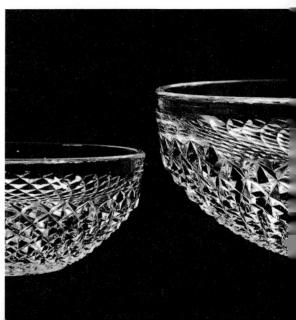

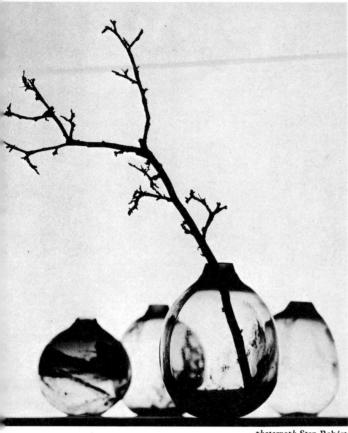

Vase in clear grey glass with black blisters: 40 cm high Designed by Eva Englund for Arvid Böhlmarks Lampfabrik SWEDEN

Unique bowl in engraved clear crystal 30 cm diameter Designed by Ove Snadeberg for Kosta Glasbruk AB SWEDEN

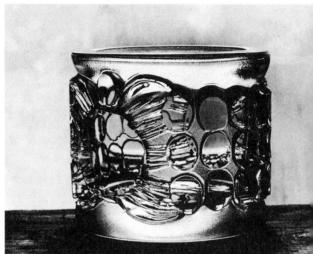

photograph Gr

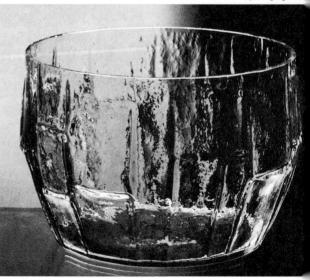

Blasted crystal bowl 18·5 cm diameter Designed by Bertil Vallien for Boda Bruks AB SWEDEN

Series 1609 bowl, clear or indigoblue crystal: 19 cm diameter Designed by Christer Sjögren for Lindshammars Glasbruk AB SWEDEN

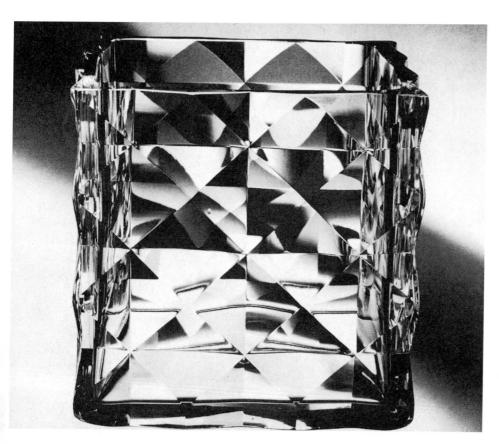

photograph Sten Robért

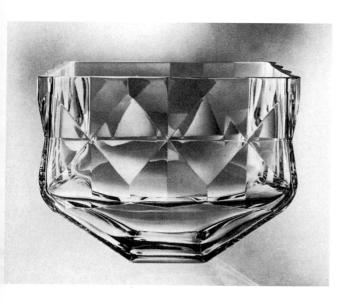

Heavy crystal bowls with cut decorations, 20 and 15 cm high Designed by Sven Palmqvist for Orrefors Glasbruk AB sweden

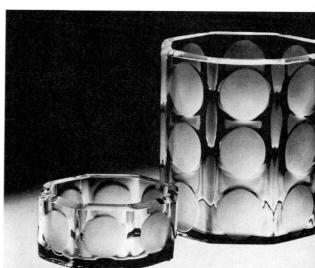

Bowl and vase in clear cut crystal: vase 23 cm high Designed by Ingeborg Lundin for Orrefors Glasbruk AB SWEDEN

top Vases in blue-grey cased crystal 23 cm high Designed by Ann & Göran Wärff for Kosta Glasbruk AB sweden

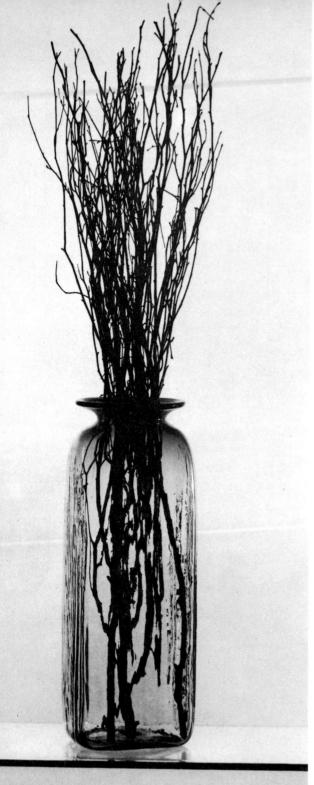

Bottle-jars handcrafted in olive, crystal, turquoise, honey, peacock or tangerine: approximately 26 cm high Designed by Joel Philip Myers for Blenko Glass Co USA

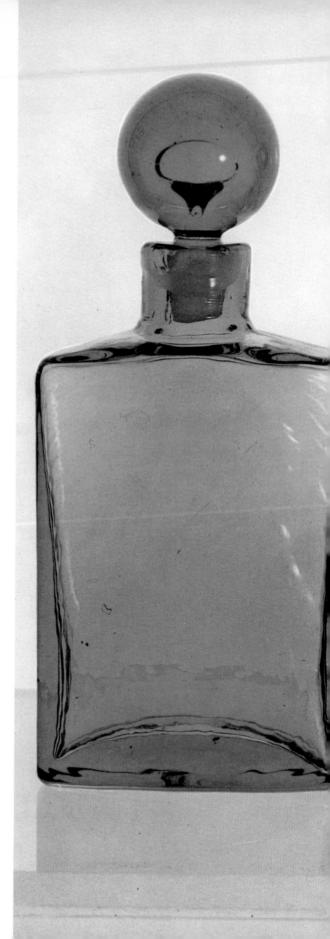

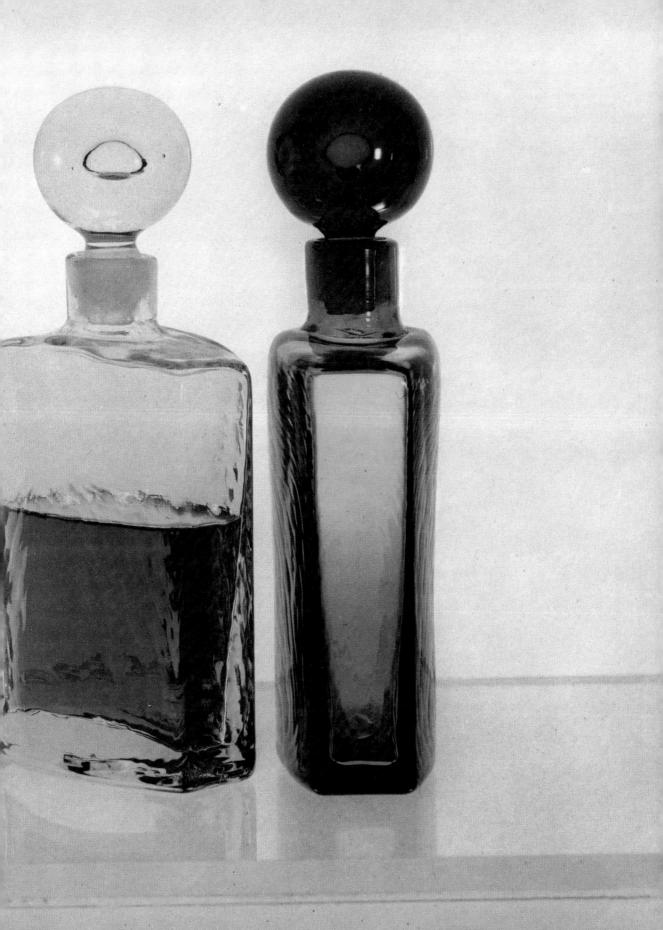

Set of stacked vases, household Designed by Alfred Seidl for Stölzle Glasindustrie AG Austria

Hand blown vase, clear crystal on smoke-green 20 cm high Designed by Nobuyasu Sato for Sasaki Glass Co Ltd *Japan*

Windhat bowl, blown household glass, clear and sea-blue, 36 cm diameter Designed by Tamara Aladin for Riihimäen Lasi Oy *Finland*

Vases K.7024/5 antique grey glass with small bubbles the larger 29 cm high Designed by Severin Brørby for Hadelands Glassverk *Norway*

Large dish machine spun, blue, honey, olive, crystal, 31 cm diameter Designed by Joel Philip Myers and made by Blenko Glass Co *USA*

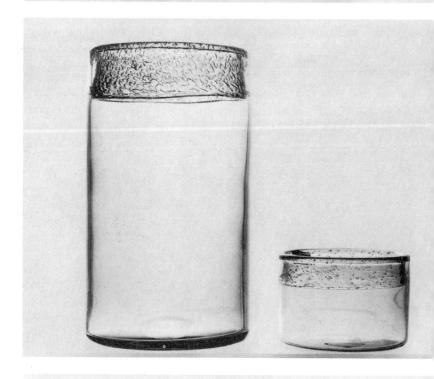

Covered bowls, mould blown, clear blue, green grey and crystal 7–10 cm high Designed by Naoto Yokoyama for Noritake Co Ltd *Japan*

Two of a series of opal crystal goblets from 18 to 28 cm high Designed by Gunnar Cyrén for AB Orrefors Glasbruk *Sweden*

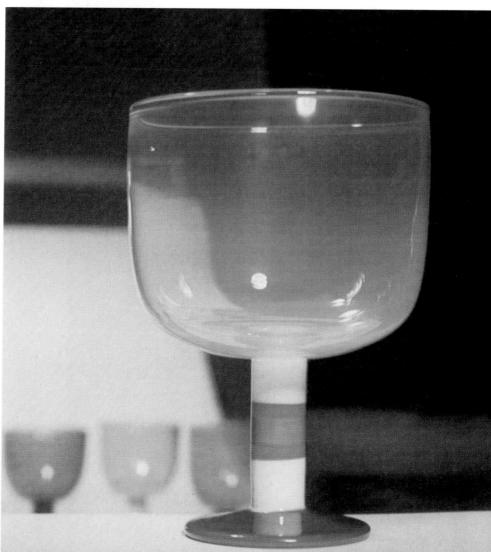

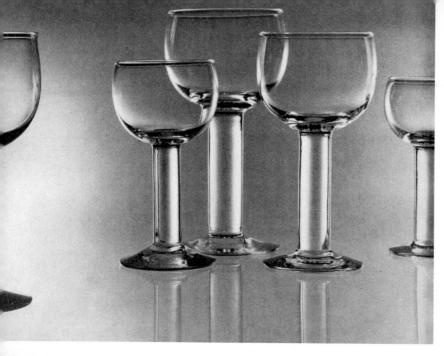

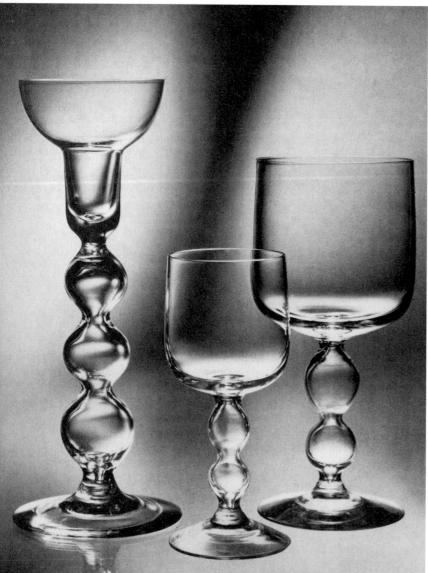

BS 2100 crystal stemware with solid stems designed by Gunnar Cyrén PS 2114 stemware with air bubbles Designed by Sven Palmqvist All made by AB Orrefors Glasbruk Sweder

Bowl from the *Sargasso* series, blister glass 15 cm high Designed by Notsjoe Glass/Kaj Franck for Oy Wärtsila AB *Finland*

Moonstone series handblown bowls and candleholders
Designed by Per Lütken for Kastrup and Holmegaards Glasvaerker A/S Denmark

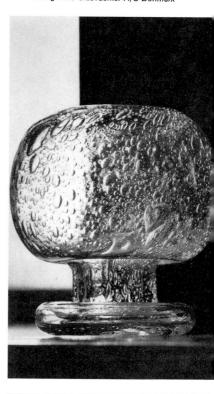

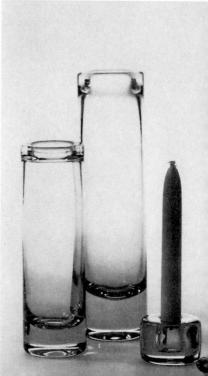

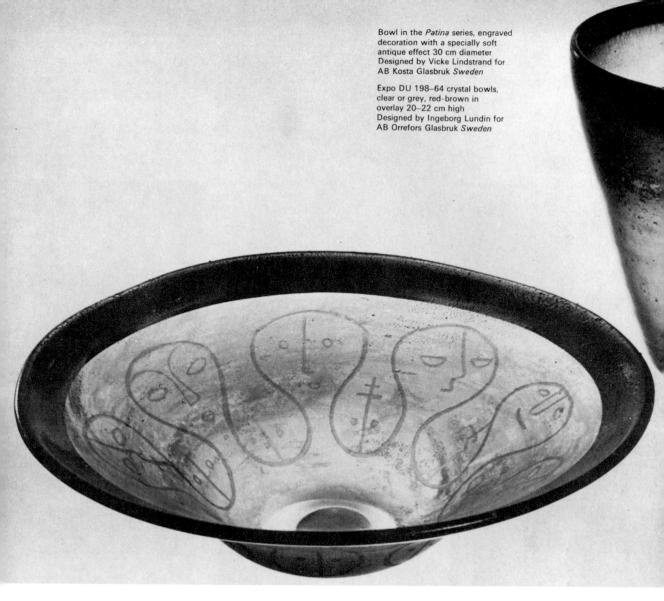

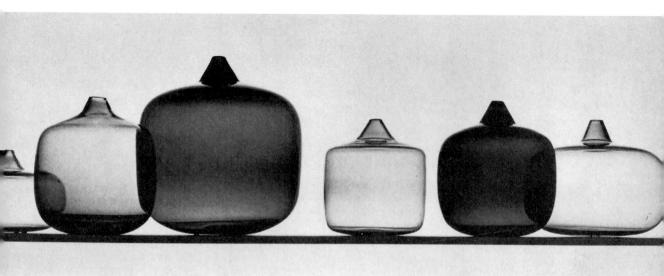

Kaja (shimmer) cut crystal with various coloured 'shade' 18 cm diameter Designed by Tamara Aladin for Riihimaën Lasi Oy Finland

Sunrise cut crystal vase 27 cm high Designed by Erkkitanio Siiroinen

Turmalin cut crystal vase with green or blue 'shade', 18 cm diameter Designed by Nanny Still both for Riihimaën Lasi Oy Finland

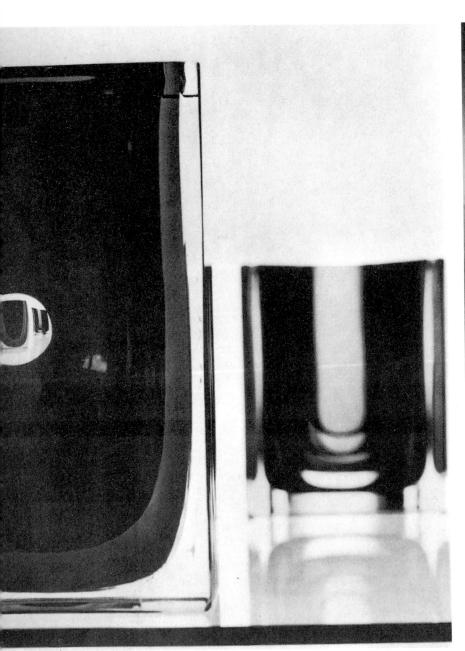

I glass tumblers ed by Kaj Franck and made Värtsilä AB *Finland*

Ila decanter and mug, blown busehold glass with blue or d tops, jug 1 litre capacity d by Nanny Still for Riihimaën Finland

right

e decanters and tumblers in d crystal with cut olives ed by Mona Morales-Schildt Kosta Glasbruk Sweden

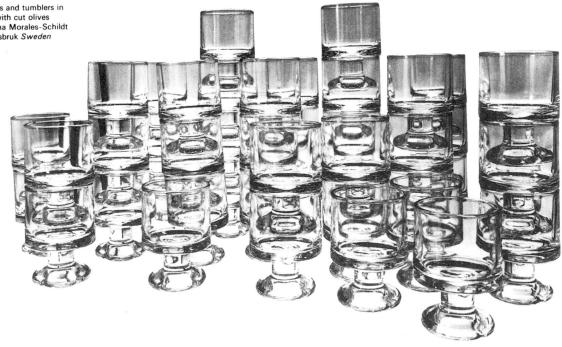

Sten Robert

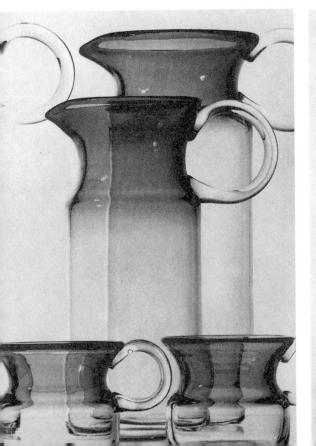

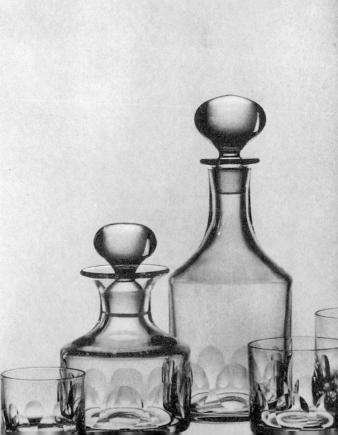

Ash tray in the *Cascade* series in clear crystal Designed by Yukio Ito

Decanter and tumbler in clear crystal from a series of table glass including stemware in various sizes

Designed by Denji Takeuchi/Nobuyasu Sato/Yuuji Takahashi

Tivoli series, tumblers, water pitcher, ice pail and decanter in smoke-green crystal, taller tumbler also available, pitcher 1 litre capacity Designed by Denji Takeuchi/ Yuuji Takahashi

opposite

Ash tray in smoke-green glass 20 cm diameter

Designed by Denji Takeuchi Wine decanter and glasses in clear crystal, decanter 72 cl

capacity Designed by Denji Takeuchi

All made by Sasaki Glass Co Lt Japan

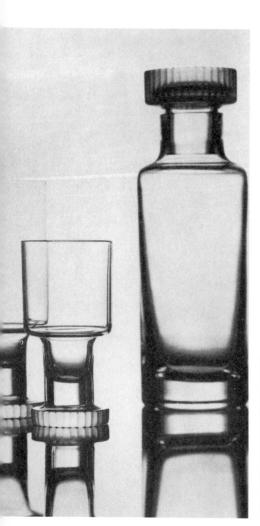

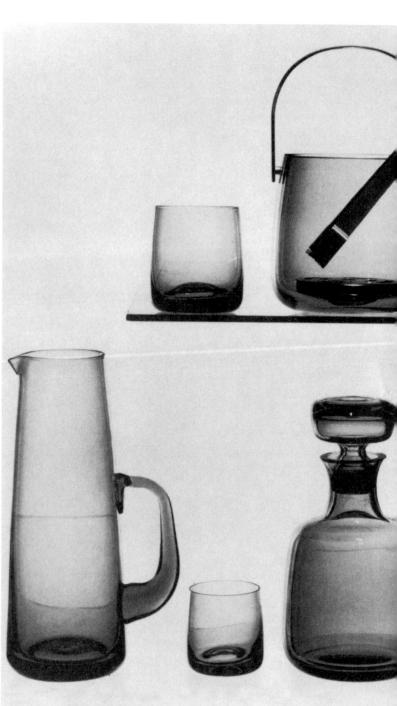

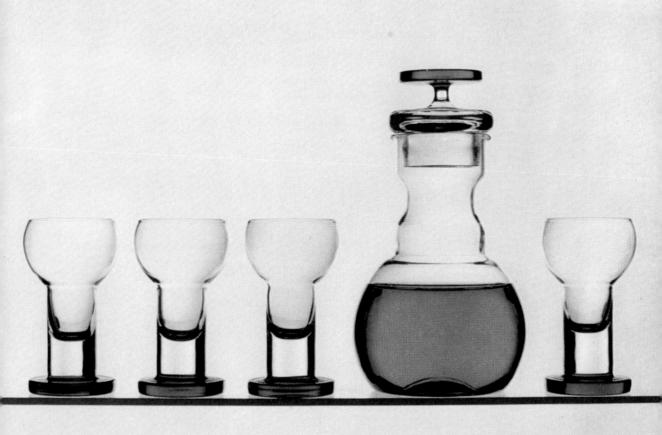

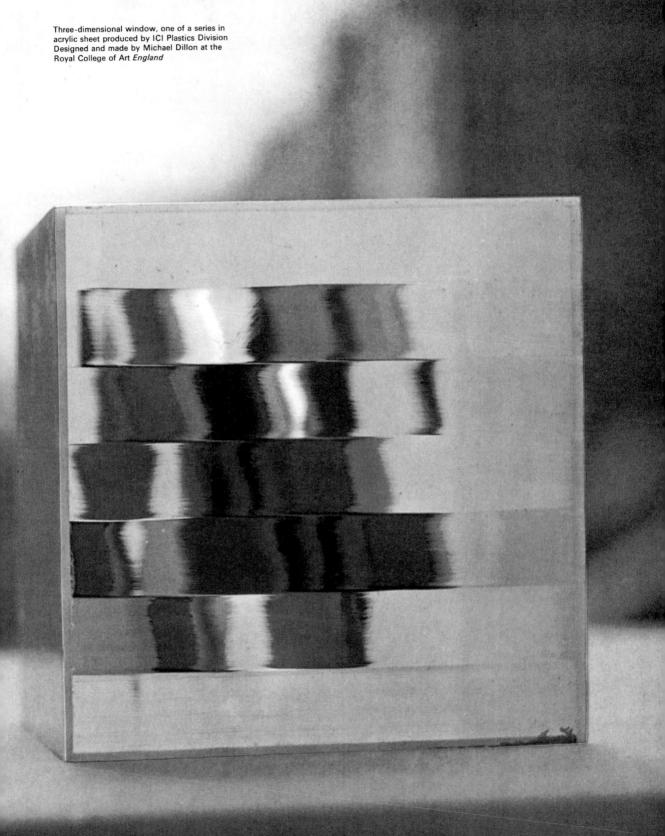

Fused glass panel approximately 30×30 cm; one of a series Designed by Alfred R. Fisher for Whitefriars Glass Limited *England*

Candleholders, mould-blown clear glass 31-5 and 18 cm high Designed by Timo Sarpaneva for littala Glassworks *Finland*

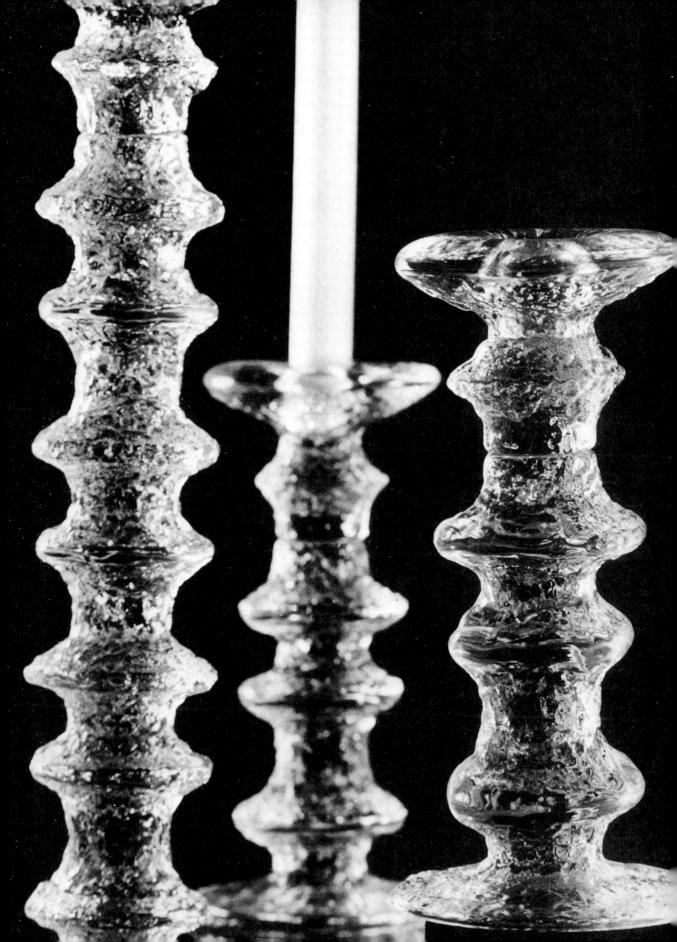

Doorstop, hand-made crystal approximately 6×9 cm

Paperweight, hand-made crystal approximately 6×6 cm

Both designed by Ronald Stennett-Willson for King's Lynn Glass Ltd *England*

Candlesticks in full-lead crystal Designed by Mona Morales-Schildt for Ab Kosta Glasbruk *Sweden*

Labyrinth clear and violet cut crystal 20 cm diameter Designed by Aimo Okkolin for Riihimäen Lasi Oy Finland 1

 $\it Glass\ Tree$ clear lead crystal, with small green balls, cast and glued: wood socle $60\times48\ cm$

Designed by Bengt Edenfalk for Skrufs Glasbruk Ab Sweden

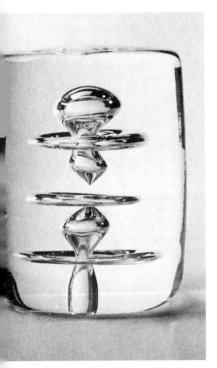

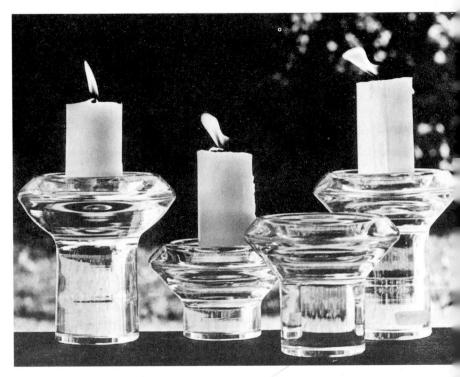

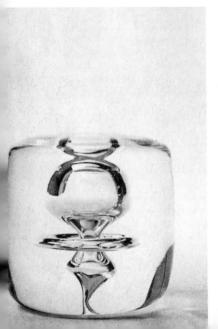

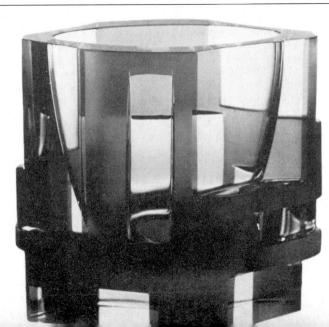

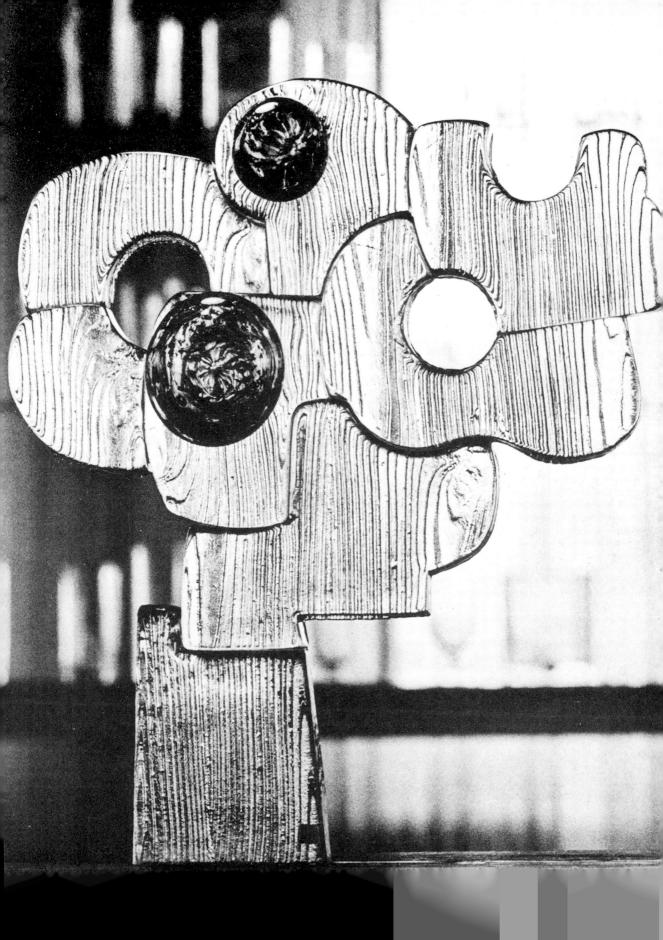

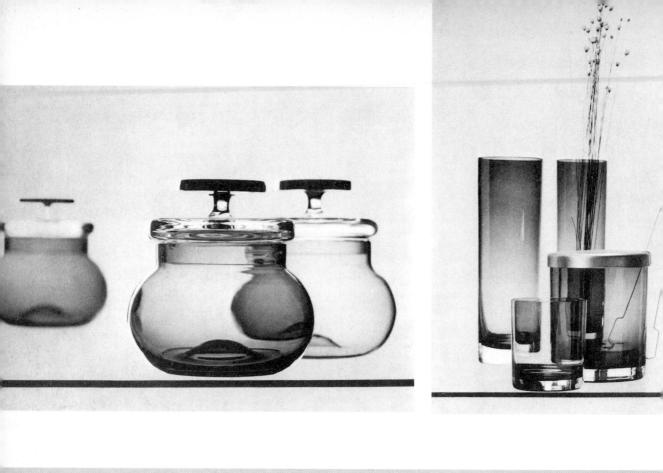

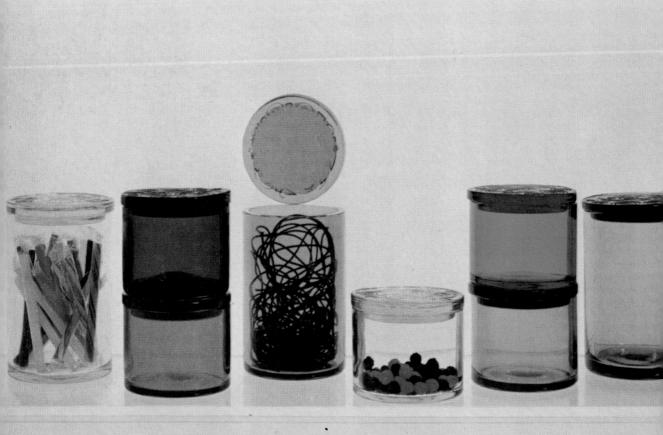

y jars in ruby, blue or green with clear I covers, 13 cm high ned by Denji Takeuchi , ice pail and tumbler, part of a series ding jugs, ashtray and cigarette box all in e/clear crystal cased glass, the vases n high ned by Nobuyasu Sato and Norimichi

r Sasaki Glass Company Limited Japan

crafted jars from 11 to 20 cm high ned by Joel Philip Myers for Blenko Glass pany *USA*

-made crystal candlesticks, 12.5 and n high ned by Ronald Stennett-Willson for King's Glass Limited England

ware, straw glass, plain crystal ned by Vera Liskova for Carlsbad Glass/ er N.C. *Czechoslovakia*

r set, ship's decanter and decanter, part range of hand-blown crystal gned by Frank Thrower for Dartington s Limited *England*

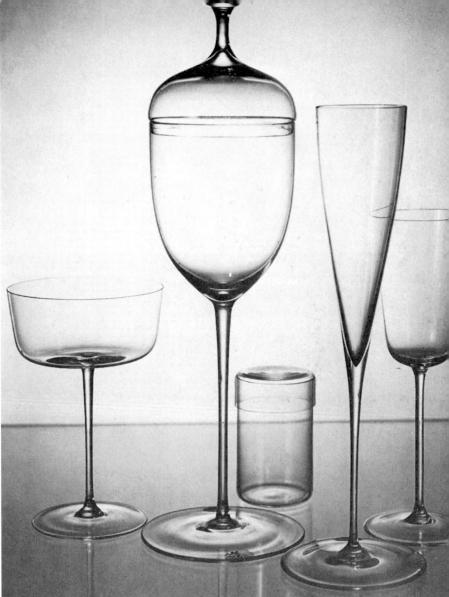

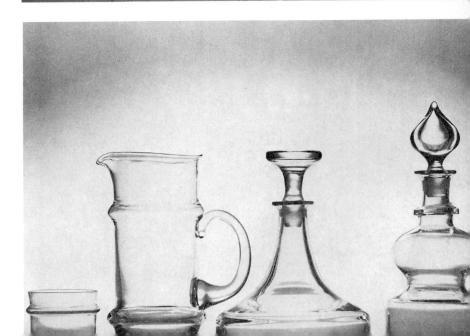

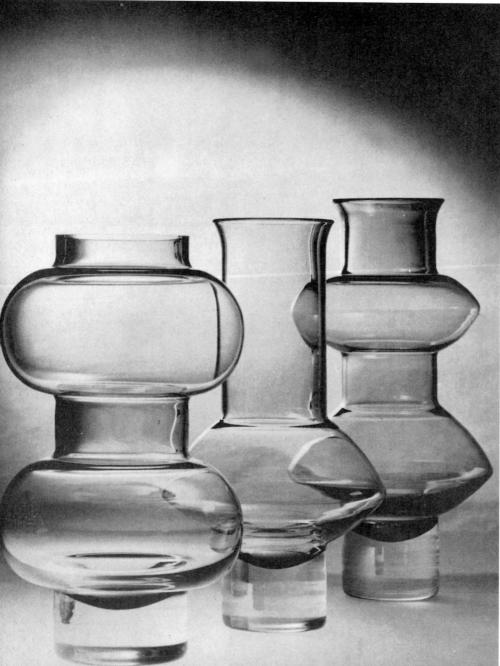

Stub handmade soda glass, flint or smoke Designed by Ibi Trier Mørch for Kastrup an Holmgaards Glassworks *Denmark*

Two-toned vases crystal with olive, amber or ocean blue: about cm 23 high Designed by Bo Borgstrom for Åseda Glasbruk Ab Sweden

Coat-hangers/striped decorative discs: cm 11 and 13 diameter Designed by Yôji Fusamae for Joetsu Crystal Glass Company Limited, *Japan* 4, 6

4, 6
NS 2130 goblets in clear crystal
Tumbler and decanter in clear cut crystal
Both designed by Nils Landberg for
Ab Orrefors Glasbruk, Sweden
5

Nut bowls; mould-blown glass, cm 10 diame Designed by Naoto Yokoyama for Joetsu Crystal Glass Company Limited, *Japan*

1 3 4 5 2 6

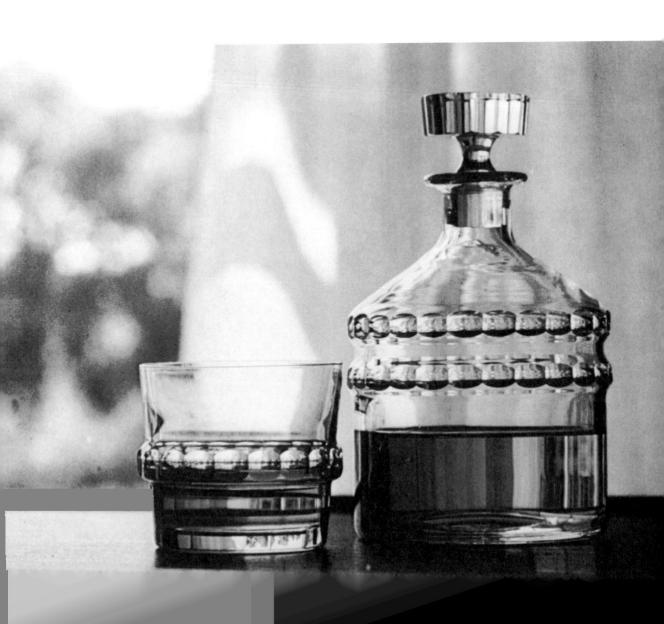

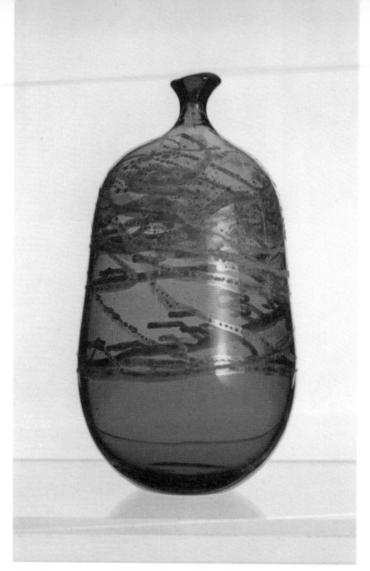

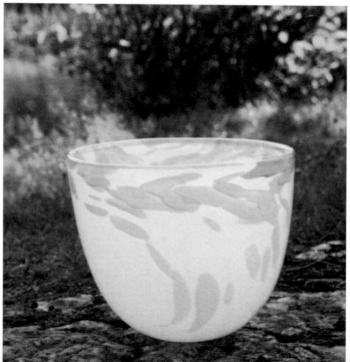

1 Vase in off-hand blown glass, purple lead glass with silver on surface: cm 18.4 × 33.3 Designed by Joel Philip Myers for Blenko Glass Company *USA*2 Bowl in full crystal, in floating colour technique: cm 23 high Designed by Rolf Sinnemark for Ab Kosta Glasbruk, *Sweden*3 Vase, layered and cut colour, opal/crystal/blue/red: cm 22 high Designed by Vratislav Sotola for Borske sklo n.p. Novy Bor. *Czechoslovakia*

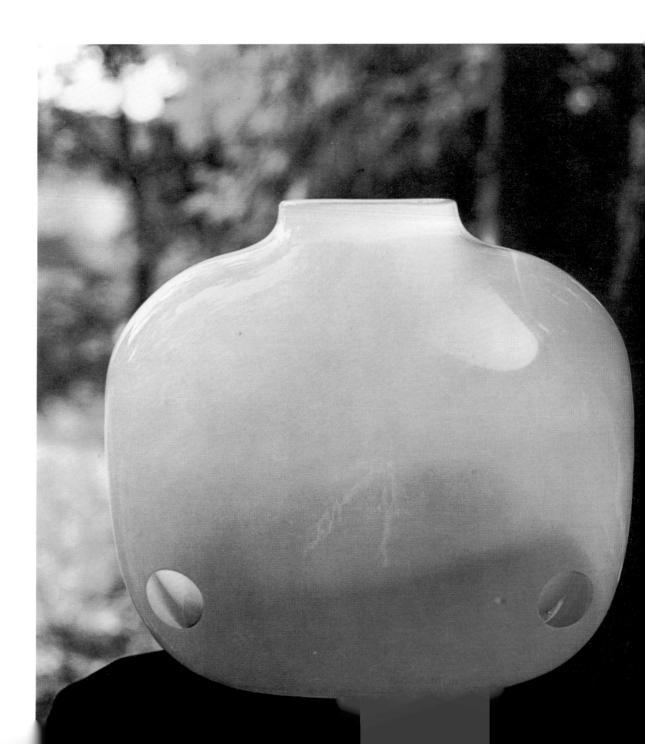

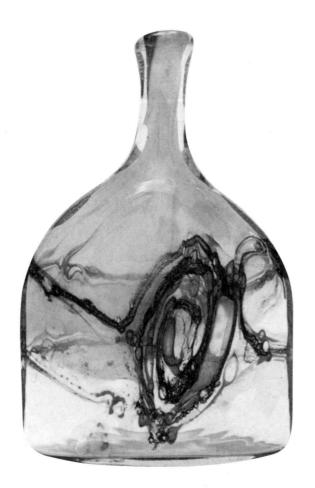

1 Plate free hand-blown, surface fumed cm 41.7 diameter
Designed and made by Gerald Rollason at the Royal College of Art, *England*2

Soda glass bottle, free hand-blown shape approximately cm 38 high Designed and made by Sam Herman, Engl

Off-hand blown vase, reverse blown crysta cased on yellow: cm 29.2 × 17.8 Designed and blown by Joel Philip Myers for Blenko Glass Company, USA

Vase, off-hand and mould-blown, blue yellow, green, red, amber and crystal: cm 21.6 × 36.9
Designed by Joel Philip Myers for Blenko Glass Company, *USA*

5 Glass form with inset brass filings: cm 35.6 × 25.4 Designed and made by Marvin B. Lipofskyl USA

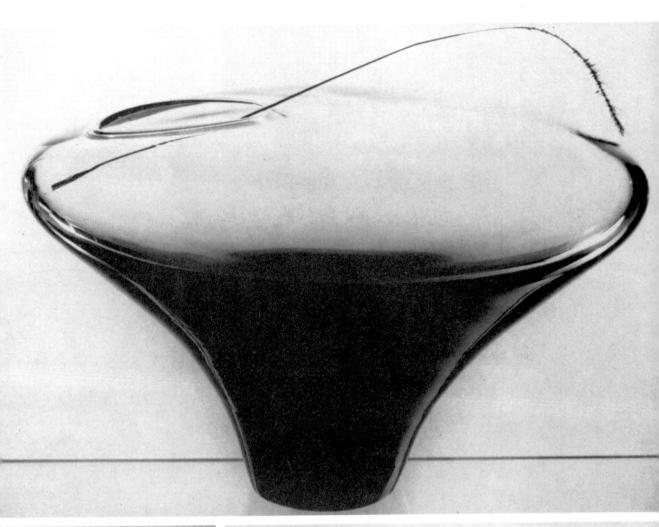

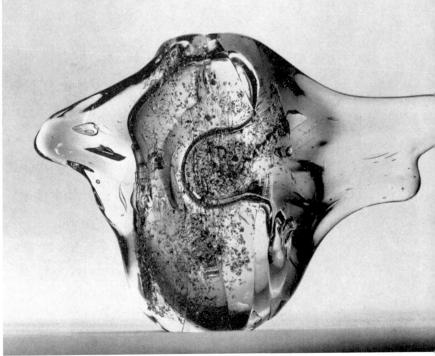

1969–70 · glass · **411**

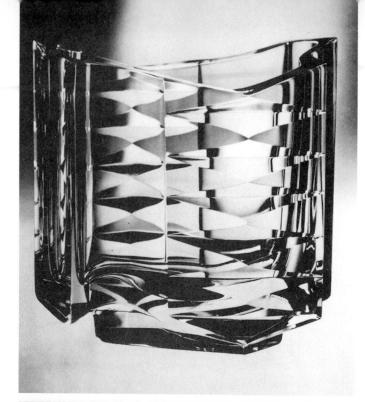

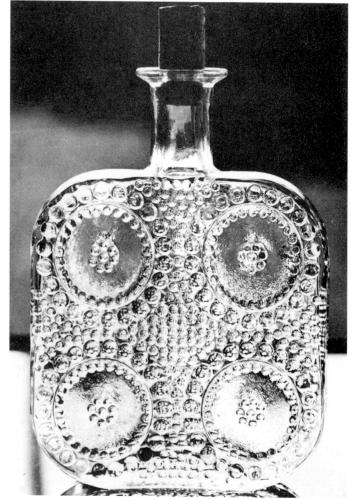

412 · glass · 1969-70

1 2 3 5 4 Konto cut crystal vase, clear and neoblue cm 25 high

Designed by Erkkitapio Siiroinen for Riihin Lasi Oy, Finland

Grapponia blown bottle in clear, mossgree and neoblue: cm 18.5 high Designed by Nanny Still for Riihimäen Las Finland

Tiara bowl, hand pressed and fire-polished soda glass: cm 10.2-22.8 diameter Designed by Kjell Blomberg for Gullaskrufs Glasbruks Ab, Sweden

Stellaria from a range of plates and dishes in hand-pressed and fire-polished soda glar cm 10.2-30.5 diameter Designed by Kjell Blomberg for Gullaskrufs Glasbruks Ab, Sweden

Kajo cut crystal vases, five colours : approximately cm 18 high Designed by Tamara Aladin for Riihimäen

Lasi Oy, Finland

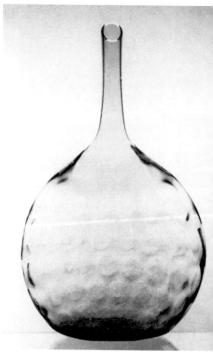

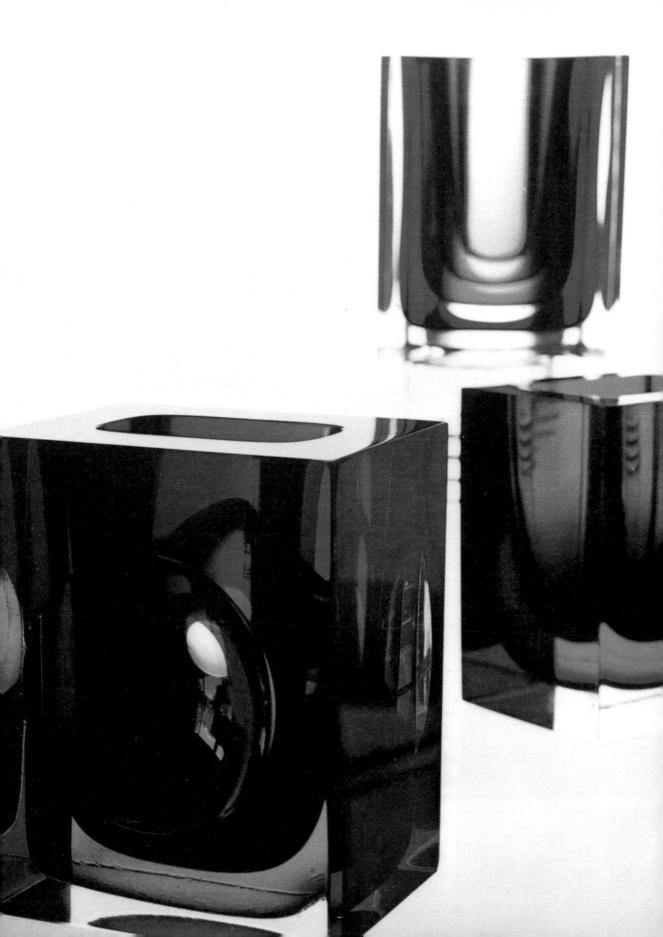

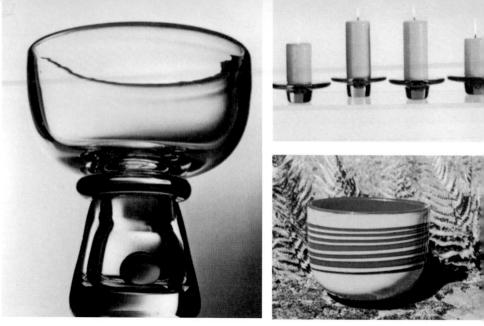

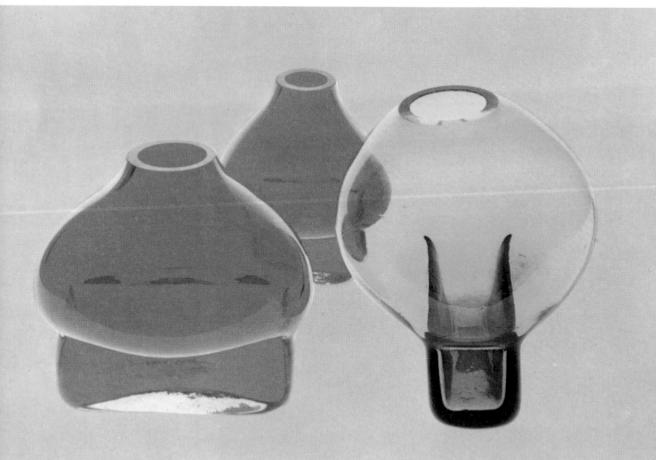

1 Free-blown wine cup of clear lead crystal, coloured glass ball in stem: cm 6 diameter Designed by Seitou Ochiai for Kagami Crystal Glass Works Limited, *Japan*

Candleholders off-hand formed glass, blue, green, amber cased in crystal: cm 16.5 Designed by Joel Philip Myers for Blenko Glass Company *USA*

Expo B 645-68 bowl, full lead crystal Designed by Gunnar Cyren for Ab Orrefors Glasbruk, *Sweden*

Vases of blown glass: cm 19 high Designed by Masakichi Awashima for Awashima Glass Company Limited, *Japan* 5

Mould-blown glass vases: cm 22 high Designed by Yukio Ito for Sasaki Glass Company Limited, *Japan*

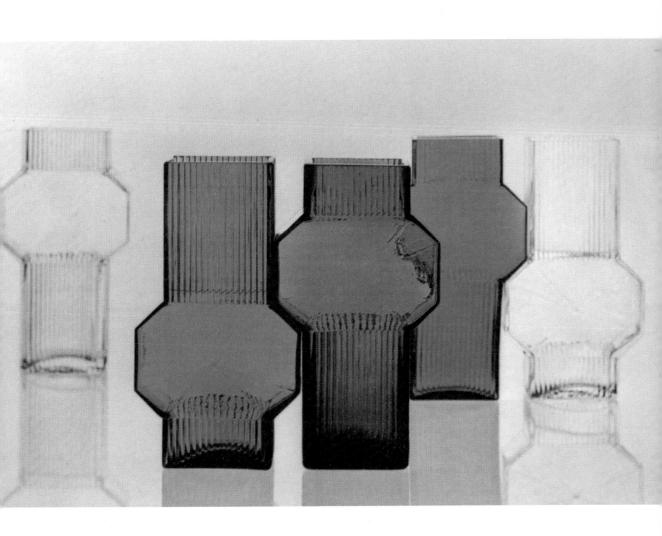

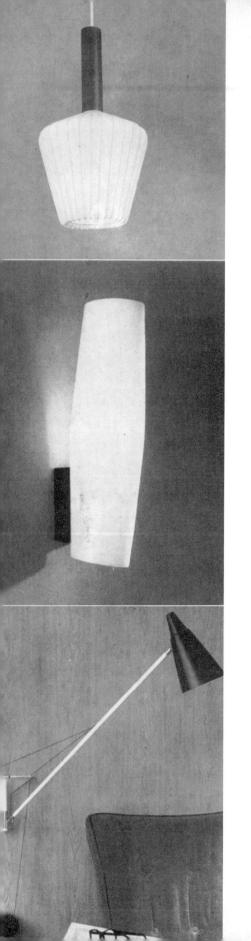

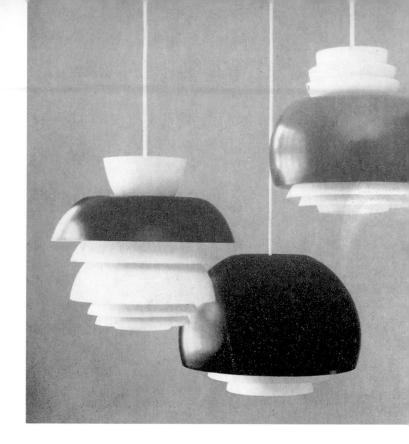

 \blacktriangle White opal glass louvred pendants with lacquered aluminium shades.

Designed by Jørn Utzon, m.a.a for Nordisk Solar Co. A/s, DENMARK 'Snowflower' table lamp of white opaline

'Snowflower' table lamp of white opaline glass on fir block mount, designed by G. L. de Snellman-Jaderholm. Shade made by Karhula-Iittala Glassworks FINLAND Lantern table light of smoke-coloured glass in metal frame. Designed by Victor Berndt for AB Flygsfors Glasbruk sweden

■ FAR LEFT: White Chrysaline pendant on matt black aluminium 'stem'. Designed by Beverly Pick, FSIA, for W. S. Chrysaline Ltd UK

Satin etched white opal glass wall light on aluminium mount with matt black exterior finish. Designed by R. Reynolds, MSIA, for The General Electric Co. Ltd UK Aluminium wall fitting adjustable in a hemisphere; lacquered shade available in several colours, boom and mount in white or black eggshell finish with brass details. Designed by Yarborough-Homes, MMSIA, of Cone Fittings Ltd UK

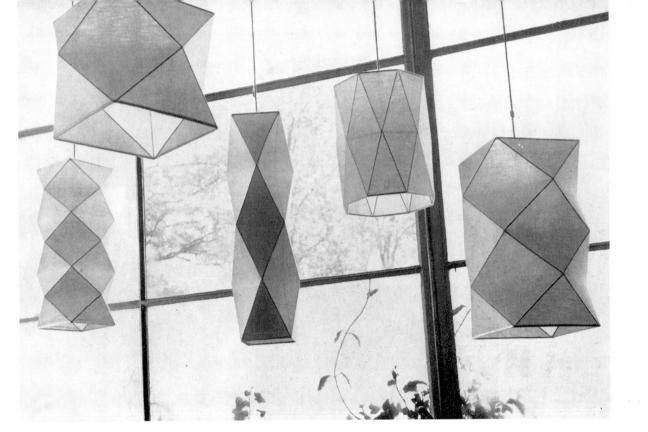

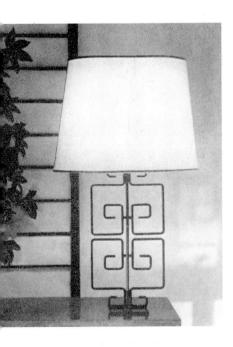

'Harlequin' pendants with shades made of chintz in different colours. Designed by Hans Bergström, SIR, for Ateljé Lyktan SWEDEN

Black wrought-iron table lamp with gold fibre-glass fabric shade. Designed by John Crichton; base made by Panoma Wrought Iron Ltd, shade by Max Robertson NEW ZEALAND

Vinyl-sprayed fish net eye-level pendant—one of several shapes designed by George Nelson for the Howard Miller Clock Co. USA

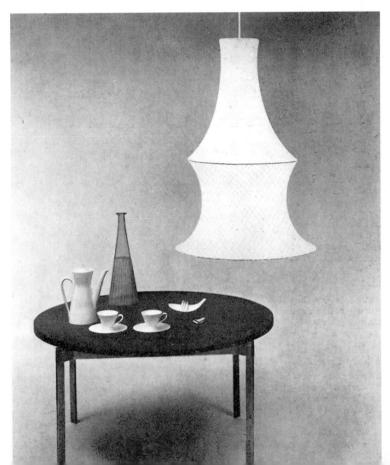

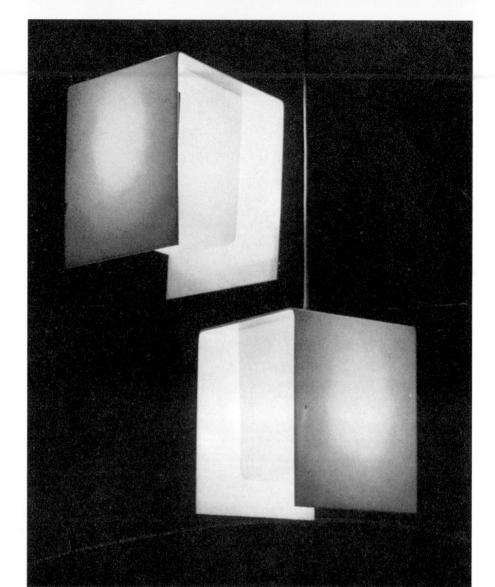

Hanging lamps of folded Perspex designed by Yki Nummi for o/Y Stockmann-Orno FINLAND

▲ Satin brass wall bracket with washable *Gaylite* shade in white, red/white or blue/white stripes.

Metal ceiling unit in matt black with polished brass reflector. Both from the Variform range designed by R. Reynolds, MSIA, for The General Electric Co. Ltd UK

Pendant, shades light grey/lilac, light grey/moss green or satin copper/black, with nylon louvre. Designed by Bent Karlby for A/S Lyfa DENMARK

Open-base globe pendant in white flashed opal glass on anodised aluminium suspension. Designed and made by Troughton & Young (Lighting) Ltd UK

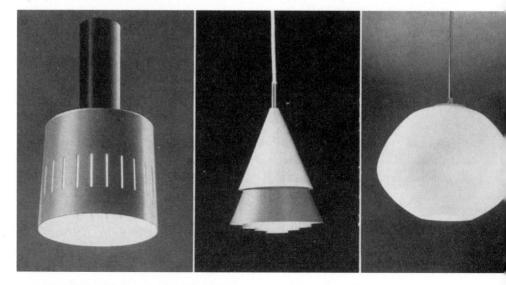

420 · lighting · 1960-61

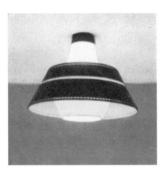

Achilles and Apollo from the Olympus range of light fittings in Pearlstone satin opal glass with eggshell finish pierced aluminium coloured reflectors.

Made by Falk Stadelmann & Co. Ltd UK

▲ Sumburst translucent Bohemian glass mosaic panel on plate glass lit from behind. Designed by Grace Grover for Dennis M. Williams Ltd UK

Wide spherical pendant of white opal glass with spun aluminium reflector available in six colours. It provides both upward and downward light and is designed by Paul Boissevain, MSIA, for The Merchant Adventurers Ltd UK

Ceiling fitting of coloured and uncoloured acrylic glass unities arranged in two layers. Designed by Hans Bergström for Ateljé Lyktan AB SWEDEN

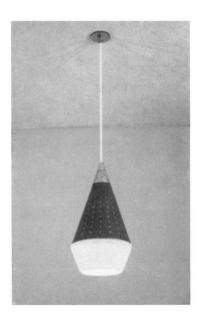

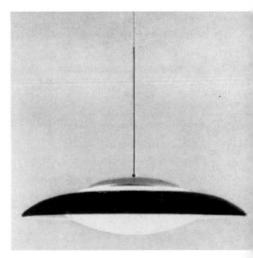

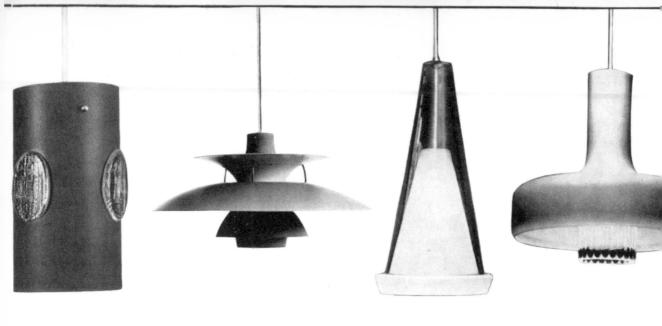

- 1 Lacquered glass with clear crystal medallions. Designed by Victor Berndt for AB Flygsfors Glasbruk sweden
- 2 Metal pendant, shades lacquered red, lilac, white or blue outside, white inside, with inner shade in red.
 Designed by Poul Henningsen for Louis Poulsen & Co. A/S, DENMARK
- 3 White opal glass with outer shade in red, green, blue, or smoke-glass.

 Designed by Sven Middelboe for Nordisk Solar Co. A/S, DENMARK
- 4 Two-part fitting: matt opal glass over inner shade in clear lead-crystal. Designed by Heinrich Fuchs for Phönix GmbH GERMANY
- 5 Matt white etched glass shade, designed and made by Hesse-Leuchten GERMANY
 6 Cascade effect multiple fitting, white opal shades with polished brass cups
- on black cord suspension: 8 Matt white etched-stripe opal glass fitting.

 Both are designed by Rudolf Hollman for Oswald Hollman Ltd UK
 7 Two-piece shade of convex acid-polished glass on black-lacquered
- 7 Two-piece shade of convex acid-polished glass on black-lacquered suspension. Designed by Max Ingrand france for Fontana Arte ITALY

- 9 Black wrought-iron standard with ivory rhoidoid lanterns edged in blac Designed by Jean Royère FRANCE
- 'egg', 27 inches diameter: 12 Black-lacquered iron pedestal terral lamp with four anti-dazzle discs lacquered white and red, and top refractor. Both are designed and made by Stilnovo, s.r.l. ITALY
- 13 Brass desk lamp with anodised aluminium shade.

 Designed by L. Summers: The Royal College of Art UK
- 14 Polished wood standard, acid-polished diffusing glass cone, polished bra ring. Designed by Max Ingrand FRANCE for Fontana Arte ITALY
- 15 Matching floor and desk lamps in metal, lacquered black or grey.

 Designed by Arne Jacobsen, m.a.a, for Louis Poulsen & Co. A/S, DENMAI
- 16 Metal standard with Perspex reflector in white and light yellow. It adjustable in the horizontal and vertical planes—the diagram shows of of the several positions. Designed and made by Stilnovo, s.r.l. ITALY

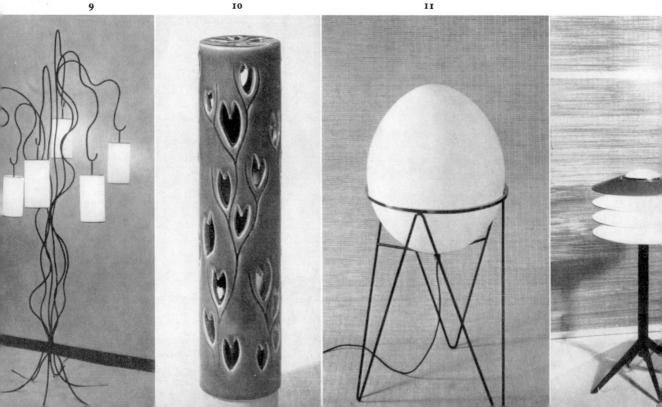

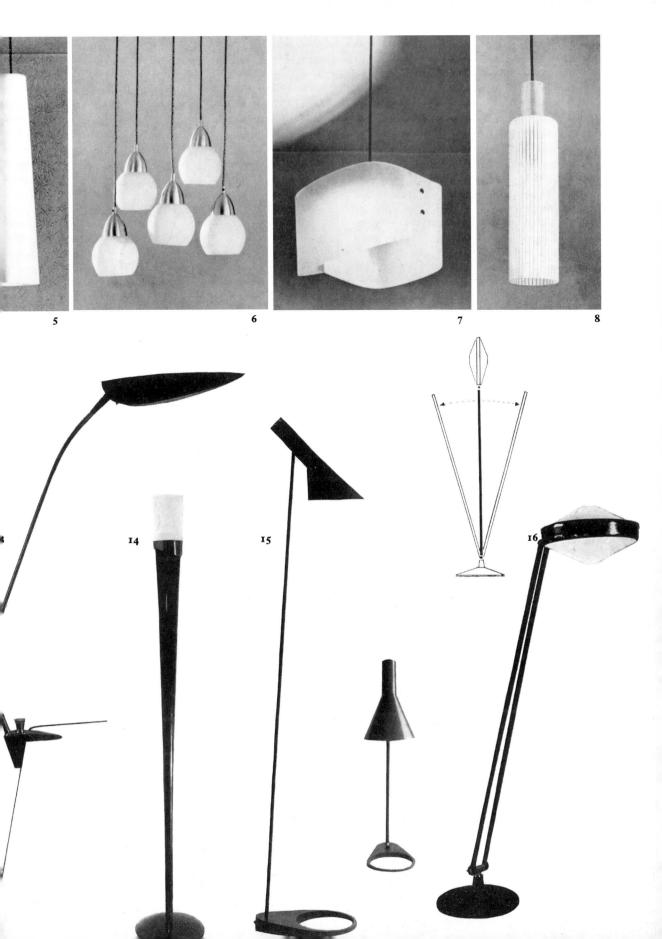

Pendants

- I Cylinder in satin opal glass and lacquered metal in a range of eight colours. By Handelsonderneming Willem Hagoort HOLLAND
- 2 Triplex Opal satin glass globe for four lamps with lacquered reflector. By Stilnovo ITALY
- 3 Perspex white opal circular bowl for three lamps with transparent outer shade
- 4 White satin etched opal inner cylinder with coloured spiral-decorated outer glass; metalwork in satin brass.
 Both designed by J. Hildred, MSIA, for the General Electric Co. Ltd UK

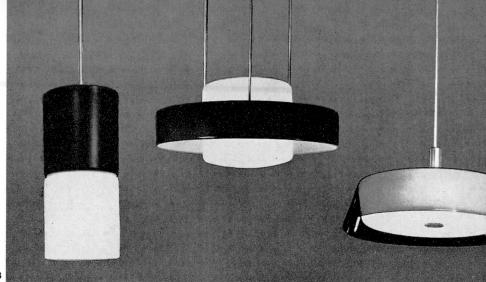

1, 2, 3

4, 5, 6

- 5, 6 Spun aluminium 'Drums' lacquered in a range of eight colours, inside white with white opal louvre.
 - Designed by R. Boissevain, MSIA, for Merchant Adventurers of London Ltd UK
- 7 Lamp ringed with twenty-eight rectangular glass reflectors on black lacquered metal mount; 8 square ceiling fitting with bowl in satin etched glass and a bevelled thick glass, framed in white lacquered metal.
- Both by Fontana Arte ITALY
 9 Cylinder in white opal glass
 with coloured outer globe.
 By Carl Fagerlund for AB
 Orrefors Glasbruk sweden

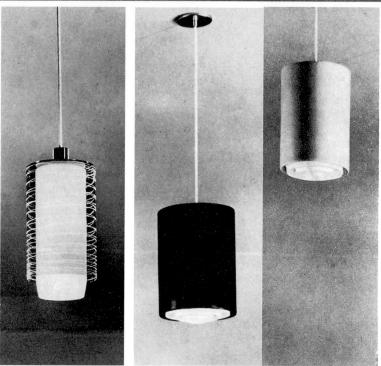

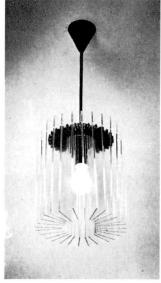

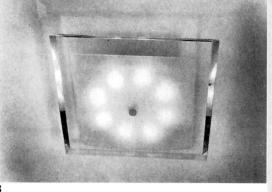

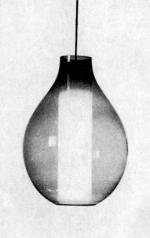

7 8

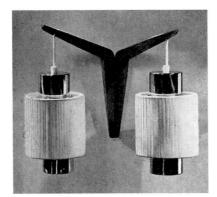

- Teak wall bracket with copper pendants and bound ramie shades. By Holm Sørensen & Co. DENMARK
 Twelve lamp candelabra in polished brass and oxidised steel. By Stilnovo, s.p.a. ITALY
- 12 Pendants in acrylic glass, transparent and white opal, with added coloured pieces. Designed by Hans Bergström for Ateljé Lyktan sweden

11

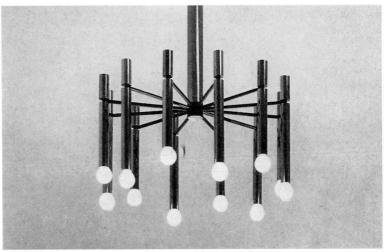

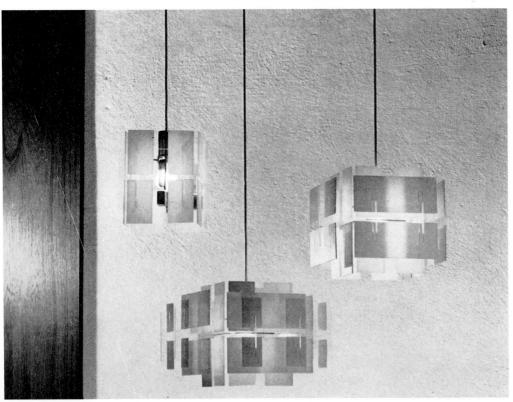

1961–62 · lighting · **425**

12

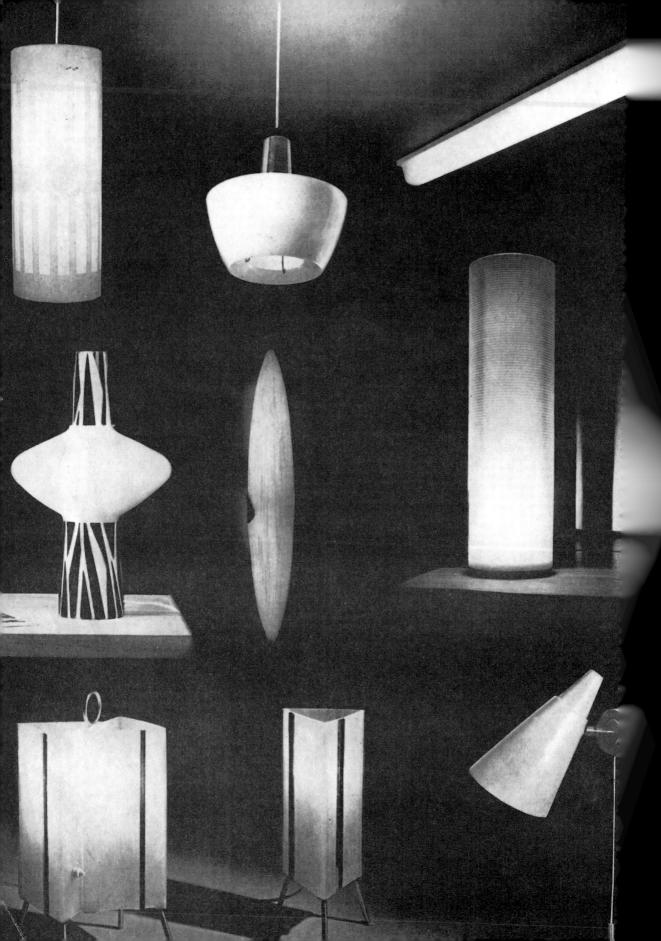

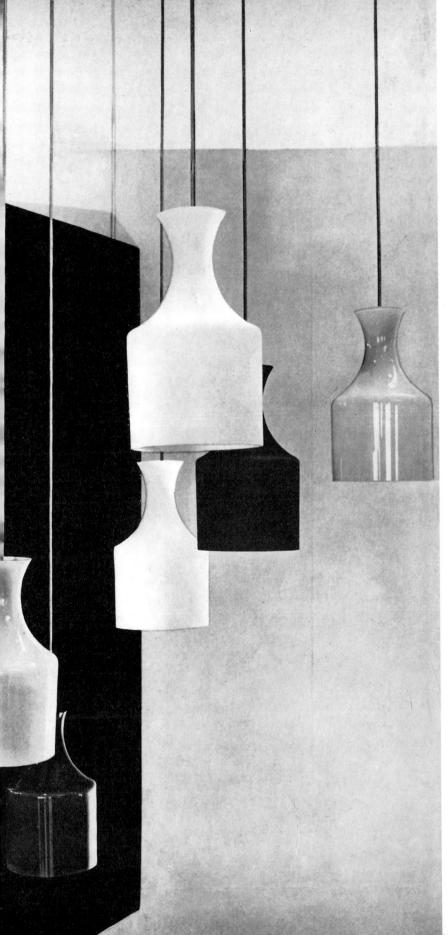

OPPOSITE PAGE

- I Cylinder pendant, 14 inches deep, made from two sheets of ingres paper. Designed by Peter Hjorth and Arne Karlsen, m.a.a., for Interna DENMARK
- 2 Pendant in aluminium anodised silver with moulded plastic diffuser; diameter 12 inches
- 3 Ceiling fitting in moulded opal Perspex with white metal mount; for 60 or 48 inch fluorescent tubes. By Troughton & Young (Lighting) Ltd UK
- 4 Table lamp in satin Triplex opal glass with fired black decoration, or in plain white; 15 inches high. Designed by Uno Westerberg for AB Arvid Böhlmarks Lampfabrik SWEDEN
- 5 Wall bracket in plexiglass on gilded brass mount; 23½ inches high. By Arlus SA, FRANCE
- 6 Cylindrical plastic table lamp with mahogany base and vertical rail carrying inner air-cooling aluminium reflector; 19 inches high. By John D. Stewart, MSIA, UK
- 7 Table lamps, single or with ring link, in white translucent glass with coloured stripes, on gilded brass mount; 15 and 17 inches high. Designed by Angelo Barovier for Barovier & Toso ITALY
- 8 Wall light in spun aluminium shade in various colours, ball joint stem and cord pull aluminium anodised warm brass. By Cone Fittings Ltd UK
- ◆ Pendants in opal glass, white or grey. Designed by Lisa Johansson-Pape for o/Y Stockmann-Orno FINLAND

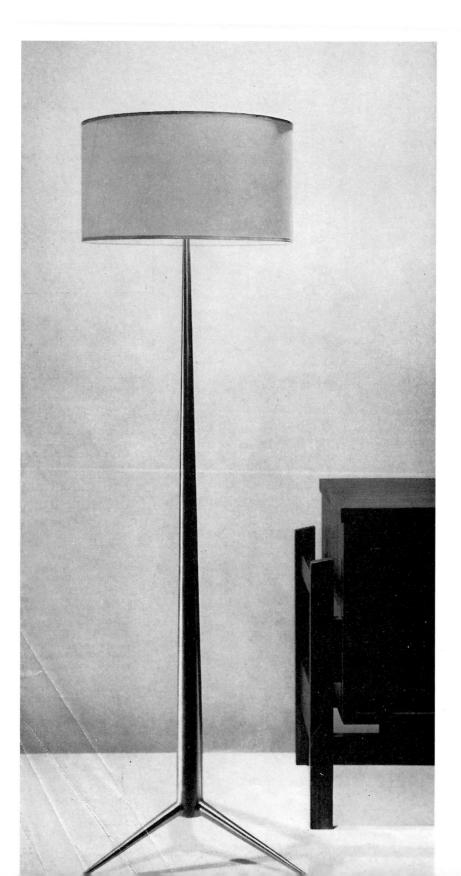

stem and base. Designed and custom made by

Veranneman for E. Langui BI photo Atelier I

- 1, 2 Umbrello and Botte Italian glass pendants. J. Wuidart & Co. Ltd UK
- 3 Cylindrical pendant, opal with slotted brushed of shade. From the Rimini sea Falk Stadelmann & Co. Lt
- 4 Square grey-green O1 Swedish glass pendant.
- J. Wuidart & Co. Ltd UK
- 5 Spanish brass lantern Homeshade Company Ltd
- 6 German matt opal etched dant. From Heal's of Londs
- 7 Yellow glass cylinder ligh Hiscock Appleby & Co. Lt
- 8 Japanese Noguchi rice pendant. From Primavera
- 9 Danish domed copper pe Louisana. From Danasco L
- 10 Satin opal glass pendant green overglass. By Free Thomas & Co. Ltd UK
- II Spanish collapsible globe in wood veneers held by wr iron rings. From Heal London UK
- 12 Table lamp with deep p ment shade on white china From G.B. Lamps UK
- 13 Matt white opal glass per By Troughton & Young Lt
- 14 Fiasco green Italian glass dant by Vistosi. From J. W
- 15 Squat light blue glass per From Danasco Ltd UK

& Co. Ltd UK

16 White opal glass pendant blue overglass. By Free Thomas & Co. Ltd UK

Courtesy 'Ideal

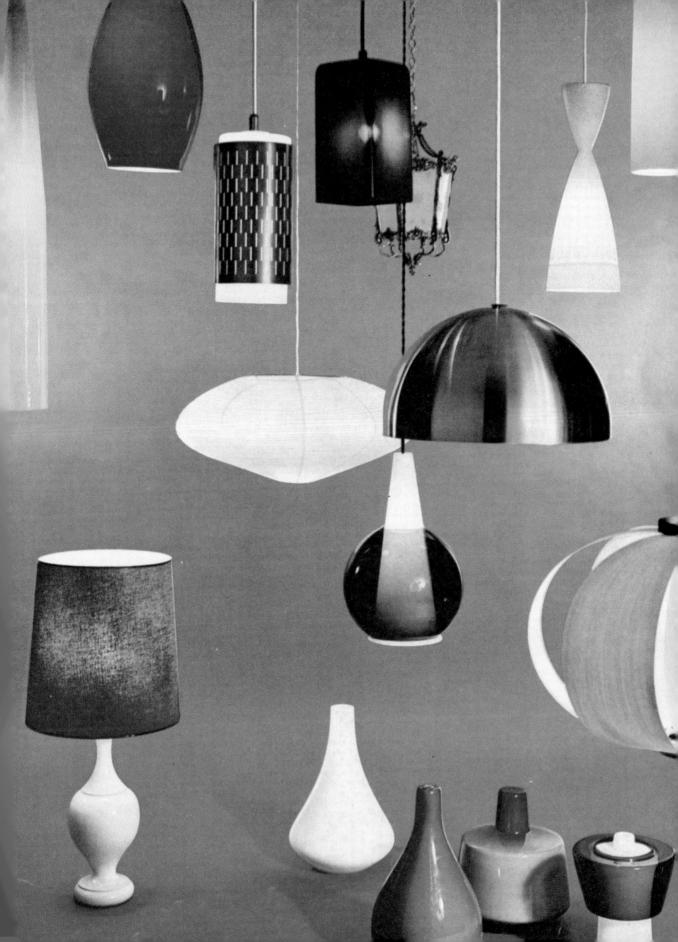

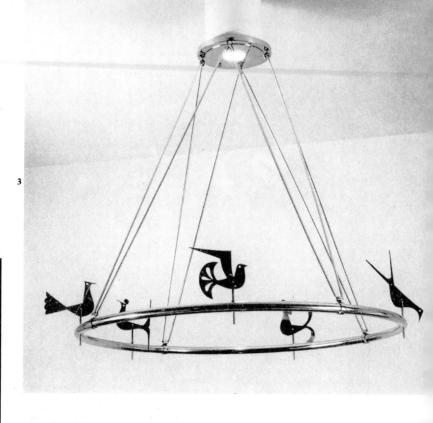

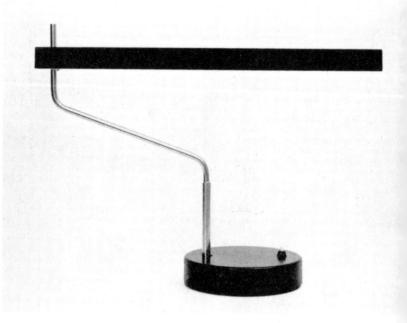

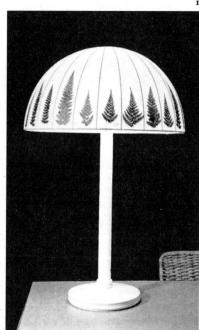

Table lamp with shaft and foot of natural pine or white-painted hardwood; plasticised shade with natural leaf inlay.

Designed by Hans-Agne Jakobsson and Arne Nilsson for Hans-Agne Jakobsson AB SWEDEN

Cylinder table lamp, 8 or 12 inches high, white

satin finish shade on waxed hardwood base. Fe a range designed by John D. M. Brown, MSIA, Plus Lighting Ltd UK

Desk lamp, black lacquered metal base and sh with polished chrome rotating arm. Designed Stahel for Telle-Büromöbel AG SWITZERLAND

Adjustable spot lamp for ceiling or wall, semi-matt black finish with chromium universal joint. Deigned and made by Troughton & Young Ltd UK

Candelabra of white-enamelled metal, with glass hades in blue, green, red or clear; the candlesticks re detachable from the base. Designed and made by Hans-Agne Jakobsson AB SWEDEN

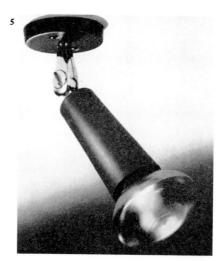

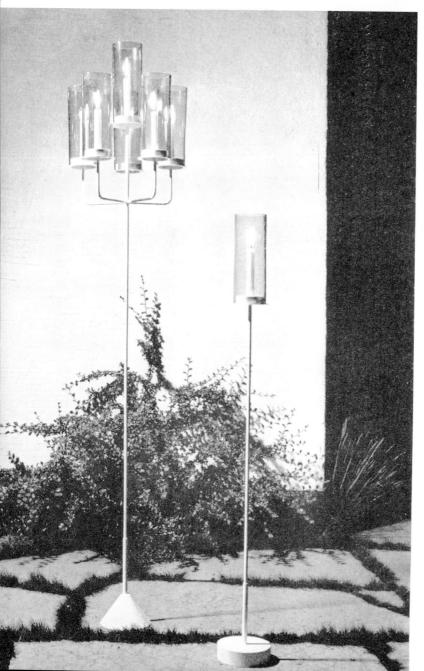

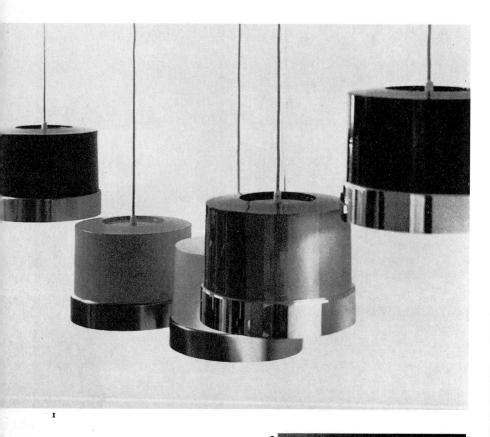

Pendants in lacquered metal with burnished steel rims. Designed by Lisa Johansson-Pape for o/y Stockmann-Orno FINLAND

2

Maple table lamp with tiered card shade in three tones of the same colour. Designed and made by Lisbeth Brams DENMARK

3 Lacquered metal and white opal bulb pendants. Designed by Tapio Wirkkala for Idman FINLAND

4
Wall lamp, copper mount with black pink-lined
perforated metal drum shade. Designed by John
Crichton. Made by E. West & CO NEW ZEALAND

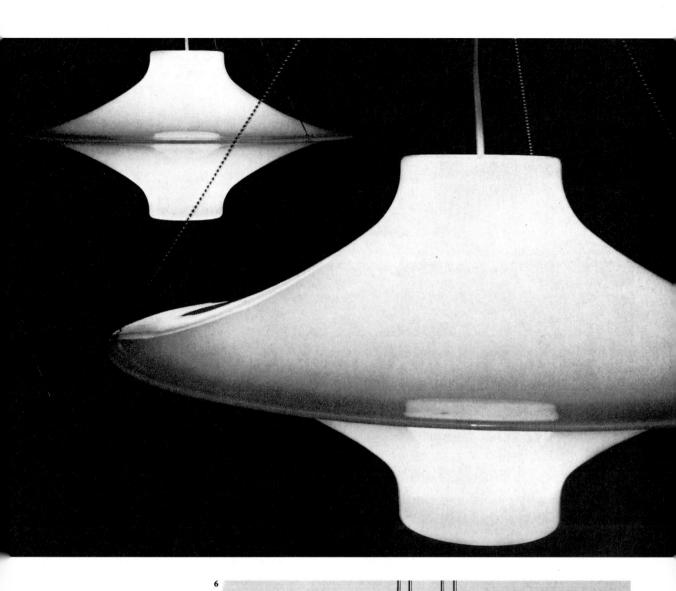

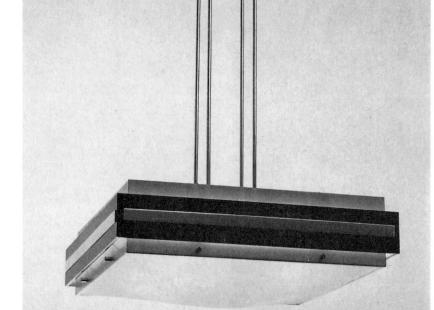

e opaline glass pendants. Designed by Yki mi for 0/Y Stockmann-Orno FINLAND

lamp pendant, black and white lacquered frame with engraved frosted crystal diffuser; s polished brass. Designed and made by ovo s.p.a. ITALY

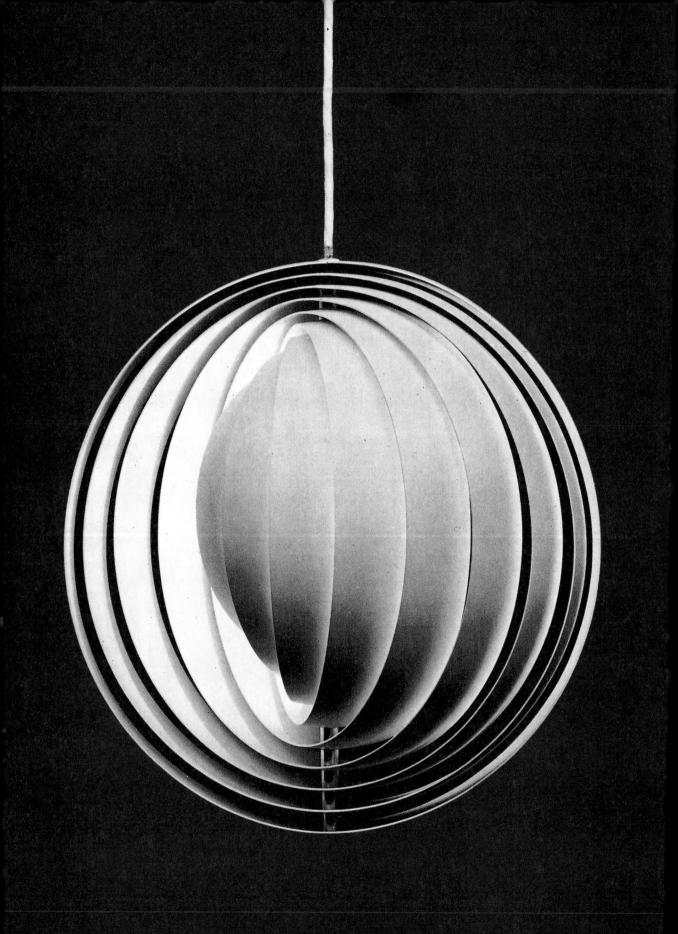

Pendant of adjustable white metal rings; 35 cm diameter Designed by Verner Panton for Louis Poulsen & Company A/S DENMARK

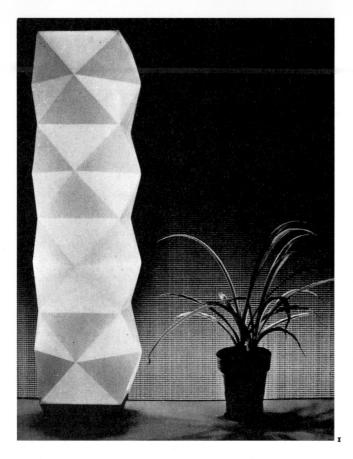

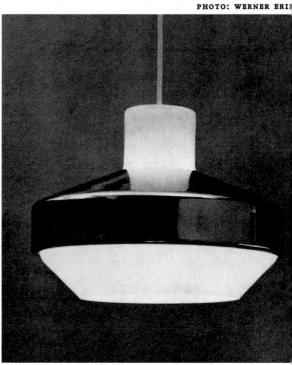

Facet table lamp, 66 cm high, of creased and folded white polypropylene with mahogany end caps Designed by Roger McClay for Cone Fittings Ltd UK

brass shade; 26 × 20 cm marks Lampfabrik sweden

Pendant of opal glass with lacquered Designed by Göran Wärff for Böhl3, 4
Tube pendant with louvre TL1432 in flashed white opal glass; 25 and 30 cm diameter Ceiling unit 1643C in matt white opal glass; 25 cm diameter. From the

Opalight Range A light fittings metal details in aluminium and satin silver, or pale gold to orde Designed by Paul Boissevair Merchant Adventurers Ltd UK

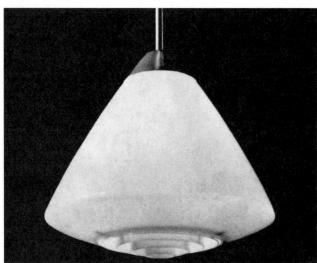

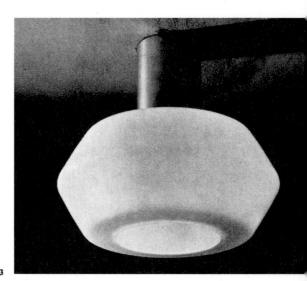

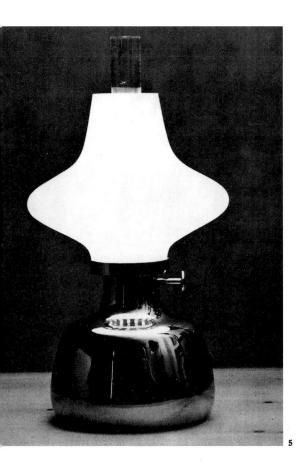

7 Table, ceiling and floor lamps with shades of white-enamelled aluminium slats; 20 cm diameter; 50, 32 and 77 cm high respectively
Designed and made by Hans-Agne
Jakobsson AB SWEDEN

np, 32 cm high, of opal glass brass base ed by Henning Koppel for Poulsen & Company A/S 6
Pendant with opal Perspex reflector
and white plastic louvre, finished with
satin nickel-plated brass; 46 cm
diameter
Designed and made by Stilnovo s.p.a.

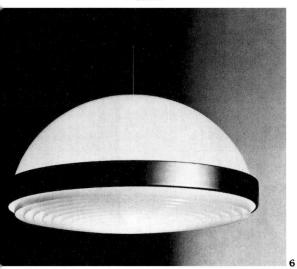

O: ALDO BALLO

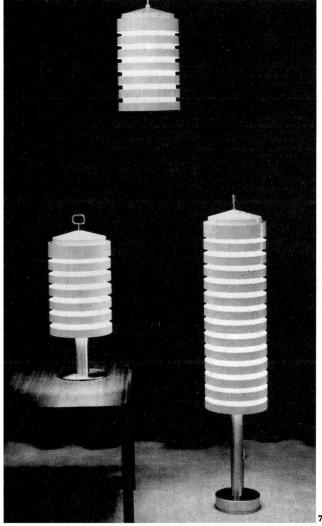

PHOTO: OVEHALLIN, WAHLBERG

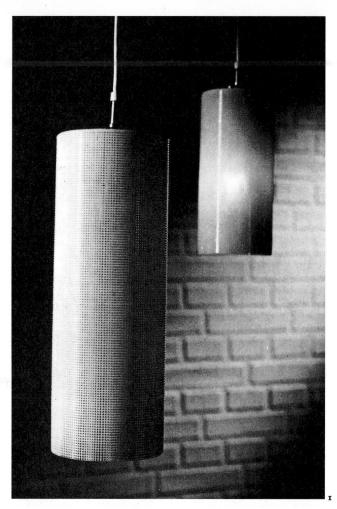

I, 2
Matt white corrugated opal glass cylinder pendants F609/610White flashed satin-opal pendant F667/R3 with burnished copper drum reflector. Designed by A. B. Read. Made by Troughton & Young (Lighting) Ltd UK

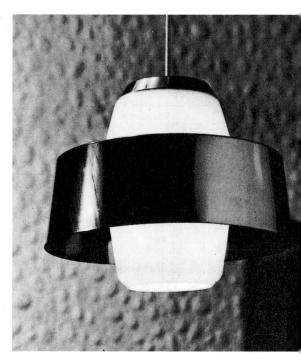

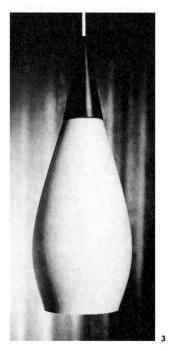

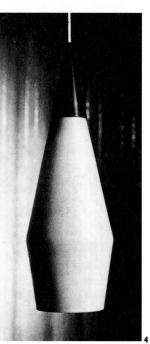

3, 4 White flashed satin-opal cone shade F/66 and tapered shade F/65 with metal details stove-enamelled black Designed for the Harlequin series of interchangeable fittings and made by Troughton & Young (Lighting) Ltd UK 5

Six-light fluorescent unit 136A with 61 cm and 122 cm tubelights on matt white spun aluminium mount; arms anodised satin silver, or pale gold Designed by Paul Boissevain for Merchant Adventurers Ltd UK

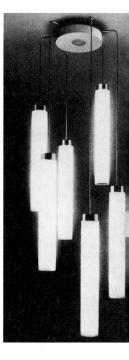

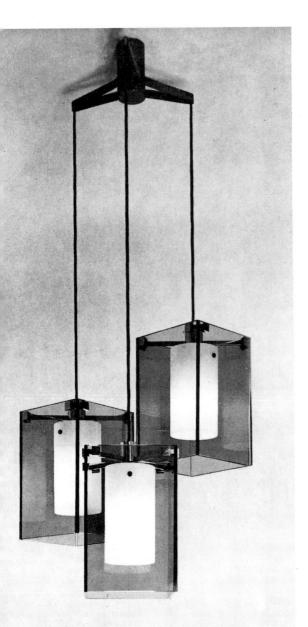

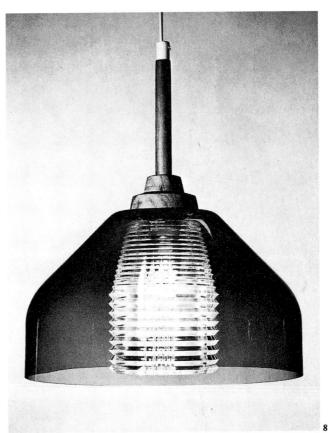

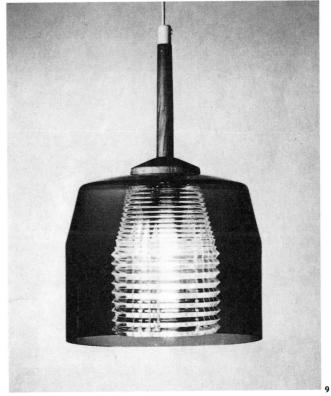

le pendant fitting 2210 with ke-grey glass shades, 63×50 cm, satin-opal diffuser; metal details uered brass

igned and made by Fontana Arte

dant series L2218/2216/2220 with r brown shade over inner cylinder lear crystal; 30 and 22 cm diameter gined by Victor Berndt. Made by Flygsfors Glasbruk for Svenska ips AB SWEDEN

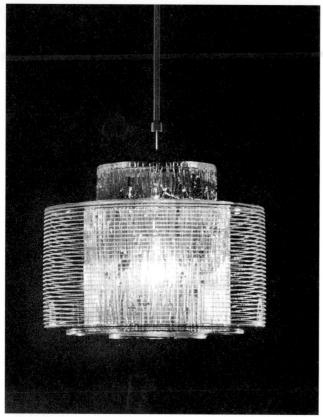

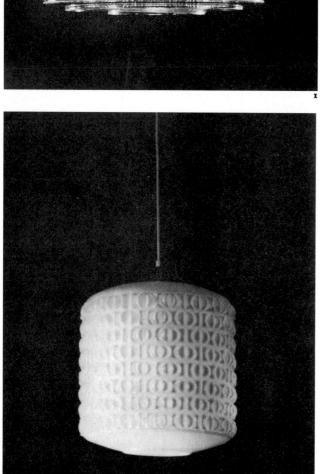

1, 2 Corona and Cordoba pendants: Corona in clear glass, crystal decor with innerglass crystal, moulded decor 27.5 cm diameter. Cordoba opal cased glass with satin etched finish 30 cm diameter Designed and made by Peill & Putzler Glashuttenwerke GmbH w.

3 Pendants in clear crystal and satinblack finished metal Additions to the *Harlequin* range for Troughton & Young Ltd UK

GERMANY

4 Hall mirror-light in etched opal glass; width overall 61 cm (the position of the mirror and grey textured pane be reversed) Made by Osram (General Electu

Ltd) UK

Wall bracket F700, random paperssed clear crystal; 25 cm dian In the Mondolite range designed Troughton & Young Ltd UK in junction with Peill & Putzler huttenwerke GmbH W. GERMAN

Opal globe pendants with white over-shades of stretch fabric over wire; 23, 28, 33 and 38 cm squar Designed and made by Raymor Division USA

рното: гох

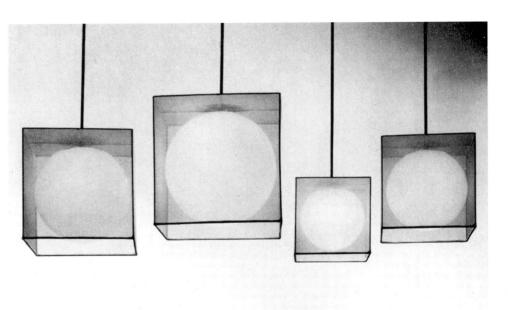

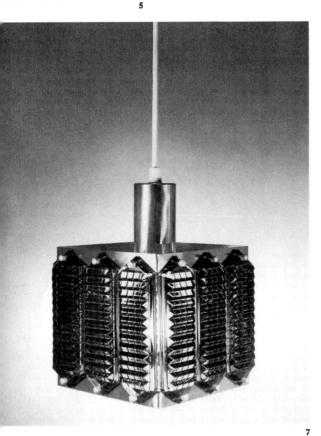

rism-cut clear amber glass pendant ith brass mounting; 18 cm square esigned by Victor Berndt for AB lygsfors Glasbruk SWEDEN Triple ceiling fitting with opal glass shades and crystal glass reflection: mounted on black anodised aluminium; 15 cm diameter

ium; 15 cm diameter Designed and made by Staff & Schwarz W. GERMANY

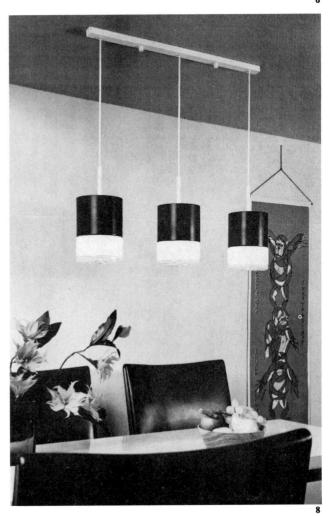

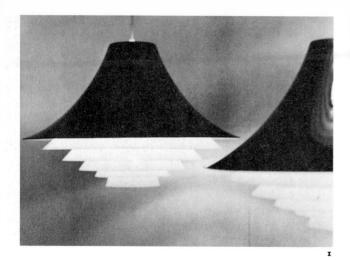

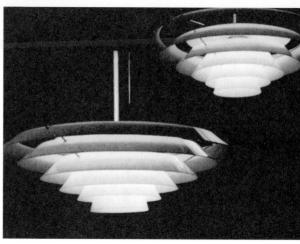

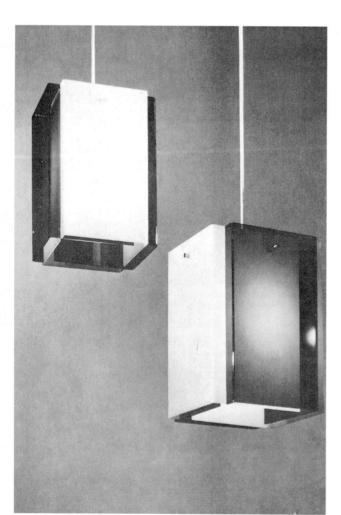

1, 2, 3
Acrylic pendants
Series R5823 in black and white; 55
cm diameter
Series 64-478 in pastel or alabaster
colours on polished aluminium suspension; 55 cm diameter
Series 64-474 in neutral light brown
or dark brown/white; 22 cm diameter

All designed by Yki Nummi

4 Pendants Series 61-044 in grey, blue grey or Havannah brown glass with matt interior; 19 cm diameter

Metal pendants transparent-lacquered Series R5792: darkest green or milkwhite with matt transparent acrylic rims and white louvre; 34 cm diameter 6

Lacquered metal shades Series 61–019 and 30–019 for pendant or floor fittings: champagne transparent-lacquered centre, banded in warm grey or sand brown; 44 cm diameter. The floor lamp is adjustable in height All designed by Lisa Johannson-Pape

All fittings made by Stockmann-Orno FINLAND

PHOTOS PIETINEN

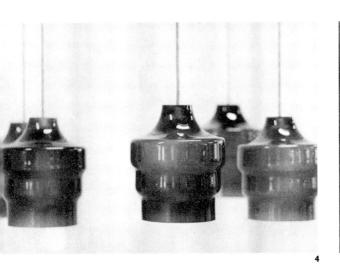

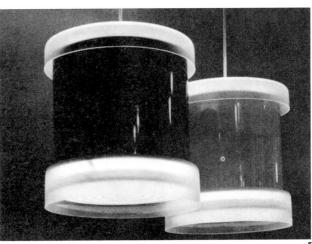

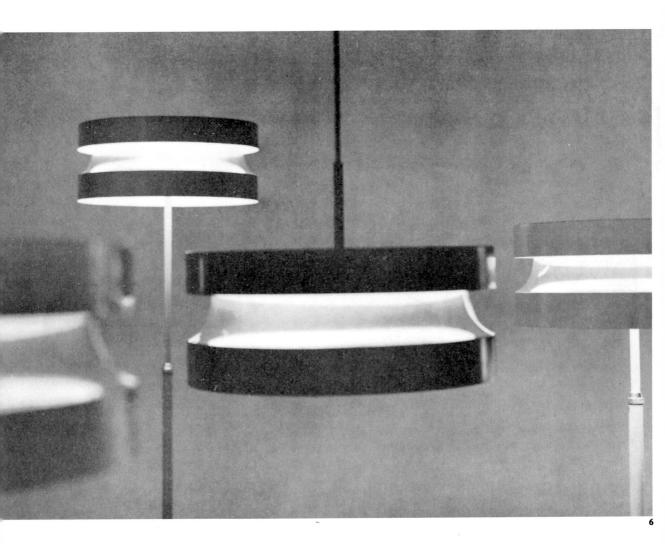

St-Just wall plaque, clear or coloured plate-glass sand- and acid-etched, on lacquered metal or brass mount; 30 cm high

Designed and made by Max Ingrand FRANCE

Floor lamp Model 1085 of transparent Perspex with black anodised aluminium; 160 cm high. Designed by Gino Sarfatti

Wall lamp Model 244 on metal spring extension with ceiling attachment; shade in smoked Murano glass

Designed by Ico Parisi Both for Arteluce ITALY

Pendant Model 1246 for two lamps black-enamelled and brushed copper reflector over exterior bowl in engraved frosted crystal and inner bowl in white satin-opal Triplex glass; 62 cm diameter

Designed and made by Stilnovo spa ITALY

Pendant Model 2259 in plate-glass on brass suspension oxidized gun-metal grey: 43 cm high

Designed and made by Fontana Arte ITALY

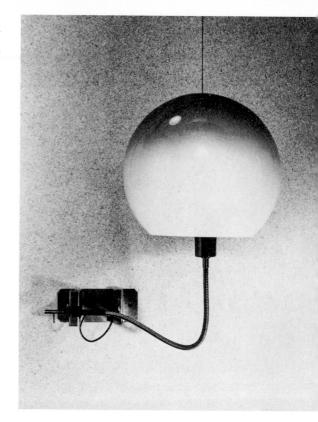

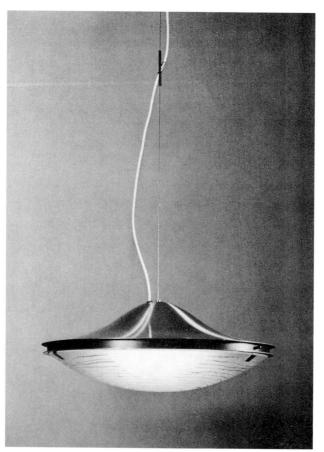

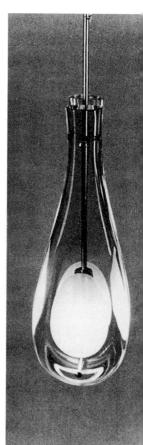

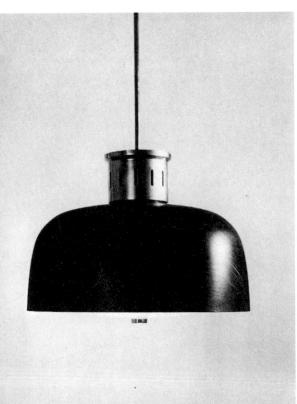

6
Brushed copper pendant with inner shade of dark red or smoked acrylic Designed by Sergio Asti, S. Favre for Kastell ITALY

7 Pendant Model 2118 in black lacquered aluminium with green or smoked Murano glass. Designed by Sergio Asti

8
Floor lamp 1086, anodised metal, with shade on swivel bracket; full height 120 cm
Designed by Gino Sarfatti
Both for Arteluce ITALY

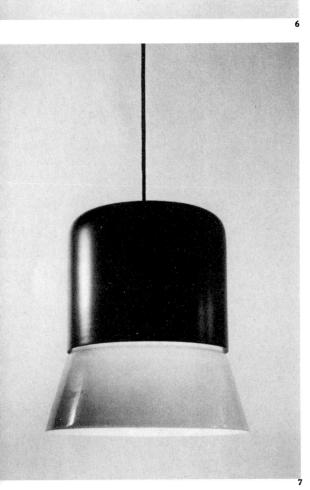

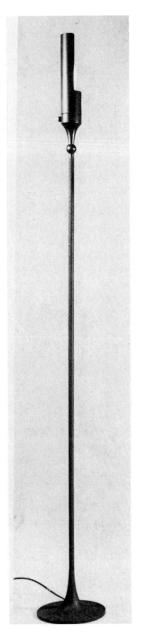

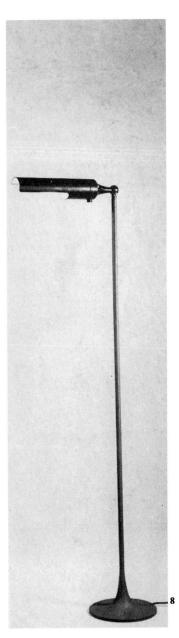

1964–65 · lighting · **445**

Pendant shade of sliced bamboo/rattan, purple-red or natural, 75 cm deep Designed by Industrial Arts Institute made by Kawai Kogyo K.K. JAPAN

Pendant or floor lamp, vinylchloride sheet assembled with acrylic pleats: opaque white, 33 cm deep Designed by Industrial Arts Institute and made by Yamada Shomei K.K. JAPAN

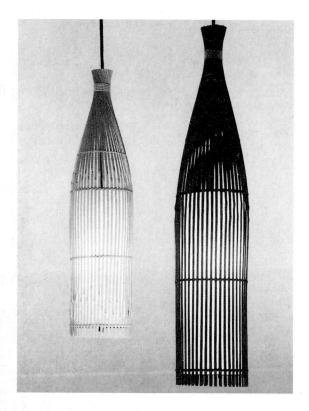

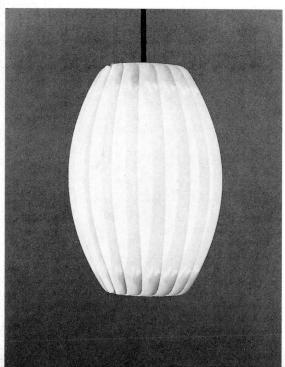

Adjustable fittings in black-sprayed aluminium, brass mountings, matt black iron stand; respective overall heights 47 cm, 148 cm (also available with 2-lamp mounting), and 50 cm Designed and made by H. & F. Beisl W. GERMANY

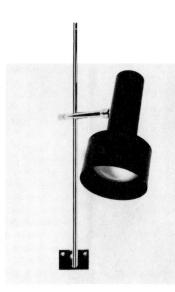

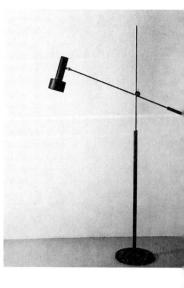

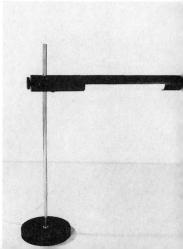

Series 2150 fitting, spun aluminium drum stove-enamelled pearl-grey, yellow, scarlet, matt black or white; or anodised finishes with moulded opal-white louvre, illuminating upwards and downwards

below Series 2160 fittings for walls and ceilings (recessed or semirecessed) matt black stove-enamelled aluminium drums with internal baffle grid for downward, concealed, light

light
Series 2150 and 2160 both made by
Merchant Adventurers UK

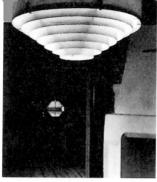

Pendant and floor lamps in finegrained natural pine veneers 53 and 26 cm diameter Designed by Hans-Agne Jakobsson for AB Ellysett SWEDEN

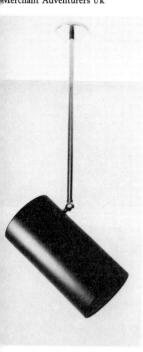

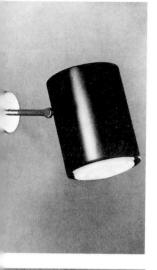

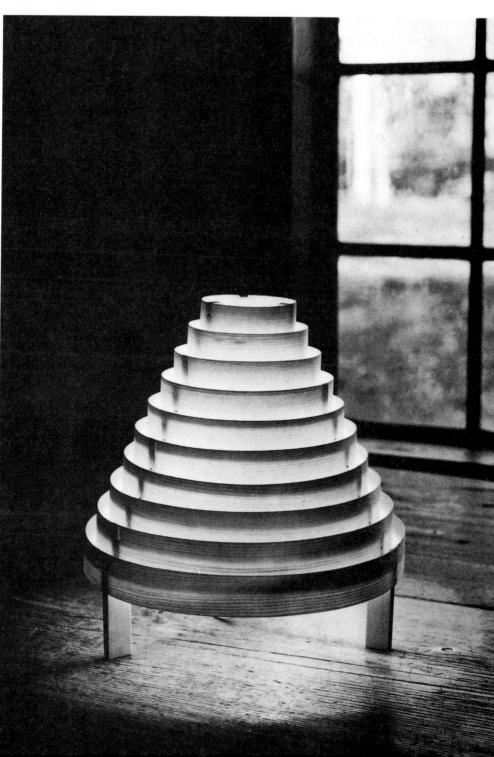

Table lamp 10,054 in satin-opal glass, the stem chromed brass on a cubic metal base, lacquered black, white or grey, 53 cm high overall Designed and made by Max Ingrand FRANCE

Nizza pendant of satin-opal and crystal lead, 30 cm diameter Designed and made by Peill & Putzler Glashüttenwerke w. GERMANY Table lamp with tipping head in black, white or deep red, polyester finish 35 cm high Designed by Umberto Riva for

Kartell-Binasco ITALY

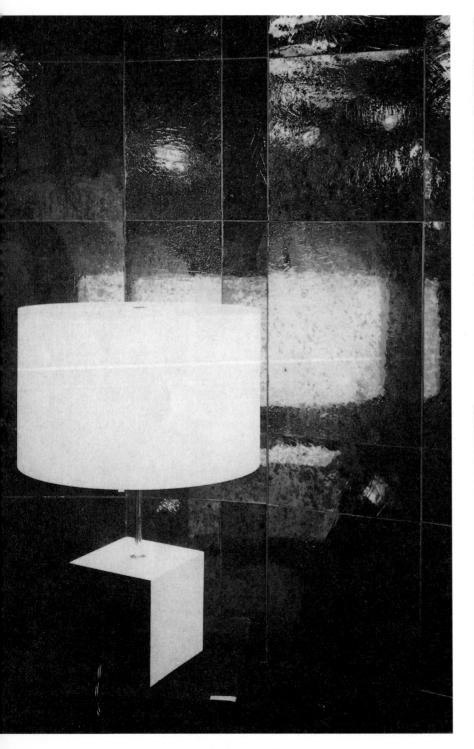

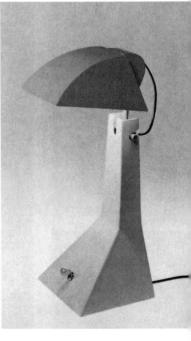

448 · lighting · 1965-66

nts, series 66-112 in white opal with red or white acrylic bowls a diameter ned by Lisa Johansson-Pape for tockmann-Orno AB FINLAND , table or wall fitting, the rotating through 360°; in

rotating through 360'; in

ned by Mauri Almari for n O/y FINLAND Brierley cylindrical fitting in amber, smoke, amethyst or crystal glass about 30 cm deep
Designed by George Elliott for
Stevens & Williams UK
Table lamp in brass,
leather-cased stem
Designed and made by Carl Auböck
AUSTRIA

Table lamps, series 40–040 in metal sprayed red, blue or white, 52 cm high Designed by Yki Nummi

Pendants, series 61–164 in coloursprayed metal, with white acrylic rims, 56 cm diameter Designed by Svea Winkler Both for O/y Stockmann-Orno AB FINLAND

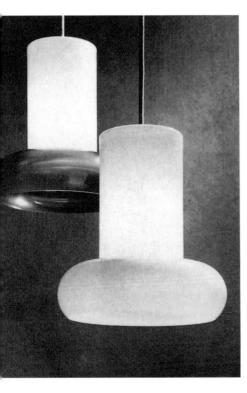

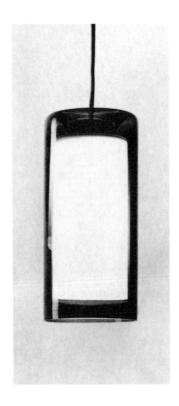

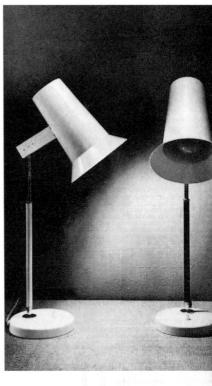

1965-66 · lighting · **449**

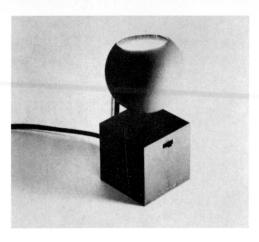

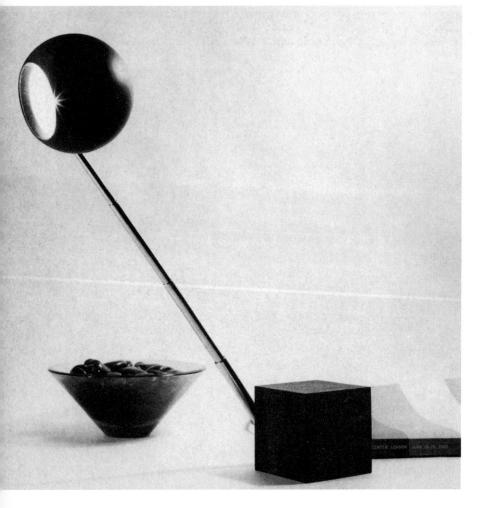

Bulb-like candleholder; porcelain with various coloured glazes: 11 cm high Designed by Industrial Arts Institute and made by Tasendo Co Ltd Japan

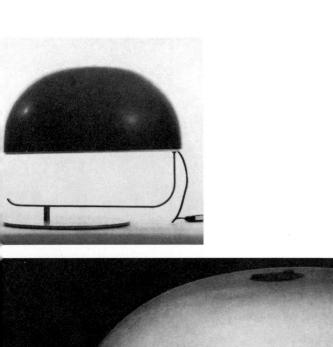

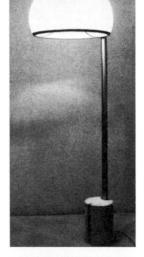

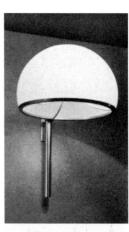

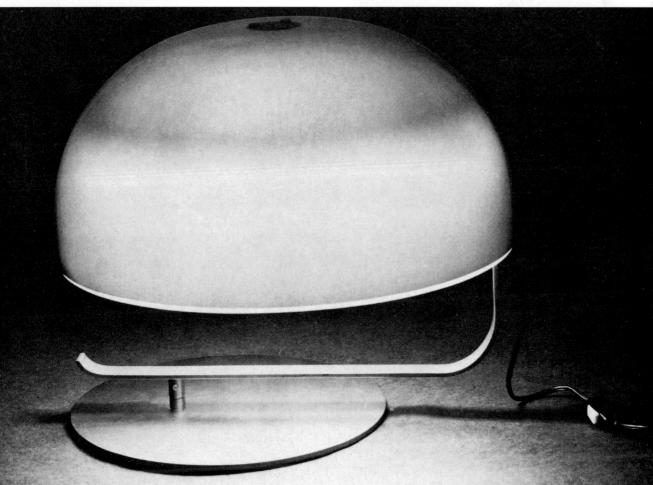

le lamp varnished iron frame, or coloured Perspex shade: m diameter igned by Marco Zanuso for uce ITALY top Wall or standard lamp with white concrete base: nickel matt brass column: opal Perspex shade Designed by Gregotti Meneghetti Stoppino for Arteluce SA ITALY

photograph Schnakenburg

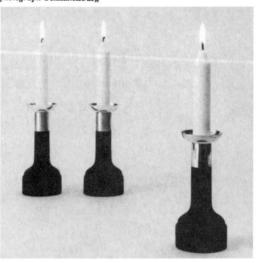

Candlesticks of stained beech and polished or silver-plated brass; total height 16 cm
Designed by Hans Bølling for Torben Ørskov & Co Denmark

Onion candlesticks, silver plated or solid brass; tapers in 13 colours Designed by Jens Quistgaard for Dansk Designs DENMARK

Staccato 100 fitting satin chrome, silvered or lacquered finish: plates built up to required size; this one 60×24 cm
Designed and made by Johann Faltermaier W. GERMANY

Magic Lantern candle holders of brass finished metal overall height 29 cm Designed by Jens Quistgaard for Dansk Designs DENMARK

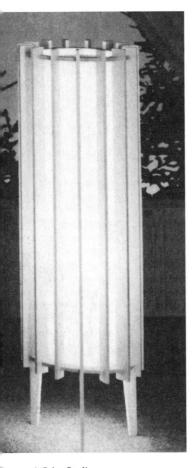

hotograph Color-Studio

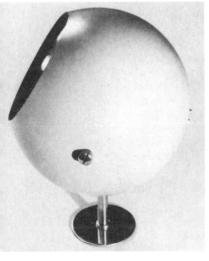

Tema floor lamp, kalmar-pine with nner linen shade, available also as table or pendant fitting: 78 cm high Designed by Ib Fabiansen for Fog and Mørup A/S DENMARK

Table lamp with orange metal shade and alux reflector, nickel arm and flange: total extension 28 cm Designed by E. Graae and H. Helgar for Louis Poulsen & Co A/S DENMARK

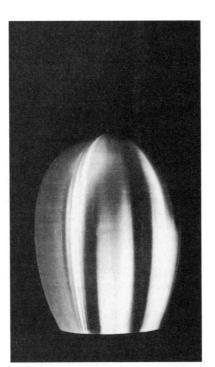

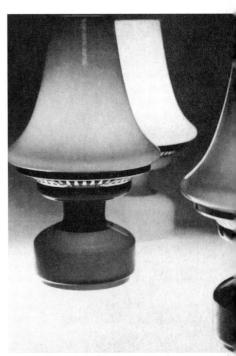

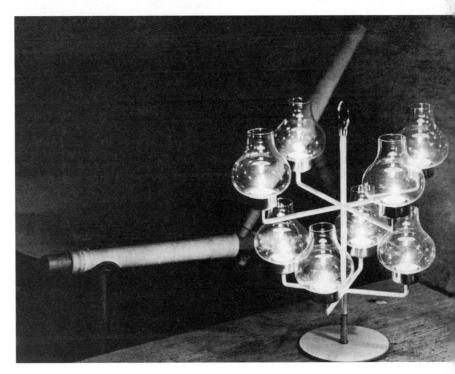

Pendant lamp in aluminium: 36 cm deep Designed and made by A. A. Gruberts Sønner DENMARK

Cluster lamp, black vion and lacquered brass with clear glass bowls; available also as pendant or standard Designed by Anders Pehrson for Ateljé Lyktan AB SWEDEN

Table lamp; base and shade of opal, amethyst, yellow, olive green or turquoise glass; available as wall fitting or nested pendant arrangement: 34 cm high Designed and made by Hans-Agne Jakobsson AB SWEDEN

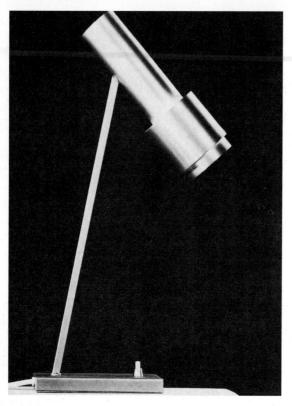

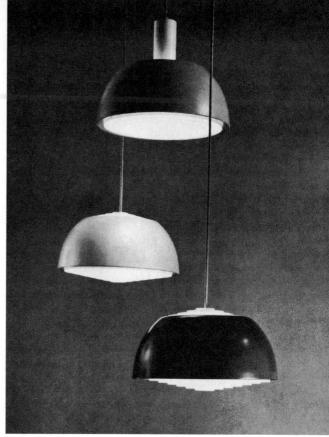

photograph Gravett

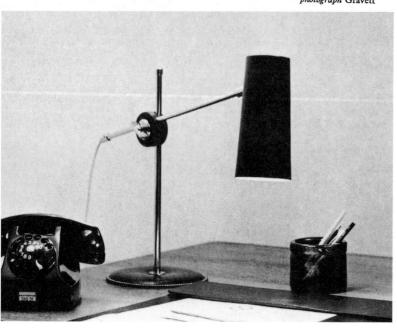

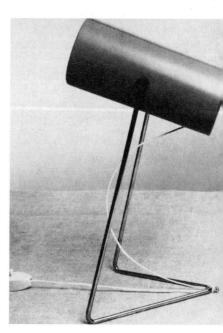

Table lamp lined with copper emitting white light, or aluminium emitting lilac light: 46 cm high Designed by Bent Nordsted for H. A. Gruberts Sønner DENMARK

Adjustable lamp of black leather, chrome and jacaranda: 36 cm high Designed by Anders Pehrson for Ateljé Lyktan AB sweden Pendants MA 3460 white plastic louvres and spun aluminium stoveenamelled grey, red, blue; 30 and 48 cm diameter Designed by Paul Boissevain for Merchant Adventurers Ltd UK

Wall or table lamp, steel tube frame with steel cylinder in six colours lined white: overall height 27 cm Designed by John Brown for Plus Lighting Ltd UK

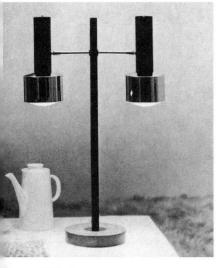

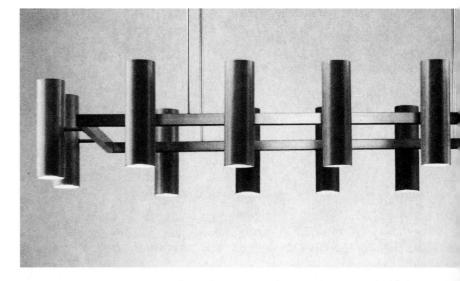

photographs Hooker

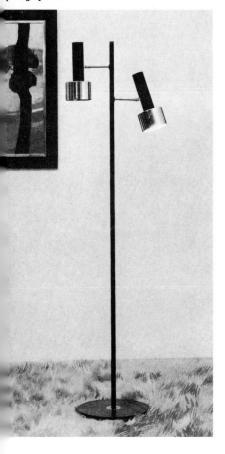

Table and standard spot lamps with reflectors (rotating only) and arm of copper, chrome or brass in square section tube, mahogany base: overall height 61 and 148 cm Designed by John D. M. Brown for Plus Lighting Ltd UK

Double hinged swinging arm wall light, adjustable reflector, rim and outer arm, anodized aluminium; shade white, black or colours: maximum extensions 91 cm Designed by E. Cooke for Cone Fittings Ltd UK

Recessed fitting soffit ring finished polished, anodized aluminium, reflector tips and rotates: overall width 28 cm Designed and made by Courtney, Pope Ltd UK

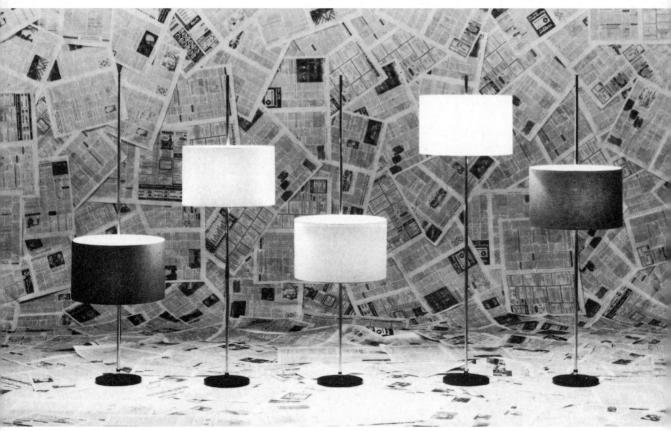

Garden lamp in yellow stoneware, demountable: 60×30 cm Designed by Mosuke Yoshitake for Ømi Kagaku K.K. JAPAN

Standard 1161–5 with chrome column and lampholder adjustable up to 160 cm; shade in white, graphite, yellow, brown or red, linen lined Manufactured by Staff Leuchten W. GERMANY

top
Pendant lamp of natural sliced
bamboo: 22 cm diameter
Designed and made by Design
Center Shizuoka Japan

top
Pendant lamp from bent metal
sheet, silver-grey or rose-pink
finish: 22 cm diameter
Designed and made by Design
Center Shizuoka JAPAN

ant made with four bent sheets on with silver-grey lacquered at 22 cm cube gned and made by Design or Shizuoka JAPAN All-white glass dome light 40 cm high Designed by Sergio Asti and made by Arteluce *Italy*

Table lamp of reinforced plastic material, white or red, 55 cm diameter Designed by an architectural group and made by Artemide *Italy*

Opaline white globe with moplen support in amarant, blue, ebony black 26 cm diameter × 23 cm high Designed by Joe Colombo and made by Kartell s.r.l. *Italy*

White smoked glass on metal base 50 cm diameter
Designed by Angelo Mangiarotti

Blue aluminium with white smoked glass diffuser 45 cm diameter × 40 cm high Designed by Leonardo Ferrari and Franco Mazzucchelli Tartaglino Both made by Artemide Italy

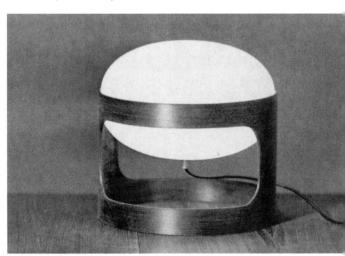

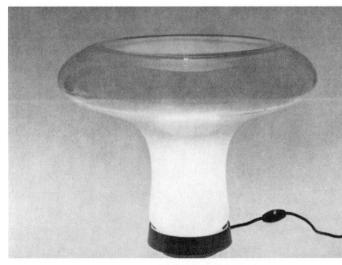

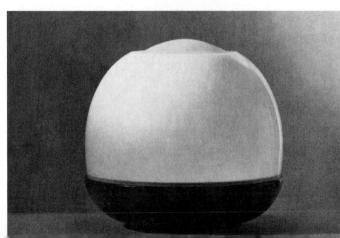

ome brass standard with opaline user 175 cm high × 48 cm diameter igned by Emma Schweinberger Gismondi, le by Artemide *Italy* Table lamp, metal lacquered white, sand or sky blue: revolving light 12 cm diameter
Designed by Vico Magistretti and made by Artemide Italy

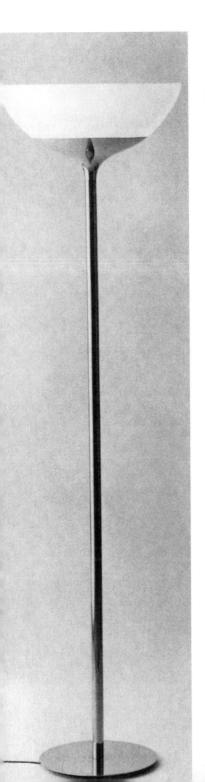

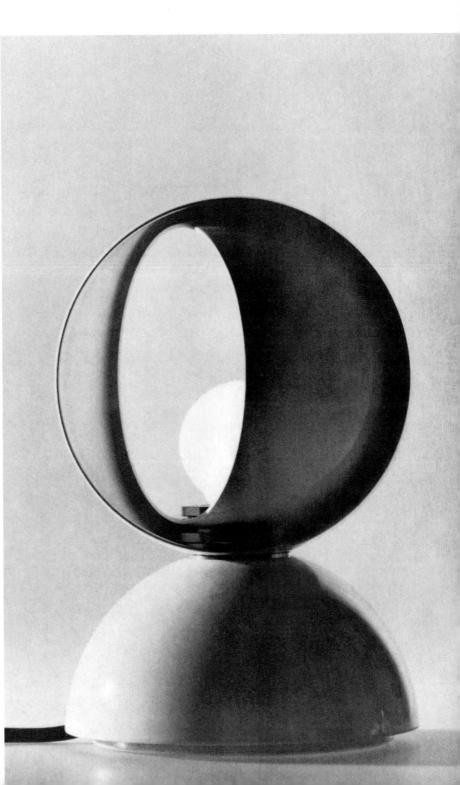

Flower illuminator of enamelled anti-rust treated metal, pillar and roof dark green 68 cm high × 18 cm square Designed and made by Hans-Agne Jakobsson AB *Sweden*

Table lamp, bent iron sheet lacquered light or dark grey, 18 cm diameter Designed and made by Design Center Shizuoka Japan

Stoneware garden lamp, 50 cm diameter Designed by Mosuke Yoshitake and made by Tokyo Craft Co *Japan* opposite
Wall-mounted swinging and
extendable fitting, grey metal and opal
glass, extends to 110 cm × 28 cm over∉
Designed by Josef Hurka and made
by Napako Czechoslovakia

Group of table lamps, acrylic tube case in bamboo, lacquered iron sheet and plywood respectively mounted on iron rims 18, 20 and 18 cm diameter All designed and made by the Design Center Shizuoka Japan

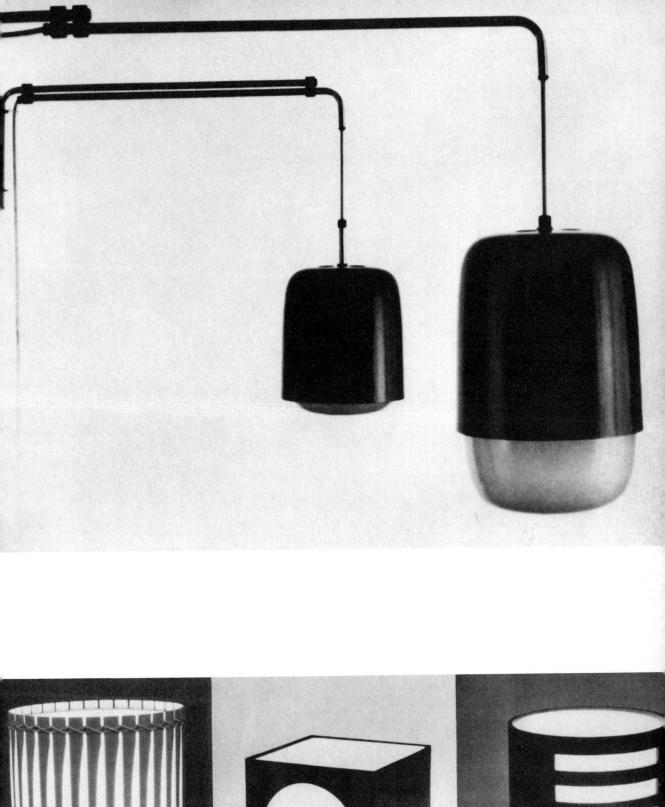

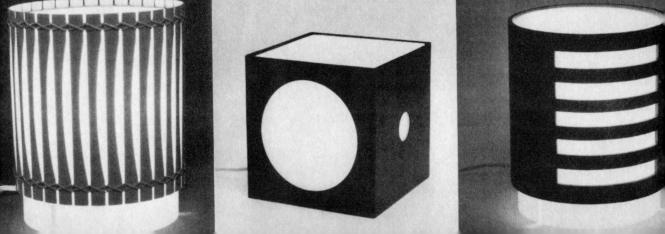

Ragusa pendant, lead crystal with matt/bright relief, 26 cm deep Designed and made by Peill & Putzler Glashüttenwerke W. Germany

Table lamp, milk-white acrylic on aluminium disc 22 cm high Designed by Industrial Arts Institute and made by Kawai Kogyo KK & Tokyo Jushi KK Japan

Tuikku lanterns, blown glass in four colours 22 cm high Designed by Nanny Still for Riihimäen Lasi Oy Finland

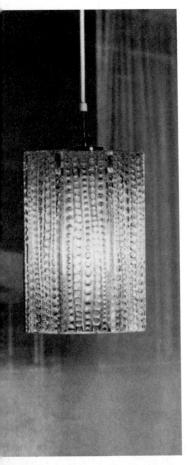

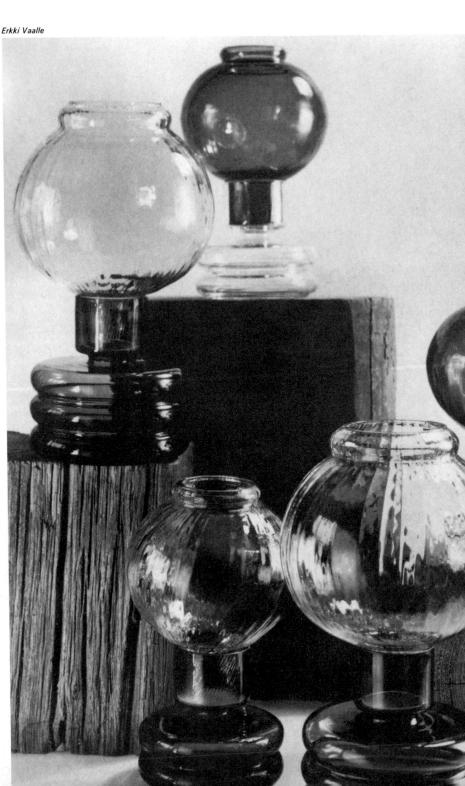

ndant, wall-mounted, table d standard fittings, satin pdized aluminium with opal and oke-grey acrylic bowls signed by Robert Welch and made Lumitron Ltd *England*

Pendant coloured acrylic with metal rim-reflector, 15 cm diameter Designed by Lisa Johansson-Pape Wall-mounted fittings in white and coloured acrylic, 15 cm diameter Designed by Yki Nummi bottom left Wall fitting, colour sprayed metal, 18 cm diameter Designed by Svea Winkler All made by Oy Stockmann Orno Finland

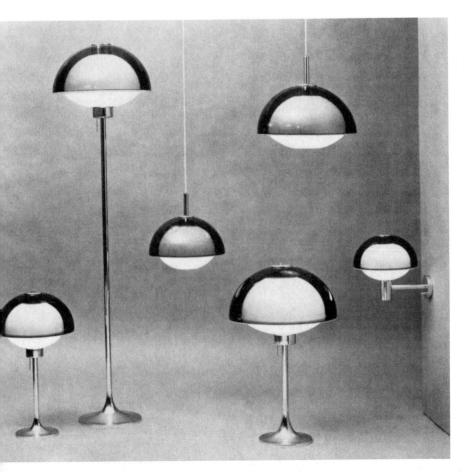

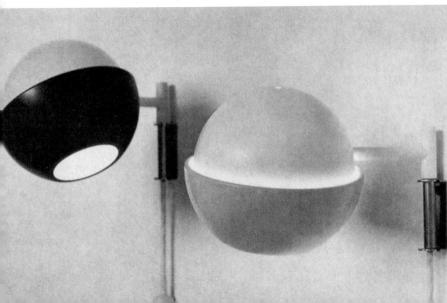

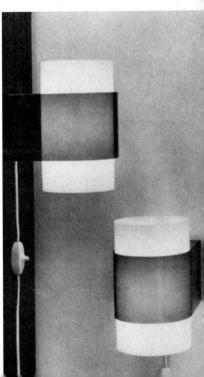

Pendant, black-lacquered and chromed metal with Perspex reflector, green, white, grey 60 cm diameter Designed by Pieter de Bruyne (Belgium) for Arteluce Italy

SEN/18 one of a range of lowglare, baffle grid units available also as ceiling mounting or recessed fittings, enamelled bluegrey and white Designed and made by Courtney, Popi (Electrical) Ltd *England*

Model 1090 demountable floor lamp in Ondolux 1·22 m high Designed by Gino Sarfatti for Arteluce *Italy*

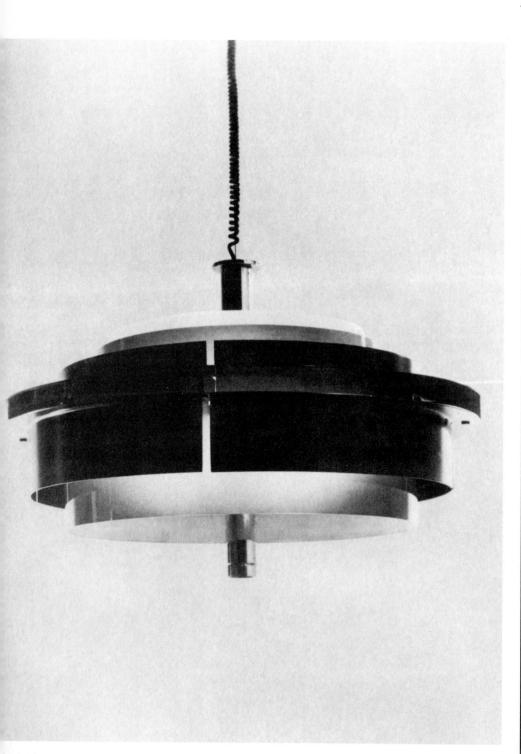

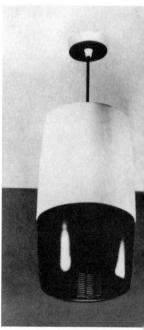

464 · lighting · 1967–68

ee-standing lamp, table or floor model, kelled brass stem with black-lacquered uminium reflectors, bright diffusers and 145 cm high

oor lamp with swinging, tipping and volving bar, nickelled brass and ack-lacquered aluminium, 135 cm high oth designed and made by Beisl uchten KG W. Germany

Wall-light, single, double or triple mounted, satin silver, light gold or copper finished aluminium with flashed opal, clear amethyst or smoke shades, projection 20 cm Simple-to-fix wall light, the white opal cylinder fitted with a sleeve in one of many colours. Available, mounted on a stem of anthracite moulded plastic and bar and fitting of anodised aluminium Both designed by E. Cooke Yarborough for Conelight Limited *England*

Trombone one of a series, chrome stems and tipping cylinders of matt aluminium 51 cm high Designed by Jo Hammerborg for Fog & Mørup Denmark

Table-spot-lights in nickelled brass and black-lacquered aluminium 23 cm high Designed and made by Beisl Leuchten KG W. Germany

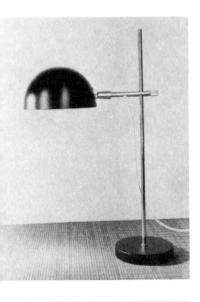

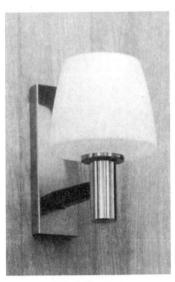

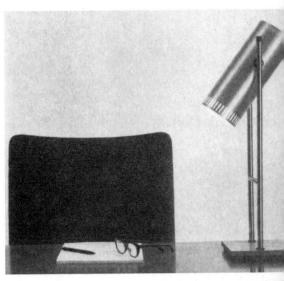

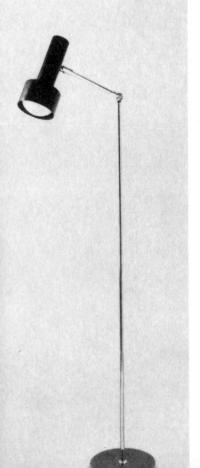

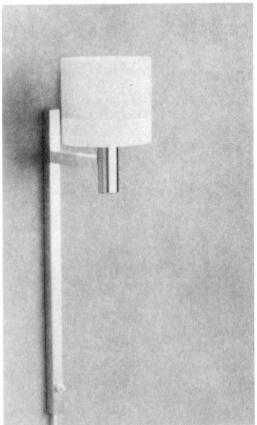

1967-68 · lighting · 465

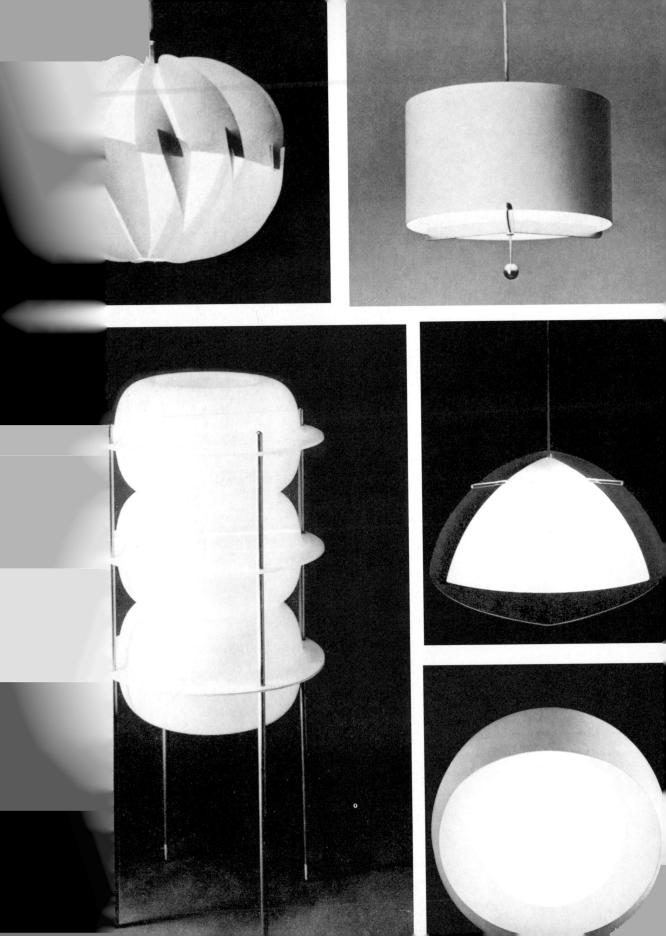

ndant, natural white impregnated paper, cm diameter esigned and made by Pavel Grus (UBOK)

zechoslovakia

Co Denmark

esk lamp, milk-white acrylic bowls on pale onze finished cast iron stand, 57 cm high, i cm diameter: demountable esigned by Osaka Industrial Research Institute Nihon Denki Sobi K.K. Japan

w pendant fitting with pull switch, matt ass holder with 3×40 kw lamps, white equered metal shade, 33 cm diameter signed by Vilh. Wohlert for Louis Poulsen Co Denmark

ndant lamp in clear/opal acryfics, lamp 3 kw maximum signed by Peter Karpf for H. F. Belysning nmark

nall wall fitting, white lacquered metal with al glass 'eye' for 40 kw lamp, 21.5 cm imeter signed by Henning Koppel for Louis Poulsen

e of a series of weatherproof box fittings for erior or exterior walls, graphite with satin al glass, here 20 × 20 cm + 20 × 11 cm

erall signed and made by Staff Leuchten GmbH Germany

andelier, shells assembled on polished as hoops, 32 cm diameter × 45 cm deep signed by Verner Panton for J. Luber & Co Germany

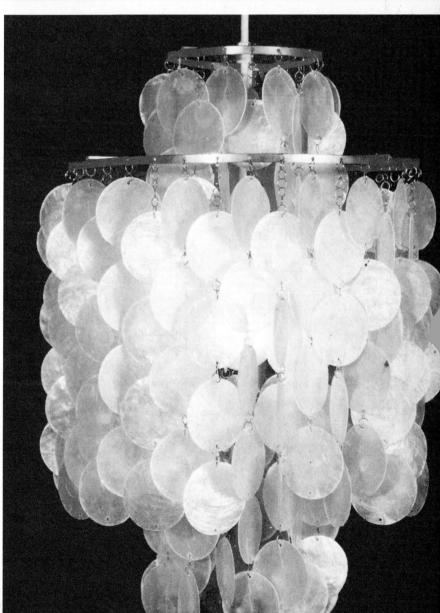

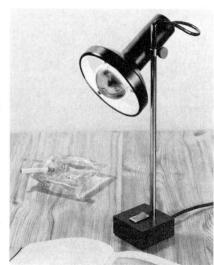

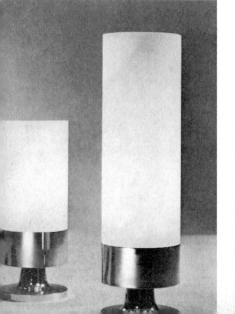

all light, polished chrome with crystal glass ns' 28 × 28 cm; 16 cm deep esigned and made by BAG Bronzewarenfabrik G *Switzerland*

las Top Spot for desk, wall or ceiling punting, using domestic-type lamp esigned and made by British Lighting dustries Limited England

10 Bed lamp, iron, stove enamelled white or own with chromed screen of ABS plastic; jht may be adjusted and/or directed up or own esigned by Per Sundstedt for Lampan

esigned by Per Sundstedt for Lampan rmatur Ab Sweden

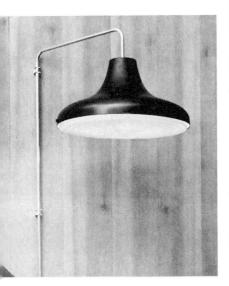

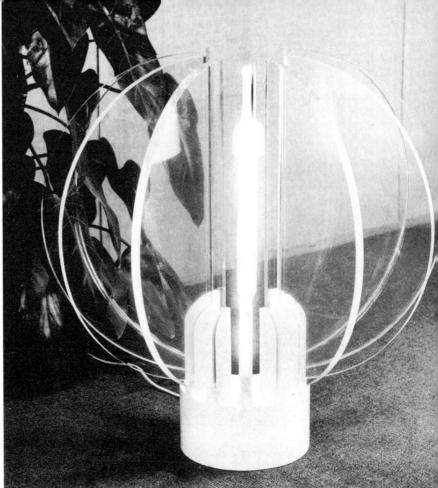

<code>onsul</code> table lamps, opal cylinders on weighted olished aluminium bases, $10\cdot1$ diameter $\times\,20\cdot2$ r $30\cdot3$ cm high esigned by John Brown for Plus Lighting Ltd <code>ngland</code>

'antilever 41555 Mark II fluorescent desk imp, self-colour anodized aluminium with lack finished steel base: reflector rotates nd pivots about the stem which can be further ngled: overall 70-21 wide x 48 cm high lesigned by Gerald Abramovitz for Best & loyd Limited England

BSW swinging wall light, black or white olystyrene shade over white louvres; 40·4 cm liameter: anodized aluminium mounting rojects 55·19 cm
lesigned by Ronald Homes for Conelight imited England

loor lamp in metacrilato on aluminium base acquered white or orange Designed by Gae Aulenti for Kartell s.r.l. *Italy*

he Ball weatherproof garden light, stainless teel lacquered red and grey, 50 cm diameter esigned by Max Ingrand for S. A. Max Ingrand rance

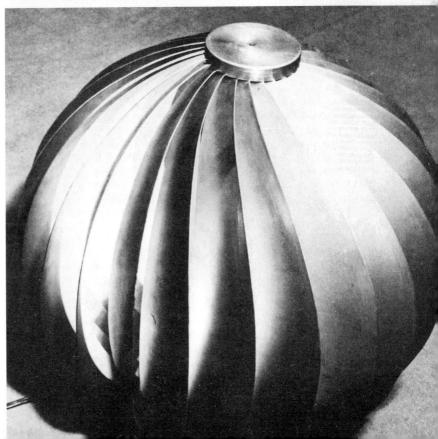

Chandelier, cut crystal and jewelry crystal with polished brass mounting: 43 cm diameter Designed by Ceno Kosak for J. & L. Lobmeyr Austria

Tiffany pendants

Waterlily green and turquoise on blue 37 cm diameter

Waterilly green and turquoise on blue 37 cm diamed Designed by David Wren
Daisy purple/orange on white 40·4 cm diameter
Designed by Pauline Butler
Nouveau Beardsley black/white 40·4 cm diameter
Designed by Ian Logan
All for X-lon Products Limited England

Tulipan chandelier blown clear glass petals' from 20 cm to 1 m overall diameter Designed and made by J. T. Kalmar Austria

Shade composed of demountable elements, pentagons and hexagons of opalescent PVC, 40-4 cm diameter Designed by Ch. M. Dethier for Ove Belgium

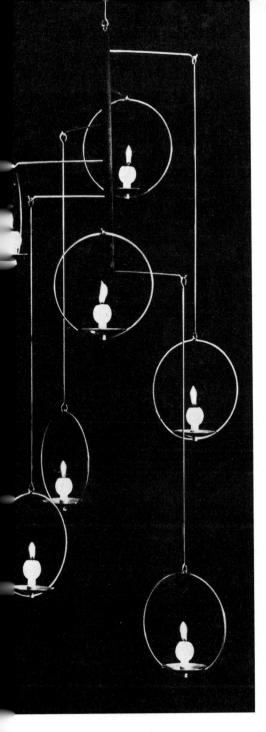

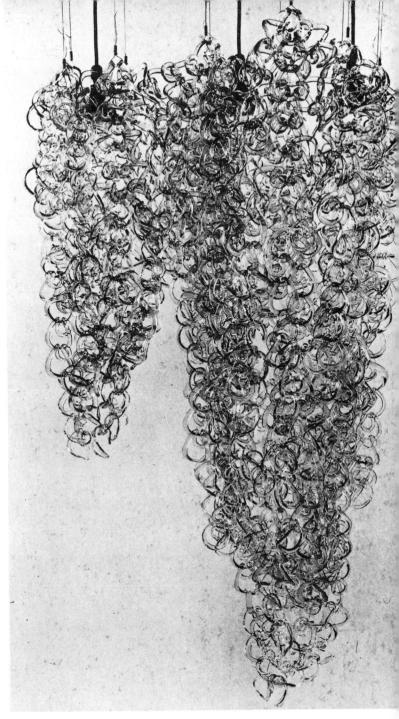

fitting, polished brass and black wood ad by Raija Aarikka, the candles by arpaneva: for Aarikka *Finland*

ce-blue, violet, ruby, tea or clear boks assembled here as a chandelier: nents may be freely arranged e.g. as with an independent light source or idirectly-lit curtain ed by Angelo Mangiarotti for Vistosi

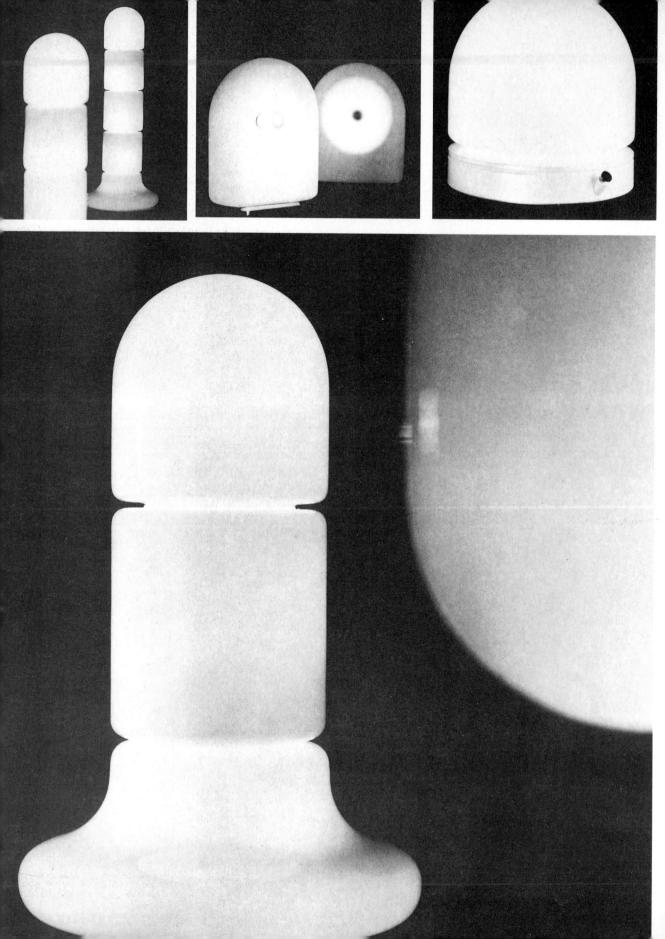

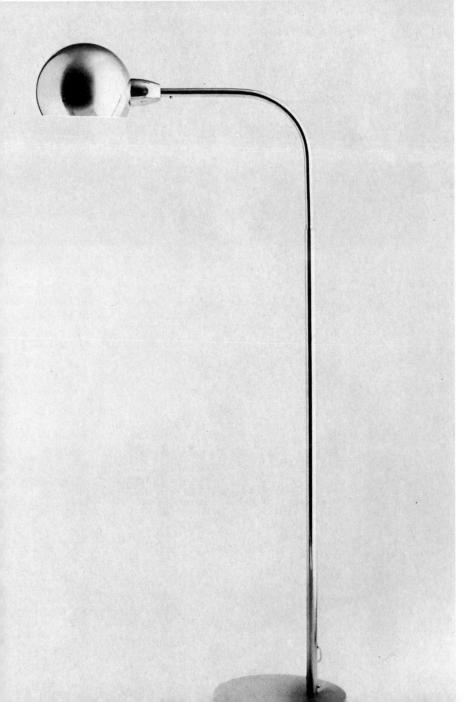

1 2 3 5

1, 4

Table lamps composed of a base, a head and one, two or three intermediate elements, white glass: cm 52 diameter base \times 74 high

2 Flattened globe table lamp, mould made white glass with aluminium base: cm 44 high All designed by Claudio Salocchi for Lumenform

Italy

Table lamp, Murano glass diffuser on lacquered aluminium base with pushbutton control, smoked rose glass/pearl white base or white diffuser/dark maroon base: cm 45 high Designed by Danilo and Corrado Aroldi for Stilnovo s.p.a. Italy

5

Passiflora table light, yellow and white

Perspex: cm 38.5 high Designed by Superstudio for Poltronova s.r.l. Italy

6

Venticinque lamp with revolving head and reflector, chromed metal: cm 110 high Designed by Sergio Asti for Candle Italy

1 2 5 6 3 4 7 8

3

Cubelight, satin etched opal sphere with amber or twilight Perspex cube Designed and made by British Lighting Industries Limited, England

Group of 'illuminated sticks' free arrangement cm 11.8, 19.6 and 27.4 deep
Designed and made by Staff & Schwarz Gmb
W. Germany

Cirkel pendant fitting, inside opal glass, outer havana brown or heliotrope transparent glass cm 30.5 deep Designed by Jo Hammerborg for Fog & Mørup A/S, Denmark

Periscopio table lamps, metal fitting lacquered amaranth.gloss black, pearl or ochre: cm 47 hig Designed by Danilo and Corrado Aroldi for Stilnovo spa, Italy

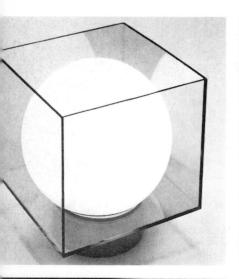

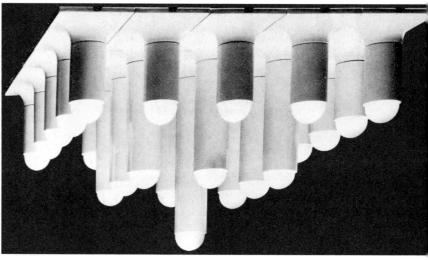

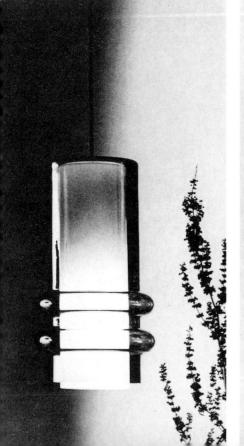

5 Self-assembly shades in heat-resistant cardboard, plain white, green/yellow, pink/orange, violet/turquoise or green/blue: cm 25.4 cube
Designed and made by Staples and Gray, England
6
Peta/ light in heat resistant card, white, pink, orange or green: cm 46 diameter
Designed by Staples and Gray for Cosmo
Designs Limited, England
7
QD4/12/C4 fitting, extruded aluminium tubes, anodised silver or straw-gold on steel ceiling plate stove-enamelled black: cm 30×30 overall
Designed by Noel Villeneuve for Allom Heffer & Company Limited, England

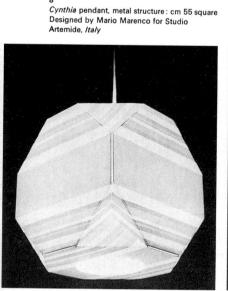

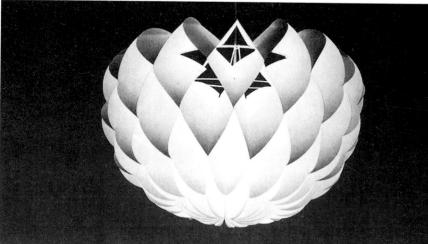

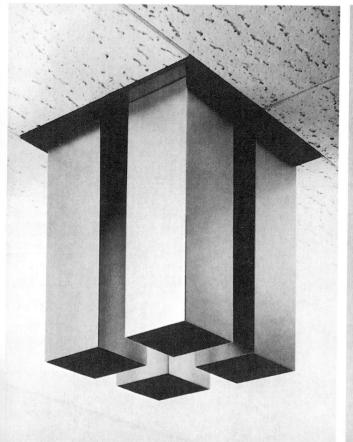

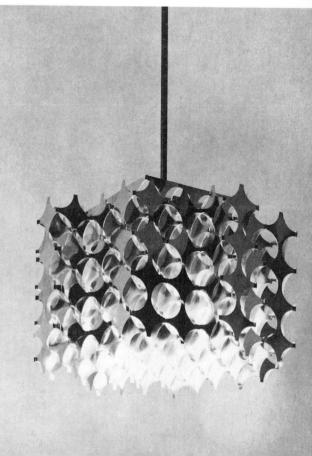

4 5 6 1 2 3 7 8 9

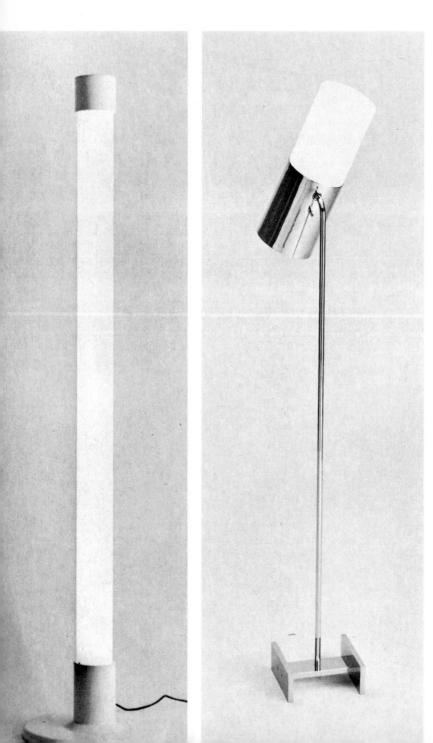

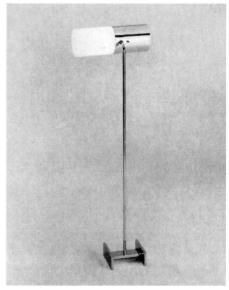

1 Tube standard, opaque white metacrilato with iron lacquered white, green or black cm 142 high Designed by Nanda Vigo for Kartell s.r.l., *Italy* 2, 3, 7

Two standards, the shades of aluminium, stems and stand chrome-plated brass: 2, 3 with acrylic diffuser: 7 with glass shelves Both designed by Paul Mayen for Habitat, Inc U.S.A.

Large floor lamp, opaque white glass and chromed brass, seven light levels: cm 80 high Designed by Gianni Celada for Fontana Arte, Italy

5
Polaris table lamp, chromed metal armature on marble base with white opal spheres:
Excelsior, the floor standard, has all-metal stand Designed by A. Natalini for Poltronova s.r.l.,
Italy

6
Bino lamp, metacrilato and metal:
cm 55 high with adjustable head
Designed by V. Gregotti, L. Meneghetti and
G. Stoppino for Candle, Italy

8
Vertical fluorescent tube light, aluminium
anodized or lacquered black, base steel and
rubber: cm 172 and 142 high
Designed by Claudio Salocchi for Lumenform,
Italy
9
Chimes steedard white Blazieles and 100 holds.

Chimera standard, white Plexiglas: cm 180 high Designed by Vico Magistretti for Studio Artemide, Italy

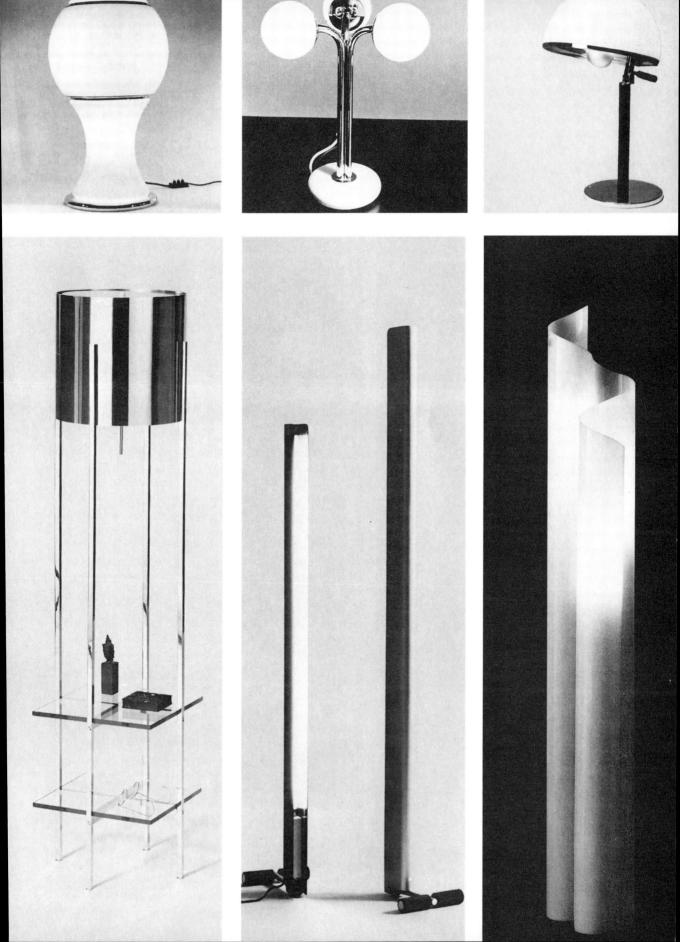

1, 4 Standard, chrome-finish metal with orange/white Plexiglas spheres cm 150 high \times 47 diameter Ceiling lamps, aluminium lacquered black, red

orange, green or violet with white glass bulb cm 16 diameter, 19-35 deep

Floor lamp, chrome or white lacquer finished metal armature with iris glass bowl: cm 53.5 high × 30 diameter All designed and made by Beisl Leuchten KG

W. Germany

3

3 Pendant, globes blown bubble glass with black armature: cm 25-45 diameter Designed and made by Peill & Putzler Glashüttenwerke GmhH, W. Germany

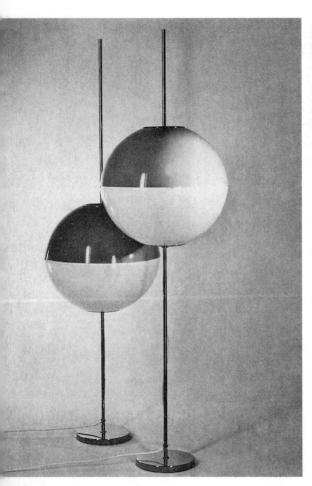

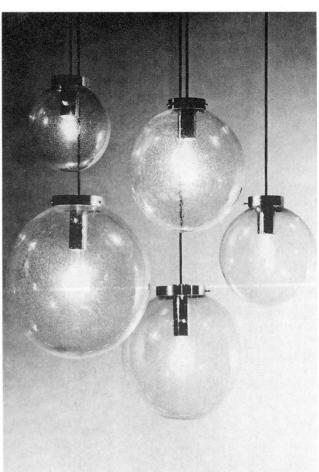

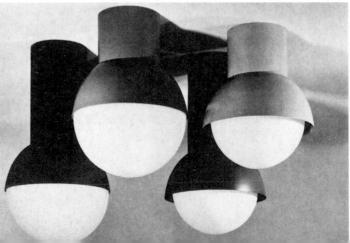

5, 6 Standard and pendant lamps, white lacquered metal with split pine shades, natural colour: cm 140 high \times 44 diameter. Pendant cm 60 diameter Both designed by Hans-Agne Jakobsson for Ellysett Ab, *Sweden*

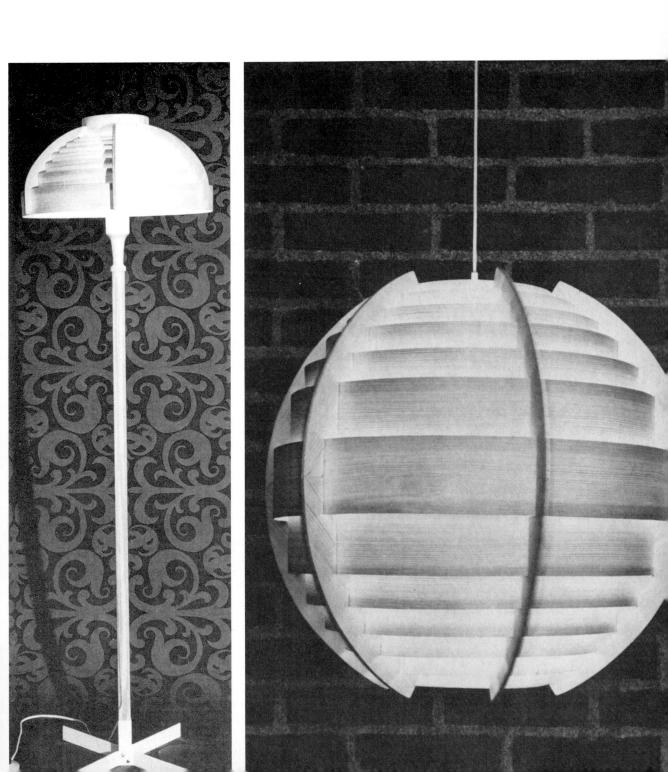

silver and tableware | Silber und Geschirr | Argenterie et arts de la table

← Fruit dish in plastic, grey vermilion, or black.

Designed by Shogoro Terashim for the Tohyoh Plastic Co. Lt JAPAN

Tray in Bangkok teak, 21½ inche long, from a series designed b Th. Skjøde Knudsen for Skjød Skjern DENMARK ▼

■ Beaker in fine earthenware with twin-tone eggshell finish in dove grey and sky blue. From a range designed by Robert Jefferson, Des.RCA, for Carter, Stabler & Adams Ltd UK

Split cane basket and tray, 15 inches diameter, natural and two-tone finish, designed and handwoven by Władysław Wołkowski POLAND

▲ Salt, pepper and sugar dredgers in teak and 18/8 stainless steel.

Designed by Heinz Decker for C. G. Hallbergs Guldsmeds AB, SWEDEN

Marbled light-grey and black opaque acrylic tray 20½ inches long, one of several opaque and transparent designs made in a wide range of colours by X-Lon Products UK

Soup bowls in Melamine, highgloss finish, available in several colours including black, limeyellow, forest green, cardinal red, gunmetal. Designed by Ronald E. Brookes, FSIA, for Brookes & Adams Ltd UK

Sandwich plates in porcelain, white glaze, with handles in rattan. Designed by Tadashi Matsumoto for Sango Toki KK, JAPAN Courtesy Japan Pottery Design Center

Salad bowls in teak with servers in palissander.

Designed by Alfred Klitgaard for 'Alfi Teak' DENMARK

1960-61 · silver and tableware · 483

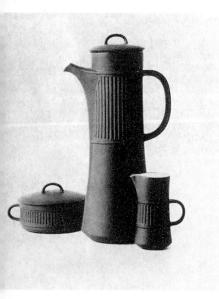

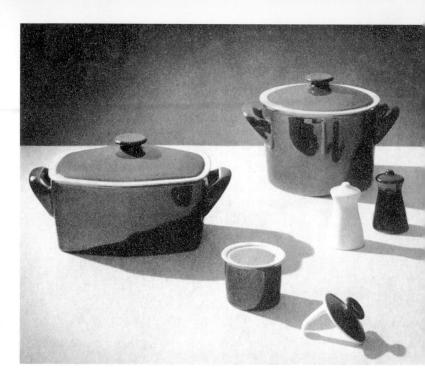

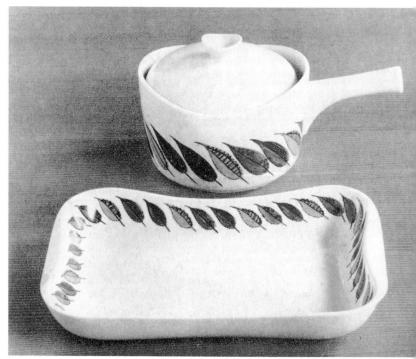

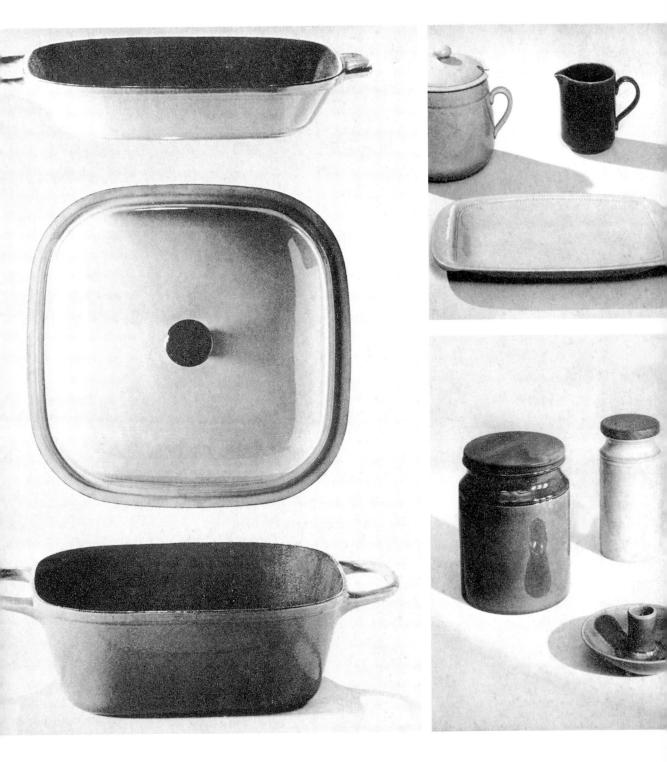

Square casserole and roasting dish in cast-iron red vitreous enamelled ware; the lid is shaped to fit either. From a range designed by Sigurd Persson for Kockums SWEDEN

RIGHT: Old Häganös hand-thrown oven- and tableware: hard-fired earthenware with olive green, mustard yellow, manganese brown, navy blue and red glazes. Designed by John Andersson for Andersson & Johansson AB, SWEDEN

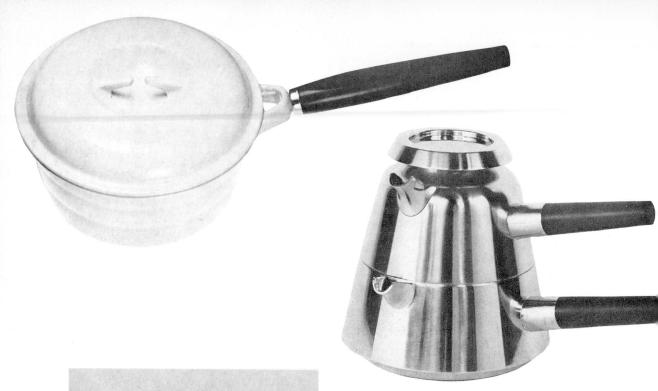

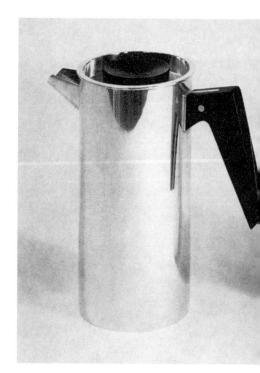

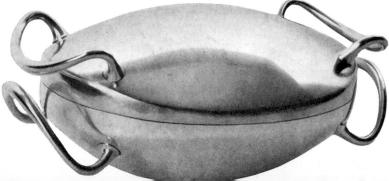

- I Colorcast vitreous-enamelled cast iron saucepar blue ribbon, red pepper, or lemon rind (inside wh A stackable design with machined base and be handle, made in three sizes by the Waterford In founders Ltd EIRE
- 2 Tea urn in stainless steel, designed by Mag Stephensen; 3 sterling silver dish on spirit la base, designed by Søren Georg Jensen; 5 oval with cover, sterling silver, designed by Henn Koppel. All made by Georg Jensen Sølvsmedie DENMARK
- 4 Coffee pot in sterling silver with ebony handle knob. Designed by Robert Welch, Des.RCA, M for J. & J. Wiggin Ltd UK

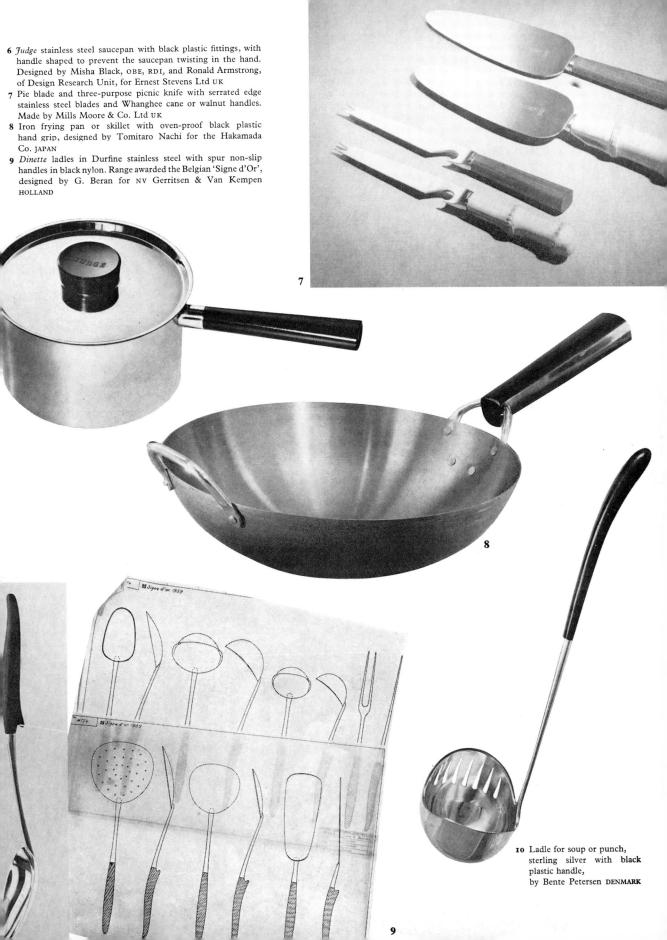

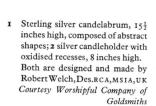

- 3 Candleholder in ebonised wood and polished brass designed by Kenneth Clark and Paul Gell UK
- 4 Grouped candleholders in brass on teak base. Unique piece by Tapio Wirkkala for o/Y Kultakeskus FINLAND
- 5 Hardwood candlestick, stained and polished jacaranda, with base and ring in polished brass. Designed and made by Hans-Agne Jakobsson AB, SWEDEN
- 6 Coffee set in sterling silver with base and finials of coloured nylon. Designed and made by Stuart Devlin: Royal College of Art UK Courtesy Worshipful Company of Goldsmiths

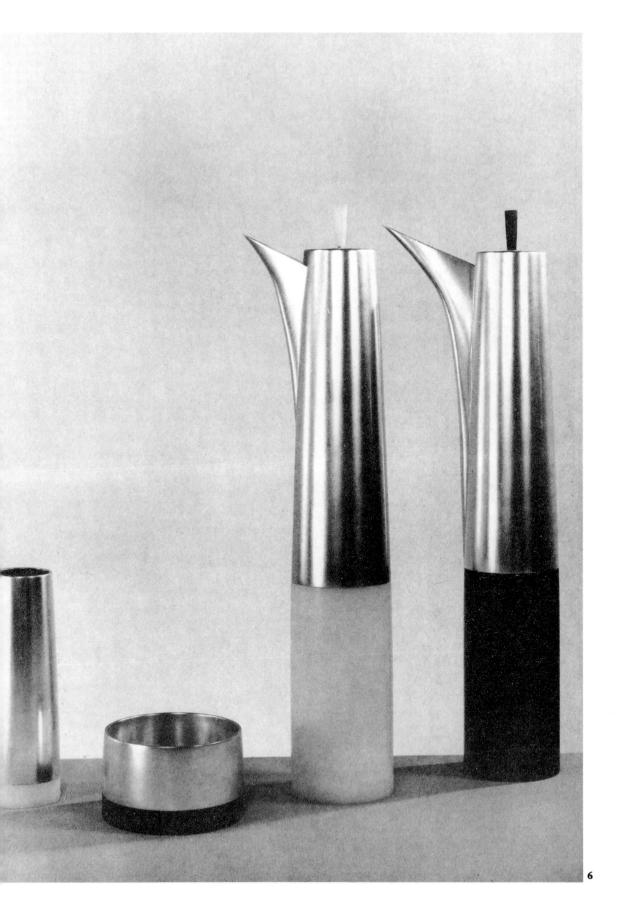

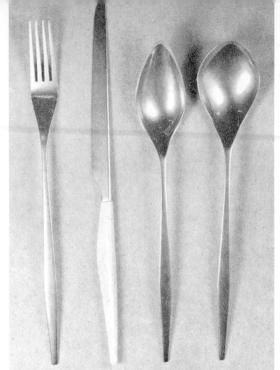

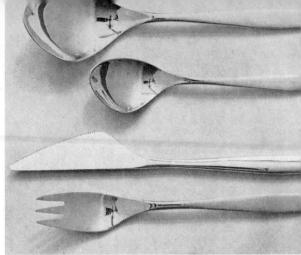

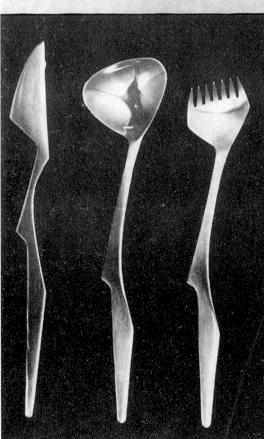

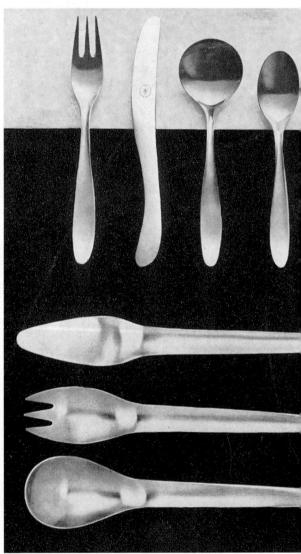

Flatware in sterling silver

- I Designed and made by Stuart Devlin: Royal College of Art UK Courtesy The Worshipful Company of
- 2 Designed and made by Robert Welch, Des.RCA, MSIA, UK

Flatware in quality stainless steel

- 3 Designed and made by Sigurd Persson sweden
- 4 Service No. 2721 designed by Don Wallance USA for C. Hugo Pott GERMANY
- 5 Three-piece child's set in 'Gero Zilduro'designed by D.W. Simonis for NV Gerofabriek HOLLAND
- 6 Spring service designed by David R. Mellor and Robert We Des.RCA, MSIA, for Walker & Hall Ltd UK
- 7 Service with nylon inlaid handles designed by Falle Uldal C. Thaysen & Co. DENMARK
- 8 Opus service designed by Tias Eckhoff for Dansk Knivfa
 A/s, DENMARK
- 9 Festi service in 'Gero Zilduro' designed by D. W. Simonis NV Gerofabriek HOLLAND

2

1

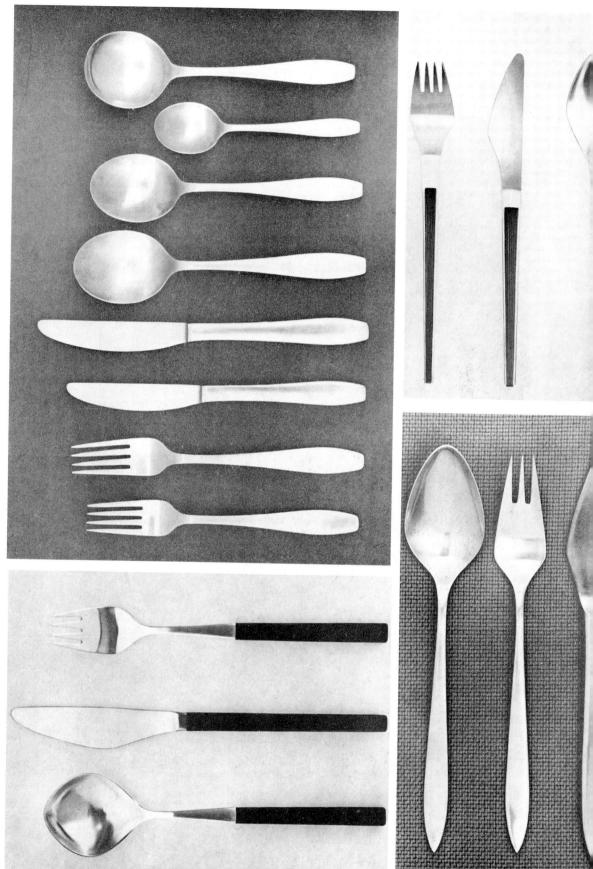

8, 9

1960–61 · silver and tableware · 491

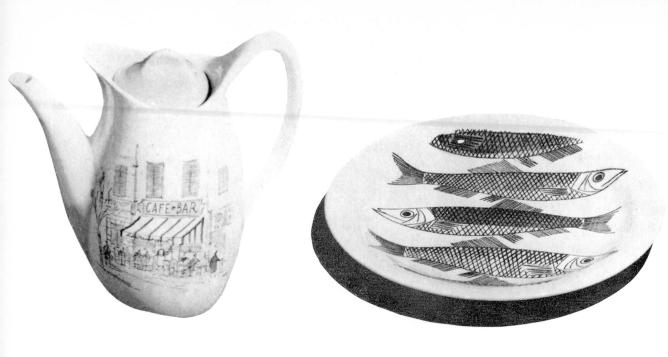

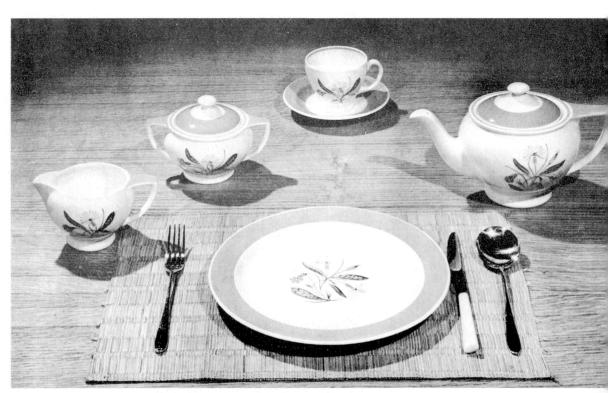

 $\textbf{492} \cdot \text{silver}$ and tableware $\cdot~1961{-}62$

TOP ROW: Coffee pot in semi-porcelain white Staffordshire china from the *Riviera* range on 'Stylecraft Fashion' shape designed by Sir Hugh Casson, RDI, for W. R. Midwinter UK

Dinner plate from the service My Garden in ovenproof earthenware, white glaze with multicolour decoration.

Designed by Marianne Westman for AB Rorstrands Porslinsfabriker SWEDEN

Oven King casserole, ovenproof earthenware: high white with underglaze decoration in pink and green. Designed by Fernando Farulli for Mancioli Natale & C. ITALY

TOP RIGHT: Romance white porcelain tableware, cobalt blue underglaze decoration on relief-patterned body with complementary matching crystal glasses and silver. Designed by Bjørn Wiinblad DENMARK

Made by Rosenthal Porzellan AG, Rosenthal Glassworks, Rosenthal Domus Gmbh Germany

◆ Pink Campion tea/dinner ware in fine earthenware with underglaze painted pink and grey decoration, grey-blue border.

Designed by Susie Cooper, RDI, for Susie Cooper Pottery Ltd UK

Jeanette service in faience, deep red exterior glaze with blue border decoration under greyish white glaze.

Designed by Nils Thorsson for The Royal Copenhagen Porcelain Manufactory A/S, DENMARK

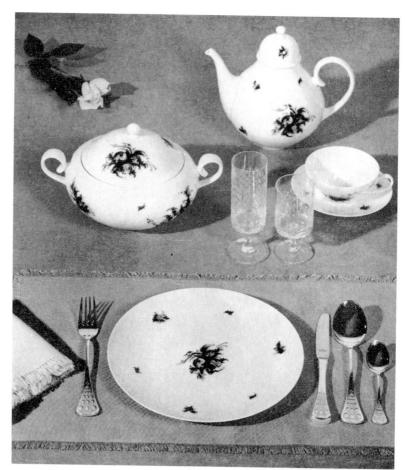

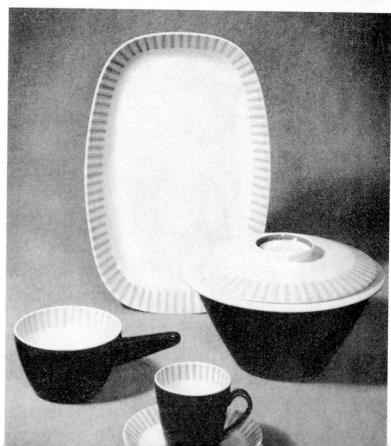

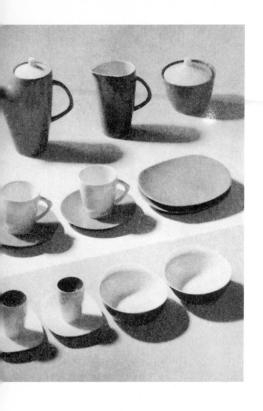

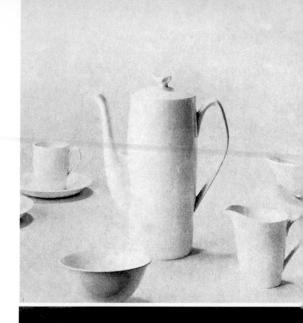

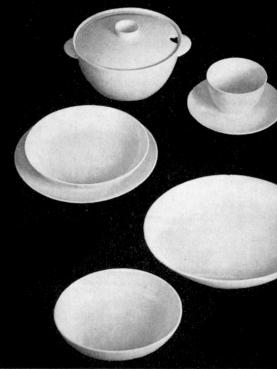

Designed by Milan Chilbec for Spojené keramické závody n.p. CZECHOSLOVAKIA

■ White porcelain coffee service with overglaze 'star' decoration designed by Bele Bachem on Berlin shape designed by Hans Theo Baumann; each cup bearing a different sign of the Zodiac.

Made by Rosenthal Porzellan AG, GERMANY

TOP: Apollo fine bone china Spode ware designed by Neil French and David White for W. T. Copeland & Sons Ltd UK

ABOVE: All purpose service No. 3510 in white porcelain made by Porzellanfabrik Langenthal AG, SWITZERLAND

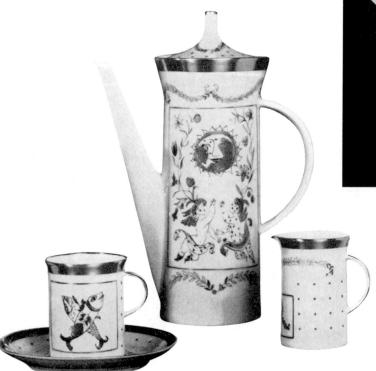

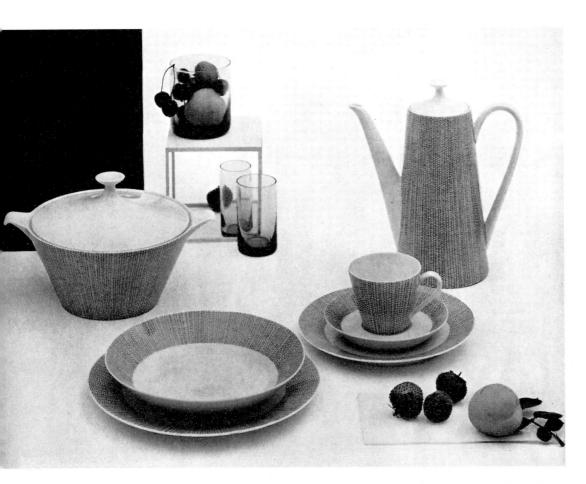

▲ White porcelain service with black linear decoration designed by H. Mayer on shape No. 311 designed by Heinrich Löffelhardt for Porzellanfabrik Schönwald GERMANY

Earthenware teapot, white glaze, with decoration in green, yellow, brown, black

Designed by Pirkko Torvinen for Kupittaan Saviosakeyhtio FINLAND ► Copper casserole with porcelain insert and detachable handle in teak (as shown): brass fittings.

Designed by Jens H. Quistgaard for Dansk Designs DENMARK

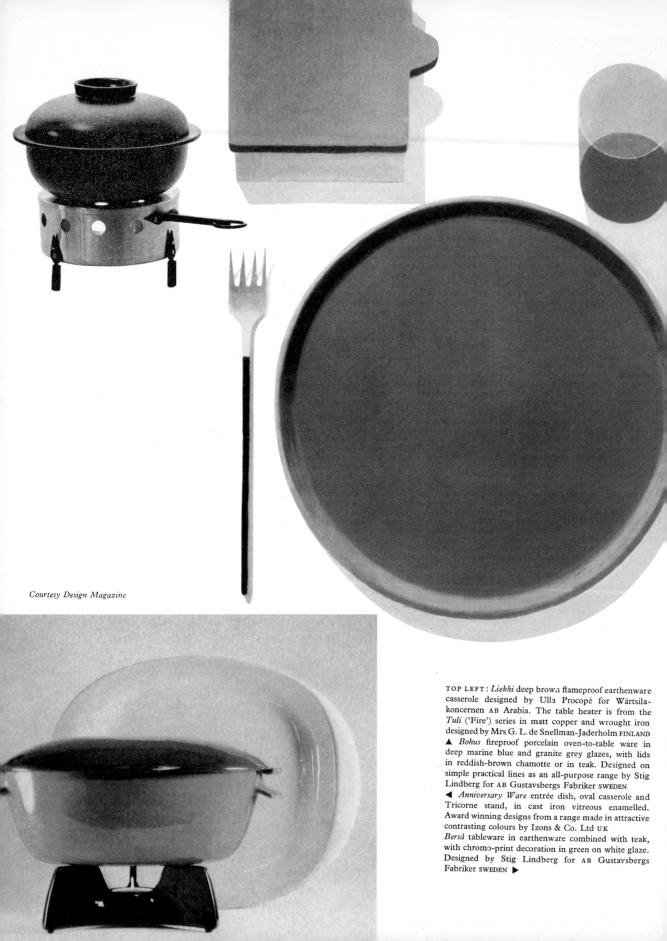

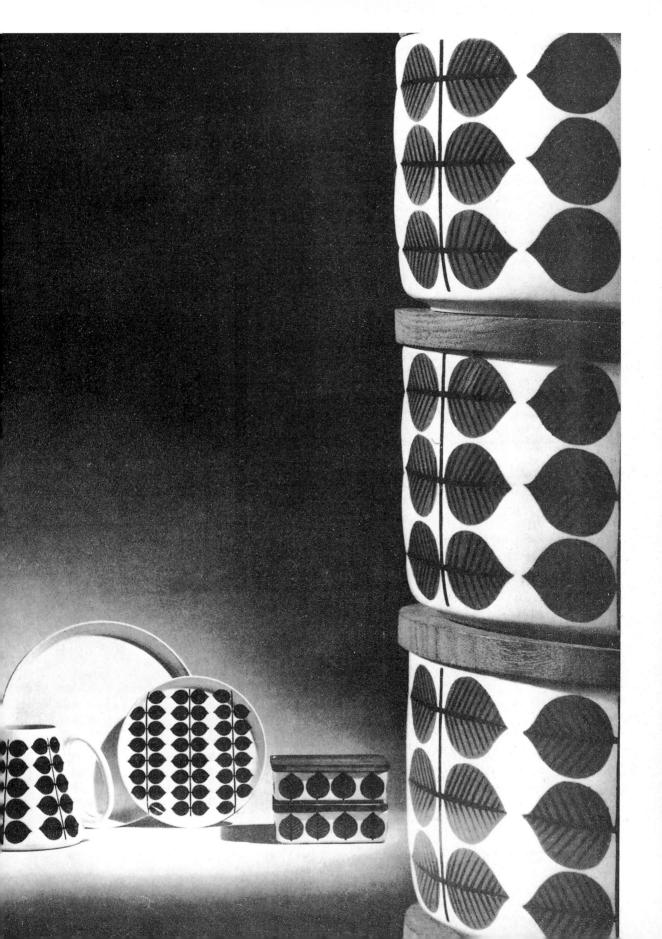

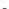

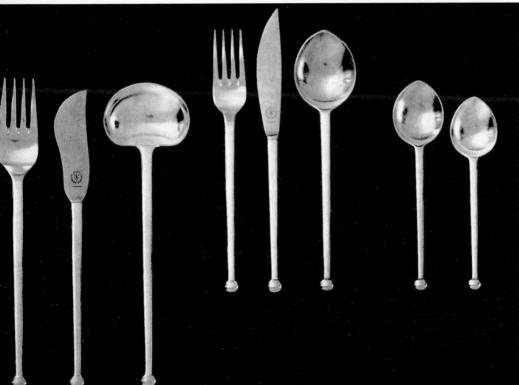

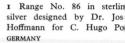

3 Table set in sterling silver de signed by Arne Jacobsen, m.a.a for A. Michelsen DENMARK

6 Serving spoon and fork in silve with enamel inlay.

Designed by Agnar Skrede for David-Andersen NORWAY

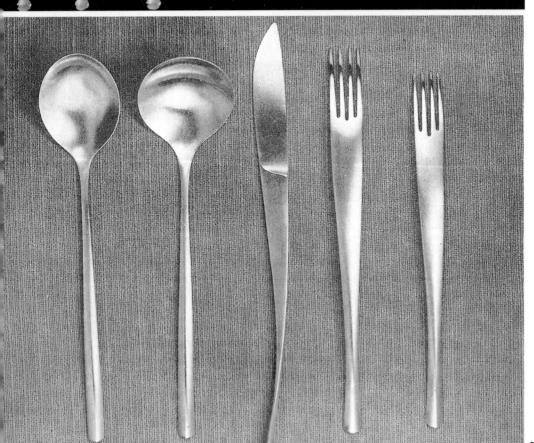

4 Table set with concave hollow ground fork bowl and serrate edge to knife blade, designed by Carl Pott. Made in range No. 87 in sterlin

silver or No. 787 silver plated by C. Hugo Pott GERMANY 7 Buffet servers from the Tjør range in sterling silver.

Designed by Jens H. Quistgaar for Dansk Designs Denmark

2 Prototype set in stainles steel.

Designed by Brian R. Marshal Royal College of Art UK 5 Spectra table set in 18/8 stain less steel. Designed by

Pierre Forssell for AB Gense SWEDEN

8 Nut crackers in stainless steel Designed by Robert Welch, Des RCA, MSIA, for J. & J. Wiggin Ltd UK

2

Candleholder from the *Tuli* ('Fire') series in copper, matt finish, with wrought-iron feet. Designed by Mrs G. L. de Snellman-Jaderholm FINLAND

Three-portion vegetable dish and servers in stainless steel designed by Robert Welch, Des.Rca, Ms1a. Dish made by J. & J. Wiggin Ltd, servers by Mappin & Webb Ltd UK

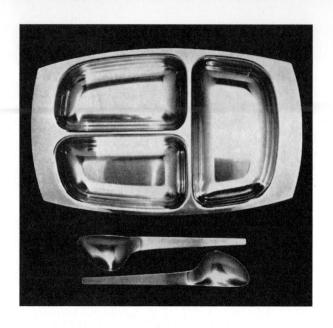

Vegetable dish designed by Henning Koppel; tray designed by Magnus Stephensen; BELOW enamel-lined butter dishes and ashtrays designed by Søren Georg Jensen. All made in sterling silver by Georg Jensen Sølvsmedie A/S, DEMMARK

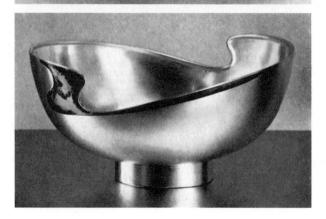

Bowl, sterling silver with blue/black enamel decoration; 6½ inches overall.

Designed by Vera Ferngren for C. G. Hallbergs Guldsmed AB, SWEDEN

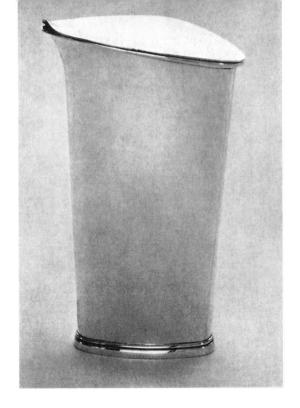

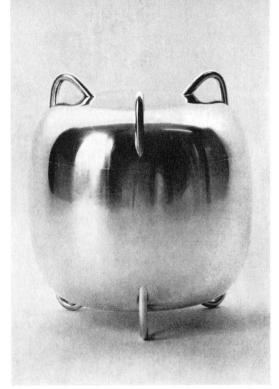

▲ Cocktail shaker in silver.

Designed by Åke Strömdahl for Hugo Strömdahl AB, SWEDEN

▶ Deep dish with fitted cover designed by Magnus Stephensen; tricorne bowl designed by Henning Koppel.

Both made in sterling silver by Georg Jensen Sølvsmedie A/s, $_{\mbox{\scriptsize DENMARK}}$

lacktriangledown Enamels on copper in rich colourings, line or sgraffito decoration; large vase 18 inches deep.

Unique pieces by Edward Winter USA

Enamel on steel plate, copper-green figure on blue ground.

Unique piece by Bob Oldrich CANADA

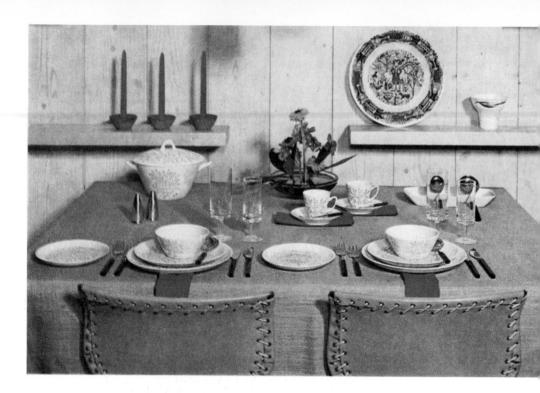

Table set with Blue Berry dinner and coffee service in porcelain, designed by Eystein Sandnes for Porsgrunds Porselænsfabrik; Grenader crystal by Axel Mörch for Magnor Glassverk; Opus stainless steel cutlery by Tias Eckhoff for Dansk Knivfabrik A/s. In the background teak candleholders by Frank V. Hansen, DENMARK, and ceramics designed by Anne Marie Ødegaard for Porsgrund NORWAY Courtesy Designs of Scandinavia, London

Stoneware teapot from a series in matt and glossy brown glazes. Designed by Ulla Procopé for Wärtsilä-Arabia FINLAND

Teak condiment set designed by Mrs. G. L. de Snellman-Jaderholm FINLAND

502 · silver and tableware · 1962-63

Beer mug in matt brown and glossy moss-green glazes. Designed by Göran Bäck

Ruska ovenware in brown glazed stoneware.
Designed by Ulla Procopé
Both made at Wärtsilä-Arabia FINLAND

Enamelled cast-iron game casserole and long fish or forcemeat dish; base surfaces are ground and a detachable teak handle is supplied for easy lifting of the lid and pots. Designed by Timo Sarpaneva for W. Rosenlew & Co A/B FINLAND

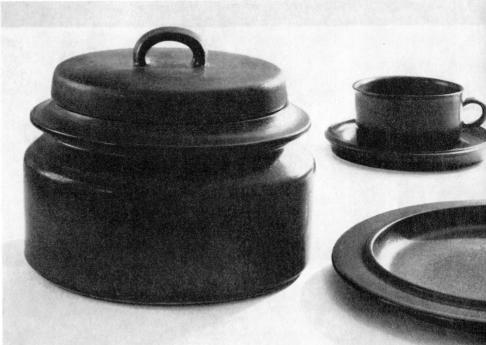

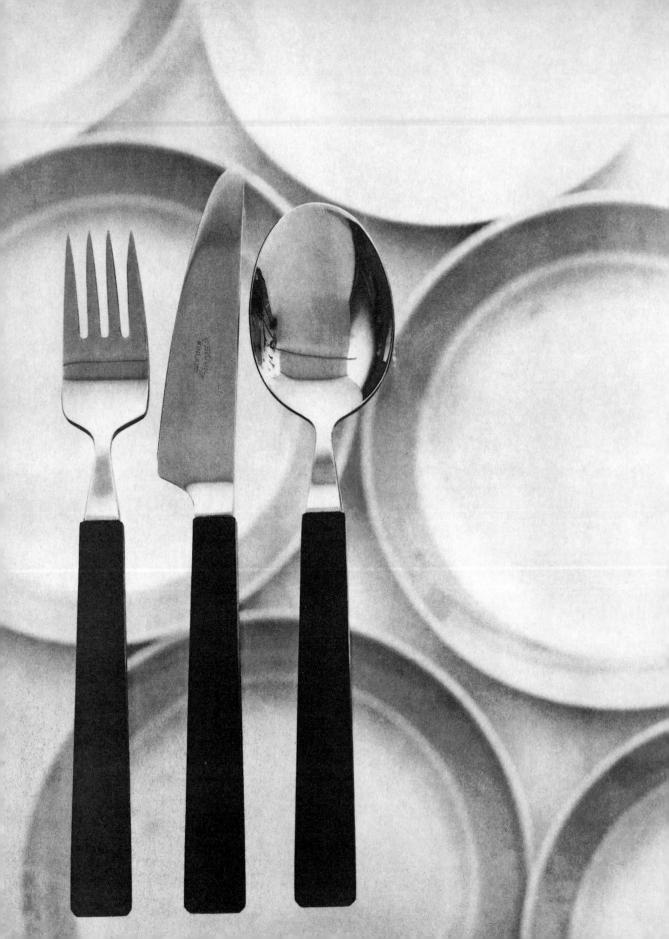

Stainless steel flatware in 18/8 chromenickel-steel with black nylon handles; the knife blades are of special highgrade steel Designed by Bertel Gardberg for O/Y Fiskars AB FINLAND

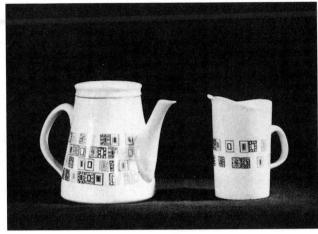

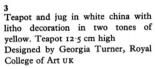

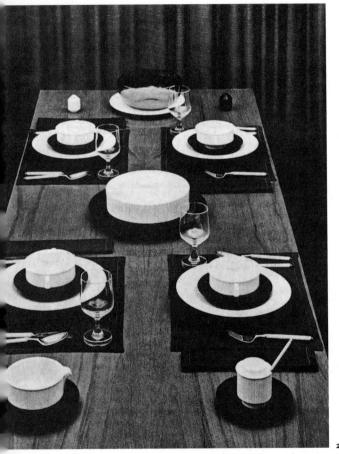

Variation dinner service in black and white with impressed design. Matching glasses with similar design on the bases. Accord porcelain-handled cutlery

All designed by Tapio Wirkkala, Finland, for Rosenthal Domus GmbH GERMANY 4
Thermos jug of aluminium, lacquered in black, red or olive, and with a teak handle; 26 cm high
Designed by Torben Lind for Torben Ørskov & CO DENMARK

PHOTO: JØRN FREDDIE

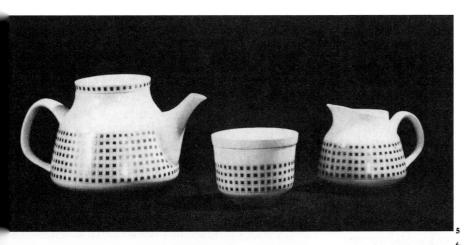

5, 6 Tea-sets in white china. Teapots 12.5 cm high. Shapes by Julia Chandler and Rosemonde M. Nuriac. 5, litho and applied gold decoration by Rosemonde M. Nuriac. 6, litho decoration in pastel and gold by Julia

Chandler 7, Condiment set in white china with impressed decoration and copper lids. Tallest 12.5 cm high

Designed by John Dodson. All at the Royal College of Art UK

Oval casserole, marmite and entrée dish from the Evesham oven-to-table range in fireproof porcelain. Made by the Royal Worcester China Co Ltd UK

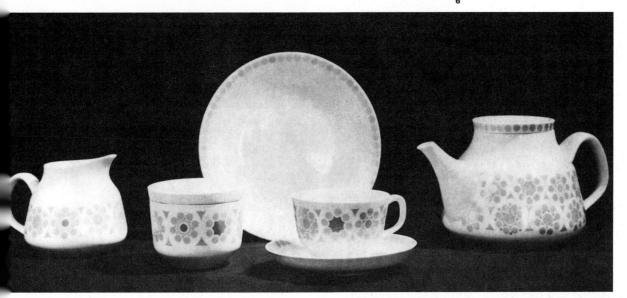

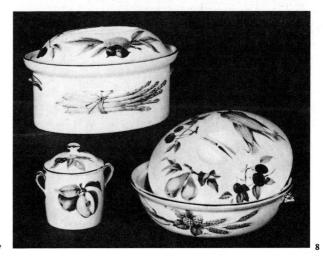

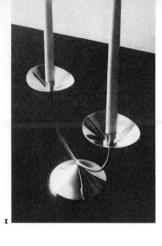

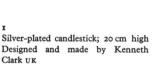

Vase and bowl of sterling silver
Designed and made by Heinz Decker
SWEDEN

3 Covered bucket-dish in sterling silver; 20 cm high

Designed by Erling Børup Kristensen for Frantz Hingelberg DENMARK

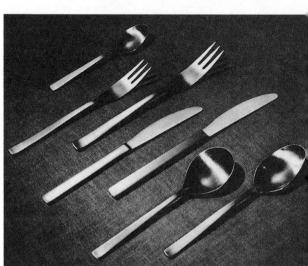

4 Sterling silver goblets Designed by Barbro Littmarck ff W. A. Bolin Hovjuvelerare SWEDEN 5 Flatware in 18/8 chrome/nickel stai

less steel, the knives of special steel
Designed by Bertel Gardberg f
O/Y Fiskars AB FINLAND

Nocturne stainless steel flatware
Designed by Eric Clements f
Mappin & Webb Ltd UK

Vase in sterling silver
Designed and made by Hugo Strös
dahl AB SWEDEN

Goblets and tray in 18/8 chromnickel steel, sterling silver and Alpasilver plate
Designed and made by C. Hugo Pe

Designed and made by C. Hugo P GERMANY

Rowena flatware in EPNS with stailess steel knife blade
Designed by Eric Clements
Heeley Rolling Mills UK

PHOTO 5: STUDIO WENDT PHOTOS 6, 9: LEWIS PHOTO 7: GRANATH

Small dish in 18/8 stainless steel with transparent porcelain enamels in olive, blue, burgundy and turquoise
Designed by Grete and Arne Korsmo for A/S Cathrineholm NORWAY

Candlestick in sterling silver; 23 cm high

Designed and made by John Grenville Copyright the Worshipful Company of Goldsmiths UK

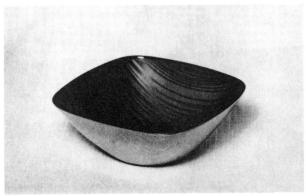

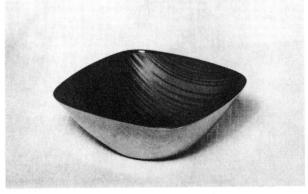

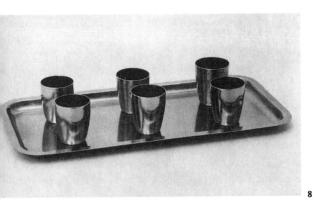

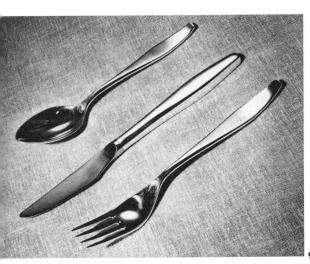

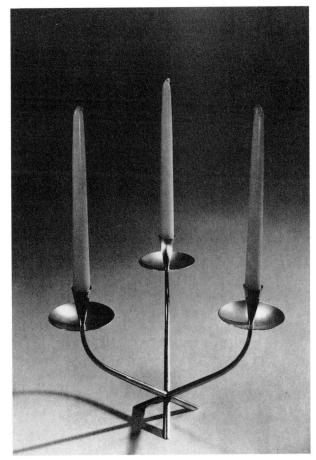

10

PHOTO: JONALS

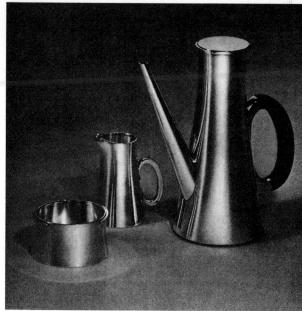

Soup ladles in stainless steel with teak handles

Designed and made by Heinz Decker SWEDEN

Coffee service in sterling silver, the pot with ebonite handle; 23 cm high
Designed by Erling Børup Kristensen for Frantz Hingelberg DENMARK

Coffee service in EPNS with lids and handles in teak: coffee-pot 20 cm high

4 'Instant-coffee' service in EPNS with clip-on spoons; lids and tray in teak. The cream pot seals hermetically and can be put into the refrigerator complete with contents

Both designed by Karl Dittert for Gebrüder Kühn GERMANY

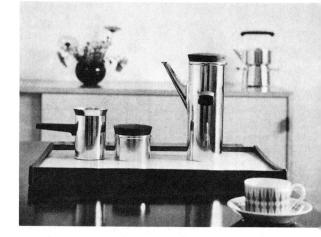

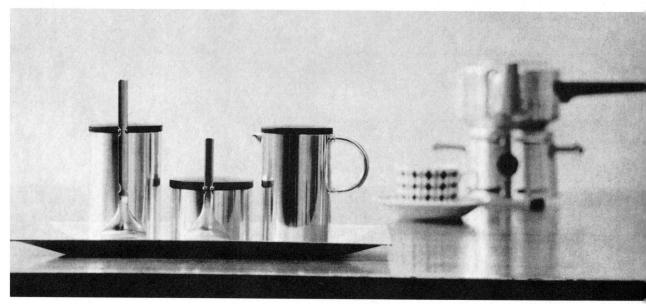

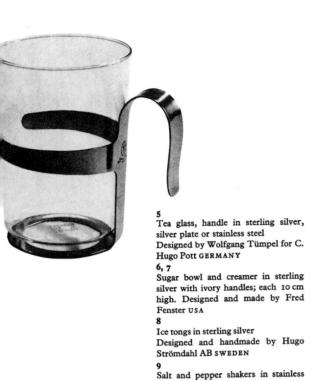

TO
Condiment set in sterling silver
Designed by Tony Laws
Made by Laws & Stevens UK
PHOTO: RICHARD EINZIG

steel

Designed by Jens H. Quistgaard for

Dansk Designs DENMARK

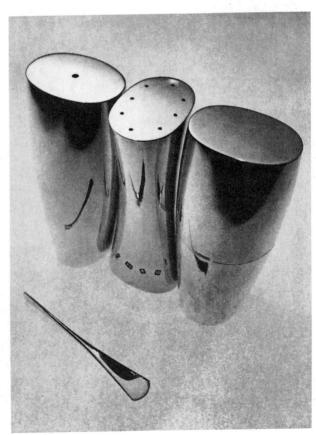

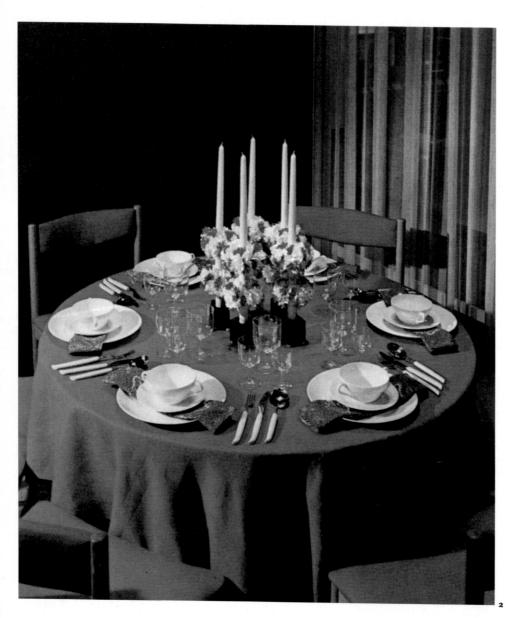

Domed cheese or food cover, cle acrylic with gilt brass knob; 23 or cm diameter

Designed by Noel Lefebvre for X-L Products UK

2

Festive setting arranged with San fine white bone china, made by Jos Wedgwood & Sons Ltd and Conna seur full lead crystal glasses design by S. Fogelberg for Thomas Webb Sons Ltd

The cutlery *Victor* is in stainless stewith Xylonite handles

Designed by Eric Cork for Thomas Cork & Sons Ltd

All on a cloth of textured linen made thirty-one colours; 122 cm wide: Fidelis Furnishing Fabrics Ltd UK Setting designed by Elgin Anders for the Daily Telegraph

Green Charade, a 122 cm woven ray by Nicholas Sekers for the West Cus berland Silk Mills, is the backgrous to Spode Elizabethan white-and-go fine bone china tableware, Royal Celege shape. Designed by Neal Fren for W. T. Copeland & Sons Ltd Wayside goblets are lead crystal wi

hand-engraving, designed and mae by Harold Gordon; the fruit bow Whitefriars M114 are designed W. J. Wilson for James Powell & Sos (Whitefriars) Ltd

Chairs, suitable for outdoor as well indoor use, upholstered in Naugahy on polished aluminium frames, a designed by Charles Eames for S. Hil & Co Ltd; Pride EPNS or sterling silv cutlery and flatware, with stainle steel knives, the handles of Ivoril vivory, designed by David Mellor fi Walker & Hall Ltd UK

Backcloth, a wool-texture acryl she fabric; 152 cm wide, in the *Midnig* Sun Swedish range from Conre Fabrics Ltd UK

Setting arranged by Mary Green of the Sunday Telegraph

The two settings photographed courtesy of the Council of Industri Design, by SPICE PHOTOS

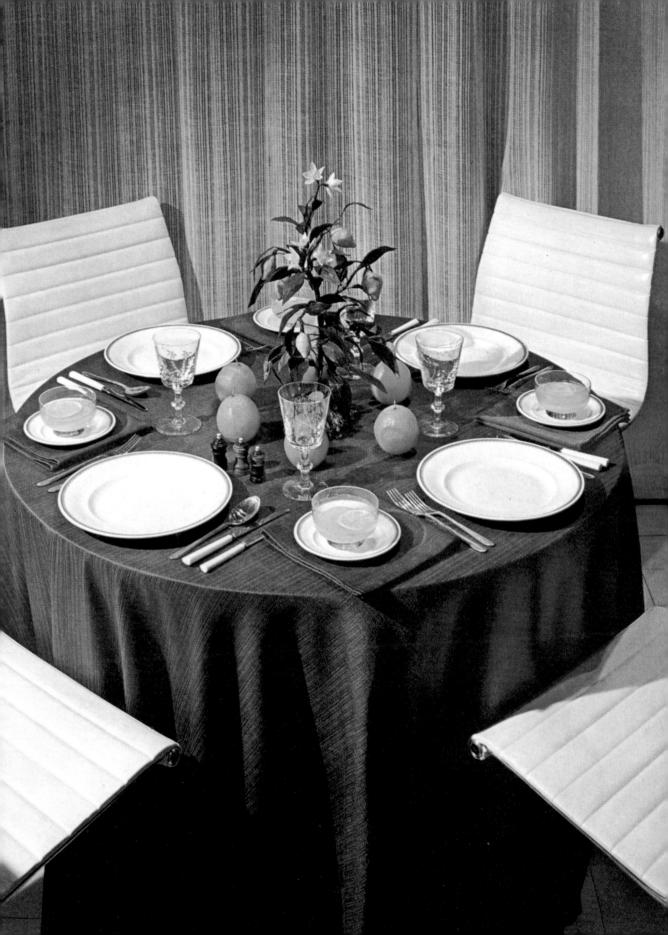

Good Morning breakfast set in flar resistant hard-fired porcelain, de rated or plain white; the lids to tea a coffee pots are unusually deep a tongued for thumb-control Designed by Nanny Still for La P celaine de Baudour BELGIUM

Contrast oven-to-table fine earthe ware range with matt black/soft whiglaze Designed by David Queensbury

Designed by David Queensbury W. R. Midwinter Ltd UK

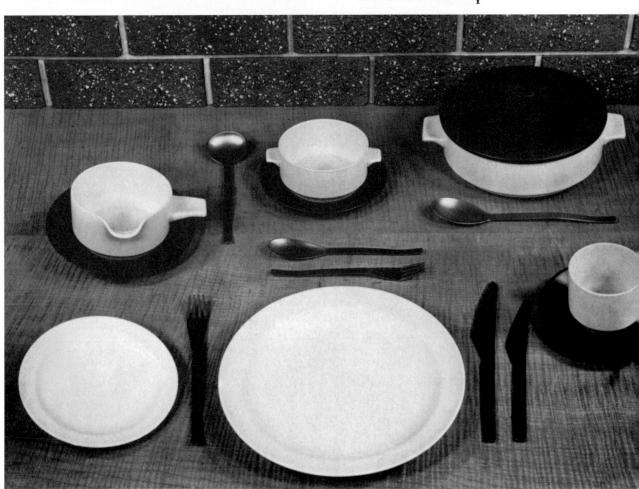

 $\textbf{514} \cdot \text{silver}$ and tableware $\cdot~1964-65$

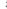

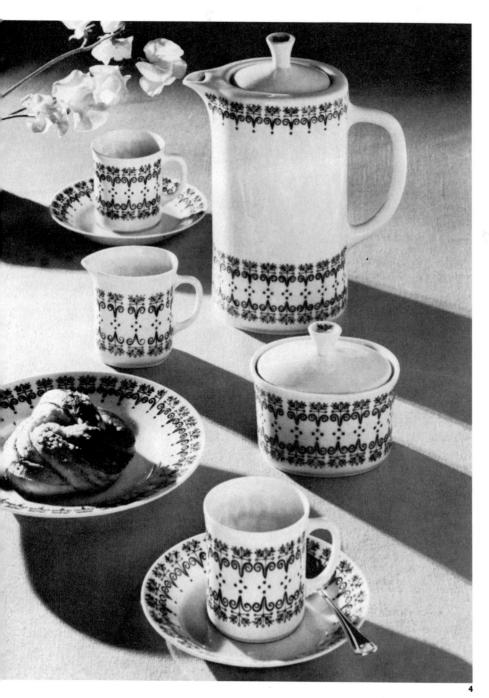

Noah's Ark children's ware in fine white earthenware with underglaze multicolour decoration
Designed by Gunvor Olin for Wärt-

silä-koncernen A/B FINLAND

4
Aurora white feldspar china coffee set
with silkscreen print decoration in blue Shape designed by Sven Erik Skawonius, decoration by Alf Jarnestad. Made at Upsala-Ekeby AB sweden

PHOTO I ROGER ASSELBERGHS

PHOTO 3 PIETINEN
PHOTO 4 ESSELTE

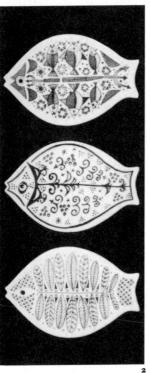

Cups and saucers, jugs and po variously decorated, from a stud produced range in stoneware Designed by Marianne Westm for AB Rörstrands Porslinsfabril SWEDEN

Fish sideplates, Series 2359, ha glaze white feldspar porcelain derated in blue; 20 cm long Designed by Arne Lindaas for Po grunds Porselænsfabrik NORWAY

Small square jars with two types of and square plates in midnight blu white or black/white *Domino* porcel, ware; a series designed for flexible and arrangement on a square or reangular wood base

Designed by Nanny Still for La Pecelaine de Baudour BELGIUM

4 Composition range of tableware a cutlery with stemmed cups and bow and a surface band which carreither a motif or a flat band of cold Designed by Tapio Wirkkala FI LAND

Table glass Composition G is design by Claus Josef Riedel and Richa Latham USA

All for Rosenthal AG w. GERMAN

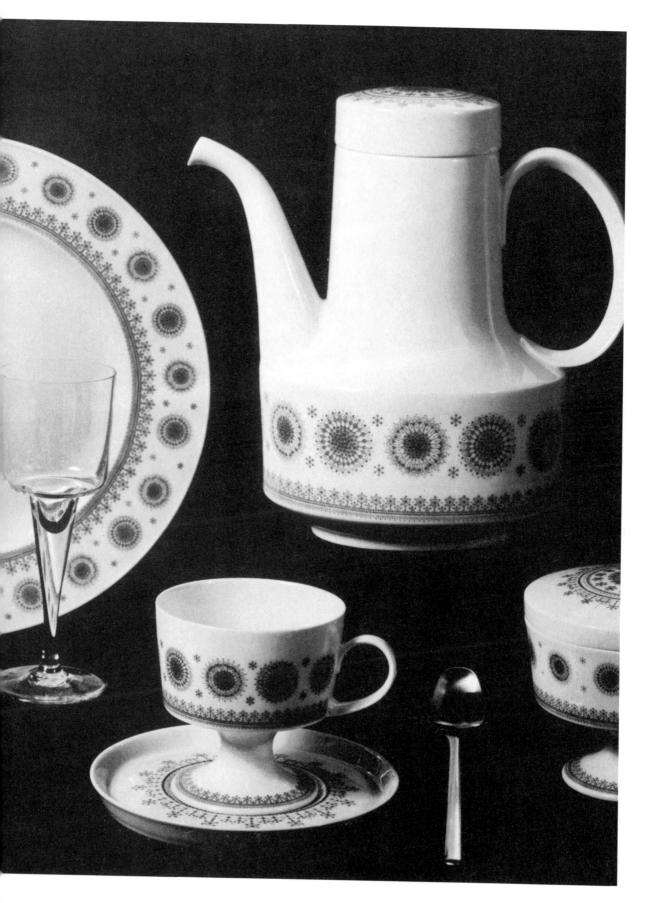

1964–65 \cdot silver and tableware \cdot 517

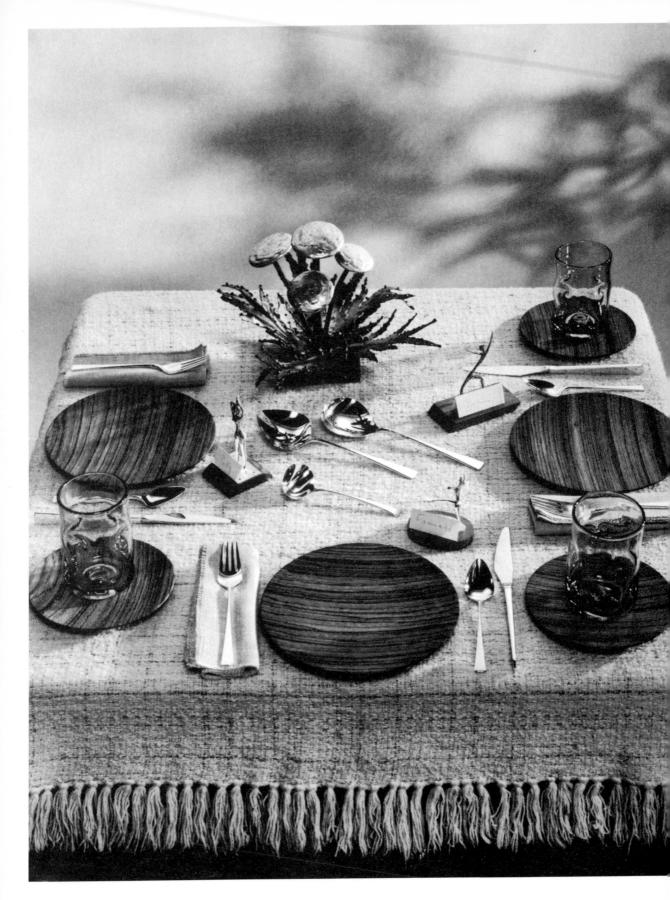

ormal luncheon table set with cling silver, copper and wood on wool texture fringed cloth handven by Catherine Welsh

bra' wood dishes are by Gordon eler—the smaller size used as sters under hand-blown dimpled nho amber glass tumblers; Sterling wer flatware Dimension was designed John Pripp for Reed & Barton

e figurine place-card-holders are Gerald Foley, and the Golden ndelion centrepiece of brazed and lded metals; 23 cm high, is by John eck

tting arranged by Betty Alswang at nerica House, New York USA

3 ielsea brick shape three-piece conment set and bar set in satin-finish inless steel; the slotted mahogany id-all has a stain-resistant finish ndiment set designed by Gerald enney; bar set designed by Bedard roson USA for Viners Ltd UK 4 Ice bucket moulded in wengé, insulated, and with frosted acrylic lid Designed by Th. Skjøde Knudsen for Skjode DENMARK

Salad bowl and servers in palissander, Series 1683/87; 28 cm diameter Designed by Jens H. Quistgaard for Dansk Designs DENMARK

Antipasto tray Series 357 in green or amethyst demi-cristal, acid etched; wood server

Designed by Sergio Dello Strologo for Il Sestante ITALY

PHOTO I HANS VAN NES PHOTOS 2, 3 WARD HART PHOTO 4 HAMMERSCHMIDT PHOTO 6 CASALI

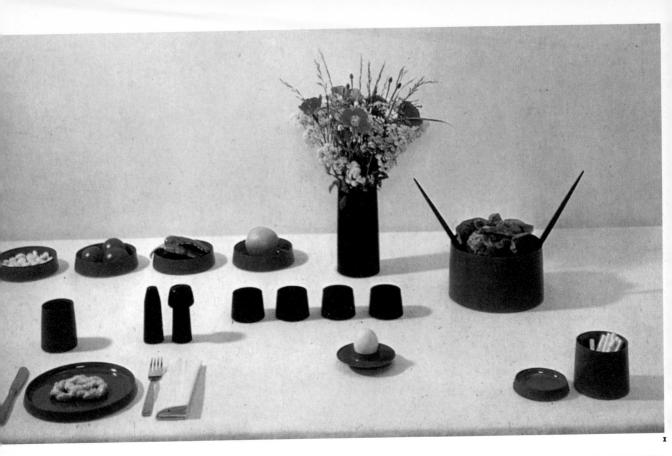

Table set with Melamine ware series 636/9, also available in dark grey and brown

Designed by Kristian Vedel for Torben Ørskov & Co DENMARK

2, 3 Handleless coffee cups in white glazed hard faience

Designed by Göran Bäck
Teapot, plate and covered dish in
ovenproof stoneware with handpainted underglaze decoration blue
Anemone or brown Rosmarin
Designed by Ulla Procopé

All for Wärtsilä-koncernen AB Arabia FINLAND

4-6

Table set with white china dinner service Galaxie, and Black Basalt fine stoneware coffee set, bowls and plates Designed by Robert Minkin for Josiah Wedgwood & Sons Ltd

White opaque glass tumblers
Designed by Timo Sarpaneva for
Karhula-Iittala FINLAND
Odin stainless steel servers and cutlery
Designed by Jens H. Quistgaard for
Dansk Designs DENMARK
All on chequered table mats and

matching plain napkins made of Thai silk from Liberty & Co UK Setting arranged by Babette Hayes at Josiah Wedgwood & Sons Ltd UK

PHOTO 2 ARKO HALLAKORPI PHOTO 3 PIETINEN PHOTO 4 AD PHOTOGRAPHY

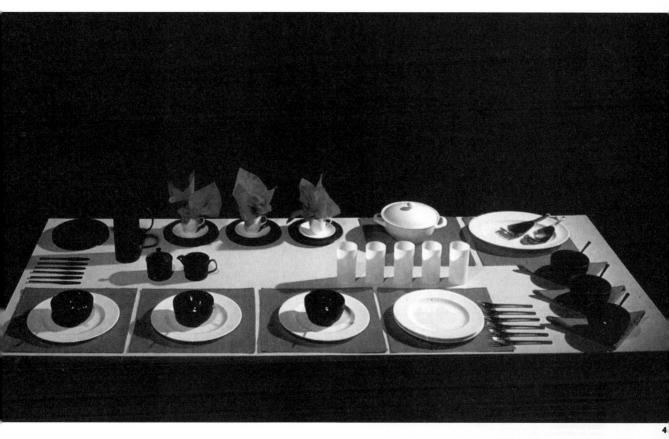

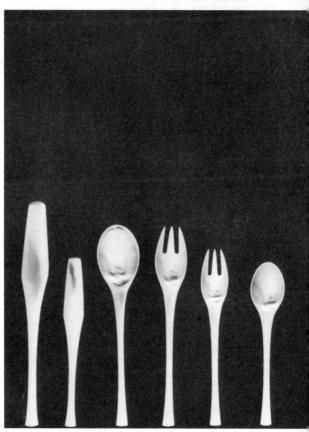

5

Enamelled-steel bowl with glass-hard surface; available in white, red, blue or olive

Designed by Kaj Franck for Wärtsiläkoncernen A/B Arabia FINLAND

Ash and cigarette boxes, each made from the same tube steel and black anodised aluminium, with cork base. The ash box is fitted with a removable disc which isolates the ash and its odour: the cigarette box with a lid of smoke grey Perspex and transparent interior fitting designed and made by Christophe Gevers BELGIUM

3 Candelabra of knotless redwood, natural finish

Designed by Hans-Agne Jakobsson for Bertil Johansson SWEDEN

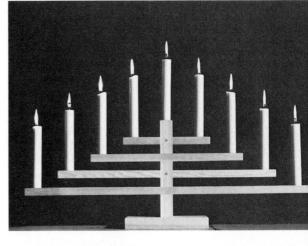

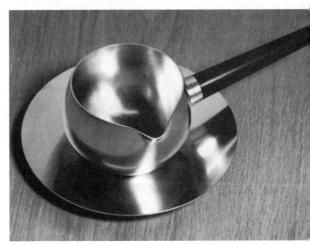

4, 5

Silver bowl and butter pipkin with ebony handle; 7 and 16 cm diameters Silver bell on ebony stand; 13 cm high Designed by Henning Koppel for Georg Jensen Sølvsmedie A/S DEN-MARK

MAN

Table ash box; a 6 or 8 cm cube of opaque melamine, black, red or grey, with extractible ash receptacle in aluminium anodised light grey

7

Floor ash box Series 2001A of square section anodised aluminium, with extractible inner ash receptacle and stabilized base: available in grey, natural, black or chestnut finish; 42 or 56 cm high

or 50 cm

Sweet dishes in alpacca metal, cut, folded and welded from a single sheet; satin finish interior with a high polish outside

All designed by Bruno Munari for Danese ITALY

9

Cast iron fruit stand, vitreous enamelled matt black. 15 cm high, 25 cm diameter. Designed and made by Robert Welch UK

1964–65 · silver and tableware · 523

Embassy flatware in hand-forged sterling silver, stainless steel blades satin finish Designed and made by David Mellor UK

Cutlery in stainless steel with satin-finished handles Designed by Industrial Arts Institute and made by Kobayashi Kogyo KK JAPAN

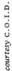

Cheese knife in stainless steel Designed by Ilmari Tapiovaara for Hackman & Co FINLAND

Cutlery 1300 in stainless steel Designed by Marianne Denzel for Vereinigte Metallwerke Ranshofen-Berndorf AG AUSTRIA

Stainless steel flatware
Designed by Henning Koppel for
George Jensen Sølvsmedie A/S
DENMARK

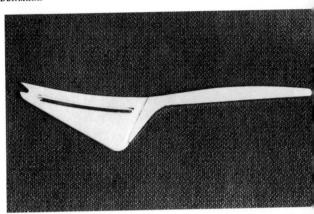

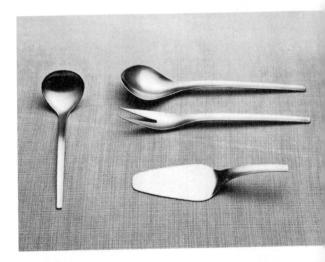

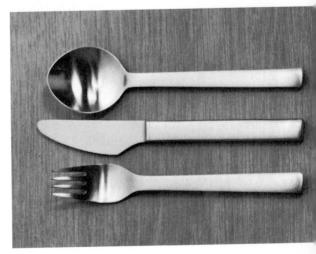

Maya salad servers and, below cutlery, all in stainless steel Designed by Tias Eckhoff for Norsk Stålpress NORWAY

Stainless steel cutlery 2080 Designed by Carl Auböck for Neuzeughammer Ambosswerk AUSTRIA

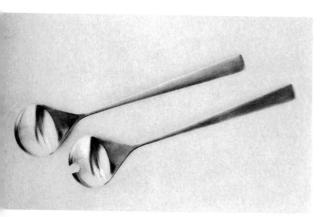

Flatware in matt-finish stainless steel Designed by Richard Rummonds USA for Supreme Cutlery JAPAN

Salad servers in stainless steel Designed by Marianne Denzel for Vereinigte Metallwerke Ranshofen-Berndorf AG AUSTRIA

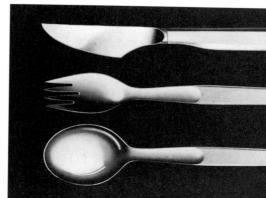

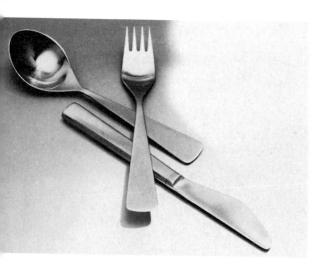

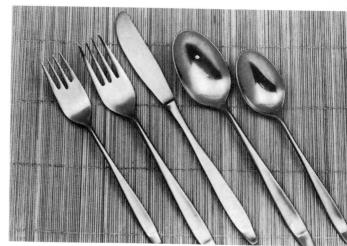

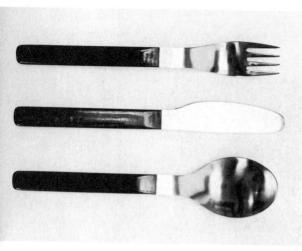

1965-66 · silver and tableware · 525

Combined egg cup and saucer 599/16 'Modular' trays and entrée dishes the smallest 140×85 mm Candle-holder for five candles. Flatware series 2725, the knives of special steel. All in 18/8 chrome/nickel steel, the trays available also in sterling silver or alpaca silver plate Designed by Carl Pott for C. Hugo Pott Besteck W. GERMANY

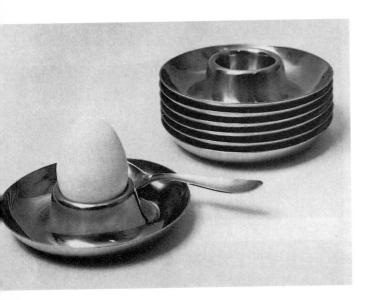

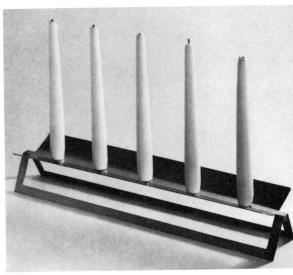

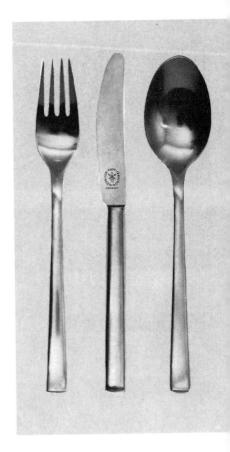

offee jug with stackable cream g and sugar bowl in stainless steel ith palisander handles, offee-pot, 16 cm high essigned by Ib Bluitgen for ndersen & Burchardt A/S DENMARK offees and tea-pots in silver and

offee- and tea-pots in silver and sewood, the coffee-pot 23 cm high lade by Robert Welch UK Combined tea-pot and hot water jug, copper with brass handles and spouts, 37 cm high Designed by Ib Bluitgen for H. A. Gruberts Sonner DENMARK New Wave cutlery in 12/12 stainless steel Designed by C. Melville Cass for John Sanderson & Son Ltd UK

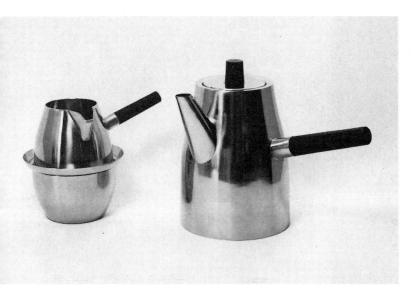

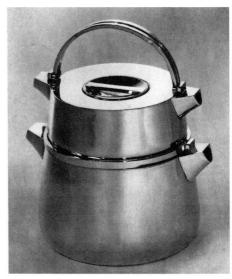

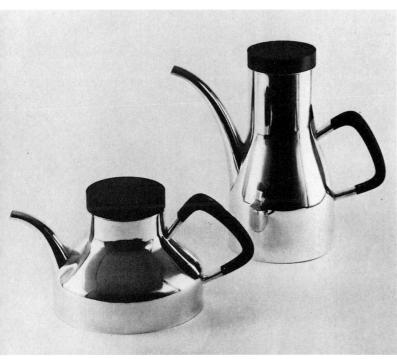

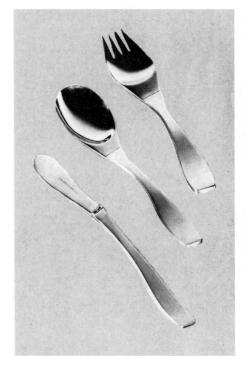

Coffee set 5140 in Gero Zilmeta stainless steel with wine-red nylon handles and lids Designed by Dick Simonis for NV Gerofabriek HOLLAND

Candle-holders of square-section chromiated brass, single holder L88: 4-flame L87, tallest 37 cm high Designed by Hans-Agne Jacobsson for Hans-Agne Jacobsson AB S WEDEN

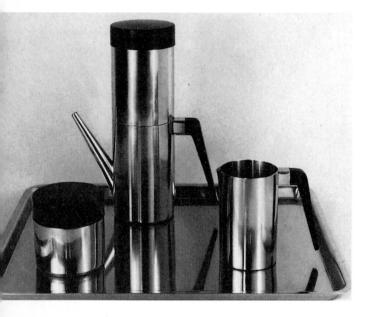

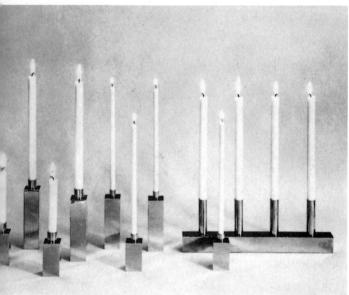

Bonbonniere, silver with knob cut from Swedish granite Designed by Heinz Decker for Heinz Decker Silversmide SWEDEN

Oil and vinegar set, 20 cm high Designed by Marianne Denzel for Vereinigte Metallwerke Ranshofen-Berndorf AG AUSTRIA

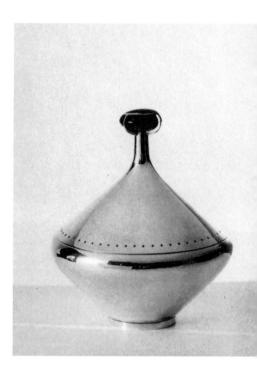

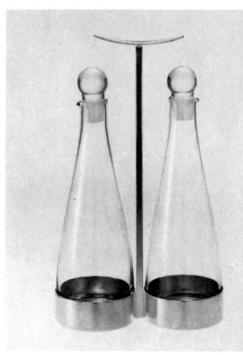

landlesticks in matt black, vitreous namelled cast-iron, 14 cm high Designed and made by Robert 7elch UK

igarette box in oiled-teak with kebi cane woven top, 13 cm high lesigned by Industrial Arts Institute lade by Marumiya Shoten for lippon Sangyo Kogei KK JAPAN

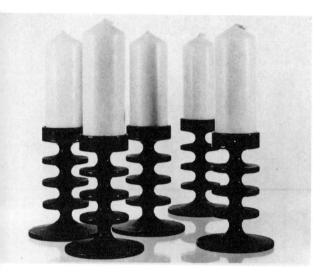

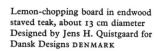

Candle-holders in walnut, red, yellow, green or blue, 10 cm high Designed by Carl Auböck for Werkstatte Carl Auböck AUSTRIA

Condiment set in stainless steel Designed by Eric Clements for J. R. Bramah & Co Ltd UK

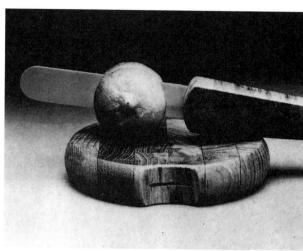

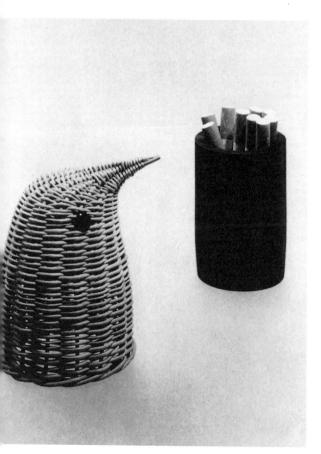

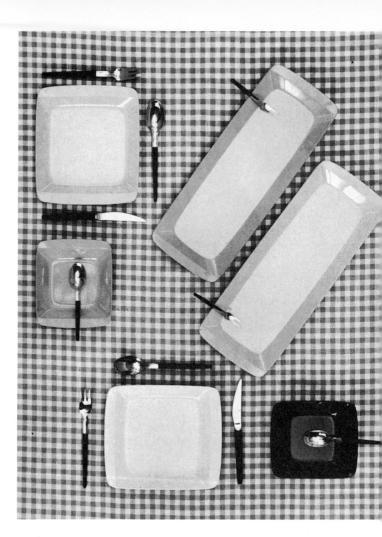

photograph Tuomi

Virva coffee-pots, Tytti percolator aluminium and plastic, the pots 1.5 litre, the percolator 0.75 litre capacity
Designed by Eero Rislakki for
Ammus-Sytytin O/y FINLAND

Covered pan, cast-iron enamelled scarlet or matt black, lined white 23 cm diameter Designed by Timo Sarpaneva for W. Rosenlew & Co FINLAND

Table set of moulded Melamine, white, yellow, orange, dark brown Designed by Olof Bäckström for Fiskars O/y AB FINLAND

Faience cutting board with hand-painted cobalt underglaze decoration Designed and made by Wärtsilä-koncernen AB FINLAND

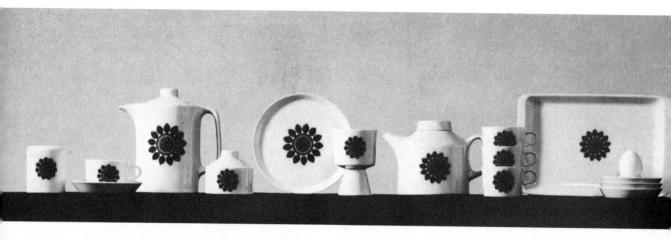

photograph Moegle

photograph Jindrich Brok

7hite porcelain fruit bowl:
5 cm high
esigned by Heinrich Löffelhardt
r Porzellanfabrik Arzberg
. GERMANY

ot from a tea-service in white orcelain with brown ferric glaze esigned by Jaroslav Pycha for arlovarsky porcelán n p ZECHOSLOVAKIA top
Blue Sun tableware: porcelain with
cobalt blue decoration
Designed by Heinz H. Engler for
Porzellanfabrik Lorenz
Hutschenreuther AG W. GERMANY

Coffee and tea-service in feldspathic china with glass inset on lids; white and with patterns
Designed by Siguard Bernadotte and Richard Scharrer for Rosenthal
Porzellan AG W. GERMANY

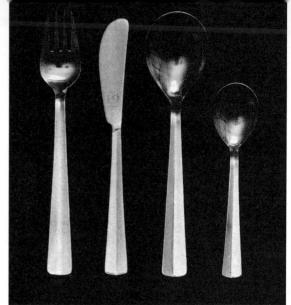

photograph Walter Zabel

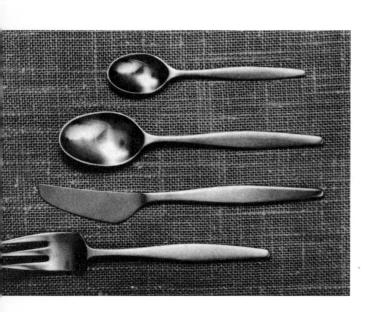

Cream set, 18/8 chrome/nickel steel seamless Designed by Carl Pott for C. Hugo Pott W. GERMANY

Aztec satin-finished 18/8 chromenickel steel Made by Norsk Stalpress AS NORWAY right
Place setting in 18/8 chrome/
nickel steel or alpaca silver plate
Designed by Carl Pott for C. Hugo
Pott W. GERMANY

Model 1300 cutlery: stainless steel Designed by Marianne Denzel for Vereinigte Metallwerke Ranshofen-Berndorf AG AUSTRIA

Cutlery in stainless steel Designed by Bertel Gardberg for Hackman & Co FINLAND

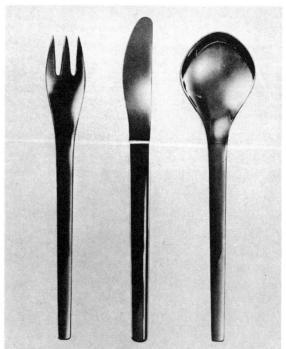

photograph Studio Wendt

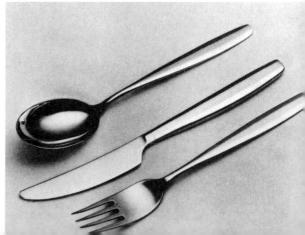

photograph Hooker

Shaker, nickel plated brass, lid of polished leather Designed and made by Carl Auböck AUSTRIA

Alveston stainless steel carving set Designed by Robert Welch for Old Hall Tableware Ltd UK

Silver condiment set Unique pieces designed by Robert Welch and made by Old Hall Tableware Ltd UK

CD 60 nutcracker in cast-iron, vitreous enamelled matt black Designed and made by Robert Welch UK 2200/3604 tableware with *Stockholm,* a new under-glaze decoration blue on white Designed by Johann Klöcker

2075/3652 porcelain ware white with solid red lids, and/or rims All made by Porcellanfabrik Arzberg W. Germany

Teapots, white stoneware with bamboo handles, overall 20 cm high Designed by Mosuke Yoshitake for Tokyo Craft Co *Japan*

New pieces in the *Berså* series white earthenware with green transfer decoration
Designed by Stig Lindberg for AB Gustavsbergs Fabriker *Sweden*

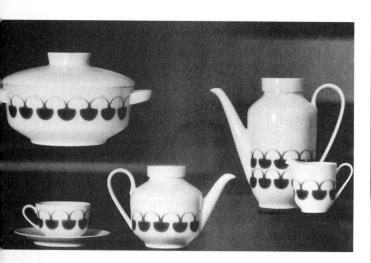

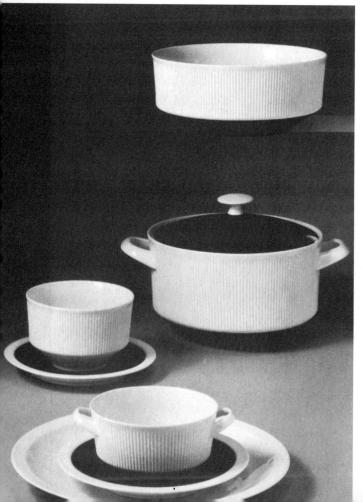

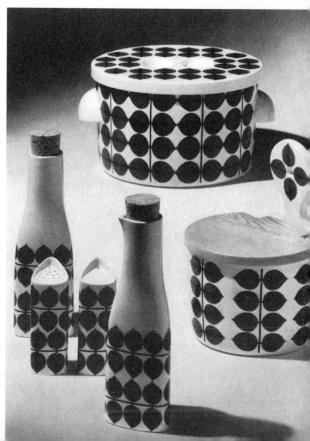

proof oven-to-tableware in white hard-Porcelain with blue/grey decoration igned by Bent Severin and made by selaensfabriken 'Danmark' A/S Denmark

rta stoneware, 2 items from a full e of oven-to-tableware available
peat, mustard or moss-green glaze
gned by Tarquin Cole and John
shaw of Ceramic Consultants Ltd **Gowancroft Potteries Scotland**

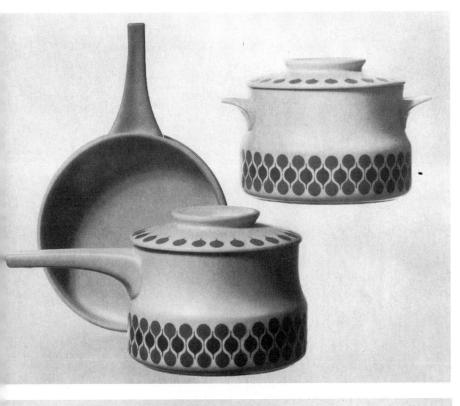

Handmade stoneware casserole, whitespeckled yellow ochre, 22 cm diameter and two other sizes Designed and made by Emmanuel

Cooper England

Handmade ceramic tea-pot, grey-brown 27 cm high Designed and made by Christel Godenhjelm-Nyman Finland

Ice pail, thin beige matt glazed porcelain with oxidized steel spots
Designed by the Industrial Arts Institute and made by Umeno Seitosho *Japan*

Erkki Tuomala

Fruit bowl, black plastic 45 cm diameter Designed by Enzo Mari for B. Danese Italy

Partridge in a Pear Tree fine earthenware beaker, white glaze with blue, brown or green resist decoration

Heirloom earthenware with black print on brown, blue or green glaze All designed and made by Hornsea Pottery Co Ltd England Heater of anodized aluminium and chromed steel 15 or $30 \times 15 \times 7.5$ cm Designed by Bruno Munari for B. Danese *Italy*

3123 spice jars, white feldspathic porcelain with gold/grey decoration, teak lids. 8 or 10-5 cm high. Designed and made by Porzellanfabrik Langenthal AG *Switzerland*

Löyly mug, faience illustrated with sauna experiences
Decor by Gunvor Olin-Grönquist for
Oy Wärtsilä AB *Finland*

3546 stackable nursery set, shockresistant white porcelain with coloured decoration, round-dance or spots Designed and made by Porzellanfabrik Langenthal AG Switzerland Beer mug, milk-white porcelain with decoration in one of several colours Designed by Industrial Arts Institute and made by Narumi Seito Japan

Sinilintu (bluebird) coffee cup and saucer handpainted cobalt blue, 46 cl capacity Shape/decor by Göran Bäck/Raija Vosikkinen for Oy Wärtsilä AB Finland

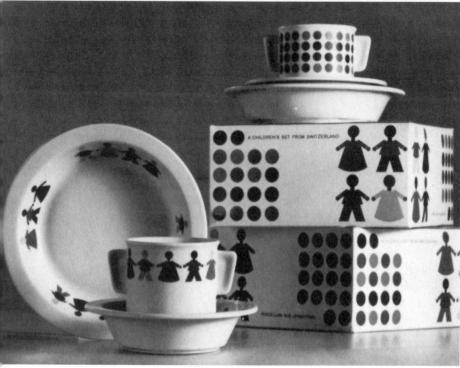

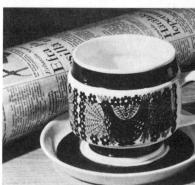

Pietinen

Salt/pepper shakers: the lid controls the outlet of each condiment, silver Designed by Sergio Asti for de Vecchi Italy

Benney condiment set, 18/8 stainless steel 9 cm high
Designed by Gerald Benney and made by Viners of Sheffield England

Fine white bone china coffee set with Black Basalt handleless coffee cups Designed by Peter Wall for Josiah Wedgwood & Sons Ltd *England* Fondu pot with hot plate, stainless steel and palisander
15 cm diameter
Designed by Ib Bluitgen and made by
Andersen & Burchardt *Denmark*

Handmade teapot, silver and moor oak Designed and made by Sigurd Persson *Sweden*

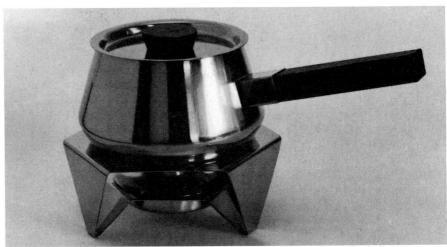

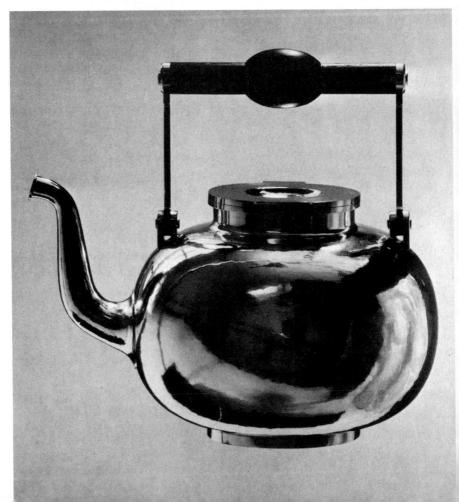

Vine coolers, spun aluminium and aminated teak,brown, silver or ght blue 21 cm high 24 cm diameter lesigned by Industrial Arts Institute nd made by Hokusei Aluminium KK lapan

Mon Amie new coffee-pot, feldspar orcelain with cobalt blue underglaze ecoration lesigned by Marianne Westman for

lesigned by Marianne Westman for B Rorstrands Porslinsfabriker weden

Teapot, creamer and sugar pot, bottom, with hot water jug, sterling silver and teak, the pot 10 cm high (a taller coffee-pot is available)
Designed by Søren Georg Jensen and made by Georg Jensen Denmark

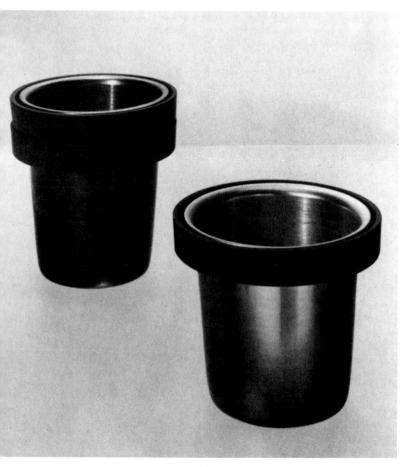

Escargot place set in 18/8 chromed steel or silver-plated Alpaka: a larger dish holding 12 snails is available

Cocktail snack dish in sterling silver or silver-plated Alpaka All designed by Carl Pott for C Hugo Pott W. Germany Honey-spoon with Jena glass *Okesto* 3202, solid silver, silver-plated Alpaka or 18/8 chromed steel
Designed by Carl Pott for C Hugo Pott *W. Germany*

Bistro place set in stainless steel and rosewood
Designed by Robert Welch and made by Old Hall Tableware Ltd England

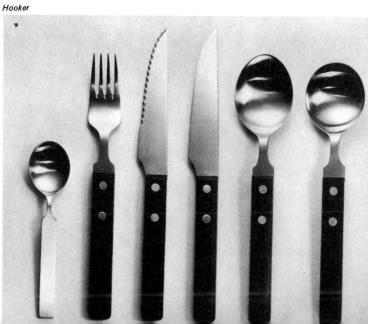

itware in satin finish stainless steel signed by Ilmari Tapiovaari for Hackman AB *Finland*

nim cutlery in stainless steel signed by David Mellor for Walker & II Ltd England

Teaglass with nickelled holder 15 cl Capacity

Designed by Timo Sarpaneva and made
by littala Glassworks Finland

Jette stainless steel cutlery
Designed by Jens H Quistgaard for
Dansk Designs Denmark

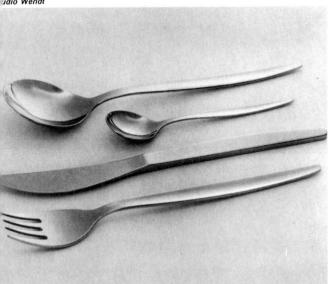

Colette tea-set in white earthenware with handpainted blue decoration: teapot with steel strainer Designed by Inger Persson for Ab Rörstrands Porslinsfabriker Sweden

2 London mug, alternate panels of blue and red Designed by Richard & Elizabeth Guyatt for Josiah Wedgwood & Sons Limited England

3
Sheba coffee, tea and dinner service, white porcelain with cobalt-blue underglaze and gold line decoration

Designed by Johannes Hedegaard for The Royal Copenhagen Porcelain Manufactory Ltd Denmark

4
Halka tea and dinner service in white porcelain
Designed by Werner Winkler for VEB Porzellanwerk
'Graf von Henneberg' E. Germany

b Faience storage boxes: white, blue or mahogany with black decoration and melamine lids Designed by Richard Lindh with decoration by Esteri Tomula for Oy Wärtsilä Ab Arabia Finland

6
Channel Isle mugs and canister, gold, blue
or grey-green with incised spots and bands
Designed by Judith Onions for T. G. Green Ltd
England

/ Canisters, white, green or brown glazed porcelain with wooden lids 9 cm diameter Designed by Masahiro Mori for Hakusan Porcelain Co Ltd *Japan*

2 3 5

4 6 7

C range of tableware, faience with *Kimmel* matt gold decor Shape by Esteri Tomula, decoration by Richard Lindh for Oy Wärtsilä Ab Arabia *Finlance*

Peppermill and casserole with matching table heater, cast iron vitreous-enamelled matt black, the pepper mill with rosewood knob: casserole also available with red or blue gloss finish, 23 cm diameter Designed by Robert Welch for Campden Designs Limited England

1 3 5 6 7 2 4 8

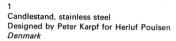

2 Covered plate, sterling silver 25 cm wide Designed by Henning Koppel for Georg Jensen Sølvsmedie *Denmark*

3
Tea or coffee pot, sterling silver with buffalohorn handle
Designed by Karl Gustav Hansen for Hans Hansen Sølvsmedie *Denmark*

4
Baking/serving dish, cast iron with white or red vitreous enamel finish inside 20 × 38·5 cm
Designed by Timo Sarpaneva for W. Rosenlew & Co *Finland*

Sauce warmer with double spout, cast iron with orange, blue, yellow or white vitreous enamel finish 35 cm diameter Designed by Michael Lax for Copco, Inc *USA*

6, 7
Two containers from a series in pvc, black with transparent covers, the ice-box 7, lined white, 18-6 cm diameter
Designed by Enzo Mari for Danese Italy

8 Brandy flasks, sterling silver with handembossed decoration 38 cm high Designed and made by Heinz Decker Silversmide *Sweden*

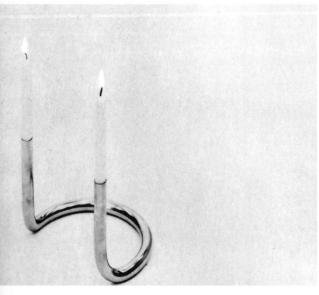

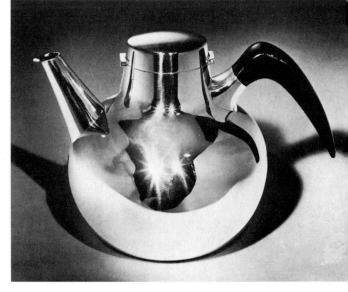

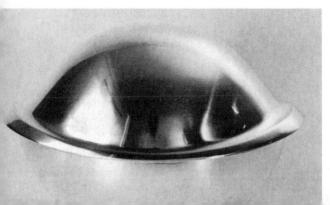

Form 678 dinnerware, all-white porcelain: includes cruet, ovenproof bowls, soup cups, tureen with lid, set of salad bowls and water jug with afromosia handle
Designed by Henning Koppel for Bing &
Grøndahl, Denmark

Smoking set of lighter, two or three ashtrays and cigarette box, porcelain glazed black or white: cm 25 high

Designed and made by Kurt Spurey Austria

Savonia flatware, stainless steel four-piece

Setting

Designed and made by Hackman & Co

Finland

1-3

Duo tableware in white porcelain and with Elliptic Cobalt decor On the same shape, gold blossom decor designed by Bjorn Winblad Shape designed by Ambrogio Pozzi Italy for Rosenthal Porzellan GmbH W. Germany

Bas and Diskant red and white Ornaminware: four shapes are a dinner-set: plus two 'boxes' Designed by Stig Lindberg for Ab Gustavsbergs Fabriker Sweden

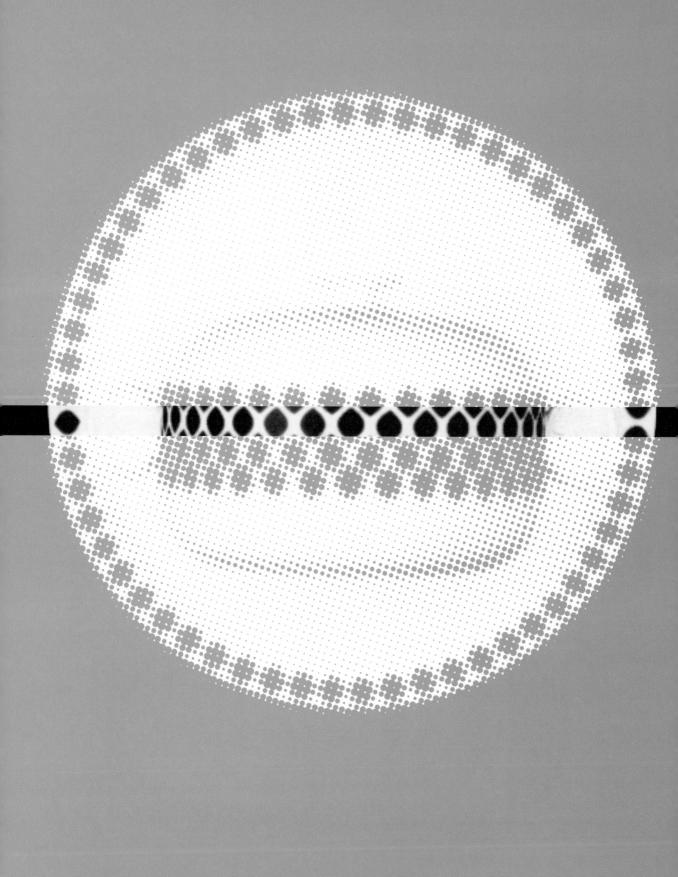

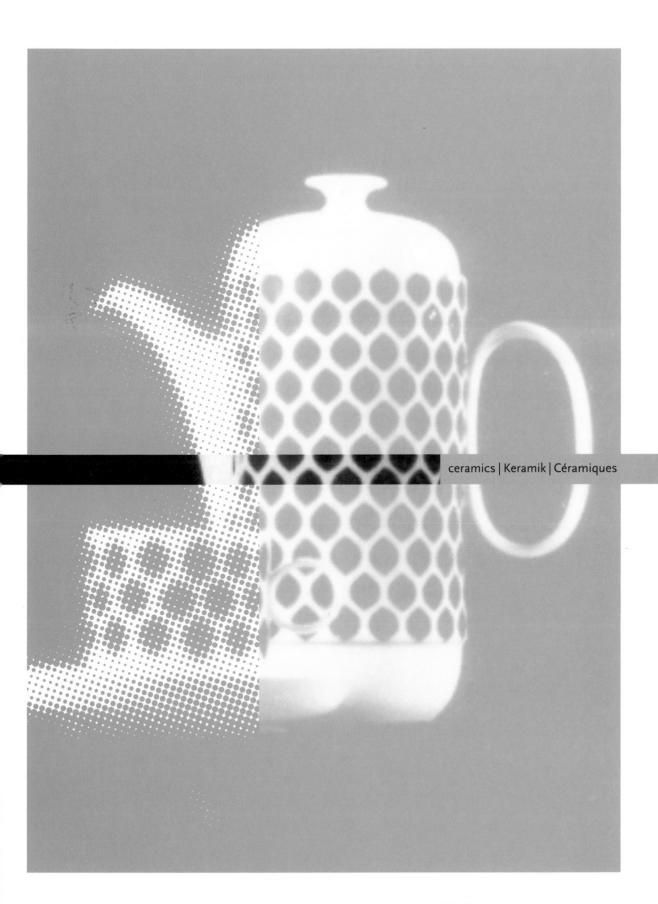

Stoneware vase and bowl, one-of-a-kind, in light brown and in dark brown glazes; height of vase $9\frac{3}{4}$ inches. By Berndt Friberg

Imprinted stoneware vase, 17½ inches high, and miniature jar in green copper glazes. Unique pieces by Stig Lindberg.
All made at AB Gustavsbergs Fabriker SWEDEN ▼

Stoneware vase with upward-springing shoots, rutile glaze; 15½ inches high. By Axel Salto: The Royal Copenhagen Porcelain Manufactory A/S, DENMARK ▼

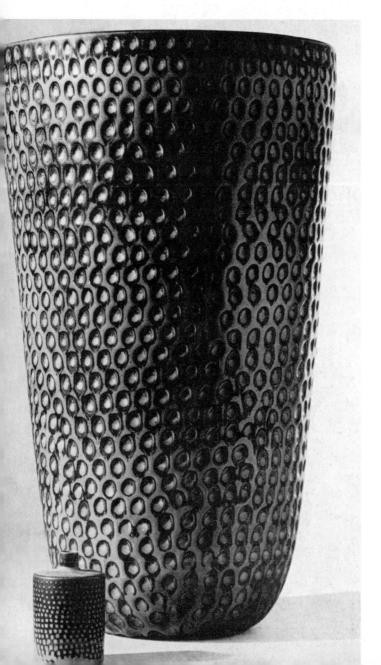

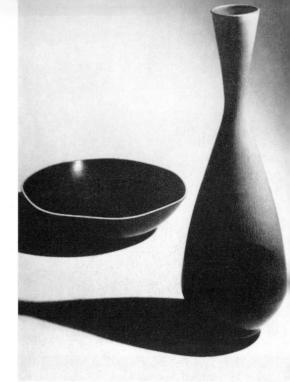

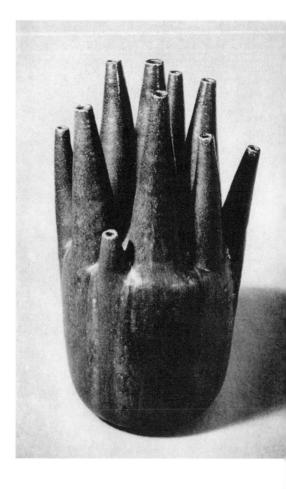

Handbuilt unique stoneware figure, yellow-brown partial glaze; 8 inches high. By Lisa Larson: AB Gustavsbergs Fabriker sweden ▶

 \blacktriangle Stoneware vase, dark blue glaze; 13½ inches high. By Stig Lindberg.

Unglazed *Terra-Farsta* red-brown jars with imprinted decoration; larger jar 15½ inches high. By Wilhelm Kåge.
All made at AB Gustavsbergs Fabriker SWEDEN

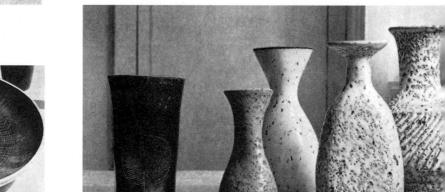

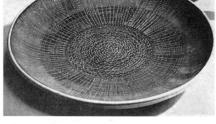

TOP: Stoneware jar, grey salt-glaze, dark slip decoration; $8\frac{1}{2}$ inches high. Designed by Nils J. Kähler for A/S Herman A. Kähler DENMARK

Earthenware dish with thin semi-covering glaze, decorated sgraffito; 15 inches diameter. By Ingrid Atterberg for Upsala-Ekeby AB, Ekebybruk sweden

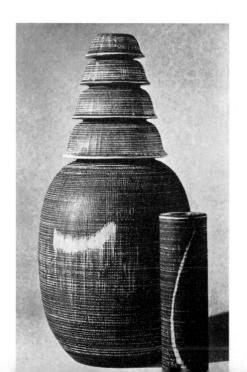

▲ Forme vase, enamel on silver, engraved decoration.

Unique piece by Studio Del Campo ITALY

■ Stoneware vases, red-rust glaze, brushwork decoration; background vase 19 inches high.

Unique pieces designed by Wilhelm Kåge for AB Gustavsbergs Fabriker SWEDEN Stoneware vase, iron glaze with incised decoration; 17 inches high.

By Erik Plöen Norway 🕨

OPPOSITE: Stoneware vase, white rough glaze, brown mottled, with fluted decora-

BELOW, LEFT TO RIGHT: Porcelain vase brown sgraffito decoration, 5½ inches high and stoneware group, green, white, off-white and grey glazes, mottled; 5, 7, 8 inches high All unique pieces by Lucie Rie UK

photographs Jane Gate

tion; 15 inches high.

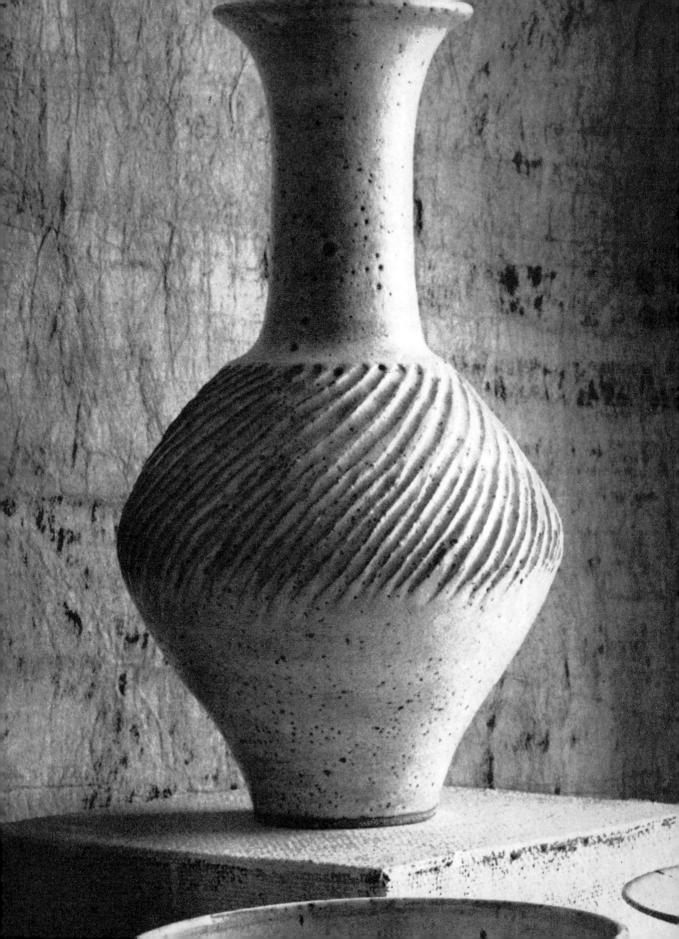

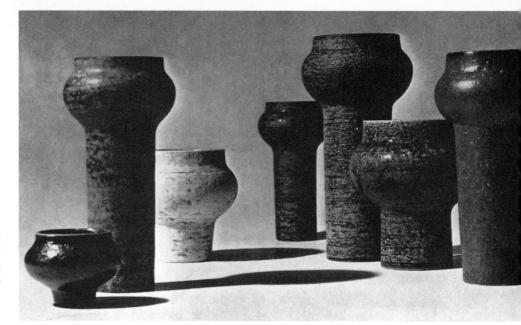

High-fired stoneware vases in brown and black clay glazes; 2 to 8 inches high.

Unique pieces by Britt-Louise Sundell for AB Gustavsbergs Fabriker sweden

Stoneware plant pot with inner holder, heavily textured rust and yellow wood ash glaze with pale celadon inside and on foot; 14 inches high. By Dan Arbeid: The Abbey Art Centre UK

One-of-a-kind stoneware vases:

▲ in brown and sand clay glazes; 7 and 11 inches high. By Francesca Mascitti-Lindh;

■ in dark brown, brownish red/sand, and iron rust glazes; centre vase 25 inches high. By Kyllikki Salmenhaara. All made at Wärtsilä-koncernen A/B Arabia FINLAND

Unglazed stoneware pots, 10 inches high, and below 6, 8 and 12 inches high. All unique pieces by Hans Coper UK

photographs Jane Gate

1961-62 · ceramics · **559**

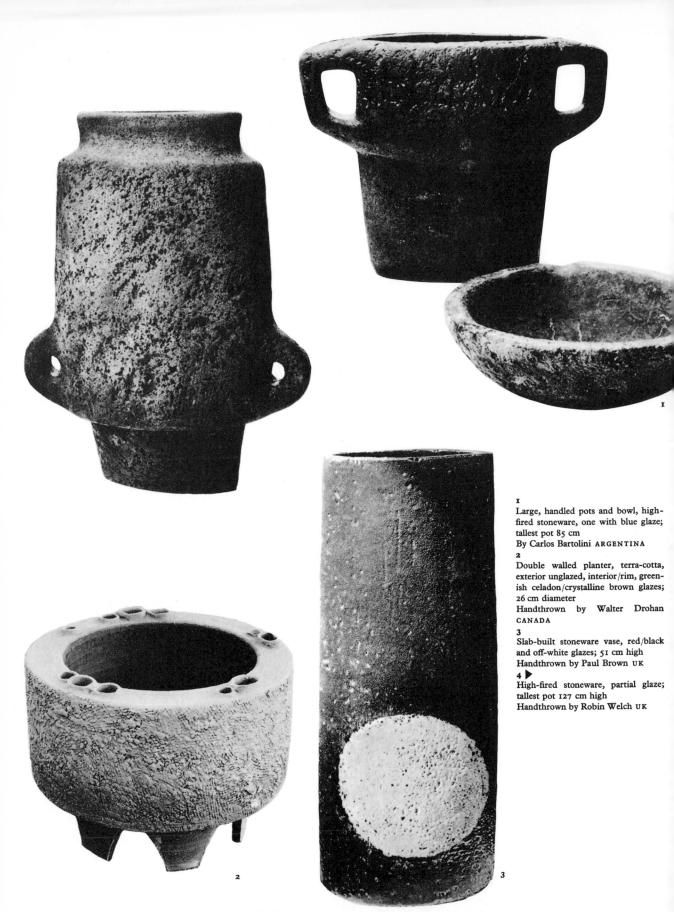

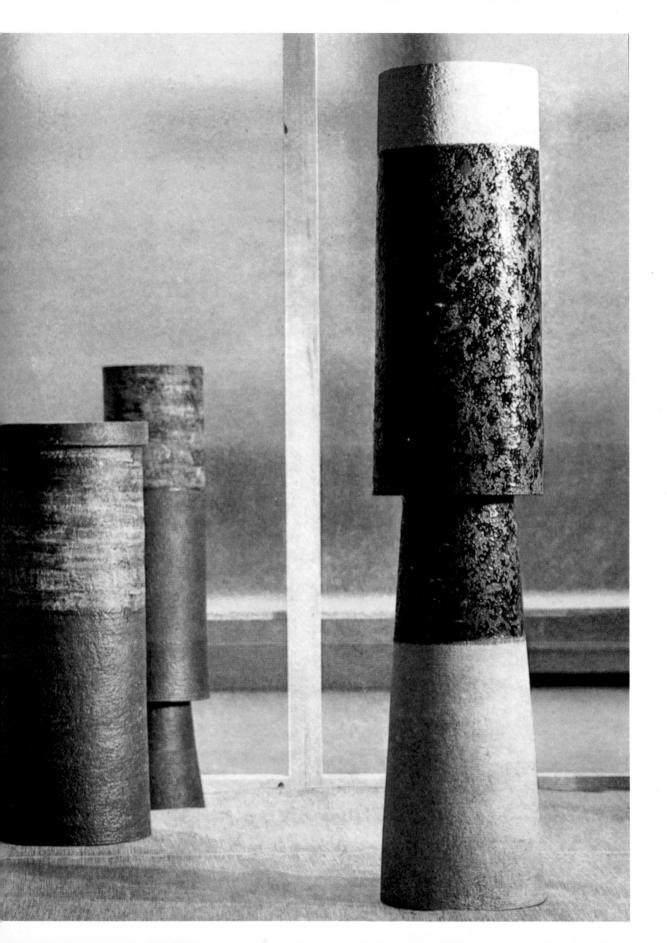

Cream and black vase in coiled stoneware, 41 cm high Designed by Delan Cookson UK

Slab-built stoneware pot with white glaze and impressed stamp, 15 cm high

Designed by Ian Auld UK

Earthenware vase with thick green or red glazes, 22 cm high Designed by Vaclav Dolejs UBOK CZECHOSLOVAKIA

Earthenware jam pot with majolica glaze in blue, turquoise, green or honey-coloured, approximately 10 cm high Made by the Guernsey Pottery Ltd UK Hand-built stoneware pot in heavily grogged red clay, glazed inside only, 45.5 cm high Designed by Eileen Lewenstein UK

Three-tiered stoneware vase in grogged orange clay, with matt white glaze and black lines, 76 cm high two-tiered vase with matt white glaze, copper-green pigment, 51 cm high

Designed by Robin Welch AUSTRALIA

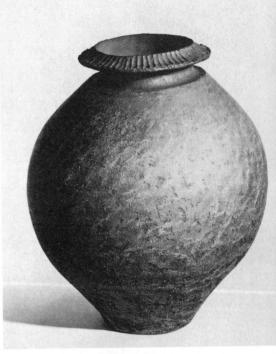

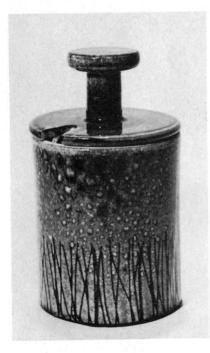

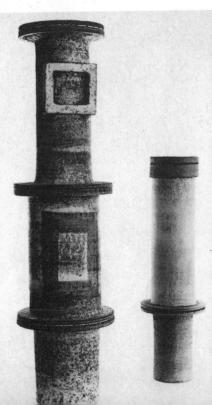

562 · ceramics · 1965-66

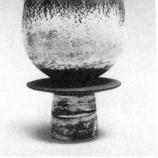

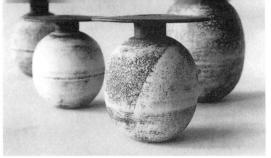

Stoneware vase with stem, 15 cm high Wide-lipped vases, 15 and 20 cm high Tall fungi-shaped vases, 30 cm high All designed by Hans Coper UK

photos JANE GATE

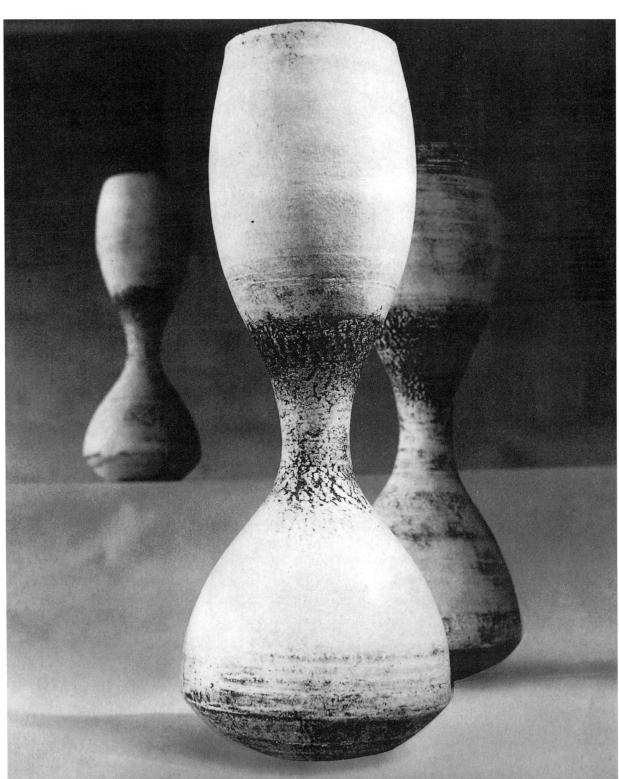

Rectangular stoneware vases in silver, blue and amaranth-purple 6·5 to 25·5 cm high Designed by Ettare Sottsass for Il Sestante ITALY Brilliant white double-pleated flower vases, 24 cm high
Tall-necked off-centre vases in various heights from 13.5 to 26 cm
Triple-pleated vase in brilliant white, blue, matt white or black
25.5 cm high
All designed by Angelo Mangiarotti for B. Danese ITALY

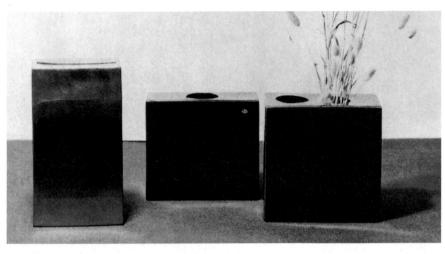

Slit-mouthed cylindrical vases, stoneware in olive/gold, turquoise/ silver, green or amaranth-purple 31 and 25 cm high Vases in graded cubes, green and amaranth-purple, 31 and 23 cm high Designed by Ettare Sottsass for

Il Sestante ITALY

Large hand-thrown bowls, chamotte with salt and copper glazes 20 cm diameter Designed by Francesca Lindh

- 'Tree' table decorations in faience approximately 17 cm high, shades of putty, grey-blues and black Designed and sculpted by Birger Kaipiainen All for Wärtsilä-koncernen AB FINLAND

photos PIETINEN

Lighthouse and other shapes, earthenware with black and white underglazes: lighthouse 23 cm high
Designed by Mogens Andersen

2
Tenera new pieces in the series, handpaintec blue underglaze decoration, 10–20 cm high All made by the Royal Copenhagen Porcelain Manufactory Denmark

Faience plate decorated with blue and grey lustre colours 34 cm diameter Unique piece designed by Hilkka-Liisa Aho

4 Mould-made garden vase: faience 44 cm high Designed by Olli Vasa

5 Mould-made hand-built figure black and white, 42 cm high Unique piece designed by Heljåtuulia Liukk Sundström All made for Oy Wärtsilä Ab Arabia *Finland*

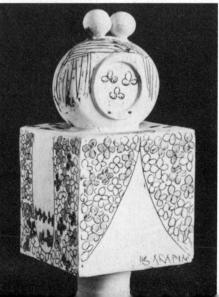

d Sun wall plate, unique piece, hand built m orange, green and brown glazed and glazed stoneware units: approximately × 70 cm signed by Rut Bryk for Oy Wärtsilä Ab Arabia Finland

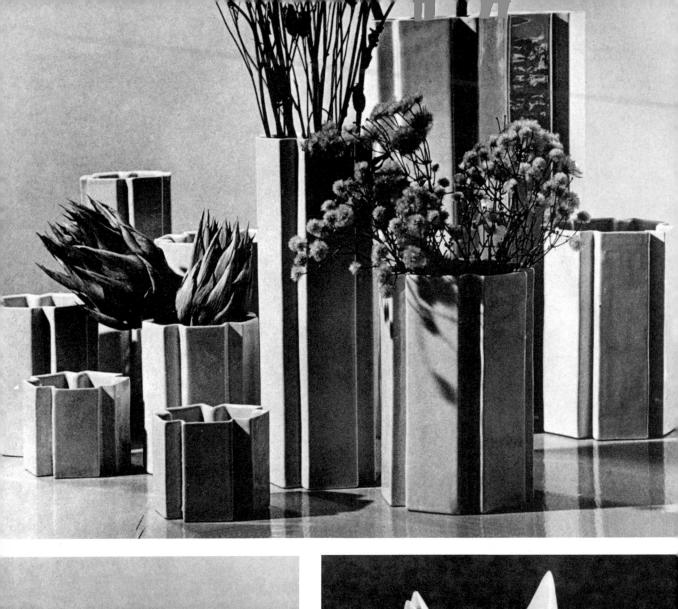

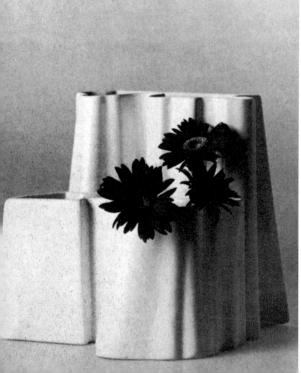

Octagon series vases: fine earthenware glazed white: cm 6-30 high Designed by Karin Bjorquist for Ab Gustavsbergs Fabriker, Sweden

2, 5
Fluted vases and squared modular elements for flowers or fruit: white, black, yellow, deep green and red Both designed by Sergio Asti for Gabbianelli *Italy*

Composition vases in moulded porcelain

cm 25 high Designed and made by Kurt Spurey, Austria

Sculpture in white porcelain with cobalt under-glaze die stamped decoration: cm 19.5 high
Designed by Vladimir David UBOK for
Karlovarsky Porcelan, n.p. Czechoslovakia

1 4 2 3 5

INDEX

Designers and architects Designer und Architekten Designers et architectes

Aarikka, Raija 471 Aarnio, Eero 223, 224, 288 Abramovitz, Gerald 469 Acking, Carl-Axel 204 Acton, Hugh 189 af Schulten, Ben 283 Ahlgren, Brita 305 Ahlmann, Lis 221, 322 Ahola, Hikka-Liisa 566 Aladin, Tamara 390, 394, 412 Albeck, Pat 330 Almari, Mauri 449 Altherr, Alfred 176, 225 Al-Veka Team 226 Ander, Gunnar 364, 383, 385 Andersen, Mogens 566 Anderson, Elgin 512 Andersson, John 485 Andrews, Colin 213 Angeli, Franco 293 Arbeid, Dan 558 Archizoom 292 Armstrong, Ronald 487 Aroldi, Danilo and Corrado 473, 474 Asti, Sergio 158, 238, 445, 458, 473, 538, 569 Atterberg, Ingrid 556 Auböck, Carl 108, 449, 525, 529, 533 Augenfeld, Felix 29 Auld, Ian 564 Aulenti, Gae 469 Awashima, Masakichi 351, 353, 362, 371, 384, 415 В Bachem, Bele 494 Bäck, Göran 503, 520, 537

Bachem, Bele 494
Bäck, Göran 503, 520, 537
Bäckström, Olof 530
Ballatore & Larsen 320
Bang, Jacob E. 371
Barovier, Angelo 364, 427
Barovier, Ercole 359
Bartoli, Carlo 272
Bartolini, Carlos 560
Bates, Trevor 307
Baumann, Hans Theo 494

Baxter, E. 353
Bellini, Mario 292
Bellman, Hans 225
Belz, Walter 169, 170, 173
Benney, Gerald 519, 538
Beran, Gustav 487
Bergström, Hans 419, 421, 425
Bernadotte, Sigvard 531
Berndt, Victor 358, 418, 422, 439, 441
Bertoia, Harry 59, 197
Bettarini, Enrico 358

Bertoia, Harry 59, 197
Bettarini, Enrico 358
Bhomik, Jyoti 331
Bishop, David 340
Bjorquist, Karin 569
Black, Misha 487
Bland, Eva 484
Blanton, John 51
Bloch, Mary Beatrice 308
Blomberg, Kjell 361, 412
Bluitgen, Ib 527, 538
Blyweert, Pierre 258
Boeri, Cini 272
Bøgeland, Gerd 422

Boissevain, Paul 421, 424, 436, 438, 454, 455

Bølling, Hans 452 Bonfanti, Renata 302 Borgstrom, Bo 406

Borsani, Osvaldo 182, 197, 206, 213, 260

Bosc, Esme 346 Brams, Lisbeth 432 Brattrud, Hans 221 Braun, Max 177 Breuer, Marcel 244 Brooks, Ronald E. 483 Brown, Barbara 310

Brown, John D. M. 430, 454, 455, 469

Brown, Paul 560 Bryk, Rut 567

Bülow-Hübe, Sigrun 194, 202, 207

Busine, Zephir 379 Butler, Pauline 470

Cadovius, Poul 55 Carlander, Rakel 308 **Casati & Hybsch** 250 **Casati**, Cesare 248, 249, 260

Cash, Judith 345 Cass, C. Melville 527 Casson, Sir Hugh 65, 493

Castelli, Anna 262
Castiglioni, Achille 255
Castiglioni, Livio 10
Castiglioni, Biar Ciacom

Castiglioni, Pier Giacomo 255

Castle, Wendell 4–5 Celada, Gianni 476 Chandler, Julia 507 Chenery, W. S. 206 Chílbec, Milan 494 Clark, Kenneth 488, 508 Clements, Eric 508, 529

Clendinning, Max 124, 125, 126 Cochrane, John 363

Cole, Tarquin 535 Collingwood, Peter 55

Colombo, Joe 20-21, 22, 23, 24, 242, 250,

260, 263, 266, 458 Conran, Shirley 313 Conran & Company 296 Conran Design Group 209

Cooke, E. 455 Cookson, Delan 564 Cooper, Emmanuel 535 Cooper, Susie 493 Coper, Hans 559, 565 Copier, A. D. 379 Cork, Erik 512

Craven, Shirley 302, 320, 334 **Crichton**, John 419, 432

Cyrén, Gunnar 391, 392

D

D'Arcy, Barbara 114
Dahlen, Arne 235
Daum, Michel 351, 374, 384
David, Vladimir 569
Davies, Frank 304

Day, Robin 14, 183, 214, 283, 285 **De Bruyne**, Pieter 464

De Carli, Carlo 248
De Mey, Jos 215

De Newbery, Beppi Kraus 180, 199 De Snellman-Jaderholm, G. L. 418, 496, 500, 502

Decker, Heinz 483, 508, 510, 528, 546 Denzel, Marianne 524, 525, 528, 532

Dethier, Ch. M. 470 Devlin, Stuart 488, 490 Dillon, Michael 399 Dittert, Karl 510 Dodson, John 507 Dolejs, Vaclav 564 Donat, John 79

Dreyfuss, Hugo 184, 191 Drohan, Walter 560 Drummond, John 307 Duckworth, Ruth 55

Dudas Kuypers Rowan 276, 281

Dumond & Leloup 384 Dumond, Jacques 36, 46

Ε

Eames, Charles 56, 104, 116, 512 Eckhoff, Tias 490, 502, 525 Edenfalk, Bengt 402 Edwards, A. M. 201 Eggleton, Colin 193

Ekselius, Karl Erik 218, 232 Elliott, George 359, 449

Engler, Heinz H. 531 Englund, Eva 386

Ercolani, Lucian R. 204

Fabiansen, lb 453 Fagerlund, Carl 424 Faith-Ell, Age 300 Faltermaier, Johann 452 Farr, Gillian 320, 331 Farulli, Fernando 493 Fasolis, Anna 335

Fehlow, Anne 340 Fenster, Fred 511 Ferngren, Vera 500

Ferrari, Leonardo 458 Fhilippon, Antoine 240

Filip, Milos 375

Fischer, Benno 51 Fisher, Alfred R. 400

Fitton, Roger 182

Fletcher, Alan 10

Fogelberg, S. 512

Foley, Gerald 519

Forss-Heinonen, Maija-Liisa 317

Forssell, Pierre 498

Franck, Kaj 17, 369, 392, 395, 522

Frattini, Gianfranco 10 French, Neil 494, 512 Friberg, Berndt 554 Friedeberg, Pedro 16 Fuchs, Heinrich 422 Fusamae, Yóji 406

GAD and Associates 95

Gardberg, Bertel 505, 508, 532

Gardella, J. 262

Gardiner, Stephen 151, 153

Gautier-Delaye 228 Gerli, Eugenio 248

Gevers, Christophe 522

Giebisch 276

Girard, Alexander 277, 328 Gislev, Erna 313, 322, 329, 330

Gitlin, Harry 62 Gjoedvad, Agnethe 332 Glynn-Smith, Juliet 328

Godenhjelm-Nyman, Christel 535

Goodship, David 270 Gordon, Harold 512 Graae, E. 453

Gråsten, Viola 56, 59, 306, 313, 331

Gray, Milner 363

Gregotti, Meneghetti & Stoppino 451, 476

Grenville, John 509 Grierson & Walker 41 Gripenberg, Raija 325 Gröndahl, Nils 322 Gronwall, Lisa 308

Grover, Grace 421 Grus, Pavel 467

Gugelot, Hans 290 Guhl, Willy 202

Guille, Frank 236

Guyatt, Richard & Elizabeth 544

Gwynne, Patrick 33

н

Hagen, Ole 80 Hala, J. 283

Hammerborg, Jo 465, 474

Hanna, William 192 Hannam, R. E. 234 Hansen, Frank V. 502 Hansen, Karl Gustav 546

Harcourt, Geoffrey 240, 252, 258

Harlis, Edelhard 268 Harris, Ruth 68 Harris, W. M. 353 Hasse, Jøgen 232 Healey, Derek 318 Heath, Sandra 210

Hedegaard, Johannes 544

Helgar, H. 453 Henningsen, Poul 422 Henriksen, Bard 296

Heritage, Robert 204, 208, 247

Herman, Sam 410 Hertz, Gisela 55 Hicks, David 191

Higgins & Ney & Partners 38

Hildred, J. 424 Hislop, N. K. 271 Hitier, Jacques 194 Hjorth, Peter 427 Hlava, Pavel 380, 383 Hoffmann, Dr. Josef 498 Hoffstead, Gunther 236 Höglund, Erik 362, 372

Holdaway, Bernard 270 Hollman, Rudolf 422 Holmes, Robert 346 Homes, Ronald 469 Honzík, Stanislav 362

Hörlin-Holmquist, Kerstin 210

Hospodka, Josef 361 Hovig, Jan Inge 230

Howell, Killick, Partridge & Amis 83

Howell, Marie 300, 326

Hugener, Paul 318 Huguenin, Suzanne 300 Hunt, Alan 213 Hurka, Josef 460 Hvidt, Peter 232

Ilvessalo, Kirsti 78 Industrial Arts Institute 385, 446, 450, 462, 524, 529, 535, 537, 539 Ingrand, Max 191, 355, 372, 422, 444, 448, 469 Isler, Vera 154, 157 Isola, Maija 11, 310, 322, 336, 340 Ito, Yukio 396, 415

Jacobsen, Arne 189, 240, 258, 422, 498
Jakobsson, Hans-Agne 430, 431, 437, 447, 453, 460, 479, 488, 522, 528
Jalk, Grete 122, 193, 240, 276
Jansen, Ute E. 307
Jarnestad, Alf 515
Jefferson, Robert 482
Jensen, Allan 128
Jensen, Søren Georg 486, 500, 539
Johansson-Pape, Lisa 427, 432, 442, 449, 463
Juhl, Finn 147, 148, 207
Jung, Dora 339
Jutzi, Herbert 276

K
Kagan, Vladimir 184, 189, 191, 197, 280, 285
Kåge, Wilhelm 555, 556
Kähler, Nils J. 556
Kaipiainen, Birger 563
Kalmar, J. T. 470
Kammerer, Hans 169, 170, 173
Karlby, Bent 420
Karlsen, Arne 128, 427
Karpf, Peter 281, 285, 467, 546
Kaufeld, Hans 78
Kay, Pamela 318

Keeler, Gordon 519

Keith, H. B. 185 Kenneth G. Warren Associates 41 Kindt-Larsen, Edvard 209 Kindt-Larsen, Tove 207, 209, 320 Kirchoff, Ernst 236 Kirkegaard, Erik 282 Kjærgaard, Richard 484 Kjærholm, Hanna 75 Kjærholm, Poul 75, 186, 221, 280 Klingenberg, Inger 208 Klipp, Roy 228 Klitgaard, Alfred 483 Klöcker, Johann 534 Knight, Christopher 151, 153 Knoll, Florence 47, 56, 217 Knudsen, Th. Skjøde 482, 519 Kofod-Larsen, lb 192, 195, 220 Kolsi-Mäkelä, Maija 316 Konttinen, Raili 339 Koppel, Henning 437, 467, 486, 500, 501, 522, 524, 546, 549 Korhonen, Toivo 133, 136, 138, 239 Korsmo, Grete and Arne 509 Kosak, Ceno 470 Koschin, Serge 51 Kristensen, Erling Børup 508, 510 Kucher, Klaus 169, 170, 173

L
Laakso, Torsten 269
Lagersson-Brucs, Elsa 322
Lalique, René 362
Landberg, Nils 372, 373, 374, 406
Landels, Willie 289
Landrum, Darrell 245
Laprell 276
Larsen, Ejner 192
Larsen, I. Kofod 192, 195, 218
Larsen, Jack Lenor 114
Larsen, Kai Lyngfeldt 182, 193, 239
Larson, Lisa 555
Larsson, Axel 218
Lassen, Mogens 240

Laverne, Estelle and Erwine 186, 322, 326

Latham, Richard 516

Laws, Tony 511

Lax Design Associates 450 Lax, Michael 546 Le Corbusier 92, 106, 158 Lefebvre, Noel 512 Leinonen, Aulis 222 Lewenstein, Eileen 564 Liang Je, Kho 227, 252 Lie, Harry G. H. 98 Lind, Torben 506 Lindaas, Arne 516 Lindau/Lindekrantz 269 Lindberg, Stig 496, 534, 551, 554, 555 Lindh, Richard 542, 545 Lindstrand, Vicke 351, 356, 379, 385, 393 Linssen, Lojo 380 Lionni, Leo 319 Lipofsky, Marvin B. 410 Liskova, Vera 405 Littell. Ross 280 Littmarck, Barbro 508 Liukko-Sundström, Heljåtuulia 566 Locatelli, Alberto 334 Löffelhardt, Heinrich 352, 495, 531 Logan, lan 331, 470 Long, Ronald 185, 206 Longstreth, Thaddeus 51 Lundin, Ingeborg 355, 373, 374, 387, 393 Lütken, Per 364, 392

Madsen, Bender A. 192, 205, 217 Magistretti, Vico 8, 244, 245, 256, 262, 459, 476 Malmström, Annika 310, 313, 314, 322 Mandelius, Marianne 310 Mangiarotti, Angelo 249, 250, 458, 471, 562 Marenco, Mario 475 Mari, Enzo 9, 262, 536, 546 Marini, Marino 302 Markelius, Sven 56 Marshall, Brian R. 498 Martens, Dino 356, 359 Mascitti-Lindh, Francesca 558, 563 Massari, N. 293 Mathew, Dorothy 313

Mathsson, Bruno 180, 283
Matsumoto, Tadashi 483
Matta Echaurren, Roberto-Sebastian 288
Mayen, Paul 287, 477
Mazza, Sergio 292
McCarty, William 151, 153
McClay, Roger 436
McCulloch, Peter 314, 329, 342
McNish, Althea 302, 307, 310
Mellor, David 490, 512, 524, 541
Metsovaara, Marjatta 339
Meydam, F. 351, 358, 372, 373
Meyer, Grethe 353
Middelboe, Rolf 147

Mies van der Rohe, Ludwig 116 Miller, Ian 328 Minkin, Robert 520 Minshaw, John 535

Mogensen, Børge 128, 221, 230, 258, 322

Mølander, Hans Harald 59

Möller, Tom 373 Monk, John 295 Montagni, Danio 179

Morales-Schildt, Mona 355, 366, 383,

395, 402

Morassutti, Bruno 264 Mørch, Ibi Trier 353, 406 Mörch, Axel 502

Morgan, James 314 Mori, Masahiro 545

Moritz, Karin 322

Morrison, Andrew Ivar 292 Motzfeldt, Benny 382

Mourgue, Olivier 253

Müller, Walter 290 Munari, Bruno 249, 522, 536

Myers, Joel Philip 388, 390, 405, 409,

410, 415

Ν

N. Nakajima and Associates 119, 120

Nachi, Tomitaro 487 Natalini, A. 476

Nelson, George 106, 419 Neutra, Richard 49, 51

Neville Conder and Partners 65

Nicholson, Roger 318

Nicol, R. J. 201

Nielsen, Erling Zeuthen 128

Niemi, Jaakko 358

Nilsson, Ake 295

Nilsson, Arne 430

Noorda, Ornella 335

Nordsted, Bent 454

Noxon, Court 190

Nummi, Yki 420, 433, 442, 449, 463

Nuriac, Rosemonde M. 507 Nurmesniemi, Antti 245

0

Ochiai, Seitou 415

Ødegaard, Anne Marie 502

Offredi, Giovanni 291

Ohlsson, Folke 218

Ohrt, Timm 86

Okkolin, Aimo 402

Oldrich, Bob 501

Olin, Gunvor 515

Oliva, Lad. 352

Onions, Judith 545

Orup, Bengt 371, 385

Osaka Industrial Research Unit 467

Osgood, Jere 238

Østergaard, Stehen 292

Ottelin, Olof 210, 224

P

Pajamies, Esko 133, 136, 138, 238

Palmqvist, Sven 474, 376, 387, 392

Pamjo, R. 293

Panton, Verner 15, 18, 25, 186, 259, 278,

285, 295, 435, 467

Panula, Mirja 270

Parigi, Marcello 177, 179, 198

Parisi, Ico 163, 164, 167, 275, 444

Parisi, Luisa 163, 164, 167, 275

Parzinger, Tommi 431

Paulin, Pierre 19, 191, 210, 226, 232, 234,

252, 259, 278

Pehrson, Anders 453, 454

Penraat, Jettie 308

Persson, Inger 544

Persson, Sigurd 485, 490, 538

Petersen, Bente 487

Pick, Beverly 418

Picone, Guiseppe 325

Plastow, Norman 53, 55

Platner, Warren 287

Plaut, Erwin 226

Ploen, Erik 556

Plunkett, William 240, 270, 283

Pokorny, Jan Hird 29

Poli, Flavio 363

Ponti, Gio 42, 205

Pott, Carl Hugo 498, 508, 526, 532, 540

Pozzi, Ambrogio 551

Price, Brian 182

Pripp, John 519

Probst, Graham 215

Procopé, Ulla 496, 502, 503, 520

Puotila, Ritva 317, 339, 342

Pycha, Jaroslav 531

Pye, David 268

Q

Queensbury, David 514

Quistgaard, Jens 191, 452, 484, 495, 498,

511, 519, 520, 529, 541

R

Race, Ernest 185, 214

Rams, Dieter 273

Raphaël 181, 191, 256

Rauber. Helmut 88

Ravier, Jacques Levy 203

Ravier, Jacques Levy 205

Read, A. B. 438

Reich, Tibor 300, 302, 306

Relling, I. 206

Rendle, Timothy 65, 67, 264

Reynolds, R. 418, 420

Rhomberg, Ulrike 322

Rie, Lucie 556

Riedel, Claus Josef 382, 516

Rislakki, Eero 530

Risley, John 238

Risom, Jens 185, 235

Riva, Umberto 448

Rodriguez, Sergio 235

Rollason, Gerald 410 Rosén, David 189 Roth, Harald 238 Rottmayer, Otto 271 Royère, Jean 76, 181, 197, 203, 422 Rummonds, Richard 525 Ruth, Theo 227 Rutili, Renzo R. 181 Ruuth, Beret Helena 316, 320

Saarinen, Eero 47, 231 Salmenhaara, Kyllikki 558 Salocchi, Claudio 261, 275, 475, 476 Salto, Axel 554 Sampe, Astrid 327 Sandnes, Eystein 502 Sandström, Yngvar 189 Sarfatti, Gino 104, 444, 445, 464 Sarpaneva, Timo 356, 379, 382, 400, 471, 503, 520, 530, 541, 546 Sato, Nobuyasu 390, 396, 405 Scarpa, Afra and Tobia 265, 281, 285 Scharrer, Richard 531 Schlechter, Ivan 282 Schlup, G. E. 247 Schneider-Esleben, Paul 78 Schultz, Richard 287 Schweinberger, Emma 262, 459

Seidl, Alfred 390 Seike, Kiyosi 35 Sekkeisha, Rengo 70 Severin, Bent 535 Shine, Archie 55

Siard, M. 263, 273

Siiroinen, Erkkitanio 394, 412

Simberg, Uhra 315, 329 Simonis, Dick W. 490, 528 Sinnemark, Rolf 409 Siwinski, Stefan 212

Sjögren, Christer 386 Skawonius, Sven Erik 484, 515

Skrede, Agnar 498 Smrcková, Ludvika 364 Snadeberg, Ove 386

Snellman-Hänninen, Atelje Airi 332

Søren, Ham 210 Sotola, Vratislav 409

Sottsass, Ettore 275, 562, 563

Sowden, Harry 204 Spencer, Hugh 283 Spencer & Gore 34 Sproson, Bedard 519 Spurey, Kurt 549, 569 Stahel 430

Stáhlíková, Maria 352 Staples and Gray 475

Steck, John 519 Steiner, Margit 340 Stenberg, Gerd 326 Stene, John M. 184

Stennett-Willson, R. 359, 402, 405

Stenros, Pirkko 242 Stephensen, Magnus 486, 500

Stève, Laureat 314 Stewart, John D. 427

Still, Nanny 379, 394, 395, 412, 462,

514, 516 Strologo, Sergio Dello 379, 519

Strömberg, Asta 379 Summers, L. 422 Sundell, Britt-Louise 558

Sundstedt, Per 469 Superstudio 473 Svefors, Lennart 304 Svenson, Alf 218

Tabraham, J. H. 182, 207 Takahama, Kasuhide 214, 293, 396 Takeuchi, Atsuchi 282, 396, 405 Tapiovaara, Ilmari 212, 524, 541 Tartaglino, Franco Mazzucchelli 458 Taylor, Kenneth F. 68, 190 Taylor, Michael 320 Tedeschi, Mario 178

Tempelman, Theo 215 Terashima, Shogoro 482 Thorne, Ross 44

Thorsson, Nils 493 Thrower, Frank 405

Tiravanti, Lanfranco Bombelli 140, 142, 144

Tomula, Esteri 542 Törneman, P. 189 Torvinen, Pirkko 495 Toso, Ermanno 293, 361 Travasa, Giovani 295 Tümpel, Wolfgang 511

Uldall, Falle 490 Utzon, Jørn 146, 418

Turner, Georgia 506

Vallien, Bertil 386 Van Megen, Max L. 176

Van Rijk, G. 252, 278 Vasa, Olli 566

Vedel, Kristian 115, 230, 520

Veevers, Edward 318

Venturi, Renato 205 Veranneman, Emile 193, 197, 428

Verelst, H. 276 Vigano, Carlo 291 Vigo, Nanda 476 Villeneuve, Noel 475 Villon, Pascaline 314 Vittoria, A. 257 Vodder, Arne 208, 240 Volther, Poul 12

von Klier, Hans 243 Vosikkinen, Raija 537

Waeckerlin, Dieter 247 Wall, Peter 538 Wallance, Don 490 Wanscher, Ole 232 Wärff, Ann 387

Wärff, Göran 371, 380, 383, 387, 436

Watanabe, Riki 243

Wegner, Hans J. 192, 242, 283

Welch, Robert 463, 486, 488, 490, 498, 500, 522, 529, 533, 540, 542, 561, 564

Welsh, Catherine 519 Westerberg, Uno 427

Westman, Marianne 493, 516, 539

White, David 494
Wild, Werner 189
Willcox, Eliza 334
Wilson, W. J. 361, 512
Winblad, Bjorn 493, 551
Winkler, Svea 449, 463
Winkler, Werner 544
Winter, Edward 501
Winter, John 116
Winther, Ole 384
Wirkkala, Tapio 59, 183, 356, 432, 488, 506, 516, 525

Y Yarborough, E. Cooke 465 Yarborough-Homes 418 Yokoyama, Naoto 391, 406 Yoshida, Teruko 97

Wollner, Leo 313, 330

Wright, Russel 60, 62

Wren, David 470

Wormley, Edward 228, 287

Wohlert, Vilhelm 467 Wolkowski, Wladyslaw 482

Zanuso, Marco 249, 256, 283, 451

Yoshitake, Mosuke 456, 460, 534

Credits Bildnachweis Crédits

Artemide, Milan: 8, 10 right, 25 right
Bonham's, London: 25 left
Christie's Images, London: 11, 17, 18, 20–21, 23 right
Fiell International Ltd. – (photos: Paul Chave)
3 (Ross & Miska Lovegrove Collection), 4–5, 10 left,
12, 14, 16, 19, 24 (Ross & Miska Lovegrove Collection)
Louis Poulsen, Copenhagen: 15
Sotheby's, London: 9

DECORATIVE ART SERIES

More titles on architecture & design from TASCHEN

Decorative Art – 1950s Ed. Charlotte & Peter Fiell 576 pages 3–8228–6619–9 [ENGLISH/GERMAN/FRENCH]

Decorative Art – 1960s Ed. Charlotte & Peter Fiell 576 pages 3–8228–6405–6 [ENGLISH/GERMAN/FRENCH]

Decorative Art – 1970s Ed. Charlotte & Peter Fiell 576 pages 3–8228–6406–4 [ENGLISH/GERMAN/FRENCH]

Design of the 20th Century Charlotte & Peter Fiell 768 pages 3–8228–7039–0 [ENGLISH] 3–8228–0813–X [GERMAN] 3–8228–6348–3 [FRENCH]

sixties design
Philippe Garner
176 pages
3-8228-8934-2
[ENGLISH/GERMAN/FRENCH]

Furniture Design
Sembach/Leuthäuser/Gössel
256 pages
3–8228–0276–X [ENGLISH]
3–8228–0097–X [GERMAN]
3–8228–0163–1 [FRENCH]

1000 Chairs Charlotte & Peter Fiell 768 pages 3–8228–7965–7 [ENGLISH/GERMAN/FRENCH]

The Rudi Gernreich Book
Peggy Moffitt, William Claxton
256 pages
3-8228-7197-4
[ENGLISH/GERMAN/FRENCH]

Julius Shulman Architecture and its Photography Ed. Peter Gössel 300 pages 3-8228-7204-0 [ENGLISH] 3-8228-7305-5 [GERMAN] 3-8228-7334-9 [FRENCH]

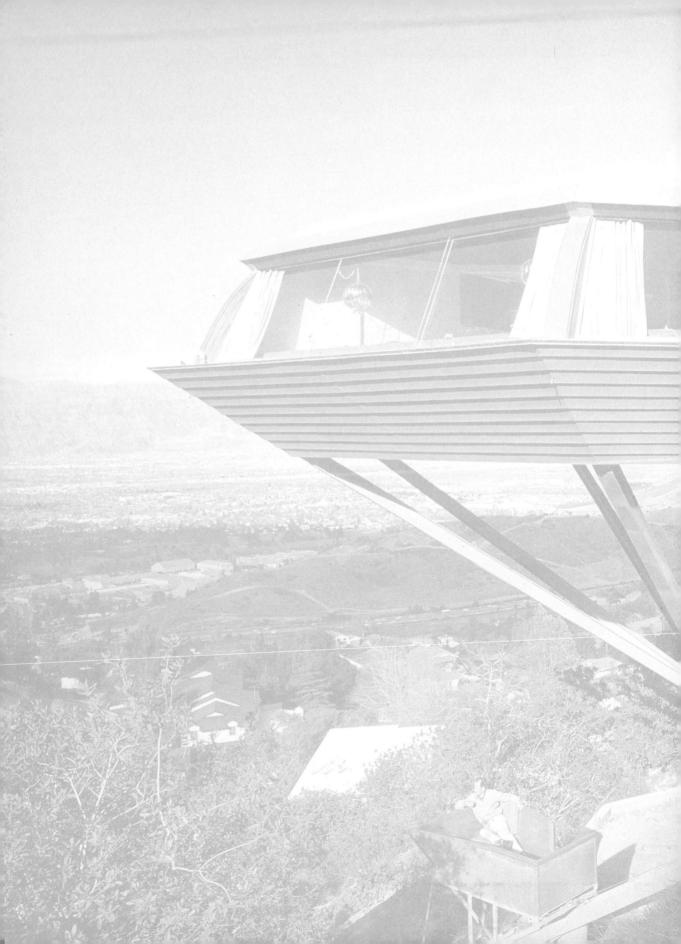